# Collecting the World

# JAMES DELBOURGO

# Collecting the World

*The Life and Curiosity of Hans Sloane*

ALLEN LANE
*an imprint of*
PENGUIN BOOKS

ALLEN LANE

UK | USA | Canada | Ireland | Australia
India | New Zealand | South Africa

Allen Lane is part of the Penguin Random House group of companies whose
addresses can be found at global.penguinrandomhouse.com

First published 2017
001

Copyright © James Delbourgo, 2017

The moral right of the author has been asserted

Set in 10.2/13.87 pt Sabon LT Std
Typeset by Jouve (UK), Milton Keynes
Printed in Great Britain by Clays Ltd, St Ives plc

A CIP catalogue record for this book is available from the British Library

ISBN: 978-1-846-14657-2

To
Rosella Maria Properzi
and
Laura Leonora Kopp

That a treasure like to this never was amass'd together, is beyond a doubt: all that is call'd great in its kind in the whole world becomes contemptible in the comparison; nor can we imagine that such an one ever can be compil'd again, unless such another almost miraculous combination of causes should appear to give it origin.

Zachary Pearce, Eulogy to Hans Sloane, 1753

Perhaps the most deeply hidden motive of the person who collects can be described this way: he takes up the struggle against dispersion.

Walter Benjamin, *The Arcades Project* (1927-40)

# Contents

List of Illustrations                                      xi

List of Maps                                              xv

Note on Conventions                                      xvii

Introduction: The Original Sloane Ranger                  xix

PART ONE
Empire of Curiosities

1 Transplantation                                          3

2 Island of Curiosities                                   37

3 Keeping the Species from Being Lost                     87

PART TWO
Assembling the World

4 Becoming Hans Sloane                                    141

5 The World Comes to Bloomsbury                           202

6 Putting the World in Order                              258

7 Creating the Public's Museum                            303

Acknowledgements                                          343

Notes                                                     349

Bibliography                                              425

Index                                                     473

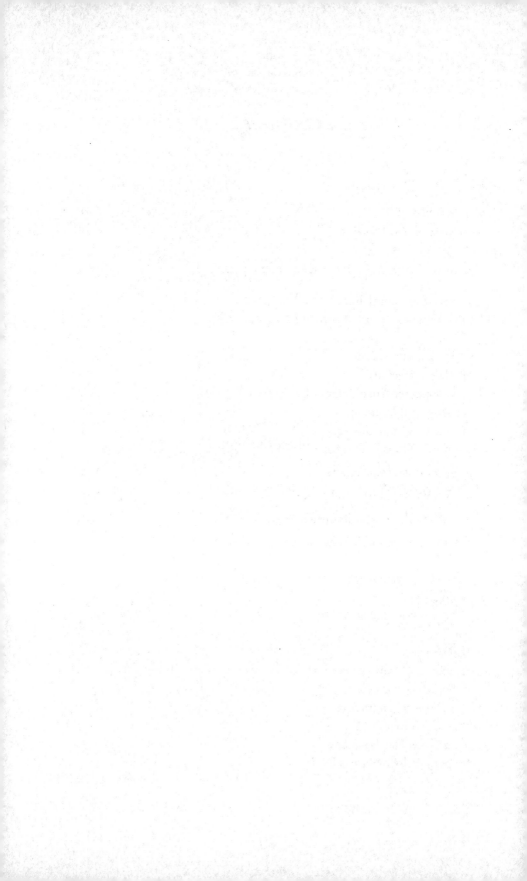

# List of Illustrations

## FIGURES

p. xxiv: The 'coral hand': Jan and Andreas van Rymsdyk, *Museum Britannicum* (1778). © British Library Board.

pp. 26–7: Curiosity cabinets as universal knowledge: Olaus Wormius, *Museum Wormianum* (1655). Courtesy John Carter Brown Library, Brown University.

p. 33: Coral-encrusted spar and coins with jellyfish: Sloane, *Natural History of Jamaica*, vol. 1 (1707). Courtesy John Carter Brown Library, Brown University.

pp. 60–61: Maps illustrating Sloane's Caribbean voyage: Sloane, *Natural History of Jamaica*, vol. 1 (1707). Courtesy John Carter Brown Library, Brown University.

p. 66: Jamaican crab specimens with fragments of pots: Sloane, *Natural History of Jamaica*, vol. 1 (1707). Courtesy John Carter Brown Library, Brown University.

p. 82: Sloane's Jamaican 'strum strums': Sloane, *Natural History of Jamaica*, vol. 1 (1707). Courtesy John Carter Brown Library, Brown University.

p. 83: African music in the Americas: Sloane, *Natural History of Jamaica*, vol. 1 (1707). Courtesy John Carter Brown Library, Brown University.

pp. 104–5: Cacao specimen and sketch: Sloane Herbarium (5:59). © Trustees of the Natural History Museum, London.

p. 106: Cacao engraving: Sloane, *Natural History of Jamaica*, vol. 2 (1725). Courtesy John Carter Brown Library, Brown University.

pp. 108–11: The Jamaican mammee tree: Sloane Herbarium (7:58–9). Photography by James Delbourgo, © Trustees of the Natural History

Museum, London; Sloane, *Natural History of Jamaica*, vol. 2 (1725). Courtesy John Carter Brown Library, Brown University.

p. 119: The Jamaican skink (*Scincus maximus fuscus*) or galliwasp: Sloane, *Natural History of Jamaica*, vol. 2 (1725). Courtesy John Carter Brown Library, Brown University.

p. 123: Burrowing worms: Sloane, *Natural History of Jamaica*, vol. 2 (1725). Courtesy John Carter Brown Library, Brown University.

p. 133: Jamaican yellow snake: Sloane, *Natural History of Jamaica*, vol. 2 (1725). Courtesy John Carter Brown Library, Brown University.

p. 155: Book-wheel: Grollier de Servière, *Recueil d'Ouvrages Curieux de Mathématique et Mécanique* (1719). © British Library Board.

p. 174: Chelsea Manor: Thomas Faulkner, *An Historical and Topographical Description of Chelsea* (1829). © British Library Board.

p. 179: Chelsea Physic Garden: engraving by John Haynes (1751). © The Royal Society.

pp. 188–9: Sloane's banking ledgers: Ancaster Deposit, with the permission of Lincolnshire Archives and the Grimsthorpe & Drummond Castle Trust.

p. 196: Design for a medal of Newton and Sloane by Jacob Smith, after Jacques Antoine Dassier (1733). © Trustees of the British Museum.

p. 198: Jamaican lagetto: Sloane Herbarium (5:82). © Trustees of the Natural History Museum, London.

p. 199: Trade card for Sloane Milk Chocolate. © Trustees of the British Museum.

p. 210: William Hogarth, *Marriage à la Mode*, part IV, 'The Toilette' (1743). © Trustees of the British Museum.

p. 268: Sloane's annotated *Natural History*: *Natural History of Jamaica*, vol. 1 (1707). Photography by James Delbourgo, © Trustees of the Natural History Museum, London.

p. 321: Montagu House: James Simon, 'Mountague House' (c. 1715). © Trustees of the British Museum.

p. 322: Touring the British Museum. By permission of Tony Spence and Marjorie Caygill.

## PLATES

1. *Sir Hans Sloane* by Stephen Slaughter (1736). NPG 569: © National Portrait Gallery, London.
2. 'Shipping Sugar' by William Clark (1824). Courtesy of the John Carter Brown Library, Brown University.
3. African market in Antigua by William Beastall (1806). Courtesy of National Maritime Museum, London.
4-6. Jamaican specimens and drawing: Sloane Herbarium (3:62, 2:2 and 3:106). Photography by James Delbourgo, © Trustees of the Natural History Museum, London.
7. Jamaican clammy cherry tree: Sloane Herbarium (7:7). Photography by James Delbourgo, © Trustees of the Natural History Museum, London.
8. *Lonchitis altissima*: Sloane Herbarium (1:51). Photography by James Delbourgo, © Trustees of the Natural History Museum, London.
9. Glazed earthenware cups. © Trustees of the British Museum.
10. Pharmacopoeia drawer. © Trustees of the Natural History Museum, London.
11. Instruments from a Chinese surgical cabinet. © Trustees of the British Museum.
12. Cappasheir's knife and sheath. © Trustees of the British Museum.
13. Surinam shaddock fruit with moths, caterpillar and chrysalis by Maria Sibylla Merian. Sloane MS 5275.29: © Trustees of the British Museum.
14. Jewelled turban button from Mughal India. © Trustees of the Natural History Museum, London.
15. Procession to the court at Edo, from Engelbert Kaempfer, *Japan Today* (1727). Sloane MS 3060, fol. 501: © British Library Board.
16. Portable Buddhist shrines. © Trustees of the British Museum.
17. Inuit sun visor. © Trustees of the British Museum.
18. Akan drum. © Trustees of the British Museum.
19. Amerindian map. Sloane MS 4723: © British Library Board.
20. *Audience Given by the Trustees of Georgia to a Delegation of Creek Indians* (1734–5) by William Verelst. Courtesy Winterthur Museum.
21. American asbestos purse. © Trustees of the Natural History Museum, London.

22. Pipe bowl or calumet. © Trustees of the British Museum.

23. John Bartram's silver cup. Courtesy of Kislak Center for Special Collections, Rare Books and Manuscripts, University of Pennsylvania.

24. *William Dampier* by Thomas Murray (1697–8). NPG 538: © National Portrait Gallery, London.

25. *Ayuba Suleiman Diallo (Job ben Solomon)* by William Hoare (1733). NPG L245: OM.762, Orientalist Museum, Doha.

26. Persian amulets with Qur'ānic inscriptions. © Trustees of the British Museum.

27. Spoon head made from auk bone. © Trustees of the British Museum.

28. A Turk and an Indian: from Engelbert Kaempfer at Isfahan, Persia, in 1684–5. Sloane MS 5027.b: © Trustees of the British Museum.

29. The Gurney herbal. Sloane MS 4013: © *British Library Board.*

30. Sloane's Antiquities Catalogue. © The Trustees of the British Museum.

31. One of ninety drawers containing Sloane's 'Vegetable Substances' collection. Photography by James Delbourgo, © Trustees of the Natural History Museum, London.

32. Pimiento specimen from Sloane's 'Vegetable Substances' collection. Photography by James Delbourgo, © Trustees of the Natural History Museum, London.

33. Guinea butterfly in mica sleeve. Photography by James Delbourgo, © Trustees of the Natural History Museum, London.

34. Sloane's shoe collection. © Trustees of the British Museum.

35. Magical instruments belonging to the Elizabethan adept John Dee. © Trustees of the British Museum.

36. Flint hand-axe excavated from Gray's Inn. © Trustees of the British Museum.

37. Carved nautilus shell with putti. © Trustees of the Natural History Museum, London.

38. The vegetable lamb of Tartary. © Trustees of the Natural History Museum, London.

39. Oak branch inside an ox vertebra. Photography by James Delbourgo, © Trustees of the Natural History Museum, London.

40. Sámi drum. © Trustees of the British Museum.

41. Glass vases of imitation realgar. © Trustees of the British Museum.

42. British Museum seal, 1755. © Trustees of the British Museum.

# List of Maps

1. London in the eighteenth century      144–5
2. East India Company settlements in
   South and East Asia, 1660–1760      214–15
3. The North Atlantic, *c.* 1740      232–3

# Note on Conventions

For the reader's convenience, I have eliminated gratuitous capital letters and italics in quotations but have retained original spelling. All dates are Old Style but treat the year as starting on 1 January. Original place and language names are given with modern equivalents in parentheses.

# Introduction:
# The Original Sloane Ranger

London, 1748. One June day, Frederick, Prince of Wales and his wife the Princess Augusta make the journey from the city to the village of Chelsea, just west along the Thames, to see 'a most magnificent philosophical entertainment'. Their destination: a former residence of King Henry VIII, Chelsea Manor. On arrival they are greeted by Cromwell Mortimer, secretary of the Royal Society – Britain's pre-eminent scientific institution. Mortimer professes 'the honour' it gives him to kiss the royal couple's hands as they alight from their coach. 'Laying aside all ceremony', the prince pledges that he and the princess shall be 'entirely under his guidance and directions'. Mortimer leads them upstairs where the current resident of the Manor awaits. Their host is the most famed collector of the day and the royal party has come to see his museum of curiosities from around the globe. The prince sits a while with this 'good old gentleman' and conveys 'the great esteem and value he [has] for him personally, and how much the learned world [is] obliged to him' for amassing such marvels.[1]

The tour commences with the spectacle of stones both alluringly beautiful and decidedly curious. The collector's assistants have arranged tables in three front rooms decked out with open drawers bristling with 'precious stones in their natural beds' as well as bezoars or 'concretions in the stomach', 'stones formed in animals, which are so many diseases of the creature that bears them' and stones from 'the kidneys and bladder[s]' of people. Mortimer poetically explains that the more exquisite specimens come from the 'bosom' of the earth, and he luxuriates in their chromatic variety: 'the verdant emerald, the purple amethist, the golden topaz, the azure saphire, the crimson garnet, the scarlet ruby, the brilliant diamond, the glowing opal, and all the painted varieties

that Flora herself might wish to be deck'd with'. The royal couple are also shown 'the most magnificent vessels of cornelian, onyx, sardonyx and jasper'. These '[delight] the eye', Mortimer states, yet do not fail to prompt spiritual reflection as well by raising 'the mind to praise the great creator of all things'.

The prince and princess stand aside while the displays are changed. As if the stage for a gluttonous banquet, the same tables are made to exhibit 'a second course with all sorts of jewels' and 'gems carv'd or engraved', now joined by the 'stately and instructive remains of antiquity'. The royal guests step aside once more while a 'third course' of this opulent mineral feast is served up featuring gold and silver ores, to which are added whole new classes of objects including 'precious and remarkable ornaments us'd in the habits of men, from Siberia to the Cape of Good Hope, from Japan to Peru', as well as coins and medals stamped with celebrated visages from the ancient world to the present such as Alexander the Great and King William III. The tour moves into a gallery measuring over 100 feet in length, festooned with corals, crystals, fossils and 'the most brilliant butterflies, and other insects', painted shells, and feathers 'vying with [the] gems' for vibrancy, followed by 'the remains of the antediluvian world'. They pass through chambers lined with manuscripts, books and albums – among them twenty-five volumes of prints sent by the King of France – accompanied by 334 herbarium volumes containing dried plants from around the world. Moving downstairs, they enter several rooms 'filled with curious and venerable antiquities' from Egypt, Greece, Etruria, Rome, Britain 'and even America'. The 'great saloon [is] lined on every side with bottles filled with spirits' that contain numerous animals while the halls are 'adorned with the horns of divers creatures, [such] as the double-horn'd rhinoceros of Africa' and 'deer's horns from Ireland nine feet wide'. Mocking Britain's great eighteenth-century rivals, Mortimer observes how the 'weapons of different countries' show that the 'Mayalese' (Malaysians) 'and not our most Christian neighbours the French, had the honour of inventing that butcherly weapon the bayonet'. He concludes by paying homage to the prince, acknowledging the 'many judicious remarks' Frederick utters in his presence. The prince, meanwhile, declares his 'great pleasure' at seeing 'so magnificent a collection in England'. 'How great an honour will

redound to Britain', he adds, 'to have it established for publick use to the latest posterity.'

Remarkably, within five short years, this is exactly what happened. The British Parliament purchased the Chelsea collections in 1753 and created the British Museum to house them. But who was responsible for accumulating such an astonishing array of curiosities in the first place? How had they been brought to London and how did they occasion the founding of the world's first free national public museum?

The man behind the collections, and the British Museum, was Sir Hans Sloane (1660–1753). It was Sloane who hosted the prince and princess in Chelsea. But who was he and why did he make these collections? Although Sloane Square is one of the most famous addresses in London today, Sloane's exploits remain little known. Born in Ulster in the year of the Restoration of Charles II, Sloane became one of the leading figures in science and medicine in the seventy years between the Glorious Revolution and the Seven Years' War. His life spanned several historical transformations that allowed him to assemble a formidable range of collections, as the British Isles evolved from a group of peoples riven by religious and ethnic conflict, deriving their livelihood primarily from agriculture, into a more united and prosperous nation that came to command the most extensive commercial empire in the world. This empire reached from North America and the Caribbean islands to South and East Asia, and thrived on the profits of the Atlantic slave trade and plantation system that generated unprecedented wealth for many, Sloane included. It was through this empire that Sloane made his fortune; constructed a vast network for making collections; and established the unique legacy of a free public museum dedicated to the ideal of universal knowledge. This book tells their story and, in so doing, reveals how encyclopaedic collecting on a global scale shaped the origins of the modern museum.

Sloane's is a curious case of fame and amnesia combined. His name has always remained visible in London, etched on to its very streets: Sloane Square, Hans Crescent, Hans Town, Hans Place, Sloane Street and Sloane Avenue, mostly developed in the 1770s by the architect Henry Holland on land originally owned by Sloane in what is now the Royal Borough of Kensington and Chelsea. Sloane's heirs, the Earls Cadogan,

are today the largest landowners in the borough and among Britain's wealthiest families. In Sloane Square, a restaurant named The Botanist contains an unexpected shrine to its hero: the back wall features specially coloured engravings of Caribbean specimens that Sloane collected on a voyage he made to the colony of Jamaica in 1687. The original plants on which many of these are based survive in the Sloane Herbarium at the nearby Natural History Museum, where the star attraction is the cacao sample Sloane brought back three centuries ago. At the Royal Society, where Sloane became president, the caption accompanying his portrait by Godfrey Kneller states not only that his curiosities 'formed the foundation collection of the British Museum' but also claims that he 'invented milk chocolate'. A historic trade card suggests that the Cadbury brothers used a Sloane recipe for their own famed brand, while the engraving he commissioned of his Jamaican cacao specimen today adorns boxes of Hans Sloane Chocolates. Additional portraits, statues and busts of Sloane can be found off the King's Road, in Chelsea Physic Garden (the forerunner of Kew Gardens), the British Library, the British Museum and the National Portrait Gallery. Asking people what Sloane *did*, however, draws a blank. In the 1980s, Sloane Rangers were much derided as the well-heeled denizens of Sloane Square, but such notoriety sparked little awareness of Sloane himself. Because the British Museum does not bear his name, the link between the two is often missed. Indeed, Sloane is frequently confused with Sir John *Soane*, the architect who redesigned the Bank of England in the nineteenth century and whose house in Lincoln's Inn Fields remains open to the public. Sloane's original abode, off Bloomsbury Square, does not, and the house at Chelsea Manor no longer stands.[2]

Sloane's story lies buried in layers of later history. Popular memory of the British Empire, for example, focuses on the Victorian and Edwardian eras, and India and Africa, glossing over earlier centuries when it was the West Indies that fired colonial ambitions. Narratives of the history of science have long venerated figures in physical science like Sloane's contemporary Isaac Newton, spinning tales of solitary genius while ignoring the highly social form of science Sloane practised through a network of correspondents: natural history. Even in natural history, Sloane has been eclipsed by the Swedish taxonomist Carolus Linnaeus, whose transformation of plant and animal classification in the eighteenth century upended botany as Sloane had known

it. British histories of science and empire have also neglected Sloane, often beginning instead with Joseph Banks's journey to the Pacific with Captain Cook in 1768, innocuously framed as a 'voyage of discovery' funded by an enlightened state in the pursuit of useful knowledge. And only occasionally have Sloane's contributions to what early modern Britons called 'the natural history of man' been acknowledged as part of the long history of ethnography. Next to heroic tales of figures like Newton, Linnaeus, Banks and later Charles Darwin, Sloane's scientific odyssey as a curiosity collector who ventured into the disturbing world of Atlantic slavery, where African men and women toiled to profit British merchants and planters, has proven a far harder story to tell.[3]

Sloane's neglect is particularly striking given that he became president of both the Royal Society and the Royal College of Physicians, that he published one of his era's most lavish natural histories, that he was instrumental in creating the British Museum and that many of his objects later became core collections in other major institutions: London's Natural History Museum, which opened in 1881 and houses his specimens, and the British Library, whose autonomous existence began in 1973 and which houses his library. A large part of these collections survives, including thousands of preserved plants in the Sloane Herbarium; objects and picture albums, numbering in the hundreds, held in the British Museum; thousands of letters, manuscripts, pictures and printed books at the British Library; and forty-four of his original fifty-four handwritten catalogues. These remarkable collections, perhaps the largest assembled by a single individual in the eighteenth century, Sloane assembled using the substantial sums he earned as a society physician, income from Jamaican slave plantations, rent collected on land in London and salaries from public offices.[4]

Sloane ranged. When the breadth of his activities is confronted, the paradox of his neglect comes into focus: Sloane is nowhere because he was everywhere. He has become invisible to us today because we cannot categorize him, since his career connected domains we now see as unrelated. Imagine the core collections of the British Museum, the British Library and the Natural History Museum all under a single roof – artefacts, books and manuscripts, plant and animal specimens. That was the roof of Sloane's house. Imagine the person assembling these collections conducting one of the most profitable medical practices in London and one of the most extensive private correspondences in

the world, writing to savants around Europe, settlers in Britain's American colonies and journeymen around India and China. Imagine that same person assembling a globally sourced plant herbarium in search of useful new drugs yet also collecting such curiosities as an enigmatic 'coral hand' (below) and a 'shoe made of human skin'; the head of an Arctic walrus and an array of magical amulets; drawings of specimens commissioned by the King of France and Buddhist shrines smuggled out of Japan; manuscripts ranging from travellers' journals to handwritten copies of the Qur'ān. Finally, imagine this grand architect of early modern European learned life – the Republic of Letters – trafficking in commercial intelligence of all kinds while watching over his family's plantations in the West Indies. Sloane did all these things and more.[5]

Sloane's neglect is most of all a result of the division of knowledge since the eighteenth century. To our eyes, his brand of natural history seems hopelessly eclectic in its universal reach: how could manuscripts

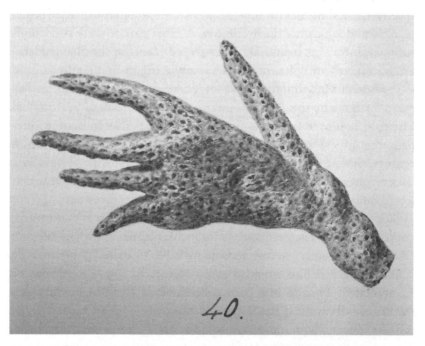

Drawing of Sloane's 'coral hand' in an early guide to the British Museum: Sloane collected curiosities of all kinds, including ones that pointed to patterns of design in nature such as the 'coral hand'.

and shells, medals and animals all merit the term 'curiosities'? His plants look recognizable enough as scientific specimens; but not so his coral hand or shoe made of skin. These varied collections, originally conceived as one, were subsequently divided in the nineteenth and twentieth centuries, as specialized modern disciplines like biology, geology, anthropology and archaeology became defined and codified, reorganizing museums in the process. Today, researchers must go to the British Library at St Pancras to read Sloane's manuscripts; to the British Museum on Great Russell Street to examine his objects; and to the Natural History Museum in South Kensington to study his plants. This physical division of the collections into different institutions has proven a stubborn obstacle to understanding the totality of what he did and why. Call it the puzzle of the Piccadilly Line: it should have been easy to take the tube and study Sloane's manuscripts, objects and specimens together, but scholarly specialization and the division of the arts and the sciences have inhibited the very idea.[6]

Not only have Sloane's collections been divided, they have often been scorned. While his European manuscripts remain intact and frequently used in the British Library, and his herbarium is still working material for botanists, other parts of the collections have been destroyed, thrown out, put into storage or simply ignored. By the early nineteenth century, the majority of his animal specimens lay 'mouldering or blackening in the crypts of Montagu House, the tombe or charnel-house of unknown treasures', prompting the curator William Leach, who 'despise[d] the taxidermy of Sir Hans Sloane's age', to organize 'cremations' that sent 'the pungent odour of burning snakes' wafting down the museum's terraces. Those animals, numbering in the thousands, are now all but gone. The nineteenth century saw a series of astonishing antiquities enter the museum, from Athens's Parthenon Marbles to the Assyrian sculptures of Nineveh and Nimrud, eclipsing Sloane's curios in the process. By 1852, one guidebook described Sloane's objects as forming 'a very insignificant part' of the museum, while the following year antiquities curator Augustus Franks came upon a medieval English astrolabe of Sloane's 'in the cellars among refuse, covered with rust'. An article in 1935, in that well-known museological record the *Daily Mail*, recounted the rescue of one of Sloane's pharmacopoeia drawers filled with 'scientific and superstitious remedies' from the basement of the Natural History Museum under the

heading ' "Magic" Chest [Found] among Rubbish'. Over time, Sloane became the curiosity at the heart of his own museum and the fortune he spent on his collections the measure of his folly. The 'fanatical' Sloane 'paid the surprisingly large sum of 10 shillings (50p) for this specimen', reads the twentieth-century caption for 'the vertebre of an ox through the hollow of wch passed an oak twigg wch grew above and below it swelling out' (Plate 39). Curators and scholars have differed over whether Sloane was a harbinger of the Enlightenment or the kind of figure the Enlightenment, in its dedication to systematic rational classification, had to sweep away. The great historian of medicine Roy Porter cheerfully listed Sloane as a member of 'any Enlightenment first team' but wrote virtually nothing about him. As recently as 1974, histories of the British Museum spoke of its 'confused beginnings' and of Sloane as a 'flamboyant eccentric'. Was Sloane one of the heroes of modernity or a pre-modern embarrassment? Only in 2003 did the museum restore its founder to a measure of visibility in its new 'Enlightenment Gallery'. But to a large extent Sloane's story remains untold, both in that gallery and beyond.[7]

To understand how and why Sloane collected requires two voyages: one into his collections and one out into the world from which he gathered them. The first involves setting aside triumphalist narratives of scientific progress that distort the past by judging it according to present concerns and focusing only on those elements that lead to the present as we see it. Treating Sloane as a fully historical figure, on the other hand, necessitates reconstructing past structures of thought and practice as much as possible on their own terms: rather than try to pull Sloane into our world, we must enter his. The point is obvious but essential because Sloane has often been marginalized by narratives of the seventeenth-century Scientific Revolution that focus narrowly on the physical sciences and the actions of a small cast of characters in metropolitan Europe alone. Sloane, by contrast, reorients our entire conception of early modern science by forcing us to open our gaze to the pursuit of natural history on a global stage through the many exchanges of knowledge that took place across cultures in this era. Though traditionally overlooked by scholars because he invented neither new theories nor new classification systems, Sloane's career demonstrates the scale on which knowledge was already globalized by the eighteenth century and how its accumulation was actually carried out. Here was a man with both the inclination and

the resources to sample and survey every single thing in God's creation – to collect and catalogue the variety of the world, or so he dreamed. But how?

Even histories of collecting have paid scant attention to this question. They have used Sloane to mark the emergence of the modern public museum as his great posthumous legacy but gloss over his vision and how he tried to realize it during his own lifetime. The marvels and rarities of the curiosity cabinets or *Wunderkammern* (wonder-cabinets) of the Renaissance – the tradition out of which Sloane's collecting emerged – were long excluded from histories of science because they were deemed unscientific by later standards. This dismissal was decisively challenged, however, by Michel Foucault in *The Order of Things*, published in 1966. The futile bloody carnage of the First World War had moved artists and thinkers early in the twentieth century to question celebratory narratives of modernity and the progress of civilization based on reason, science and technology. The Surrealists, as they became known, chief among them André Breton, became fascinated by curiosities precisely because they defied rational classification. Half a century later, Foucault found inspiration in the writings of Jorge Luis Borges, specifically his essay 'The Analytical Language of John Wilkins' (1942). In this work, Borges recounted how Wilkins, one of the founders of the Royal Society, sought to devise a universal or natural language for classifying every thing in the world, in his 1668 *Essay towards a Real Character and a Philosophical Language* (one of the first books Sloane acquired for his library). Borges, however, countered that the kinds of classifications Wilkins proposed were not in fact natural or rational but arbitrary. He compared them to an imaginary 'Chinese encyclopaedia entitled the "Celestial Empire of Benevolent Knowledge"', which sorted animals into comically asymmetrical categories: animals '(a) belonging to the emperor, (b) embalmed, (c) tame, (d) sucking pigs . . . (h) included in the present classification . . . (k) drawn with a very fine camelhair brush, (l) et cetera'. The lesson Foucault drew from Borges's fantastical list was not so much that the past was a foreign country as that foreign countries pointed to Europe's own past. Borges's Chinese encyclopaedia suggested the possibility of finding exotic yet discernible principles of order in early European classification systems, whose histories Foucault and subsequent scholars then proceeded to reconstruct. The key to this historical recovery was the

realization that what was considered scientific or rational was not static or fixed but varied according to time and place.[8]

Borges's association of curious classification systems with exotic societies points to the second voyage required to make sense of Sloane's collections: one out into the British Empire and the early modern world. Sloane's engagement with that world has been interpreted very differently over time. His last biographies, published in 1953–4, treated his story essentially as a European one, despite his voyage to Jamaica and his many colonial connections. One of those biographers was the evolutionary biologist, veteran of military intelligence and director of London's Natural History Museum Gavin de Beer, who lionized Sloane as a model of disinterested truth-seeking and international cooperation during wartime. This was a Cold War view of Sloane: writing in years fraught with the dread of nuclear war, de Beer in his aptly titled book *The Sciences were Never at War* (1960) held Sloane up as exemplary of how scientists should be 'above the battle' in political affairs. But half a century later a rather different Sloane emerged from feminist historian of science Londa Schiebinger's groundbreaking *Plants and Empire* (2004), which showed how Sloane's work in natural history was part of the militarized expansion of European capitalism, in which rival empires fought rapaciously to seize natural resources from indigenous peoples through violent means such as slavery. From Cold War diplomat to neo-liberal bioprospector, accounts of Sloane's engagement with his world have inevitably shifted with changing preoccupations.[9]

Scholarly accounts of collecting, especially art, often emphasize the 'passion' and individual psychology of the collector. But this approach gives individuals too much credit and their contexts too little. *Collecting the World* argues above all that for Sloane collecting a world of things meant collecting a world of people. Universal knowledge demanded universal acquaintance, up and down the social hierarchy and reaching across different cultures. As the sociologist and philosopher Bruno Latour has pointed out, the word *assemble* means both to construct something and to bring people together. *What* Sloane assembled was a function of *whom* he assembled. The origins of the British Museum lie in the many relationships he cultivated in Britain and around the world, as well as the contacts his correspondents cultivated among the peoples of Asia, the Americas and beyond. These networks were not the context for Sloane's work, they *were* his work, and

required constant management and negotiation. But what sort of creature was the man at the heart of this web? That the identity of a collector may be discovered in his or her possessions is a renowned cliché. Books and films have often explored this notion, most famously Orson Welles in *Citizen Kane* (1941), where journalists investigating the death of the eponymous newspaper magnate (based on William Randolph Hearst) scour his enormous collections for clues to the meaning of his dying words and thus his life. Yet, it seems, the more someone collects, the harder they become to find in their collections – Kane dies an enigma.[10]

In the pages that follow what is striking is not how much Sloane revealed himself through his collections but, rather, how little. There were different Sloanes to different people: friends praised his conviviality and good company but at least one contemporary judged him reticent and a poor speaker, and he made his share of enemies. The collector who amasses such a varied museum haunts posterity: it beggars belief that one person could make so many judgements about so many different things. In Sloane's case, the key to the puzzle is that he did *not* make such judgements alone, often relying on others. Yet there *is* a personal story in his collections that has never been told. This is the tale of Sloane the outsider, the Ulsterman in London, the consummate tactician who eschewed conflict in favour of discretion, connection and advancement in Britain's imperial capital, turning himself into one of its shrewdest resident gentlemen and a pillar of the establishment. It is also the story of Sloane the doctor, the professional identity that shaped his judgements about what counted as science rather than superstition, and about who was enlightened and who was not – judgements that animated his collecting and informed his vision of his museum. This story, hitherto invisible in institutional histories of the British Museum, is explored in the chapters that follow. They describe how Sloane realized his dream of universal knowledge through a brilliant alignment of institutions of state, trade and colonization to serve his personal ambition.[11]

Sloane's story is told here through his manuscripts, correspondence and published writings but also, and for the first time, through his surviving specimens, objects and their voluminous catalogues. Part One charts his colonial origins and travels. Chapter 1 traces Sloane's Irish background in the years after the Restoration, his relocation to

London and his training as a physician, including a tour of France, set in the context of early modern science, collecting and colonization. Chapters 2 and 3 show how slavery provided an essential foundation for Sloane's scientific career, medical reputation and personal fortune. They focus on his voyage to Jamaica as physician to the governor and the fifteen months he spent there, doctoring and making collections through extensive interactions with the island's planters and also its African slaves. The specimens he collected enabled the production of an encyclopaedic two-volume *Natural History of Jamaica* (1707–25), which established him as a leading naturalist on topics ranging from botany to race. The process by which Sloane turned specimens into scientific art for his lavishly illustrated book, cataloguing the resources of England's rising slave colony as an exemplary work of colonial science, is described in detail.

Part Two traces Sloane's rise in London after the Glorious Revolution as one of Britain's elite physicians with a central role in public medicine, and as a fixture of the Whig establishment and ambitious collector. Chapter 4 shows how Sloane set himself up in private practice while securing a key position at the Royal Society, acquiring numerous offices and completing his *Natural History*. But it also argues that from early on Sloane's natural history collections, associated as they were with new professional fortunes and the profiteering of global trade, were vexed by accusations of intellectual shallowness and social climbing. Not everyone saw the beauty or utility of all those curious bezoar stones Sloane delighted in showing off. Global trade enabled the pursuit of universal natural history, aimed at gathering as much of the world's variety as possible, yet troubled its status in an era of ambivalence about Britain's interactions with the wider world. Chapter 5 reveals how Sloane's collections were the fruit not of individual genius but of collective labour, exploring the processes by which numerous colonial travellers in foreign cultures generated the contents of his ever-expanding museum and how he negotiated with them to obtain their curiosities. Chapter 6 shows how managing the collections through cataloguing, labelling and annotating also required collective endeavour through a team of curators, to realize Sloane's dream of total information architecture, even as he began to display his museum to friends, scholars and dignitaries. It examines how Sloane envisioned his collections as a providential exhibition of natural resources to be exploited by enlightened savants while

mocking those who saw nature as a magical entity to be coaxed with spells and charms. Critics, however, continued to doubt the pretensions of the parvenu physician, deriding his growing museum as the expression of a corrupt materialism.

Finally, Chapter 7 describes how the British Museum came into being as a result of the terms Sloane laid down in his will. As people collect objects, objects collect people, drawing communities to them that preserve, study and venerate them. The idea of some form of public museum was not new in Sloane's day but a legacy of the ancient world. The library at Alexandria in fourth-century Egypt, for example, was part of its Musaeum, a term originally denoting a temple devoted to the Muses (the mythical goddesses who inspired literature, culture and the arts), designed for a community of scholars and modelled on Aristotle's school at Athens. Sloane's vision *was* original, however, in calling for a universal museum in both senses: a gathering of all the things of the world open to all the citizens of the world. The result was the creation of the world's first free national public museum, although the terms of public access were to be bitterly contested and even resisted by the museum's early managers. The establishment of the British Museum thus produced both a great historical irony and an enduring cultural debate. It created the conditions for Sloane's subsequent disappearance within the walls of his own museum and, more importantly, posed an urgent question still with us today. What – and who – are public museums for?[12]

# Empire of Curiosities

# I

# Transplantation

## THE NATURE OF OTHER COUNTRIES

The few memories Sloane recorded of his youth tell of a life lived hunting after nature's treasures. He had always been 'very much pleas'd with the study of plants, and other parts of nature', he recalled in the introduction to his *Natural History of Jamaica* in 1707, and had seen many curiosities 'either in the fields, or in the gardens or cabinets of the curious' in his native land. In 1710, thanking the Earl of Cromertie for a description of the curiosities buried in the bogs of Scotland occasioned a comparison with his home soil. 'I have seen many such,' Sloane told the earl, 'and know your Lordship's account of them to be very exact and true.' Sloane remembered watching labourers cut up turf to harvest peat for fuel and how they discovered fir trees' roots and stumps, the roots' branches matted together under the sod. This wood was sometimes turned into candles or rope, and used for windmill posts and masts for ships. There were skeletons of giant elk, golden chains, 'pieces of money', and bark that locals used to fashion vessels for storing butter. Years later in 1725, thanking the Yorkshire botanist Richard Richardson for some specimen woodcock birds, Sloane recounted how he used to visit 'many small uninhabited islands' as a boy 'where the ordinary sea-mews, &c. have laid their eggs often on the ground, without any or with at least very small nests, so thick, that it was difficult to pass along without treading on them; while the birds made a terrible noise over our heads'. The scene is brief but suggestive of the career that followed: Sloane and his companions coolly invade a natural preserve to gather precious specimens, unfazed by the uproar around them.[1]

These scenes took place not in England or Scotland, or on some

3

remote tropical isle, but in Ulster in the north of Ireland where Sloane was born and grew up. The world of his youth was one remade by the Protestant Reformation, the conflicts it fostered in the British Isles, the union of the Crowns that created the nation of Great Britain and England's colonization of Ireland. Ireland was invaded by its eastern neighbour as early as the twelfth century, when Norman barons attempted to subjugate Ulster's ruling Gaelic lords, the O'Neills and O'Donnells. It was a drive that intensified with the threat posed to Protestant England in the sixteenth century by Spain, which had acquired immense wealth and power through the extraction of silver from mines in American colonies like Peru. English colonists claimed it was necessary to hold Ireland in self-defence against the possibility of Spanish attack and chopped down its woods for the purpose of fuel and building. In 1603, James VI linked England, Wales and Ireland with his native Scotland, becoming King James I. After the O'Neills and O'Donnells fled to mainland Europe in 1607, the English disqualified Catholics from owning property and holding political office, while transplanting Protestants from England and south-west Scotland, many of them Presbyterians, to take possession of the land. As the invaders gained the upper hand, a series of fifty-five London companies organized themselves into a joint-stock venture or corporation known as the Irish Society, for clearing Ulster of its Catholic inhabitants and overcoming the resistance of wood-dwelling rebels called 'woodkernes', facilitating colonization. According to King James's attorney general Sir John Davies, Ulster was 'the most rude and unreformed part of Ireland'; settling it, said His Majesty, would 'establish the true religion of Christ among men ... almost lost in superstition'. To many like Thomas Blennerhasset, however, who arrived from Norfolk in 1610, what counted about 'goodly Ulster' was the profitable cultivation invited by its 'pleasant fields and rich groundes'.[2]

The Sloane family came to Ulster as servants of the aristocracy. Among the new Protestant arrivals was James Hamilton from Ayrshire in Scotland in 1603. Hamilton acquired land and title, becoming the first Viscount Clandeboye in 1622 in reward for working as an agent for King James. When Clandeboye died in 1644, his son, also named James Hamilton, inherited his land and became the first Earl of Clanbrassil. Clanbrassil married Anne Carey, daughter of the Earl of Monmouth, in 1641, but his affairs floundered after he supported

Charles I's losing cause in the Civil Wars of the 1640s against Oliver Cromwell. The Hamilton–Carey marriage, meanwhile, indirectly brought about the wedding of two of their servants: Alexander Sloane, a cousin of the Hamiltons, who had also come from Ayrshire to manage their estates, and Sarah Hickes, who had come with Anne Carey. Alexander and Sarah Sloane went on to have seven children, although only three survived to adulthood. James became a barrister and MP; William became a merchant. Their youngest son, Hans, was born in the market town of Killyleagh, County Down, on 16 April 1660. His name, not uncommon in Scotland at the time, was evidently given in honour of the first James Hamilton's father back in Ayrshire, the Reverend John (Hans) Hamilton of Dunlop. The significance of the name Hans is thus two-fold: it reflects the closeness between the aristocratic Hamiltons and their faithful servants the Sloanes, and speaks to the Reformation heritage of Sloane's family, since Hans Hamilton had been the first Protestant vicar of Dunlop. Sloane's father Alexander did well for himself. After Charles II's Restoration in 1660, he mustered troops on behalf of the king as a commissioner of array and became a landowning member of the gentry, employing tenant farmers to work his land. On his death, he left behind estates at Rowreagh and Ballygarvan in County Down. These, however, went to his first-born James, according to the conventions of primogeniture. Hans, his youngest, would have to make his own way in the world.[3]

Even though Hans's most youthful years were a time of relative peace, uncertainty stalked the Hamiltons' fortunes. The Civil Wars had spawned bloody Irish rebellions during 1641, when Catholic gentry and Gaelic peasants took retribution against the Protestants, although the uprising was fiercely put down by Cromwell's New Model Army. After the Restoration, Charles extended greater toleration to Catholics, Ulster developed economically and the Protestants consolidated their ascendancy. Division nevertheless remained a hazard of new Irish fortunes. While the Hamiltons backed Hans's brother James as Whig MP for Killyleagh, his father Alexander became involved in disputes over the will of the Earl of Clanbrassil. The will stated that Clanbrassil's land must pass to his son Henry, but should Henry and his wife the Countess Alice lack an heir, the property would be shared among Henry's uncles. One story has it that the countess persuaded Henry to make his legacy over to her, before Henry suddenly

died – some allege poison – leaving the dowager Alice to claim everything for herself. Servants then recovered an original copy of the will, prompting legal suits to reinstate the uncles. Ultimately, the estates were divided among several bickering relatives, with much of the property passing to Sophia Hamilton, daughter of yet another James Hamilton, a County Down squire.[4]

Such were the quandaries of Hans Sloane's early existence. Born into a land remade by conquest and colonization, he grew up the child of servants of the aristocracy and an Ulster Protestant of Scottish descent, one of the so-called New English settlers of Ireland. He was, therefore, strictly speaking neither English nor Irish (nor Scottish) but a member of the minority ruling elite, who were heavily outnumbered by the disenfranchised Catholic majority, and tended to identify themselves as 'the English of Ireland'. The political identity of the Ulster elite was ambiguous. They simultaneously asserted loyalty to Ireland while expressing desire for close ties to England. Archbishop James Ussher of Armagh, the leading defender of the Protestant Church of Ireland in the early seventeenth century, advanced the argument that Protestantism was in fact much closer to the original form of Irish Christianity than Roman Catholicism. 'The religion professed by the ancient bishops', Ussher controversially wrote in his *Discourse of the Religion Anciently Professed by the Irish and the British* (1631), was 'the very same with that which now by public authority is maintained therein, against the foreign doctrine brought in thither in later times by the Bishop of Rome's followers'. Ussher's improbable contention was that Catholicism had been imposed while Protestantism was indigenous. On the other hand, the directors of the Irish Society were based in London and many colonists kept up close links to the capital, entertaining hopes of greater political union and looking to the British monarchy and their fellow Protestants for direction. How Sloane understood his own ethnic and national identity is not entirely clear, as he left no written statements on the subject. But the shape of his life was very much a British one rather than an Irish or, for that matter, English one in any narrower sense. While he always maintained family ties and allegiances to Ulster, Sloane would later move to London, never to return to his native soil.[5]

As an Ulster Protestant, Sloane benefited from the suppression of Ireland's Catholics, the seizure of their land and the wealth this brought

the colonizers. He likely enjoyed highly cordial if not familial relations with the aristocratic Hamiltons, whose company appears to have lent him an easy sociability around persons of different rank, which was later to become one of the hallmarks of his own extensive social circles. Writing to Sloane to describe his qualifications as a scholar in 1728, Thomas Stack, who became his librarian, flattered his patron with a paean to the easygoing character of the Irish nobility, which he insisted Sloane had inherited. 'In this blest isle the supercilious frown / Marks not the greatest lord from meanest clown. / Easy access and affability / Are Characters to know the nobles by . . . / Then all a free and friendly ear may claim, / And peer and peasant are to them the same.' But Sloane's youth offered vivid lessons of the perils of discord, too, from the bloody struggle over Ireland to the acrimonious dispute over the Hamilton will in what was virtually his second family. He witnessed his father's example of how professional service and property owner-ship could confer genteel standing yet also how such property required resolute management to avoid division and conflict.[6]

Most importantly, Ulster was where Sloane discovered the natural world and was first captivated by the prospect of its possession. He marvelled at the flora and fauna around Killyleagh, at the western edge of Strangford Lough, not far from the Irish Sea. The eggs he and his companions took from the seagulls probably came from the nearby Copeland Isles. The Hamiltons likely gave him his first intellectual exposure by granting access to their library at Killyleagh Castle, and although no record survives of what he read there, the young Protestant Sloane surely read his Bible. This heritage would have rooted him in a tradition of Christian reverence for the natural world but it would also have given him a sense of duty to use it for human advantage. For early modern Christians, the Book of Genesis taught that the laborious con-version of 'wilderness' into gardens was a pious act that redeemed the original sin of Adam and Eve, the Fall from grace and the loss of Eden. 'The world is a great library, and fruit trees are some of his bookes wherein we may read & see plainly the attributes of God his power, wisdom [and] goodness,' the Staffordshire Puritan and gardener Ralph Austen wrote in one of many such statements in his *Spiritual Use of an Orchard* (1653). English Protestants often understood their possession of others' land in the terms of a providential capitalism: as a means of 'improving' both the soil and themselves through mastering botany,

cultivating gardens and profiting from agriculture. Sloane would adopt such views and later wrote that it was 'a great contentment' to him 'to see many things cultivated in English gardens which I had seen grow wild in other countries'. When he gazed at nature as a boy in Ulster, he saw a landscape under colonial occupation. So the first of those 'other countries' was, paradoxically, his own native land.[7]

## CURIOSITY AND CONNECTION

Sloane's youth was no jaunt, however, but one almost terminated by severe illness at the age of sixteen. In 1676, Sloane was afflicted by a 'violent hæmorrhage' and started spitting blood. According to the historian and secretary of the Royal Society Thomas Birch, whom Sloane later made one of his trustees and to whom he granted a lengthy interview late in life – our main source for his youth – Sloane spent the next three years largely confined to his room in Killyleagh. He slowly recovered his strength, although the problem was to recur throughout his life. The illness marked him and proved formative in more ways than one. From this moment on, Sloane took care always to monitor his diet and, unlike many of his contemporaries, moderate his drinking. He made himself a study in sobriety and became expert, as Birch put it in a resonant phrase, in 'the prudent management of himself'. While the fight over Hamilton's Ulster estates suggested the wisdom of efficiently managing one's affairs and relationships, the severity of Sloane's illness taught him the necessity of managing his body with scrupulous care. Likely as a consequence of this illness, at least in part, he determined to seek his professional fortune by embarking upon a career as a doctor.[8]

Three years later in 1679, like many of his fellow Ulstermen, Sloane crossed the Irish Sea and made his way to London. Transferring to the English capital, with its beckoning opportunities, was a sign of his ambition. 'Most of our young gentlemen are gone or going to London,' Viscount Rosse later complained of his Protestant countrymen early in the eighteenth century; 'what is to be done', reflected another Irish observer more resignedly, 'will be done in London.' London was the centre of the British world but it was roiled by Protestant–Catholic tensions. The year before Sloane arrived, the Anglican priest Titus Oates divulged details of a fictitious Popish Plot in which he alleged the existence of a

Catholic conspiracy to assassinate Charles II. The ensuing Exclusion Crisis of 1679–81 revealed that Charles's brother James, Duke of York, was in fact a practising Catholic. Alarmed at this turn of events, the Whig Party moved to bar James by law from becoming king, although Charles, with the support of the Tories, succeeded in blocking them by repeatedly dissolving Parliament. Charles, meanwhile, was seeking greater toleration for Catholics because of a secret pledge he had made to convert to Catholicism in return for assistance from his cousin Louis XIV, the King of France, against England's leading commercial and military rivals, the Dutch. As the Oxford anatomist William Gould told Sloane in January 1681 – in the oldest letter extant in the Sloane correspondence – it was a time of 'troublesome, jealousyes, fears, plot & counterplots' that left England an 'unsettled and tottering nation'.[9]

Sloane must have been concerned by this state of affairs but he focused on learning the craft of medicine and grounding himself in the study of botany. He took lodging in a house in Water Lane, Blackfriars, next to the chemical laboratory situated at Apothecaries Hall, headquarters of the Society of Apothecaries, which had been set up early in the seventeenth century to organize the apothecaries' challenge to learned physicians for the right to prescribe and sell medicines. Here Sloane met Nicolaus Staphorst, a German chemist who instructed him in the art of decocting, fermenting and distilling plants for 'the preparations & uses of most chemical medicines'. He thus began on the most practical rung of the medical ladder. He started frequenting anatomy lectures, too, still controversial at the time because of their associations with grave-robbing and commercial entertainment, though just whose lessons Sloane attended or what they emphasized is not known. Sloane did not obtain a university education so his reading at this time likely had something of an autodidactic quality. His tendency was, in any case, to things as much as words and to gardens as much as libraries. To Sloane, rather, gardens *were* libraries; as Christian botanists like Austen insisted, the 'book of nature' was written by God to be read by the pious, species by species. To this end, he made trips out west to Chelsea Physic Garden, maintained by the Society of Apothecaries since 1673, training his eye to distinguish between different species and commit them to memory, as well as learning their virtues as ingredients for herbal medicine. One could only judge whether the price of a medicament was fair, Sloane later told a friend, if one knew its ingredients – the

judgement of one schooled in the art of pharmacy. Chelsea also boasted the latest botanical technology, which Sloane observed with keen interest by permission of Mr Watts, the head gardener. 'He makes under the floor of his greenhouse a great fire-place . . . and conveys the warmth through the whole house by tunnels,' he excitedly told a friend. This system for transplanting and acclimatizing exotic species to produce new fruits was among the first of its kind in England and seized Sloane's imagination with its potential to domesticate foreign plants via artificial climate control. Watts 'thinks to make, by this means', he continued, 'an artificial spring, summer, winter, &c.'.[10]

Beyond his apprenticeship, Sloane enjoyed advantageous social connections that bridged the Irish Sea, and he soon began insinuating himself into genteel and learned society. The Anglo-Irish were a close-knit diaspora, with especially tight links between Ulster and London, where the Irish Society was headquartered. In his memoir of Sloane, Birch indicates that the key to his early London progress was his fellow countryman the noted experimental philosopher and pre-eminent Fellow of the Royal Society Robert Boyle, a native of County Waterford on Ireland's south coast and heir to the fortune of the Earl of Cork. There is some evidence to suggest that Boyle may even have maintained ties with a former romantic interest who was the sister-in-law of the Earl of Clanbrassil, the employer of Sloane's father; and that Clanbrassil had courted Boyle's sister Mary. Sloane's close family friends the Hamiltons may thus have furthered his career from back in Ulster. Boyle's wealth, reputation for Christian morals and standing as a founding member of the Royal Society meant that his friendship could open doors to both learned and polite acquaintance for the young Sloane, and his patrician character surely disposed him to do so. Boyle's youthful compatriot left nothing to chance, however, and Birch teasingly records that Sloane 'cultivated [Boyle] by communicating to him whatever occurr'd to himself, which seem'd curious & important', although what these things were he does not say. Reports of rare objects, perhaps, unusual phenomena or novel apparatus, such as Watts's furnaces or Staphorst's laboratory (Boyle owned his own experimental laboratory), or some of the plants Sloane started collecting around London about this time. Whatever he offered, it worked, and Boyle received him with 'every mark of civility and esteem'. Curiosity was the currency of learned exchange and favour, as Sloane quickly grasped. His oldest-surviving

plants are specimens he gathered in 1682, not for himself but for the gentleman collector William Courten, who also became Sloane's 'very particular and intimate friend' at this time.[11]

Sloane trained as a physician at a moment when philosophical accounts of the natural world were very much in flux. The original writings of ancient Greek and Roman philosophers on topics ranging from natural philosophy (the physical sciences) to medicine and natural history had been lost with the decline of Greece and the fall of the Roman Empire. But many Greeks and Romans had been translated into Arabic (and Aramaic) by scholars under the Islamic Caliphates that extended from the Middle East and North Africa to the Iberian Peninsula (al-Andalus) after the seventh century CE. This translation work was supported by the House of Wisdom (Bayt al Hikma) in early ninth-century Baghdad, founded by the Abbasid Caliph al-Ma'mūn, and included intensive commentaries on such key writings as Galen's treatises on medicine by the tenth-century Persian Muslim polymath Ibn Sīnā (known in Europe as Avicenna). Innovative mathematics and experimental sciences also flourished under the Caliphates, such as the tradition of al-kīmiyā' (alchemy) which derived from Greek, Egyptian and other sources and was described in manuscripts like the Corpus Jabirianum, attributed to the Muslim Arab polymath Jābir ibn Hayyān (later called Geber in Europe). After the Ottoman Empire conquered Constantinople (Istanbul) in 1453, bringing down the Eastern Roman Empire of Byzantium, numerous scholars and manuscripts travelled west, especially to the Italian peninsula, prompting new Latin translations by Renaissance Humanists. Although most European university scholars would adhere to ancient philosophical teachings until well into the eighteenth century, the retranslation of this Arabicized scientific corpus stimulated considerable ferment. The sixteenth-century Polish astronomer Nicolaus Copernicus adopted techniques used by Muslim astronomers of the Marāgha school (in Iran) and posited a mathematical explanation for a cosmos in which the earth revolved around the sun, rather than the sun around the earth as the Almagest of Ptolemy of Alexandria had insisted, even though Copernicus' objective was not revolutionary scientific change but reconciling his views with Aristotle's model of a geometrically perfect cosmos, which he still supported.[12]

The Pisan natural philosopher Galileo Galilei's observation of

ungeometrical spots on the surface of the sun using powerful new telescopes during the early years of the seventeenth century, and his support for Copernicus' hypothesis that the sun was indeed the centre of the universe, further undermined the scientific orthodoxy of Aristotelianism. Some began to question both the ancient teachings that dominated university curricula and esoteric or so-called occult philosophies that, like Aristotelian theories of causation, characterized nature as an entity imbued with its own soul or inherent purpose. These traditions included Hermetic magic (after the fabled pagan deity Hermes Trismegistus), varieties of Neo-Platonic thought and practices such as alchemy and astrology. In writings published during the second quarter of the century, René Descartes and Pierre Gassendi in France, and Boyle in England, articulated a 'mechanical philosophy' that rejected the idea that nature behaved purposefully. Instead, 'corpuscularianism', as it also became known, focused on what Descartes termed 'matter in motion' and accounting for the behaviour of 'corpuscles' (atoms) without reference to innate principles of activity. Experimental programmes dedicated to reassessing physical causation in mechanical terms became established in new scientific institutions such as the Accademia del Cimento, founded by Galileo's students in Florence in 1657, and the Royal Society, founded in London in 1660.[13]

Scholars have often labelled these events the Scientific Revolution, associating them with a momentous shift towards truly empirical scientific methods. At their most emphatic, as expressed in works like Herbert Butterfield's *Origins of Modern Science* (1949), such narratives have identified this shift with the birth of a modern secular worldview that embodied the triumph of human reason and the supremacy of western civilization. The phrase 'Scientific Revolution' was coined only in 1939, however, by the French historian of science Alexandre Koyré, while teaching in Cairo, and tends to distort how seventeenth-century sciences were in reality marked by important continuities with the past as well as significant change. By contrast with the classic narratives of revolutionary change, virtually all natural philosophers, including Descartes and Boyle, were committed Christians who saw their mechanical account of nature not as a replacement for the biblical story of the creation but as a complementary account of the workings of God's universe. The devout Boyle, architect of the Royal Society's experimental programme, was also a practising alchemist

with an extensive interest in the supernatural. Experimentation had been carried out in many other cultures in previous periods, for example by the alchemists who maintained laboratories in the medieval Islamic Caliphates. The mechanical philosophy, meanwhile, was neither novel nor particularly empirical, since it drew on ancient Greek sources like Democritus and Epicurus and no one could actually *see* the atoms it posited as the basic building blocks of matter. Isaac Newton's epochal *Principia mathematica* (1687) reduced the movements of both heavenly and terrestrial bodies to mathematically computable laws of motion and gravitation, leading eighteenth-century disciples to celebrate a Newtonian universe that ran like a machine, a vision reviled by Romantic-era critics such as William Blake, whose famous 1795 print *Newton* depicted the great natural philosopher as a soulless geometer indifferent to the sublimities of nature. Both of these views, however, were distortions of Newton's work and of how he saw the world. In secret, Newton too was a practising alchemist, a zealously unorthodox Christian who denied the Holy Trinity and a prophetic millenarian who spent more time calculating biblical chronology than on the mathematics of the *Principia*. He estimated that the Day of Judgement would come in the year 2066. Rather than describing a randomly mechanical universe, Newton's discussions of the 'active powers' at work in matter such as electricity and magnetism in his *Opticks* (1704) were taken by some to reintroduce the controversial possibility that matter behaved according to innate principles of activity, resembling the 'occult' conceptions of Aristotelians and magicians.[14]

Sloane's exposure to doctrines of mechanical matter appears to have come primarily through chemistry. 'Chymistry', as it was then known, referred to a range of practices that ran the gamut from rigorous technical experimentation to mystical visions of its role in charitable Christian living. In its medical application, chemistry provided an alternative to Galenical healing, which focused on balancing the four humours (blood, phlegm, black and yellow bile) to promote bodily health through interventions such as bloodletting and purges. The sixteenth-century Swiss-German healer known as Paracelsus (Philippus Aureolus Theophrastus Bombastus von Hohenheim) was accused of engaging in demonic magic, but his adaptation of alchemical techniques for the medical preparation of minerals was nonetheless highly influential, as he espoused a vision of the body as a microcosm of the material

universe (the macrocosm). His followers coined the term *iatrochemistry* for chemical healing. The Flemish chemist Johannes Baptista van Helmont subsequently rejected Paracelsus' microcosm/macrocosm model, but his own spiritual quest to discover a liquid subtler than fire that would dissolve material bodies (the *alkahest*) still derived from Paracelsian principles. The ideas of both Paracelsus and van Helmont appealed strongly to English dissenters and reformers during the Civil Wars and the Republic, but after Puritanism had been repudiated during the Restoration mechanical theories of matter as a passive rather than active entity gained currency.[15]

We have no direct record of Sloane's reading during his medical training, but the French chemist Nicolas Lémery, whose lectures Sloane later attended in Paris, likely played an important role in shaping his attitudes. Sloane probably first met Lémery in London in 1681 on a trip the Frenchman made to England to seek patronage from Charles II, and they would meet again in France two years later. At some point – it is not clear when – Sloane acquired a series of notes based on Lémery's Paris lectures on fermentation, the use of furnaces and experiments on animals, as well as several published writings including Lémery's *Cours de chymie* (1675). In the widely read *Cours*, which ran to multiple editions, Lémery decried alchemists' claims to produce gold as an 'ars sine arte, cujus principium mentiri, medium laborare, et finis mendicare': an art without art, whose principle was to lie, to toil and finally to beg. In truth, Lémery himself employed apparatus and techniques developed by alchemists and even acknowledged Hermes Trismegistus as the 'father' of the chemical enterprise, but cut all discussion of the transmutation of metals from the third edition of his *Cours*. Sloane's exposure to the chemical ideas of Lémery, perhaps reinforced by his friendship with the corpuscularian Boyle, evidently imbued him with an animus against all notions of magical matter, and an unshakeable conviction that nature was a mechanical entity designed by God to be exploited for human profit. Such views would profoundly shape his attitudes as a collector.[16]

Sloane made a series of further intellectual contacts, probably through Boyle, with scholars engaged on pressing questions of global variation in both nature and society prompted by increasing travel, trade and colonization. In the *Principia*, Newton had shown that the motion of all bodies behaved with uniformly computable regularity

both on earth and in the heavens. Whether or not such uniformity extended to the world's peoples, plants and animals remained to be seen. Sloane came to know the philosopher John Locke, a friend of Boyle's since 1660, who served not only the aristocratic English lords proprietor of Carolina who ruled the new southern American colony established in 1664 but also on the Board of Trade and Plantations (Locke later called Sloane his 'ingenious' and 'very good friend'). In his analyses of different societies across the world, Locke did not find the moral equivalent of the global physical uniformity Newton had demonstrated. After studying travel accounts detailing the practice of human sacrifice in Mexico, for instance, Locke contradicted Christian orthodoxy in his *Essay Concerning Human Understanding* (1689) by concluding that there was no such thing as an innate (and innately moral) human nature. Instead, he underscored the need for a 'natural history of man' to gather evidence of moral and cultural variation in human societies, a goal towards which Sloane's collections would later substantially contribute.[17]

Sloane's most decisive engagement with questions of global variation came through the field of botany and his friendship with John Ray. Ray had trained at Cambridge before moving to Essex and was both an ordained priest and Fellow of the Royal Society. He became a leading exponent of 'physico-theology' (natural theology) and emphasized the divinely rational structure of nature in such pious works as *The Wisdom of God Manifested in the Works of the Creation* (1691). 'There is for a free man no occupation more worthy and delightful than to contemplate the beauteous works of nature,' he wrote in 1660, 'and honour the infinite wisdom and goodness of God.' As ships brought unfamiliar specimens into European ports, naturalists like Ray sought to produce expanded catalogues of plants and animals to determine whether exotic species were different from or the same as those in Europe, and classify them in systematic taxonomic orders. By the time Sloane met him in the early 1680s, Ray was hard at work on a three-volume botanical taxonomy, the *Historia plantarum* (1686–1704), as well as catalogues of insects, fish, birds, snakes and quadrupeds. Classification required formidable powers of observation, memory and verbal description, as well as mastery of Latin – the lingua franca of the natural sciences – to apply lengthy descriptive polynomial labels. Picturing species was increasingly desirable but entailed a

manual dexterity most naturalists lacked, so they resorted to employing artists if they could afford them (Ray, for one, could not). When it came to plants, Ray's favoured method of classification required taking multiple anatomical characters into account to fix the identity of a species, rather than opting for a single feature, as advocated by the Paris botanist Joseph Pitton de Tournefort and Augustus Rivinus of Leipzig, his leading rivals. Ray's was the method Sloane would adopt for his own botanical work.[18]

A continental tour capped Sloane's formation. In the spring of 1683, he crossed the Channel to Dieppe with two fellow naturalists, Tancred Robinson and Thomas Wakley, and rode by coach down to Paris, the Italian peninsula their ultimate destination. This was not Sloane's first Channel crossing, as he had already visited Montpellier in the south of France in 1680, evidently for health reasons, since English travellers esteemed the 'great benefit of the French air' (William Gould had told Sloane he hoped 'Mompellier' would restore him). But this second trip proved much more significant. This was not the Grand Tour of noblemen like the Earl of Arundel who aimed to become art and antiquities collectors by versing themselves in the classics and fine arts. Sloane was no aristocrat and lacked classical or university education (the Society of Antiquaries was one of the few London clubs he did *not* later join). His, rather, was a scientific pilgrimage. In Paris, he continued his botanical training under the eminent Tournefort at the Jardin du Roi, where he studied plants in the garden from six to eight in the morning much as he had in Chelsea. From two to four in the afternoons he attended the fashionable yet pious anatomy lectures of Joseph-Guichard Duverney, which featured graphic studies of both human and animal bodies (living and dead). Not unlike the chemistry of Lémery, Duverney's anatomy lessons emphasized mechanical rather than Galenical or Aristotelian explanations of physiology and may have reinforced Sloane's tendency to mechanical views of matter. Sloane likely saw the natural history and anatomical collections these savants curated as well. He paid visits to the renowned Hôpital de la Charité to observe the treatment of its patients and sat in on the lectures of a chemist named Sanlyon. Armed with a letter of introduction from Tournefort, Sloane then travelled south to Montpellier to continue studying medicinal plants in its botanical garden under Pierre Magnol and Pierre Chirac, the latter known for his emphasis on the healing effects of plants' chemical properties.[19]

Robinson and Wakley continued on to Italy, but Sloane remained at Montpellier for several months. As a result, he missed seeing the celebrated natural history collections of Ulisse Aldrovandi in Bologna and those at the Collegio Romano in Rome curated by the great Counter-Reformation Jesuit polymath Athanasius Kircher. 'We saw Aldrovandus his musaum an incomparable collection of all sorts of naturall raritys,' Wakley wrote to him, 'reduced into order with ye name of every thing almost written on them wch is one of ye best prospects I ever saw.' Sloane had felt compelled to linger in Montpellier, passing many hours in its physic garden and visiting the city's fish market, a common haunt for naturalists since local fishermen often brought in rare species. Montpellier was also home to a community of Protestants. French Protestantism was under severe duress at this time, as the state took measures to suppress it that were soon to culminate in the Revocation of the Edict of Nantes in 1685, which saw many Huguenots flee across the Channel to England, North America and beyond. Robinson wrote back alarmedly to Ray about 'daily skirmishes between the king's soldiers and the Protestants of these parts', as French dragoons used force to coerce the Huguenots into renouncing their faith. The chemist Lémery was himself a Protestant who had probably told Sloane of his own travails when they met on the road to Paris. According to Birch, Sloane cemented his connection to Lémery with a precocious gift of rare phosphorus samples (perhaps obtained from Boyle, who had conducted extensive trials with the stuff), which 'that great chemist had not seen before, tho' he had mention'd them in his course'. This was more than the passing kindness it might seem: it shows Sloane shrewdly realizing at a young age, perhaps for the first time, how to use rare objects to distinguish himself as a rare *person* and a useful contact. But Lémery had fallen on hard times. He had lost his position as *apothicaire du roi* and had his shop closed down by 1683 because of his religion, obliging him to convert to Catholicism in order to resume work. Sloane's Montpellier host Magnol was also a Huguenot, so Sloane likely heard of his co-religionists' trials from several different sources.[20]

Sloane's French tour culminated in another Protestant haven. On 28 July 1683, he received his medical degree at the University of Orange, the only Protestant university in France, north-east of Montpellier in the principality of Orange, ruled by the Dutch stadtholder William III.

Here Sloane was examined on the doctrines of the four humours – the orthodoxy of European medicine – establishing the framework in which he would practise during his long career, one that combined copious bloodletting with recourse to the many different herbal remedies he was also learning. For all the emphasis he would place on botanical empiricism and mechanical philosophies of matter, therefore, like most physicians of his day he remained an unwavering adherent of humoralism – one of the most ancient dogmas of bodily health. The examination record notes that Sloane 'was examined and found competent' on works by Hippocrates and Galen, 'did argue and maintain a disputation, and was awarded the highest honours'. It also describes his appearance as a young man: 'of medium height, hair very short, light chestnut, face rather long and grave, marked with the small pox'. Conferred in the presence of the Bishop of Orange, Sloane's degree underscored the Ulsterman's membership in the international Protestant community while foreshadowing the role William III would play in his fortunes when he assumed the English throne in 1689.[21]

Sloane returned to London in the summer of 1684. He took up residence in Fleet Street and, while continuing his botanical studies, at last commenced a private medical practice. The friendship and patronage of the physician Thomas Sydenham, well known for his hostility to medical theory and his emphasis on empirical methods, here proved instrumental. Boyle, who not only knew Sydenham but also appears to have influenced his approach to medicine, probably brokered the introduction; Sloane's friend Locke also knew Sydenham. According to one anecdote, Sloane carried a letter of recommendation that described him as 'a ripe scholar, a good botanist, [and] a skilful anatomist', leading Sydenham to reply, 'this is all very fine, but it won't do – anatomy – botany. Nonsense! Sir, I know an old woman in Covent Garden who understands botany better, and as for anatomy, my butcher can dissect a joint full as well; no, young man, all this is stuff: you must go the bedside, it is there alone you can learn disease.' Birch records that Sydenham soon offered Sloane his 'greatest intimacy and friendship, and desir'd . . . him to settle in his neighbourhood, that he might introduce him into practice, recommending him in the strongest terms to his patients'.[22]

Sydenham's mentorship helped steer Sloane away from the classical physician's emphasis on reasoning from first principles and providing

causal explanations of illness towards direct observation of individual cases instead. Like the debates over matter in natural philosophy, the relationship between medical theory and practice was also in ferment. In 1543, the same year Copernicus had advanced the doctrine of heliocentrism in *De revolutionibus orbium coelestium*, the Brussels anatomist Andreas Vesalius had published *De humani corporis fabrica*, in which he used first-hand dissections and graphic illustrations to challenge Galen's classical account of human anatomy. But learned physicians took care to distance their new interest in empirical techniques from the methods of those they contemptuously labelled 'empirics'. The possibilities for employing the magical arts in healing had long intrigued the learned. Adepts like the fifteenth-century Neo-Platonist physician Marsilio Ficino, for example, had seriously studied the alleged healing powers of talismans and amulets. As many learned Europeans were gradually moving away from belief in magic towards the end of the seventeenth century, physicians derided the activities of lower-class folk healers they branded 'quacks' and 'cunning men', with whom they competed for patients, and who in turn scorned elite doctors as peddlers of meaningless Latin jargon. Sloane sought to navigate this fraught space between learned physic and empirical healing, reproducing Sydenham's anti-theoretical rhetoric in the process. 'The knowlege of natural-history,' he later wrote in his account of Jamaica, 'being observation of matters of fact, is more certain than most others, and in my slender opinion, less subject to mistakes than reasonings, hypotheses, and deductions are.'[23]

Thus it was that Sloane began to make his way. Being born without property into Ulster's Protestant elite had dealt him a mixed hand. He gained no wealth from his family, was an outsider to the seat of power in London and was undoubtedly concerned by the simmering conflict between Protestants and Catholics. Such concerns, in addition to his youthful illness, may well have contributed to the 'grave' countenance his medical examiners noted in Orange. Yet Sloane's progress was brisk thanks to his contacts and the new associations he forged. No xenophobic patriot abroad, he had used his travels well to master Latin and French, and returned from the continent with a growing network of friends that crossed national and confessional lines, telling Ray he would 'do all in my power' to obtain specimens for him from the gardens of Paris and Montpellier if he wished. By the time Sloane was back

in London and under Sydenham's tutelage, the trainee apothecary had transcended the menial station of common pharmacists and surgeons and was ascending to the status of gentleman physician. The landless Ulster Protestant was now a well-travelled cosmopolitan, skilled in the arts of curiosity and connection.[24]

## BURIED TREASURE AND THE PILLARS OF HERCULES

Wider and more dangerous worlds than those of a London doctor soon beckoned, however. The city to which Sloane returned was fast becoming one of the great commercial emporiums of the world. The acceleration of trade and migration in the British Isles meant that by 1700 London would outstrip Paris as the largest city in Europe, with a population of around 575,000. Despite the Catholic sympathies of the Stuart monarchs, the English capital became a haven for Protestant immigrants, attracting Dutch and German artisans as well as Swedes, Moravians, émigrés from the Palatinate, French Jews and Huguenots after the Revocation of the Edict of Nantes. London also became home to labourers from beyond European shores, in particular several thousand men and women from West Africa, who arrived as a result of the burgeoning Atlantic slave trade, many of whom worked in domestic service once in England. By 1684, Ray was directing letters to Sloane 'at Mr. Wilkinson's, bookseller, at the Black Boy, over against St. Dunstan's Church, in Fleet-street'. The 'Black Boy' was a shop sign, one increasingly common at the time, and emblematic of the rise in importance of slavery to English economic fortunes, as well as a sign of things to come for Sloane personally. Though he did not know it yet, within three short years of returning from France, he would find himself embarking on an altogether more hazardous voyage: to the Caribbean island of Jamaica, to work as a physician and make collections in natural history.[25]

After Christopher Columbus' first Atlantic voyage in 1492 and landfall on the island of Hispaniola (today divided between Haiti and the Dominican Republic), the Portuguese and Spanish had divided the world into two jurisdictions by the Treaty of Tordesillas in 1494. The Portuguese claimed Africa, South and East Asia and the easternmost

lands of South America that would become Brazil, while the Spanish conquistadores established the kingdoms of New Spain (Mexico) and Peru further west. Brazil turned to the importation of African slaves to harvest sugar on plantations, while Peru became a source of immense wealth in the form of silver, as the Spanish enslaved indigenous American populations to toil in the mines at Potosí and elsewhere. According to the reigning economic philosophy of mercantilism, nations conceived the amount of wealth in the world in finite terms, measuring it by the size of their stockpiles of bullion and the balance of trade. This made Spain the wealthiest European empire of the sixteenth century, allowing it to use precious metal to pay for luxurious silks and spices imported from both India and China.[26]

By the second half of the seventeenth century, however, Spanish might was in decline, as the mines yielded less and rival powers exploited new sources of wealth. The French had run a lucrative fur trade in Québec since the 1530s, although capturing part of Hispaniola in 1659 (which they christened Saint Domingue) was to bring them far greater riches as they imported African slaves to harvest sugar, coffee and other crops. But it was the Dutch who decisively challenged the Iberian model of colonization. Rather than organizing colonial viceroyalties as extensions of the state, the Dutch licensed private companies to carry out the work of colonization, breaking the Portuguese stranglehold on the slave trade in West Africa in the process. Instead of mining bullion or harvesting staple crops (though they did plant sugar in Surinam and elsewhere), they excelled as private oceanic traders. The English, meanwhile, envious of Spanish wealth, had dreamed of finding their own mineral paradises from New England and Virginia to the jungles of Guiana on South America's northern coast, where the Elizabethan privateer Walter Ralegh reported wondrous tales of an entire city made of gold called 'el Dorado'. But nothing came of such visions. Instead, it was the island of Barbados that emerged by the mid-1640s as England's first profitable Atlantic colony thanks to sugar and slavery, copying the pattern set by the Portuguese, Spanish and Dutch in the Azores, Brazil and elsewhere in the West Indies. In 1655, the English added Jamaica to their possessions, when Cromwell's forces invaded as part of his 'Western Design' to strike against Spanish America. By now, the Dutch were England's main rivals. So, starting in 1651, Parliament passed a series of Navigation Acts to bar Dutch merchants from the

lucrative carrying trade that brought English crops like tobacco to market in Europe, and fought three Anglo-Dutch Wars between 1652 and 1674. London's rise, as Sloane experienced it during the late seventeenth century, thus came about as a result of these campaigns which stimulated English shipbuilding and the many skilled trades that supported it, trebling imports from the colonies and generating increased customs revenues for the Crown.[27]

European colonization of the Americas also initiated the Columbian Exchange: a momentous transfer of diseases, plants and animals that transformed the environments and populations of the Americas, Europe and West Africa. Native American societies, which had remained isolated from other continents for centuries, were decimated by European diseases such as smallpox and their landscapes transformed by European farming and the introduction of domesticated animals like horses, cows and pigs. Europeans came to consume new foods like sugar, chocolate, maize and potatoes, which provided precious new sources of energy, while African plant species from okra to wild grasses made their way to American soil via the Atlantic slave trade. These exchanges had a profound impact on European knowledge of the natural world. Because neither the Bible nor Aristotle contained any mention of the Americas, their accidental discovery by Columbus (who was looking for a new passage to Asia) helped erode the credibility of both scriptural and ancient knowledge even before the writings of Copernicus and Galileo. The existence of this New World was a wonder that provoked new philosophical scepticism, though it by no means instantly transformed science and medicine. Systems of magic remained part of the framework for understanding the Americas as a source of what adepts called nature's 'secrets'. John Dee, for example, a mystic who advised Elizabeth I, advocated the colonization of the Americas and is sometimes credited with coining the phrase 'the British Empire', was expert in both navigation and astrology.[28]

European landfall in the Americas did, however, prompt an intensified commitment to collecting information, specimens and objects. It was not only natural philosophy that changed during the sixteenth and seventeenth centuries but natural history too through ambitious projects to catalogue the contents of the world. Columbus and the Iberians showed the way forward. Sloane later observed in his work on Jamaica how the Italian navigator had collected specimens of 'gold, parrats,

maiz, or Indian corn, and other valuable or strange things' to impress his patrons back in Spain with the potential wealth of American resources. Inspired by the creation of the Casa da Índia in Portugal (1434), Queen Isabella of Castile founded the Casa de Contratación (House of Trade) in Seville in 1503, dedicated to the oversight of commerce, taxes and exploration through the accumulation of navigational charts, plants and medicines. Developing state institutions and an imperial infrastructure, the Spanish began conducting trials on new drugs and publishing compendious natural histories like the mining inspector Gonzalo Fernández de Oviedo's *Historia general y natural de las Indias* (1535–49), which inventoried American plants and animals as imperial possessions, very much in the tradition of Pliny the Elder's *Historia naturalis*, the first-century encyclopaedia that catalogued the Roman Empire. The Madrid cosmographer Andrés García de Céspedes depicted the new travel-based knowledge in the frontispiece to his *Regimiento de navegación* (1606) via the image of a ship passing through the mythical Pillars of Hercules in the Strait of Gibraltar, symbolizing the limits of the known (European) world at the western edge of the Mediterranean, adorned with Christian crosses and the exhortation to explore *plus ultra* – further still.[29]

European collectors had been scouring the trade routes and outposts of Asia as well. The correction of errors in classical texts carried out by Renaissance humanists included naturalists' efforts to revise ancient authorities like Pliny through new programmes of botany and horticulture. The cultivation and symbolic identification of botanic gardens as spiritual paradises can in fact be dated back at least to the eighth-century Islamic Caliphates, whose scholars drew in turn on Sanskrit sources and Indian traditions. This fusion of botanical traditions, fed by translations of ancient works by authors such as Avicenna from Arabic into Latin, as well as by the Venetian Republic's commercial links to the Levant, inspired the creation of new gardens on both the Italian and Iberian peninsulas, where they served medicinal purposes while also symbolizing Christian redemption for original sin and the recovery of lost knowledge. By the seventeenth century, such gardens were increasingly to be found in northern Europe too. The Flemish botanist Carolus Clusius journeyed to Spain to observe American plants, translated texts drawing on Asian sources like the Portuguese physician Garcia da Orta's *Colóquios dos simples e drogas* (1563) and set up a botanical

garden at the University of Leiden in the 1590s. Clusius instructed merchants in the Dutch East India Company, founded in 1602 as a joint-stock venture to conduct trade in Asia, to send him as many specimens as possible, making Leiden uniquely well stocked with plants from a network that stretched around the Cape of Good Hope to India's Malabar Coast and Batavia (Jakarta) on the island of Java where the company had set up its capital. This commercial network yielded monumental surveys of tropical natural history like the twelve-volume *Hortus Malabaricus* (1678–93) overseen by Malabar's colonial governor Hendrik van Reede, which contained information and illustrations of almost 800 plants gathered through extensive interactions with local Ezhava (Kerala) botanists. The success of these Dutch networks began to draw South Asian knowledge, from Ayurvedic and Malayali traditions, into the European world and formed a model of colonial botany the French and English eagerly emulated.[30]

In addition to gardens, Europeans created museums for both natural specimens and artificial objects that showcased these new worlds. Instituting collections of objects was not a new phenomenon in Europe although they had often focused on forms of matter believed to possess magical properties. During the Middle Ages, Catholic church treasuries acted as repositories for relics of saints' bodies and remnants of the true cross, drawing the sick to them for their alleged healing powers as well as pilgrims. In addition to reliquaries, Renaissance princes assembled wonder-cabinets to show off 'marvels' as courtly spectacles intended to move viewers to awe and amazement. Renaissance traditions of compendious collecting aspired to total or universal knowledge by recreating the world in microcosm as a *theatrum mundi* or theatre of the world. In his *Inscriptiones vel tituli theatri amplissimi* (1565), possibly the first printed treatise on assembling an encyclopaedic collection, the Bavarian Protestant Samuel Quiccheberg outlined a systematic classification scheme intended to comprehend the divine creation in its entirety by defining categories into which to sort every single form of matter. These included 'crafted artefacts (artificialia)', 'world of nature (naturalia)', 'tools of artifice (means of acting on nature)' and 'enacted knowledge (representations)' – the kind of categorical divisions Sloane would later take up and refine to organize his own collections. Both working pharmacists like Ferrante Imperato of Naples and noblemen like Fernando Cospi and Ulisse Aldrovandi in Bologna assembled microcosmic

museums (pp. 26–7). There was no single way of collecting the world, however, and no two collections were exactly alike. The most spectacular example of encyclopaedic collecting was that of Athanasius Kircher at the Collegio Romano, whose museum, filled with objects sent by Jesuit missionaries the world over, Sloane's travelling companions Robinson and Wakley had visited. Steeped in Neo-Platonism and the natural magic tradition, Kircher's methods were strikingly learned yet imbued with mystical overtones. He made studies of fossils, monsters, volcanoes, medicines, languages, musical harmonies, comparative religion and the history of China; worked on technologies such as magnetic clocks and magic lanterns (early image projectors); and notably, though quite erroneously, translated the hieroglyphics on Egyptian obelisks brought to Rome. To Kircher, the world was a grand esoteric and Baroque puzzle to be assembled and solved with virtuosic ingenuity.[31]

The English were latecomers to these widening worlds. Since the sixteenth century, advocates of imperial expansion had published collections of travel accounts such as Richard Hakluyt's *Divers Voyages Touching the Discoverie of America* (1582), urging competition with Spain. England's response to the threat of Iberian domination included linking science and the state through a programme of collecting. This initiative, which would influence Sloane decisively, was proposed by Francis Bacon. Born in 1561, Bacon was a lawyer who became lord chancellor under James I. He was directly involved in American colonization as a shareholder and council member in the fledgling Virginia Company and promoted the settling of plantations in his essays. In this context of state service, private colonial enterprise and resurgent geopolitical ambition, Bacon called for a 'great instauration' or reformation of scientific knowledge. He was well aware of the innovations of the Spaniards, some of whose works on navigation and cosmography the English had hungrily translated, as well as the gardens and collections at Padua, Leiden and elsewhere. Inspired by such examples, the *Gesta Grayorum* (1594), a revel attributed to Bacon, envisioned the progress of the natural sciences and technological arts on new empirical, collective and institutional foundations. These were to include 'a most perfect and general library', 'a goodly huge cabinet', an experimental 'still-house ... furnished with mills, instruments, furnaces, and vessels' and 'a spacious, wonderful garden' that would constitute 'a model of universal nature made private'.[32]

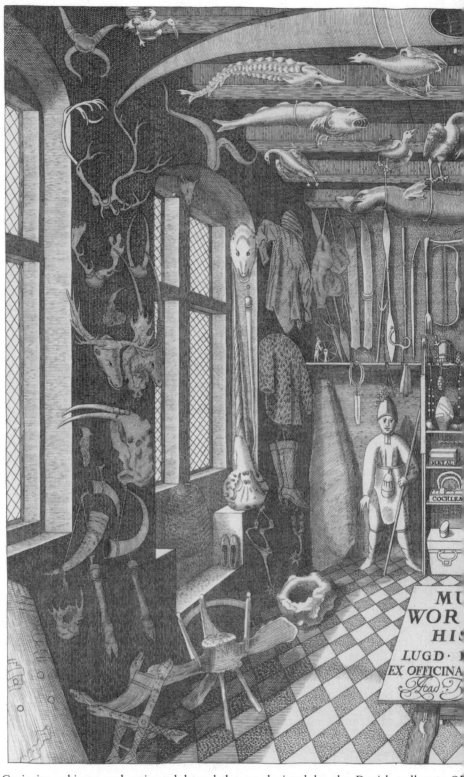

Curiosity cabinets and universal knowledge as depicted by the Danish collector O
dreams of assembling the world in microcosm as a *theatrum mundi*, including nat

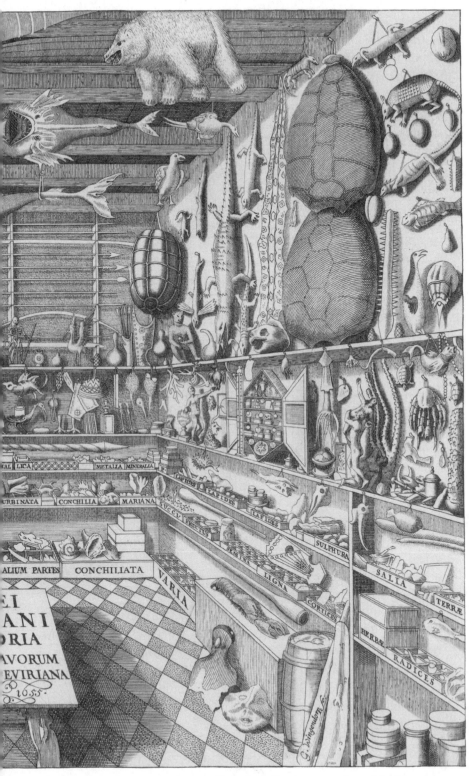

...ormius in *Museum Wormianum* (1655): Sloane's collecting was shaped by Renaissance ...ecimens and artificial objects of all kinds.

In the *Novum organum* (1620), Bacon argued that rather than look to common experience of the natural world as it was to frame axioms about its regularity, in the manner of the Aristotelian scholastics, the learned should examine not regular phenomena but unusual ones, and produce useful matters of fact through the staging of artificial experiments to test nature's capacities under specific conditions. He renewed his vision of science as a collective endeavour vital for the health of the state in his fictional *New Atlantis* (1627), where he envisaged the practical benefits of knowledge gathered through maritime exploration centred on an institution of scientific learning named Salomon's House on the imaginary island of Bensalem. Bensalem dispatched 'merchants of light' to collect information for study by 'interpreters of nature' who would 'enlarg[e] . . . the bounds of human empire' by 'finding out . . . the true nature of all things . . . whereby God might have the more glory in the workmanship of them, and men the more fruit in the use of them'. Acknowledging Iberian precedence, Bacon's Bensalemites spoke Spanish and Salomon's House included a gallery of 'principal inventors', the first of which was 'Columbus, that discovered the West Indies'. Bacon also helped himself to Céspedes' Habsburg emblem of a ship passing beyond the Pillars of Hercules and used it on the title page of his *Novum organum*, adding the legend 'Multi pertransibunt et augebitur scientia': many shall run to and fro, and knowledge shall be increased. This was a quotation from the Book of Daniel (12:4) where Daniel interprets apocalyptic visions concerning Israel, its salvation and 'the time of the end'. Bacon thus mimicked Daniel's millenarianism to suggest that the salvation of Protestant England would be new knowledge itself. The lord chancellor's message resonated with Sloane, who later emblazoned the title page of his *Natural History of Jamaica* with the same verse.[33]

Bacon's legacy took lasting form later in the century as his teachings inspired the institutionalization of scientific curiosity, including the gathering of collections. The stripping of the altars during the Reformation had distanced Protestants from the veneration of ornaments, relics and magical objects elsewhere in Europe, while the collection of works of art became synonymous with the sensory corruptions of Catholic finery. Indeed, Cromwell's forces confiscated Charles I's art collection and quickly sold it off to raise funds for the Puritan Republic. Natural history collecting, however, was considered by Protestants

to be both a devout pursuit and a highly useful one. After Bacon's death, an influential circle of Protestant millenarians around the Polish intelligencer Samuel Hartlib championed his ideas in England. Hartlib outlined programmes of agricultural and economic reform in areas from mining to alchemy, aimed at the 'discovery of infinite treasure' by tapping the full 'fatnesse of the earth', as the agriculturalist Gabriel Plattes put it in 1639. Collections also began to proliferate. South of the Thames, John Tradescant and his son maintained a botanical garden at mid-century, engaged in collecting for aristocratic patrons and opened their own museum of curiosities piously styled 'Tradescant's Ark', subsequently purchased by the antiquarian and alchemist Elias Ashmole and absorbed into the Ashmolean Museum at Oxford University in 1683. The Royal Society pursued an explicitly Baconian programme of natural history collecting. Shortly after it had received a formal charter from Charles II in 1662, the society set up its own museum, the Repository. The Repository eschewed wonders and marvels in favour of the factual documentation of nature through common and quotidian specimens. This strategy was allied with projects in comprehensive or 'universal' knowledge such as John Wilkins's proposal to frame a natural language for naming and classifying every single thing in the world in rigorously logical fashion, as well as planned histories of trades and artisanal techniques.[34]

As a botanist, and especially after he was made a Fellow of the Royal Society in 1685, Sloane would have become familiar with the Tradescants and the Repository, while Wilkins's treatise was one of the first books he acquired for his library. He began his own private collections by gathering plants and animals but would gradually branch out to minerals, fossils, coins, antiquities, books, manuscripts and curiosities of all kinds. Individual models of the collector as learned virtuoso undoubtedly played a key role in his formation. Unlike Bacon's imaginary Salomon's House, the Casa de Contratación or the Académie des Sciences (founded in Paris in 1666), the Royal Society was not in fact a state institution but a congeries of independent gentlemen pursuing their private interests, even as they sought to produce knowledge valuable to the English state as a source of 'publick treasure', in the words of its early historian Thomas Sprat. But assembling collections was also a strategy employed by physicians seeking genteel status. While curiosity in women was associated with Eve's sinful tasting of forbidden

knowledge in Eden and often considered unfeminine and threatening, male collectors enjoyed imagining themselves as Promethean heroes – masculine, cunning and inventive. In Sloane's London, personal models abounded of the virtuoso – the courtly man of parts, conversant in all branches of learning, expert in 'the excellencie' of all manner of objects and adept at conversational performance: John Evelyn, William Courten and the Duke of Chandos, not to mention the physicians John Woodward and Richard Mead, all of whom Sloane came to know and who encouraged his collecting by their example.[35]

Unlike these men, however, Sloane's formation as a collector also lay in natural history's myriad commercial and colonial embroilments. In works like the *Natural History of Oxfordshire* (1676), the chemist and Ashmolean curator Robert Plot had published detailed studies of English counties in the tradition known as chorography, whose content ranged from antiquarianism to surveys of local commodities. As England acquired possessions overseas, natural history was adapted to survey colonies as well. The royalist Richard Ligon travelled to the Caribbean in 1647 and published *A True and Exact History of the Island of Barbadoes* in 1657, describing the island's flora and fauna and including technical information for would-be planters on how to set up sugar mills. The profitability of sugar, publicized by writings like Ligon's, drew naturalists to the Indies. Henry Stubbe, another physician and Fellow of the Royal Society, wrote about the increasingly fashionable commodity of chocolate in his book *The Indian Nectar* (1662) and visited Jamaica shortly afterwards. The secretary of the Royal Society Henry Oldenburg armed travellers with questionnaires, composed by Boyle and his colleagues, in which commercial issues figured prominently. In 1670–71, Colonel Thomas Lynch sailed for Jamaica as its new governor with a list of queries (which Sloane later acquired for his collections) that asked about the direction of the winds for the purpose of navigation, how hurricanes affected the workings of the compass and whether Jamaican sugar dried faster than Barbadian, as well as requesting specimens of seeds, fruits and soils and suggesting trials for growing rice, olives and coffee. Thomas Sprat went so far as to characterize the Royal Society and the Royal African Company, which enjoyed a legal monopoly on the transportation of African slaves in these years, as 'twin sisters'. Sprat's comparison was especially apt at a time when presidents of the Royal Society and governors of

Caribbean colonies were sometimes the same people: the Earl of Car-
bery, Sir John Vaughan, acted as governor of Jamaica in 1674–8 and
president of the Royal Society in 1686–9. Knowledge and profit went
hand in hand. When not busy selling his own English servants into
slavery while in Jamaica, Carbery corresponded with Henry Olden-
burg in London about matters of scientific interest.[36]

The waning years of the century saw the English once again copy the
Dutch, this time financially through the creation of new instruments of
credit, the public trading of stocks and the practice of speculative
investment, culminating in the founding of the Bank of England in
1694. The period became notorious for its 'projects', where inventors
aimed to ensnare investors with the promise of quick fortunes, often in
the form of new-fangled machines, though their schemes often came to
naught or proved fraudulent. Before he turned to publishing novels, the
merchant and journalist Daniel Defoe was himself an arch-projector
who lost significant sums on schemes that ranged from salvage dives to
recover bullion from sunken treasure ships to the breeding of civet cats.
'The tradesman often-times drowns', Defoe rued, 'owing to an adven-
turous bold spirit in trade, joined with too great a gust of gain.' While
the selling of shares in such projects was a novel form of financial
capitalism, the projecting spirit had roots in much older traditions
of treasure hunting and continued to draw on arcane if not occult
methods. In 1691, for example, the Whig politician Goodwin Wharton
invoked the assistance of angels in his attempt to salvage a sunken
Spanish galleon at Tobermory in Scotland (Wharton's professed angel-
ology did not prevent him from later being appointed a lord of the
admiralty). The anonymous author of an anti-projecting pamphlet en-
titled the Angliae tutamen (1695) complained that diving bells were all
'noise and nonsense' and 'pernicious projects' that 'tickled . . . the ear
with the vast wealth of gold and silver that should be taken out of the
sea with these tools'. Such magical allure, however, proved hard to
resist.[37]

A striking group of underwater objects that came into Sloane's pos-
session in the 1680s, and which he later had engraved for his Natural
History of Jamaica, show how the mania for treasure hunting drew
him personally into worlds of speculation, colonization and profiteer-
ing by luring him to the West Indies (p. 33). These consisted of a spar
from a sunken Spanish treasure ship and several silver coins that had

been recovered from it, which had become so encrusted by coral in the depths of the Caribbean Sea as to appear curious hybrids of art and nature. Sloane was sufficiently intrigued to tell their story in a letter he wrote in early 1687 to one of his acquaintances in Ireland, the Ulster landowner Arthur Rawdon. Sloane recounted how a New England sea captain named William Phips (whose journal he later acquired) had obtained a royal patent with the backing of six London partners gallantly styled the 'Gentleman Adventurers', including Christopher Monck, the second Duke of Albemarle. Phips coerced Native American, African and East Indian divers from as far away as the Ceylon pearl fisheries to locate 'a rock on which grew vast quantity of coral' encasing a wreck from the middle of the century. This was one of the great Spanish treasure ships that had brought silver from Cartagena via Hispaniola through the perilous Caribbean Sea en route to Europe. The Gentleman Adventurers struck it rich: Phips's prodigious divers succeeded in bringing up 15 tons of pieces of eight and 'a great many ingots of Mexicon silver in bars'. Albemarle's share alone was 'about 50,000 or 60,000 pounds worth of cobs, bars, gold, plate, and pretious stones . . . some saphirs, emeralds, and rubies', with their total value estimated at £210,000 (roughly £18 million in today's money). The English may have failed to find gold and silver on American soil, but they successfully plundered it from their rivals under the sea.[38]

This spectacular result nonetheless prompted disapproving commentary from Sloane on what would prove to be one of his enduring themes: the follies of credulity. In the expanded version of the story he later included in his *Natural History*, he noted that many people fruitlessly sought to emulate the Duke of Albemarle's good fortune, including 'the Prince of Orange, afterwards King William, from Holland', who 'equip'd a ship which was sent thither, but they came too late'. Albemarle's lucky strike was the exception, not the rule. Sloane also discussed the invention of a diving bell, great numbers of which were then being demonstrated up and down the Thames, by the astronomer Edmond Halley, with which Halley had attempted (in vain) to salvage ivory from a ship returning from West Africa and wrecked off the Sussex coast. The 'money brought into England from the first wreck was very considerable', Sloane conceded, 'yet much more was lost on projects of the same nature. For every silly story of a rich ship lost, was credited, a patent taken out . . . and a ship set out for bringing home

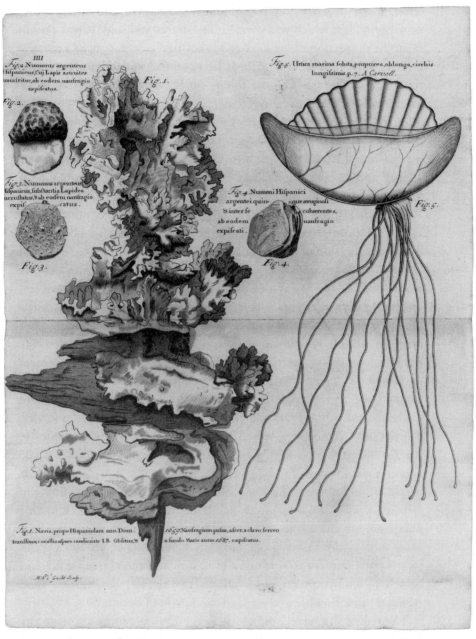

Coral-encrusted spar and coins with jellyfish as curious hybrids of art and nature: treasure hunting brought Sloane to Jamaica in 1687 when he sailed as physician to the Duke of Albemarle, who hoped to make a fortune from salvage dives on sunken Spanish galleons.

silver. There was one ship lost amongst the rest, said to be very rich, near Bermudas, which was divided into shares and sold. It was said to be in the possession of the devil, and they told stories how he kept it.'[39]

This 'silly' obsession with treasure nevertheless drew Sloane across the Atlantic. Hungry for coin to pay off his debts, the Duke of Albemarle had accepted the governorship of Jamaica in order to pursue more salvage operations on sunken wrecks. Christopher Monck was the son of George Monck, the military commander who had played a pivotal role in the Restoration of Charles II. Sloane met the younger Monck and his wife the duchess before going to France, in 1680–81 if not earlier, perhaps through Arthur Rawdon, whose father George Rawdon had fought the Irish rebellions alongside George Monck in the 1640s. By 1687, Sloane's status as a prominent doctor was confirmed by his membership of the medical elite as he was admitted to the Royal College of Physicians, an exclusive professional club whose Fellows would number only forty-five by the middle of the eighteenth century. On the recommendation of the king's physician Peter Barwick, Albemarle offered Sloane an appointment as his personal doctor and, crucially, the chance to sail with him to Jamaica. The prospect may have discomfited Sloane since Monck was a Tory whose appointment as Jamaica's governor came from the new Catholic king James II. Sloane's political sympathies, by contrast, lay with the Whigs: he had made his first trip to France in 1680 in the company of Charles Paulet, Marquess of Winchester, a leading Whig who had opposed James in the Exclusion Crisis. But beyond the political awkwardness of the appointment lay considerable potential for scientific glory in collecting specimens unknown in Europe. 'I have talked a long while of going to Jamaica with [Christopher Monck,] the Duke of Albemarle as his physician, which, if I do,' Sloane told Ray, 'next to the serving of his grace and family in my profession, my business is to see what I can meet withal that is extraordinary in nature in those places.' 'I hope to be able to send you some observations from thence,' he went on, 'God Almighty granting life and strength to do what I design.'[40]

The risk of shipwreck, piracy, disease and slave rebellions made any Caribbean adventure a highly dangerous prospect, and several of Sloane's associates were against his going. 'You must not go to Jamaica,' Sydenham apparently warned him; 'better drown yourself in Rosamund's pond,' he quipped, referring to a common place for suicide in St

James's Park. Ray was also worried. 'Were it not for the danger and hazard of so long a voyage, I could heartily wish such a person as yourself might travel to Jamaica,' he told his friend. Perhaps Sloane's training as a physician gave him confidence that he could withstand both the Atlantic crossing and life in the tropics; perhaps surviving his youthful illness convinced him he was seasoned against physical adversity. Despite his scorn for the treasure hunters, moreover, he too must have dreamed of making his fortune. He accepted Albemarle's offer: he would follow in his father's footsteps and serve the aristocracy in an English colony. Because it was rare for learned naturalists to make such dangerous voyages themselves, Sloane's fellow botanists rejoiced at the thought of how he might expand their collective knowledge of the world's known species. 'We expect great things from you,' Ray nudged him, warming to the prospect, 'no less than the resolving all our doubts about the names [of plants] we meet of in that part of America' and observing 'whether there be any species of plants common to America and Europe'. 'You alone might furnish a vast stock' of new species, Tancred Robinson agreed, with 'the hott part of the West Indies being before your eyes'. 'I will never lett you rest', he continued, 'till you do it.' '[I] never had the opportunity of soe curious a collector as yr selfe in those parts,' chimed in the keeper of Oxford's botanical garden Jacob Bobart, swelling the chorus of approval that launched Sloane on his scientific mission.[41]

Sloane himself spoke of his desire to see first hand the plants he had only heard of in order to burnish his credentials as a doctor, 'many of the antient and best physicians having travell'd to the places whence their drugs were brought, to inform themselves concerning them'. In addition to expanding European knowledge of the world's plants, iden-tifying new drugs might prove highly lucrative. The 'hope of finding a specific remedy like Quinquina', an anti-malarial extract commonly termed the Peruvian or Jesuit's bark (a forerunner of quinine), 'determined my decision to go to the Indies', he told a French acquaintance in 1714. Birch cryptically refers to 'the fortune, which [Sloane] . . . acquir'd' in the West Indies, without specifying its source, though he likely meant just this kind of commercial bioprospecting. Sloane was also well aware that Jamaica's planters would pay handsomely for his medical services, not least to keep their slaves alive and their profits flowing: 'planters give a great deal of money for good servants, both black and white, and

take great care of them for that reason', he observed, 'when they come to be in danger of being disabled or of death.' Finally, there was the matter of salary, and Sloane negotiated to his advantage. In return for services rendered to the Crown, he secured complete medical oversight of the duke's fleet, including authority over all its surgeons and apothecaries, for the hefty sum of £600 per year, with an additional £300 to be paid upfront. With these arrangements made, and after several months of preparation, Sloane left London at the age of twenty-seven and set sail with Albemarle's fleet on 12 September 1687 from Spithead, Portsmouth. 'I thank God I am very well & well pleased with my undertaking,' he wrote to Rawdon, whom he asked to convey his regards to the Hamiltons back in Ulster. 'I doubt not but that it will turne to account.'[42]

# 2

# Island of Curiosities

## THE INDIES BEFORE YOUR EYES

The Duke of Albemarle's fleet consisted of His Grace's yacht *Elizabeth*, two merchant vessels named *William and Thomas* and *Salusbury*, and the forty-four-gun frigate HMS *Assistance*. Once aboard, Sloane's first task as chief physician was to treat the seasickness that quickly afflicted the crew. 'Keep in a quiet posture, in a place where is the least motion,' he stoically counselled as he noted in his *Natural History of Jamaica*, the main source for what we know about his voyage to the Caribbean. Sailing towards the western edge of the English Channel, the fleet was escorted for a time by ships bound for Africa's Guinea coast, in all probability slave-trade ships. Sloane, meanwhile, took advantage of his berth to observe the seabirds, porpoises, jellyfish, flying fish, dolphins and sharks that accompanied the fleet on its progress. He also noticed 'sparks of fire' in the sea that leaped 'up into the air as if a flint and steel were struck', recalling his gift of phosphorus to the chemist Lémery. Sometimes they lasted 'half a minutes time, like the icy noctiluca or phosphorus, the light of this being as to colour, very like that of the other'.[1]

On 21 October 1687, the fleet dropped anchor off the Portuguese island of Madeira to take on provisions. Sloane stepped ashore with the duke. 'The air is very temperate,' he observed, and the soil 'very fruitful'. The island was a natural laboratory for profitable botanical transplantation, he noted, 'fit for producing the fruits of both hot and cold countries'. Madeira wine had replaced sugar as the island's most lucrative commodity and was now 'exported in vast quantities to all the West-India plantations'. In just three days, Sloane made observations

and gathered fifty-seven specimens of fern, grass and fruit around Funchal on the coast. But Madeira also presaged some of the hazards that lay ahead in the Caribbean. Every merchant carried 'a long big hilted dagger, with a sharp knife in his pocket'. None dared go out after dark 'lest any who has a grudge at him should shoot him'. The islanders had African slaves harvest sugar and remained 'very much serv'd by negros', another source of danger: 'I was told half a piece of eight to a negro would purchase any man's life.' Sloane also bristled at the treatment of his fellow Protestants in Madeira, where local officers of the Inquisition had 'compell'd the French Protestants to change their religion'. The island was rumoured to be teeming with exiled criminals, leading Sloane to expect 'a great deal of barbarity and rudeness', yet he met only gentlemen with 'all the civility one could desire'. As a doctor, he was accorded a privileged welcome. The islanders had 'a great opinion of the skill of English physicians' and invited him to minister to the 'melancholy' nuns at the convent of Santa Clara, which he duly did.[2]

Reprovisioned, the fleet began its Atlantic crossing. The travellers were forced to endure a month of rains, calms, boredom and yet more seasickness before eventually arriving at the port of Bridgetown on the island of Barbados on 25 November, where the notoriously heavy-drinking Albemarle was given a rousing welcome. 'My Lo Dukes reception here has been very great,' Sloane wrote to William Courten, noting his intention 'to tarry some days'. After reviewing the island's defences, tarry the duke did. Barbados was an island fortified against its enemies by both nature and arms, 'with many rocks to windward . . . which defend the coast on that side' as well as 'batteries at every place a canoe can land'. Albemarle was 'well pleased with the great reception and entertainment he had here' and drank 'much more than ordinary', with the result that blood 'leap[ed] out in a small stream' from his nose, which Sloane staunched with some difficulty. But His Grace was not one to be deterred by the adverse effects of those epic debauches in which he delighted. As patent holder in the Royal Mines in the West Indies, he proceeded to make 'great inquiry after minerals' even though all his men spotted was a 'hill where was a shining substance which look'd very fine' – nothing more than glittering marcasite (white iron pyrite or fool's gold). As the duke drank and chased mirages of treasure, Sloane enjoyed the local hospitality in more scientific fashion. To the botanist, Barbadian dinner tables were specimen trays. 'For my

own part I lik'd so well the dessert after dinners, which consisted of shaddocks, guavas, pines, mangrove-grapes, and other unknown fruits in Europe, that I thought all my fatigues well bestowed when I came to have such a pleasant prospect.' Sugar had been Barbados's economic engine since its introduction in the 1640s, but it had 'fallen much off' due to 'the great labouring and perpetual working of' the island's soil. As on Madeira, Sloane made observations and collected plants. He also talked to planters. One who specialized in domesticating exotic species showed him a specimen of wool-producing East Indian *Moxa*. 'This is indeed a new world in all things,' Sloane wrote to Courten. Jamaica would offer even more, if only he could survive the climate. 'I find this place very warme,' he confessed. 'My greatest work is sweating and drinking water which I find does well and better than other small liquors of this place,' he added, congratulating himself on his own abstemiousness.[3]

After ten days, the fleet once more weighed anchor and navigated the Caribbean Sea, legendary for its shoals and pirates, heading north-west and sighting St Lucia (crawling with serpents, it was said), French Martinique, Dominica (still inhabited by indigenous Caribs), Guadeloupe, Montserrat (controlled by the English but populated by the Irish) and the tiny island rock of Redonda (brimming with boobies and iguanas). The fleet then arrived at Nevis, another fortified English colony, smaller and more mountainous than others. Here Sloane took greater notice of the island's African slaves, evidently because they posed a greater threat. 'The ground is cleared almost to the top of the hill, where yet remains some wood,' he wrote, 'and where are run-away negros that harbour themselves in it.' Nevis' colonists didn't seem particularly appealing either. Sloane found them 'more swarthy, or of a yellowish sickly look, than any of the inhabitants of these islands'. Back at sea, the fleet finally sighted Jamaica and made its way into Port Royal. On 20 December 1687, three months after leaving England, Albemarle disembarked under a twenty-one-gun salute that ricocheted around the harbour. According to one observer, His Grace was led into St Paul's Church, where an extravagant chair of state awaited him, 'cover'd with azur velvet, richly bost, fringed and emboideried with silk, gold and curious work, with a cushion of the like for his feet, in which was said to be 2,000 pistolls of gold'. Evidently finding his reception insufficiently grand, however, the duke refused to sit down. Back

in England, Sloane's associates, teased by swirling rumours, had no idea if their friend was dead or alive. 'This hopes to find you safe at St. Iago notwithstanding the great reports at London of the [duke's] dying at sea,' Tancred Robinson wrote, 'and of his being taken by pyrates.' Robinson had 'sacrificed daily to Neptune for your preservation [and] your friends at Dicks and Bettys were mourning for you'. But for now at least the gods had smiled. Sloane was alive and well and eager to explore England's most alluring if forbidding colony.[4]

Jamaica is the third largest Caribbean island after Cuba and Hispaniola. Its varied terrain ranges from the Blue Mountains and their rainforest climate to expanses of grassy savannah. Its first known inhabitants were the Taíno, a people who spoke the Arawak language in common with other Caribbean islanders and who had probably migrated from Hispaniola at some point after 600 CE. Archaeological remains tell us that the Taíno were skilled hunters, navigators and craftspeople, who harvested starches like yams and yucca through an agricultural system known as *conuco*, and used canoes to maintain links with other island peoples. When Columbus arrived in 1494, the cleric Andrés Bernáldez recorded that he had been greeted by 'so many Indians . . . [that] they covered the land', which was 'filled with villages'. But after the Spanish had gained the upper hand, they enslaved the Taíno to force them to mine for gold. The Taíno resisted, but overwork, starvation and their lack of immunity to common European diseases like smallpox and measles rendered them all but extinct by the 1520s. Their name for their island home did survive the calamity of first contact, however: Xamayca – land of wood and water.[5]

After seizing Xamayca, the Spanish began importing West Africans as slaves to work as cattle ranchers, making hides the island's first key export, while setting up modest estates for growing sugar and cacao. The population remained small, numbering only about 700 Spaniards and 600 Africans by the early 1600s, the absence of gold leading imperial administrators to ignore the island. In 1655, however, Jamaica fell under attack: English forces invaded and captured the island as part of Cromwell's Western Design. In reality, the island was a booby prize, seized upon by the English after they failed to take Hispaniola, their main target. The Spanish resisted for five long years, while diseases like malaria and dysentery claimed two-thirds of England's soldiers in the

first year of invasion alone. Many slaves took their chance to flee to the mountains amid the conflict and confusion, combining with different native islanders to establish a free community of 'Maroons'. Jamaica officially became an English royal colony in 1660 (the year the Royal Society was founded), but merchants still had to persuade Charles II that this ingloriously unprofitable isle was worth keeping.[6]

At first the English turned to piracy, parasitically striking at Spanish treasure ships loaded with bullion and bound for Europe. Captain Henry Morgan became famous as a privateer (a state-licensed buccaneer), sacking Panama in 1670 to great patriotic acclaim and garnering himself a knighthood and the governorship of Jamaica in the process, even though his campaigns violated the Anglo-Spanish peace treaty then in force. Factional conflict soon broke out, however, between the buccaneers and Jamaica's rising planter class. Caribbean merchants had resented the disruption by Cromwell's fleet of their contraband trade with neighbouring Spanish colonies, so merchant councillors in the Jamaica Assembly sought to shield their interests from outside interference in the name of 'English liberties'. Albemarle's mission, part of a larger drive towards increasing imperial control from London, was to rein in planters seeking an end to the Royal African Company's state monopoly on the slave trade and who feared that the Dominion of New England – a centralized government imposed on a cluster of North American colonies by James II in 1685 – set a precedent for their own subjection. The duke thus sided with the buccaneers, muscling his own placemen into local offices and intimidating opponents with fines and prison sentences. His new chief justice began 'telling the people, in open court, they should be ruled, with rods of iron'. The English set up livestock pens on Jamaica's southern and eastern savannahs and increasingly planted subsistence crops. Cromwell had sent over Irish Catholic rebels from Ulster to swell the number of indentured servants, who laboured a term of several years before earning their freedom and acquiring land of their own (such at least was the promise). In addition to English soldiers, early Jamaica settlers also included Barbadian migrants enticed by offers of land grants, along with journeymen from Nevis, Bermuda and Virginia, as well as a number of Sephardic Jewish merchants.[7]

The planters and their merchant allies prevailed, however, thanks to the growth of sugar and slavery. It was men, women and children from

West Africa who made Jamaica profitable through their labour as slaves, as the English began importing them in greater and greater numbers in the late seventeenth century. Many Jamaica buyers acquired only one or two slaves to begin with, although officeholders like Governor Thomas Lynch and potentates like Henry Morgan bought fifty or more from the Royal African Company. The Duke of Albemarle purchased sixty-nine slaves soon after arriving with Sloane in 1687. Most Africans brought to Jamaica in the early decades of British Caribbean slavery were Akan, a distinct ethnic and linguistic community in territory now encompassed by Ghana and Côte d'Ivoire. English merchants bought from African traders around the ports of Bonny, Old and New Calabar in the Bight of Benin ('the Slave Coast'), the Bight of Biafra, the Gold Coast and West Central Africa to the north of the Kingdom of Congo. Once they had been marched to the sea, purchased and held in forts on the coast, these captives were forced to endure the Atlantic crossing now known as the Middle Passage. These journeys were horrific and very often lethal. Densely packed into the holds of ships, captives were subjected to disorientation, malnutrition, illness, whippings and constant threats if they resisted. Many died from disease, while others committed suicide to avoid enslavement by throwing themselves overboard. The African abolitionist Olaudah Equiano later described English slave traders as 'bad spirits' who flogged him with 'brutal cruelty', and told of how the stench of the slave ship 'was so intolerably loathsome, that it was dangerous to remain there for any time', so that he 'wished for the last friend, death, to relieve me'. The late seventeenth-century phase of the slave trade witnessed some of the most statistically fatal crossings in its long history. Voyages from the Bight of Biafra to the West Indies took three months and had mortality rates of around 30 per cent. Many of those who did survive were called Coromantees – named for the Gold Coast slave port of Kormantse through which they passed – and known for their physical strength, military prowess and rebelliousness. As slavery expanded in Jamaica, uprisings became more common, so the Assembly passed slave codes legalizing the use of violence against Africans in both 1664 and 1696. The colony's 1664 law reasoned that 'commanding and punishing the aforesaid negro slaves will tend verry much to the generall advantage of settlers'. Punishments included whipping for disobedience and execution for open resistance. By establishing African slavery as a

permanent and heritable state of bondage, the slave codes enshrined white racial supremacy in law.[8]

Sugar profits, combined with high slave mortality due to poor diet and overwork, quickly produced a pattern of escalating importation to the Caribbean. Growing sugar involved exhausting and dangerous labour. After clearing entire acreages of woods, and planting and weeding and manuring, sugar cane took as long as eighteen months to ripen, when slaves harvested it using knives called bills. They transferred the cane to mills, which they turned themselves alongside cattle, to grind out juice in sweltering heat, sometimes being maimed or killed in the process as their limbs got caught in the machinery. They then boiled the juice to clarify and evaporate it into sugar crystals, drained out the molasses for distillation into rum, and cured the sugar, readying it for shipping to Britain in the form of dried cones packed into hogshead barrels. The business boomed. Between 1670 and Sloane's arrival in 1687, the number of Jamaican plantations (including those that grew cotton, cacao and indigo) jumped from 146 to 690, with 246 devoted to sugar. The 1680s marked the turning point for sugar sales in Britain, with Jamaica supplying up to 7,000 pounds per year. By 1700, British domestic consumption (including Barbadian sugar) had trebled, reaching 14,000 tons annually. Sugar now sweetened cups of tea, coffee and chocolate around the British Isles, providing their inhabitants with an addictively potent new source of energy and pleasure.[9]

Forcing slaves to harvest sugar by no means guaranteed high returns, however, since crops could fail, slaves died from overwork and sometimes fled, and because setting up plantations entailed major capital investment and potentially unserviceable debts. So investors used new instruments of credit and insurance to borrow money to buy slaves as well as purchase stocks in the Royal African Company, while new brokerage houses like Lloyd's of London (founded in 1688) began insuring slave cargoes to manage the risk of losses at sea. These innovations conspired to draw spiralling numbers of Africans into the vortex of slavery. In the last quarter of the seventeenth century alone, the British transported 77,000 Africans to Jamaica, outstripping Barbados, raising their price from £3 to £30 a head, the trade in slaves proving so lucrative that the Royal African Company soon lost its monopoly as private merchants lobbied Parliament to deregulate it. According to estimates, by 1700 slaves outnumbered whites on the island by 40,000 to 7,000.

The English had transported a quarter of a million Africans to their Caribbean colonies as a whole by this time. Yet this startling number marked only the beginnings of a business that would bring 1 million Africans to Jamaica by the early nineteenth century – a figure exceeded only by Brazil in the entire history of Atlantic slavery. This was the island colony Sloane encountered in 1687: one of intense violence and volatility, increasingly devoted to slavery and beginning to assume its pivotal role in England's expanding empire.[10]

## THE DUNGHILL OF THE UNIVERSE

Sloane's first order of business on the island was not collecting but healing. He lived in Spanish Town (St Iago de la Vega), where the duke was based and the Jamaica Assembly and courts met, ministering to Albemarle's family, making house calls on horseback and offering his services to planters on occasional excursions. That the colony was mortally hazardous was both a fact of demography and a legendary intellectual construction. In his account in the *Natural History of Jamaica* Sloane identified the island as one 'placed in the torrid zone'. Classical authorities such as Aristotle and Ptolemy had divided the earth into torrid, temperate and frigid climate bands, leading Europeans to doubt they could even survive beyond their own temperate lands. In 1602, for example, the traveller Edward Hayes feared that the 'burning zoanes' of Virginia, as he evocatively called them, would be 'unto our complexions intemperate'. Humoral theory since Hippocrates held that different environments produced distinct human constitutions and characters and warned that those who changed zones risked physical degeneration. This fear lingered obsessively. In the questionnaire Thomas Lynch took to Jamaica in 1670–71, one query asked whether eating turtles turned travellers' urine yellow-green, while another raised the unsettling matter of spontaneous generation, asking if there was indeed a 'magotti savanna, in wch whensoever it rains, ye rain as it settles upon ye seams of any garment turns in half an hour to maggots'. What came to be known as 'the dispute of the New World' turned on European boasts that the peoples and fauna of the Americas were inferior. Such boasts, however, were hedged by a persistent dread that Europeans would degenerate across the Atlantic.[11]

Jamaica came in for special treatment as the butt of English jokes. In his popular satire entitled *A Trip to Jamaica* (1698), the fortune-seeking Grub Street hack Ned Ward lambasted the island in cosmic terms as the 'dunghill of the universe' and 'the refuse of the whole creation . . . a shapeless pile of rubbish confus'ly jumbl'd into an emblem of the chaos, neglected by omnipotence when he form'd the world into its admirable order'. Talking up Jamaica's physical corruption doubtless reflected its easy morals, of which Ward was keenly aware, since Port Royal was synonymous with the pleasures of drink, prostitution and general carousing, a fact not lost on vindictive sermonizers who applauded the earthquake that destroyed it in 1692 (though they had strangely little to say about the sin of slavery). But even before making landfall, Sloane and the crew had noticed various physical changes south of the Equator: their urine suddenly stank more 'intollerably' than usual, their liquor went sour and the fleet's candles melted. The altered climate also 'show'd its self on every one, not only by sweating, but by their breaking out all over into little whales [wheals], pimples, or pustles'. Sloane reasoned, however, that this was a *good* sign – a providential augury of the 'proper seasoning' foreign bodies required to adapt to the American environment, thus offering pious 'grounds to admire the contrivance of our blood'. Jamaica might be a dunghill but God had designed Englishmen to flourish there.[12]

Dietary adaptation was one of the first issues to confront Sloane on the island. Since humoral theory held that food played a decisive role in shaping individual constitutions, eating tropical foods raised the spectre of degeneracy. Sloane noticed that Jamaica's 'best inhabitants' aimed to reproduce English diets of beef, poultry, pork and fish, even as they obliged their slaves to eat animal feed like Guinea corn, rotten meat, rats, snakes and raccoons. Inevitably, however, Jamaican diets diverged from English ones. The Jamaican equivalent of bread was 'very different', Sloane noted, being made of cassava root. The meat of turtles was different, too, and 'infected the blood of those feeding on them', he believed, 'whence their shirts are yellow, their skin and face of the same colour, and their shirts under the armpits stained prodigiously', changing 'the complexion of our European inhabitants' – 'complexion' referring to character and temperament rather than skin alone. He was, moreover, 'surpriz'd to see serpents, rats and lizards, sold for food, and that to understanding people, and of a very good and nice palate'. Rats

were 'sold by the dozen, and when they have been bred amongst the sugar canes, are thought by some discerning people very delicious'.[13]

Rather than criticize colonial tastes, Sloane rationalized them in a catalogue of 'extraordinary instances of feeding'. Throughout history, he observed, humans had thrived on a remarkable range of foods. People had used ryegrass and cockle seeds to make bread; a woman had lived for months on fenugreek seeds and hemp-seeds; some lived only on vegetables, while others made meat from the unlikeliest of animals: mules, panthers, lions, rhinos, bats and toads. Birds' nests were esteemed delicacies from Europe to the East Indies, while the inhabitants of the Cape of Good Hope consumed the guts of sheep and cattle. A man once survived on a desert island eating only oysters, while in Cataluña Spanish soldiers had stayed alive by feeding on candles. It might seem strange to eat whales, squirrels or elephants, Sloane conceded, yet 'those us'd to them, prefer them to other victuals'. You *weren't* what you ate – this was his implication – you could be civilized no matter what your diet. But the Spanish had not been so understanding. The 'Indians of America were made slaves to the Spaniards', Sloane pointed out, *because* they ate *Cossus* worms, although this was only a 'pretence' to 'drive them to slavery in mines, where the greatest part of them perished'. Yet Sloane *did* link diet and civility elsewhere. That the *Cossus* worm was enjoyed both by African slaves and by the ancient Romans – 'the most polite people in the world' – surprised him.[14]

English dietary adaptation in Jamaica was not a barbarous mutation, Sloane insisted, but providentially ordained. His reasoning drew on his knowledge of chemistry. 'I believe mankind can live on many sorts of vegetables and animals and their parts,' he later told the mathematician John Wallis. Certain foods 'are very strange & yet sufficient to sustain nature. Our bodies are so contrived as to prepare and take out of all these substances what is beneficiall' while purging off 'the useless excrements. In this matter', he continued, 'nature far surpasses chymistry in wch. different bodies require different menstruums to dissolve them.' His chemical training had in fact left him sceptical about some of the pretensions of the art: 'chymists have with great industry many years sought after an Alcahest, universal dissolvent, or menstruum,' he commented in the *Natural History*, 'whereby to open or extract the quintessence of bodies, and have not, so far as I can see or learn, been yet able to attain it.' Human beings, rather, made the best

natural machines thanks to their 'cutting and tearing, as well as grinding teeth, and a natural menstruum or dissolvent in [the] stomach and guts, of great force and power in extracting nourishment from the great variety of meats', which had been designed by 'the all-wise author' to digest whatever they ate. This dietary relativism was highly compatible with English claims that their bodies were destined to prosper in the Americas rather than degenerate, by contrast with native populations who had been decimated by disease in their own homelands.[15]

Jamaican diets may not have concerned Sloane, but the drinks that wreaked havoc with English health did. Water, Sloane impotently observed, was the most 'wholesome' draught on the island and a great 'counter-poison' but it was unpopular, in part because colonists believed digestion in fiery climates required imbibing equally fiery liquors. They guzzled Madeira wine, which kept longer in the heat than the 'much coveted' draughts of home: beer and ale. Ever the documentarian, Sloane could not resist collecting recipes for the local brews beloved of his patients: plantain drink, Acajou wine (brewed from cashews), 'cool drink' (from sugar), Perino (from cassava), corn drink, cane drink and rum punch – 'the common fuddling liquor of the more ordinary sort', made of rum, water, lime juice, sugar and nutmeg, and which put servants 'into a fast sleep, whereby they [fell] off their horses in going home'. The abstemious Sloane was appalled. In a letter to Edward Herbert, chief justice of the Court of Common Pleas back in England, he complained that the locals 'on a false principle concerning the climate kill themselves by adding fewell to the fire and drinking strong intoxicating liquors'. But he bit his tongue, reluctant to fault his clients: 'I must not be too troublesome to your lordship with idle tales.' There was no escaping the lure of liquor in the West Indies. Caribbean hospitality demanded violently inebriated excess to enliven the mind-numbing boredom of plantation life and also as a rite of white bonding to dull the fear of death from disease or slave rebellion.[16]

White paranoia was fuelled by extraordinary English mortality rates. Many colonists died in their twenties; only 1 per cent of them reached the age of sixty. Business boomed not just for planters, therefore, but also for doctors, although newcomers like Sloane had to work to gain locals' confidence. 'At first', he admitted, the inhabitants would 'scarce trust me in the management of the least distemper'. Some doubted the basic efficacy of European medicine: 'I was told that the

diseases of this place were all different from what they are in Europe, and to be treated in a differing method.' Another Jamaica-based English doctor named Thomas Trapham, whose *Discourse of the State of Health in the Island of Jamaica* (1679) Sloane had likely consulted before travelling, opined that 'place alters much the cure of the disease', holding that smallpox, scurvy, plague and consumption were almost unknown and that venereal disease was 'lessened' there. Sloane proceeded cautiously. In the unregulated medical world of the Caribbean, apothecaries and surgeons competed with more learned physicians for clients, and Sloane faced stiff competition from rivals like Trapham (whom he met while there) as well as from the island's African healers, who boasted far greater local knowledge than he. So he made sure to wear his wig as he rode about town, distinguishing himself as a gentleman physician, no matter what the weather. 'A great dew in the morning early,' he remarked of 6 September 1688 in the journal he kept in Jamaica, 'getting on horse back, after day light, my periwig and cloths were thoroughly wet with it before sun rising.' It was only after news travelled of Sloane cooling the fevers of the duke and duchess (probably brought on by malaria, which Sloane also endured) by a course of vomiting and bleeding that 'people had a belief I could help them'.[17]

Sloane's *Natural History of Jamaica* includes a total of 128 case histories, a form of medical record championed by his mentor Sydenham as a means of observing and classifying different diseases. These histories provide a lurid tableau of Jamaican life, all the more striking for their matter-of-fact tone, as Sloane documented the destruction the islanders wrought on themselves through chronic heavy drinking. One John Parker, for example, was 'a lusty full-blooded fellow' and 'much given to drink' who, suffering high fevers, 'committed a great debauch in rum punch' that led him to pass out on a cold marble floor. Parker woke, 'very incoherently', only to gulp down yet more rum, increasing 'his rage . . . to a very high degree', and died soon afterwards. A servant named Charles was a 'very lazy fellow' who had become 'discoloured all over his body'. Sloane pored over the man's troublingly distended genitalia: his 'scrotum was so swell'd with serous matter, as that it was much bigger than his head, yet almost transparent'. Sloane cured his dropsy (an oedema) by 'some jalap in powder' (a purgative root), which helped him at last to defecate, but the servant ignored his instructions, relapsed and, despite taking several 'opiats', perished. Thomas

Ballard, one of the planters who hosted Sloane as he travelled around Jamaica, was laid low by cold sweats and palpitations brought on by a particularly enjoyable 'debauch in brandy'. Sloane bled and blistered the fellow and plied him with cordials. Ballard was seized by a violent paroxysm after riding one day, but he survived. Sir Francis Watson, another of Sloane's new planter friends, and a member of Albemarle's council, suffered a high fever after a bout of heavy drinking yet survived thanks to a course of the febrifuge Peruvian bark which Sloane administered. Finally, there was the case of the 'extremely corpulent and fat' Mr F, as Sloane referred to him. Mr F had engaged in a drinking contest in which, 'by computation', he consumed a quart and a half of Madeira, which he washed down with a further six draughts swilled out of calabashes, measuring a quart each. This was too much to bear. F's eyes 'turn'd in his head [and he] stood fix'd' as he sank into a chair and fell unconscious. Sloane had him propped up and ordered feathers thrust down his throat to make him vomit while 'keeping his mouth open with a great key thrust between his teeth'. Foaming at the mouth and breathing hard, F was bled and somehow made it through the night. 'Penitent, and with tears in his eyes', he pledged eternal gratitude to Sloane for saving him. But the reprieve was not lasting; he died some time afterwards.[18]

Sloane's case histories also reveal a history of intimate contact between whites and blacks, shedding light on how slavery allowed Englishmen to exploit black women in particular for their well-being and pleasure, which Sloane abetted as a doctor. Captain Nowel 'had drunk very hard, and was very thin of flesh', threw up repeatedly and frequently went 'to stool'. So Sloane prescribed him a decoction of laudanum. Nowel's vomiting returned, he lost his appetite and complained of pain under the sternum. Sloane tried bitter wine, diet drinks, a course of electuary of steel (iron) and bloodletting. Nowel, however, would not curtail his penchant for morning drams of brandy with sugar. His stomach was now so weak, Sloane wrote, that he could keep down only 'the milk of a negro woman he suck'd'. Nowel's case was not unique. Another man 'given to good fellowship' was also debilitated with severe belly ache yet 'suckt two negro womens milk, by which he was perfectly recovered'. In addition to using the bodies of enslaved women for sex, often through rape, whites encouraged them to have children to increase the number of slaves, and used them as wet-nurses

for white infants, making their milk a precious resource, especially on an island with few white women. 'Blacks are as often taken for nurses as whites, being much easier to be had,' Sloane observed. He defended black wet-nursing on health grounds. He conceded that their milk was generally 'not coveted' by whites – Nowel notwithstanding – but he for one 'never saw' such women 'infecting their children with any of their ill customs' as others feared. He was 'sure a blacks milk comes much nearer the mothers than that of a cow'.[19]

Doctoring in Jamaica involved healing slaves too, but here the dynamics of Sloane's interactions were completely different. He responded solicitously to white patients' complaints, no matter how self-inflicted, resisting any temptation to criticize. This was normal in a period when doctors paid close attention to patients' testimony about their own constitutions, because patients were deemed to know their own bodies best and because they often outranked doctors in social status. By contrast, Sloane repeatedly challenged slaves' statements about their health. Medical attention to the enslaved was perverse in its motivation. The experience of pain was normal for slaves who toiled as field-hands through overwork, malnutrition, disease and punishment; pain that prevented them from labouring, however, had to be relieved. Plantation healing was thus pivotal to maintaining the profitability of slavery. Sloane embraced this task. He treated several ailing children, for example, so they could return to work and defied those 'cunning' women who, trying to spare their unborn a future life of slavery, feigned illnesses 'to make the physician cause abortion by the medicines he may order for their cure' (Sloane tried to 'put them off'). Ailments that appeared specific to Africans were most worrisome to planters, such as one flesh-eating affliction which Sloane was assured 'was peculiar to blacks', leading him to guess that 'some peculiar indisposition of their black skin' might be the cause. He observed several cases of worms and linked these to the consumption of 'corrupt fruits, roots, and other meats', as well as noting cases of infected skin and bones (yaws).[20]

Sloane interrogated Africans – many of whom acquired some English in the course of their enslavement – about their physical complaints and mostly assumed they were lying to avoid work, confident they could not trick him into getting them off their duties. It was 'very ordinary for servants, both whites and blacks', he commented, 'to pretend, or dissemble sickness of several sorts', but their 'lyes' were 'very

easily with attention found out by physicians' who asked 'proper questions'. A 'lusty negro footman' named Emanuel had been ordered to help intercept some pirates carrying looted silver but 'pretended' to be sick and begged off by 'dissembling himself in a great agony'. Sloane 'questioned him about his pain' or, rather, questioned his pain: either this was some 'new strange disease' or typical black dishonesty. Having evidently absorbed the instinctive violence towards slaves of his planter hosts, Sloane sent for a 'frying-pan with burning coals' to be applied to Emanuel's head and 'candles to be lit at his hands and feet' – a tactic that mimicked whites' methods for torturing and executing slaves. In his telling, Sloane found both Emanuel's resistance and capitulation equally risible: he suddenly recovered and resumed work. Mental distress figures in Sloane's case histories as well, though here again they are blind to the plight of the enslaved. An African woman called Rose had become 'melancholy' and 'morose' and also refused to work. 'She would not speak to any body, would not eat nor drink, except when forc'd' and 'would forget what her commands were'. If one 'put a broom in her hands to sweep the house, there she stood with it, looking on the ground very pensive and melancholy'. Sloane tried herbal decoctions, cupping, scarification and purging with emetics 'forc'd down her throat'. The scene is highly troubling: Sloane trying to 'cure' resistance to slavery. Some refused such cures outright. A slave named Isaac insisted to Sloane that 'say what I could . . . he would not recover' – and so he died. 'The passions of the mind,' Sloane blandly reflected, 'both hope and fear, have a very great influence on the body.' Nowhere in the case histories does he acknowledge the miseries suffered by the enslaved. While he ministered with care and respect to white alcoholics, he scorned slaves' troubles and sought to force them back to work for his planter friends.[21]

Case histories were classically construed as empirical observations of the facts of individual medical biographies, but this did not stop Sloane from passing judgement on a range of issues, and asserting his medical authority in the process. Contradicting his rival Thomas Trapham, he declared that he 'never saw a disease in Jamaica, which I had not met with in Europe', so there was no reason he couldn't treat them as well as anyone else, no matter how recently he had arrived. He talked up the utility of the Peruvian bark for fevers, 'in very great disrepute here' but which he favoured, to relieve fever and produce 'a perfect

recovery'. He attacked rival healers, pouring scorn on astrologers who were 'much esteemed in Jamaica'. These sages had informed one dying man that 'if he surviv'd the next day's noon, the aspects of the planets positively agreed to save his life.' When the man died, however, 'these same people said they had by the stars exactly foretold the minute of his death.' But Sloane saved his most biting remarks for black healers. These men and women resorted to 'cupping with [hot] calabashes' and used sharp knives for surgery but 'instead of relieving, [this] sometimes seems rather to add more pain to the place.' They were both entirely artless and excessively artful. On the one hand, they employed 'very few decoctions' of the kind Sloane routinely made up and relied on only the most basic knowledge of plants they had taken from others. 'I have heard a great deal of their great feats in curing several diseases,' he commented, but 'that little they know of simples here, seems to come from the Indians.' On the other hand, blacks mistook mental disorders for the effects of sorcery which, they supposed, demanded ritual super-natural redress. The slave woman Rose, who refused to work, was thought 'bewitched by her own country people'. Yet hers was merely one of those 'diseases of the head' often 'not understood, [and] attributed by the common people to witch craft, or the power of the devil'. Sloane allowed that the foul-smelling asafoetida gum might contain ingredients that could indeed relieve 'hysterick or nervous disorders', but this was hardly because it 'offend[ed] the nostrils of the devil', as exorcists liked to claim. To enlightened humoralists, happy to bleed their patients at a moment's notice, these were laughable superstitions.[22]

In addition to reflecting racist assumptions about black inferiority, Sloane's judgements about African healing have to be understood in their Jamaican context where he was competing directly with slave doctors. He was vying for patients by burnishing his own credentials and attacking others' reputations since, despite much rhetoric to the contrary, many whites – desperate to ward off disease and death – trusted African healers more than English ones. There were good reasons for this. African herbalists were thought to possess deeper knowledge of the island's medical resources going back to the period of Spanish control; in addition, black doctors used plants to heal rather than toxic substances like mercury or violent methods such as blood-letting, both of which Sloane employed. When the pirate Henry Morgan fell ill, he consulted Sloane and other white physicians, but the old

buccaneer ultimately rejected them in favour of a slave doctor who administered clysters (enemas) and plastered him with clay and water, albeit to no avail – Morgan finally met his end in August 1688. In some cases, Sloane engaged directly in trials of prowess with slaves. A man named Hercules, he wrote, was 'a lusty black negro overseer, and doctor' whose medical abilities were 'famous'. Yet, on Sloane's telling, it was Hercules who came to him, begging for help with his own gonorrhoea, which his 'country simples' had failed to relieve. Sloane treated him with mercury, declared him cured and concluded that 'there are many such Indian and Black doctors, who ... do not perform what they pretend' because of their 'ignorance of anatomy, diseases [and] method'.[23]

Sloane used his *Natural History* to portray himself as a doctor of singular ability, but his account did not sit well with all his readers. Some of his Jamaica hosts later accused him of impugning their 'civility' in his descriptions of them including his mention of their taste for lizards. 'It hath been said, that lizards were not eaten in Jamaica or the West-Indies,' Sloane replied in his second Jamaica volume, but that was 'notoriously false' since 'all nations inhabiting these parts of the world esteem them.' Not for nothing did they sell at a 'very dear rate in the common markets'. He was also accused of speaking 'disrespectfully of the inhabitants . . . by naming them in my observations of their distempers'. Sloane had indeed named names but this was entirely necessary, he claimed, 'to prove that the diseases there were the same as in England' and in any case it was 'the practice of all physitians who write observations' (although, as we have seen, he did conceal the identity of some, like 'Mr F'). Pointing out that Jamaicans wore cheap canvas clothing was 'no reflection' on them, Sloane insisted, quite the opposite, since he himself had sensibly 'made use of it as being lighter and more cool then most sorts of other apparel'. Perhaps over time Sloane had become less attuned to his hosts' sensitivities, since it took twenty years to publish his first Jamaica volume. Perhaps his own exemplary moderation led him to regard his Caribbean patients as degenerate after all, as the criticism he muttered of their drinking habits in his letter to Edward Herbert might be taken to imply. The people in Jamaica were demonstrably 'more debauch'd than in England', he concluded rather ambiguously. If their bodies had not physically altered, their behaviour seemed more extreme. Ironically, it was the slaves who,

deprived of good food, were 'temperate livers' and sometimes reached 'one hundred and twenty years of age', or so Sloane believed.[24]

There was certainly nothing temperate about the most demanding of all Sloane's cases, one he discreetly omitted from the *Natural History* but kept in manuscript: that of his patron, His Grace the Duke of Albemarle. Albemarle was thirty-four when the fleet left England and, Sloane observed, of sanguine complexion, yellowish skin and eyes, yet also a 'reddish' countenance that betokened his need for regular blood-letting. Sloane knew that the duke was 'accustomed by being at court to sitting up late and often being merry wt his friends'; one observer reported that an eminent London merchant had refused to issue a life insurance policy for him, citing his love of Madeira and claret. Albemarle had been named chancellor of Cambridge University in 1682 but proved unable to match his famous father's military glory, failing, for example, to mobilize his Devon militiamen to oppose the Duke of Monmouth's rebellion against King James in 1685. His early years as a huntsman and fowler had been drowned in drink and debt; now he hated exercise and deplored most medicine. Even before sailing, he had complained that his head was 'out of order' and called on Sloane and others to advise. Forbearance and 'good hours' was their prescription but Jamaica, Sloane realized with delicate understatement, being 'a very hott place . . . could not in probability agree with his body'. After being bled by Sloane, Albemarle swallowed his usual pills for his 'habituall jaundice', concocted from saffron and aloes. But his head only got worse. His imagination grew 'deprav'd' and he started up in the night, chattering. Time now for oxymels of squill (vinegar and honey) and emetic wine: antimony tartrate dissolved to induce vomiting. Some relief came, though it proved temporary and he once more fell 'out of tune' with paroxysms. Sloane could not overrule his aristocratic master: the duke simply refused to vomit as he was told. No more emetics, His Grace insisted, preferring again to be bled, and he finally recovered – until, that is, blood gushed from his nose in Barbados. In Jamaica, several months miraculously passed without incident, even as Albemarle carried on carousing.[25]

Ceremonial occasions posed irresistible temptations, however. The duke could not but indulge. He plunged back into crisis: violent pains gripped his legs, which came out in inflamed yellow wheals. He was bled again and downed decoctions of wormwood sage, rosemary rue,

wild sage and pimiento leaves, fermented with wine and soap, and was rubbed with Castile soap. The pain lessened but his ankle remained puffy. Sloane feared the onset of a lethal dropsy: a collection of fluid under the skin. He consulted the duchess, something that annoyed the duke, and brought in other physicians, swelling the din of advice. The duke consented to Sloane's plan to drain his legs but did not stick to the treatment, preferring to bathe, have his legs rubbed with Hungary water and be bandaged. After returning from Sir Francis Watson's one day, he suffered a fit and became constipated but refused all enemas and suppositories. Trapham then arrived on the scene. With more than a hint of rivalry, Sloane described him as one who claimed 'to understand the countrey diseases having liv'd there severall yeares'. He challenged Sloane's authority. There *was* no belly ache, he decided and proposed, Sloane sceptically noted, 'a graine of bird pepper whole in a potch'd egg affirming parrats to flye to this as to a naturall remedy and that it was very necessary for every one to take it in this climate'.[26]

Albemarle defied both Sloane and Trapham, however, so the two men made common cause, jointly ordering an ounce and a half of manna in chicken broth. Two or three nice stools resulted but no real relief. The fits returned, aggravated by melancholy, and everything imaginable was tried, including cupping on the shoulders, which drew a few ounces of blood, and blistering on the neck, wrists and ankles. Another physician by the name of Fulke Rose joined them and bled the duke still more. There was some improvement but by this point His Grace could barely eat. Blood now spurted from his mouth, which he 'spit out by great coagulated lumps'. His blistered ankles were dressed but the pain continued, so once again the doctors conferred. Sloane wanted to resume the duke's jaundice pills and try powdered jalap with bitter wine, while Trapham counselled a smorgasbord: taking the air and exercising; rhubarb; manna in chicken broth; a tincture of serpentaria Virginiana in Rhenish wine; spirit of scurvy grass. Sloane warned against the exercise but the duke sided with Trapham, going to Liguanee, east of Spanish Town, before returning and making merry once more to celebrate the birth of the son of the Prince of Wales back in England, news of which had just reached Jamaica. As a result, Albemarle's head started pounding, his gums bled and he became delirious. This time there was no recourse. His Grace dropped dead on 6 October 1688. It was over.[27]

But Albemarle's death did not release Sloane from the battle to pre-
serve him – it merely transformed the fight. Like everything else under
the Jamaican sun, the duke's corpse was soon imperilled by the heat
and humidity. The air was 'so hot and brisk as to corrupt and spoil
meat in four hours after 'tis kill'd', Sloane remarked, so it was 'no won-
der if a diseased body must be soon buried'. Twelve hours was the local
limit. Sir Francis Watson succeeded the duke in the governor's chair at
an emergency meeting of the Assembly. Trapham 'and the rest of his
Graces physitians', Sloane undoubtedly among them to help look after
his remains, 'desired that this board would appoint some body to view
his Graces corps which they are now going to embalme because there
is a report spread abroad that they have not dealt fairly with him'. It is
not clear what Watson meant by this but Ballard and Freeman, old
English soldiers turned planters, were ordered to accompany two sur-
geons to 'be present at the opening of his Graces body'. They duly
reported that 'his vitalls were very defective except his heart, and that
it was the opinion of all . . . present that he could not longer subsist'.
Many planters had themselves buried in their own gardens because it
was difficult to get bodies in timely fashion to the cemetery outside Port
Royal ('I never heard of any of them', Sloane quipped, 'who walk'd
after their deaths for being buried out of consecrated ground'). But His
Grace was no common planter. His body had to be preserved for ship-
ping back to England where it might receive a proper Christian burial.
His bowels and brain were quickly removed to prevent putrefaction
while a powder was prepared using aloe, myrrh, nutmeg, cinnamon
and caryophill, combined with quicklime. His skin was separated and
the muscles 'gasht into the bone' and filled with the powder to dry up
his remains. All cavities were filled and sewn up. Strong linen was cut
into long strips and dipped in hot pitch, wax, rosin and tallow, and
applied to the corpse and left to cool.[28]

The body thus sealed up, melted pitch was poured into the duke's
coffin. Bubbles began rising from his hand so 'some fresh ingredients'
were inserted. The coffin was nailed shut and loaded into a second box,
made of lead, and the space between them filled with pitch. But the
'plumbers and joiners' had blundered: 'a very fresh cadaverous smell'
began seeping out. In death, as in life, the duke resisted – he was decom-
posing. The corpse's attendants frantically assembled a new cedar
coffin, sealing it up with a fresh round of ingredients. New linens were

prepared and draped over the box, which was covered with a black cloth. The division of the corpse and its preservation were soon completed and the duke made stable at long last. His entrails were placed in a second cedar box and buried in hallowed ground under the altar of the former Catholic church in Spanish Town. The rest of his body, sealed tight in two boxes, could now wait until the time came for the Duchess of Albemarle to take him back to London, when His Grace would be interred under the cold stone of Westminster Abbey. In death, as in life, Sloane had resolutely done his duty by his incorrigibly dissolute patron.[29]

## JOURNIES IN THE ISLAND

In addition to his work in Spanish Town, Sloane made a series of what he called 'journies in the island', which confronted him with the ruins of Spanish Jamaica and the expansion of African slavery under English control. Sloane would have seen Africans during his early years in London but the spectacle of a slave ship arriving in Port Royal one day was an altogether different proposition. 'I saw', he wrote, 'a ship come from Guinea, loaded with blacks to sell' at one of the slave markets that took place every day in the Americas. He was close enough to smell the stench of waste, disease and death accumulated on the Middle Passage: 'the ship was very nasty with so many people on board.' He mixed with onlookers, probably merchants and planters looking to buy. They told him 'that the negroes feed on pindals, or Indian earth-nuts, a sort of pea or bean', as well as boiled Indian corn twice a day. Selecting healthy labourers was their overriding preoccupation. 'The negroes from Angola and Gamba, are not troubled with worms,' Sloane observed, reflecting buyers' concerns, 'but those from the Gold Coast very much.'[30]

Visiting local plantations, Sloane saw for himself how sugar was made. He spent little time noting the conditions under which Africans worked (he merely spoke of them 'scratching up some earth'), focusing instead on the technical aspects of the operation. The cane was 'bruised' between iron rollers in mills driven by oxen before the juice was taken into boiling houses, mixed with lime and the scum drawn off. The 'black and glewy' residue was strained and cured, ready for storage and shipping as unrefined brown muscovado, which kept better than more

refined sugar. The observer turned participant and even performed his own experiments: 'I tried to boil the sugar-cane juice, without any mixture, to sugar, but it would not coagulate.' 'Good sugar', Sloane declared like a connoisseur, 'is known by those used to making it, by its smell before it is made.' This emphasis on technique, rather than the technicians, was characteristic of Sloane's *Natural History*: he commissioned a diagram of a cotton gin that featured none of the slaves who worked it, while the only engraving that *did* picture plantation work ironically showed kneeling Amerindians harvesting lucrative cochineal dye for the Spanish in Mexico. Such crops were a source of great commercial interest to the English in their quest for profits. Sloane collected samples of sugar, cotton and tobacco, which he noted was 'worth twelve pence a pound in England'.[31]

Sloane used his status as the governor's physician to establish good relations with Jamaica's planters, whose friendship was essential for his island travels. Sir Francis Watson, who liked to get drunk with Albemarle, hosted Sloane on his plantation and engaged him in conversation that ranged from Watson's asthma to the profitability of sugar. The letters Watson wrote during 1689–90 after Sloane had sailed for London convey the friendly dynamic between the two men. Watson asked for 'ye news books & ye other books you promised to send me'; made clear that he had tried to convince Thomas Trapham, who had ended up in court, that Sloane had not set out to accuse him (over what is not clear, perhaps Albemarle's death); and passed on the news that 'Coll Ballard wants you being troubled with a pain in his hipp.' Sloane evidently promised he would return to Jamaica but Watson was doubtful: 'if through any accident you should alter your resolutions of coming here (wch I hope will not be) pray continue sending me what news is currant.' 'I hope you are safe arived in Ingoland,' William Bragg similarly wrote to Sloane in April 1689 a month after he had left. Bragg was another major planter, who owned about fifty slaves in St Thomas in the Vale, just a few miles north of Spanish Town. He updated Sloane with news of commissions, militia regiments, local grievances and illnesses. Bragg's spelling suggests he was not a highly educated man but he wrote with feeling: 'Docktour we wont your good cumponey hear for ye peepel begines to bee verey sickley' and are 'extraudinarey trubbelled with fevers' that 'falls much upon [the] negrouse'.[32]

Taking advantage of his increased freedom after Albemarle's death,

Sloane made one extended trip to St Ann's on Jamaica's north coast in October 1688 (pp. 60–61). He selected a good horse, a company of 'some gentlemen of the country' and a 'very good guide' – probably an African or Indian and likely a skilled hunter, able to navigate the island better than any colonist. Heading north from Spanish Town, the group passed through St Thomas in the Vale (today part of St Catherine Parish) after a few miles and came upon an area known as Sixteen Mile Walk. Its cacao 'walks' had been blighted by disease for some years but heavy rains made the valley richly fertile nonetheless. The planter John Helyar called Sixteen Mile 'the piss pot of the island', and Sloane noted that the rain there was 'so furious as sometimes to wash out of the ground the roots of all the plants set in it'. In the 1670s, Jamaica's former governor Thomas Modyford had owned an enormous estate there with over 600 slaves and servants, and the area remained busy with labour. While there, Sloane probably visited Dr Fulke Rose, himself a major slave owner and with whom Sloane had collaborated in treating both Captain Henry Morgan and the duke. The meeting was also highly significant in ways Sloane could not have guessed at the time, for in all likelihood this was where he met his future bride in the form of Rose's wife Elizabeth, a match that was to bring Sloane a significant fortune from these same sugar estates for many years afterward.[33]

But that was in the future. For now, Sloane and his companions continued north, proceeding to the 'magotti savanna' and Mount Diablo, where they camped and spent the night. This was not freewheeling exploration but a delicately devised itinerary to avoid the Maroons who controlled the Blue Mountains to the east and the Cockpit country to the west where, as Sloane put it, 'runaway negros ... lye in ambush to kill the whites who come within their reach.' After tying and feeding their horses, the travellers settled into 'a hunters hut, and lay on plantain and palm-leaves all night', for once sleeping in the style of slaves rather than planters, who typically reposed in hammocks. Or tried to sleep: 'our sleep was very much interrupted by the croaking of a sort of tree frogs,' Sloane recalled, 'the singing of grasshoppers, and noise of night animals.' But at least it was cool thanks to a gentle breeze blowing in from the coast. The next morning, they crossed Mount Diablo, where Sloane was thrilled to collect several 'wonderful' species of fern, before arriving at St Ann's or, as the Spanish had called it, Sevilla

Maps from the *Natural History of Jamaica* (1707) illustrating the Atlant colony in Britain's commercial empire thanks to the acceleration of

Caribbean islands, Jamaica and Port Royal. Jamaica was a rising
tic slave and sugar trades.

la Nueva (New Seville) – the site of Columbus' original Jamaican land-fall in 1494 and the island's first Spanish capital.[34]

Sloane was so intrigued by the area that he spent five days exploring it, hosted by Richard Hemmings, a soldier turned planter. This Sevilla, as Sloane put it, was 'now Captain Hemmings's plantation'. Writing about the ruins of Spanish Jamaica was not a neutral act of description, however, but one charged by a context of polemic between Protestants and Catholics. The Dominican friar Bartolomé de Las Casas, who sailed with Columbus, had infamously described how Spanish colonists tortured and executed Native Americans in his *Brief Account of the Destruction of the Indies* (1552), inaugurating the so-called Black Legend of Spanish cruelty that became a fixture of Protestant propaganda. In addition to Flemish, French and German editions of this work, English translations of Las Casas appeared in 1583, 1656 and 1689, with depictions of graphic violence added by the Liège engraver Theodor de Bry, which showed Spaniards burning Amerindians, dismembering them and cannibalistically serving their limbs to other natives. In his emotively retitled 1656 translation of Las Casas, *The Tears of the Indians*, the Englishman John Phillips lamented that these 'Spanish cruelties' were 'enormities to make the angels mourn and bewail the loss of so many departed souls, as might have been converted and redeemed to their eternal mansions'. Phillips argued that these horrors justified Cromwell's brutal campaigns against Irish Catholics, while others justified England's colonization of the Americas by invoking Protestants' mission to save native souls from 'the bloudy and popish nation of the Spanish', envisioning their plantations as morally preferable to Spanish mines. 'I like a plantation in a pure soil,' Francis Bacon wrote in his essay 'Of Plantations' (1625), 'that is, where people are not displanted to the end to plant in others. For else it is rather an extirpation than a plantation.'[35]

As examples from the killing of Catholics in Ireland to the African slave trade make obvious, however, indigenous populations were often 'displanted' in settling English plantations. Gold – the tantalizing source of 'Spanish cruelty' – was, moreover, hard to forget in Jamaica, an island haunted by mirages of treasure both offshore and on. The planter Thomas Ballard told Sloane about a wreck off the Seranata Islands with the potential for salvage, while a soldier named Lloyd gave him a sample of gold from a neighbouring Spanish colony. 'The Duke

of Albemarle once shew'd me a very rich piece of silver oar [ore],' Sloane noted, 'which his father had sent him from the Apalathean Mountains on the confines of Carolina.' Treasure seemed everywhere and nowhere. Dr Henry Barham, who later became Sloane's most trusted Jamaica correspondent, was an officer of the Royal Company of Mines and recorded the anti-climax of the duke's mineral projects. Barham sent Sloane some yellow marcasite to show him the kind of 'gold' peddled by those who 'impose upon people ignorant of these matters'. Local landowners proved uncooperative when Albemarle and his mates came looking for treasure, bridling at the governor's intrusion into their affairs, though their seriousness was doubtful. It was merely 'under pretence' of searching for mines, Barham reported, that the duke and his men 'went to planters houses & got drunk'. From the beginning, Cromwell's Western Design had been a quest for bullion to pay off the Protectorate's debts and the English did ultimately secure large amounts of Spanish treasure in Jamaica – albeit second hand. By selling slaves to neighbouring Spanish colonies, merchants obtained £100,000–£200,000 worth of silver per annum in the 1680s.[36]

Commercial pragmatism notwithstanding, the struggle between Protestants and Catholics framed Sloane's account of Jamaica's Spanish ruins. Of all the objects he might have used to open his *Natural History*, he tellingly chose one that was missing: the map Columbus' brother Bartholomew had presented to Henry VII in 1488 to invite England to sponsor Christopher's first Atlantic voyage. However, 'instead of discovering the West-Indies,' Sloane sarcastically recounted, 'there was bought at Antwerp a suit of fine tapistry hangings, with money that had been set apart, and thought sufficient for that purpose. These hangings are now said to remain at Hampton Court.' (Sloane later tried to obtain this map for his own collections, as if the act of acquiring it might somehow redeem England's failure to seize the Americas, but these efforts also ended in failure.) Previous collectors had already compared themselves to Columbus, such as the Bologna naturalist Ulisse Aldrovandi, who had sought patronage for an American voyage of his own from Philip II of Spain in the 1570s, declaring, 'my intention is similar to that of the diligent and ingenious admiral Christopher Columbus.' Sloane himself was well aware of Columbus, who had read his Pliny, as the first person ever to make American collections, bringing back gold, plants, animals and even Caribbean

islanders. Indeed, objects marked every stage of the Italian's progress, as he had originally been encouraged to sail west by a trail of objects in the Azores including pieces of wood, cane and pine and, intriguingly, 'two mens bodies with larger faces, and different aspects from Christians', as Sloane noted. Columbus later divined the proximity of the Bahamas from sightings of birds, land herbs and various sea creatures. But Sloane took note of Columbus' darker legacies as well. He embroiled himself in 'mortal discords . . . about gold and women' in Hispaniola; he 'took the advantage' of a lunar eclipse in Jamaica to deceive the Taíno into provisioning his men by assuring them it was a warning from an angry god; and his men spread disease (syphilis) once back in Europe, or so Sloane maintained. Sloane made the language of the Black Legend his own. He acquired several editions of the works of Las Casas and cited him when describing how the 'severities' of the Spanish had brought about the extermination of Jamaica's Taínos: 'in some small time the Indian inhabitants, to the number of sixty thousand were all destroyed by the severities of the Spaniards, sending to mines, &c.' The contrast between the moral legitimacy of Spanish versus English colonization would have been clear to Sloane's readers, but his balancing act was a delicate one. While distancing himself from Columbus' 'cruel' quest for gold, he ambitiously identified his own journey as successor to the Italian's historic odyssey.[37]

The ruins of Sevilla spread out for miles around. There was a 'bastard mammee-tree' growing through the battlements of a tower; the remnants of a castle built to defend the nearby harbour; a 'great sugar-work' that had been driven by a watermill; and the remains of houses and blocks of masonry. Sloane dwelt on the ruins of an unfinished Catholic church – its construction 'cut off by the Indians' who fought the invaders – made of freestone and marble and which he measured by pacing (20 paces wide, 30 paces long). Odd lumps of masonry bearing the grandiloquent coats of arms of dukes and counts littered the ground; Sloane supposed they had belonged 'to Columbus his family, the proprietors of the island'. Carvings and arched stones lay where the altar must have been, the church's western gate exhibiting 'very fine' craftsmanship. The gate's rather punitive sculptures bore figures of violent Christian martyrdom including 'our saviour's head with a crown of thorns between two angels', with on one side 'the round figure of some saint with a knife struck into his head' and on the other 'a Virgin

Mary or Madonna, her arm tied in three places, Spanish fashion'. Under another coat of arms, there was a solemn if Ozymandian inscription carved in stone:

PETRUS. MARTIR. AB. ANGLERIA ITALUS. CIVIS. MEDIOLANEN. PRO-
THON. APOS. HVIVS INSVLE. ABBAS. SENATVS. INDICI. CONSILIARIVS.
LIGNEAM. PRIUS. ÆDEM. HANC. BIS. IGNE. CONSVMPTAM. LATERI-
CIO. ET. QUADRATO. LAPIDE. PRIMVS. A. FUNDAMENIS. EXTRUXIT.

(PETER MARTYR OF ANGLERIA, AN ITALIAN, CITIZEN OF MILAN,
CHIEF MISSIONARY AND ABBOT OF THIS ISLAND, A MEMBER OF THE
COUNCIL OF THE INDIES, FIRST RAISED THIS BUILDING FROM ITS
FOUNDATION WITH BRICKS AND SQUARED STONE; FORMERLY IT
WAS BUILT OF WOOD AND TWICE DESTROYED BY FIRE.)[38]

Sloane was in one sense just describing the world around him, and his interest in the coats of arms of the island's former proprietors was consistent with the attention paid to local antiquities and aristocratic pedigree by the natural histories of English counties of the period. At the same time, his account also reflected the competition for New World ascendancy between Protestant and Catholic. In the anti-Spanish context in which he wrote, his mention that the church's construction had been 'cut off' by the Taíno likely reminded readers of his *Natural History* of the Black Legend and the atrocities committed against the natives. Nature itself, he observed, appeared to be on the side of the English. He casually reported Hemmings's remark that he sometimes found Spanish 'pavements under his canes, three foot covered with earth'. The ruins of Spanish Jamaica were not just a curious spectacle but a strikingly natural one: English plantations were literally burying Jamaica's Catholic past in billowing fields of cane. The English were the masters now. Sloane's account was, however, selective. He made no mention, for example, of the slaves he must have seen toiling in and around Hemmings's fields.[39]

A couple of months after returning from Sevilla, on 30 January 1689 – the fortieth anniversary of the execution of Charles I – Sloane made another trip, this time to Guanaboa Vale, north-west of Spanish Town, which moved him to reflect once more on 'Spanish severities'. He crossed an area called Red Hills, in reality a well-planted valley where it rained every day and red dust from the clay-like soil stuck to

travellers' clothes. A few miles on, he met a man named Barnes, a carpenter and planter. A prickly yellow kind of wood grew nearby, the carpenter told him, 'good for nothing but to burn'. They talked about 'extraordinary' weather: how a blast of punishing hail 'beat down' Barnes's orange trees and cassava plants 'to the roots'. The hailstones had been 'as big as pullets eggs, of various shapes, some corner'd like cut diamonds, some shap'd like a heart'. Barnes tried to preserve them by packing them in flour but collecting ice in Jamaica proved difficult. Showing Sloane around, Barnes pointed out where the Spanish used to

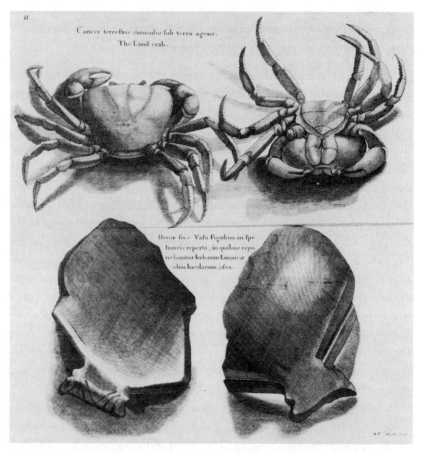

Jamaican crab specimens with fragments of pots from the cave Sloane was shown by a carpenter named Barnes. Sloane believed the pots contained indigenous Taíno remains. He may have juxtaposed these objects in his *Natural History* to compare natural and artificial textures.

plant cassava. It was common, he said, to find palisades, orange walks and limes amid the vestiges of 'formerly planted ground'.[40]

But Barnes had stranger tales than these to tell. Ten years before, about half a mile from his plantation, he had come across a cave about 8 or 9 feet across and 5 feet high, perched on a steep precipice and 'curiously shut on all sides with thin, flat stones'. Barnes had removed these, entered and found 'a coffin partly corrupted, with a body in it, he suppos'd to have been some Spaniard thrown in there in hast[e]'. The corpse had been devoured by carnivorous ants yet the bones remained 'all in order'. The cave contained large ants' nests and 'pots or urns' with parallel lines 'grosly cut' on them 'wherein were bones of men and children' (opposite). Barnes showed Sloane how 'the ants had eat[en] one carcass to the bones, and had made holes in their ends, whereat they enter'd, I suppose, to eat the marrow'. Sloane, meanwhile, supposed that 'negroes had remov'd most of these pots to boil their meat in', leaving only a few fragments behind. Barnes's cave thus possessed a complex layering of historical presences: there were the ants; the alleged black raiders; and, inevitably, the murderous Spanish. Indeed, Sloane believed that the bones in the pots belonged to the natives of the island and that Barnes's cave was a site of Taíno suicide in flight from the Spanish: 'I have seen in the woods, many of their bones in caves . . . starved to death, to avoid the severities of their masters.' Intrigued, he indulged in some impromptu grave-robbery, removing several objects for his collections: 'the skull of an Indian taken from one of the caves in Jamaica where they used to be enterred'; 'the arm bone or the humerus of an Indian perforated and the cartilage and marrow eat by the ants'; 'part of an earthen urn found full of Indians bones'; and 'part of an Indians upper jaw – taken from their buriall place in Jamaica'. Whether Sloane paid Barnes for these items or simply helped himself is unclear. In any case, taking possession of them made Sloane the curator of what he described as Jamaica's 'inhuman' past. If only, exclaimed the Jamaica planter Bryan Edwards after reading Sloane's description of the cave a century later, 'heaven in mercy had permitted the poor Indians in the same moment to have extirpated their oppressors altogether!' Accounts like Sloane's enabled the English to imagine themselves – improbably – as Taíno allies outraged by Spanish atrocities, and to rationalize their own colonial efforts as a moral counterweight to Iberian barbarity.[41]

Sloane's excursions led him to reflect on Jamaica as a whole. In some ways, the island appeared a deeply alien world. 'The outward face of the earth seems to be different here from what I cou'd observe in Europe,' he wrote. Violent rains lashed the landscape, leaving the roads barely passable, obliging him to make his physician's rounds on horseback; torrents of water 'wash away afterwards whatever comes in their way'. Nature itself seemed different out here. Thunder boomed and tremors regularly shook the earth. 'I dread earthquakes more then heat,' he confessed, 'for we had a very great one I finding the house to dance and cabbinetts to reel ... [and] casting my eye towards ane aviary saw the birds in as great concern as my self.' But unlike earlier travel accounts that questioned whether Europeans could even survive outside the temperate zone, Sloane's Jamaica was no land of monsters and marvels. Quite the contrary: in many ways, it resembled nowhere so much as England. Jamaica's 'green and pleasant' savannahs, as he called them, 'answer our meadow-grounds'. Torrid Jamaica turned out to be 'temperate': 'I'me sure I have felt greater heat in some parts of France then ever I did here yet.' Nor did he 'observe any difference in the layers of earth ... from those in England'. Instead of tales about rains that bred maggots, he compiled a year's worth of orderly weather charts from March 1688 onwards, evidently with instruments he brought with him, that confirmed Jamaica's similarity to the mother country: 'the mercury in the barometer stands at about the same heighth and has the same alterations as in England.' Such comparisons were typical of English writers in the late seventeenth century, as they sought to rehabilitate Jamaica, and other West Indian islands, as viable sites of colonization, even as mortality rates soared and many doubted their worth.[42]

Instead of waxing lyrical about enchanted marvels, redemptive Edens or magical paradises in the tradition of Shakespeare's *The Tempest* as some travel writers liked to do, Sloane inventoried Jamaica as an island of commodities in a frank survey of its environmental resources. Jamaica's commercial identity was cartographically inscribed in his *Natural History*. As if to answer the historic loss of Columbus' Atlantic chart, Sloane commissioned no fewer than four maps for his book which framed Jamaica as part of England's Atlantic empire (p. 60). One charted the Western Ocean, as the Atlantic was then called, the littorals of western Europe, the Americas and, the source of

plantation labour, West Africa; a second provided a closer view of the islands south of Jamaica; a third, a view of the superb deep-water harbour of Port Royal; and the largest was a detailed plan of the island itself. This last map followed the convention established by the genealogist William Camden in his *Britannia* (1586), since which English natural histories had depicted localities through the boundary lines of local lords' private properties. While ostensibly describing natural landscapes, therefore, natural histories naturalized social ones. On Sloane's densely tattooed island map, Jamaica's planters substituted for lords and plantations for manors, with markings indicating, for example, Watson's sugarworks west of Spanish Town, Bragg's and Ballard's plantations just north, and Fulke Rose's estates in St Thomas in the Vale.[43]

From the expanding inventories of merchants' goods to the tables of commodity and stock prices being published in London, it was the age of the commercial list and Sloane became a master of the form, tallying the loading and unloading of ships at Port Royal. The English imported European flour, biscuit, beef and pork; clothing for masters, servants and slaves; and all kinds of liquor, including Madeira wine, which brought a handsome 50 per cent profit. In return, Jamaica sent back sugar, indigo, cotton, cacao, ginger, pepper, fustick-wood, prince-wood, lignum vitae, arnotto dye and logwood. Because Jamaican soil was overwhelmingly devoted to sugar and other export crops, merchants sent brigs loaded with rum, sugar and molasses up to New England and New York to trade for food such as beef and pork. Selling contraband to 'enemy' Spanish colonies flourished. Hispaniola, Cuba, Portobelo, Santa Martha and Cartagena were 'very great places for trade', furnishing Jamaica with cascarilla, sarsaparilla, pearls, cacao, cochineal dye and the Peruvian bark 'in exchange for blacks and European commodities'. Sloane even listed eighty of Jamaica's rivers one by one, as though the English owned these too: Sawl's River and Crawle River and Lynch River and Negro River and White River, and so on and so on, for more than two pages. While mapping rivers on a chart served practical purposes, collecting their names into a list did not. Listing territorial features was, however, a tradition that dated back to Pliny's encyclopaedic Roman natural history – modelled on the Roman Triumph – as a ceremony of imperial possession. To list was to claim ownership.[44]

Jamaica, Sloane reasoned, was divinely designed for commerce: the islands to its east 'guard it from the violence of the winds, and great Atlantic Ocean, and render it fitter for the produce of the manufacture and trade of those parts, than any of them'. In an article for the Royal Society's *Philosophical Transactions* in 1699, he cast the Atlantic as a providential medium connecting the Old World and the New. Here he described how not one species had been destroyed 'from the creation to this day', God having 'orderly disposed all things' to 'bring to perfection several vegetables and animals . . . [and] keep the species from being lost'. The leaves and stalks of Jamaican mistletoe shot up to procure moisture for their hydraulic systems from the rain and the spring-loaded spirit weed scattered its seeds at just the right time of year so that the winds 'direct[ed them] to all quarters'. Species were 'wonderful contrivances', he went on, once more employing the language of divine design. The appearance of 'strange beans' (cocoons and nickar nuts) in both Jamaica and the Orkneys in Scotland and Ireland led him to draw similar conclusions. It was 'very easie to conceive', he thought, that they grew in Jamaica and 'may either fall from the trees into the rivers, or be any other way conveyed by them into [the] sea', whose currents carried them through the Gulf of Florida to the Atlantic and finally the British Isles, 'as ships when they go south expect a trade easterly wind, so when they come north, they expect and generally find a westerly wind'. The paths of human commerce thus provided a model for nature's own journeys, serving 'necessary ends' through 'great endeavours'. 'There appears so much contrivance, in the variety of beings, preserv'd from the beginning of the world', Sloane observed in the *Natural History*, 'that the more any man searches, the more he will admire; and conclude them, very ignorant in the history of nature, who say, they were the productions of chance.' Nature had not changed 'since the creation, and will remain [so] to the end of the world, in the same condition we now find [it].'[45]

Yet for all his providentialism, Sloane could not resist collecting many strange tales of the Caribbean as well, the truth of which remained elusive and mysterious, enveloped in rumour and hearsay. There was the story of one King Jeremy of the Mosquito Indians who came to Jamaica to ask Albemarle's aid against pirates and Spanish marauders, claiming an ancient alliance from the time of Charles I. Sir Henry Morgan told uncanny stories of 'thick clouds' of mosquitoes at Lake Maracaibo on

the northern coast of South America, and Colonel Nedham of locusts that made 'a heap as big as the greatest ship' when settling on the water off Tenerife. True to form, Catholic 'ecclesiasticks' had absurdly sought to expel them 'by penances, with swords tied to their arms, voluntary whippings, &c. by excommunications by bell, book and candle, by sprinkling with holy water', all to no avail. There were reports of the fortunes to be made through the logwood trade at Campeche and the Indian divers of the fabled pearl fishery at Margarita Island who could remain under water for seemingly impossible lengths of time; of myth-ical cargoes of curative Peruvian bark lost en route from the South Seas, tragically thrown overboard; and of the commodity trades, contraband and treasures sunk beneath the waves of the Caribbean Sea. There were the shoals that wrecked ships approaching Port Royal; the Latvian Cur-landers left on Tobago who had survived on a diet of armadillos and hogs; and the tale – told by an escaped slave – of the capture of English forces on Crab Island by Spanish pirates masquerading as their country-men. Sloane relayed these stories, which he described as coming 'from several credible persons' and 'for the better understanding of several matters in the West Indies'. These, however, were not the matters of fact he liked to champion but tales of the Caribbean mixing fortune and danger in equal measure. For all his sober commercial piety, these stories suggested that the West Indies were themselves an impenetrably curious tale, where the realities of nature and the mirages of fortune could never quite be told apart. Such was the science of natural history as Sloane and many others practised it: a form of inquiry that dealt in the niceties of natural species and theological homilies about the won-ders of the creation; the sober commercial exploitation of natural resources; but tall stories as well. To Sloane, there was no contradiction between collecting matters of fact and the most titillating rumours. In Jamaica, plunder and piety, science and lucre, went hand in hand.[46]

## A VERY PERVERSE
## GENERATION OF PEOPLE

Sloane's Jamaican explorations brought him into sustained contact with enslaved men and women. These were not purely medical encoun-ters: he scrutinized slaves' bodies and behaviour, driven by both

scientific and racial curiosity, in order to study the nature of black people. His views should be understood in the context of contemporary European attitudes to slavery, racial difference and the use of natural history to assess foreign peoples. Although there was no organized anti-slavery campaign in the late seventeenth century – the campaign to abolish the slave trade in the British Empire would not intensify until the 1780s – Atlantic slavery was prompting serious debate even before Sloane's voyage. The Puritan Richard Baxter had declared slave owners in 'rebellion against God' as early as 1673, while the Anglican missionary Morgan Godwyn decried slavery's 'soul-murthering and brutifying state of bondage' in Barbados in 1680. Both demanded the amelioration of the institution, in line with Christian paternalism, rather than its abolition. Aphra Behn's fictional story *Oroonoko* (1688) was likewise limited in its critique: it expressed sympathetic outrage at the plight of its eponymous African prince, who falls into slavery, but depicted his resistance as evidence of exceptional character that placed him 'above the rank of common slaves'. The London merchant, astrologer and mystic Thomas Tryon was more radical. He had visited Barbados in the 1660s and in 1684 published a 'Negro's Complaint', in which he excoriated 'nominal Christians', turning the accusation of 'cruelty' from the Black Legend back on to the English. 'The stronger and more subtle murder, enslave and oppress the weaker, and more innocent and simple sort at their pleasure,' Tryon wrote, 'and pretend they have a right, because they have got a power to do so.' By the time Sloane was in Jamaica, therefore, slavery was already subject to searching criticism, of which he likely became aware, since he later acquired works by both Godwyn and Tryon.[47]

One significant effect of accelerating European trade and colonization was the intensification of attempts to describe and classify the world's peoples. European debates about human variation did not yet, however, posit a unified notion of 'race' that cast Africans as irrevocably inferior to whites for biological reasons, as would become the case in the nineteenth century. Instead, the term 'race' connoted stock (both animal and human), nation and aristocratic lineage. Europeans notionally regarded all human beings as possessed of rational souls and descended from Adam and Eve, and from Noah and his sons after the Flood. But they did distinguish between Christians who possessed

'civility' and 'barbarous' heathens who had not received the gospel and thus required conversion. Physical difference also formed an important part of how Europeans assessed others. Hippocratic theory militated against the idea of essential racial characteristics and implied that switching climates would alter complexions (as the English feared). It also associated peoples outside the temperate zone with 'degenerate' forms of monstrous variation from European norms, encouraging the fictions that the harshness of hot climates inured Africans to hard labour and that African mothers could bear children with ease because they suffered little or no pain in giving birth. Explanations remained in flux. Europeans continued to explain dark skin in moral terms, particularly the biblical 'Curse of Ham' which proposed that darkness was a mark of the sin committed by Ham – who was said to have looked upon Noah while he was naked. But they increasingly invoked mechanical causes such as prolonged exposure to the sun. In Spanish America, meanwhile, the notion of *limpieza de sangre* (purity of blood) was systematically applied to justify social hierarchies based on physical difference.[48]

By the late seventeenth century, naturalists were rethinking both causation and classification. In the 1660s, the Bologna anatomist Marcello Malpighi undertook experimental dissections of Africans, hoping to isolate a subcutaneous source for dark skin. In 1684, the French polymath François Bernier made one of the first attempts to taxonomize human beings into geographical groupings and according to facial characteristics in his 'new division of the earth, by the different species or races of men who live there'. Through his membership of the Royal Society, Sloane would have been familiar with the travellers' questionnaires written by Oldenburg and Boyle, William Petty's statistical surveys of the land and people of Ireland (an approach that became known as 'political arithmetic') and the questions concerning moral variation articulated by John Locke in his call for a 'natural history of man'. The instructions for travellers published by the naturalist John Woodward suggest just how intent learned curiosity about Africans became in these years as English slave trading and Caribbean profits increased. Woodward asked for comments on Africans' 'eyes whether large, or small'; their 'noses whether flat and low'; the curliness of their hair; 'the colour of their skin whether white, brown, tawny, olive, or

black'; 'whether white people removing into hot countries become by degrees browner, &c. and blacks removing into cold countries, paler'; whether their children were *born* black; and what their cosmology, religion and magical arts consisted of.[49]

While racial difference was ever more debated by the learned, it was an established fact of life in the West Indies. Slavery had existed in different forms since the ancient world, and English sailors were routinely taken captive in North Africa and the Eastern Mediterranean. But Atlantic slavery was different, both because of its intensely commercial character and industrial scale, and because of its explicit racialization of Africans. In legalizing the use of violence to maintain slavery, the Jamaica slave codes consolidated a shift from distinguishing between 'Christians' and 'heathen' to new rhetorical oppositions between 'white' and 'black' by the 1670s. In the English imagination, blackness became synonymous with slavery and slavery with blackness. 'Negro and slave' had 'by custom grown homogeneous and convertible', Morgan Godwyn observed in 1680, while illustrations in successive editions of Daniel Defoe's *Robinson Crusoe* (1719) depicted the character of the Spanish Morisco Xury as black *because* Crusoe sold him into slavery (Europeans had distinct visual conventions for representing Moors as Muslims rather than 'negroes'). To conduct physical investigations into the cause of skin colour was, therefore, to imply that what was in fact a construct of law had an identifiable basis in nature; if the source of blackness could be located enslavement would be physically justified. So making colour a pressing scientific question contributed to the naturalization of slavery and encouraged the perception of Africans as a strangely exotic people in need of description or explanation (unlike the English or Jamaica's many Irish servants, whom Sloane virtually ignored in his *Natural History*). When Sloane made observations about 'blacks' and 'negroes', he was ostensibly describing a natural human group; in reality, he was lumping together a collection of peoples from different West African nations, the Indian Ocean world and Caribbean-born Creoles united by the social institution of slavery.[50]

Sloane addressed many of the questions naturalists like Woodward had been asking. 'The negros are of several sorts,' he wrote. The ones 'reckoned the best slaves' came from Guinea; 'Madagascins' from East Africa were 'reckoned good enough, but too choice in their diet' and

often died without the meat and fish to which they were accustomed. Island-born 'creolians' or those 'taken from the Spaniards' were 'reckoned more worth than others', being 'seasoned'. Most male slaves wore canvas but often went 'almost naked'. Some believed that they would return home when they died so 'often cut their own throats'. Their deaths occasioned 'great lamentations, mournings, and howlings', accompanied by the tossing of 'rum and victuals into their graves, to serve them in the other world'. Blacks were 'fruitful' and 'very much given to venery' and 'bawdy' song. Knowing that males would be placated by sexual companionship, planters took care to 'buy wives in proportion to their men' to 'keep the plantations chiefly in good order'. 'Their little ones are not black but reddish brown when born' and, when slaves had children, their mothers carried them on their backs, 'whence their noses are a little flatted ... which amongst them is a beauty'. As a result of nursing, their mothers' breasts hung 'lank ... like those of goats'. Their children had overseers set over them with a rod and were 'rais'd to work so soon as the day is light ... by the sound of a conche shell', although they did get time off at the end of each week and for Christmas. Many blacks bore 'scarifications' (surgical scars) yet esteemed these for their beauty. Although they believed in an afterlife, they seemed to have 'no manner of religion', their ceremonies being 'so far from being acts of adoration of a god, that they are for the most part mixt with a great deal of bawdry and lewdness'. But it wasn't true that they sold their children to strangers. African wars drove enslavement, not the greed of parents, who demonstrated 'so great a love' for their young that masters sold them only at their peril. Ultimately, however, most slaves 'would not willingly change masters' even if they could.[51]

In making these observations in his *Natural History*, Sloane drew together notes from his travel journal, intelligence gathered from planters (and probably from slaves themselves) as well as information from books he read in the intervening years between voyage and publication, and went beyond mere descriptive natural history to make several subjective judgements about blacks as a racial group. His basic criterion of internal differentiation was commercial and strategic: the degree to which different blacks made good slaves. He then went on to offer an intimate yet generalized survey of body and mind that presented all blacks as beholden to their passions and their sexuality ('bawdry and

lewdness'), as creatures who acted strangely ('howlings'), harboured odd opinions (the beauty of flat noses and scarifications) and in many ways came closer to animals than to rational beings (children were summoned to work by the conch shell, which was also used to call livestock; they allegedly lacked religious concepts; and the breasts of African mothers resembled those of goats). Several of Sloane's statements possess an air of sympathy for those he observes, such as his defence of African parents. But this apparent sympathy is ambiguous. Taken in context, such remarks are consistent with the kinds of information that planters – whom Sloane befriended and who hosted him in Jamaica – sought to manipulate slaves by threatening, for example, to separate them from their loved ones. Sloane's remarks concerning blacks' beliefs about death might be seen as evidence of ethnographic curiosity and to stem from the impulse in natural history to construct a universal survey of the world's peoples. To some extent this may be true. But understanding the motivations behind phenomena such as slave suicide was also an economic priority for masters who did not want to lose their property and the source of their wealth. The ethnographic curiosity Sloane evinced is ultimately indissociable from the kinds of practical questions his planter allies wanted answered so they could fortify the institution of slavery.[52]

Blacks also attracted Sloane's attention as a source of curious physical spectacle. One such was the phenomenon of black albinism, which French commentators referred to through the figure of the *nègre blanc*. Sloane learned of a young woman at Captain Hudson's plantation in Liguanee who, although 'born of a black mother', was 'white all over'. 'I had the curiosity to go and see her,' he confessed and made his way to Liguanee, where Mrs Hudson summoned her for his examination. Sloane made a close anatomical evaluation, typical of the intrusive regime of bodily inspection slavery imposed. The 'woman' in question was twelve years old, 'perfectly' white, as Sloane described her, yet 'ill favour'd and countenanc'd like a black' with a broad face and flat nose. Her hair was pale, not 'lank like ours' but woolly and curled like that of the natives of Guinea. Hudson had bought her pregnant mother, who was 'perfectly black', and who had borne white offspring once before back in Guinea. Sloane was to remember the case for years. After returning to London, he would raise it at a meeting of the Royal Society in 1696 during a debate on 'the cause of blacknesse

of the negers' over which he presided. He assured 'the company that he had seen in Jamaica a perfectly white woman with woolly white hair on her head wch was certainly born of a black woman came bigg with child from Guinea'. To Sloane, this creature was evidence not of miscegenation but some unaccountable colour variation: he believed that 'she could not come of a white father, because then the woman would have been ½ black ½ white as mulattos are'. He also saw in England at this time 'a black, a servant of Mr Birds [the Virginia planter William Byrd II], which was mottel'd or spotted with white spots in several parts of his body and penis', so curious to Sloane that he published a description of him as editor of the society's *Philosophical Transactions*.[53]

Dangerous associations with inexplicable supernatural prodigies intensified the curiosity of such cases. Once more emphasizing the superstitions of Africans, Sloane pointed out in his *Natural History* the range of interpretation to which such fantastical beings were subject: white children born of black parents were worshipped in Ethiopia 'as the off-spring of the gods', while elsewhere in Africa 'they are put to death for being reputed the children of the devil'. Although Sloane sought to omit talk of wonders from his *Natural History* in preference for matters of fact, he could not resist indulging in curiosity about unusual phenomena like albinism, harking back to medieval notions of the *lusus naturae* (sports of nature), which implied that nature was playfully irregular and inscrutable in its operations rather than mechanically predictable. He himself offered no explanation. Clearly, however, he had been thinking about racial difference while bleeding black patients in Jamaica: he had 'fluxed severall of them in Jamaica for sevll distempers . . . [and noted that this] altered not their colour', he told the Royal Society. Racial alteration, manifested in such changes of colour, and the instability of racial categorizations it implied, was a persistent fear in Sloane's circles. A few years later the physician James Yonge would tell him disconcertedly about a Plymouth girl whose skin 'suddenly turn'd black like that of a negro', an 'accident [that] amazed and frighted' her. Sloane told London colleagues in 1690 that the skin diseases of 'negrows' suggested 'a specifick difference as to the skin' and maintained that woolly hair was 'characteristick' of 'the negro race of mankind'. The Royal Society archives for later that year record that he 'shewed severall sculls of different nations' from his private collection

to argue for essential rather than merely 'accidental' physical differences between nations. And he listed several skin specimens in his Humana Catalogue of anatomical curiosities, with descriptions such as 'the skin of a negro' and 'part of the skin of the arm of a black', including references to Malpighi's dissections, designed to isolate the source of skin colour. Sloane's racial curiosity, kindled in Jamaica, lasted many years.[54]

The spectacle of public tortures and executions of slaves also drew Sloane's curiosity and he recorded these in shocking detail:

> The punishments for crimes of slaves, are usually for rebellions burning them, by nailing them down on the ground with crooked sticks on every limb, and then applying the fire by degrees from the feet and hands, burning them gradually up to the head, whereby their pains are extravagant. For crimes of a lesser nature gelding, or chopping off half of the foot with an ax. These punishments are suffered by them with great constancy. For running away they put iron rings of great weight on their ankles, or pottocks about their necks, which are iron rings with two long necks rivetted to them, or a spur in the mouth. For negligence, they are usually whipt by the overseers with lance wood switches, till they be bloody, and several of the switches broken, being first tied up by their hands in the mill-houses. Beating with manati straps is thought too cruel, and therefore prohibited by the customs of the country. The cicatrices are visible on their skins for ever after; a slave, the more he have of those, is the less valu'd. After they are whip'd till they are raw, some put on their skins pepper and salt to make them smart; at other times their masters will drop melted wax on their skins, and use several very exquisite torments. These punishments are sometimes merited by the blacks, who are a very perverse generation of people, and though they appear harsh, yet are scarce equal to some of their crimes, and inferior to what punishments other European nations inflict on their slaves in the East-Indies.[55]

The violence characteristic of plantation societies, choreographed as a ritualistically punitive performance to deter slaves from rebelling, erupts in this brutal passage. Its vivid precision suggests that Sloane witnessed such scenes first hand, although again he may have written it by combining observation with information gathered in conversation and from travel accounts. It was specifically this graphic quality that prompted leading abolitionists a century later, including Anthony

Benezet and Thomas Clarkson, to quote it as prime evidence of what Benezet called the 'horrid cruelty' of slave owners' violation of 'the Mosaic Law'. As an inventory of 'exquisite torments', Sloane's words are eerily dispassionate in tone, all the more so because they do in fact acknowledge rather than deny the suffering slaves endure 'with great constancy'. An ambiguous sympathy is once more evident. Acknowledging such pain potentially contradicted European claims that Africans lacked bodily sensitivity. It might also point to a common humanity. Locke had already written of the 'constancy' of the Canadian Hurons in 'enduring inexpressible torments' as an example of the 'law of opinion', according to which all human beings sought to do credit to their reputations in the eyes of others. The resemblance of Sloane's language to Locke's also suggests that what appeared to be personal responses were framed, at least rhetorically, by the conventional terms of the discourse of moral philosophy. Emphasizing the pain experienced by dying slaves, however, also affirmed the supremacy of their masters and their power over those who dared to defy them.[56]

There were also limits to the violence the English used to maintain slavery, Sloane indicated. 'Manati straps', whips made from the hide of the manatee or sea cow, had been banned in Jamaica because they were deemed 'too cruel'. This rejection of 'cruelty' was consistent with English desires to differentiate themselves from bloodthirsty Spaniards. But the prohibition was in reality strategic: manatee straps were banned because they scarred slaves so badly that they robbed them of value and left them unfit for the labour market. 'Bad' slaves, Sloane pointed out, or those 'mutinous in plantations ... are sold to very good profit' (including to the Spanish), but 'if they have many cicatrices, or scars on them, the marks of their severe corrections, they are not very saleable.' Ultimately, Sloane defended the tortures he described, although not without further ambiguity, such 'punishments' being 'sometimes merited by the blacks', the implication being that sometimes they were not. Conscious of their disturbing character, he acknowledged that 'they appear harsh' but justified them through a generalized racial characterization of blacks as 'a very perverse generation of people': unreasonable beings who required coercion through punishments which in any case paled next to their own 'crimes' and the violence employed by other European nations. Sloane omitted any mention of

the recent slave revolts about which he must have heard a good deal and which might have disturbed his readers even more. Albemarle discussed these at the Assembly and Sloane visited plantations where they had occurred, such as Madam Guy's where, in 1685–6, a group of some 150 slaves had seized guns from the servants and killed fifteen whites. That Sloane defended slavery is not surprising. By the time he published the *Natural History* in 1707, he was not a mere observer of the institution but an interested participant in its workings with a significant financial stake in the plantation system through his marriage.[57]

Sloane's defence of slavery did not, however, keep him from expressing substantial curiosity about Jamaican blacks and making the effort to collect artefacts related to their lives. He obtained several such items including a 'ladle made of the Calabash for taking water from the jarrs, made by the Indians in Jamaica'; a 'spoon used by the Indians & Negros of Jamaica made of the side of a Calabash'; and a pair of 'Jamaica strum strum[s] or musicall instrum[ents]' – early forms of banjo whose stems measured approximately 2 feet in length. Sloane's use of 'Indians & Negros' in his labels raises an important question: who exactly were the Indians he meant? Returning to the Black Legend one more time, Sloane explained that 'the Indians are not the natives of the island, they being all destroy'd by the Spaniards.' Mosquito Coast and Florida Indians, he clarified, had been 'brought by surprise' (kidnapped) to Jamaica to help manage the slaves, while the English had also seized natives from the Spanish. These were 'nought at working in the fields or slavish work' but made 'very good hunters, fishers, or fowlers'. Sloane did not say so but the Maroons harboured indigenous elements among them too, while Amerindians were also sent down from the mainland colonies as slaves. His recurrent use of the phrase 'Indians & Negroes' suggests that he may have been aware of the relationships that had formed between Africans and Amerindians in Jamaica. But, like most Europeans, he probably struggled to tell these peoples apart with any precision.[58]

Sloane was so intrigued by the banjos he acquired that he later commissioned careful engravings of them for the *Natural History* (p. 82). He also obtained a sample of African music taken down at his request by one of the 'negro musicians' he had met in Jamaica named Baptiste – his name suggests he may have hailed from the French Antilles, possibly Saint Domingue (Haiti) – at a 'festival' Sloane attended one evening,

likely an early version of the Afro-Caribbean Christmas carnival that came to be called Jonkonnu (p. 84). This sheet, complete with words, is probably the earliest-recorded sample of African music in the Americas and, as such, precious evidence of the development of the musical culture of the African diaspora. Part pidgin and part Creole, it contains distinct West African elements labelled *Koromanti*, *Papaw* and *Angola* as well as fusions of newly emergent Caribbean forms. Sloane's description of the instruments was meticulous: they consisted of small gourds fitted with necks and 'strung with horse hairs, or the peeled stalks of climbing plants' or of 'hollow'd timber covered with parchment or other skin'. He found the spectacle of African dance arresting: the performers he saw shook rattles, 'keeping time with one who makes a sound answering it on the mouth of an empty gourd or jar with his hand'; 'their dances consist[ed] in great activity and strength of body' and made 'a very extraordinary appearance'. But his language also reinforced views of blacks as creatures of animal passion. They tied 'cows tails to their rumps' and their songs were 'all bawdy'. He wasn't even sure their 'noise' merited the label 'music': theirs were instruments only in 'imitation of lutes', through which they kept time, he wrote, 'if it can be'.[59]

The care Sloane lavished on preserving African music and instruments was nonetheless remarkable. Why did he do so? The answer is more complex than simply gathering these objects in order to disparage them or their makers. A tradition of European curiosity about African-American music was already established in colonial natural history. Richard Ligon had described slaves' music in Barbados, while the Dutch East India Company traveller Johannes Nieuhof had published engravings of Africans playing calabashes and tambourines in Brazil in 1682. Sloane's account of his banjos' physical composition, and juxtaposition of their engravings with pictures of wood samples in the *Natural History*, suggests that they served him as examples both of natural materials and of craft traditions in Jamaica. At the etymological root of the word 'curiosity' is *cura*, connoting care, design and labour, while the style of Baconian natural history Sloane embraced emphasized understanding which natural materials could be transformed to make tools. Unlike the many imported items slaves owned – such as the cutlasses, pots, gaming pieces and pipes they obtained at local markets – banjos were made from local island materials. Where English county

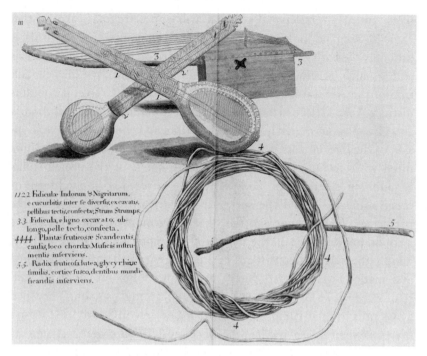

Two 'strum strums' (middle), made and played by enslaved Africans in Jamaica, and acquired by Sloane while on the island, juxtaposed with similar instruments, vines and 'chew-sticks' used by slaves to clean their teeth.

natural histories used antiquities to celebrate the ancestry of local lords, Sloane used slave banjos to illustrate both the natural and artificial productions of Jamaica. This was bitterly ironic but also strangely logical: with Jamaica's indigenous population seemingly extinct, and since English colonists imported almost everything they used, Sloane made instruments fashioned by slaves the quintessential local objects of English Jamaica. In addition to such local purposes, he had global objectives in collecting them too. Where Nieuhof depicted Africans dancing, Sloane pictured his instruments juxtaposed with others he acquired later on: a harp or *mbira* that may have been the Jamaican adaptation of a West African original (in the background) and what is either a second banjo or a South Asian *tanpura* (pictured crosswise). Jamaican banjos thus also took their place as part of a comparative survey of the craftsmanship of the world's peoples through their different instruments.[60]

Perhaps the earliest known transcription of African music in the Americas, made for Sloane in Jamaica by a man named Baptiste, from a performance he witnessed while there in 1687–9, and included in the first volume of his *Natural History*.

Collecting is not just a question of taking but often involves the art of relating – of interacting and exchanging. We have seen why Sloane was interested in these strum strums, but we have not yet explained how or why their makers came to part with them. Musical instruments served important functions in New World slave societies. In enabling communal self-expression, they contributed to the forging of new cultural styles, identities and bonds, as members of different West African nations found themselves thrown together by enslavement and invented new languages of various kinds, music included. Colonial authorities grew alarmed: Sloane noted that trumpets and drums were banned in Jamaica because they were 'thought too much inciting [slaves] to rebellion'. Thanks to Baptiste's notations, we know what some of their music may have sounded like,* although there is no one way to play it and the precise meaning of the songs remains open to

* To hear recordings of this music by Laurent Dubois, David Garner and Mary Caton Lingold, visit http://www.musicalpassage.org/#explore, accessed September 2016.

interpretation. For example, the word *ho-baognion*, noted in the section labelled 'Angola', may connote sexual pleasure, the giving of comfort or a child's play-song, or it may relate to the diasporic practice of healing, poison and spirit-worship known as Obeah. The words labelled 'Koromanti' derived from either Fanti or Twi, Akan languages spoken in West Africa. The instruction to 'clap hands when the base is plaid, and cry *Alla, Alla*' suggests the possibility of Islamic influence.[61]

How Sloane actually obtained his instruments may be the hardest question of all to answer. Quite possibly, they were taken by force or the threat of force. Slaves had no property rights; by law, there was nothing to prevent whites from dispossessing blacks or threatening violence against them to do so. The Jamaican authorities did not hesitate to confiscate horns and drums after they realized the role they played in slave rebellions. Sloane's planter hosts would certainly have been keen to facilitate any such acquisition to curry favour with the governor's personal physician. But some form of exchange cannot be ruled out either. Scholars continue to grapple with the profound challenge of understanding slavery as a dominating institution in which personal negotiations between blacks and whites were nonetheless essential to its daily functioning. Exchange coexisted with violence. For example, the mid-eighteenth-century diary of the Lincolnshire overseer Thomas Thistlewood, who worked in Savannah La Mar in western Jamaica, records the predatory sexual conquests and humiliations he routinely visited upon enslaved women and men. But it also describes how Thistlewood relied on slaves as couriers between plantations, went hunting with his African slave driver Dick, loaned his horse to slaves and sometimes gave them gifts of rum, food and animals. He received objects, information, stories and sexual pleasure in return. It was through such exchanges that one enslaved woman named Phibbah, with whom Thistlewood had a lengthy relationship, came to own livestock which she traded at market, and accumulated some possessions of her own. Planters held the upper hand with brutal self-regard and whites were untouchable according to the letter of the law. But they knew that Africans could retaliate by refusing to work, poisoning them, damaging property or rebelling outright. The existence of the Maroons was a reminder to everyone that flight and liberation were not impossible.[62]

Sloane may have offered medical services in exchange for the banjos, although blacks typically preferred their own doctors and, as Sloane's case histories suggest, likely rejected his medicine as a form of coercion rather than healing. He may instead have offered goods that slaves, in their deprivation, craved: better clothing, meat, fish, tobacco or rum, or simply money, which they could use to trade at weekly markets they ran on the island. Musical instruments were precious sources of solace and community for Africans but they may have been willing to exchange for them in the knowledge that they could replace them with new ones made fresh from local materials. Even if Sloane did buy them, however, this was no exchange between equals but one embedded in the constant threat of violence on which slavery was based. From his mentions of 'goods' in the 'small, oblong, thatch'd huts' where slaves lived, the mats they slept on and their utensils, it appears Sloane may have visited their 'home-places', usually set close to the plantations. Perhaps this was where he gained a sense of what they might want in return. What *they* made of him, meanwhile, is difficult to say, though one thing seems certain: since most planters took little or no interest in the lives of blacks away from their plantations, Sloane's curiosity about them must itself have been a curious sight.[63]

Sloane's Jamaica was a series of contradictions. Sloane dismissed African healers out of hand and claimed that the island's climate and diseases were little different from those of England, and yet soaring English mortality rates and his case histories of white alcoholic self-destruction thwarted his own efforts as a plantation doctor. His observations on the ruins of Spanish Jamaica reinforced the Black Legend of Catholic atrocity and pointed self-servingly to a happy transition from Iberian treasure hunting to English plantation agriculture. Yet Sloane's devotion to what he called 'very strange, but certain, matters of fact' and his vision of Jamaica as a providential trading isle were controverted by the curious and often mystifying tales he collected as he went. These included lurid portraits of English debauchery, rumours of unaccountable phenomena and close encounters with slaves that ranged from musical performances to the spectre of racial degeneration and spectacles of sadistic public violence. Such was Sloane's natural history: a hybrid of providentialism, profit and savagery designed simultaneously to enlighten and beguile. These tales brought Sloane's island of curiosities back to the kinds of Baroque horrors the English colony had

supposedly transcended. He nevertheless went about his business with characteristic discipline, and set about making meticulous collections of plants and animals which were to form the core of his work in natural history.[64]

# 3

# Keeping the Species
# from Being Lost

## INTERSPECIES ISLAND

The Jamaican landscape had been remade over decades not merely by the migration of peoples but by the transplantation of animals and plants too. The island was a battleground: Englishmen and Africans faced off for control of both terrain and species. Europeans were the accidental beneficiaries of diseases that decimated local populations as entire ecosystems proved vulnerable to catastrophic change. In Jamaica, during a famine in 1494, hungry Spanish colonizers consumed the *aon* – dogs that had flourished since their introduction by the Taíno centuries earlier – to extinction. After consolidating their position, the Spanish then introduced new species that profoundly altered the island's ecology such as horses, cattle and pigs, to provide labour and food for themselves, as well as new agricultural crops from the American mainland like sugar and cacao. These changes continued in the seventeenth century as the English expanded the number of livestock pens and created ever larger plantations.[1]

The Columbian Exchange did not just involve interplay between Europe and the Americas, however. Africa was also a significant agent in the environmental transformation of the Atlantic world. Slaves remade Caribbean landscapes by clearing and harvesting plantation land, while plants and animals travelled west to the Americas, sometimes quite inadvertently. Guinea grass, for example, appears to have been brought over as feed for Guinea sheep on slave ships but subsequently grew wild across Jamaica, providing an important food source for the island's livestock. Africans established their own botanical traditions in the colonies in order to survive under slavery. Planters devoted

as much land as possible to growing cash crops, so set very little aside for subsistence for slaves. As a result, Africans in the West Indies were obliged to cultivate plots that came to be known as provision plant-ations or more fancifully as slave gardens, usually located at some distance from sugar plantations and their own dwellings, thus beyond the surveillance of most masters. Historical and archaeological research on such grounds has shown the variety of foods grown there with links to West African agriculture to include okra, maize, Guinea corn (sor-ghum), millet, rice, ginger, oranges, limes, coffee and beans. As Sloane observed, slaves enjoyed the 'culture of their own plantations to feed themselves from potatos, yams, and plantanes, &c. which they plant in ground allowed them by their masters, besides a small plantain walk they have by themselves'.[2]

How specific plants were brought across the Atlantic is largely undocumented, although the oral traditions of more than one free black Maroon community in the northern reaches of South America tell of enslaved women who concealed rice seeds in their hair prior to the Middle Passage. A Brazilian variation claims that one such woman, 'unable to prevent her children's sale into slavery, laced some rice seeds in their hair so they would be able to eat after the ship reached its des-tination'. The story is a parable of the African origins of New World agriculture and a warning about the theft of botanical knowledge by whites: it concludes with merchants discovering the rice seeds and taking them. Despite such seizures, and though Africans and their descendants enjoyed no legal property rights in Jamaica, many planters acquiesced in slaves' custom of willing plots of land from one gener-ation to the next. This included both provision plantations and burial grounds. In the early nineteenth century, the Gothic novelist Cynric Williams even wrote of one slave who claimed compensation from a master who had cut off the branch of a calabash tree he regarded as his: 'the negro maintained that his own grandfather had planted the tree, and had had a house and garden beside it, and he claimed the land as his inheritance.'[3]

Trees played crucial roles in Jamaican life as the struggle for control of the island played out between whites and blacks. Colonists tied slaves to trees to whip them, but trees could serve as sites of peace-making too. In 1739, for example, the leader of the Windward Maroons Cudjoe and the English colonel James Guthrie would sign a peace treaty under

a cotton tree by which the British, unable to defeat the Maroons, recognized their right to exist. Some Africans believed trees harboured mischievous spirits they called Duppies, yet trees also offered refuge from pursuers and perches for casting spells against their foes. Practitioners of Obeah – and its Maroon equivalent, which Maroons called their 'Science' – placed talismans for protection or attack under specific tree-trunks. Trees also figured repeatedly in West African Anansi stories, which later colonists recorded in some detail. In one tale, a Maroon mother ignores a medicine man's advice to cut down a papaya tree in order to save her daughter's life, thinking it mere superstition, only for her daughter to die and the papaya to bear withered fruit. Around the turn of the nineteenth century, as some planters became more interested in African tales as a form of folklore, the Gothic novelist and slave owner Matthew 'Monk' Lewis recorded a host of such stories with animistic and supernatural resonances featuring cotton, cacao and mahogany trees.[4]

In Jamaica trees were no less vital to the English, albeit for the opposite reason: as commodities. Deforestation was the norm in virtually all the wooded territories Europeans colonized in the early modern era, whether in the West Indies or the East. '[N]othing ... seems more fatally to threaten a weakning, if not a dissolution of the strength of this famous and flourishing nation', John Evelyn had written in *Sylva* (1664), 'then the sensible and notorious decay of her wooden-walls ...' Evelyn, the virtuoso and man of letters, doubled as an economic strategist in an era when Restoration planners and Royal Society naturalists backed tree-planting programmes to compensate for deforestation in England caused by shipbuilding, in order to refurbish the Royal Navy. Sloane observed that 'the greatest part of the island of Jamaica was heretofore cover'd with woods,' before its own partial deforestation brought about by raiding it for timber. The engravings of living trees he included in volume two of his *Natural History* formed a key component of his commercial inventory of the island, as he surveyed the uses of different Jamaican woods. These included juniper, used 'for wainscoting rooms, making escritores, cabinets, &c cockroches and other vermine avoiding [its] smell'; fustic, 'one of the commodities this island naturally affords', 'used by the dyers, for a yellow colour' and 'worth fifty shillings per tun'; Jamaican ebony, 'for its fine greenish brown colour capable of polish ... much coveted in Europe'; and the

poisonous worm-proof whitewood, 'fell'd and made into planks to sheath ships'.[5]

Many of Jamaica's trees were so 'very tall' that Sloane 'could not come at their leaves, flowers, or fruit' to examine them properly. Only dextrous slaves, he conceded, could scale their summits. 'The negroes climb'd up' the cotton tree, for example, 'with pegs of hard wood ... the smoothness [of its trunk] not admitting other climbing'. Black mastery of the Jamaican environment was politically significant. Maroons concealed themselves in the Blue Mountains to the east and the Cockpit Country in the west, feeding themselves from the land and raiding plantations to plunder provisions. Understanding the dangers they posed, Sloane studiously avoided Maroon country on his island manoeuvres. Such places, he wrote, 'are often very full of runaway negros, who lye in ambush to kill the whites who come within their reach'. Sloane's use of the term 'ambush' suggests that he was aware of Maroons' use of camouflage as part of a set of survival tactics colloquially known as 'dodging'. In an oral history collected in 1978 by the anthropologist Kenneth Bilby, a Maroon descendant named David Gray described how the Windward leader Cudjoe had hidden himself in a cacao tree to attack British soldiers during the First Maroon War of the 1730s: 'another one tek a cocoa-tree ... and put it pon Kojo back, big cocoa-tree. And Kojo sit down here so. Kojo deh pon a route, like Seaman's Valley bridge, that is a gate. When you come where him deh, and you start dead, is only big cocoa-tree you start dead from.' In Maroon parlance, nature itself resisted colonization: the same trees the English routinely harvested could kill their aggressors. Hidden African presence was, indeed, a theme of Jamaican life. In the Afro-Caribbean Jonkonnu festival Sloane witnessed, he would have seen revellers dressed up in camouflage as a figure named Pitchy-Patchy, a Jamaican phrase meaning patchwork. In his *Sketches of Character* (1837), the Kingston-born artist Isaac Mendes Belisario later associated this figure with the English folk character Jack in the Green, although in all probability Pitchy-Patchy evolved from masquerade traditions brought over from West Africa.[6]

Animals, too, shaped the economic and social life of Jamaica. They provided crucial sources of power in the pre-industrial era: both slaves and oxen were, for example, used to turn the sugar mills that ground juice from freshly harvested cane. Although conspicuously romantic in

conception and produced over a century later in the British colony of Antigua, artist William Clark's watercolour *Shipping Sugar* (1824) usefully anatomizes several of the interlocking components of the sugar and slave trades. These include the oxen and horses that cart hogsheads of sugar to the coast; the slaves who roll them into longboats for transfer to ships bound for Europe; and the distant windmill that symbolizes the wind-power on which transatlantic shipping depended (Plate 2). That planters listed both their slaves and their animals together as property in inventories and wills is unsurprising, not least because whites liked to claim that slaves *were* animals, although Caribbean authorities also took care to separate slaves and key animals to ensure their own security. Slaves were forbidden by law, for example, from riding horses in Jamaica for fear of their mobility, but such prohibitions had symbolic functions too, since ease of mobility was a badge of white freedom; low-status whites who walked rather than rode about were tarred with the disdainful epithet 'walking buckra' (*buckra* being a black word for whites). Access to good meat was a signal white privilege. In his diary, Thomas Thistlewood recorded his enjoyment of sumptuous dinners of roast beef and plum pudding, while slaves often received impoverished rations of discards: half-rotten meat, the head or feet of animals and diseased carcasses rather than meaty rumps. Beset by malnutrition, some slaves resorted to eating soil, a practice known as geophagy or pica, a behaviour brought on as a result of psychological distress but in some instances also a strategy to stave off the stomach pains caused by iron-deficient diets and worms.[7]

Despite this radical inequality of access to the fuel, comfort and status prized animals could provide, blacks developed their own traditions of animal use. Many slaves lived near the livestock pens they maintained for white masters, where they carried out the work of branding and castrating bulls, while 'hogmeat gangs' made up of children collected grasses as fodder for these beasts. Slaves kept their own livestock in yards close to their dwellings, areas that, like provision grounds, planters tended to overlook. Sloane noticed that slaves kept their own pigs, an example as he put it of their 'small wealth'. They traded such 'wealth' at Sunday markets, which became a staple of the internal economy of slavery in West Indian society. It is likely that Sloane visited such markets while in Jamaica, looking for specimens – naturalists regularly targeted markets as places to see rare species.

Doctors in South Asia, for example, frequented bazaars to acquire herbs and drugs, while John Ray regularly attended fish markets in England. Later on, the Jamaica-based doctor Henry Barham would write to Sloane about visiting the 'negro market' in Spanish Town.[8]

British artist William Beastall's watercolour *Negroes' Sunday Market at Antigua* (1806) visualizes the multiracial and interspecies character of Caribbean marketplaces, already well established in Sloane's day (Plate 3). Like Clark's *Shipping Sugar*, the image has a romantic quality but nonetheless illustrates English fascination with African traders and their wares. In Beastall's tableau, blacks trade goods and produce including livestock, from hogs to chickens and eggs, attracting the attention of whites with rare specimens as well. Two dark-skinned men, wearing only trousers, emphasize the range of African access to Caribbean animals. In the centre, a man in light-blue trousers drags a hog after him, while on the far left, with the gesture of a proud hunter, a man wearing a skullcap and earring holds a reptile resembling a skink up to view. The vertical hierarchy of the scene suggests the racial hierarchy of Caribbean society, determined in no small part by access to animals: several whites ride to market on horseback, while the white officer with his back to the viewer sports a feather-topped hat that pierces the sky, making a striking contrast to the low horizontality of almost all the blacks and their creatures. Only one African stands tall: the hunter who holds up his reptilian prey and draws the curiosity of English ladies as well as black boys, suggesting the value of his prize – one of great potential interest to specimen hunters like Sloane, who ended up with several skinks in his collection.[9]

Slaves used their access to animals, as well as plants and objects, to invent their own cultural forms in Jamaica. They made musical instruments from country materials, while for performances like Jonkonnu they strapped cow tails to their bodies and donned ox-horn masks. Maroon fighters converted the *abeng*, a cow horn that planters used to summon slaves, into a horn for communication and battle. Blacks recycled common objects such as the iron strips they used both to cut cane for planters and to work their own land, as well as European gaming pieces they bought at market and used in their own games. One highly significant ritual involved the burial of their dead together with 'grave goods'. The mathematician and traveller John Taylor, who was in Jamaica at the same time as Sloane, noted in his diary the variety of items blacks

buried, which included animals: 'casadar [cassava] bread, rosted fowles, sugar, rum, tobacco and pipes with fier to light'. In contrast to the stereotypical association of slavery and nakedness, Afro-Caribbean peoples' natural and spiritual worlds possessed a rich vernacular material culture. To this day, Maroons still speak of the pot with a mysterious power to kill British soldiers wielded by Nanny, another fabled eighteenth-century leader of the Windward Maroons; and descendants still place a bottle of rum inside Ambush Cave near Accompong, a site they associate with the military victories over the British that culminated in the treaty of 1739.[10]

Obeah involved one of the most dynamic ways slaves used animals, plants and objects in Jamaica. The term – also rendered as *Oba, Obia* and *Obi* and its cognate *Myal* – probably derives from the Ibo-speaking peoples of the Bight of Biafra, *dbia* connoting an adept or master. To British observers the practice was a form of demonic magic. 'Most people in the West Indies', commented the Barbados soldier Thomas Walduck in one early report around 1710, 'are given to the observation of dreams and omens, by their conversation wth the negros or the Indians, and some of the negros are a sort of magicians.' While insisting that he personally was 'very free from superstition', he conceded he had 'seen surprizing things done by them'. He could not help recording the story of one black man who appeared able to make birds disappear: 'the master, mistress, and severall white people in the plantation would see them flye upon the tree, and then the negro would tell them if they could finde any of these foules . . . they have gott up into the tree severall at once, and could not.' That 'the negros here use naturall (or diabolical) magic no planter in Barbados doubts', he reflected, 'but how they doe it non of us knows.' 'That one negro can torment another is beyond doubt, by . . . unaccountable paines in different parts of their body, lameness, madness, loss of speech' as well as the loss of the use of their limbs 'without any pain'. Observers like Walduck tended to dismiss Obeah as mere trickery on the one hand while nevertheless granting the reality of its effects, suggesting how many whites placed their trust in black healers without ever understanding what they did.[11]

Those men and women who practised Obeah used plants in order to achieve hallucinogenic states of communion with ancestral spirits; to heal both whites and blacks; and to cast spells against and poison their enemies, from sadistic overseers to blacks who stole from each other's

provision grounds. Evidence collected in the late eighteenth century suggests the remarkable range of ingredients they incorporated. In 1789, the Jamaica Assembly's London agent Stephen Fuller – who just happened to be Sloane's step-grandson by marriage – enumerated for the House of Commons 'the farrago of materials', as he put it, which made up the contents of the *obi* or 'fetish' that Obeah men carried, often around their necks. These materials would be placed inside the hollow of a goat horn and included 'blood, feathers, parrots beaks, dogs teeth, alligators teeth, broken bottles, grave dirt, rum, and egg-shells'. The following decade, the Jamaica physician Benjamin Moseley wrote that the contents of the 'obiah-bag' carried by the fabled run-away slave Jack Mansong (known as Three-Fingered Jack) contained ashes, human and animal fat, a cat's foot, a dry toad, a pig's tail and 'a slip of virginal parchment, of kid's skin, with characters marked in blood'. Obeah turned abject substances, odd animal parts and the commonest objects into magical instruments that emboldened resistance to slavery. Tacky's Rebellion, the largest slave uprising in the eighteenth-century British Caribbean, was led by Akan-speaking Coromantees in 1760 who were also practitioners of Obeah, leading the British authorities to ban its materials by law afterwards as a security measure.[12]

What did Sloane make of all this and what attention did he pay to the ways blacks engaged with the Jamaican environment? A number of English commentators at the time made tentative attempts at noting how blacks conceived of the operations of body and soul. In the 1680s, John Taylor claimed to have 'discoursed with many old negroas, of witt and sence' who told him that their '*camaix* (which signifies in their language shape and understanding) soon after death passeth into [their] own country, and ther lives for ever'. Writing to Sloane years later in 1717, Henry Barham described blacks' use of a plant they called Attoo to plaster the bodies of the sick, as well as their interpretation of how it worked. They ground it into a paste to apply to the head and face and 'sometimes their stomach if their heart is affected: for they attribute all inward ails or illness to the heart saying their heart is noe boon not knowing the situation of the stomach from that of the heart'. In the 1780s, Stephen Fuller would tell Parliament that Obeah men used 'a narcotic potion, made with the juice of an herb (said to be the branched

*Calalue* or species of *Solannum*) which occasions a trance or profound sleep of a certain duration'. He cited Sloane as a source.[13]

Sloane did collect species of Jamaican *Solanum* and, as we saw in the previous chapter, quizzed Africans repeatedly about medicinal plants. But, unlike some of his contemporaries, Sloane is strikingly quiet in the *Natural History* about practices such as Obeah, and makes only a few oblique references to black witchcraft. He was less curious about slaves' knowledge than other travellers. A short, undated but singular entry in the catalogue of bird specimens he assembled typifies his dismissive attitude to black knowledge: 'feathers made up to fright the slaves. Wald. Barb.' The entry refers to some feathers sent by Captain Walduck in Barbados that were evidently part of the regalia of an Obeah man: the Jamaica planter historian Bryan Edwards later noted that one of the leaders of Tacky's Rebellion, who had 'administered the fetish' to his associates, was 'hung up with all his feathers and trumperies about him' and publicly executed. Sloane's catalogue entry thus turned the 'frightening' instruments of slave rebellion into a mere ornithological curiosity, jumbled among a list of hundreds of bird specimens. Sloane seems, moreover, to have been indifferent to the uses blacks made of the Jamaican plants he set about collecting. For example, the plant he described as *Senae spuriae aut aspalatho affinis arbor siliqua foliis bifidis, flore pentapetalo vario* (now known by the Linnaean name *Bauhinia divaricata* and popularly as the pom pom orchid tree) has been identified as one used hallucinogenically by slaves. If Sloane knew this, he did not say so in his writings. As we shall see, he composed lengthy descriptions of plants and their uses in his *Natural History* but for the most part did not include uses made by blacks. Part of the reason is surely that because African herbalism presented a formidable alternative to European medicine in the West Indies, Sloane had little motivation for crediting those black understandings of body and cosmology with which he was competing. Instead, he focused on turning Jamaican plants and animals into natural history specimens.* It is to this process that we now turn.[14]

---

* For an illustrated exhibit on Sloane's collections and their links to African slaves, visit http://www.brown.edu/Facilities/John_Carter_Brown_Library/exhibitions/sloane/index. html, accessed December 2016.

# FROM PLANTATION TO HERBARIUM

Anyone who opens Sloane's *Natural History* is struck by the quantity and detail of the hundreds of life-size engravings that burst from the pages of its two large folio volumes. Consider his engraving of cacao, the source of chocolate (p. 106). Sloane intended such pictures not simply as supporting illustrations of the verbal descriptions of plants he composed but as carriers of essential scientific information about the anatomies of species which words alone could not arguably convey. These pictures constitute one of his greatest scientific achievements in providing a model of visual knowledge and by communicating the results of his Caribbean research to successive generations of botanists. Understanding how he made them requires exploring a chain of transatlantic processes: collecting, preserving, describing and drawing specimens in Jamaica, combined with subsequent research and additional illustration back in London. Executing these processes was a remarkable feat for the time. Turning specimens into anatomically precise pictures was arduous, especially in the Caribbean. 'In that distant climate the heats and rains are excessive,' Sloane admitted, 'so that there are often hindrances upon those accounts.' Jamaica's uninhabited regions contained 'several things very curious, but have no conveniencies for lodging men or horses, and are often full of serpents and other venomous creatures' – not to mention fugitive slaves who stood ready to ambush their white enemies.[15]

Sloane's plant collecting took advantage of environmental transplantations set in motion by others long before he ever stepped ashore in Jamaica. Cacao, for example, does not appear to have been native to the island but originated on the American mainland where the Maya and the Mexica (the pre-eminent people of the Aztec Empire in the Valley of Mexico) had consumed it for centuries. The Mexica served cacao, both hot and cold, mixed with various spices, maize and chili peppers, as a brew they knew as *chocolatl* – a Nahuatl word meaning bitter water. The Spanish discovered this drink in the sixteenth century, calling it *chocolate*, though Catholic observers baulked at its consumption in ritualistic indigenous ceremonies they identified with devil worship and, in line with Hippocratic assumptions about local climates moulding physical constitutions, feared that it would render them humorally

degenerate and make their bodies more like those of Native Americans. Gradually, however, both Spanish-American Creoles and consumers on the Iberian Peninsula became avid chocolate drinkers, albeit in altered form, as they sweetened cacao with sugar. They brought the plant to Jamaica, establishing it as one of the island's profitable early crops, harvested by slaves. Only 'the most handy negroes' were skilled enough to do this work, according to the French naturalist D. Quélus. They 'go from tree to tree and from row to row, and with forked sticks or poles, cause the ripe nuts to fall down, taking great care not to touch those that are not so, as well as the blossoms'. When Sloane was in Jamaica, the cacao crop remained ravaged by a blight that had struck in the 1670s. Yet by this time various recipes for chocolate were already circulating in France, the Netherlands and England, giving rise to a flourishing culture of chocolate houses, the more socially exclusive counterparts of coffee houses. As a sign of his affiliation with this culture of luxury consumption, Sloane later acquired several gilt-rimmed earthenware chocolate cups bearing elaborate painted illustrations, apparently including one of Moses striking water from the rock (Plate 9).[16]

Sloane's excursions from Spanish Town were also plant-hunting expeditions. Although he displayed little interest in what blacks thought about plants, he would have been well aware of how other naturalists used slaves to gather specimens for them. 'Gathering and preserving . . . may be done by the hands of servants,' advised John Woodward in his instructions for collectors, 'and that too at their spare and leisure times: or in journies, in the plantations, in fishing, fowling, &c. without hindrance of any other business.' After all, it could not be expected 'that any one single person will have leisure to attend to so many things'. By the late seventeenth century, travellers increasingly employed slaves as collectors. Please 'bestow on me 4 or 5 guinny negros', the Virginia naturalist John Banister asked the Royal African Company. James Petiver, an apothecary based in Aldersgate, London, developed one of the largest natural history correspondences and became a close associate of Sloane's after his return from Jamaica. Although he never credited their contributions in the lengthy specimen lists he published, Petiver systematized the use of slaves as collectors. By the 1690s, he directed correspondents to show slaves how to collect 'shells with live snails inside' and pin insects into pillboxes (or to the insides of hats), offering

twelve pence per dozen plants and half a crown per dozen flies, beetles, grasshoppers or moths. 'Procure correspondents for me wherever you come,' he instructed the servant George Harris, who sailed on HMS *Paramour* with the astronomer Edmond Halley in 1698, 'and take directions how to write them, and procure something from them [with whom] you stay, showing their slaves how to collect things by taking them along with you when you are abroad.'[17]

Sloane stated at its outset that the *Natural History* was based on local knowledge from 'the inhabitants, either Europeans, Indians or Blacks', but on only a few occasions did he credit slaves for accessing specimens he gathered. The company in which he rode up to St Ann's, for example, included both knowledgeable planters and a 'very good guide', most likely an African (though possibly an Indian). Blacks, Sloane realized, knew the island better than anyone. Writing about the *Palma spinosa minor* (the prickly-pole), he noted that 'negro's travelling barefooted thro' the woods, very carefully avoid places where these grow, because of the many prickles that fall from their stems and leaves'. His *Radix fruticosa lutea* or 'chew sticks' that were 'us'd by the negroes for cleansing their teeth', consisted of a root 'taken up out of the woods of Jamaica by the blacks'. There was 'no great difficulty in the curing or preserving of this fruit for use', he wrote in the Royal Society's *Philosophical Transactions* of the Jamaica pepper (which he expected to surpass 'the East-India commodities of this kind' in value) because ''tis for the most part done by the Negro's; they climb the trees, and pull off the twigs with the unripe green fruit.' Such acknowledgements were rare, but simply because Sloane said little about slaves' work in finding plants does not mean that it was not substantial. As Petiver's example shows, it was customary for naturalists *not* to credit their contributions, just as natural philosophers like Robert Boyle failed to acknowledge the laboratory technicians who carried out the experiments they then wrote up as their own. Notwithstanding this silence, there is little doubt that Sloane turned to slaves to aid his collecting since he regarded Jamaican blacks as a living link to Spanish and Taíno knowledge of the island's species. He was well aware that the Jamaican environment had been reshaped over many years by botanical transplantation: the Spanish, he wrote, 'had brought many fruit-trees from the main-continent, where they are masters'. And he believed that their knowledge had been passed on: 'the skill of using'

Spanish crops 'remain'd with the Blacks and the Indians'. So, while Sloane derided African healing, he 'look'd into [it] as much as I could' to try to know what they knew, not least 'because of the great effects of the Jesuits Bark [Peruvian bark], found out by them'.[18]

Sloane therefore made sure to visit slaves' provision grounds, their own 'small plantations ... wherein they took care to preserve and propagate such vegetables as grew in their own countries, to use them as they saw occasion'. He described several of their crops in the *Natural History* and collected specimens that remain immaculately preserved to this day in the Sloane Herbarium at London's Natural History Museum. His herbarium volumes are astounding scientific pop-up books that contain dried fruits, leaves and stalks glued to the page as they were over 300 years ago, such as 'the great bean' (*Phaseolus maximus perennis*), which was 'planted in most gardens, and provision plantations, where they last for many years' (Plate 4). His sample of *Milium indicum arundinaceo caulo granis flavescentibus* is a striking specimen of Guinea corn 'met with in some negro's plantations' (Plate 6). His okra probably came from provision grounds too; 'Indians and Negroes commonly plant[ed] and use[d]' the bell-peppers he collected as both medicine and food; and his *Ceratoniae affinis siliquosa lauri folio singulari*, 'called Bichy by the Coromantin Negros', was brought over on slave ships and used by blacks to treat stomach complaints. Rice was also 'sowed by some of the negro's in their gardens, and small plantations in Jamaica'. Whether Sloane seized the specimens he collected or exchanged for them is again unknown but he did talk to slaves about them. Writing about the so-called 'hog doctor-tree', he remarked that 'a very understanding black assur'd me he saw a wounded hog go to this tree for relief.'[19]

Sloane naturally talked to many planters as well. He learned about how botanical transfers linked West Africa with the Caribbean. He noted how Bichy came to Jamaica as 'a seed brought in a Guinea ship from that country' and was 'planted by Mr Gosse in Colonel Bourden's plantation beyond Guanoboa'. *Arachidna Indiae utriusque tetraphylla* were nuts 'brought from Guinea in the negroes ships, to feed the negroes withal in their voyage from Guinea to Jamaica', which Sloane saw 'planted, from Guinea seed, by Mr. Harrison, in his garden, in Liguanee'. And he observed that Scotch grass (later known as Guinea grass) came from 'that part of Barbadoes called Scotland', had been

'brought hither, and is now all over the island in the moister land by rivers' sides', serving as feed for livestock. Comparison with other travellers again makes clear, however, the limits of Sloane's curiosity about African knowledge. He described, for example, how vervain (verbena) was combined with onions in poultices for the treatment of dropsies; taken as a kind of hot tea; used in clysters (enemas) for belly ache; and drunk warm with lime root. He cited eminent European authorities' accounts of it – the Spanish naturalist Nicolás Monardes and the Dutch physician Jacobus Bontius – and added, 'it is very much in repute among the Indian and Negro doctors for the cure of most diseases.' But there he stopped. Henry Barham, by contrast, went much further. In a manuscript natural history he later passed on to Sloane, Barham related how blacks used vervain to help those 'bewitched with Oba [Obeah] which is a sort of Negro fascination or sorcery' and relieve swellings, palpitations and fatal debility. Like Walduck, Barham thought Obeah was a trick of 'faith' and art of 'persuasion', though the effects of its poisons were undeniable and its antidotes, therefore, worth knowing about. Where plants like vervain provided Barham occasion to comment on black belief systems, Sloane limited his remarks to plants' practical uses as he saw them.[20]

Such were Sloane's observations from what he could see and learn through conversation. Once he had plants in hand, preserving them required enormous care. He did not record the exact techniques he employed, but contemporary accounts provide a good indication of how he probably proceeded. Herbaria were collections of dried plants that originated as objects of spiritual devotion but, after the work of Renaissance naturalists like Luca Ghini of Pisa, they evolved into botanical documentation centres replete with technical labels and notes. The practical demands were many. If the specimen was large, Woodward advised in his instructions the taking of 'a fair sprig, about a foot in length, with the flower on'; for smaller ones like grasses and ferns, 'take up the whole plant, root and all.' Desiccation was of the essence: collectors should press plants between leaves of paper and hang them up to dry 'in the air, at the top of some cabin, to keep them from rotting'. After thorough drying, they should then be placed between the leaves of a large book or quire of brown paper, spreading them smooth and even, before transferring them to more fresh pages 'in some dry place, till they be sent over' and flattened with a heavy weight.

Costly supplies were called for which only wealthy patrons could afford. William Courten's instructions to the Quaker James Reed, bound for the Caribbean in 1689, priced a single ream of paper at three shillings and sixpence. 'I [have] gott severall plants not usuale,' Thomas Grigg wrote to James Petiver in 1712 from Antigua, 'but cannot save ym haveing no brown paper' – itself a precious commodity imported from continental Europe. Sloane evidently faced no such difficulties and must have made few excursions without numerous quires to hand, likely carried by slaves.[21]

Labelling each specimen was crucial. The provenance of every sample should be noted on an accompanying sheet, urged Woodward, with the names 'by which the country people call the plants . . . and the medicinal, or other uses, they make of them'. Ray provided a model of exactitude in provenance: in one memorable instance, he had described a plant in Cambridge as growing 'on Jesus Colledge wall'. Sloane didn't always measure up, however. 'I found it in the woods,' he later wrote of the *Tilia forte arbor racemosa* in the *Natural History*, 'I cannot exactly tell where.' 'I found it in Jamaica' was a phrase he reiterated several times, unable to summon further detail from either his notes or his memory. Slave plantations, however, provided trusty coordinates for mapping species in many instances. The fern *Trichomanes foliolis longioribus eleganter* grew 'out of the fissures of the rocks, of each side on the Rio d'Oro, near Mr. Philpot's plantation in Sixteen Mile Walk'; *Hemiontidi affinis filix major* thrived 'on a woody shady hill, near the banks of the Rio Cobre, by the orange walk in the Crescent Plantation'; and the fern *Filix ramosa maxima scandens* flourished 'in the woods on the roads between Guanaboa and Colonel Bourden's plantation, on the side of Mount Diablo, and Archers Ridge'. Such observations underscore how important the assistance of Jamaica's planters was in enabling Sloane to make collections and how his mapping of the island's natural species relied on the artificial reference points supplied by plantations.[22]

Sloane's main purpose in collecting plants was to publish pictures of them. Visualization, naturalists agreed, was essential to producing better scientific knowledge. In his *Essay towards a Real Character and a Philosophical Language* (1668), John Wilkins had argued that language itself should be reformed to possess an immediacy akin to that of pictures. Obfuscating words were the problem, he held, and pictures

the solution: language should *be* more like a picture. Increasingly, those few naturalists with sufficient wealth turned to the production of engravings using finely wrought copper plates to print multiple copies of drawings, a technique that succeeded the cruder woodcuts of the sixteenth century. There was, however, no self-evident form of 'accurate' scientific representation: as methods of visualization continued to evolve, naturalists did not reach consensus about *how* best to picture nature. After the 1730s, Linnaean botany would usher in a tendency among illustrators to draw pictures that gathered together anatomical characteristics from several different samples of the same plant to create idealized composite images of a given species, believing these to be truer to their essential forms than any individual specimen could ever be. But Sloane was guided by his Baconianism, which prescribed the gathering of strictly factual particulars in all their unsystematic and unidealized individual variety as the greatest guide to what existed in nature. He also placed his trust in Ray, adopting as his own his friend's method of classification by scrutinizing all of a plant's characters rather than focusing on one single feature. These commitments led Sloane to produce large and detailed pictures of individual specimens.[23]

Sloane's handling of cacao provides a vivid example of how he turned specific plants into pictures of scientific species. The cacao specimen he collected in Jamaica is stuck on to the fifty-ninth page of the fifth volume of his Jamaica herbarium (pp 104–5). The browned leaves of the cacao tree are pressed on to the right-hand side of the page, where they have been glued (and subsequently taped) in place, with only incidental damage and decay over three centuries. Glued above the leaves are several of cacao's tiny flowers, also brown with age, while below a cacao nut has been stuck to the page with fragments from the bark of the pod that contained it. In Jamaica, Sloane would have placed freshly acquired specimens into loose quires of paper, dried and repacked them in the manner described by Woodward, before putting them (long afterwards) into the bound folio volumes of his herbarium once back in London, where his herbarium was 'pasted and sticht' together by several assistants, possibly including Henry Hunt, who worked at the Royal Society assisting Robert Hooke with his experiments, drawing and printing, and curating its Repository. Once the plant was in place, Sloane wrote up a label and pasted it at the foot of the page to identify each sample, whose names he derived

wherever possible from previous descriptions in Ray's *Historia plantarum*, which he used as a guide to known species.[24]

But Sloane brought more than just specimens back from the Caribbean. Pasted opposite his cacao sample is a page of paper that came from Jamaica and which bears the image of a living cacao plant with its weighty nut-filled pods ('a stalk or branch of cacao wt ye fruit', as Sloane labelled it). The picture was not, however, drawn by Sloane. Most naturalists were not accomplished in artistic technique, since they aspired to be recognized as gentleman authors and men of letters, while draughtsmanship was typically regarded as a form of lower-class artisanal dexterity. This picture of a live cacao plant was in fact drawn by one of Sloane's companions on the journey to and from St Ann's: a minister named Garrett Moore, who was 'one of the best designers I could meet with there', Sloane wrote, and so '[I] carried him with me into several places of the country.' Drawing plants *in situ* was another means of collecting them when one 'met with fruits that could not be dried or kept', such as the pineapple, which Moore sketched for Sloane (Plate 6). Moore executed a number of drawings in both terracotta crayon and pencil, including many trees done 'from the life [and] in their natural bigness'. Sloane undoubtedly paid Moore well for his labours, but he had other promises at his disposal as well. 'You were pleased when heare to promis to speake to my Lord Bishope of London,' Moore later reminded him, intimating a pledge on Sloane's part to improve his standing within the church. Moore also requested cloth, oil and pencils 'to draw what peeces you will have done', which Sloane undoubtedly supplied.[25]

Moore's sketches were only the beginning of the visualization process: they provided the basis for a second round of illustrations completed years later, a full decade after Sloane returned to London. After Jamaica, Sloane became so busy with his medical practice, his work at the Royal Society and his collections that it was only during 1699–1701 that he commissioned Everhardus Kickius, one of many Dutch artists working in England at the time, to complete his visual catalogue for the *Natural History*. Kickius' task was two-fold: to draw those dried specimens from Jamaica that Moore had not sketched *in situ* (and objects like Sloane's strum strums); and to use Moore's original sketches of living plants and combine them with details from dried ones to produce composite pictures that captured all of a

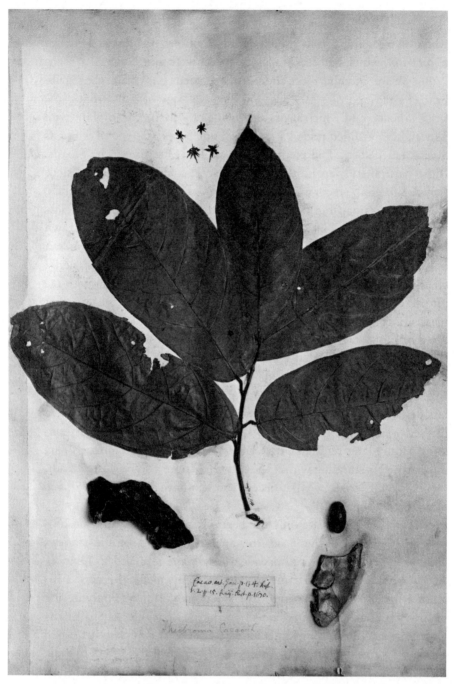

Cacao specimen and sketch: Sloane's Jamaican cacao specimen was harvested by enslave
in Jamaica and inked over a decade later in London by the Dutch draughtsman Everha
(leaves, pods and branches) and dried ones (flowers, pod fragment and nut) in his sketc

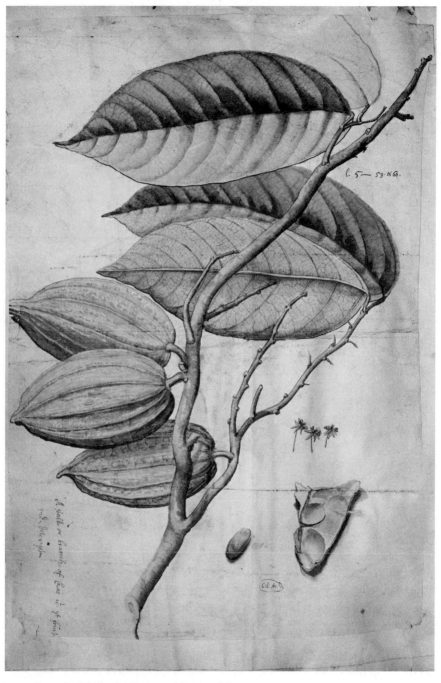

ricans, drawn from the life by the Reverend Garrett Moore
ckius, who combined both live elements

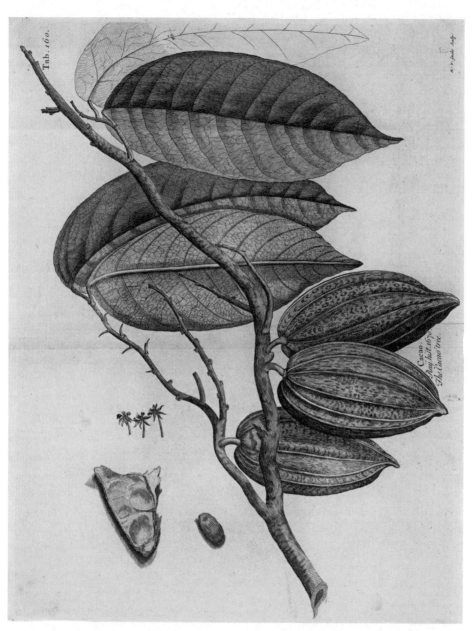

Cacao engraving in Sloane's second Jamaica volume (1725): the finished engravings presented composite views of species, made from both living and dried specimens to show them with the greatest possible number of characters, and which botanists like Linnaeus prized for their accuracy.

flowering plant's different parts. The drawing of the live cacao plant in
Sloane's herbarium is thus signed 'E. K.' for Everhardus Kickius – but
in reality it is a sketch done by Moore in Jamaica which Kickius inked
over later in London, either to correct certain details according to
Sloane's instructions or simply to preserve the pencil sketch from fad-
ing. To this he then added sketches of the dried cacao flowers, nut and
pod bark done from Sloane's specimens. This composite picture of
cacao, including both live and preserved elements, then formed the
basis for one of the engravings in Sloane's second Jamaica volume
(opposite), which were executed for him by another Dutchman, Michael
van der Gucht, and by an English engraver, John Savage, who also
made pictures for the *Philosophical Transactions*. At one point in the
herbarium, Moore and Kickius seem to meet where both of their names
appear next to a picture of a Jamaican jasmine tree. But this meeting is
an illusion – one produced by Sloane's ability to collate the work of
different artists separated both by an ocean and by a decade in time.[26]

There was, therefore, a distinct art to the naturalism of Sloane's
pictures: he artificially combined the elements of both living and dried
specimens in unified views to depict all of a plant's features. There are
numerous examples of such artifice in his *Natural History*. His engrav-
ing of the mammee tree was a composite based on a drawing by Kickius
that again combined elements from Sloane's dried specimen with a live
picture Moore had drawn in Jamaica (pp. 108–11). Yet Sloane evidently
wished his readers to believe they were seeing an individual specimen
exactly as it was, so the line of shadow across the mammee fruit Moore
and then Kickius drew, cast by an overhanging stalk, was retained in
the final engraving, conveying the illusion of a specific plant drawn at
a given moment in time. Sloane's engraving of the clammy cherry tree
likewise combined fruits and leaves drawn in crayon by Moore (on a
piece of paper Sloane brought back from Jamaica and had pasted into
his herbarium) with anatomical details Kickius later supplied from
Sloane's dried specimen of the same species (Plate 7). 'I saw it in
Jamaica,' Sloane routinely remarked of the species he had illustrated.
The seemingly self-evident act of seeing plants in the pages of his *Natu-
ral History* is, however, to behold a subtle work of colonial scientific
art. These were pictures made neither in Jamaica nor in London, strictly
speaking, but by movement and coordination between England and the
West Indies.[27]

The Jamaican mammee tree: this specimen and sketch show how Kickius combined bo (p. 110) in the same drawing.

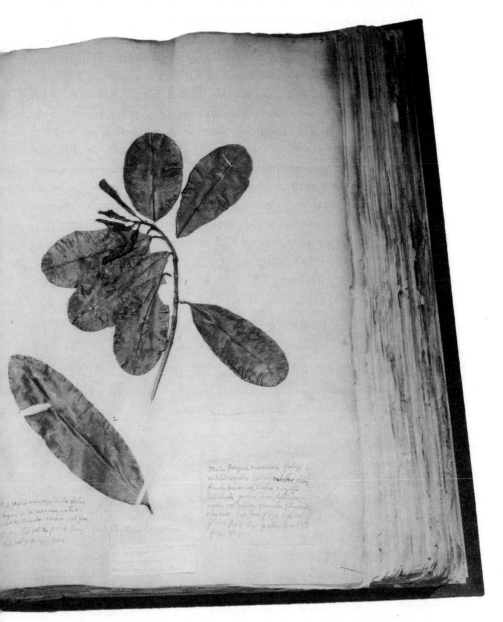

elements from Sloane's herbarium sample and the picture of a living fruit by Moore

Like numerous gentleman naturalists who depended on others to make pictures for them, Sloane sought to exercise close scrutiny over his draughtsmen. Although their skills were fundamental to his science, the difference in status between learned authors and visual 'workmen' (as Sloane referred to them) was significant. Engravers signed their pictures in published books, but apart from a brief acknowledgement in Sloane's introduction, the names of Moore and Kickius were absent from the *Natural History* (other assistants like Henry Hunt, who may have assembled Sloane's Jamaica herbarium, left no named trace behind them at all). Such collaborations were subject to disagreement, as authors tried to ensure that their artists gave them exactly the kinds of pictures they were paying for. Some of Sloane's corrections of Kickius' drafts can be found in the herbarium. 'Leaves sett too thick', he wrote on a piece of paper with an ink sketch of a convolvulus stalk; 'disjoine the leaf and flour at ye stalk which should be left out,' he indicated elsewhere. The detail both Moore and Kickius rendered is extraordinary, as shown by countless examples like Kickius' painstaking work on specimens of *Lonchitis altissima* (Plate 8), which lies folded several times

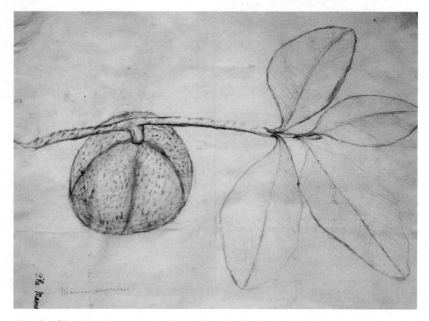

Sketch of living mammee tree fruit: this sketch drawn by Moore in Jamaica provided additional source material for Kickius' composite.

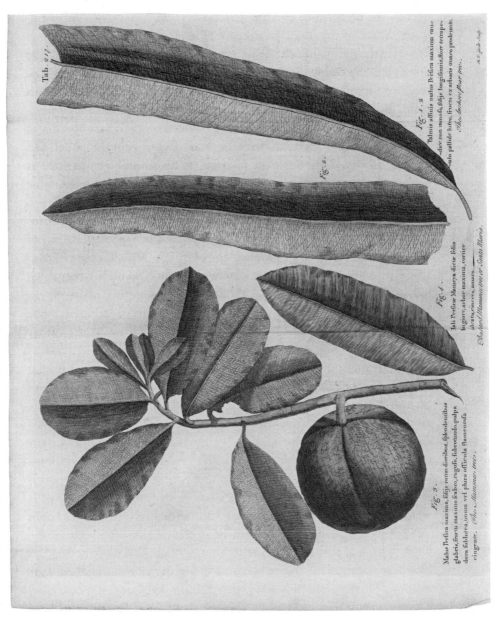

The art of naturalism: Sloane's published engraving of the Jamaican mammee tree appears to be an individual specimen but, as its preparatory sketches show, it was in reality an amalgam of details from different plants, both living and dead, artfully unified in a single image.

over in the herbarium, and his striking *Viscum cariophylloides maximum*. Much of the scientific value of Sloane's Caribbean travels lay in this artistic command. 'I am sensible that the charge of figures may deter you,' the penny-pinched Ray had earlier counselled him, so 'draw them *in piccolo*, using a small scale, and thrust many species into a plate.' But this was precisely what Sloane did not do, ultimately spending a remarkable £500 on a total of 274 engravings. Where specimens were invariably subject to damage and decay, publishing detailed engravings would allow Sloane to circulate his stunning collections as ageless pictures, allowing readers, wherever they might be, to examine them as if they too had made the voyage to Jamaica.[28]

When the Swedish naturalist Carolus Linnaeus reorganized plant classification according to sexual characteristics and through the use of binomial nomenclature, beginning in the 1730s, his achievement consisted in doing away with the cumbersome polynomials over which Sloane spilled so much ink. Although Sloane went on to become a standard reference point in natural histories of the West Indies, some Linnaean naturalists like the Irish physician Patrick Browne (the author of a work on Jamaica published in 1756) criticized his labours as inaccurate and outmoded. Linnaeus himself, however, worked from a copy of Sloane's *Natural History* as he composed his 1753 *Species plantarum* – still the standard departure point for plant taxonomy – citing its engravings as authoritative illustrations of the species he classified. Many of Sloane's fellow botanists around Europe (Linnaeus included) were in all likelihood unable to read his plant descriptions, since these were written in English for the benefit of his fellow countrymen, rather than in Latin, the lingua franca of natural history. And it was for this reason that the botanist Antoine de Jussieu asked Sloane in 1714 if 'a sample of figures could be detached from the body of the work' and sent to Paris, regretting that his 'ignorance of the English language deprives me of the benefit I might derive from reading your history'. Sloane doubtless obliged. At least one London bookseller, Thomas Osborne of Gray's Inn, sold 'cuts' of Sloane's pictures without the *Natural History*'s text – such was their value as stand-alone scientific sources. For many of Sloane's readers, the greatest scientific value of his *Natural History* lay in its artistic ability to show them what grew in Jamaica without their ever leaving Europe.[29]

*

But pictures could never completely do away with words. Sloane collated his images with vast amounts of text to produce a work that combined extraordinary visual detail with encyclopaedic botanical description. Indeed, verbal description remained important in late seventeenth-century botany as an authoritative (and inexpensive) means of assembling information about species, as exemplified by works like Ray's densely textual *Historia plantarum*. In addition to producing a wealth of pictures, therefore, Sloane made thorough verbal accounts of species to record information not easily captured in visual terms such as colour (though he admitted colour was 'very hard to describe') and to preserve information that might be lost if his specimens got damaged in transit. Like picturing, verbal description entailed an extended transatlantic process. Sloane 'immediately described [plants] in a journal' as he collected them and kept both notes and specimens together. Page 68 of volume three of the Sloane Herbarium, for example, contains a specimen with a sheet of paper pasted opposite with notes in Sloane's hand. These appear to be notes made in Jamaica that label the sample *Filia forte foliis subrotundis mali colonea* and record its anatomy: it 'had a gray smooth bark wt a white wood under it' and had 'on its branches & twiggs many leaves wch grew out alternatively'. Sloane also noted measurements of the plant's parts and the 'yellowish green colour' of its leaves. He fell back on the authority of his own senses, expecting that readers would trust his word as a gentleman as he explained that he measured plants' 'several parts by my thumb, which, with a little allowance, I reckoned an inch', although he conceded that measures taken in this 'gross manner' sometimes proved unsatisfactory and that 'more nice measuring' would have been preferable. Many species had parts 'so extraordinary small as not to be easily visible', he granted, 'and perhaps others have perfect flowers, which escap'd my observation.'[30]

Emulating Ray once more, Sloane chose to exclude folkloric and philological information about species and concentrate on their physical characteristics, distancing himself from the methods of famed Renaissance naturalists like Konrad Gessner and what Ray called 'human learning'. 'We have wholly omitted', Ray had declared in his *Ornithology* (1678), 'hieroglyphics, emblems, morals, fables, presages or aught else appertaining to divinity, ethics, grammar, or any sort of human learning; and present . . . only what properly relates to natural

history.' Sloane thus focused on providing detailed anatomical descriptions. The cacao tree he observed was 15 feet tall, he wrote, 'with a grey and almost smooth bark, and a trunk as thick as ones thigh'. Its flowers had only half-inch stalks and were 'made up of 5 capsular leaves, 5 crooked petals, several stamina, and a stylus, of a very pale purple colour'. Its fruit was '7 inches long and two and a half broad in the middle where broadest, of a yellowish green colour, hard and pointed' and, when ripe, 'as big as one's fist'. It was 'a deep purple colour' and its shell 'about half a crown's thickness'. It contained many kernels 'of an oval shape', each covered by a mucous membrane and each as large as a pistachio nut. The nuts inside the pods were 'made up of several parts like an ox's kidney' and the pulp inside the pods – which Sloane tasted – was 'oyly and bitterish to the taste'.[31]

In his analysis of the development of early modern natural history, Michel Foucault argued that the seventeenth century witnessed a decisive shift from depicting species as magical Renaissance emblems, oozing with symbolic meaning, to naturalistic anatomical diagrams that stripped them down to their corporeal essence, exemplified by the dominance of Linnaean plant illustration in the Enlightenment. Sloane shunned anthropomorphism and folklore, yet anatomical description constituted only a small fraction of his account of cacao, as he compiled a series of notes about the culinary, medicinal and commercial aspects of plants, which he later combined in London with information excerpted from books in the library he began building up. This utilitarian encyclopaedism followed the example set by previous travel writers. A century earlier, the Spanish naturalist Francisco Hernández had taken extensive notes on the medicinal properties of a drink known as *cacahoaquáhuitl* (a version of chocolate) based on interviews with the indigenous inhabitants of Mexico City, where he spent several years during 1570–77. These notes were published in his posthumous *Rerum medicarum Novae Hispaniae thesaurus* (1651), and Sloane subsequently acquired a number of Hernández's Latin manuscripts, from which he would translate a total of forty-eight extracts for his own *Natural History*. Combining botanical, medicinal and commercial intelligence about species was common in natural history. Sloane's contemporary Thomas Trapham had advocated the use of chocolate as a health food since at least 1670 and Sloane followed suit. 'Chocolate is here us'd by all people, at all times,' he observed, noting how cacao

trees had to be shaded from the sun and their nuts thoroughly dried for torrefaction, although it was precisely their 'oiliness' that made chocolate so nourishing, especially when mixed with eggs. 'The common usage of drinking it came from the Spaniards,' he acknowledged, earlier recipes including spices such as Indian pepper, and he raided the accounts of Spanish rivals to cite well-known sources such as the Jesuit José de Acosta as well as Hernández. English recipes for chocolate, however, were different: 'ours here is plain, without spice,' and Sloane later collected recipes for making chocolate 'the Spanish way' and 'the English way' – with eggs and milk, respectively. Chocolate 'colour[ed] the excrements of those feeding on it . . . a dirty colour', he found, and was 'nauseous, and hard of digestion', which made him 'unwilling to allow weak stomachs the use of it', even though infants drank it in Jamaica 'as commonly as in England they feed on milk'. If taken warm, however, it proved especially beneficial. So Sloane experimented by sweetening medicines with chocolate. The stuff could stop bloody fluxes (dysentery), he believed, provide essential nourishment and even promote 'venery'. It was also highly lucrative. When English merchants sold slaves as contraband to neighbouring Spanish colonies, they often got large quantities of cacao in return, which they then sold back in England at a hefty mark-up of 55 per cent.[32]

Sloane also remained fascinated by the striking cultural functions attached to specific plants. Cacao, he noted, was particularly curious because it was used as a form of money in several Native American societies and he spent considerable time scouring other books to find evidence to this effect. He cited sixteenth-century Spanish sources like Peter Martyr and Hernández, who had concocted a romantic contrast between Europeans' corruption by gold with Native American virtue as embodied by their use of cacao nuts as money. In addition to raiding the natural histories of England's imperial rivals, Sloane quoted English sources, too, such as the traveller John Chilton, who described how the natives of Nova Hispania 'pay the king their tribute in *cacao*, giving him four hundred carga's, and every carga is twenty four thousand almonds', as well as the pirate William Dampier, who circumnavigated the globe in the 1690s and who likewise observed that cacao grew 'in the Bay of Campeche, where the nuts pass for money'. In the end, despite his commitment to the sober anatomical depiction of species through both word and image, Sloane actually spent more time in his

*Natural History* describing chocolate's function as currency than on its medicinal properties or even commercial value. Unlike Martyr and Hernández, he did not comment on the meaning of such intriguing usages, however, preferring to curate the pages of his book like a cabinet of curiosities – leaving it to readers to form their own judgements about what they found there.[33]

Thus it was that Sloane assembled with enormous pains, and over many years, the vast botanical catalogue that constituted the centrepiece of the *Natural History*. While in Jamaica, he collected plants, took notes on them and had them drawn from the life as he travelled between plantations, preserving his specimens, notes and pictures as he went. Back in London, he had his specimens transferred to a bound herbarium, had more drawings made and conducted further research. His drawings formed the basis for his numerous 'large copper-plates as big as the life', as advertised on his title page, inviting readers to examine his specimens as though looking at the real things, spread over double pages in an unstitched folio edition designed to be opened out, complete with wide margins for making annotations. At the same time, Sloane compiled an encyclopaedic work of reference that showcased his learning by combining anatomical description with medicinal, commercial and ethnographic information. The result was a work that invited readers to move back and forth between image and text and study them together. Joining fieldwork with research back in London, Sloane's natural history was at once emphatically visual and deeply learned, intended for both Caribbean colonists and European naturalists, and one of the age's most spectacular works of colonial science.[34]

## FLESHY BODIES ARE CERTAINLY PRESERVED

Plantations transformed Caribbean landscapes in obvious ways but also in ways Sloane and his contemporaries little suspected, with creatures sometimes barely visible playing dramatic roles. Sloane's Jamaican medical career owed a great deal to the buzzing of the mosquito, for instance, and the environmental factors that allowed it to reproduce in great numbers. The Taíno had regularly burnt woods as part of their

pastoral culture, so their extinction led to a temporary reforestation of the island before the clearances the English made to establish plantations and harvest timber. This deforestation, however, produced unintended effects. Sloane remarked in passing on the 'troublesome' buzzing of mosquitoes, observed that whites used gauze nets to keep them at bay and noted that Africans and Indians set smoky 'fires near the places where they and their children sleep . . . both for their healths sake, and to keep themselves from gnats, mosquitos or flies'. But he did not dwell on the matter. He did not realize that these creatures carried diseases that would later be identified as yellow fever, brought over from West Africa on slave ships, and malaria. Nor did he understand that the accumulation of stagnant rainwater in cisterns and clay pots allowed mosquitoes to hatch eggs on a far greater scale than before, exacerbated by the clearing of Jamaica's woodland (which reduced the island's insectivorous bird population) and the fencing in of savannahs to create livestock pens (which expanded the numbers of cattle and pigs on whose blood mosquitoes gorged). Sloane's livelihood was thus gifted to him in part by the unanticipated environmental consequences of colonization and the mosquito's meddlesome buzz.[35]

Collecting animals formed an integral part of natural history, and one that inevitably presented greater practical challenges than the collection of plants. Sloane hoped to contribute specimens for the compiling of new species catalogues by colleagues like Ray, who were busily engaged in assembling comprehensive classifications of fish, insects and other creatures based on what travellers could find. They often focused on animals they believed would be relatively straightforward to accumulate in great numbers, allowing them to constitute entire series as God had created them, such as insects, their physical fragility notwithstanding. Typically, the questions European naturalists asked about animals pertained to commercial exploitation as much as taxonomy. Could horses, cats and cows survive on the island while drinking virtually no water? Did fireflies stay bright after they died? Could hogs tolerate brackish water even though men could not? And was there really a 'magotti savanna' where maggots bred spontaneously in the rain? Such questions, posed by the questionnaire Governor Thomas Lynch took with him to Jamaica in 1670–71, show the range of concerns animating animal study at the time. They reveal how ignorant English naturalists remained concerning the basic behaviours

of many different creatures. Most interestingly, the query about spontaneous generation shows that while naturalists may have dreamed of assembling providential catalogues that brought their taxonomies to a state of rational perfection, they still wondered whether monstrous forms of life awaited them in the degenerate landscapes of the torrid zone.[36]

Sloane's ability to acquire Jamaican animals depended on local assistants, including African and Indian hunters, fishermen and divers. For example, Sloane had many birds and fish sketched by Garrett Moore, whose drawings formed the basis for a large number of engravings. These were almost certainly done from creatures obtained by local hunters. Although Sloane did not acknowledge this, he tellingly remarked several times on hunters' prowess. He noted how blacks and Indians used 'gangs of dogs' to catch wild hogs, for example, which they 'fill'd with salt and expos'd to the sun, which is call'd jirking' and 'brought [them] home to their masters'. Indians in particular made 'very good hunters, fishers, or fowlers' and were 'very exquisite at this game', while Africans cleverly caught fish 'by intoxicating them with dogwood-bark'. Sloane conversed with African hunters: 'a negro hunter told me the berries [of the currans tree] were not eatable but poysonous,' he noted, while another told him of saving a companion from a snake who had twisted itself around his body until 'he could not speak'. Sloane bought animals at market. Iguanas, which he collected and had figured, made 'very fat and good meat'; he was assured they had been 'commonly sold for half a crown a piece in the publick markets' when the English first arrived. He saw pampuses, garfish, gurnets, pilot fish and barracudas for sale; the geroom, he noted, was 'taken at Old Harbour, and brought to market, where I had it'. He likely bought his corals and sea urchins from Indian and African divers, who harvested the nearby pearl fishery off Santa Margarita Island for the Spanish, and whom the English employed on salvage dives and to conduct hull maintenance on ships at Port Royal.[37]

Sloane inventoried the island's beasts of burden and its livestock. Under the heading *equus*, for instance, he related that Jamaica's horses had first been introduced by the Spanish, were 'small, swift, and well turn'd' and were often taken wild; he added that he had 'several stones taken out of dead horses bodies in Jamaica, which are very ponderous and of different shapes'; and he referred his readers to previous accounts

in works on quadrupeds by Ray and the German naturalist Elias Brackenhoffer. But that was it – no anatomical descriptions and no pictures. His accounts of oxen, deer, hogs and chickens also lacked detail. Sloane dutifully catalogued these commodities but they held little interest for him: they were simply too common. They weren't *curious*. The *Ovis africana* (Guinea sheep) interested him because of its African provenance but little more. *Asinus*, the ass, merited but one sentence: 'they are in Jamaica.' Cattle were redeemed only by the hairballs that 'the peristaltick motion of the paunch' threw up as 'a fine and comely ball of the bigness almost of ones fist'. Sloane acquired several samples. Here at last was something curious with hidden utility. These oddly attractive clumps of matter harboured little-known medicinal properties: 'some of this powder'd and given half a drahm is said to be a powerful astringent.'[38]

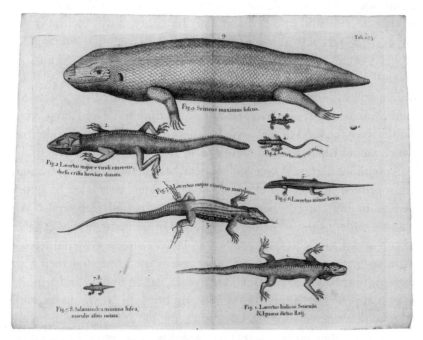

Placed above a series of lizards in this engraving is a sizeable Jamaican skink (*Scincus maximus fuscus*) or galliwasp. Skinks were difficult to catch, so Sloane, who kept dried specimens of these creatures as medicinal resources, probably acquired the animal featured in this engraving in the second volume of his *Natural History* from an African hunter.

Sloane lavished attention instead on rare species about which Europeans were ignorant. His exacting curiosity about the skink, or galliwasp as it was called in Jamaica, makes a vivid case in point (p. 119). Sloane dissected and examined skinks, meticulously describing their anatomy. *Scincus maximus fuscus* was 11 inches from head to tail and 6 around the middle; its 'back was hard, and a little compress'd, and so was the belly'; it had two 'round *spiracula* or nostrils in the two corners of the snout'; and its feet resembled those of a lizard, with two joints and five toes. Its anus was covered 'with a transverse flap' and its back was covered with 'rhomboidall small rowes of scales of a brown colour, with spots of orange'. It had a 'short larinx' and 'lungs not altogether membranaceous, the heart as of other animals, the stomach not all muscular, but made not sack fashion, but of several wide circumvolutions, with cells like those of the colon in other animals, and with all very thin and wide'. It lived on marshy ground, fed on crabs and was 'reckoned very poisonous in the bite': Sloane was 'told one [person] had his thigh bit by this creature and dy'd the next day'. In reality, it was incurably shy but even though 'it flyes from a man,' it 'loves to feed on the remainder of his victuals'. Sloane acquired several samples, listing 'skinks of severall colours' in his Quadrupeds Catalogue; had pictures of them drawn and included in the *Natural History*; and stored specimens for medicinal use in his pharmacopeia drawers. Both timid and dangerous, skinks were the kind of prey which only skilled hunters could take and which Sloane likely bought, therefore, at African markets.[39]

As with his plants, Sloane did not detail his methods of preservation, but a printed sheet of 'Brief and Easie Directions' circulated by James Petiver to his correspondents describes key period techniques. All 'beasts, birds, fishes, serpents, lizards, and other fleshy bodies capable of corruption, are certainly preserved', Petiver directed, by immersing them in 'rack, rum, brandy or other spirits' or brine, together with three or four handfuls of salt added to each gallon of fluid and a spoon or two of powdered alum. Any simple pot, bottle or jar would do, with a corked or resined top. For large fowl, the head, legs or wings were welcome; smaller birds and insects should be sent entire 'drowned' in spirits. If dried, the entrails should be removed first by cutting under the wing, stuffing with ockham or tow mixed with pitch and tar, and drying in the sun. Desiccation was again vital to 'kill the vermin which often breed in' specimens. Woodward's instructions suggested the

considerable dexterity required to secure delicate specimens in boxes padded with chaff or cotton. Shells, minerals and corals 'ought to be put up carefully in a piece of paper . . . by it self, to prevent rubbing, fretting, or breaking in carriage: and then all put together into some box, trunk, or old barrel, placing the heaviest and hardest at the bottom'. Woodward insisted that 'great caution ought to be used that the boxes wherein they are, be not turned topsy-turvy, or much tumbled and shaken in carrying to and from the ship'. Courten's collector James Reed carried a dozen pairs of scissors that cost a shilling and sixpence; two dozen knives at four pence; fish-hooks at two shillings and sixpence; one hundred needles for a shilling; a gallon of spirit of wine for sixpence; several boxes, also for sixpence; and two glass bottles for three pence. Sloane doubtless carried a large number of such supplies.[40]

Insects commanded special attention. Because they were especially challenging to collect and preserve, they had become a darling fetish of the naturalist in a spectacular reversal of cultural fortune. Christians believed that insects had been absent from the Garden of Eden and had only emerged as a consequence of original sin. So, in addition to scathing vernacular about 'dunghills' and 'pisspots', Caribbean travellers' invocation of insects to paint Jamaica as physically degenerate (hence the 'magotti savanna') smacked of ungodliness as well. However, since the sixteenth century, insects had risen to divine heights in human estimation. Through its microscopic engravings of fleas and flies, Robert Hooke's *Micrographia* (1665) astounded readers with glimpses of undreamed-of worlds. Sloane, in common with many contemporaries, emphasized the value of insect study in revealing the microstructures of the creation. 'The power, wisdom and providence of God Almighty, the creator and preserver of all things,' he declared, 'appear no where more than in the smallest animals, called insects', which, despite their 'little bodies and many enemies . . . live, thrive, and propagate their kind, so that since we have an exact history of them, none seem to be lost.' This was the dream of total knowledge in Christian natural history: the universe had not changed since the creation so naturalists could aspire to assemble complete catalogues of natural kinds.[41]

Obtaining insects in Jamaica served this aim of universal cataloguing. Some Sloane evidently caught himself, perhaps even in his own house in Spanish Town, such as the great house spider that was 'very

common in all houses, running about even on their cielings'. Slaves probably contributed a number of specimens. Petiver directed his correspondents to pay slaves to collect and went into great detail regarding insects in particular. 'Hire a negro or any labouring man', he told one supplier, 'to goe up into ye island or ye woods and highest mountains.' He worked out a pay scale of 'halfe a crown a dozen for every different fly, beetle, grasshopper, moth &c'. Like Petiver, Sloane did not record which species he got from slaves, but he did provenance such specimens like his plants, observing for example that he had found the 'naked white' snail *Limax nudus* 'in the woods near Captain Drax's plantation in the north side of the island by the old town of Sevilla'. Other samples came to him as gifts. After leaving Jamaica, he received a parcel of cotton-tree worms (the *Cossus*, that delicacy savoured by both African slaves and ancient Romans) from the wife of a planter named John Leming, 'according to promise . . . together with the wood wherein they were'. The brown and white spider called *Araneus niger minor*, he noted, was 'brought to me from Jamaica by Mr. Barham'.[42]

Mrs Leming's worms fascinated Sloane for what they did as much as for what they were. He listed several of them in his Insects Catalogue as well as 'a piece of sallow wood wherein was lodged a cossus'. Sloane dissected a number of these creatures, describing the water and fat that issued from their bodies as he worked and the 'black, hard, hairy sharp claws, with which it . . . corroded rotten wood'. Insects like the cochineal beetle, used to make a lucrative red dye, could make imperial fortunes: Sloane reported with furtive excitement that a few bags of them had been brought to the island by privateers and had 'taken life and crept about'. But worms like the *Cossus* could devour imperial fortunes just as fast. Sloane's collection of worm-eaten keels testified to this menace: in one instance, he shelled out one pound and six shillings to procure a single exemplary 'timberworm which eats ships in West Indies'. He commissioned engravings for his *Natural History* that deviated from the customary specimen views of most naturalists – decontextualizing the specimen by abstracting it on to a white background – by illustrating such worms boring through wood, for example the *Scolopendra maxima maritima*, which burrowed through the oak and cedar hulls of English ships, notwithstanding their coats of allegedly impervious resin (opposite). The wood of the juniper tree could, it was said, withstand such 'all-devouring' vermin, but Sloane

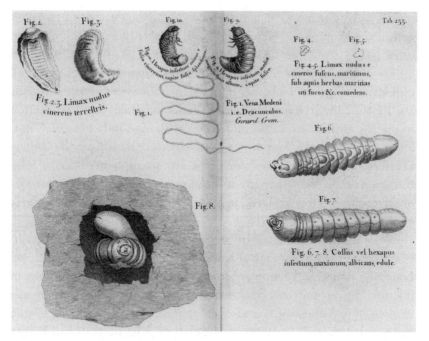

To Sloane, burrowing worms were threats to British imperial interests both because they ate through the hulls of British ships and because they afflicted the bodies of enslaved Africans in Jamaica.

for one doubted it very much, having 'seen keels of ships of this wood eaten thro' and thro''.[43]

Sloane's entomology was thus embedded in British maritime and imperial economic interests, which worms also threatened by invading the bodies of slaves. 'Worms of all sorts are very common amongst all kinds of people here,' Sloane observed, 'especially the blacks and ordinary servants.' They caused fevers, convulsions and stomach pains, rendering slaves unfit for work. The long worm lodged 'amongst the muscular flesh under the skin, in several parts of the bodies of negroes and others coming from Guinea'. Gold Coast natives suffered more than Angolans or Gambians. Sloane examined at least one slave who had a worm 'in his thigh, [whence] half an inch of the end of was hanging out, which was flat and blackish'. He 'was told that the only remedy for this distemper was to draw it out by degrees every day some upon a round piece of wood, as a piece of tape or ribbond' and was 'assured that if any part of this worm, which is tender and very long, and

requires great care in the management of it, should chance to break within the skin, that there follows an incurable ulcer'. Black children often got worms from sucking raw sugar cane, vomiting them up in 'divers shapes and magnitudes', prompting Sloane to try a range of purgatives as well as bleeding, but often without success as the worms ate 'through the[ir] guts'. His interventions were once more an attempt to use his medical expertise in defence of slavery. In his Insects Catalogue, he described a 'long worm drawn by piece meal from the Guinea negros leggs and other muscular parts' sent to him years later by John Burnet, a South Sea Company surgeon tasked with inspecting cargoes of slaves shipped to Cartagena in South America for sale to the Spanish colonies.[44]

While dismissive of African healers, like many whites in the Caribbean Sloane took advantage of blacks' manual dexterity to rid his own body of a parasite. 'I found an uneasiness, soreness, or pain in one of my toes,' he recounted of one occasion, so he sought help from a slave woman. 'I had a negro, famous for her ability in such cases, who told me it was a chego.' The woman in question, who he said 'had been a queen in her own country', opened Sloane's skin with a pin above the swelling, pulled out the 'tumour' and filled the wound with tobacco ashes from a pipe she had been smoking. The swelling had resulted from eggs laid by female fleas and 'after a very small smarting it was cured.' Sloane recorded another case that showed how delicate such operations were, where 'a very neat lady had one of these bags bred in one of her toes' and 'part of it was by a black taken out with a pin,' though 'not the whole bag'. As the swelling ulcerated, Sloane declined to intervene, protesting that as a physician this was not his 'proper business', referring the woman instead to a surgeon, 'who applying poultesses, &c. to it, it broke and kept running for a long time, after which it cicatriz'd not without great trouble'. A later report by Henry Barham calls forth an interesting question about *which* blacks were most adept at such operations. Writing to Sloane in 1718, Barham described the 'trumpery' of 'oba or doctor negroes', some of whom 'whissels at the time they draw [the worm] out pretending they got it out by that', rather than attributing their success to the quill they used to perform the extraction. This raises the intriguing possibility that Sloane may have had his swelling healed by one of the Obeah women whose beliefs he so scorned.[45]

Once secured, insects again confronted Sloane with the question of how to have them drawn. In the late seventeenth century, consensus was elusive on whether insects should be classified according to their modes of generation or their anatomical variation, so naturalists differed over whether artists should draw them to capture their development over time or to render their bodies as they appeared at a specific instant. Because he was collecting and preserving dead specimens, rather than keeping live insects over an extended period, Sloane had Garrett Moore draw specimen views that brought out static yet clear anatomical details. Table 237 in volume two of the *Natural History* presents a host of insects in this way, including beetles, cockroaches and bedbugs. Sloane supplied full Latin polynomial labels and, as with his plants, referred readers back to descriptions by previous naturalists including Ray, gave insects' English names and provided brief descriptions. He also had these specimens arranged to produce aesthetic effects. While table 236 presents locusts, crickets and other creatures in miscellaneous physical arrangement, table 239 artfully arranges butterflies in symmetrical formation, their labels moved down to the bottom of the page to create space for an attractively harmonious pattern. Such arrangements reflected a belief in the inherent beauty of nature, which naturalists believed derived from its divine origin. By curating his insects in this artful manner, Sloane cast himself not merely as a conscientious contributor to animal taxonomy but as a pious exhibitor of the aesthetic splendour of God's creation.[46]

From Moore's neat portraits of fish and birds, which appeared to sit up to attention just so they could be drawn, to his careful insect anatomies, Sloane's creature pictures suggest a cool mastery of Jamaican animal life. Harping on a familiar theme, Sloane insisted that the island's beasts were not so different from English ones. The 'great green humble-bee' went 'from flower to flower, and sucks something from them, making such noise as our English bees only stronger'; the firefly was 'no bigger than English flies'; and the cobweb of the brown and white spider was 'like an ordinary English spiders spiral web'. Cabinets of curiosities and exotic travel accounts often included various 'monstrous' animals, but such creatures were conspicuously absent from Sloane's Jamaica. Instead, Sloane articulated a vision of providential order and cornucopian abundance for human benefit. The Christian conception of the Chain of Being was one that placed God above the

angels, angels above human beings and humans – the only entities in the cosmos that combined both spirit and matter – above animals, which were thought to descend in gradations of complexity down to the humble mollusc, leading, ultimately, to vegetable forms of life. This Chain of Being was also a food chain that gave humans alimentary dominion over God's lesser creatures. Jamaica was not the degenerate dunghill imagined by Ned Ward, Sloane insisted, but a divine provisioning station designed to allow venturesome Protestants to flourish around the world. 'I know not', he declared, 'of any place where there are [as] great plenty of fresh water and sea fishes, which is a great providence and contrivance for the support of the inhabitants.' Melodiously throated and exquisitely plumed though they were, Jamaica's birds also made 'very good food'. After all, God had expressly given humans 'instruments . . . for maintaining themselves by the destruction of others'. Had there not been such 'a good stock of these creatures they [would have] come to an end', but thanks to divine supply, it was impossible to conceive of any environmental crisis of exhaustion or extinction. God's message was clear to the faithful who heard it: the creation is yours to consume.[47]

Rather than telling tales of monsters, Sloane offered object lessons in converting exotic animals into new commodities. The manatee (or sea cow) was, for example, a marvel of commodification, less interesting for its taxonomic or anatomical peculiarities than for its nutritional and medicinal capacities. These creatures were 'taken in the quieter bays of this island', and 'by the multitude of people and hunters catching them' had in fact been consumed almost to 'destruction', Sloane wrote. This was an interesting choice of words: it suggests that Sloane did possess awareness of the environmental impact of colonization. Further circumstantial evidence of his consciousness of ecological fragility includes an undated entry in his Quadrupeds Catalogue that refers to the spotted deer of the Philippines as 'endangered' and his ownership of an oil painting of the dodo bird, which Europeans realized had already been wiped out by the end of the seventeenth century. Writing about manatees prompted no explicit conclusion that contradicted Sloane's faith in the permanence of God's creation, however, which could be exploited by humans seemingly with impunity. Manatees, he went on, were 'reckon'd extraordinary food': fried in butter, they made 'the best fish in the world' and their 'cur'd flesh

[lasted] long without corruption . . . never turning rancid, though kept very long'. In addition, their 'powdered hard stone, or rather bone is reckoned an extraordinary medicine in the stone or stoppage of water'. They fed on underwater grasses and had 'stones in their heads, good for the diseases of the liver burnt and powder'd' that relieved 'pain in the kidnies'. Their hides were made not only into whips for beating slaves but also into fine shoes. This was total commercial cataloguing: no part of such creatures need go to waste. A luxuriously fetishistic gift later sent to Sloane from Jamaica by a woman named Mrs Sadler embodied such dreams of total animal commodification: 'the foot of a small Guinea deer tipped with gold for a tobacco stopper'.[48]

Spectacles of animal obedience were as pleasing to Sloane as were visions of commodification. The blast of an overseer's conch shell induced hogs to 'come home' at night, he remarked, after foraging all day in the woods. 'It was not a small diversion to me, to see these swine . . . lift up their heads from the ground where they were feeding, and prick up their ears to hearken,' almost 'under command and discipline, [more] than any troops I ever saw'. Animals mediated human interactions on the island and could sometimes be conscripted to maintain the institution of slavery. The great blackbird 'haunts the woods on the edges of the savannas . . . making a loud noise, upon the sight of mankind, which alarms all the fowl in their neighbourhood'. While such bruiting about made hunting animals all but impossible it cruelly helped to prevent slaves' flight to freedom. 'When negros run from their masters, and are pursued by them in the woods to be brought back to their service, these birds on sight of them . . . will make a noise and direct the pursuers which way they must take to follow their blacks, who otherwise might live always in the remoter inland woods in pleasure and idleness.' The carrion crow (or vulture) also played a role in policing the island by consuming dead bodies, the corpses of slaves included. The wingspan of this imposing creature measured 4 feet and it possessed a crooked and sharp beak, forbidding 'ash-colour'd scales' and 'brown blunt claws'. It 'flies exactly like a kite' and 'preys on nothing living, but when dead, it devours their carcasses', Sloane wrote, among them runaways who had died in flight. He recorded the tale of an unidentified woman, probably a slave, who had tried to abort her child and buried it in a field where it was eventually 'discovered by birds, which feed on corrupting flesh'. These vultures were 'soe usefull

in devouring carrion carcasses', John Taylor noted, which 'infect the air and so breed foul and contagious distempers' that the Jamaican authorities passed a law to fine those who killed them the sum of five pounds.[49]

At the same time, uncontrollable wild animals were the stuff of legend in Jamaica. Blacks told their own tales about the island's creatures, featuring a recalcitrant animism that spoke of both human and animal defiance of slavery. In one story later taken down by Thomas Thistlewood under the title 'How the Crab got its Shell', the eponymous crab magically takes on its characteristic shape only after an enslaved woman hurls a calabash at it. Oral histories tell of Maroons' fears that goats would give them away by bleating out to their pursuers, but they also celebrate the worms capable of devouring evil whites: 'Congo-worm a go nyam you,' goes one of their songs (*nyam* means eat). As part of the intricate spiritual rites they continue to conduct called Kromanti, Maroons also commemorate a man by the name of Granfa Welcome as a 'Guinea Bud' who finds his freedom by flying home to Africa. Perhaps the most celebrated magical hero to feature in the West African tradition of Anansi stories is the 'spider man'. One explanation of this figure points to the Middle Passage, as the limbo dance originated on slave ships, in which an African was said to be able to pass through a slit 'with spreadeagled limbs' so that 'he passes like a spider'. From this origin in captivity, the spider man became a potent symbol of rebellion as a cunning trickster and folk hero who flouted all authority.[50]

Sloane recounted no African animal tales in his *Natural History* but he did repeat several stories he heard describing beasts of wondrous ferocity that posed a grave mortal threat to Jamaica's human populations. The island abounded with haunting rumours of unseen creatures and memories of wild animals. The very term *Maroon* derived from the Spanish word *cimarrón*, originally used to refer to Jamaica's wild hogs. When he spent the night under the stars on Mount Diablo, Sloane found his sleep 'interrupted by the croaking of a sort of tree frogs ... the singing of grasshoppers, and', in a phrase that evokes innumerable hidden life-forms, the 'noise of night animals' (he ended up taking for his collections 'a large tree frogg from Jamaica' which 'make[s] a great noise in the night'). Monkeys, Sloane was told, 'are found wild in this island, where in the woods they live on the fruits', and were 'said to have come originally from some ship wreck'd on the coast', but he never

saw them. At the Rio Nuevo on the north coast, the planter Thomas
Ballard told him how vicious Spanish hunting dogs, as big as Irish grey-
hounds, 'went all wild' when the English arrived in 1655. These brutes
made 'much mischief in the night', feasted on livestock and had been
used by the Spanish to hunt down the 'poor Indians' – yet another
reminder of the Black Legend.[51]

Sloane's natural history collections rested on a dream of preser-
vation, wholeness and salvation from decay. But he could not resist
repeating nightmarish tales of bodily destruction in which animals
devoured humans and consigned them to oblivion. The insects that
marched through his pages, like the chego that invaded his own body,
were harbingers of disintegration. Sloane told no trickster tales of
spider men, though his description of 'the great yellowish wood-spider'
did speak of webs that not only trapped 'small birds, but even wild
pigeons' and, ominously, were 'so strong as to give a man inveigled in
them trouble for some time'. Black ants were a terrifying menace and a
primordial consuming force. Sloane repeated stories he had heard
about the *Formica maxima nigra*, 'said to have killed the Spanish chil-
dren by eating their eyes when they were left in their cradles' – it was
they, rather than any human foe, who forced the Spanish to evacuate
Sevilla. Just 'thrust an animals thigh-bone into one of their nests',
Sloane suggested, to witness the miracle of their voraciousness. Beds
creaked and even collapsed at night as these ants drilled at their joints.
Sloane marvelled at their prodigious appetite: 'if you put sugar into a
room troubled with bugs in Jamaica, the ants will come for love of the
sugar and at the same time destroy the bugs.' The smaller black ant was
barely less formidable, as potential specimens turned devourers of
specimens. 'I attempted to preserve the skins and feathers of humming
birds,' Sloane recalled, 'and was oblig'd, to keep them from these ants,
by hanging them at the end of a string from a pully fasten'd in the ciel-
ing and yet they would find the way by the cieling to come at and
destroy them.' His Birds Catalogue lists the skeleton of at least one
Jamaican hummingbird – possibly these same remains.[52]

Sloane's engravings also hinted at the perils of Jamaican life. The
vast majority of his pictures were specimen views that abstracted plants
and animals from their contexts on white backgrounds, making them
visual collector's items, ideal for study and classification. But occasion-
ally Sloane deployed an alternative scheme of representation, not one of

Baconian factual views, but an older mode of knowledge making known as emblematic natural history. Rather than the spirit of precise scientific cataloguing, this way of knowing nature was inspired by the courtly playfulness of the *Wunderkammer*, where aristocratic collectors liked to juxtapose different kinds of object to tease viewers with puzzles about the relations between them. Two such juxtapositions stand out in Sloane's *Natural History*: the coral-encrusted spar and Spanish silver coins pictured with a jellyfish (p. 33); and the potsherds from Barnes's cave he had placed below two Jamaican land crabs (p. 66). Here Sloane combined nature and artifice rather than sorting them into discrete categories. The potsherds and crabs invite the viewer's attention to the textural resemblance between the pottery and the shells, while the viewer is encouraged to imagine the depths of the Caribbean Sea through the spar, coins and jellyfish, suggesting the dangers that hedged the treasures of the West Indies. The potsherds return us to the scene in Barnes's cave (featuring murderous Spaniards, devouring ants and thieving Africans), and the crabs are threateningly upturned, rather than docile lifeless specimens, while the coins and spar recall the many shipwrecks of the Caribbean and the hazards lurking beneath the waves like jellyfish (this one was aptly known as the Portuguese man-of-war) – not to mention those pitiless denizens of West Indian waters, sharks.[53]

The tendency of Christian naturalists to ascribe divine meaning to the workings of nature led them to perceive conscious design in the actions of animals, prompting uncanny visions of omnivorous rivals for the same natural resources. Perhaps because scientific orthodoxy, especially after Descartes, often considered animals to be little more than soulless machines, intimations of animal intelligence were disturbing. Ants 'have all one soul', wrote Sloane, fascinatedly quoting Richard Ligon's account of Barbados, and fancied he saw compelling evidence to this effect for himself in Jamaica: 'I have seen them when one of these travelling about hath found a dead cockroch [and] he hath gone back to his hole from whence came great numbers to it, and . . . disjointed it to carry it in by piece-meal.' Henry Morgan told Sloane about mosquitoes in the shape of 'clouds', while Colonel Nedham recalled locusts swarming as large as 'a ship'. Sharks, meanwhile, were a ubiquitous menace and swallowed objects, fish and people whole. That their victims often lay undigested inside them for days was so well

known that Petiver recommended that his correspondents open up their stomachs if they caught them as an indirect but efficient means of collecting 'divers strange animals'. Sometimes the yield was prosaic enough. A sailor on HMS *Assistance* lost his jacket overboard and recovered it a couple of days later from the belly of a shark taken by the crew. Sloane performed a rather more interesting dissection when he himself opened up a great white and found a shark foetus as well as five undigested fish inside. Sloane copied into the *Natural History* several older stories of humans swallowed whole, such as the French scholar Pierre Gilles' tale of a shark caught 'wherein was a solid man', while fishermen in Marseilles once captured a shark containing a complete suit of chainmail.[54]

The crest of English Jamaica officially indulged the fantasy of human mastery of the island's most ferocious beasts as part of its colonial ideology: it placed an alligator at its summit. In reality, *Lacertus omnium maximus* was the most dangerous man-eater in Jamaica and terrifying to most colonists. These beasts lurked on the coasts and in the rivers, where they picked off horses and sometimes people. That Sloane described one in detail suggests he dissected one himself. It had four glands, 'two under the jaws, and two near the anus', he wrote; its lungs were 'vesicles with blood vessels intermixed'; its heart was small; and it had 'one large stomach, with a rugous coat within, containing many round smooth stones and sand . . . and some bones in it'. The specimen he examined was 7 feet long. So much for the empirical part of his account. He also told a local alligator tale that acted as a parable of Jamaican life and the violent tangle of species it entailed. One especially canny alligator – some 19 feet long – had been in the habit of 'coming round . . . every night' in the vicinity of Port Royal and Passage Fort, where it did 'abundance of mischief to the peoples cattle in the neighbourhood of this bay, having his regular courses to look for prey'. So one of the locals decided with somewhat reckless ingenuity to take matters into his own hands. He 'tied a long cord to his bedstead, and to the other end of the cord [outside his window] fastened a piece of wood and a dog'. When the predator came calling one night, the trap, loaded with its canine bait, was sprung: 'the allegator swallowing the dog and piece of wood, the latter came cross his throat, as it was design'd, and after pulling the bedstead to the window, and awaking the person in bed, he was caught.' This was Jamaica: an island where

humans and animals found themselves locked in a struggle for domin-ion. 'Allegators love dogs extreamly' was Sloane's dry conclusion, although, incorrigible collector that he was, he could not but strike a note of regret as well. 'The skin was stuffed and offered to me as a rarity and present, but I could not accept of it because of its largeness, wanting room to stow it.'[55]

# SLOANE'S ARK

After fifteen months of doctoring and collecting, Sloane finally left Jamaica in March 1689. The Duchess of Albemarle had decided to return to England, and it was Sloane's duty as her physician to accom-pany her – but not before he had stashed a richly varied cargo aboard her ship for the journey home. His Grace the duke's well-sealed corpse took pride of place. Next, there were the varied objects Sloane had acquired, from the pot fragments and human remains of Barnes's cave to the strum strums played by slaves. And, of course, there were the hundreds of preserved plants and animals he had patiently closed up in papers, boxes and bottles together with their sketches and the notes he had made: samples of cacao, sugar, pepper, corals and numerous ferns; worms, insects, lizards, birds, fish and shells. In addition, though he 'foresaw the difficulties', Sloane decided to make the attempt to trans-port 'some uncommon creatures alive'. The chance was too good to miss. He had a 7-foot yellow snake brought on board, together with an iguana and, perhaps inevitably, an alligator. The snake's fangs were potentially fatal but Sloane couldn't resist the idea of taking one as a pet. 'I was here told by eye-witnesses', he wrote, that a man named Fos-ter at Sixteen Mile Walk 'had tam'd a great snake or serpent, and kept it about him within his shirt'. It would 'wind it self fast about his arm, and drink out of his mouth, and leap at a call on the table, to eat crumbs of cassada bread'. So he got one of his own, 'tam'd by an Indian', which 'follow[ed me] as a dog would his master' and had it immortalized by Garrett Moore (opposite). Once on board, it was kept in an earthen jar sealed with wooden boards and was 'well pleas'd' by a diet of fowl and rats. The iguana, which Sloane probably bought at market, also thrived, on a diet of calabash pulp, while the alligator was kept in a saltwater tub towards the forecastle. It, too, proved partial to

fowl. If the fleet could survive the shoals of the Caribbean and the storms of the Atlantic, and evade pirates and enemies, Sloane would have a prize collection to show off in London. But there were other hazards as the fleet sailed. Lawrence Wright, captain of HMS *Assistance*, had recorded in his log on 17 January that a ship from Bristol arrived at Port Royal with 'news of the Prince of Orange's landing an

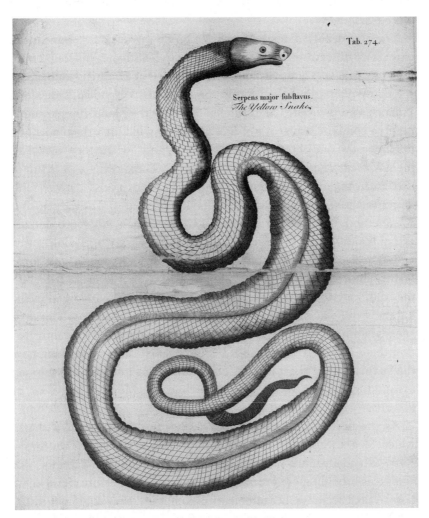

Sloane was fascinated by snake-charming and brought a live seven-foot yellow snake back from Jamaica. After it escaped and was regrettably shot on board ship, he had it stuffed for his collection and engraved for his second Jamaica volume (1725).

army in England' and 'that they had taken Exeter without any resistance'. Rumours followed that King James had been deposed, which disrupted the supply of food, slaves and goods to Jamaica. As the duchess's fleet set sail, no one knew for sure whether they would find England plunged back into civil war, and whether the Catholic James or the Protestant William would be on the throne. If William won out, war with France would likely ensue, making the ocean crossing still more perilous.[56]

The fleet departed on 16 March. As on the voyage out, Sloane made numerous observations in his journal. He heard the 'hideous noise' made by the 'very great echoes' in the cavern at Point Pedro and saw the many plantations that dotted the island as they sailed west along Jamaica's south coast. They rounded Negril at the island's westernmost point, a common refuge for pirates. A strong wind took them north by north-west to one of the smaller Cayman Islands, where they 'tack'd all night for fear of coming too near the shore'. The Caymans were full of turtlers from Jamaica, he noted. 'Feeding only upon turtle', it was said, 'cures the pox,' though Sloane was having none of it: 'I never saw that this method, or any other boasted of by the Indian, or Negro doctors of any kind, was to be depended upon.' After surviving a violent tornado, the fleet successfully navigated 'very dangerous shoals' and 'great quantities of sea weeds and sea blubber'. Off Cuba, Sloane jotted down the testimony of one Morris, a man on board who had worked in the logwood trade at the Bay of Campeche before being held as a slave in Mexico until he escaped. Morris had the most prized strategic information there was – reconnaissance behind enemy lines – describing how the Spanish could coast along Cuba's northern shore without running aground and how 'bread was very cheap at Mexico, and dear at Havana'.[57]

As the fleet moved towards open seas, the crew caught a shark, which Sloane eagerly dissected, finding 'yellowish eggs in the ovary fill'd with a substance like yolks of eggs as big as small wallnuts'. But open seas brought more pressing concerns. In an era before crews knew how to take accurate measurements of longitude, they could not establish how far west they were with any certainty. Nor could vessels at sea for several weeks be entirely sure whether they were at peace or war with other nations, so gathering news en route was vital. A month into the voyage on 17 April, somewhere in the Atlantic, the ship carrying

the duchess fired off a gun as a distress signal when a number of its planks began to give way. The rest of the fleet sent carpenters to help while the duchess 'carried her plate and jewels into the late Duke her husband's yacht, and afterwards into a ship of better defence against enemies of those seas'. Security was doubtful: the commander of HMS *Assistance* said 'that he could not fight any ship', making the duchess 'afraid she might be carried with her plate and jewels into France, apprehending from the situation of publick affairs, some differences between the two nations'.[58]

The spectre of Anglo-French hostilities preyed on Sloane's mind. By 6 May, almost two months after setting sail, the fleet entered 'a wetting fogg', seemingly off the banks of Newfoundland and the Canadian coast, where Sloane witnessed 'a great many English and French to fish on the bank great cod', keeping a suitable distance between them. The fleet pressed on, desperate for information at this point: 'we try'd all ways we could, to speak with ships (which shun'd us all they could) that we might learn news.' They fired on a nearby French vessel and its commander was brought on board, bringing papers with him. The ship was from La Rochelle and had sailed from Bordeaux laden with wine and provisions, bound for Québec and the West Indies. The captain pleaded that they were just merchants, 'des pauvres negotians', as he said, 'with tears in his eyes, which mov'd my compassion for his circumstances'. Sloane's compassion did not stop him from scouring the Frenchman's belongings, however: his knowledge of French served the duchess well since he was 'the only person in the fleet who could understand his papers'. But still he was not 'able to discover by them, or his crew, that there was war between the English and French'. They bought a hogshead of the Frenchman's wine, let him go and his ship slipped off in the night. The fleet then sailed east for three more weeks to find itself 90 leagues west of the Isles of Scilly. Here they encountered another vessel, this time an English pink belonging to a logwood cutter from Campeche named Slaters. But again 'he could tell us no news.'[59]

By the end of May, however, they were finally close to home. On the 29th, the fleet took soundings that confirmed they were now in shallow waters and they soon sailed past some 'dangerous rocks call'd the Bishop and his Clerks' that led them on to Land's End and finally towards Plymouth – the scene of their departure nearly two years earlier. At last they entered the English Channel, but even here they could

not be sure of their progress or of what they would find at home. Still they strained for 'intelligence whither there was peace or war, and with whom, lest going up the Channel, we might be taken as prizes'. Here Sloane's odyssey came full circle with that of Columbus. As the Italian had deciphered his initial westward course through strange objects in the Azores, Sloane and the fleet now spotted 'boards, chests, &c. floating in the sea' which they guessed 'to have been thrown over board to clear ships for a fight'. And so it proved: these turned out to be the remnants of a skirmish between English and French ships in Bantry Bay off Ireland's south coast. Sloane set off to make sure of the news before making any attempt at landing: 'I was sent in an arm'd long boat, to get certain knowledge of the situation of publick affairs.' A small fishing boat came into view and Sloane demanded 'what news, and where the king was'. The initial answer was quizzical and surely gave Sloane pause: 'he ask'd what king we meant.' But the explanation that followed finally told them what they needed to know: 'King William was well at Whitehall, and King James in France, that there was war with France, and that the Channel was full of privateers.' Sloane relayed this information and shortly afterwards the fleet at long last entered Plymouth. Sloane's duty to his patrons was all but discharged. 'The Dutchess of Albemarle landed with most of us, her plate, jewels &c. and came up thanks be to God, with safety by land to London.'[60]

Back on board ship, Sloane's creature cargo had sadly not fared so well. His snake had grown 'weary of its confinement', broken out of its container and writhed its way to the sleeping quarters of the duchess's servants, where they shot it dead. So Sloane had it stuffed: his Serpents Catalogue includes the consolation of 'a yellow snake of Jamaica which I kept tame'. His iguana had been spotted 'running along the gunnel of the vessel' one day, when 'a seaman frighted it, and it leap'd over board and was drown'd.' The alligator very nearly made it home alive, but not quite: Sloane recorded its death on 14 May, just two weeks shy of Plymouth. 'Thus I lost, by this time of the voyage,' he stoically concluded, 'all my live creatures, and so it happens to most people.' But it was far from all loss. The vast majority of Sloane's Jamaican specimens were intact: the hundreds of plants and animals and his curiosities, all carefully labelled and stowed with his voluminous journal, stuffed full of notes on their scientific, medicinal and commercial uses. Through his privileged position as a colonial governor's physician, Sloane had taken

brilliant advantage of the resources of the English state and its burgeoning empire, riding its coattails across the Atlantic, surviving months at sea, the perilous tropical environment, the threat of slave rebellions and now even the dangers of revolution and war as he sailed up the English Channel. The conclusion of his voyage aptly symbolized his single-minded pursuit of his own interests even as he served his patrons in the most dangerous of circumstances. His reward was a stunning hoard of scientific treasures that laid the foundations for his historic collections, as he set about re-establishing himself in London life.[61]

# PART TWO

# Assembling the World

# 4

# Becoming Hans Sloane

## THE ART OF RISING IN PHYSIC

Although Sloane arrived back in London in the midst of a revolution, the timing of his return proved impeccably fortuitous. The struggle for power in the British Isles had already come to a head in the dramatic events of what came to be known as the Glorious Revolution. In December 1688, while Sloane was still in Jamaica, William of Orange-Nassau, Stadtholder of the Netherlands, had occupied London with 20,000 Dutch soldiers at the encouragement of factions within Parliament seeking an end to the reign of the Catholic James II, whom opponents reviled as an absolutist monarch. On 23 December, James fled across the Channel to exile in France and, after an interregnum, William and his wife Mary – James's reassuringly Protestant daughter – were invited to become king and queen by the terms of the Declaration of Rights in February 1689. They were crowned at Westminster in April that year.[1]

Sloane re-entered London the following month. He avoided touting partisan political sympathies, but his allegiance to the Whigs dated back at least to 1680 and his friendship with Charles Paulet, Marquess of Winchester, who opposed James during the Exclusion Crisis and backed William in 1689. In 1685, Sloane had even enjoyed a prestigious scientific gift from William of Orange himself, to whom he was evidently already known, in the form of 'a sett of microscopes made by Mr Musschenbroock of Holland sent me from the Prince of Orange'. The transfer of power in 1688–9 may have been gloriously non-violent in England, but in Sloane's native Ireland the conflict between Protestants and Catholics involved several bloody battles. In Ulster, Catholics

besieged Derry and temporarily took control of Belfast. Sloane monitored events keenly. 'All things are here quiet and easy,' he informed his Ulster friend the botanist Arthur Rawdon in June 1690, as William departed London for the Battle of the Boyne River. Here the Dutchman won decisive victories over James and those loyal to him, repeated at Aughrim the following year, which the historian Jonathan Bardon has described as 'the bloodiest battle ever fought on Irish soil': over 7,000 people died. The Jacobites' defeat allowed Ireland's Protestant Parliament to pass Penal Laws that limited Catholics' ability to own property and to participate in political life, and subordinated Irish Presbyterians to the Anglican Church of Ireland. It was good news for Sloane. William's conquests secured the prospects of his family, of his relations the Hamiltons and of friends throughout Ireland. In 1691, a certain 'Mr Sloan' appears to have assisted in the prosecution of magistrates who had charged Protestant Ulstermen with treason during James's reign. 'Mr Sloan' may have been James Sloane, MP for Killyleagh, or possibly even Hans.[2]

While dooming James's hopes to use Ireland as a base for regaining his crown, William's victories heralded new military alliances between England and several of its former rivals to oppose the rising power of the Sun King, Louis XIV of France. In the Nine Years' War (1688–97), England cooperated with the Dutch, the Spanish and the Holy Roman Empire against their new prime enemy. In the War of the Spanish Succession (1701–14), an Anglo-Dutch-Austrian coalition formed to prevent Louis from bringing the entire Spanish Empire under French influence. Effective military mobilization required the development of a system of regular taxation on consumer goods to fund both administration and munitions. It also prompted the creation of the Bank of England in 1694 to stabilize the currency and national credit, as private creditors loaned William over £1 million in return for the right to issue banknotes and bonds, encouraging speculative trading in debt as a commodity and in stocks issued by public corporations like the Royal African and South Sea Companies.[3]

The domestic political order remained fractious, however. MPs embraced William and Mary as guarantors of Parliament's legislative supremacy while the fiction of an empty throne vacated by an abdicating king finessed the distinct constitutional embarrassment of a hereditary monarch ousted by foreign invaders. The Act of Settlement

in 1701 consolidated the Protestant succession by preventing Catholics from acceding to the throne and placed new limits on monarchical prerogative. In 1707, the Act of Union joined the English and Scottish Parliaments into a single body at Westminster, although Ireland remained separate with its own Protestant Parliament. This secured a unified monarchy north and south and arguably helped the Scottish economy recover from financial disaster when the Darien Company, an attempt to establish a colony on the Isthmus of Panama in which many Scots had invested heavily, collapsed in 1700. But the path of dynastic succession remained troubled. The Stuarts fled but did not renounce their claims to the throne, while those who refused to pledge allegiance to the new regime were excluded from office as 'non-jurors'. Neither William and Mary nor their successor Queen Anne (Mary's sister) produced any heirs. Therefore, when Anne died in 1714, Georg Ludwig, Elector of Hanover – a Stuart relative but crucially a Protestant – was invited by Parliament to come to Britain as King George I. Political division also remained chronic between the Whigs (formed in opposition to the Stuart kings) and the Tories. Jacobite rebellions supported by Catholics, Stuart sympathizers and some Tories threatened to re-ignite civil war in both 1715 and 1745.[4]

The character of English society was changing with the rise of new commercial fortunes. English wealth had long been rooted in agriculture and dominated by the landed aristocracy. There was a direct correlation between land, religion and politics because the Corporation and Test Acts of 1661 and 1673 dictated that only property-owning men who were members of the Church of England could vote and hold office, thereby excluding Catholics, dissenting Protestants, other minorities and women. The novelist Henry Fielding was only half joking when he defined the word 'nobody' as 'all the people in Great Britain except about 1,200'. The value of land doubled during the eighteenth century, agriculture remained profitable and landowners secured advantageous rents from their tenants. The landed gentleman thus remained both an economic reality and a cultural ideal: only gentlemen were considered trustworthy actors in realms from politics to natural philosophy because their wealth gave them no motive not to tell the truth, or so it was asserted. According to this view, mastery of passionate self-interest allowed gentlemen to act on behalf of the common good; by contrast, women and men of the lower orders were considered

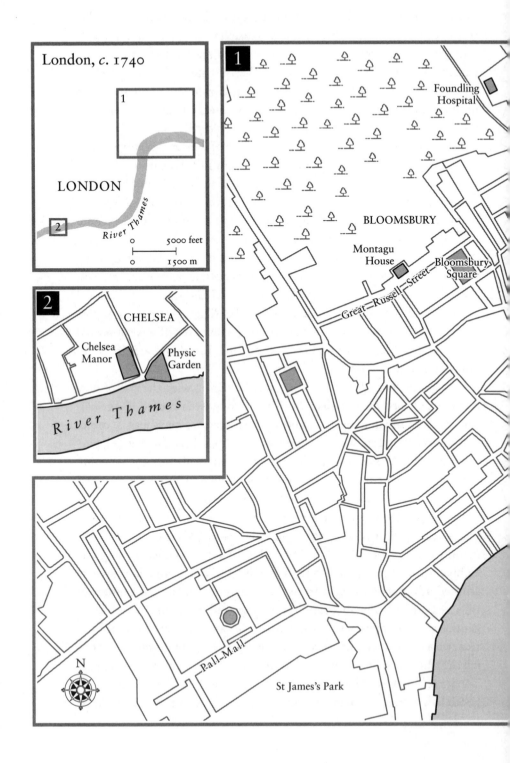

London, *c.* 1740

LONDON

River Thames

0    5000 feet
0    1500 m

CHELSEA

Chelsea
Manor

Physic
Garden

River Thames

1

Foundling
Hospital

BLOOMSBURY

Montagu
House

Bloomsbury
Square

Great Russell Street

2

N

Pall Mall

St James's Park

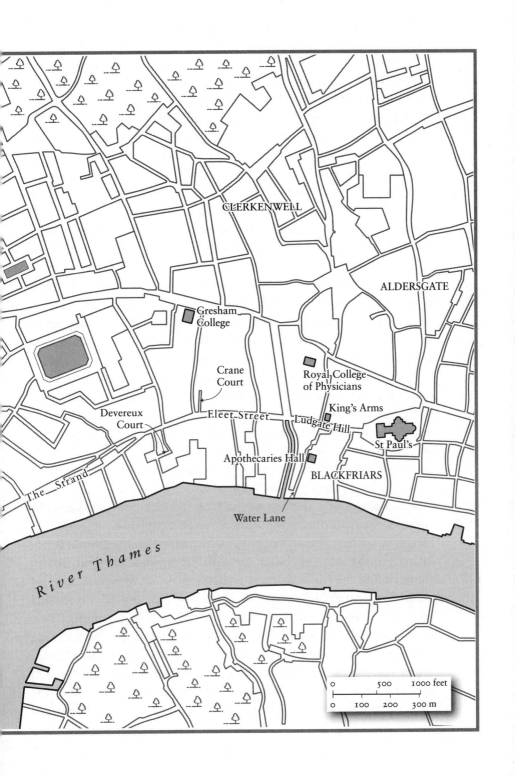

CLERKENWELL

ALDERSGATE

Gresham College

Crane Court

Royal College of Physicians

Devereux Court

Fleet Street

Ludgate Hill

King's Arms

St Paul's

Apothecaries Hall

BLACKFRIARS

The Strand

Water Lane

River Thames

| 0 | | 500 | 1000 feet |
|---|---|---|---|
| 0 | 100 | 200 | 300 m |

persons of dependent status who enjoyed no such self-mastery and whose judgement was deemed irredeemably prey to their passions.[5]

Wealth and status were distributed with great inequality in this society. Period estimates were not systematic but do provide a general guide. In 1688, the population analyst Gregory King reckoned that the top 1.2 per cent of the English people were landowners who controlled over 14 per cent of the nation's wealth. By 1759, with the population then exceeding 6 million, the antiquarian Joseph Massie calculated that there were over 2,000 aristocratic families with an annual income over £800, while nearly three-quarters of a million families headed by husbandmen, sailors and soldiers, labourers and small manufacturers earned under £24 per year. To compensate for this imbalance, local charities and the poor law offered piecemeal relief and support for the indigent. Social cohesion was also fostered by the fact that food remained relatively cheap and employment steady across the first half of the new century. Political consciousness remained essentially vertical rather than horizontal: people of all ranks tended to remain more mindful of who was above and below them, rather than making common political cause with those of their own station.[6]

Britain's imperial economy, however, was transforming society, increasing the consumption of goods and creating new merchants' fortunes. The Peace of Utrecht formally ended the War of the Spanish Succession in 1713 and marked the beginning of a period of prolonged commercial expansion in Britain's American colonies, driven by slavery and sugar (and other export crops like tobacco, rice and wheat) and the colonies' role as legally protected markets for the sale of British manufactured goods. By the second half of the eighteenth century, the colonies would provide the natural resources, labour (slaves) and wealth to support Britain's population expansion and Industrial Revolution, as the country began to shift from wood to coal power, transcending the environmental constraints on its economic development. But Sloane's Britain was by no means at the centre of the world economy. In the pre-industrial era, the increasing profitability of Britain's colonies was offset by rising domestic consumption in foreign luxuries that it could not produce efficiently at home. In South Asia, rather than populous settler colonies, the British presence consisted of military and commercial garrisons run by the East India Company such as Fort St George at Madras (Chennai), Calcutta (Kolkata) and

Bombay (Mumbai), which competed with Portuguese and Dutch traders in the region and bought spices, dyes, silks, cottons, porcelain and tea. The British were desperate to break into China's mainland trade too but, lacking goods the Chinese desired in return, could do little to stem the eastward flow of precious silver, mined in the Americas, to pay for luxury goods. So while the value of British exports would increase from £6.5 million to £12.2 million between 1700 and 1770, thanks in part to the turn to industrial manufacturing, the value of imports would rise even more sharply, from £6 million to £14.3 million in the same period.[7]

Britain's growing empire of goods allowed many with new fortunes to procure unprecedented status, prompting heated debates about social mobility. Many lionized what they saw as the cultural virtues of commerce and finance. The noted essayist Joseph Addison, for example, took to the pages of the new *Spectator* magazine in 1711 to praise the Royal Exchange, where stocks were furiously traded, as a cathedral of cosmopolitanism and religious toleration. Admiring foreign commentaries like Voltaire's *Letters on the English* (1734) would follow suit, contrasting the liberal Protestant genius for commerce with the inveterate social and ecclesiastical hierarchies of France. Merchants and manufacturers married the daughters of aristocrats, boosting the fortunes of the nobility as they secured titles to veneer their riches with ancient privilege, while landed lords invested in urban properties, stocks and projects such as canal building. Arrivistes and their families increasingly sought to pass themselves off as respectably polite gentlemen and ladies by acquiring fashionable clothes and houses, and by reading the new novels and magazines issuing from the presses. An expanding middle rank of society emerged in which people defined themselves less by birth than by the acquisition of goods, literacy and participation in a public sphere spearheaded by proliferating coffee houses and cheap popular print.[8]

But new fortunes brought new dangers as the troubled history of the South Sea Bubble made plain. To reduce the national debt and bolster economic confidence, the Tory administration of Robert Harley strenuously promoted investment in the newly formed South Sea Company from 1711, which expanded the slave trade to Spanish America under the so-called *asiento* contract. Insider trading, however, and rampant speculation led to the price of company stocks becoming highly inflated,

prompting a precipitous decline and sell-off in the summer of 1720, which ruined many. Commentators seethed at what the Scots surgeon James Houstoun (who later collected specimens for Sloane in the Caribbean) referred to as the 'golden phrenzy' of the fortune seekers as the image of rational economic management dissolved into tirades against the cronyism that had turned investors into money-mad stooges. 'What magick makes our money rise,' the satirist Jonathan Swift lamented in his poem 'The Bubble' (1721). 'So much for monys magick power', echoed the artist William Hogarth in his 'emblematical print' that same year, which he baptized as a 'monument . . . erected in memory of the destruction of [London] by the South Sea'.[9]

New money unsettled cherished certainties regarding social distinctions. By 1759, Joseph Massie would count 13,000 families headed by men he categorized as 'merchants' earning between £200 and £800 – only 2,000 fewer than 'gentlemen' earning the same amount – with 7,500 familes headed by 'tradesmen' in the same income bracket. In this new Britain, where the trappings of status could be purchased as well as inherited, the question became whether it was still possible to tell true gentility from slick impersonations. Popular tales like those published by Daniel Defoe, himself a merchant and speculator, dramatized the new hazards of fortune and identity. In works like *Moll Flanders* and *Colonel Jack*, both published in the aftermath of the Bubble in 1722, Defoe allegorized the social volatility of the economic order with its credit crises, mounting personal debts and calamitous bankruptcies. His protagonists acquired and squandered money and property, voyaged out to the American colonies to make their fortunes, and boomeranged from paupers and prostitutes into ladies and gentleman and back again with dizzying rapidity. He memorably captured the new hybridity of British social identity – investing in trade and finance while dreaming of old-style gentility – when he had Moll denigrate one of her husbands as an 'amphibious creature, this land-water-thing, call'd a gentleman-tradesman'. These notorious creatures increasingly animated the society to which Sloane had returned and in which he would seek to make his way. Indeed, several critics would later claim he was one such creature himself.[10]

On returning to London, Sloane continued in service to the Duchess of Albemarle, spending time with her in Clerkenwell, a former suburb of

the city that had recently become fashionable as a salubrious spa resort, and at her country seat in Essex. He resumed his medical practice and, as we shall see, became one of the most famous doctors in London. All that lay before him, but first he needed to marry and set up his own London residence. More than once he spoke of friends 'acquiring' wives, a telling choice of words, since widows had become a fashionable choice for men with ambitions to climb the social ladder. The Irish wit and *Spectator* regular Richard Steele married a wealthy Barbadian heiress; Gilbert Heathcote, the son of an ironmonger turned slave trader and merchant who helped found the Bank of England, did likewise. Sloane's own match with Elizabeth Langley Rose on 11 May 1695 linked him permanently to Jamaica and slavery. Little is known about Elizabeth. She was the daughter of London alderman John Langley and had married Fulke Rose. Sloane had worked with Rose to try to save the Duke of Albemarle and praised his estates at Sixteen Mile Walk as 'some of the best and securest plantations of the island'. A prominent councilman and planter advocate, Rose had also been one of Jamaica's leading slave owners, reckoned to be one of only six colonists who regularly purchased hundreds of Africans in the 1670s. He owned 3,000 acres. When he died in 1694, Elizabeth became his sole executor. Sloane married her the next year in London. By the terms of their marriage, and the tradition of coverture that 'covered' a wife's legal identity with that of her husband, Sloane received Elizabeth's one-third share of the net profits from the Rose plantations, the other two-thirds passing to her two daughters by Rose (she also received £2,000 plus plate, jewels and all household possessions). Not for nothing did Sloane make jocular reference to 'us planters' in a letter he wrote to John Locke the year after his wedding.[11]

So established, Sloane set about building on the professional foundation provided by the patronage of Thomas Sydenham before he had left for Jamaica. His status was enhanced by his growing reputation for learning, both because of his membership of the Royal Society and the Royal College of Physicians and owing to the collections he had made in the West Indies. Eminent Fellows of the Royal Society who were personal friends became his patients: John Evelyn, William Courten, John Ray, John Locke and Samuel Pepys, who had served as president during 1684–6. Sloane's letters to Ray, while mainly concerned with botany, repeatedly prescribed treatment for Ray's persistent diarrhoea

and leg sores. 'I thank god I am able to goe on with [my] work,' Ray confided to him in 1700, 'though I have little or no absolute intermission of pain.' The following year, Sloane was advising Locke on his suspected 'diabetes' and recommending bleeding and emetics for his fevers. Sloane's friends prized his company as much as they trusted his judgement. '[I'm] almost wishing myself sick', Pepys wrote in 1702, 'that I might have a pretence to invite you for an hour or two.'[12]

It was the acquisition of aristocratic clients, however, that proved pivotal to Sloane's fortunes and his elevation as one of the most celebrated society physicians in London. After 1695, he and Elizabeth made their home on the south side of Bloomsbury Square, a fashionable area that had been developed after the Great Fire of 1666 as a smart new suburb on the city's north-western edge, where aristocrats and affluent lawyers were settling. In 1700, they moved to its north-east corner, taking a house and garden on Great Russell Street, taking the building next door later on in 1708 in order to accommodate Sloane's growing collections. Whig affiliations were again in evidence: Sloane's landlady was Rachel Wriothesley, daughter of the Earl of Southampton, a leading supporter of William III. Prominent neighbours included Sir Richard Steele, Sloane's fellow physician and collector Dr Richard Mead, the portraitist Sir Godfrey Kneller, the architect Sir Christopher Wren, the Earl of Northampton and the Earl of Chesterfield.[13]

It was from this network of friends, colleagues and acquaintances that Sloane expanded his clientele into a substantial base of patients. A letter from Thomas Osborne, the Duke of Leeds – otherwise known as the Earl of Danby, who had been impeached over the Popish Plot against Charles II in the 1670s – exemplifies the kind of medical request that became Sloane's stock in trade. Leeds wrote to Sloane from his house in Wimbledon in 1705 to provide him with 'an acct of the state of my health'. He reported that after returning home from a recent trip, he had endured several 'severe fitt[s]' of pain. These had receded but he was then vexed by an 'ill cold' that kept him from leaving his apartment. He felt 'very sickish after meales' and 'hecktick heat' was preventing him from sleeping till six or seven in the morning, leaving him decidedly weak. This, he surmised, lay at the root of all his complaints. 'I desire therefore to know what you think adviseable to be done.' Leeds obediently pledged to do nothing 'without your opinion, which I much rely upon, who am, sir, your most humble servant'.[14]

Sloane was to receive countless such letters. It is not known what he prescribed for Osborne, since his surviving correspondence overwhelmingly consists of incoming rather than outgoing communications. But letters like Osborne's do at least reveal the medical culture in which Sloane worked. In early eighteenth-century British medicine, direct examinations of the body were not yet regarded as crucial to a physician's work, though physicians did studiously pore over patients' excretions. As we have already seen, it was incumbent upon doctors to listen carefully to their clients' accounts of their constitutions; aristocratic clients above all expected close attention from doctors who were their social inferiors. Sloane would listen and respond, recommending combinations of drugs, exercise and purges. Some doctors sought to distinguish themselves in the bustling medical marketplace by championing new theories. John Colbatch, for example, became noted for his advocacy of the healing power of acids rather than alkalis, while the obese and depressive yet highly sociable George Cheyne of Aberdeen aligned his practices with iatro-mechanical theories of the body as a machine, inspired by Newtonian natural philosophy. Heeding his mentor Sydenham's injunction 'to cure disease, and do naught else', Sloane by contrast continued to rely on traditional Galenical bleeding to balance the humours in combination with the restorative virtues of herbal medicines. He visited many of his clients in person and, as Osborne's letter shows, carried out his practice by mail as well thanks to the penny post, newly introduced in 1680.[15]

Sloane's growing reputation brought him many elite clients, from prominent Whigs to members of the royal family. They came to include the first man to be called prime minister, Sir Robert Walpole, whose administration dealt with the financial crisis of the South Sea Bubble; Walpole's close parliamentary colleague the Duke of Newcastle; the prominent banker Sir Francis Child; the Duke of Bedford; the Earl of Orrery; and Queen Anne, George I and George II. It is impossible to quantify Sloane's earnings with precision but they netted him a fortune. His time *was* money. According to the Frankfurt savant Zacharias Konrad von Uffenbach, who visited him in Bloomsbury in 1710, Sloane earned a guinea an hour, a rate well in the upper echelon for society physicians. While Britain's poorer labourers earned roughly £10 a year at this time, a note by Queen Anne's treasurer records Her Majesty's order to pay Sloane £100 for services rendered to her

husband, Prince George of Denmark, in 1709, and in 1711 Sloane received the neat sum of £43 for attending the Duke of Bedford. Sloane would likely have commanded something in the order of the £7,000 Richard Mead is known to have earned annually, if not more. In his biographer Thomas Birch's words, he became 'one of the ablest physicians of his age & country; & in this last character he was so distinguish'd, that for many years he had a flow of business, which inabled him not only to lay out such vast sums in his collection . . . but to leave besides a fortune behind him of £100,000'. To put that in perspective, the richest commoner of the early eighteenth century is thought to have been the merchant and banker Gilbert Heathcote who, in addition to his Caribbean trading, urged the deregulation of all trade monopolies, advocated war against France and made a fortune through military contracts and investments totalling an estimated £700,000 on his death in 1733.[16]

Sloane became something more than a physician, however. From early on, acquaintances came to place a remarkable trust in him that related as much to his judgement of character and his personal discretion as to his medical abilities. 'Fixing' the character of others was a vital means of regulating the eighteenth-century social order; deciding who was trustworthy and who was not was especially vital in an era of new social mobility and shifting identities. Requests for letters of reference and endorsements thus formed a frequent part of Sloane's correspondence; his coming to know so many people made *him* a great person to know. In June 1689, for example, just weeks after returning from Jamaica, he received a note from Nicolaus Staphorst, the younger son and namesake of his chemistry teacher at Chelsea Physic Garden, asking whether he would endorse Anna Orton, his wife's kinswoman, for service in the household of the Duchess of Albemarle. This was just the beginning. The secretary of state for Ireland Sir Robert Southwell enjoyed a family fortune made in Munster and served as president of the Royal Society from 1690 to 1695 but needed Sloane's advice on a personal matter. 'Your acquaintance in the world being so generall,' Southwell wrote, 'let me request you to think where I may find a fitt companion for my nephew Sir John Percivale, who is taking a progresse about England.' In 1706, Elizabeth Newdigate thanked Sloane for being 'so kind a friend' by supporting her both through illness and in a bitter family dispute over the property of her father Sir Richard

Newdigate, a Warwickshire baronet and parliamentarian. A couple of years later, Sloane's medical judgement was given legal weight. He testified in the Court of Chancery on behalf of a Huguenot schoolmaster named Abraham Meure to establish that the faculties of Meure's father were seriously impaired by old age, advising the court that the handling of his affairs should pass to his son.[17]

Sloane's ascent as a professional physician brought him tremendous personal wealth through his immersion in the great web of contacts that constituted London society. Just as importantly, it garnered him a reputation for trustworthy judgement above the fray and gentlemanly discretion on the most intimate of matters. Years later in 1728–9, Lady Sondes would ask his opinion on the character of her son's governor, a Catholic by the name of Dassas who had converted to Calvinism. Sondes sought Sloane's advice, as she put it, 'because you allways give it empartially, and amongst all my acquaintance, I never met with any that had so true a sence'. Sloane reassured her that he knew Dassas personally from his service to the Duke of Bedford and there was no cause for concern. But, Sondes continued, should her daughter Catherine marry Edward Southwell? Again, Sloane knew the parties involved, in this case Robert Southwell's father, the secretary of state for Ireland. 'I know no body', Sondes effused, 'who will be so secret, in the enquirey, nor so likely to judge empartialy, as you.' By way of thanks, she gave Sloane a gold snuff box containing her portrait. Around the same time, Lady Ferrers begged Sloane for 'pity' in her 'deplorable' state, confiding to him that she had contracted a venereal disease from her 'cruell' husband, who was now trying to prevent her from travelling to Italy for treatment. Sloane sent her to Antoine Deidier, a doctor he knew in Montpellier. Ferrers made the trip and sent him the skeleton of a bird and a snake from the south of France as a gift in return. So it was that even the most intimate medical favours brought Sloane curiosities for his collections.[18]

Sloane's rising fortunes as a doctor were part of the establishment of a new generation of commercial and professional men as Britain's economy expanded after the Glorious Revolution. The growing natural history collections he made were part of his transformation from Ulster-born apothecary to London physician and enhanced his intellectual, medical and social standing. But, as we shall see, Sloane's professional status and the commercial profile of his collections would

also expose him to stinging criticisms that what underlay his rise was in reality neither judgement nor learning but mere ambition and the brute power of money.

## PHILOSOPHICAL TRANSACTIONS

Sloane never left England again after his return from Jamaica. But he never stopped moving either. 'Sir,' Staphorst the younger wrote to him in June 1689, 'I called this morning betwine 6 & 7 att your lodging butt was not so successfull as to finde you att home.' Private and public business vied for Sloane's time, intertwining in highly productive fashion, keeping him in constant contact and not just with patients. The turn of the century was a period of restless clubbability as the capital hummed with business. Coffee houses became a hub of conversation, where gentlemen drank, chatted and pursued their affairs. As a haunt for Fellows of the Royal Society, the Grecian in Devereux Court, just south of the Strand, became a personal favourite of Sloane's. While pouring his energies into his practice, he also worked on his collections and began to invite friends to see them. 'I went to see Dr Sloane's curiosities,' John Evelyn recorded in his diary in 1691, 'being an universal collection of the natural productions of Jamaica ... collected with greate judgment ... very copious and extraordinary, sufficient to furnish a history of that island, to wch I encourag'd him.' Evelyn's praise was most welcome and, as time allowed, Sloane began the arduous work of composing the *Natural History of Jamaica*.[19]

He began by publishing a Latin dictionary of Jamaican plants in 1696 entitled the *Catalogus plantarum*, listing each species he had identified with its synonyms and references to descriptions in previous works. 'I cannot but admire your industry & patience in reading & comparing such a multitude of relations & accounts of voyages,' Ray told him. The personal library Sloane had begun to assemble, which would eventually include 45,000 books and over 3,500 manuscripts, allowed him to supplement his fieldwork with extensive research. As we have already seen, he scoured printed works in several different languages, from the Elizabethan travel compilations of Richard Hakluyt to first-hand travel accounts by Spanish naturalists like Francisco Hernández and José de Acosta, and French voyagers such as

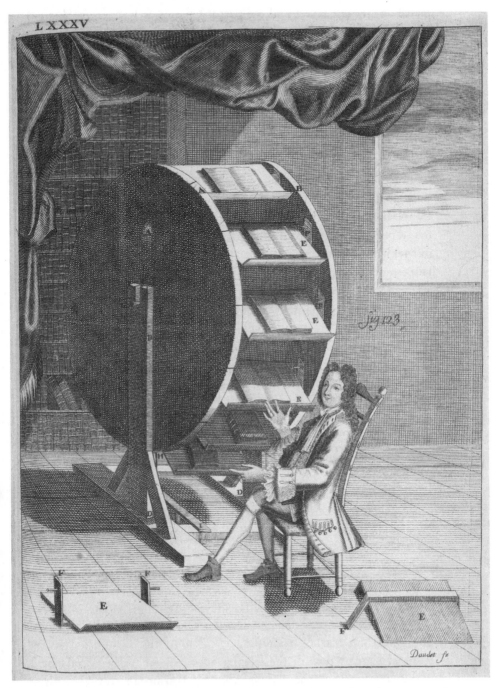

Sloane acquired a vast library, which he used to compile his encyclopaedic account of Jamaica. He owned a book-wheel like this one depicted in Grollier de Servière's *Recueil d'Ouvrages Curieux de Mathématique et Mécanique* (1719) for consulting several volumes at once.

Jean-Baptiste Du Tertre and the pastor Charles de Rochefort. Sloane's prodigious bibliographical industry is aptly symbolized by the book-wheel he acquired and used which permitted him to study several open volumes at once (p. 155).[20]

Sloane embarked on near-obsessive hunts for manuscripts from rival collections to acquire materials for his researches. In the preface to the *Natural History*, he recounted the pains he took to track down the original writings on Mexican botany penned by Hernández, whom he quoted repeatedly in his work. He acknowledged the Spaniard as a key predecessor 'sent by the King of Spain, to search after natural productions about Mexico' and whose illustrated work cost '60,000 ducats'. Sloane had met 'with many of the plants he describes in Jamaica' but found published versions of the Spaniard's work, including one printed in Mexico in 1615, to have been altered and thus 'short and obscure'. Hope remained, however, that his original manuscripts survived in the Spanish king's library at the Escorial near Madrid, even after the great fire that destroyed many of its holdings in 1671. Perhaps driven on by the unsuccessful attempts already made by others to find them, including his Paris mentor Joseph Pitton de Tournefort, Sloane used his connections to write to William Aglionby, William III's ambassador to the Spanish court, to solicit descriptions of them in the 1690s. Aglionby was 'told that the book was there, and that he should some time or other see it' but although he 'endeavour'd several times, yet he could never effect [this]'. Others fared no better and Sloane surmised that Hernández's manuscripts must now be in either Naples or Rome, but still he could not find them. As with Columbus' Atlantic map, the most elusive objects became the most desirable.[21]

Sloane's admission of visitors to see his collections was not merely to show them off but to facilitate collaboration and exchange with fellow naturalists, often through couriers who acted as go-betweens. He received the botanist Andreas von Gundelsheimer in 1698, for example, bearing gifts of books and engravings from Tournefort. Scientific diplomacy dictated that even though England and France were then at war Sloane sent sixty Jamaica ferns (duplicates) back to Paris. Tournefort also asked that Sloane do him 'the favour of having [Gundelsheimer] buy all the botany books that have been published during the war'. Sloane claimed that his Caribbean travels inspired Tournefort's colleague the Minim friar and botanist Charles Plumier to

make his own botanical voyages to the West Indies and later cited Plumier's illustrated *Description des plantes de l'Amérique* (1693) in his *Natural History*.[22]

More significant was the visit paid to Sloane by his Ulster friend Arthur Rawdon. Back in Jamaica, Sloane had noticed that Captain Harrison's garden in Liguanee was 'the best furnished of any in the island with European garden plants'. But thanks to the use of stoves, West Indian plants (including cacao) were now also being raised in English gardens at Fulham, Oxford, Badminton and Chelsea, after the model established by the botanical garden at Leiden. Rawdon saw Sloane's herbarium in London and subsequently dispatched his own gardener James Harlow to Jamaica to 'bring the plants themselves alive to him, for his garden at Moyra in Ireland', just west of Killyleagh in Ulster where Sloane had grown up. Harlow came back in 'a ship almost laden with cases of trees, and herbs, planted and growing in earth' – a feat Sloane lacked the horticultural skills to undertake – some of which Rawdon and his assistant the Leicestershire botanist William Sherard then passed on to Sloane as gifts to assist his researches. By consulting the specimen collections of his associate James Petiver, as well as pictures and descriptions contained in the Dutch East Indian herbal the *Hortus Malabaricus*, Sloane could claim that his was not merely a local Jamaican herbal but a guide to plants that also grew in England, Europe, the greater Caribbean, West Africa and the East Indies. Though Jamaica was 'very remote', he told readers of the *Natural History*, many of its species had 'been brought over' and were already being 'used in medicines every day'. His was therefore a work of both local and universal botany: a guide to Jamaican plants cross-referenced with attempts to catalogue flora on a global scale.[23]

Such collaborations, as well as the many demands on Sloane's time, significantly slowed the production of the *Natural History*. It was only in 1699, a full decade after his return, that he finally commissioned Everhardus Kickius to draw his specimens, a task that took two years to complete. Equally crucial, and time-consuming, was Sloane's partnership with John Ray. Maintaining friendships with both Ray and Tournefort entailed great tact, since the two naturalists were rivals: Tournefort talked with Sloane about Ray's criticisms of his work, and Ray did likewise. Sloane relied on Ray, adopting his methods of classifying species according to the number of their flowers' petals and, for

non-flowering plants such as ferns, according to their leaves. But botany joined the two men in piety as well. I was 'very much taken with the[ir] beauty', Ray wrote, referring to some Maryland plants Sloane had sent him, and returned the favour by offering to send on a pamphlet of his entitled *A Persuasive to a Holy Life* (1700). His devotion rubbed off on Sloane, who later wrote that plants 'at each glance give us evident proofs of the greatness of their Creator'. Ray nourished Sloane's mind and Sloane nourished Ray's body, sending gifts of venison and a steady supply of sugar, probably from the family plantations in Jamaica, as well as medical advice, especially on Ray's bothersome leg sores, which Ray imagined resulted from the actions of 'invisible insects'.[24]

Because of Ray's poor health, the two men rarely met in person. Instead, Sloane couriered specimens to Ray's house at Black Notley in Essex. The relationship was highly complementary. Sloane sent specimens, pictures, notes and books, and Ray made meticulous comparisons and contrasts, using Sloane's materials for his own compendious *Historia plantarum*, which Sloane cited in both his *Catalogus plantarum* and *Natural History* as an authoritative source for known species (he also annotated a copy of Ray's *Historia* as an index for his herbarium). Sloane later wrote that he used to show his Jamaica plants 'very freely to all lovers of such curiosities', but at a time when exotic specimens were precious and naturalists competed to identify new species, sending his Jamaican treasures to Essex was an exceptional act of trust. He swore Ray to secrecy, to which Ray dutifully replied, 'your instructions in letting nobody have a sight of what you sent shall be observed ... no-one has seen any of the papers you have sent me, nor shall they.'[25]

Things inevitably got damaged in transit. Ray confessed to Sloane that a fungus had 'unluckily' slipped out of a letter and been 'trod to pieces' in his candle-lit room by guests. Returning books on one occasion, he begged Sloane's pardon for having 'in some measure defaced them', being forced to read them by the fireside, 'and partly by a child's unluckily scattering ink upon them'. But it was worth it: Ray's knowledge was remarkable. The Jamaica pepper was indeed different from Clusius' *Amomum*, he told Sloane: comparing Sloane's sketch with his own description confirmed it. Sloane's Jamaica cedar, however, appeared to be nothing other than a large juniper. Seeing Sloane's plants first hand, rather than reading others' descriptions or examining

pictures alone, made a difference: it allowed Ray to correct errors by those who made identifications sight unseen from written accounts only. One of the grand objectives of botany was a scientific community unified by a common language – purifying the Babel of competing terms for the same plants, a process known as the art of 'reduction'. 'Endeavouring to express new things by old classic words' had hindered natural history, Sloane observed, although new-naming based on every trivial anatomical difference was also a 'great obstruction to the knowledge of natural things'. So he aimed to use Ray to identify which plants were already known and which required new polynomial labels. Sloane reasoned, for example, that his Jamaican coco tree was identical to plants found in Goa and Brazil and had already been 'so well and so often describ'd and figur'd, especially in the Hortus Malabaricus, that I shall do neither, but refer to authors taken notice of in my catalogue of Jamaica plants'. In return for identifying which of Sloane's species had already been described and which not, Ray enjoyed access to rare specimens from Jamaica to the Straits of Magellan and the South Seas, as well as expensive volumes like Sloane's copy of Paul Hermann's *Paradisus Batavus* (1698), a catalogue of the Leiden botanical garden.[26]

In addition to his medical practice and work on the *Natural History*, Sloane also took on a variety of public offices in the years after Jamaica. Private and public interests converged to generate wealth, connections and fame that provided enormous advantages to him as a collector. At a time when William's wars against France demanded effective medical coordination, Sloane was appointed to Christ's Hospital in 1694, the charitable school charged with training navigators, merchants and naval officers. He was already sufficiently affluent to be able to refuse its yearly £30 salary since he was soon making far more from his own patients. More significantly, the previous year he had been elected secretary of the Royal Society, then presided over by his friend and fellow Irishman Sir Robert Southwell. He embraced the considerable task of managing the society's correspondence across Europe and Britain's American and Asian colonies, and took the initiative to revive the society's flagging journal, the *Philosophical Transactions*, which he was to edit until 1713. In so doing, Sloane became one of the pivotal information brokers in the Republic of Letters, a trafficker in scientific news, or 'intelligencer' in the parlance of the times. To some, he took to the role instinctively and with natural sociability. 'Please bestow your self on

me at the usuall hour at the King's Arms on Ludgate Hill,' the astrono-
mer Edmond Halley asked him in October 1700, hoping to 'enjoy your
good company over a bottle of wine'. It is thought Sloane reserved one
day a week for inviting guests to dine with him at home in Bloomsbury,
limiting himself to a single glass. Johann Gaspar Scheuchzer, who later
became one of his curators, praised Sloane's 'known communicative
disposition'. Others, however, claimed that Sloane was a poor public
speaker. 'He has no faculty of speaking, either fluently or eloquently,'
the clergyman William Stukeley noted in 1720, 'especially before any
number of people, & he do's it with great timidity.'[27]

If Stukeley's observation is accurate, it makes Sloane's career as sec-
retary of the Royal Society all the more remarkable. Sloane chaired
discussions by the Fellows on topics ranging from natural philosophy to
the skin colour of African slaves, proudly telling the society's president
Lord Sommers in 1699 that their 'meetings [had] been more frequented'
than before and that the society's 'correspondence at home and abroad
[was] enlarged, and many things [had] been added to the history of art
[and] nature'. Sloane published several of his own essays which exem-
plified the same combination of commercial and providential curiosity
that characterized his work in the *Natural History of Jamaica*. These
included a paper on the Jamaica pepper tree and the root *Cortex Win-
teranus* as a medical commodity; another on the exotic 'Cuntur' bird
from Chile (the condor) and the virtues of coffee; reports of the earth-
quakes that struck Jamaica and destroyed Port Royal in 1692; his
description of the 'strange beans' that circulated from Jamaica to the
Orkneys; descriptions of fossils found in both Jamaica and Maryland;
an account of the drug known as ipecacuanha root; and his discussion
of the global distribution of plant species via winds and sea currents.
He also published a wide range of reports about curious lands, phe-
nomena and peoples by other travellers such as a letter 'concerning the
cure of the bitings of mad creatures' by George Dampier, brother of the
famed navigator William Dampier; Thomas Shaw's maps and descrip-
tions of Tunis in North Africa; and the naturalist Edward Lhwyd's
essay on antiquities and folk beliefs regarding amulets and similar
subjects in Wales and Scotland. In so doing, Sloane revitalized the
*Transactions* in line with his predilection for global natural history,
making the journal a clearing-house that knitted together reports from
around the British Isles as well as Britain's empire.[28]

Sloane formed a vital association at this time with the Aldersgate apothecary James Petiver. The son of a haberdasher, Petiver was dispensing medicines at St Bartholomew's Hospital by the 1690s when Sloane met him, but also building up an unrivalled correspondence with colonial travellers who supplied him with specimens, which he listed in pamphlets grandly styled the *Musei Petiveriani*. Petiver and Sloane congregated regularly with other naturalists in a botanical club at the Temple Coffee House. 'If you have any thing that is curious lately come to hand,' Sloane informed him one typically busy day, 'pray bring it to Gresham college & come early.' In return for botanical news, and access to his specimens, Sloane secured Petiver a fellowship at the Royal Society in 1695. It was a high honour for an apothecarial tradesman to be admitted to a society of gentlemen and one Petiver cherished, identifying himself on his subsequent title pages as both 'Pharmacop. Londinens' (London pharmacist) and 'Regiae societatis Socio' (Fellow of the Royal Society). Sloane published several of his articles in the *Transactions*, including one entitled a 'Catalogue of Some Guinea-Plants, with Their Native Names and Virtues' that presented 'an African materia medica' sent over by one John Smyth, minister at the Royal African Company's factory at Cape Coast Castle, a leading slave trade outpost captured by the English in the 1660s.[29]

Personal and institutional networks intersected at the Royal Society in highly productive fashion for Sloane. Correspondents contributed both to the society's Repository and to Secretary Sloane's private collections. Sloane was on good terms, for example, with several men in Ireland's ruling Protestant elite, who sent specimens to the society and to him personally. Edward Southwell, son of the secretary of state for Ireland, gave Sloane 'a rope made of underground firr wood' found preserved in the peat bogs of his native soil, about which Sloane wrote in the *Transactions*. Sir Edward Hannes sent a specimen of mouldy ground from near Lord Blessington's house that glowed strangely, which Sloane examined through a microscope to find 'many small half transparent whitish live worms' wriggling inside. Hannes was a physician who wrote poems celebrating William's victories in Ireland, while Viscount Blessington was Murrough Boyle, a government official and son of the lord chancellor of Ireland and archbishop of the Church of Ireland Michael Boyle.[30]

Correspondents talked up Sloane's capacity to compare objects from

different English colonies, undoubtedly flattering him, although his centrality at the scientific hub of an expanding empire was no exaggeration. In 1697, the Physician General to the Army in Ireland Thomas Molyneux wrote to ask him 'whether the large horned deer of Ireland [is] . . . the same with the moose of America [which] I phansy may be easily made out by you in London'. Molyneux felt sure 'you may procure some genuine moose-hornes brought back from the West Indies' and compare them 'with the description and figure I have given of the hornes found here in Ireland'. Whether Molyneux was writing to Sloane personally or in his capacity as secretary of the Royal Society is tellingly unclear: Sloane's personal access to rare specimens was obviously enhanced by his position as secretary. Molyneux's brother William, an Anglican landowner and theorist of Anglo-Irish political relations, sent Sloane a gift of stones from the Giant's Causeway at Coleraine on Ulster's north coast the following year; Thomas Molyneux was among the first to argue that these stones were in fact giant works of nature rather than the work of ancient Irish giants. Some of these stones stayed at the Royal Society but others found their way into Sloane's private collection. Many years later in 1742, Sloane gave some to the poet Alexander Pope for the grotto at his Twickenham villa (where they remain), while others went on display in the new British Museum when it opened.[31]

No article Sloane published better exemplifies his enthusiastic curiosity-mongering – and its sometimes rocky reception – than the four-part illustrated essay that described what he called a 'China cabinet' in 1698–9 (Plate 11). Sloane explained to readers that this cabinet had been sent to the Royal Society by Edward Bulkley, a surgeon with the East India Company stationed at Fort St George in India. It included rustproof razors, brass and steel knives, bezoar stones, tweezers, combs, ink and paper, and assorted specimens. But 'the most unusual instruments that came over in this cabinet were, those contrived for the taking any substance out of the ears, or for the scratching or tickling them, which the Chinese do account one of the greatest pleasures'. Such implements were adorned with pearls and consisted of a silver wire, 'hog's bristle' and tortoise-shell handles, one of which 'very much resembl[ed] our common European ear-pickers'. Sloane included the image of a Chinese figurine, supplied by William Courten, in the process of 'using one of these instruments, and expressing great satisfaction

therein', while pointing out the 'misfortunes' such devices occasioned to those given to 'picking their ears too much'. He may have fancied there was a certain harmless mirth in such curiosities but ended with a serious message that touched on their very real economic significance. 'It were to be wished other travellers into parts would make such inquiries', he wrote, 'into the instruments and materials made use of in the places where they come . . . that we may content our selves with our own inventions, where we go beyond them, and imitate theirs wherein they go beyond ours.' As British silver flowed east to pay for luxuries such as Chinese porcelain and 'Japanned' cabinets veneered with black lacquer, which remained far cheaper to import than to produce domestically, scanning foreign craftsmanship for information about manufacturing technique and raw materials was imperative. Natural history, as Sloane saw it, was really all about scanning: a speculative exercise in scouring the globe for things that might seem odd or trivial at first sight, in which utility and value were not immediately apparent, but which could ultimately result in the discovery of prized new resources and goods.[32]

This speculative natural history left the kind of descriptive, fragmentary and miscellaneous essays Sloane liked to publish open to criticism. The 'Quarrel of the Ancients and the Moderns', in which polemicists clashed over the achievements of Greek and Roman civilization versus those of contemporary society, was raging at the turn of the eighteenth century. In 1704, Jonathan Swift published *A Tale of a Tub*, a work whose ostensible purpose was to satirize religious enthusiasm and the follies of credulity, and one of whose sections was entitled the 'Battle of the Books', which soon became a synonym for the Quarrel. Swift blasted the shallowness of modern learning. He poured scorn on those who obtained 'a thorough insight into the index, by which the whole book is governed and turned, like fishes by the tail. For, to enter the palace of learning at the great gate requires an expense of time and forms; therefore men of much haste and little ceremony are content to get in by the back door.' Swift may have had Sloane specifically in mind as one of these hasty scholars when he had his fictional author of 'A Discourse Concerning the Mechanical Operation of the Spirit' regret the intellectual evil of 'careless and sudden scribbles'. A few years later in his *Characteristicks of Men, Manners, Opinions, Times* (1711), the Earl of Shaftesbury likewise lamented 'the way of miscellany or

common essay, in which the most confused head, if fraught with a little invention and provided with commonplace-book learning, might exert itself to as much advantage'. Such writings were 'patchwork' lacking 'design' or 'coherence' and where 'cuttings and shreds of learning, with various fragments and points of wit are drawn together'. For these confounded 'miscellanarians', 'grounds and foundations are of no moment in a kind of work which, according to modern establishment, has properly neither top nor bottom, beginning nor end.'[33]

Such criticism impugned the miscellaneousness of the Royal Society's *Transactions* under Sloane's editorship. Sloane frankly conceded that there had been some initial problems with the early printings. 'I am very sensible there are too many errata's to be found in them,' he admitted, due to the 'variety of matter, characters and translators' involved, and because 'my necessary attendance on my profession . . . has sometimes hindered me from taking due care to revise the press.' This acknowledgement of distractions may have been unwise. For, even before the more famous Quarrel erupted over literature, Sloane was targeted for his scientific publishing by an associate of Swift's named William King, author of a series of sarcastic *Useful Transactions* and a sustained personal attack on Sloane entitled *The Transactioneer* (1700), which took the form of a dialogue between a 'Virtuoso' and a 'Gentleman'. The classically educated King was a High Church Tory and Little Englander who regarded Sloane's exotic natural histories as evidence of the corruption of learning by Britain's increasingly commercial culture. 'The person who makes the chief figure', he began his preface, 'has certainly nothing but a bustling temper to recommend him, and yet has gained . . . much upon many people.' This Sloane, however, had 'neither parts nor learning'; 'he writes in a hurry and has not time to correct and finish it.' He was, King added in a signal phrase, the 'master of only scraps pick'd up from one and from another, or collected out of this book or that, and these all in confusion in his head'. The hapless miscellenarian 'should have kept to his old way of bustling, vying with Dr. Salmon at auctions, mustering up books for a shew, and of acting by signs, scrapes, and wriggles'. Sloane's subjects were 'so ridiculous and mean', his work at the Royal Society so 'trifling and shallow', that that august body's reputation was now in tatters.[34]

To King, Sloane was little more than a peddler of exotic non-sequiturs. 'He hath exceeded the age in every thing,' observed his fictional

virtuoso, and 'been so curious that nothing almost has pass'd him'. But in his breathless curiosity Sloane had never taken the time to stop and think. What did he mean, for instance, when he wrote that certain stones are 'a sort of coral'? "Tis as much as if one should say, this elephant is an apple-tree.' King mercilessly ransacked the real *Transactions* to lampoon Sloane in his own words. 'How are we to interpret him, when he says, the limestone marble that was found in Wales and was a coral, and the Lapidis, and the Lord knows what, grew in the seas adjoyning to Jamaica?' The very notion of long-distance circulation was risible to the Little Englander. 'Do you think you could guide a ship from Jamaica to Scotland, or Ireland?' asked King's virtuoso who, on receiving the answer 'no' from his friend, continued, 'you understand very little then indeed; for our secretary gives us [an] account of four silly beans that could [steer] that course.' In making these jibes, King was continuing the tradition of anti-scientific satire made famous on stage by Thomas Shadwell's parody of 'Sir Nicholas Gimcrack' in the Restoration play *The Virtuoso* (1676), and which would recur in Swift's parody of the experiments of the Academy of Lagado in *Gulliver's Travels* (1726). King, however, heaped special scorn on Sloane's exoticism, deriding, for example, the use of African rather than Latin names for Guinea plants by Petiver, whose fellowship and publications were a scandal. 'But hear this Affrican Doctor,' King had his fictional Sloane intone, 'he has Aclowa good for Crocoes or Itch. Bumbunny boil'd and drank causeth to vomit. Affunena boil'd and drank causeth a stool ... Mening is good for the stoppage of the head. Apputtasy is good for the scurvey in the mouth.' Such language was inherently ridiculous to King. Nor, he quipped, was 'Mr Petiver's physick beyond his breeding'.[35]

Petiver's breeding was precisely the issue. King sneered at the very notion of crediting the testimony of a mere tradesman. In the *Musei Petiveriani*, Petiver had printed lists of his specimen suppliers as well as species, to advertise the prodigious reach of his network of itinerant surgeons in India, China, Africa, Ottoman Turkey, North America and the Caribbean, whom he rather improbably identified as 'gentlemen'. Advertising this reliance on journeymen presented the irascible King with another prime target. He assailed the 'darling of the Temple-Coffee-House-Club' and the 'Philosophick Sancho' to Sloane's Don Quixote as an over-reaching 'Muffti' who had embarrassed his

suppliers by 'concluding his museum, with a catalogue of his kind friends', since 'nobody sure will . . . envy them the honour of being in that catalogue.' The dunce Petiver had schooled the mighty Sloane, he insisted, not vice versa: 'I have learnt more of him than ever I did at Orange,' King had his Sloane confess, which it turned out he had selected for his medical training only because it 'was quicker and cheaper than [studying] at Leyden or Padua'.[36]

King reserved his greatest disdain for the contents of Sloane's China cabinet, irrefutable proof that Sloane was a mere Orientalist whore:

Virtuoso: This sir is a rarity that few people hath found it worth their while to write dissertations about, or indeed worth their notice; but I can assure you, our virtuoso, who is indeed the wonder of his age, values it at a high rate, and hath taken care to adorn several of the transactions with an account of its contents, and hath engraven them curiously upon copper-plates.

Gentleman: Oh dear! a great deal of curiosity must needs lye in those things: and the curiosity of the doctor, as well as his humility in stooping to take notice of such trifles is very commendable.

Virtuoso: Sir, he hath not so much as neglected an ear-picker or a rusty razor, for he values any thing that comes from the Indies or China at a high rate; for, were it but a pebble or a cockle-shell from thence, he would soon write a comment upon it, and perpetuate its memory upon a copper-plate.

Gentleman: Pray do you remember whose picture that is, that is engraven among the razors and tooth-pickers? What, is it the author's?

Virtuoso: Fie! No. It's a Chinese figure, wherein is represented one of that nation, using one of these instruments (that is an ear-picker) and expressing great satisfaction therein . . .

Gentleman: A great deal of satisfaction, indeed for a man to stand picking his ears! But pray of what use are the China ear-pickers, in the way of knowledge?

Virtuoso: . . . The chief design was, to entertain the philosophical secretary; for he took as much satisfaction in looking upon the ear-picker, as the Chinese could do in picking his ears. And truly, I think, that learned naturalist is obliged in gratitude to make some suitable return of our rarities to the Chinese.[37]

King had his Sloane conclude with a paean to the coffee houses that 'make all sorts of people sociable [and] improve arts and merchandize, and all other knowledge'. His point was that as a product of the coffee-house world of stock talk and tall tales, Sloane's bustling amounted to little more than tradesman's tittle-tattle, his curiosity about Chinese ear-pickers a sorry emblem of slavish fashions for Asian goods. Credulity had long been the battle cry of Protestant polemics against Roman Catholics: he is 'a credulous person', was how Ray maligned the Jesuit Athanasius Kircher, 'who delight[s] to tell strange and miraculous tales to amuse & delude ye vulgar'. But the speculative sifting of art and nature for profitable knowledge common to much natural history now exposed Sloane to the same charge. 'You have a peculiar faculty of believing almost any thing,' King's gentleman told his Sloane, 'but pray what reasons can be given to justifie the sincerity of your correspondents?' 'Reason! Psha! I don't trouble my self to enquire after the reason of every thing that's told me.'[38]

To some extent, King misjudged the issue. Sloane's publication of curious articles in natural history did not necessarily constitute an endorsement of their claims, or so Sloane's allies insisted. Years later, in 1724, the Dundee surgeon Patrick Blair got into a fight with the botanist Richard Bradley over an article in the *Transactions* on the mechanics of plant generation. When Sloane did not side with Blair, the botanist John Martyn explained to the disappointed Scotsman that Sloane's 'publishing your letter was not giving his assent to the doctrine maintained in it. He was willing the world should know what you had to offer & if any objected against it it could be no offence to him,' but, keeping himself as ever above the fray, he had no wish to be 'a party in the dispute'. Yet, for all his venom, King was right to point out that Sloane did not possess the knowledge to confirm or deny the many different claims he published and was indeed obliged to trust in his correspondents' good faith. As we shall see in the next chapter, Sloane depended heavily on journeymen to amass collections from around the world, so the question of their trustworthiness was a genuine issue. How, King asked for example, could one credit Sloane's account of a slave woman in Nevis allegedly giving birth to the *bones* of a child? 'I rely so much upon the sincerity of my correspondents', came the dummy Sloane's answer, 'that I cannot tell how to disbelieve it.' Yet, he vowed

with comic defiance, 'my correspondents will not be discouraged from pursuing their design, though the whole world laugh at them.'[39]

Sloane was stung by King's attacks, which he denounced as 'scurrillus and injurious' to colleagues. But they did not stop him. 'I know 'tis impossible to escape the censure of ... envious and malitious [men],' he wrote in his Natural History, 'who will, I am sure ... strive to make ridiculous any thing,' but, he insisted, he would 'treat them with the greatest contempt'. Notwithstanding the code of polite conduct in the Republic of Letters, fighting was far from unusual in scientific circles and Sloane readily took on his enemies in his Jamaica volumes, hitting back above all at the botanist royal and gardener to Queen Mary Leonard Plukenet. Sloane bitterly rejected Plukenet's accusations that he had misidentified species in his Catalogus plantarum and criticized Plukenet's own identifications and engravings, which he claimed had been rushed into print just to pre-empt his own. Plukenet 'pretends to find fault with my making use of his synonymous names', he complained, but it was Plukenet, he said, who had stolen from him in using information he had given him on the Jamaican ebony plant 'without mentioning my name'. Sloane's friends defended their man. Plukenet 'begins to grow waspish and angry with all professors of botany', wrote Petiver, 'and is for correcting their faults before he mends his own'. Even the peaceable Ray singled Plukenet out as 'a man of punctilio' who was guilty of 'arrogance & [an] overweening opinion of himself'. Ideally, Plukenet and Sloane would reconcile their differences in person 'by conference and mutual inspection of each other's dried specimens', Ray wrote, but even he was forced to concede that the botanist royal made this impossible.[40]

In the course of his parallel careers as doctor and editor, Sloane finally released his first Jamaica volume in 1707 and the second in 1725, delayed another eighteen years, as he explained to his readers, by his 'multiplicity of business'. They totalled roughly 600 pages each and at a cost of £4–£5 (approximately £400 in today's money) were among the most expensive books of their kind. Describing Jamaica as 'one of the largest and most considerable of Her Majesty's plantations' in his dedication to Queen Anne, the Natural History was a spectacular publication: the Royal Society secretary's indispensable guide to what was fast becoming the British Empire's indispensable colony. Printed on high-quality paper as lavishly illustrated folios, the volumes took their

place in the burgeoning luxury market for natural history, combining entertaining travelogue with an encyclopaedic species catalogue and visual album. Their reception, however, was mixed. For one thing, their cost and size limited their circulation to wealthy gentlemen or those on whom Sloane bestowed copies as gifts. He sent a copy of volume one to the physician Henry Barham in Jamaica, although, while visiting London one year, Barham asked if he could consult Sloane's, since the thing was simply too big to carry over. Other Caribbean travellers asked for copies in exchange for favours. A Jamaica-bound journeyman named Joseph Browne requested one in 1707, promising anything Sloane desired in return. While seeking Sloane's advice on the market price for some ipecacuanha he had sent him, the Virginia planter William Byrd 'begged' for a copy, while also begging forgiveness for 'making a merchant of' Sloane by suggesting he pay himself back for the expense 'out of the profits of the cargo' Byrd had sent. Byrd pushed too hard: the catalogue of his extensive library shows he never received the favour he so desired.[41]

Dispatching the *Natural History* as a gift allowed Sloane to increase its readership and enrol new collectors as correspondents. He sent copies to the Antigua merchant Walter Tullideph and the Pennsylvania botanist John Bartram, both of whom sent specimens in return. The Hudson's Bay Company trader Henry Elking received a copy from Sloane as thanks for the head of an Arctic walrus he had sent to London. But not everyone was so desperate to own the book, especially when they actually read the thing. ''Tis a majestique book,' was the initial comment of the Reverend George Plaxton in 1707 to the Leeds antiquarian Ralph Thoresby, an associate of Sloane's. But looking at it more closely, Plaxton decided it was 'good for little'. For a book on the Americas it was really quite boring: 'I thought I should have found wonders in it.' In 1710, William King struck again, this time taking aim at Sloane's medical pretensions. In *A Voyage to Cajamai* (Sloane's voyage to *Jamai-ca* cunningly reversed), King dismissed Sloane's case histories as 'more like a house-wife's receipt [recipe] book' than the records of a physician, which contained only common-sense remedies any surgeon might perform, adorned with unconvincing 'pretences' of anatomical and chemical learning. King pilloried Sloane as a 'white physician of superior genius' who claimed to have 'outshone the black as much as the sun does the black of night'. For good measure, he had

his fictional Sloane rubbish his own abilities by acknowledging that a Jamaica doctor always needed 'convenient burying-places for his patients' and was always 'looking out for good church-yards'.[42]

The reception of Sloane's book in the West Indies was mixed as well. Sloane's stated aim was that English colonists might use his work to 'understand [the] uses [of] the plants they have growing *sponte* or in gardens'. His stepson, the Jamaica resident John Fuller, not surprisingly thanked him for such a 'noble present' and was confident the book would 'make our island of Jamaica better thought of as well for health as physick'. Henry Barham's report was more frank. Barham assured Sloane that he had received 'great benefitt' from the work and thought the whole island 'ought unanimously [to] joyne in their thanks to you'. However, he continued, such was human vanity that, unless an author credited his sources by name, 'a book is oftimes condemned in generall before ever it is particularly read' and 'such misfortune your labories and usefull history hath mett with here; for you shall not meet with one in tenn that sp[e]aks highly of it that ever read itt.' Some were 'dissatisfyed with putting names in your observations of diseases' and complained 'that the practis is very mean & plaine'. But the main Jamaican objection was that Sloane had 'writt the names and their severall kindes of plants in Latin wch very few understands in this island . . . [even though] you have described their groath in English'. 'I observed', Barham went on, 'that the people in America being for the most part altogether straingers to the Latin names of plants [they] were at a loss how to make a rite use of your most usefull book.' Writing for a general readership was hard if not impossible: while Sloane's descriptions in English flummoxed learned readers on the continent, his use of Latin vexed colonists in Jamaica.[43]

Sloane's *Natural History* wasn't simply an instrument for its author to collect new correspondents, however, but also a means by which readers forged new connections to him. Barham cleverly turned others' reproaches into a badge of his own loyalty. In the ensuing years, he dispatched a slew of letters to court the man he hoped would act 'as a father' to him. He pitched his botanical and medicinal reports, based on extensive contact with slaves, so well that Sloane had several of his notes transcribed into the master copy he kept of the *Natural History* and even printed some as addenda to his second Jamaica volume. Such emendations afforded Sloane an occasion to carry on collecting in

Jamaica long after he had left, while exhibiting the modesty of an author who embraced criticism and revision. Barham's son, Henry Junior, who ran a major slave plantation on the island called Mesopotamia, kept up these contacts, though his words of appreciation unwittingly sent more mixed messages about the merits of Sloane's work. He wrote to Sloane from Spanish Town in 1726 that he had delivered his second volume to his ageing father, much to the latter's delight, adding that this new volume was 'soe likd by others thatt its neaver at home being borrow'd from hand to hand there not being above two of them in ye island'.[44]

Among London friends, by contrast, the *Natural History* occasioned Sloane's acclamation as a man of letters. The engravings he commissioned from his artists were central to the scientific value of his work yet, as we have seen, he took pains to embed them in encyclopaedic descriptions. While Scientific Revolution narratives have often emphasized the supplanting of merely textual authority with the authority of truly empirical observation, Sloane's words – many of which he culled from other textual sources – remained integral to his work. He made this explicit when, in his second volume, he responded to criticism that he had not included more species drawn from living plants rather than dried ones, a point of contention among botanists in search of anatomical accuracy. In defending his work, Sloane pulled rank on his artists, whom he referred to as his 'workmen' and blamed them for certain errors: 'both the person who fastened [my plants] into the books, he who design'd them afterwards, and the engravers have committed several mistakes.' (Some early printings had apparently omitted Guadeloupe from Sloane's Caribbean map, an error by an engraver named Harris, which Sloane pledged to correct in future editions.) 'If', he crucially continued, 'there were any slips of that kind in the prints, they were easily to be mended, by perusing their descriptions': if some of his engravings raised doubts, in other words, readers could reliably fall back on his verbal descriptions of the species in question. In any case, he added, no one 'who minds those things in Jamaica, ever miss'd by my descriptions and figures, to find the plants I meant'. For all the time and money Sloane spent on his pictures, he still advised readers that they could 'see' his plants just as well through his words.[45]

The *Natural History of Jamaica* did not go on to become a classic in the history of science or travel writing. A dense and technical work, it

offered no new theory of the natural order nor made any particularly influential statements of providential natural theology of the kind published by Ray. A work of meticulous descriptive science combined with systematic catalogues, and a miscellaneous collection of observations that do not form a coherent narrative, it does provide a vivid account of early English Jamaica that reveals much about how science was practised in the tropics, especially in relation to the institution of slavery. But it remains a difficult read – hence, at least in part, its relative neglect by scholars to this day. The lack of colour in Sloane's engravings has likely reduced their aesthetic value as scientific art. And while the book did become a reference point for Caribbean travellers and naturalists, Linnaeus' use of Sloane's engravings for his reform of taxonomy in the *Species plantarum* (1753) significantly narrowed appraisals of what was valuable about Sloane's work, by ignoring almost everything Sloane *wrote* and focusing instead on what his artists drew.

In its day, however, the *Natural History* was a major scientific work that heralded Sloane's eminence in the Republic of Letters. The tension between word and image in his text corresponded, moreover, to a significant tension in the way Sloane presented himself to the world through this work. Here was a gentleman naturalist visibly immersed in commercial worlds of goods and commodities yet who claimed to be an impartial man of letters, as the apothecary who lacked a university education built a massive personal library to transform himself into a forbiddingly encyclopaedic authority in the tradition of ancient masters like Dioscorides, Galen and Pliny. Only a botanist who had seen 'the nondescript Americans ... growing in their natural places', Ray remarked, *and* had 'read, considered and compared what hath been written of them' could have realized such a monumental scientific achievement. The *Natural History* was a work, wrote Birch, 'which perhaps no library in the world but his own could have enabled him to make'. According to his allies and contrary to classic narratives of the Scientific Revolution, Sloane's achievement lay not in rejecting learned authority in favour of empirical matters of fact but, rather, in a conspicuous display of reasoned knowledge that redeemed empirical facts with truly learned judgement.[46]

## LORD OF CHELSEA MANOR

The second decade of the eighteenth century marked a turning point for Sloane, as his private fortune grew and he became a gentleman of singular public standing. The bountiful fees from his medical practice allowed him to join the ranks of the rentier class. Many gentlemen at the time, including his acquaintances Richard Mead and the Duke of Bedford, were buying up freeholds in and around London, generating additional income through rents; Bedford had been collecting a couple of thousand pounds a year since 1700. This was a shrewd investment in an era of urban expansion, which Sloane emulated when he purchased Chelsea Manor, formerly a residence of King Henry VIII, from Lord Cheyne in 1712. The manor cost the considerable sum of £17,800 and included a total of eleven houses and the Manor House itself (nos. 19–26 Cheyne Walk were later constructed on this site in 1759–65) (p. 174). Not yet incorporated as part of London, Chelsea was to become Sloane's regular refuge from Bloomsbury during weekends, the residence of his sister from 1736 and ultimately the site of his retirement home and private museum from 1742. As the suburban equivalent of a country seat, the manor grounded Sloane's gentlemanly identity. It also brought him about 90 acres of land (out of an original 166) as freeholder, and an unknown number of tenements, on which he began to collect his own rents.[47]

Four years later, in 1716, George I made Sloane a baronet. This honour may have come in return for the role some allege Sloane to have played in ensuring the succession of the House of Hanover in 1714. When the heirless Queen Anne fell gravely ill that year, the Tory minister Viscount Bolingbroke took steps to enthrone the exiled Stuart Pretender, Bonnie Prince Charlie, James II's grandson. Sloane may have been the one to keep the queen alive long enough to arrange for George I's coronation, although no direct evidence confirms this. In any event, Sloane's baronetcy raised him well above the majority of his physician peers, and he helped himself to a coat of arms, suitably ornamented with a sword, boars' heads and the figure of a lion, took to riding about town in his own carriage, carrying a 'walking cane of tortise shell wt my court of arms at top' (which his nephew had made for him in Naples), and now went by the style 'Sir Hans'. Not for nothing did London

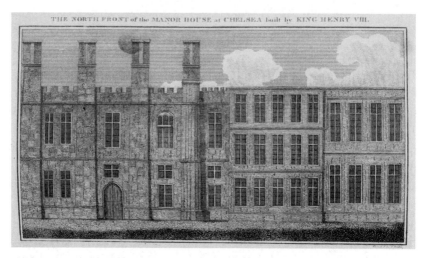

THE NORTH FRONT of the MANOR HOUSE at CHELSEA built by KING HENRY VIII.

Sloane's house at Chelsea Manor: in 1712 Sloane acquired and then expanded the former residence of Henry VIII (depicted here in 1829 in Thomas Faulkner's *Historical and Topographical Description of Chelsea*), where he spent weekends before retiring there with his collections in 1742.

gazettes take to calling him the 'Lord of Chelsea Manor'. As medical fame brought honours, honours brought more patients and more lucrative offices, including appointments as physician-in-ordinary to the king and physician-general to the army in 1716, the latter carrying an annual stipend of £300. This salary he did not refuse. In 1719, Sloane was recognized as Britain's pre-eminent doctor by his election as president of the Royal College of Physicians.[48]

As his stature grew, Sloane became a major medical patron and took several younger physicians under his mentorship. He was liberal with his sponsorship, assisting the Irish Catholic doctor Bernard Connor, for example, who went on to publish a controversial attempt to reconcile miracles with the mechanical philosophy, as well as the unorthodox Dutch physician Joannes Groenevelt and John Colbatch. Sloane refereed others' cases at the behest of influential clients. When Lord Leominster fell ill, Lady Leominster asked Sloane to check the course of treatment prescribed by James Keill (although to no avail – his lordship died in 1711). In 1715, George Cheyne asked Sloane for advice on treating the Whig theologian Gilbert Burnet and in 1720 wrote again

about the case of Catherine Walpole, the prime minister's daughter, who fell ill during the South Sea Bubble crisis with 'fitts', loss of appetite, menstrual problems and what Cheyne nebulously termed 'hysteria'. The case was long and painful, so Cheyne was keen for advice from Sloane, whom he referred to as 'you who move in superior orbits'. The prime minister himself contacted Sloane before following Cheyne's advice and it was on Sloane's word that Catherine moved from the spa town of Bath to take a different set of waters at Bristol, a common medical strategy at the time. When she returned to London Catherine seemed 'most miraculously recovered', according to Cheyne, but, after a regime of purgatives, sadly died in 1722. Such fatalities were regrettable but also routine in Sloane's world. Indeed, the death of the patient was something of a running joke in Augustan medicine. In his satirical poem *The Dispensary* (1699), the Tory wag Samuel Garth tarred both physicians and apothecaries as 'assassins', the only difference being that physicians killed more people because their carriages took them further across town.[49]

By the early 1720s, Sloane became entrusted with medical affairs of state during the period of public crisis that succeeded the South Sea Bubble. As president of the College of Physicians, he endorsed a petition to Parliament to combat the effects of gin consumption (Gin Acts raising duties and imposing licences were later passed in 1729 and 1736) and in 1721, together with Richard Mead and John Arbuthnot, advised the House of Lords on the momentous question of imposing a quarantine and shutting the port of London to prevent plague reaching British shores from Marseilles. Disease was an urgent state concern; 100,000 Britons died in the 1720s alone due to contagious fevers engendered by poverty and overcrowding. But quarantine was a sensitive matter that raised questions about the proper extent of state power, since it involved the suspension of merchants' activities and commercial shipping from overseas. Popular pamphlets fired off salvoes against the 'tyranny' of the measure and Sloane's acquaintances complained to him of its 'severity' and the 'misery' imposed by a strong-arming administration that had already undermined its own credibility through the fiasco of the Bubble. With Sloane's support, however, the Quarantine Act successfully passed in 1721, affirming his stature as an eminent medical counsellor in the process.[50]

Inoculation against smallpox was another controversial policy

enacted at this time that also showed Sloane's growing public influence. The practice of inoculation may have originated among the peoples of West Africa; by the early eighteenth century, it had been adopted by European slave-ship captains. Sloane had heard reports of its utility from China, Guinea, New England, Greece and especially Ottoman Turkey, via Lady Mary Wortley Montagu at Constantinople and William Sherard, then consul for the Levant Company at Smyrna (İzmir). In Britain, many regarded inoculation as a dangerous innovation. Sloane was nonetheless invited by Queen Caroline, keen to protect her children from disease, to take the unusual step of trying it out on a captive sample of six condemned prisoners at Newgate Jail in 1721. Accustomed to experimenting with poisons on dogs (the traditional experimental animal of choice), Sloane oversaw these rare trials with human subjects and recounted the results in the *Philosophical Transactions*. The Newgate experiment was deemed a success and the queen, being 'exemplary, prudent and wise', encouraged further trials with 'charity-children' belonging to St James's Parish and, after Sloane had secured permission from the king, her own children. There were many successes but several high-profile deaths also occurred, including the Earl of Sunderland and his son, and the sub-governor of the South Sea Company. 'Many physicians, surgeons, apothecaries and divines, seem to oppose it,' Sloane wrote in 1722, though only one case in 200 had gone awry in his estimation.[51]

Sloane and his Royal Society colleague Dr James Jurin persevered and later adapted the statistical methods of political arithmetic pioneered by William Petty in Ireland to demonstrate the viability of inoculation at the Foundling Hospital, a charitable institution founded on Lincoln's Inn Fields just north-west of the city with Sloane's support in 1739, where it was made compulsory. Embracing his new role as doctor of state, Sloane mobilized statistical methods again to advocate breastfeeding rather than dry-nursing at the Foundling Hospital, asserting that 'the strength and wellfare of any nation depends on the number and health of its inhabitants.' The Newgate inoculation trials provided a model for colleagues in the Royal African and South Sea Companies to conduct their own experiments on African slaves as they sought to reduce the financial losses caused by smallpox fatalities on the Guinea coast and the Middle Passage. Sloane's trials conferred truly privileged status on him back in London, meanwhile. He was no longer simply a rich

doctor or even just president of the College of Physicians but the man who, with royal blessing, wielded the power of life and death over His Majesty's subjects – including the king's own children – in the name of the public good.[52]

Sloane's embrace of his new-found prominence led him to become a scourge of 'quackery', although at a time when elite physicians still bled their patients, employed arcane remedies and routinely lost patients, what constituted quackery remained a matter of perspective. Several of Sloane's pharmacopoeia drawers survive, furnishing evidence of the kinds of medical resources, traditional and novel, he had at his disposal (Plate 10). They contain an eye-catching raft of substances, including goats' blood, a moss-covered human skull, burnt deer antlers, burnt ivory, bones from the hearts of deer, beaver glands, rhino horns, silkworm cocoons, crab claws, boars' teeth and a mummy's finger. Some of these were ancient medicinal ingredients that dated back to the prescriptions of Dioscorides and Pliny, while others were recent imports from the colonies such as the 'Vomiting Root' which came from Virginia (ipecacuanha) and the febrifuge Peruvian bark. Birch noted that Sloane invested heavily in the bark for use in his practice against 'agues & intermittent fevers' and nervous disorders; used it to relieve the Archbishop of Canterbury's gout; and even 'happily prolong'd by it his own life to an extreme old age, tho' frequently attack'd with great vomitings of blood'.[53]

These drawers recall Sloane's formation in the apothecarial arts. As a physician, however, he had gone on to have a complex relationship with the community that first nurtured him. He operated in a hierarchy where physicians styled themselves learned gentlemen, far above what they regarded as the menial know-how of apothecaries and surgeons. When Sloane went to Jamaica, for instance, he insisted on supervisory authority over all apothecaries and surgeons in Albemarle's fleet and did not shy away from savaging other healers as quacks. On returning, he took the physicians' side when they created their new London dispensary, launched in the 1690s to undercut the apothecaries by selling 'medicines at their intrinsic value', as Birch put it. This battle lasted for several years until the House of Lords finally found in favour of the apothecaries, marking a setback in the physicians' attempts to regulate the rivals with whom they competed for patients – both the apothecaries and the unorthodox popular healers they considered quacks. The

Lords ruled that the people should have the power to judge who to buy their medicaments from and even curbed the College of Physicians' role in supervising the supply of medicine to the armed forces.[54]

Sloane nonetheless threw his weight (and money) behind the Society of Apothecaries, with which he had first associated around 1679 while training in botany. He guaranteed the apothecaries' continued use of Chelsea Physic Garden by buying the land on which it stood and renting it out to them at a nominal £5 per annum beginning in 1722, in return for which they sent a parcel of fifty plants to the Royal Society each year. Sloane's correspondents sent the garden numerous exotic seeds; the first cotton plant to reach the new colony of Georgia in the 1730s, co-sponsored by Sloane and whose botanical garden was supplied with seeds by travellers he patronized, may have come from Chelsea; and the garden's plants achieved ornamental fame after being painted as decorations for locally made chinaware known as 'Sloane Plates'. To a remarkable degree, therefore, Sloane's personal contacts animated a network of institutions, gardens and colonies around Britain's growing empire. Out of thanks to their dutiful patron, the apothecaries mounted a statue in Sloane's honour by the Flemish sculptor Jan Rijsbrack in the very centre of the garden (opposite). As a gentleman physician, Sloane had others make up the remedies he ordered for his patients but insisted on identifying himself with the honest empiricism of the apothecary, defending his prose in the *Natural History* by likening it to 'the common language known in apothecaries shops', which he preferred to the pretentious 'Latin turns and words' of his brother physicians. Perhaps he had forgotten Barham's reports about how his own Latin terms utterly befuddled readers in Jamaica. However improbably, the rich society physician claimed the moral authority of the humble druggist as his own.[55]

Unorthodox therapies flourished in eighteenth-century Britain in a medical culture that lacked powerfully centralized institutions. Yet Sloane was determined to regulate what he saw as illegitimate healing. As president of the College of Physicians, he enjoyed the 'power . . . to inspect all ye apothecarys shops in ye metropolis of this nation', as one of his correspondents put it. In 1721 he oversaw the publication of the *Pharmacopoeia Londinensis*, designed to police the use of approved drugs only, both old and new, endorsing exotic simples like *Contrayerva*, *Quinquina* (the Peruvian bark) and the *Cortex Peruanus* and

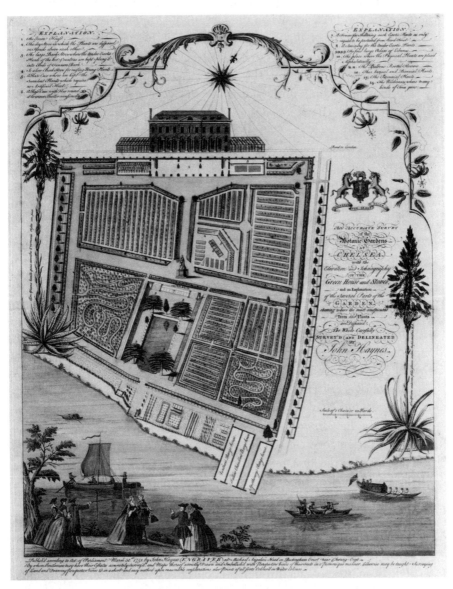

Chelsea Physic Garden as engraved by John Haynes in 1751: Sloane trained
in the garden, supplied it with seeds from his contacts in Britain's colonies
and leased it to the Society of Apothecaries for a nominal £5 a year –
for which they erected a statue (centre) in his honour.

*Winteranus*, while rejecting potentially harmful drugs such as *apocynum*, which Barham had linked to poisoning in Jamaica. 'I desir'd the censors of the college of physitians, and the wardens of the company of apothecaries, when they were going upon their search to take particular care of this [last] drugg.' Sloane 'was extremely cautious', Birch observed, and rarely prescribed ipecacuanha, 'lest in any unhappy mistake of the apothecary the poisonous sort might be given'. The class tensions in Sloane's professional identity was again in evidence as the apothecaries' champion assumed the role of state regulator. Under Sloane's authority, the College revised its official guide to pharmacy in 1727, based on a review of apothecaries' shops that he had ordered, to clarify 'the sophistications which chymists and wholesale dealers practise', to root out 'impostures', 'superstition' and 'false philosophy', to establish 'laws for the composition of medicine' and promote 'the publick health' according to 'reason and experience'.[56]

In pursuing this regulatory programme, Sloane articulated the core purpose of his medical career as he saw it. Physicians of his era often imagined healing as a means to civil regeneration. His mentor Sydenham, for example, had served Cromwell and the republican cause in the Civil Wars and during the Protectorate, turning to medicine as an alternative means of healing the body politic after the return of the monarchy. Restoration commentators recast the religious enthusiasm of Puritan revelation as a pernicious combination of mental disorder and political extremism, and became interested in the sciences as forms of reasoning that might produce rational consensus and unify the polity. In *Leviathan* (1651), Thomas Hobbes urged the need for an authoritarian sovereign to keep the peace, recommending geometrical reasoning as the best method of producing certain knowledge about the operations of the world and thus absolute assent to the dictates of the state. By contrast, Robert Boyle's experimental programme at the Royal Society – which Hobbes rejected as lacking in certainty – espoused a moderate and oligarchical order of knowledge, in which assent to claims about the natural world would be established as probabilistic matters of fact through the collective witnessing of experiments. Towards the century's end, the natural theology espoused by Anglican divines such as Samuel Clarke and Richard Bentley used the intellectual authority of Newton's account of gravity and the laws of motion

in the *Principia* to espouse a vision of social harmony modelled on cosmological harmony.[57]

Sloane was a product of this conciliatory culture of the post-Restoration era and, as such, preferred to remain discreet when it came to his political and religious opinions. The remarkable authority others granted him stemmed, as we have seen, from perceptions that he was coolly impartial and above partisanship, though he confessed to friends the civic responsibility that weighed on him as a physician charged with saving 'life tho of the meanest person'. More suggestive is his comment in the preface to his Jamaica volumes that 'the knowledge of natural-history, being observation of matters of fact, is more certain than most others, and in my slender opinion, less subject to mistakes than reasonings, hypotheses, and deductions are.' In endorsing observation over ratiocination, Sloane aligned himself with Boyle's probabilism against Hobbesian rationalism, and he approvingly cited the French scholar Gabriel Naudé, who 'used to say he acquiesc'd in the ecclesiastical history, doubted the civil, and believ'd the natural. These are things we are sure of, so far as our senses are not fallible' and which inspired trust in the 'providence of almighty God', whose 'contrivance' of the world could not have been 'production of chance'. Religion required pragmatic accommodation; political claims deserved scepticism; only the observation of nature merited credit and, indeed, faith in God's providence. Sloane's language here is consistent with the preoccupations of the post-Civil War decades: the quest to avoid epistemological error and social discord through sober empirical knowledge of the external world as God had designed it. On those rare occasions when Sloane did fleetingly comment on social questions in private letters, he voiced his support for freedom of conscience. Regarding 'natural and revealed religion and predestination', he once wrote, 'I am no ways farther concerned than to act as my own conscience directs me in those matters, and am no judge for other people.' Although a Whig, he extended sympathy to non-juring friends such as Patrick Blair, who hailed from a family of Jacobites in Aberdeen, and whom Sloane appears to have saved from execution after his involvement in the Jacobite Rebellion of 1715. He seems to have intervened in a similar fashion to help his friend the non-juring Anglican bishop George Hickes, who feared imprisonment after the rebellion had been put down.[58]

Sloane may have been liberal, but he was no relativist. He identified patterns of belief and practice, especially in relation to medicine, which deserved neither respect nor toleration in his view. The language of the *Pharmacopoeia* he published shows how he framed his plan to regulate medicine as protection for patients from unsafe drugs in the name of opposing 'reason and experience' to 'superstition' and 'imposture'. Here, Sloane embraced the model of the doctor as scourge of popular credulity, as embodied by predecessors such as the learned seventeenth-century Norfolk physician Sir Thomas Browne. Browne was an aristocrat, Anglican and royalist who lived through the Civil Wars and a Baconian-minded scholar who diagnosed an 'epidemic' of errors about the natural world in need of correction in works like his *Pseudodoxia epidemica* (1646). Sloane appears to have left no commentary on Browne, but his interest in him is evident from the many Browne items he bought at auction in 1711, making Sloane one of the greatest collectors of Browneana in England. These included manuscript notes on the *Pseudodoxia* as well as correspondence, anatomical specimens, Browne's copy of Francisco Hernández's *Rerum medicarum*, and plants and curiosities such as the burial urns discussed in Browne's study of the world's burial practices, *Hydriotaphia, [or] Urn-Buriall* (1658).[59]

As we shall see, Sloane's commitment to public medical regulation and the eradication of error also drove his collecting, through his determination to use collections in almost therapeutic fashion to expose and correct what he considered the follies of credulity, in particular magical explanations of the natural world. But medical practice fed his collections more mundanely as well. Sloane collected a variety of bezoar stones, for example, consisting of petrified clumps of matter from animal and human digestive tracts, traditionally thought to possess quasi-magical healing powers, as personal keepsakes from his patients. In his Humana Catalogue, he listed a gallbladder that his colleague the prominent surgeon William Cowper (the source of many of Sloane's anatomy specimens) had removed from the natural philosopher Walter Charleton, as well as stones from Charles II's tapestry maker and the mayor of Derby, among others. Some made their remains into fine gifts. The Reverend George Hickes refused to have his bladder-stone removed during his lifetime but, mindful of his debts to Sloane, ordered his executors to take it out after his death and 'put into a silver box, and given to him, who had been his physician for many years, to place it in [his]

collection of such kind of curiosities'. To Sloane, such stones were not magical objects but personal remembrances, through which his acquaintances might procure a degree of immortality by becoming part of his collections. Item 749 in Humana tells of one particularly curious remembrance: a 'rib of beef that was swallowed wt some greens at dinner by a woman that seldom used to chaw her victuals', which Sloane had extracted from her oesophagus 'with a piece of spunge introduced on a whalebone'.[60]

Other medical objects contributed directly to the documentation of popular error. Sloane amassed hundreds of what he called 'Quacks Bills', detailing the foibles of unorthodox healers and their patients, as well as a very large number of protective prayers and 'charms' from previous centuries. He himself had never seen 'any effect of gibberish or other words used as charms to cure or rather fright diseases', he declared in the *Natural History*, 'tho' in ancient times, and even now some have a great opinion of them from a belief they have in an axiom *herbis, verbis, et lapidibus, inest magna vis*' – there is great power in herbs, words and stones. Patients and colleagues regularly furnished Sloane with tall medical tales. A Dublin surgeon named Proby described how people mistakenly swallowed cherry stones 'according to a vulgar notion to prevent the mischief of the fruit'. Another featured a woman who consumed vast quantities of strawberry seeds for similar reasons, only for them to lodge dangerously in her insides. In 1733, Sloane's librarian Thomas Stack told him about Elizabeth Brian of Tottenham Court Road who 'gave suck to two of her grand-children' at the age of sixty-eight, and whose 'full, fair' breasts Stack had personally examined, getting her to 'squeeze out' milk she could 'spout ... above a yard'. Brian regarded her fecundity as a 'miracle'. Sloane included Stack's account in the *Philosophical Transactions* as part of his ongoing commitment to scrutinizing 'very strange, but certain, matters of fact'. William King would have had a field day. Here on display once more was the signal ambiguity of Sloane's brand of curiosity. While many of his learned contemporaries now rejected the study of strange and unaccountable phenomena, associating it with vulgar wonder-mongering unbecoming of learned scientific study, his commitment to examining bizarre matters of fact left him open to charges of credulity. It wasn't that he believed such stories – it was the sheer fact that he considered them worthy of attention.[61]

Brian's 'miracle' talk was a reminder that, although marginalized by the eighteenth century, belief in the supernatural nevertheless persisted in British society and, in Sloane's view, continued to demand opposition. Strange phenomena were acceptable, even welcome; strange explanations were not. Miracles had, indeed, haunted the Glorious Revolution, which was not only a political *coup d'état* but in several respects a medical one too, since the old Stuart monarchs had fancied themselves to possess magical healing powers. Between 1660 and 1685, Charles II claimed to have cured more than 90,000 of his subjects of the King's Evil (scrofula) by means of the ceremony known as the Royal Touch, in which he placed special amulets around the necks of the afflicted. The Royal Touch embodied Stuart pretensions to divine-right monarchy and became associated with Catholic tyranny in the minds of Protestant critics, even though several prominent Protestants claimed its power as well, including the Irish Cromwellian Valentine Greatrakes, the Duke of Monmouth – Charles II's illegitimate Protestant son, who tried to seize the throne by armed rebellion in 1685 – and even Queen Anne. Savants were unsure how to deal with the awkward fact that the monarch who had signed the charter of the Royal Society carried on as a magician. Boyle, for one, did not denounce Charles, and even the College of Physicians took talk of miracles seriously during the 1690s. In the aftermath of the Glorious Revolution, the politics of healing turned schizophrenic. No one was sure who, if anyone, might still lay claim to the potent triad of political authority, religious leadership and magical healing.[62]

As secretary of the Royal Society, Sloane diplomatically had Charles's bust installed in the society's assembly room in 1711, the year he oversaw the society's move from Gresham College to Crane Court above Fleet Street. But in time it became clear that the Glorious Revolution had redefined the relationship between politics, religion and medicine, and that Sloane epitomized the transfer of medical authority from royal healers to professional doctors. In 1702, Sloane had bought the collections of his friend William Courten, among whose coins and medals was a 'silver meddal model of ye gold [piece given] to those yt [that] were touched for the Kings Evil in K. Ch. ye 2ds time *Soli deo gloria*'. Bought for three shillings by Courten, this was one of the amulets Charles had given out as part of the Royal Touch. Sloane left no comment on this amulet; he may barely have noticed it in his constantly

expanding museum. But its very presence in his collections is significant. By buying this object from Courten, Sloane helped strip it of its magical charisma. New Whig fortunes enabled acts of collection that disenchanted sacred instruments of royal authority by turning them into mere curiosities to be bought and sold, effectively recasting divine-right monarchs as royal quacks in the process. Charles's amulets were surely little different to Sloane from the 'charms' used in Obeah or the 'gibberish' trotted out by folk healers. In the new medical order, the healing touch that counted was no longer that of the monarch but that of doctors like Sloane.[63]

The sober judgements of professional physicians promised solutions to the enduring problems of superstition and tyranny that Protestants associated with Roman Catholic doctrines of magical matter, from the miracle of transubstantiation in the Eucharist to the healing power of relics. In 1722, the Whig surgeon and antiquary William Beckett attacked the pretended powers of 'Romish' amulets in a withering history of the Royal Touch which insisted that the reason why so many had submitted to it was not faith in Stuart magic but the desire to acquire amulets and sell them for cash. The Royal Touch had been nothing more than a cynical manipulation of the 'imagination' to cow His Majesty's subjects with a non-existent 'supernatural power', while inquiries like Beckett's testified to the genius of Protestant scepticism and the 'free and inquisitive age' ushered in by the Whigs. Attacks contrasting Catholic superstition with Protestant rationality were persistent, kept alive by the ongoing wars with France. 'No absurdity can be too big for a Catholick faith,' declared the divine Samuel Werenfels in his *Dissertation upon Superstition in Natural Things* (1748). It was entirely fitting, moreover, that Beckett dedicated his views on magical superstitions in a public letter to the man he regarded as the paragon of rational medical judgement: 'Sir Hans Sloane, Bart. President of the College of Physicians'.[64]

## DOCTOR SLYBOOTS

As Sloane became one of the most trusted public figures in British society, he continued to amass a great private fortune. This included taking an interest in the running of Lady Sloane's Jamaica estates,

as documented by a series of surviving account books dating from 1719–27. These books were managed by Gilbert Heathcote, with whom Sloane became intimately associated: Heathcote acted as Sloane's banker and Sloane became Heathcote's doctor, while Sloane's nephew William married Heathcote's daughter. The accounts show, for example, that on 9 December 1720 Sloane paid one-third of the cost of the passage to Jamaica for men named Joseph Slades, Lewis Laundys and Will Morris; the following October he did likewise for Francis Hiornes, Thomas Hewet and Francis Challoner, costing him roughly £57. These journeymen were either indentured servants or overseers and plantation managers. Records for 5 September 1723 list further payments totalling around £14 for 'wages and board' for a group of workers by the names of Spikes, Gravner, Smith, Pope, Sterling and Baslington, bound for the Jamaica plantations owned by the Fuller and Isted families. The Fullers and Isteds were Sloane's extended family through his marriage to Elizabeth: Thomas Isted had married Ann, Elizabeth's daughter by Fulke Rose, and John Fuller had married Elizabeth's other daughter from her first marriage, also called Elizabeth.[65]

Absentee ownership of slave plantations became one of the paths to spectacular wealth in the eighteenth century, but like all remote plantations the estates owned by Sloane's extended family were vulnerable to misadventure. 'I do not know who looks after your interests in Sixteen Mile Walk,' Henry Barham warned him after a violent storm damaged property in 1722. By the 1730s, Sloane took a more active interest, dispatching a family member to take matters in hand. Rose Fuller was Elizabeth Sloane's grandson by her first marriage, making him Sloane's step-grandson. Sloane's patronage of Rose exemplified the range of networks he commanded, from the Republic of Letters to Britain's colonies. Armed with letters of introduction from his illustrious relative, Rose first set about obtaining medical instruction in Paris and the Netherlands. He reported his visits to book auctions and natural history collections, including his reception in Amsterdam by the naturalist Albertus Seba, assuring Sloane that Seba's snake collection 'come[s] far short of yours', estimating his museum to be only one-fortieth the size of Sloane's. Sloane then packed Rose off to Jamaica with instructions to supervise the family estates and another set of introductions, this time to the governor of the colony who, Rose recounted, 'receiv'd me mighty well, and desir'd I wou'd make his compliments to you'. Fuller

furnished a fine return, sending back botanical information and the good news that 'rebellious negroes' (the Maroons) were now hunting down fugitive slaves after signing the peace treaty of 1739.[66]

Sloane's accounts demonstrate the financial benefit he derived from the labour of slaves and point to the role they played in his collecting. In September 1721, for example, the books record proceeds from the sale of 6 hogsheads of sugar (one hogshead contained approximately 1,000 pounds of sugar) worth £25 16s 1d, brought to London on the ship *Loyal Charles* from 'MP', as well as £37 9s 4d from 'KP'. 'MP' was Middleton Plantation and 'KP' was Knowles Plantation, both located at Sixteen Mile Walk. These deposits into Sloane's account derived from the one-third of the net profits from Jamaica to which Elizabeth was entitled as Fulke Rose's heir, and which went to Sloane as her husband (Isted and Fuller, as the husbands of Fulke's two daughters, received the other two-thirds). Similar sugar profits are recorded in Sloane's ledgers from a number of ships involved in the Atlantic triangular trade: the *Loyal Rachel, Swallowfield, Copper, Jenny, Beckford, Christobella, Eagle, Neptune, Burrell, Loyal Jane, Oldfeild* and *London*. In a single day on 7 February 1723, Sloane's books record proceeds from several different sugar shipments totalling approximately £228 (upwards of £20,000 in today's money). One of the vessels whose itinerary can be most fully reconstructed is that of the South Sea Company ship *Neptune*. The *Neptune* left London in December 1721 and transported 395 enslaved men and women taken from Cabinda, near the mouth of the Congo River in West Africa, to Jamaica. It then returned to London on 9 April 1723. Two days later, on 11 April, Sloane's books record the proceeds from 8 hogsheads worth £32 1s from Knowles delivered by the *Neptune*, as well as a further £27 19s 3d from 6 hogsheads on 3 December (pp. 188–9).[67]

The amount of money Sloane received from the Jamaica plantations cannot be known with certainty because accounts do not survive for his entire lifetime, but a range of possibilities can be estimated. Sloane's accounts show sugar income totalling £1,429 17s 4d for the period 16 June 1719 to 12 February 1725. In today's money that is approximately £120,000. If one assumes that Sloane's sugar income for 1719–25 was roughly typical for the entire thirty-year period from 1695 to 1724/5 – Lady Sloane's death in 1724 terminated this income by legal arrangement – his total Caribbean profits would have surpassed £7,145,

Profiting from sugar and slavery: Sloane's surviving banking ledgers from 1719–25, now
sugar plantations inherited by his wife Elizabeth.

or more than £600,000 in today's money. This was a substantial sum
that would have gone much further than it does today and can be put
into perspective by recalling that footmen at the time earned about £8
per year and that a middling family required £100 per annum to live
on. Fulke Rose's income from his plantations is, however, said to have
been £4,000 per year at his death. If Elizabeth received one-third of
this amount annually, Sloane's total Jamaica income would have been
closer to £40,000, or over £3 million in today's money.[68]

Contemporaries certainly had little doubt that sugar money played
an important role in Sloane's collecting. Birch stated that marrying
Elizabeth made 'a very considerable addition to his fortune', while the
Swedish naturalist Per Kalm, who visited Sloane in 1748, noted that it

_London Anno 1723_

| | | Contra | | Cr | | | |
|---|---|---|---|---|---|---|---|
| 23 | | | | | | | |
| il | 11 | By Balance agreed this day | | | 251 | 7 | 11 |
| | | his ⅓ neat proceed of 10.hh⁴ ⅙ Loyal Jane K.P. | | | 42 | 12 | 9 |
| | | Ditto ............ 9 d°. Neptune ... K.P. | | | 32 | 1 | |
| s | 3 | Cash for Doc.ʳ Stegerthalls Bill return'd | | | 100 | | |
| | | his ⅓ neat proceed of 6.hh⁴ p Neptune. K.P. | | | 27 | 19 | 3 |
| | | Ditto ............ 6. d°. London K.P. | | | 28 | 4 | 5 |
| | | Ditto ......... 12. d°. Loy.ᵗ Charles K.P. | | | 44 | 12 | 5 |
| | | Ditto ......... 12. d° p d°. M.P. | | | 37 | 9 | 11 |
| | | Lady Eliz.ᵃ Sloane p her at several times as by her Acc.ᵗ of 9 June 1721 | | | 136 | 15 | 6 |
| | 18 | Lady Eliz.ᵃ Sloane p her at several times as by her Acc.ᵗ date this day | | | 217 | 9 | 8 |
| | | | | | 918 | 6 | 6 |

n the Lincolnshire Archives, record regular deposits of income from the Jamaican

was Sloane's 'very rich widow, which placed him in a position to fulfil his bent for natural history, and enabled him to buy the greater part of the natural history collection he now owns'. There is at least one instance in the ledgers that shows the translation of sugar money directly into collections, where Sloane pays two men named Lutman and Remers the sum of £111 6d for 'raritys' on 6 August 1724. Elizabeth never produced a male heir for Sloane: a son (Hans) and a daughter (Mary) died in infancy, although two other daughters did survive – Sarah, who married George Stanley of Hampshire, and Elizabeth, who married Charles Cadogan, later the first Earl Cadogan. That Sloane and his wife continued to try for a son is suggested by the miscarriage Elizabeth suffered in 1723, one year before she died on 27 September

1724. She did not succeed in furnishing Sloane with the heir he surely desired, but her inheritance unquestionably played a key role in Sloane's fortunes and his collections.[69]

In addition to spending on collections and residences like Chelsea Manor, Sloane ploughed the earnings from his medical practice, salaries and Elizabeth's plantations back into investments. These included land in Chelsea, from which he collected rents, as well as stocks and other financial instruments. Modest returns on East India Company shares are recorded at regular intervals in his accounts, such as a rise in value of nearly £7 on stock worth £600 on 28 October 1721. Sloane also invested in the slave trade, purchasing £200 worth of South Sea Company stock in May 1722, shrewdly *after* the Bubble had burst. A letter to Charles Lockyer, the South Sea Company accountant, shows that Sloane and Thomas Isted jointly held £1,260 worth of stock in 1723, which paid out an annual dividend.[70]

Sloane's ongoing involvement with the slave trade extended to various forms of brokerage. The Duke of Chandos asked him in 1721 if he could advise the Royal African Company about who to send to Guinea to make specimen collections there. Perhaps, Chandos wondered, the same man whom Sloane had just proposed for travel to the Caribbean might visit 'part of Africa in his way', since the company could 'with great ease convey him to any part of the West Indies in one of their negro ships'. Sloane complied, annotated the plant catalogues Chandos subsequently sent him and, 'for the kind expressions in your letter towards the welfare of the company', received a present of woods and ointments from Guinea. The South Sea Company, which sold slaves in Spanish America, asked Sloane to review candidates for their directorship. Please 'signify [the] character' of Lewis Way, Esquire, the company secretary Henry Newman asked in 1724. Sloane was routinely approached for assistance in commercial matters pertaining to the slave trade. '[I remember] that you have a plantation of suggar and tabacco in Jamaica,' wrote Nicolas Martini in 1717; he asked if Sloane might help establish trade links between the Russian-controlled city of Riga and the West Indies. Joseph Browne of Bow Street was a surgeon bound for Jamaica in 1718, 'where I am inform'd you have an interest or considerable acquaintance'; he implored Sloane for 'as many letters of recomendacon' as possible. 'I am told your interest is good in all the trading companies,' wrote the Belfast physician Magnus Prince in 1740.

He asked for help getting his nephew, who had experience with the East India Company, promoted to third mate.[71]

Travellers, meanwhile, bestowed extraordinary gifts on the author of the *Natural History of Jamaica* relating to Africans and slavery. A number of these objects reached Sloane via traders on the Guinea coast. They included caps, pipes, woven fabrics, ivory bracelets and war trumpets from Guinea, Angola, Congo and Madagascar. Other striking curiosities included 'thongs of leather wch. the Hottentot [Khoikhoi] women wear about their leggs' and 'a fetish shell worn abt. the ancles' for magical protection against enemies. Still others related directly to the institution of slavery. John Covel, master of Christ's College, Cambridge, gave Sloane 'a manati strap for whipping the negro slaves in the hott W. India plantations', as Sloane described it in his Miscellanies Catalogue – and about which he had written in the *Natural History* – as well as a 'scourge or discipline'. Sloane also had a 'barbary scourge wt. wch. the slaves are beaten' made from a palm tree. Others gave Sloane Maroon objects as rare artefacts of slave resistance. Henry Barham sent a 'bullet used by the runaway negros in Jamaica', while Robert Millar, an itinerant Scots surgeon, sent two 'coat[s] of the runaway rebellious negros who lived in the woods' and 'britches of the same coarser'. Sloane acquired a 'noose made of cane splitt for catching game or hanging runaway negros' (origin unknown) and a cappasheir's knife, carried by the African captains who ran slave forts in Ouidah, from an obscure merchant named Walker (Plate 12). Very often, these acquisitions resulted from the judgement *others* made about Sloane's curiosity, showing how decisions made by many other people helped constitute the content of his collections. Jonathan Symmer, a Virginia surgeon, sent Sloane an astonishing parcel in 1736 containing snake and worm specimens together with 'stones I extracted from the vagina of a negroe girle (affrican)'. Remarkably, this was Symmer's letter of introduction to Sloane; the two men had never met. And it worked: Sloane wrote back. In fact, Sloane so valued Symmer's 'stones', which resonated with the racial curiosity he expressed in the *Natural History*, that he copied the Virginian's lengthy account of them into his Humana Catalogue, where he also recorded the details of his 'negro' skin samples. Symmer later followed up by sending Sloane some 'pieces of the scull of a negro child that exfoliated on the cure of a large burn'.[72]

One of Sloane's correspondents even sent him his own living slave as

a present. Back in January 1710, a Scottish trainee physician whom Sloane patronized named Alexander Stuart had sent him a young African man from Leiden. 'If the bearere can be any wayes serviceable to you or your lady, I have sent him to wait on you for that end,' Stuart wrote. 'If he is acceptabl I shall be glad. I told you the main of his character in the coffee-house.' 'I shou'd be glad', he added, 'to hear that the black boy behaves himself to your satisfaction, that being what I proposed to myself in makeing such a present.' Such 'presents' were not unheard of. Those involved in missionary ventures like the Society for the Propagation of the Gospel sometimes gave slaves as gifts to well-placed friends. Perhaps Stuart was inspired by portraits of the time where bejewelled Africans waited on aristocratic masters and, as a sign of their rising status, on wealthy merchants. His gesture backfired, however. 'Im extremely troubled,' he wrote in May of that year, embarrassed 'that you shou'd have had such trouble with that black boy'. What happened is not clear; Stuart did not say how his African present had disturbed Sloane's household, but he realized he had failed the vital test of gentlemanly judgement in which Sloane himself was so expert – the connoisseurship of character. 'I beg of you that you'd be pleasd to dispose of him as you shall think best, in sending him to the West Indies or elsewhere: and pray pardon my haveing given you the trouble of such a rogue.' What Sloane ultimately did with his recalcitrant African is not known.[73]

The fortune Sloane amassed through his medical practice, salaries and slavery enabled him to engage in extensive acts of charity. He reportedly began each day by ministering to the poor free of charge. Birch gives an account of Sloane's philanthropy that is just that – an accounting. Sloane personally assumed the debt of the College of Physicians, charging them a lower rate of interest than they had previously paid, gave them books and donations worth £100, and bought them some 'magnificent' iron gates. He gave £100 to the Royal Society, while an additional £100 he secured to fund its new Copley Medal for outstanding scientific work allowed him to use the interest collected on that sum for a gold medal worth £5 for the best experiment performed each year. He gave £160 to Chelsea Physic Garden to repair its hothouses as well as £100 for its watergate on the Thames, and yet another £100 to several London hospitals, in whose governance he was actively involved.[74]

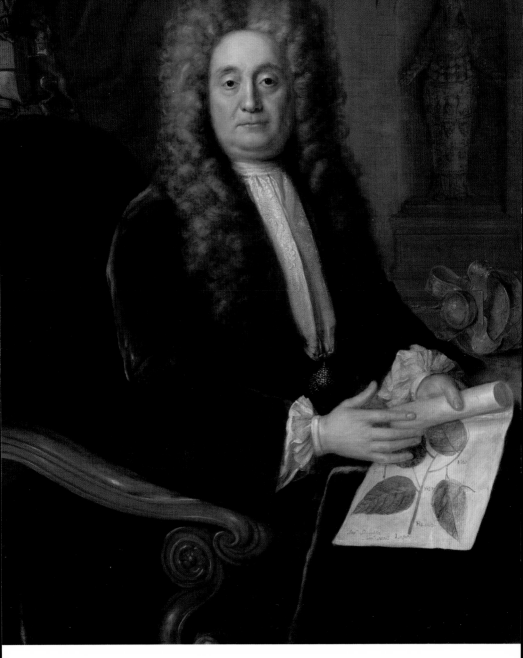

1. *Sir Hans Sloane* by Stephen Slaughter (1736): seated in his chair as president of the Royal Society, Sloane holds an illustration of Jamaican lagetto, displaying his work as a natural historian and master of visual knowledge.

2. Enslaved Africans transporting hogsheads of sugar: this lithograph of Antigua by William Clark in the early nineteenth century romanticizes Caribbean slavery but captures the combination of slave labour and animal power that produced sugar for export to Europe.

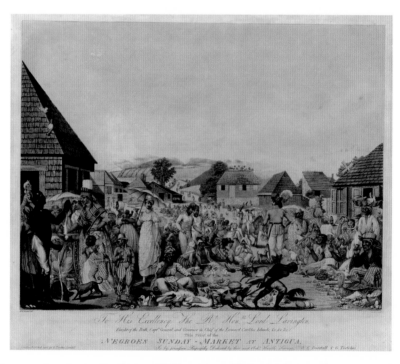

3. African markets in the Caribbean: William Beastall's early nineteenth-century etching of a market in Antigua shows how English colonists regularly frequented African markets throughout the West Indies, where naturalists like Sloane went to purchase rare specimens.

4–6. Jamaican specimens and drawing from the Sloane Herbarium: Sloane probably acquired these *Phaseolus* beans (*top left*) from provision grounds, which he visited, where enslaved Africans grew their own food. Sloane noted how African foodstuffs had been transplanted to the Americas by the slave trade and observed that Guinea corn or sorghum (*top right*) was 'used to feed the slaves'. When specimens were too difficult to transport, Sloane had them drawn: this pineapple (*left*) was sketched in terracotta crayon in Jamaica by the Reverend Garrett Moore.

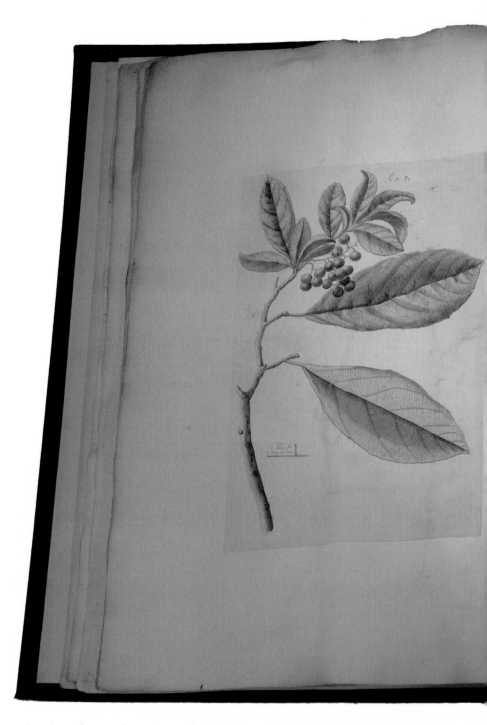

7. Jamaican clammy cherry tree: a sketch in terracotta crayon (*right*) by Moore of a live specimen has been pasted into Sloane's herbarium next to the dried specimen Sloane brought back from Jamaica in 1689. Everhardus Kickius' drawing on the left-hand page (*c.* 1700) shows the process of combining living and dried elements in composite pictures that formed the basis for the engravings published in the *Natural History of Jamaica*.

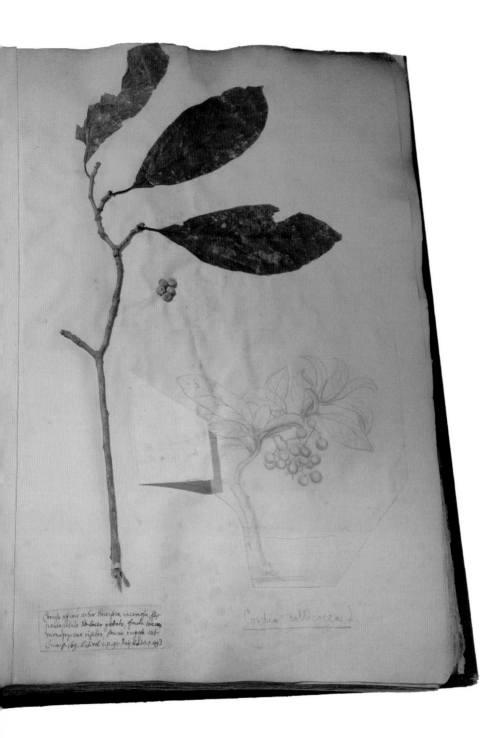

Cerasi affinis arbor baccifera racemosa flo-
ribus albidis tetrasido gobato, fructu coccineo
monopyreno viscido, semine rugosa cat-
Jum p. 169. Raj hist 2 p. 95. Raj histor p. 453

Cordia rubicaeru L.

8. *Lonchitis altissima*: this specimen and sketch from the Sloane Herbarium show the painstaking verisimilitude Sloane demanded from his draughtsmen as well as the care taken to fold and preserve large specimens, which have survived intact to the present day.

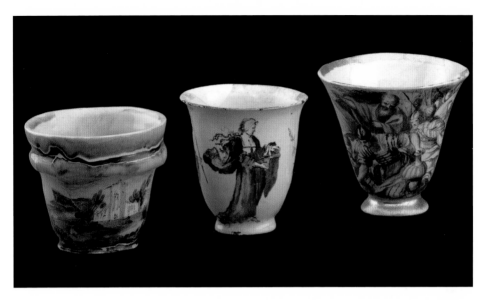

9. Chocolate as a luxury commodity: Sloane owned these glazed earthenware cups, now in the British Museum, for drinking chocolate. Their elegant styling, complete with painted biblical scenes, indicates the elite status of chocolate consumption in late seventeenth-century England.

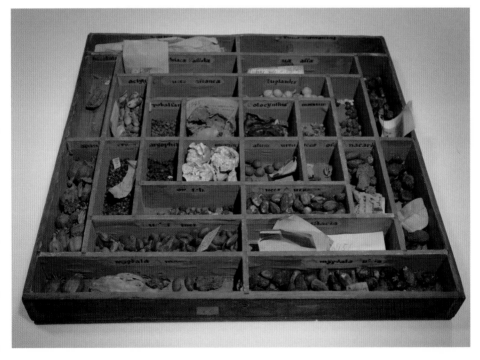

10. Pharmacopoeia drawer, now in the Natural History Museum: Sloane, who first trained as an apothecary, kept both ancient and novel remedies in his collection. He undertook to reform British pharmacopoeia as president of the Royal College of Physicians.

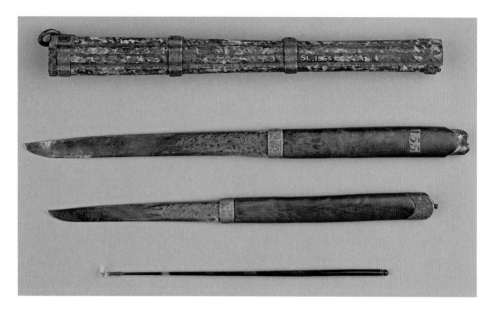

11. Instruments from a Chinese surgical cabinet: Sloane was mocked for his interest in Asian curiosities, which some critics lampooned as mindlessly fashionable Orientalism.

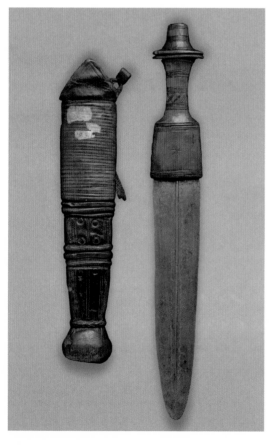

12. Cappasheir's knife and sheath: Sloane acquired a unique collection of objects relating to Atlantic slavery, including this weapon carried by those Africans who ran slave forts in Ouidah (Benin), via a British merchant named Walker.

Conspicuous new fortunes, however, threatened to undermine their own moral authority. In the eighteenth century, gentlemen were deemed morally creditable insofar as they were seen to act on behalf of the common good rather than out of self-interest. This applied to those engaged in natural philosophy, but physicians were different. The fortunes doctors made *gave* them credibility as a sign of their professional ability and trustworthiness. Yet accusations of quackery and cupidity were often extended to members of the medical elite whose upward social mobility critics ferociously maligned as arrivisme. A poem dedicated to Sloane entitled 'Aesculapius' (the Greek god of healing) unwittingly drew attention to the magical quality of medical reputation, praising Sloane's prowess in the 'misterious art' of physic. 'Form is now the main chance . . . without that, there is nothing to be done,' advised the mocking author of *The Art of Getting into Practice in Physick*, an anonymous medical satire published in 1722 immediately after Sloane's highly public roles in the quarantine and smallpox episodes, and which one historian has interpreted as a personal attack on Sloane by his rival collector John Woodward. 'Make all the noise and bustle you can, to make the whole town ring of you . . . so that every one in it may know, that there is in being, and here in town too, such a physician.' The work excoriated a certain 'Dr Timothy Vanbustle' and an 'ingenious Dr Slyeman', who enjoyed 'great hurry of business'; years later in subsequent editions of his works, William King likewise rechristened Sloane 'Jasper Hans Van Slonenbergh' and Dr 'Slyboots'. These cartoonish monikers bespoke an anti-Dutch animus that reframed Sloane's easy and friendly sociability as the relentless opportunism of a cunning outsider who always took care to side with the powerful – in Sloane's case, the Dutchman William of Orange and his Whig attendants – to further his ambitions.[75]

Eschewing fashionable medical theories was not evidence of open-mindedness or the virtues of philosophical modesty, according to such critics, but a shrewdly self-serving strategy for accumulating the maximum number of patients, contacts and fees. The way to 'get universal business' was to 'swim with the tide' and 'court, follow and chime in'. 'Clubbing with some other physicians' was vital, as was the ability 'to please and keep company' and 'fawn and sooth[e]' to 'increase your friends and acquaintance'. Titles made very fine 'trappings', as did piling up a 'mountain of books'. Fine libraries and curiosities were ideal for

bamboozling the gormless, since few could see through what were in reality little more than jumbles of knick-knacks. With 'a heap of any thing, or every thing, you will then accordingly be judged to understand every thing, and acquire the reputation of a very learned and ingenious gentleman'. Even the lowest baubles served 'to gather people together to stare, as at a High-German raree-show, or as children at a toy-shop; and the more higle-pigledy they lye, natural or artificial, false and true, the more marvellous they will appear to your spectators'. Collections didn't merely show off physicians' wealth – they helped to generate it in the first place by constructing a spuriously learned façade. Collecting objects helped with collecting patients, monies and influence. An article in the *Westminster Magazine*, 'Dr. Wriggle, or The Art of Rising in Physic', may also have been written with Sloane in mind and fired off a similar harangue excoriating the brute power of medical fame: 'bring your name before the public; it will, by degrees, become familiar to them and they will at length think you a man of consequence.'[76]

The attacks kept coming, but Sloane kept going. In the same year he sailed for Jamaica in 1687, Isaac Newton published his *Principia*, bringing him a wave of acclaim he rode to the presidency of the Royal Society in 1703. As secretary, however, it was Sloane who performed most of the society's managerial work: organizing meetings, running the society's correspondence and publishing the *Transactions*. His tasks included offering support for Newton's experimental programme and encouraging the activities of his associates Francis Hauksbee and John Desaguliers in exploring both the mechanical and active powers of matter, from practical applications of Newton's work on gravitational force to new investigations of air, light, electricity and magnetism. This programme might seem utterly distinct from Sloane's, but the differences between natural history and natural philosophy have in some ways been overdrawn. Sloane often encouraged experimental trials: to disprove the theory that rattlesnakes 'charmed' their prey, for example; on the rearing of exotic animals; on the transplantation of exotic species; and, as we have seen, on inoculation. He hosted dissections of exotic creatures in his garden for anatomical and physiological examination, including a Sumatran elephant brought to England by the East India Company in 1720 that he took apart with William Stukeley; bore testimony to experimental technologies, such as a new machine for extinguishing fires he witnessed in Belsize Park, with the ability to issue

Royal Society patents at his disposal; and supplied Newtonians like Hauksbee with materials for their experiments, such as metals for the calculation of their specific gravities.[77]

Yet tensions between Sloane and the more theoretically inclined Newton and Woodward divided the Royal Society. When Sloane exhibited a sample of amber the size of his fist during a meeting, Woodward countered that he could produce one four times as big. Sloane was a man of 'very moderate understanding', Woodward charged. 'Speak sense, or English,' he reproached him at a council meeting in 1710 where he openly harangued his colleague over a paper about bezoars. Woodward lodged a formal complaint against Sloane for what he regarded as the low content of the *Transactions* and refused to apologize for 'grimacing' at him during meetings, for which he was removed from council (for the record, Woodward accused Sloane of grimacing right back). 'There is nothing I love so much as quiet,' the conflict-averse Sloane pleaded in a letter to Ralph Thoresby. But Woodward was unshakeable: the secretary was 'very deep and designing' and had 'engross'd the whole management of the society's affairs into his own hands'. He's 'a villain and rascal', Newton reportedly concurred, 'a very tricking fellow' who was determined to bend the society to his own ends. The two men finally combined to oust Sloane from the secretaryship in 1713. Sloane was not a man of genius but merely 'an instance of the great power of industry which can advance a man', the Newtonian Stukeley agreed. 'The whole business of his life has been a continued series of the greatest vigilance over his own interest, & all the friendships he ever makes are to himself.' To Newton and Woodward, the Janus face of Sloane's easy 'friendliness' was a quietly remorseless quest for power.[78]

The year 1727, however, brought vindication. Sloane now succeeded Newton to become the only simultaneous president of the Royal Society and the College of Physicians in history – but again not without controversy. The society council's vote was unanimous in Sloane's favour but the membership was split. James Jurin, whom Sloane had patronized, with whom he had collaborated and to whom he had even entrusted Lady Sloane's medical care, became one of his most vocal opponents. Jurin recalled that Newton had always been of the view 'that something more than knowing the name, the shape and obvious qualities of an insect, a pebble, a plant, or a shell, was requisite to form

a philosopher, even of the lowest rank, much more to qualifie one to sit at the head of so great and learned a body'. Newton frequently stated that natural history was but a 'humble handmaid to philosophy'. Let her never 'forget her self, and the meanness of her station, if ever she should presume to claim the throne, and arrogate to her self the title of the queen of sciences'. After Newton had scaled the heights of genius in natural philosophy, Sloane the trafficker in baubles was a rank embarrassment. In 1733, the Swiss medallist Jacques Antoine Dassier designed a medal that commemorated both Sloane and Newton with the legend 'Ecce Gloriae Mathematicarum et Physicarum': behold the glories of mathematics and medicine (below). Dassier's medal, unlike Jurin's invective, recognized that there were two sides to the coin of knowledge in eighteenth-century Britain: physical science, and medicine and natural history. In its way, natural history was just as important as natural philosophy, accumulating and assessing natural substances on an increasingly global scale. Though a work of physical science, Newton's *Principia* itself mimicked natural history by collecting and assaying observations on phenomena such as tidal flows and the lengths

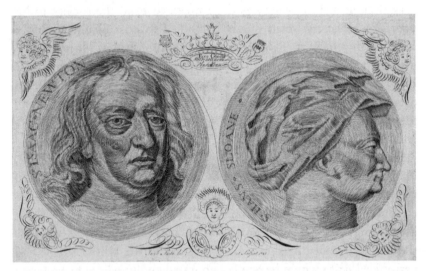

This design for a medal of Isaac Newton and Sloane by Jacob Smith, after Jacques Antoine Dassier (1733), might suggest the equality of natural philosophy and natural history in British scientific culture. But when he succeeded Newton as Royal Society president in 1727, critics derided Sloane and his brand of natural history as woefully inferior to Newton and Newtonian science.

of pendulum-swings from journeyman travellers around the globe. Though often rhetorically scorned, in other words, the methods of global accumulation Sloane employed proved fundamental even to the most prestigious forms of theoretical science with which they were sometimes damningly contrasted.[79]

Sloane remained undaunted and committed to his scientific programme. His contributions as society president were, typically, financial and cosmopolitan in character: he dropped annual subscriptions for foreign members while chasing up arrears from Fellows at home. As though to vindicate his election as president, a position he held for fourteen years until 1741, he sat for three major portraits during the 1730s. The most significant involved a defiant affirmation of his identity as a naturalist (Plate 1). This impressive oil, executed at his behest by Stephen Slaughter in 1736, places him in his presidential chair, with the society's mace near his left hand and its motto evident beneath the crest at the summit of his seat – 'Nullius in verba': on the word of no man – with figures representing Diana of Ephesus (a symbol of nature's fecundity) and Aesculapius in the background. Sloane holds a botanical illustration of Jamaican lagetto in his hands – a very particular choice. In Sloane's herbarium, lagetto is one of his most stunning pop-ups: it unfolds as a finely diaphanous natural lace shaved from the bark of the lagetto tree (p. 198). It 'so resembles our cloth[e]s', Sloane remarked of it in the Natural History, that the inhabitants of India and Africa thought that the clothing of Europeans 'grew upon our trees', while Charles II reportedly owned a Jamaican lagetto cravat. Lagetto, in other words, was exotic material fit for a king, a refinement Sloane regally adopted for himself, the delicately patterned cravat he wears in Slaughter's portrait recalling lagetto's natural latticework. Here was the figure President Sloane chose to present to the world: not the trafficker in natural commodities but the learned virtuoso and master of nature as an exquisite work of art.[80]

Sloane's scientific identity remained split, however, between public service and private commercial interest. Slaughter's portrait depicted him as Royal Society president while handling an image from his own highly commercial natural history based on a specimen in his private collection. In 1745, Sloane notably published the recipe for an ointment for sore eyes – an ailment Charles II had claimed to cure by the Royal Touch – that he had acquired in manuscript from the royal physician

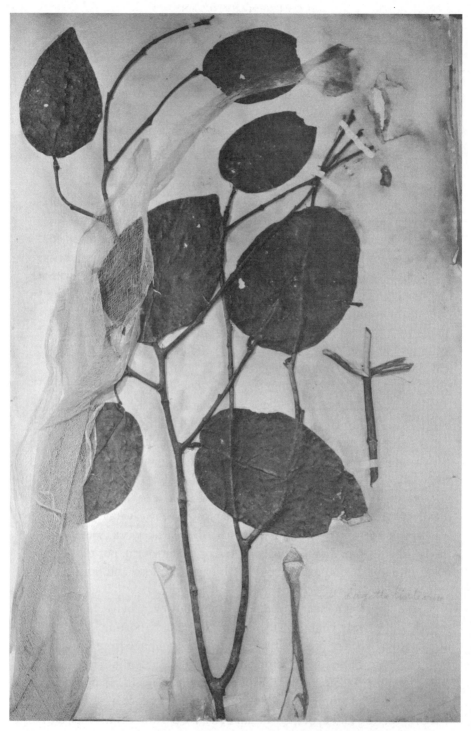

Sloane brought this stunning natural gauze specimen of Jamaican lagetto, now housed in his herbarium, back from the West Indies. Charles II reportedly owned a lagetto cravat, to which Sloane's own fine cravat in Stephen Slaughter's portrait perhaps refers.

Luke Rugeley. This formerly secret recipe was a blend of aloes, lapis and tutty (zinc oxide) in viper's grease. 'I have been always very free, and open,' Sloane stressed to readers, 'far from following the example of some physicians of good morals and great reputation, who have on many occasions thought proper to conceal part of their own acquired knowledge.' Sloane used his fortune to bankroll private collections he then aimed to disseminate – at least some of the time – affirming his civic-spiritedness and advancing still further his transformation from private physician to public benefactor. In the process, he himself nevertheless became a commercial brand. In the 1750s, a Soho grocer named Nicholas Sanders started selling what he called 'Sir Hans Sloane's Milk Chocolate', allegedly made from an original Sloane recipe. There is no corroboration for Sanders' claim and Sloane certainly did not invent milk chocolate: recipes mixing chocolate and milk date back to the late seventeenth century in France as well as England. Yet by 1774 a certain William Bill was also selling 'Sir Hans Sloane's Medicated Milk Chocolate', and by the early nineteenth century William, Edward and John White were marketing 'Sir Hans Sloane's Milk Chocolate' as 'greatly

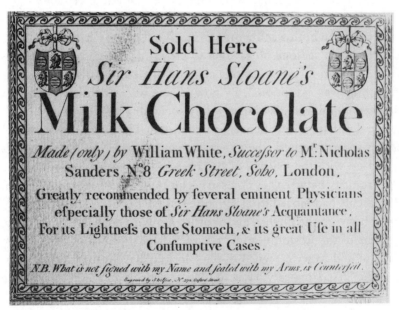

Sloane Milk Chocolate: Sloane did not invent milk chocolate but probably had the first brand milk chocolate named after him, sold by the Soho grocer Nicholas Sanders in the 1750s and later William White.

recommended by several eminent physicians, especially those of Sir Hans Sloane's acquaintance' (p. 199). Paradoxically, Sloane's reputation for disinterested judgement became a prized commodity in the medical marketplace.[81]

As Sloane turned himself into one of the pillars of the London establishment, his Irish origins became all but invisible. Ireland's Protestants were bound to England through allegiance to William III, but, in part because no formal political union was established between their two countries, they increasingly embraced their Irishness during the eighteenth century, even as they maintained hopes for closer ties to London. Sloane kept up his Irish links: he corresponded with veterans of the Irish military campaigns and contributed to charities for their welfare, and stayed in touch with his family, the Hamilton clan and friends in County Down, sending them books and medical advice from time to time. But he never revisited his native soil. Since the English associated the Irish brogue with proverbial provincial barbarism, he must have quickly shed any accent he may have had in his youth. Despite their common language and religion, 'the English of Ireland' were neither fish nor fowl in London, where the Irish enjoyed a reputation for extravagance and debt. Sloane, however, differed markedly from his countrymen in both wealth and status. 'What glory, when I think of it, for Ireland to see one of its sons so crowned,' his librarian Thomas Stack told him in 1728, but this mention of Sloane's origins by a contemporary was exceptional. By now Sloane was a rich baronet and a metropolitan fixture. With exemplary sociability, redoubtable shrewdness and unflappable patience, he had installed himself at the centre of British society. Indeed, the extent to which Sloane's self-making was bound up with the making of Britain is suggested by the remarkable synchronicity between key dates in his life and the forging of the nation. His parents had moved from Ayrshire to Ulster in 1603, the year of the union between the English and Scottish Crowns; he was born in 1660, the year of the Restoration; he returned from Jamaica in 1689 to see William and Mary crowned in the Glorious Revolution; and he dedicated his first Jamaica volume to Queen Anne in 1707, the year of the Act of Union with Scotland.[82]

Sloane's prominence at the heart of London life placed him at the centre of Britain's empire. This was an empire of peoples and goods and, as he would show with spectacular effect, an empire of curiosities.

By the second quarter of the eighteenth century, he had become famous. Londoners now read about him in their gazettes as a unique index of Britain's access to the wonders of the globe. He was Sir Hans Sloane – the most curious man in the world. The *Daily Post*, for example, reported that on Pall Mall between ten in the morning and eight at night, paying customers could see a woman with a ten-inch horn growing out of her head described as a 'miracle in nature' and 'the wonder of the age', and whom Sloane had declared the 'greatest rarity [he] ever saw'. Sloane presented the royal family with a rare mynah bird from Borneo, 'which talks better than a parrot, & is reckon'd a very great curiosity', as well as 'the effigies of a Chinese nobleman wrought in China, a curiosity of great value'. He examined a labourer in Suffolk with bristles for skin like a rhino or hedgehog, a true 'prodigy of human nature'. At Charing Cross Coffee House, a 'wonderful and surprising' creature called the 'Oran-hauton' from the East Indies was 'approv'd of' by Sloane 'to be a great rarity' and 'found worthy of seeing'. A 'flying basilisk dragon' that burnt the ground it walked on and caused 'great destruction among the negroes of the coast of Guinea' Sloane declared 'the greatest curiosity in England'. 'Madame Chimpanzee', a female ape with a penchant for drinking tea, was dissected and judged by Sloane to possess an anatomy 'perfectly human' in character. A 'wonderful' young man who wrote with his mouth 'better than thousands who pretend to it can do with their hands' likewise enjoyed the signal 'honour to be viewed by Sir Hans Sloane'. An illustrated handbill advertised a 'wild man' from the Davis Strait off Greenland, the like of which had 'never been seen in Europe', yet he had already been 'shewn twice before the Royal Family and Sir Hans Sloane'. There was no greater destiny for any rarity in the world than to be judged curious by the all-seeing Sloane.[83]

# 5

# The World Comes to Bloomsbury

## COLLECTING COLLECTORS

The vast collection of curiosities Sloane assembled was not ultimately the achievement of a single individual but the result of exchanges involving countless people across the globe. Sloane was a collector of collectors. To begin with, his wealth, connections and sheer longevity enabled him to absorb the life's work of several friends at home in England. Early on, in 1702, he took possession of the antiquities, coins and medals, plants and paintings of his 'very particular and intimate friend' William Courten. Acquiring Courten's cabinet not only boosted Sloane's collections; it was a personal homage. Almost twenty years Sloane's senior, Courten was probably the most important model of the collector Sloane knew. Taking his collections entailed a promise that they would not be dispersed – a common fear among collectors, whose sense of integrity hinged on property and posterity: they *were* what they bought and what became of what they bought. Auctions could easily split them asunder; Sloane provided sanctuary. When the Frankfurt savant Zacharias Konrad von Uffenbach visited in 1710, he remarked on seeing Sloane's 'Charleton cabinet' (Courten's alias), suggesting that Sloane may have kept Courten's objects together rather than integrating them with his own. Courten's legacy was no gift but a *quid pro quo*. Courten was in fact the grandson of Sir William Courteen, one of the early Barbados merchants, and son of William Courten who died in debt in 1655. The younger William evidently inherited those debts and used the alias 'Charleton' to evade creditors. Although he valued his objects at £50,000, he offered them to Sloane for £2,500. The arrangement helped settle the family debts while keeping the

collections together. Sloane, never short of money, and devoted to his friend, happily obliged.[1]

Despite the gender conventions that militated against their involvement in collecting, several women made key contributions to Sloane's collections. Coverture legally disqualified wives from owning property, while hostility to the very notion of female curiosity took its cue from Eve's sin in the Garden of Eden, leading female virtue to be associated with a reassuring ignorance. But this is far from the whole story. As we have seen, at one end of the spectrum, Lady Sloane's Jamaican income played a major role in Sloane's fortunes while, at the other, unnamed slave women gathered specimens for colonial collectors who sent them back to patrons like James Petiver and Sloane. The wives of merchants and planters made contributions, too, such as Mrs Leming, who sent Sloane cotton-tree worms from Jamaica, and Rachel Grigg, who sent Petiver specimens from Antigua. The names of several women appear as suppliers of objects in Sloane's catalogues. The list accompanying a collection of curiosities from Lapland (Finland), sent by Charlotta Adelkrantz from Stockholm in 1736, is particularly striking. It includes a coat and gloves, a spoon made of bone, a sledge and collar, halter and reins for reindeer, snow shoes, a drum with a hammer and a Laplander's bag 'with some odd little trifling things preserved in it'.[2]

The contributions of Maria Sibylla Merian were spectacular. Born in Frankfurt-am-Main in 1647, Merian learned to paint under the tutelage of her stepfather and was raised in the radical Pietist tradition of Labadism, which instilled in her a zealous appreciation for the natural world as a divine source of wonder. She moved to Amsterdam and, after separating from her husband, crossed the Atlantic to visit the colony of Surinam in 1699, which was run by the Dutch East India Company. There, with her daughter Dorothea, and with the assistance of Amerindian natives and African slaves – 'myne slaven' as she called them – she made collections and completed numerous pictures of plants and animals. Remarkably, Merian negotiated both the vicissitudes of colonial travel and the hierarchies of the Republic of Letters where artists – whether male or female – rarely published their own work, instead contributing to the natural histories of gentleman authors like Sloane. She resold specimens she had received as gifts, sold her own insect preparations as well as fabrics embroidered with her designs, and took advantage of the market for exotic scientific art,

publishing a book of great interest to specialists in insect generation under her own name, the *Metamorphosis insectorum Surinamensium* (1705). Sloane took notice. After Merian had returned to Amsterdam, he acquired sixty of her Surinam drawings through Petiver, who met with her there (Plate 13). This was a tonic for Merian's income, her reputation, Sloane's collections and also Petiver, who prided himself in prising open his patron's purse on the strength of his judgement. Merian's art was beyond compare, he boasted to the Danzig botanist Johann Philipp Breyne, and 'hath cost Dr Sloan on my recommendation about 200 guineas'.[3]

Merian's productivity was facilitated by her separation from her husband. But other female contributors to Sloane's collections found themselves embroiled in struggles over family property. Where Sloane was lampooned over collecting, women could face legal accusations of insanity. Eleanor Glanville (née Goodricke) of Tickenham Court in Somerset was a wealthy widow who devoted herself to insect collecting and corresponded with Petiver, giving him a number of rare butterflies. After Glanville remarried, her second husband sued for control of her estate. Both Sloane and John Ray appear to have testified on her behalf, and with effect, although her son contested her will after she died in 1709, citing her lepidopterism as proof of madness. Mary Somerset, Duchess of Beaufort was a serious botanist who, also liberated by the death of her husband, developed plant nurseries at Chelsea and Badminton stocked with specimens from Asia to the Caribbean. Badminton was 'a paradyse of a garden', thought Petiver; Sloane judged it the finest in Europe, complete with 'matchless stoves' for breeding tropical species. The duchess delighted in gaining admittance to Sloane's circle. 'When I get into storys of plants I know not how to get out,' she confessed. She exchanged seeds and plants with Sloane, Petiver and William Sherard; was thrilled that Ray cited her plants in his work; and corresponded with naturalists around Europe. Sloane recommended Everhardus Kickius to draw for her, and Sherard as a tutor for her grandson, and provided moral support as she too fought her family for control of her husband's estate. In return, she bequeathed her twelve-volume herbarium to Sloane in 1715. Two decades later, Sloane bought up her fine Chelsea residence at Beaufort House not far from Chelsea Manor.[4]

Widows played a pivotal role in transmitting collections. Sometimes they did so for sheer economic survival. One, Mary Campbell, wrote to

Sloane to tell him that her husband had died, leaving many things 'I am ignorant in the value of', including precious stones and books. 'I leave the judgment of them both to your honour and am certain you will not undervalue the merits of them especially as they are the present treasures of a poor widow.' Sloane's response is not known but other instances, especially where he was close to the deceased, show the interest he took in such cases. After Ray had died in debt in 1705, his widow Margaret complained that she was now forced to live on £40 per year. The botanist Samuel Dale, to whom Ray left his papers, conveyed her wish that Sloane help her to obtain £100 for her husband's library rather than the £80 she had been offered. Sloane intervened and Mrs Ray got her extra £20. He also brokered further contributions from Ray's old patrons, the Willughby family, on her behalf. At times Sloane's collecting came close to charity. 'For god sake save me from utter ruine,' begged the calico printer and firearms inventor Claudius Dupuys, who put on commercial curiosity shows in London. Dupuys received several loans from Sloane, on one occasion requesting £100 to prevent his falling foul of certain 'unconscionable people'. But desperate debtors could pay handsome dividends. Sloane ended up with rarities Dupuys had from China, Japan, Poland, Mexico and Turkey.[5]

James Petiver was the most energetic specimen collector of his day. He was a one-man accumulation centre, sending instructions for making specimens to contacts in the Americas and both South and East Asia, repeating these often in pamphlets and letters. Should you happen upon a curious surgeon, he instructed one of his correspondents, 'you may be pleased to give ym a copy of what in this paper may be most to their purpose . . . and I should be very glad to hold a correspondence with ym and most willingly inform ym of ye utmost of my power in any thing they shall demand'. Like Sloane, Petiver was a collector of collectors. He directed a surgeon named Gidly on Tenerife to hire a Spaniard or an islander to carry a basket and quires of paper to fill with plants from the island's mountaintops, offering to cover all costs, and instructing Gidly to paste his instructions 'on ye inside of yr surgery chest, that by yr daily sight of it I may prevent yr forgetting me'. Petiver's 'catalogue of friends', as William King had scorned them, constituted the largest collecting network Sloane knew of and fuelled Petiver's hectic publication programme of booklets that listed and illustrated plants, animals and minerals. Petiver used his contacts to

gather 'a greater quantity [of specimens] than any man before him', Sloane wrote, many 'not taken notice of by any natural historian before him'.[6]

But there was a price to be paid for such furious industry. 'Any child of 6 years old' could follow his instructions, Petiver barked at one of his correspondents; 'we know not how long we have to live,' he scolded another. 'It is a great[er] charge & trouble to make collections than you suppose,' still another hit back at him. Petiver was a brilliant mess whom Sloane praised for his zeal but also blamed for 'retarding' the appearance of his second Jamaica volume, so time-consuming was it to 'bring his collections and papers out of the confusion I found them in' after he took charge of them. Despite or perhaps because of his 'very great and indefatigable industry', Sloane explained to his readers that Petiver 'did not take equal care to keep' his specimens but 'put them into heaps, with sometimes small labels of paper, where they were many of them injured by dust, insects, rain, &c'. Like Courten, Petiver realized that Sloane made the logical custodian for his life's work. So he redrafted his will and, after he had died in 1718, Sloane paid his sister £4,000 for his thousands of plants and insects. Again, Sloane set the seal on a friendship by buying collections that dramatically enlarged his private museum in a single stroke, while promising to keep them 'for the good of the publick, doing right to his memory', as he put it, 'and my own reputation'.[7]

By the eighteenth century, collections were no longer the exclusive playthings of aristocrats obsessed with courtly self-fashioning and family lineage. Auctions opened up new possibilities for others to buy them. Little evidence exists of Sloane refusing curious or rare objects outright, but if he did, the issue was probably cost. Finding the right price was one of the measures of a connoisseur's judgement – and that of his brokers. Such responsibility caused Sloane's agents no little stress as they could never be entirely sure how much he wished to pay during the time-sensitive negotiations in which they engaged on his behalf. Pioneered by the Dutch in the seventeenth century for the sale of art, regular auctions were established in England after the Restoration and, especially after the opening of Sotheby's (1744) and Christie's (1766), became a prime avenue of social mobility, allowing those with new money to buy up the trappings of gentility in an instant. Auctions were thus a natural hunting-ground for Sloane, particularly as they

began to feature *naturalia* and because they afforded access to rarities acquired by travellers beyond the British world.[8]

The death of the Halle botanist Paul Hermann in 1695 presented one such opportunity. Hermann had been engaged as a surgeon by the Dutch East India Company, which had successfully beaten out Portuguese and English rivals in the spice trade. Since 1672, Hermann had spent time at the Cape of Good Hope, where the Dutch had established a settlement, and several years in Ceylon (Sri Lanka), where he formed botanical collections with help from the indigenous Khoikhoi and Sinhalese respectively. Hermann's renowned herbal entitled the *Paradisus Batavus* (1698) illustrated the East Indian species being cultivated in the University of Leiden's botanical garden, where he had returned to assume a professorship.[9]

Sloane's man in Leiden was the botanist William Sherard, who had known Hermann and edited the *Paradisus* after he died as a favour to Madam Hermann, whose livelihood was to be secured by the auction's proceeds. Sherard wrote to Sloane that though there were only about twenty 'Indian animals in spirit of wine' for sale, there were a thousand rare plants. But prices proved volatile. Hermann's books reportedly sold for a vast sum, especially his botanical volumes, three times as much as they had cost. The auction was crowded with many 'curious men', Sherard told Sloane, each bidding 'according to ye phantasie he has or occasion for them'. He sent several sale catalogues, essential tools for buying at a distance, back to London for Sloane to mark up, a practice he would later repeat from Venice and Rome, where he distributed lists of books Sloane wanted to local booksellers (some 700 sale catalogues remain in Sloane's library, many of them marked up). Communications were slow, however, and Sherard wasn't sure how high Sloane, who observed that Madam Hermann 'asks too much for her rarities', wished to go. 'Had you put any prices upon those you mark'd in yt letter,' Sherard explained, 'I shou'd have known what to have done.' In the end, he had to make decisions on his own. He acquired several volumes but offered to buy them back if Sloane judged the price too steep. On the occasion of another Hermann sale in 1711, Sloane sent Petiver a letter of credit for £50, receiving annotated catalogues in return that tallied up how much Petiver had spent, including for example the guinea Petiver had put down for a single bird of paradise which, he wrote, 'I hope you will not think too much.' Petiver explained how

he, too, had to contend with 'potent antagonists' during the bidding. Thanks to Sherard and Petiver, as well as his own dealings with Anna Hermann, Sloane eventually acquired Hermann's precious Cape specimens (some of the earliest South African botanical collections to reach Europe), some Ceylon material and original drawings for the *Paradisus*.[10]

Sloane purchased numerous such collections over the years. He bought the plants of the physician Christopher Merrett (d. 1695); the seeds and fruits of his Royal Society colleague Nehemiah Grew (d. 1712); and ninety-six drawers of insects and albums of insect paintings from Joseph Dandridge (d. 1747), who designed patterns for silk weavers in Moorfields. Many if not most such acquisitions were handled by brokers. In London, John Bagford, a shoemaker turned bookseller and denizen of St Paul's Churchyard, procured books and clients for Sloane. Sometimes the two went shopping together. 'I shewed [Sloane] your catalogue,' Bagford informed one acquaintance who was looking to sell, asking his price and promising that Sloane's money was as good as his word: 'I know no man so curious . . . or of more generous disposition.' Sloane was not shy about bulk-buying. He bought a sizeable cache of ancient coins and Greco-Roman antiquities, originally belonging to Cardinal Filippo Gualtieri (d. 1728), in a single purchase through the reportedly unscrupulous Abbé Bernardo Sterbini in Rome. Indeed, Sloane bulk-bought perhaps two-thirds of his antiquities, including Egyptian antiquities. He was always poised to strike. He snapped up books from Louis XIV's secretary of state Jean-Baptiste Colbert (d. 1683), colleagues like Grew and Robert Hooke (d. 1703) and celebrated writers such as Daniel Defoe (d. 1731) when their libraries came up for sale. Death was the collector's friend: it could turn enmities, as well as friendships, into significant gains. After Sloane's nemesis Leonard Plukenet died in 1706, his extensive specimen collections passed to John Moore, Bishop of Ely, who died in 1714, leaving his widow to handle his estate. Within two years, Sloane had bought Plukenet's 8,000 plants and numerous insects through a private sale.[11]

Sloane was, of course, only one of many learned collectors in early eighteenth-century Britain. Bagford, for example, also bought for Courten, Samuel Pepys and John Woodward. Sloane realized the impossibility of achieving primacy in every domain, so made natural history and medicine his focus. 'You cannot err', he told Sherard, 'in

buying [me] any books of voyages . . . or old physick books.' He reached agreements with competitors, acquiring many medieval manuscripts on alchemy and medicine but forwent historical manuscripts to a large degree, yielding to deep-pocketed rivals such as the Earls of Oxford Robert and Edward Harley. In return, he secured the earls' agreement to defer to *him* on travel and natural history through the brokerage of his librarian Humfrey Wanley, who persuaded Sloane that if he let the earls buy up the items they coveted, they would 'readily yield up divers things to you'. Competition could not be completely curbed, however. Sherard also bought for himself, Courten and Woodward, as well as for aristocrats such as Lord Pembroke and the Duke of Buckingham. The son of a landowner, Sherard was well connected and though lacking in wealth was not afraid to speak his mind. 'I hear not a word of yr History of Jamaica, pray don't defer it,' he told Sloane in 1706, 'ye longer you stay, ye more business will croud upon you.' After working for the Duchess of Beaufort, he obtained the lucrative post of consul for the Levant Company at Smyrna in Ottoman Turkey, where he occupied himself with antiquities, travelling through Asia Minor. Collecting inscriptions from monuments and medals became his solace in exile, though their pursuit cost him much 'anger, fatigue, and expense', distracting him from his first love of botany and the goal of publishing his own authoritative *pinax* (catalogue) of plant species. After his house had been burgled and his collection of ancient coins stolen, he returned to England in 1717, facilitating Sloane's access to Arthur Rawdon's live Jamaica plants in Ulster, while also collaborating with the German botanist John Jakob Dillenius.[12]

Relations between Sherard and Sloane soured, however. Pious botany could turn bitter, as Sloane's intercourse with Plukenet and Woodward attested. Sherard's resentment had been simmering for years. '[He's] wallowing in money,' he snarled to their mutual friend Richard Richardson. Trying to raise funds for the naturalist Mark Catesby's expedition to the American colonies in the 1720s, he protested that '[Sloane] will not procure a subscription among his friends, as he easily might' and that this smacked of hypocrisy, since he had already enjoyed 'a large share of all that has come into England'. Earlier on, Sherard had assured Sloane that a certain parcel of specimens would 'come not into Dr. P[lukenet]'s hands' and told him how glad he was Sloane now owned Plukenet's plants. But at some point during

the 1720s, it seems that Sherard withheld some specimens from Sloane (originally from the Danzig botanist Breyne) and in response Sloane refused to share the plants *he* had obtained from Petiver and Plukenet. The impasse poisoned their relationship. Sloane's refusal undermined Sherard's *pinax* project and he died soon afterwards in 1728, his ambitions in ruin, though he did exact a measure of collector's revenge. While a number of his specimens are scattered throughout the Sloane Herbarium, Sherard bequeathed most of his plants (over 10,000 sheets) and his library to Oxford, where he had studied.[13]

Sloane's ability to collect others' collections was unmatched by his contemporaries. But there was perhaps something cannibalistic about the way he swallowed entire lives' work, and to some, the means by which new collectors bought their way to massive new holdings became

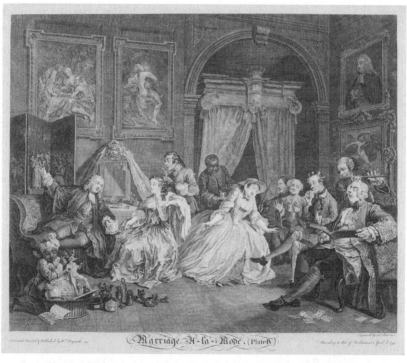

Consumption and corruption in Sloane's London: in William Hogarth's satirical series *Marriage à la Mode,* part IV, 'The Toilette' (1743), an African servant (centre) dishes out hot chocolate while an Asian boy (left) fondles curiosities with an auction catalogue at his feet.

increasingly associated with fears that the fortunes which enabled voracious acquisition portended the ruin of British society. In the fourth scene of *Marriage à la Mode* (1743), his biting commentary on parvenu Britain, William Hogarth linked together the consumption of commodities, people and objects by juxtaposing a foppish London crowd with a liveried African servant doling out a dish of chocolate and a turbanned boy in Oriental garb fondling a figurine, an auction catalogue lying suggestively open beside him (opposite). Chocolate and curiosities; African servants and eastern baubles – this was the world of colonial commodity and metropolitan accumulation in which Sloane moved, made his fortune and assembled his collections. The growth of such collections was one powerful expression of Britain's expanding commercial and imperial reach. For Hogarth, however, the spectacle of accumulation was neither tasteful nor enlightened but ridiculous and corrupt.[14]

## KEEPING COMPANY IN THE EAST

In 1749, Sloane published an investigation into the alleged healing powers of the 'serpent-stone' and the 'rhinocerous bezoar' in the *Philosophical Transactions*. The sceptical doctor was determined to sort through medical fables of Oriental lore. The first specimen was said to have been extracted from the head of a poisonous snake called the *Cobra de Cabelo*. But Sloane judged that both stones had issued from the stomach of a rhino. He recounted how he had received a pair of rhino horns from his 'ingenious friend and acquaintance' Charles Lockyer, who had braved the 'barbarity and cruelty' of Africa's southeast coast to procure them. Their correct anatomical placement was a mystery – so Sloane resourcefully used the picture on 'a very small brass medal of Domitian in my collection' as a guide for the illustration he commissioned for his article. His focus, however, was on bezoars' legendary curative powers. He himself had purchased several rhino stones from one Daniel Waldo, an 'old acquaintance' of his in the East Indies, although he strenuously counselled the Duke of Bourbon against spending a hundred pistoles on a single snake-stone, offering instead 'to make him a present of one, which I afterward did, lest he should be imposed upon by giving such a price'. Sloane obtained several more

stones from the itinerant surgeon Alexander Stuart, who explained that they derived from the insides of buffalo, not serpents as others believed, or so he had been informed by a knowledgeable Catholic missionary. According to the traveller from Lemgo in Westphalia Engelbert Kaempfer, cobra stones did indeed possess medicinal qualities that helped soothe viper bites, only they didn't come from snakes. They were the artefacts of 'a secret art made by the Brahmens' of India.[15]

This was a vintage performance by Sloane, using his personal collections to sift through claims about supposedly magical substances. Just as significant as what he said, however, was *how* he said it, drawing on a range of contacts in colonial trading companies. Waldo and Stuart worked for the English East India Company (EIC); Lockyer for the EIC and South Sea Company; and Kaempfer for the Dutch East India Company. Just as Sloane's private affairs intertwined with public institutions at home in London, he tapped a variety of state-sponsored commercial and military operations to amass great numbers of curiosities from abroad. His Asian contacts stretched from the Cape of Good Hope and East Africa to India and China, as he carefully recorded in the provenances he specified in his many catalogues. Among the astounding variety of rarities that came to him via this network was a zebra from the Cape of Good Hope; the 'habet of the Queen of Madagascar' woven from palmleaf; shells from Surat and Bombay (Mumbai); an 'instrument or whisk [brush] for cleaning of pictures or China ware of an Indian cows tail with a mother of pearl handle' from Surat; shoes from the Coromandel Coast; Indian ink and an Indian lantern; 'Streynsham Masters an English merch[an]ts passe or privilege from the East India princes'; Indian plates or saucers made of cane with Japanned bottoms; a live porcupine from the Bay of Bengal; rose oil perfume from Persia which 'by the great Mogol . . . is used as a great perfume in their baths'; a pigeon from Pegu (Bago, Myanmar); shells from Malacca (Malaysia); beetles from Pulo Condore (Côn Sơn Island, south of Vietnam); a 'hollow trunk tube of [palm] wood for shooting poyson'd arrows . . . likely from the Celebes' (Sulawesi, Indonesia); butterflies from Bencoolen (Bengkulu, Sumatra, in Indonesia); an orang-outang from Batavia (Jakarta) and a 'homo sylvestris' from Borneo; an elephant's brains contained in a gold case originally from the Sultan of Jambi (Sumatra); a large Sumatran bat; 'a rib'd two eard China bottle very ponderous made of redish earth glaz'd over wt. green said to be

1000 years old'; 'a China tomb stone taken of a grave at Vampo . . . a small town or village in the river of Canton [Guangdong]'; 'a hatt from Tunquin [Tonkin] where it belonged to the queen'; a Chinese compass; 'a bowl, a tea pott, 7 saucers, 6 cups, a sugar dish & cover & tea canister all made of pastboard & paper painted upon to imitate China ware made by a Dutchman who lived in Japan'; 'an east Indian god [or] idol made in gold'; and grains of Asian sand.[16]

Excepting those objects from Sumatra and Japan, these curiosities came to Sloane from employees of the EIC, many of the provenances he recorded being the locations of company factories (trading stations). A preponderance of them came from India under the reigning Mughal Empire (1526–1857). The Mughals were Muslims who during the sixteenth and seventeenth centuries had conquered many of the Hindu dynasties of the Asian subcontinent under Babur (d. 1530) and subsequent emperors such as Babur's grandson Akbar (r. 1556–1605), who developed a centralized bureaucracy that generated substantial revenue for administering these dramatic territorial gains. Akbar was liberal and tolerant in matters of religious conscience with respect to India's majority Hindu population, but his successor Aurangzeb was more conservative and reinstated controversial policies such as the *jizya* tax on non-Muslims, fostering disharmony. Conflict with Hindus, notably under the Maratha leader Shivaji, with Sikhs in the north-west and with rival Muslim states like Golconda also took their toll. Yet despite serious challenges from the Marathas, the Mughals remained the dominant force in the subcontinent and thus proved instrumental in the improvement of British fortunes towards the end of the seventeenth century.[17]

Asia's extensive trading opportunities enticed several European powers. The EIC had originated under Elizabeth I in 1600 as a monopoly joint-stock company to compete with Portuguese and Dutch merchants for the commerce in spices and textiles run by Hindu and Muslim merchants, which reached from the Red Sea and Persian Gulf in the west to Ming China and Tokugawa Japan in the east. Beginning in the 1670s, the company took advantage of a boom in textile production on India's Coromandel Coast to develop Fort St George, which was attached to the expanding population centre of Madras (Chennai). It pursued a strategy of opportunism in the context of violent confrontation, ingratiating itself with Mughal potentates to obtain armed protection against local rivals such as the Marathas, with whom the

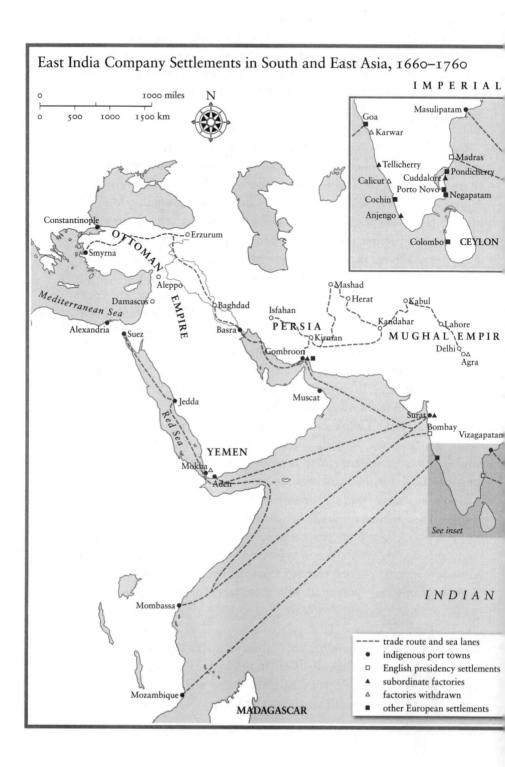

# East India Company Settlements in South and East Asia, 1660–1760

**IMPERIAL**

N

1000 miles
500   1000   1500 km

Goa
△ Karwar
Masulipatam ●

▲ Tellicherry
Calicut △   Cuddalore
Cochin ○   Porto Novo
Anjengo ▲

□ Madras
● Pondicherry
■ Negapatam

Colombo ■   **CEYLON**

Constantinople ●
● Smyrna
**OTTOMAN**
○ Erzurum

*Mediterranean Sea*
Damascus ○
Alexandria   ● Suez
Aleppo ○
**EMPIRE**
Baghdad ○
Basra ●

Isfahan ○
**PERSIA**
○ Kirman
Gombroon ● ▲ ■

○ Mashad
○ Herat
○ Kabul
Kandahar ○   ○ Lahore
**MUGHAL EMPIR**
Delhi ○ ○ △
Agra

● Jedda
Muscat ●

*Red Sea*
**YEMEN**
Mokha △
Aden ●

Surat ● ▲
Bombay □   Vizagapatan

*See inset*

**INDIAN**

Mombassa ●

□

Mozambique ●
**MADAGASCAR**

- - - - trade route and sea lanes
● indigenous port towns
□ English presidency settlements
▲ subordinate factories
△ factories withdrawn
■ other European settlements

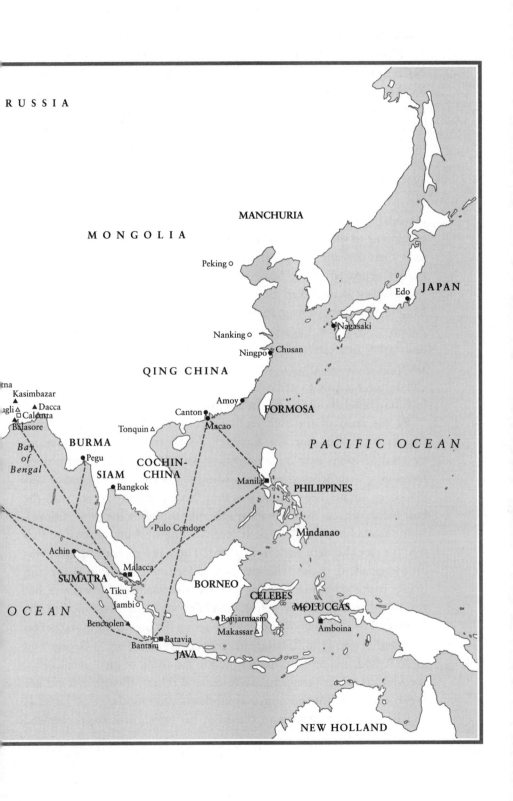

RUSSIA

MONGOLIA

MANCHURIA

Peking ○

JAPAN

Edo ●

Nanking ○

Nagasaki ●

Ningpo ● Chusan

QING CHINA

FORMOSA

tna

Kasimbazar ▲

ugli △ ▲ Dacca

□ Calcutta

Balasore ▲

Amoy ●

Canton ●

Macao ●

Tonquin △

PACIFIC OCEAN

Bay
of
Bengal

BURMA

Pegu ●

COCHIN-
CHINA

SIAM

Bangkok ●

Manila ■

PHILIPPINES

Pulo Condore ●

Mindanao

Achin ●

Malacca
■

SUMATRA

Tiku △

Jambi ○

BORNEO

CELEBES

MOLUCCAS

OCEAN

Banjarmasin ●

Amboina ●

Bencoolen ▲

Makassar △

■ Batavia

Bantam

JAVA

NEW HOLLAND

Mughals were often at war. Mughal hegemony thus allowed the EIC to establish a toe-hold in India, initiating a half-century of commercial expansion in tense coexistence with their hosts. The company used local traders to act as intermediaries with agricultural producers and craftspeople and forged links to well-connected merchants like Kasi Viranna, who was highly influential at Madras. EIC factories were headed by English merchants but harboured a mixture of different groups, faiths and agendas. The English used slaves from Madagascar to build their trade forts, which contained numerous foreigners including Africans, Portuguese, Persians and Armenians, and contracted mercenaries and slaves to fight their enemies, though they also lost employees to the Dutch and the Indians (some converting to Islam) to seek their fortune. Desperate to consolidate local support, company envoys appeared at the Mughal court bearing gifts for the emperor, though they struggled to identify novelties that might win favour. The Mughal emperors were undoubtedly curious about the Franks (as South Asians termed the Europeans) even if they saw them as uncivilized and rather untrustworthy characters. But perhaps because rulers like Jahangir (r. 1605–27) had already amassed curiosities from Portuguese emissaries, ranging from exotic fruits to cartographic globes, they were less than bowled over by English offerings.[18]

By the start of the eighteenth century, the EIC was challenging for an increased share of Europe's Asian trade but faced serious internal divisions over its organization and the distribution of profits. Interloping – unlicensed private trading – was rife, and allegiance was always in doubt. The trouble was that those company agents with the best local contacts were the most valuable *and* often the most disloyal. Many made handsome personal profits while working, at least in theory, for stockholders back in England. Thomas Pitt, for example, was an independent trader who amassed a fortune trading in sugar and horses in the 1670s before being arrested and fined as an interloper, but continued to flourish as a free merchant with the assistance of the Nawab of Bengal, who invited him to set up his own trading station on the Hugli River. Pitt ultimately became governor of Fort St George and an MP. Endemic profiteering resulted in the recall of men such as Pitt, the Madras factor Streynsham Master and others, though this did not prevent Master from gaining a knighthood afterwards. Since James II had been a major backer of the EIC, his exile encouraged renewed

debate about what role the state should play in its running after 1688. To many, the company was a tyrannical monopoly that needed to be broken up. Ambitious challengers, including several Sloane associates such as the banker Gilbert Heathcote and the Bombay factory governor Sir Nicholas Waite, formed a 'New Company' in 1698. Its creation spawned a decade of wrangling over rising profits until 'Old' and 'New' Companies finally merged in 1709.[19]

Sloane obtained Asian curiosities by deftly cultivating contacts with those running the company, as well as those challenging it. Elihu Yale, for example, was a friend of Pitt's and a rapacious private trader who curried favour with local governors through ostentatious gifts, made a fortune in diamond trading and succeeded Streynsham Master at Madras before he too was recalled for profiteering. Yale collected fine Asian furniture and had a particular fondness for gems. His collections included a Mughal turban button he had acquired from Sloane that featured a sapphire surrounded by gold, quartz, emeralds and rubies. Yale, meanwhile, gave Sloane a 'very large shield . . . made of an elephants or rhinocerous hide', procured himself a Royal Society fellowship with Sloane's help and ultimately immortalized his name by bankrolling a new college in the American colony of Connecticut. The bath perfume Sloane owned which was used by 'the great Mogol' (the Mughal emperor) came from Sir Nicholas Waite at Bombay, who also sent him some 'very large and strong' Indian paper. Sloane's live porcupine came from the Bay of Bengal as a gift from Gilbert Heathcote; he kept it alive for several years in his garden, nursing it on a strict diet of fresh carrots. His South African zebra came from Charles DuBois, EIC treasurer, while his Chinese compass, Indonesian arrow-shooter and several swords and spears came from John Heathcote, son of Gilbert, and an EIC director. Charles Lockyer, the accountant, EIC man and manager of Sloane's South Sea Company investments, who published an *Account of the Trade in India* in 1711, gave Sloane the rhino horns, the orang-outang and the Vampo tombstone. Sloane even obtained the 'passe or privilege' Streynsham Master had used in his personal dealings with Indian merchants, albeit as a gift from the Archbishop of Canterbury (how His Grace acquired it is a mystery).[20]

The prestigious pedigree of souvenirs like Master's pass clearly contributed to their value for Sloane, but he obtained many more curiosities from those lower down the EIC hierarchy, especially journeyman

surgeons. Such collections were the fruit of extensive interactions with the inhabitants of the subcontinent. For example, the Madras-based surgeon Samuel Browne ran the botanical garden (tended by slaves) at Fort St George, where he worked in the company hospital. He also flourished as a diplomat and mediator. In the 1690s, the Mughal general Qasim Khan availed himself of Browne's services, encouraging him to broker relations between the company and the Mughals' nawab clients in the Carnatic in southern India (Tamil Nadu). Browne's activities encouraged and riled company officials at the same time: they were happy to have his intelligence on Mughal plans but feared he might defect. Browne observed the practice of Greco-Arabic-Ayurvedic Unani medicine in Mughal courts and camps and dispatched specimens to Petiver, including plants with Malabar and Gentue (Telugu) labels as well as Persian provenances, obtained from local bazaars. Medicinal gardening was a tradition not only in Renaissance Europe but also among Asia's Hindu and Muslim populations, who possessed vast knowledge of Indian flora. European projects in compiling catalogues of species were thus not unique but parallelled by Indian botanists in places like Madras, who were already experimenting with species from South and East Asia, Europe and the Americas. When Petiver died, Sloane inherited the specimens Browne had sent him, and they remain in the Sloane Herbarium today. Sloane also advised the EIC on specimen preservation and sent the Royal Society fruits grown in England from company seeds.[21]

Sloane's greatest hauls often came from the most obscure suppliers, and came not via gifts but through business transactions. Daniel Waldo was a company surgeon in the Gujurati port city of Surat on India's north-west coast in the early 1700s. A site of persistent conflict between the Mughals and Marathas, Surat was being outstripped by neighbouring Bombay but remained an important node in regional trading. Waldo sent Sloane the 'whisk' for cleaning chinaware; the thousand-year-old bottle; a variety of Asian oils; 'idols' and amulets; a brush made of bamboo cane; a ruby-encrusted dagger; and minerals and stones. One single parcel (probably sent around 1704–5) included a stuffed bird and a box containing a Chinese snail, a large shell, red beans and a bottle of sulphur oil. Waldo was no one-man show, however; he bought from Indian traders at bazaars; sent Sloane a writing box via his London-based sister; and supplied some medicinal balm of Gilead through a courier

named Lock. Sloane paid £1 6s for the whisk; 7s 6d for the writing box; and £2 2d for the dagger.[22]

Sloane first met Alexander Stuart when the young Scot was setting off for Asia, like so many of his countrymen, to seek his fortune as a company surgeon. 'I beg your pardon for not waiting upon you last night according to promise,' Stuart told Sloane in one note in the early years of the century and promised 'to wait upon you to morrow morning att your house by nyne; or att the coffee-house by seven att night and shall give you what satisfaction you please to demand'. A gift of conspicuously exotic mangoes followed to underscore the point, as did promises to send back treasures from men already out in Asia. In the meantime, perhaps Sloane might be interested in some 'uncommon, tho very regular' ice? Stuart missed another appointment, so made more promises: Sloane would have anything he wished from China, Batavia, Borneo and beyond. The message in the mangoes was that Sloane needed voyagers like Stuart to build up his collections as much as they needed him for his patronage. Sloane was not to be disappointed. Stuart's present of an African servant may have gone awry years later, but by then he had already transmitted plants from the Levant and a rich array of Asian curios, including ink, a cup crafted from a shell, medicinal beads, a sample of lapis, a Malaysian dagger made from antelope horns and a coarse cloth pocket-book with notes in Malabar (Tamil). In return, Sloane helped Stuart to become a physician and author, publishing his account of an Indian temple in the *Philosophical Transactions* and co-sponsoring his training in Leiden, where he arranged for his introduction to the renowned anatomist Hermann Boerhaave. Stuart later became physician to the royal family and a Fellow of both the Royal Society and the College of Physicians, winning the society's Copley Medal for his research on muscular anatomy. It was an impressive climb but, typically for the age, a bumpy one. Stuart died in debt after the South Sea Bubble wiped him out in 1720.[23]

The EIC did not limit its operations to India but pushed on aggressively, if falteringly, to try to establish itself in and around China. Zhōngguó or the Middle Kingdom was so called because its inhabitants believed that it lay at the centre of the civilized world, where their emperor acted as the lynchpin between earthly and celestial realms, leading them to regard foreigners as uncivilized barbarians. Although

the Chinese had made exploratory and trade expeditions into the Indian Ocean, and their merchants had established themselves in much of South-east Asia, they retrenched after 1433 to focus on stabilizing their northern frontier against the Mongols. Rather than developing their maritime trade, the Chinese relied instead on fertile soils and rich agricultural traditions to feed their populations, in particular through the cultivation and distribution of rice through extensive use of canals. The imperially expansionist Qing dynasty seized power from the declining Ming in 1644 and embarked upon a series of daring campaigns that resulted in the conquest of Central Asia, extending their borders to Tibet and East Turkestan in the west and stabilizing the Mongol border. The Qing were Manchus from the north, an ethnic minority far outnumbered by the majority Han Chinese, so they built on China's long and sophisticated tradition of centralized 'Mandarin' bureaucracy and meritocratic civil service to consolidate their power. They pursued a programme of cultural assimilation by inculcating Confucian values through the school system to encourage civil obedience. They also undertook ambitious surveys to map both their territories and their new subjects: the 'Miao' albums they produced pictured and described China's fifty-five official minority ethnic groups as aids to local administrators. After the suppression of the Revolt of the Three Feudatories by the Kangxi emperor in 1681, the Qing were unified and powerful, the greatest power in Central Asia, but remained highly cautious about foreign overtures, even as they welcomed Jesuit missionaries into their midst bearing new scientific knowledge.[24]

The English drive to penetrate the Middle Kingdom and access new markets produced mixed results for traders, but for Sloane it was a boon. One of his most productive relationships was with another Leiden-trained Scot, James Cuninghame. Encountering Cuninghame in the Sloane Herbarium today is a remarkable experience: it contains the plants he gathered in Ascension Island; the Canaries; the Cape of Good Hope; Batavia; the Chinese islands of Crocodile (Matsu), Emuy/Amoy (Xiamen), Colonshu and Chusan (Zhoushan); the Straits of Malacca (Malaysia); Cochinchina (South Vietnam) and, to the south, the island of Pulo Condore. These are some of the earliest East Asian specimens brought to Europe; Cuninghame transmitted some 600 plants and nearly 800 watercolours done by local Chinese artists – roughly the size of Sloane's own Jamaica collections. He maintained

relations with multiple sponsors, from gardeners such as Samuel Doody and Robert Uvedale to major patrons like Petiver, Plukenet, DuBois and Heathcote. Ray and Woodward also made use of his specimens, but the majority of his plants ended up with Sloane when he acquired the Petiver and Plukenet collections.[25]

Cuninghame made three trips to Asia. He returned from an initial foray in 1696 with a number of rare specimens, which first gained Sloane's attention. He then set sail again in 1697 on the *Tuscan*, an interloping vessel owned neither by the East India nor New Company but by the private merchant Henry Gough. Some doggerel Cuninghame contributed to the *album amicorum* of the botanist David Krieg that year gives a sense of his objectives: 'The energetic merchant hastens to the furthest Indies, / Escaping poverty through the sea, through rocks, through fires.' In a foretaste of trials to come, the *Tuscan*'s crew was taken prisoner by the Spanish authorities after making landfall on La Palma in the Canaries and attempting to apprehend a group of deserters. Within ten days, however, Cuninghame had been released and the *Tuscan* continued on to Amoy where the Scot collected plants and animals, eventually returning to London in 1699. Sloane was sufficiently impressed to obtain a Royal Society fellowship for him that year. A few months later, Cuninghame sailed again, this time as surgeon on the EIC ship *Eaton*, likely preferring the relative security of company work, probably secured with Sloane's help. On arrival, he took up his post as physician at the company factory at Chusan.[26]

Chusan was an island off China's east coast where, as Cuninghame explained in a letter Sloane later printed in the *Transactions*, the Kangxi emperor and 'the Chineses have granted us a settlement and libertie of trade'. Chusan was in some ways a prison as well as an entrepôt, a site to which European traders were confined by the authorities as a precaution against their incursion into mainland Chinese markets. Like their South Asian counterparts, Chinese merchants regarded European traders with curiosity but ultimately as a marginal concern, something of a nuisance to be tolerated, and were content to contain their activities (they later relocated them to Canton). British commercial envy produced a certain Sinophobia meanwhile: Chusan's denizens were 'beggarlie' and lacked great merchants, Cuninghame complained. He was itching to witness the emperor's 'superstitious pilgrimage' to the island of Po, but this was called off when 'his mandarins . . . made him believe that the terrible

thunder there was very dangerous.' His own immobility was even more frustrating: 'even upon this island we have not much freedome of going abroad.' But he was able to make collections, sending Sloane tea, baskets, hats and a compass. Danger abounded, however, and cargoes often went missing. He asked Sloane on one occasion if he had received the plants he sent from the Cape of Good Hope, where he had seen the botanist John Starrenburgh, a correspondent of Petiver's. But communications were slow. One parcel took three years to reach London. 'I hope to give some satisfaction to your longing expectations,' Cuninghame pledged.[27]

By 1703, Cuninghame had moved on to the new company factory on Pulo Condore, another self-contained trading island, south of Cochinchina, at the invitation of the Nguyễn people, who had recently wrested the island from its Cham and Malay inhabitants. Despite warnings to exercise caution from London, English private traders (including Elihu Yale) were in the habit of commandeering EIC ships to seek out new trading bases and pre-empt Dutch and French trade. But such manoeuvres proved hazardous and were subject to dramatic reversals in the absence of steady relationships with local powers. European traders had, for example, been routed and expelled from Siam (Thailand) by 1688. For the Nguyễn, an alliance with the English augured well for securing customs duties and military assistance against their own rivals, the Cambodians and the Trịnh dynasty to the north. At first, Cuninghame's new station offered tantalizing prospects for rarities. He sent Sloane plants, beetles and even delicately dried sea urchins; chatted about merchandise expected from Macao, Siam, Cambodia and Canton; and promised an account of an expedition to the Nguyễn court.[28]

Cuninghame was all but swept away, however, by an episode that revealed the fragility of England's East Asian adventures. In 1705, the company employees at Pulo Condore were massacred when Nguyễn fighters and Makassarese mercenaries joined forces to expel them. Makassarese frustrations seem to have boiled over as the company failed to release them after a three-year term of service, while the Nguyễn had had enough of English 'pirates' camping on their doorstep. Despite exchanging diplomatic gifts, the EIC factory council had not sent emissaries to the Nguyễn court and failed to see that their overtures to the Cambodians provoked Nguyễn hostility. Most at the factory perished. Miraculously, Cuninghame survived to tell the tale,

though he was imprisoned for two years. After being released in 1707, he made his way to Banjarmasin in Borneo where he took up yet another factory post, although this too was abandoned when the Chinese, ever protective of their trading prerogatives, incited the locals against the newcomers. Once more Cuninghame moved on. 'I still remain alive,' he doggedly informed Sloane from Batavia, 'and shall not pine at whatever disappointments.' He continued sending plants and animals until in 1709 he left Calcutta (Kolkata), bound for London. But he never completed the voyage home: having survived all these years, he died at last when his ship was lost at sea.[29]

While promising to advance British trade, journeymen like Cuninghame also stood to help the Royal Society catch up on European rivals in their knowledge of Asia. Ingenious Jesuit missionaries from Italy, Portugal and elsewhere had blazed a trail since the sixteenth century in establishing relations with the Ming dynasty in China. Well before the Royal Society and the Académie des Sciences in Paris organized their own global correspondence networks, missionaries from the Society of Jesus travelled the world as part of the Catholic Counter-Reformation in response to the challenge of Protestantism, seeking converts and exchanging knowledge as they went. Led by the Italian Matteo Ricci in 1583, the Jesuits in China had used impressive new clocks and other mechanical and astronomical instruments to impress their hosts and gain their trust. In the seventeenth century, both Italian and French Jesuits worked with Chinese scholars to produce world maps and cadastral surveys of the expanding Celestial Empire. The Jesuits eventually claimed to have converted tens of thousands of Chinese to Catholicism by such overtures and sent back information, objects and specimens to Athanasius Kircher at the Collegio Romano. Sino-Jesuit relations soured, however, as the eighteenth century wore on. The Kangxi emperor, who had been tutored in the sciences by a Jesuit named Johann Adam Schall von Bell, came to resent the pope's claims to spiritual authority over his subjects, whom he deemed compromised by their dual observance of both Christian and Confucian rites, and ultimately expelled the Jesuits. Cuninghame had sent Sloane evidence of Jesuit cultural penetration in the form of a Chinese Book of Common Prayer that included the Lord's Prayer and the Ten Commandments in Chinese, but optimistically reported that 'the Jesuits interest at Pekin is upon the declining hand.'[30]

Yet the rivalry between Protestant and Catholic powers by no means precluded informal cooperation. While he readily indulged the rhetoric of Spanish 'cruelty' in his *Natural History of Jamaica*, Sloane was pragmatic when it came to tapping Catholic sources to advantage. This was especially the case in East Asia regarding information that could serve British commercial interests and the accumulation of new knowledge. For example, Father George Camelli was a Spanish Jesuit who transmitted some of the first plants to Europe from the Philippines. Both Samuel Browne and Edward Bulkley in Madras forwarded specimens they obtained from Camelli to Petiver, while seeking Camelli's assistance to establish contacts with other Jesuit missionaries. In return, Petiver sent Camelli works of natural history and the two men published articles as co-authors in the *Transactions*. Petiver credited Camelli by name in his species catalogues as an advertisement of his access to exotic suppliers. When Sloane acquired Petiver's collections, he made scrupulous note of their tortuous provenance, listing one well-travelled butterfly as coming 'from Mr Dandridge who had it from Mr Petiver to whom it was sent from the Philippine Islands by Father Camelli'.[31]

Sloane engaged extensively with the French Jesuit astronomer and China missionary Jan de Fontaney. Sloane provided Fontaney with passports for EIC ships – brokered by the ubiquitous Gilbert Heathcote – to afford Jesuit travellers passage to China. In return, Fontaney sent Sloane a rich cache of curiosities that evoked Chinese inventiveness: a ruler made from bamboo, perfumed candles, a gunpowder horn, an explosive 'squib', a 'chauffer mains . . . filld wt. ashes to warm the hands in cold' and 'tea from China with wch they cure colds'. Fontaney assisted Sloane as well in the investigation of a singular Asian puzzle. In 1703, a man who went by the name of George Psalmanazar, and claimed to hail from the island of Formosa (Taiwan), had arrived in London. But not everyone believed he was who he said he was. Asian visitors to western Europe were rare in this period. In 1697, John Locke had excitedly told Sloane to head to East India House, the company's headquarters in Leadenhall Street, to interview a recently arrived native of Japan, since 'we have soe little commerce with Japan and there are soe few of that country come into ours.' Psalmanazar's hosts were stunned, therefore, by the gifts he bore from Formosa including maps, manuscripts and descriptions of places, a

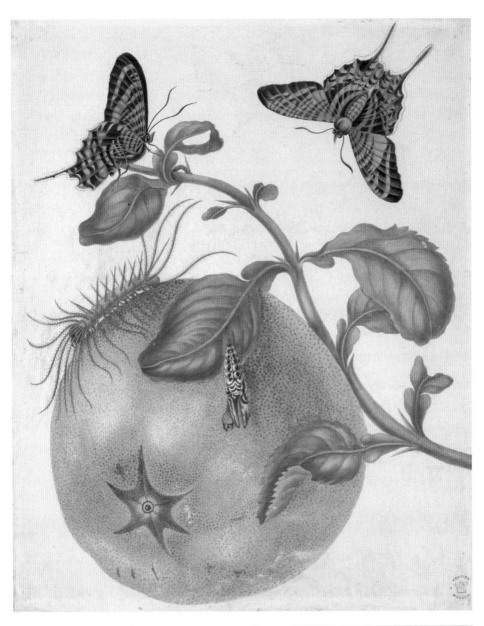

13. Surinam shaddock fruit with moths, caterpillar and chrysalis, by the celebrated naturalist, traveller and artist Maria Sibylla Merian: Sloane acquired many of Merian's illustrations through a purchase brokered by James Petiver.

14. Jewelled turban button from Mughal India: Sloane gave this button to the East India Company officer, profiteer and gem collector Elihu Yale, who gave Sloane several curiosities in return, including a shield made from rhinoceros hide.

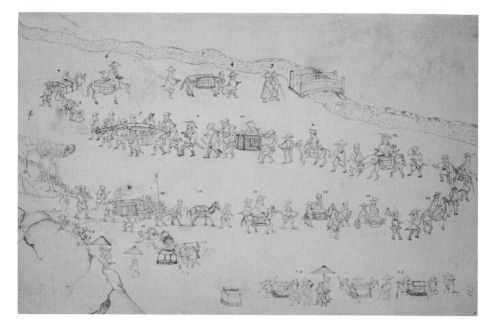

15. Procession to the court at Edo later published in the German doctor Engelbert Kaempfer's *Japan Today* (1727): this was a rare excursion for Kaempfer (possibly the figure labelled '15'), who was based with the Dutch East India Company in Nagasaki, where he smuggled out rare collections Sloane would later buy via brokers in Hanover.

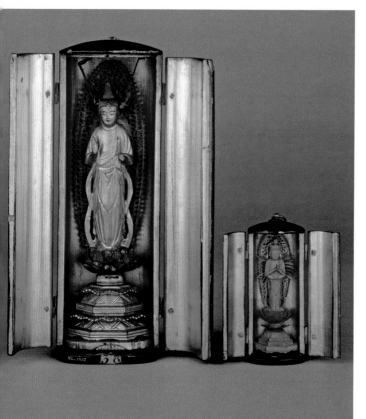

16. Portable Buddhist shrine of the Bodhisattva Kannon (*left*): Sloane labelled this gilt shrine – smuggled out of Japan by Kaempfer with the assistance of his translator Imamura Gen'emon – a false 'idol'.

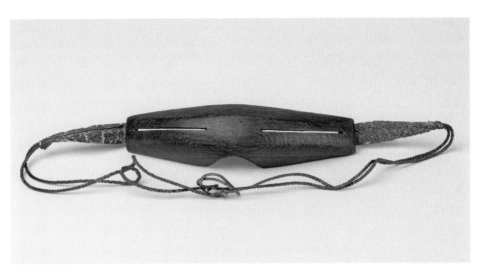

17. Inuit sun visor acquired by Hudson's Bay Company trader Henry Elking: Sloane marvelled that British company agents pushing into the Arctic could trade mere baubles to obtain precious ivory and other objects from the Inuit.

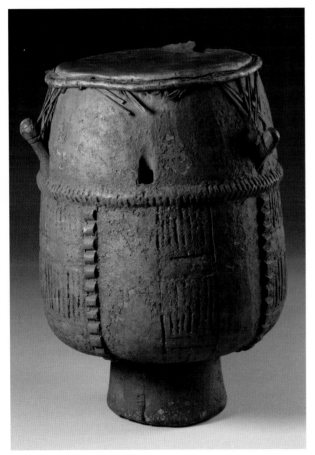

18. The Akan drum: made of West African wood and covered with an American deerskin, this is one of the drums used for 'dancing the slaves' on the Middle Passage, acquired by Sloane from a merchant named Clerk in Virginia.

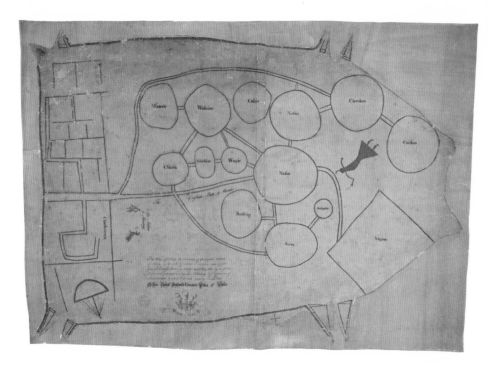

19. 'Map describing the situation of the several nations of Indians between South Carolina and the Massissipi River': part of Sloane's map collection, this deerskin copy of an Amerindian chart was given to him by the governor of South Carolina Sir Francis Nicholson.

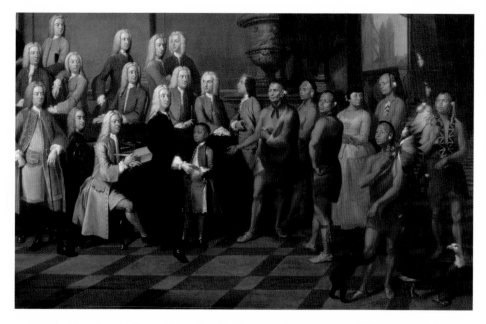

20. William Verelst, *Audience Given by the Trustees of Georgia to a Delegation of Creek Indians* (detail; 1734–5): colonial diplomacy routinely featured exchanges of gifts. Sloane acquired the skin and kidney of the eagle and bear (*right*), respectively, after they had died.

21. American asbestos purse: the ambitious young Philadelphia printer Benjamin Franklin sold this purse to Sloane during his visit to London in 1725 when Franklin was nineteen.

22. Pipe bowl or calumet: a peace pipe from the world of violent conflict between Amerindian nations and British-American colonists, sent to Sloane by the Pennsylvania botanist John Bartram, who collected plants for Sloane in what he called the 'wilderness' of Indian country.

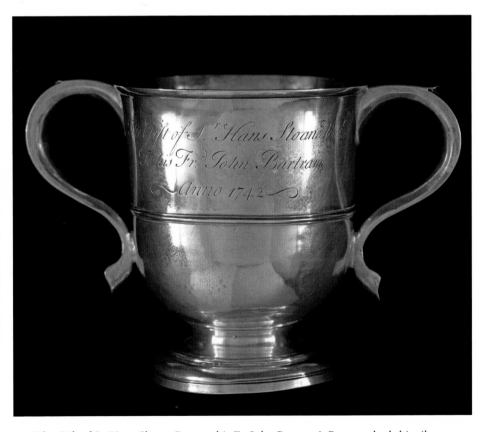

23. 'The Gift of Sr. Hans Sloane Bart. to his Fr. John Bartram': Bartram had this silver cup made up himself, using money Sloane sent for plant specimens, to impress his friends in the colonies.

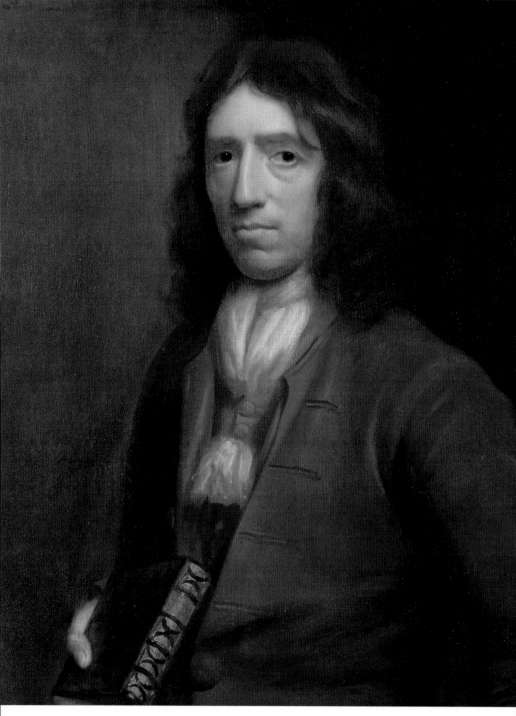

24. *William Dampier* by Thomas Murray (1697–8): the brilliant if ill-fated pirate, hydrographer, global circumnavigator and author, whose travel journal Sloane acquired in manuscript. Sloane commissioned this portrait and hung it in his museum.

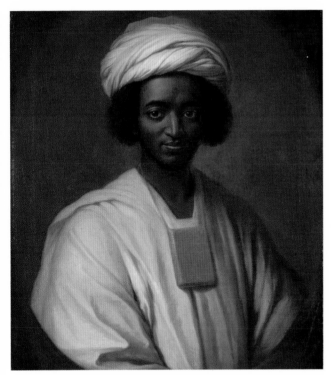

25. *Ayuba Suleiman Diallo (Job ben Solomon)* by William Hoare (1733): a West African Muslim trader from Bundu (Senegal), Diallo was enslaved and brought to London, where Sloane and his associates arranged for his emancipation. He returned to Africa as an agent of the Royal African Company.

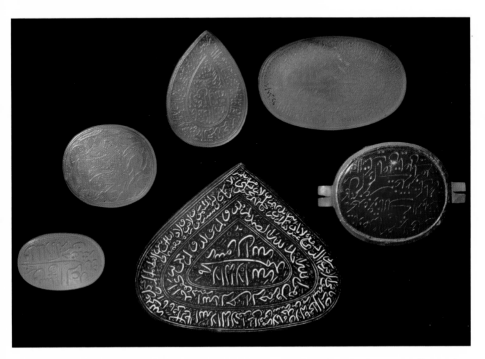

26. Persian amulets with Qur'ānic inscriptions: while awaiting his liberation, Diallo used his knowledge of Arabic to translate these protective prayers for Sloane, who regarded belief in such 'charms' as a benighted superstition.

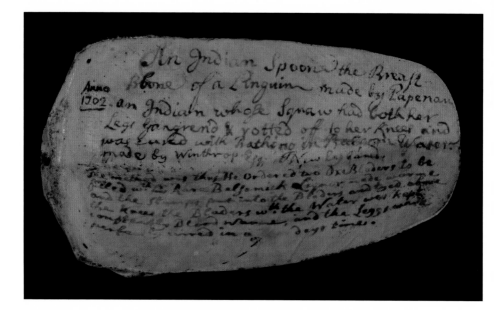

27. Spoon head made from auk bone: the description by Professor John Winthrop of Harvard College, transposed by Sloane on to the spoon itself, implies that this artefact may have been the gift of a Native American called Papenau in return for medical aid.

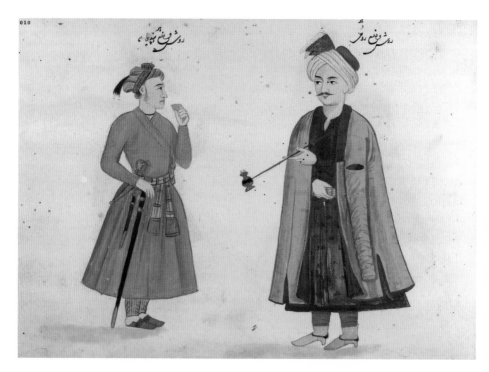

28. A Turk and an Indian: from Engelbert Kaempfer at Isfahan, Persia, in 1684–5, these pictures show how early modern collectors like Sloane gathered ethnographic information about foreign cultures through drawings that featured close attention to costume.

collection of which he published as a natural history in 1704, garnering an Oxford lectureship for himself in the process. Sloane oversaw his reception at the Royal Society, where the Fellows were highly curious about their noteworthy guest.[32]

There was just one problem: was the white-skinned Psalmanazar an impostor? European ignorance about Formosa made it hard to be sure. Europeans did not yet automatically identify Asians in racial terms as having 'yellow' skin, as they would by the eighteenth and nineteenth centuries, so Psalmanazar's complexion did not immediately disqualify him. Rival camps emerged. Lord Pembroke defended Psalmanazar's claims but the astronomer Edmond Halley produced maps that contradicted them. Sloane obligingly hosted a dinner in order to investigate the matter further. 'I could make you very merry,' he teased Locke, with the 'diversion' of the affair. The issue of exotic credibility was nevertheless an urgent one. In an age of travel, colonization and exploration, the question of whose reports to trust of the world beyond Europe was as critical as it was vexed. Not for nothing did Jonathan Swift toy with readers of *Gulliver's Travels* by juxtaposing tales of imaginary islands such as Lilliput with mentions of real ones like Japan. Sloane had been wounded by William King's tirade in *The Trans-actioneer* against his own credulity, which had singled out his Chinese ear-pickers as worthless baubles. So he asked Fontaney to check with his Jesuit colleagues about the details of Psalmanazar's story. Fontaney obliged: none of his contacts in Avignon, which Psalmanazar claimed to have visited, had laid eyes on the man. It seemed odd, moreover, that he possessed no great command of Asian languages. Where Lord Pembroke trusted the word of a suitably enigmatic Asian who ate raw meat and talked up alleged acts of Catholic cannibalism, Sloane placed his trust in Fontaney and concluded that the 'Formosan' was a fraud. This did not prevent Psalmanazar from settling in London and later becoming the drinking companion of Samuel Johnson, who hailed him as the most pious soul he had ever known.[33]

Cultivating ties with foreigners was one means of reaching beyond British networks. Sloane's wealth, longevity and connections allowed him to reach back in time, too, as he did to secure a set of remarkable collections from Japan. Japan had been roiled by medieval conflicts between competing feudal lords and Samurai warriors, and in the sixteenth century experienced further civil strife due to the arrival of

Portuguese missionaries hungry for converts. By the seventeenth century, however, these missionaries had been expelled or executed, and the Tokugawa shōgunate (1600–1868) began to subdue rival factions through martial rule. It instituted a policy of national seclusion, known as the Edo period (named for the location of the Japanese court at Edo – Tokyo), to prevent renewed foreign incursion. It made an exception, however, by nurturing commercial relations with the Dutch East India Company, albeit in highly cautious fashion. The authorities permitted the company to station a hundred or so merchants on Dejima Island in Nagasaki harbour, at the sufferance of the shōgun, for a period of several months each year under strict surveillance and armed guard. Britain thus enjoyed no commercial relations with Tokugawa Japan where 'Dutch cunning', as Charles Lockyer enviously put it, 'foil'd us in the more profitable trade'. As a result, Sloane and his contacts never penetrated Japan – but Japan nevertheless found its way to him. In addition to a variety of specimens, maps and manuscripts, he was able to acquire a set of surgeon's instruments made from fish skin; inks and inkhorns; face-paint; medicinal powders and pills; women's shoes made of leather and silk; gold and silver pins and needles for the practice of acupuncture; tobacco pipes; several portable Buddhist 'idols'; gilded rhinoceros horns; 'metallick burning glasses'; and 'a ball of severall colours to be thrown into the fire to perfume a room'.[34]

The source of these objects was neither Japanese nor Dutch but German. In 1723, Sloane received word from Johann Steigertahl, a physician friend in Hanover who was assisting with the marriage of a relative of George I, Elector of Hanover. Steigertahl had happened upon Johann Hermann Kaempfer, an impoverished doctor and nephew of Engelbert Kaempfer, who had worked for the Dutch East India Company on Dejima in 1691–2. Johann did not have much money but he did have his uncle's collection of Japanese curiosities. Steigertahl obtained a catalogue for Sloane and sent it to London. Given the real paucity of European knowledge about Japan at the time, the range of materials was dazzling. Sloane moved quickly. Realizing how valuable his uncle's curiosities might be, Johann Kaempfer set about turning the collector's interest to his advantage. In addition to a considerable sum of money, he demanded a full translation of his uncle's description of Japan and, now that he thought of it, a nice position for himself as a provincial physician. Surely that was not too much to ask the great

Sloane, who suddenly became a cog in the machinations of the impecunious medic. Steigertahl relayed Kaempfer's demands and Sloane agreed both to pay for the collections and to commission a translation of *Heutiges Japan* (*Japan Today*) from German into English. He engaged the scholar Philip Henry Zollman to handle the sale, and rewarded him with a Royal Society fellowship. But Johann Kaempfer proved a slippery customer. He stalled, selling Sloane only part of his collection at first, and let it be known that a man named Rott in Bielefeld desired his Buddhist shrines in particular, which featured figurines of Bodhisattvas like Kannon on pedestals of lotus flowers symbolizing compassion and purity (Plate 16). The gambit worked. Sloane doubled his offer for the remainder of the collection to the hefty sum of £250 and raised a subscription to pay for the translation. When Zollman withdrew due to other commitments, Sloane employed Johann Gaspar Scheuchzer, son of the Swiss naturalist Johann Jakob Scheuchzer and one of his curators, to complete the assignment. The result was the illustrated two-volume *History of Japan* (1727), a landmark in European Japanology stuffed with observations on Japanese customs and society.[35]

Embedded in Sloane's Hanoverian negotiations for these Asian treasures are the stories of yet more go-betweens. Johann's uncle Engelbert had been a highly charismatic confidence-man. Having studied in Königsberg and worked in Sweden, he had travelled down through the Levant, Persia and India as a Dutch company employee in the waning years of the seventeenth century, acquiring renown as a healer and even gaining entrance (so it was said) to the harem of the Shah of Persia at Isfahan, south of Tehran. On Dejima, like Cuninghame on Chusan, he chafed at being caged up by his hosts, as he wrote in his account of Japan. Only if the Dutch performed rituals of subservience that disavowed missionizing activities by stamping on the Christian Bible were they permitted to receive visitors, trade and make excursions, such as the yearly procession to the Edo court (Plate 15). Here they presented silks, exotic animals and specimens as gifts to the shōgun and were called on to perform a variety of 'monkey tricks' for his amusement, which they did to further their trade mission. Kaempfer danced and even sang ditties about remaining loyal to his 'beloved' back in Europe despite the exotic temptations of Japan's 'court of empty pleasures'. Such encounters, he insisted, were a 'farce' involving 'meaningless

questions', though they do reveal Japanese curiosity about the state of European knowledge at the time. 'How far is Holland from Batavia?' a Dutch captain was asked, and 'Batavia from Nagasaki?' Which illnesses did Kaempfer consider the most dangerous and how did he treat them? Had he searched 'for an elixir of long life like the Chinese doctors ... and [had] our European doctors discovered anything?' When asked to specify which European medicines worked best, Kaempfer mentioned a 'certain alcoholic spirit' which, noting the Japanese 'esteem' for long names, he called 'Sal Volatile Oleosum Sÿlvii'. When asked if he had some to share, he coyly replied, 'Yes, of course! But not here,' whereupon the shōgun 'asked that a sample be sent on the next ship'. Kaempfer snubbed his hosts in *Japan Today*, painting Japan as an idiosyncratic society of despots and dullards, easily dealt with by a cool trickster such as himself, more than a match for the court's ceremonious interrogations. He did acknowledge, however, with perhaps a hint of regret, that Dutch willingness to do almost anything in pursuit of profit convinced the Japanese that their guests 'could not be true of heart'.[36]

While excelling in the role of courtier before the shōgun, Kaempfer assembled collections in secret by twisting Japanese loyalties to his own ends. In this he was crucially assisted by his appointed translator, a young man named Imamura Gen'emon, later known as Eisei. Eisei, who became a controversial figure in Japan when his identity was finally uncovered in the twentieth century, helped Kaempfer to sketch prohibited maps (craftily labelled in Arabic, which Kaempfer figured his hosts could not read) and gather specimens on the procession to Edo. Despite strict legal sanctions against passing knowledge into foreign hands, Eisei risked his life to help Kaempfer. Kaempfer's mentions of Eisei in *Japan Today* do not identify him but do acknowledge him warmly. Kaempfer confessed that he had relied on the assistance of 'a learned young man, by whose means I was richly supplied with whatever notice I wanted, concerning the affairs of Japan'. Eisei, he went on, was 'learned in Japanese and in Chinese writing and science and at the same time eager to learn ... something about medicine'. Kaempfer 'taught this clever fellow Dutch grammar ... so that he could speak it far better than any Japanese interpreter before him', instructing him in 'anatomy and medicine' as well. 'I never sent him home without some silver to open doors, in addition to special rewards for such

dangerous tasks.' A vital symmetry was thus at work in Kaempfer's collections. His knowledge of Japan was made possible by Eisei's own desire for European learning, which presaged the fascination that would grip Japanese society more generally for *Rangaku* – the new mechanical technologies and ways of knowing brought by the Dutch that contrasted so exotically with local traditions of *Shingaku* ('heart-learning').[37]

Johann Steigertahl, Johann Kaempfer, Engelbert Kaempfer and Imamura Gen'emon: this was the chain of intermediaries across continents and decades that allowed Sloane to assemble the most spectacular Japanese collection of its day in Europe. The chain shows how collecting was a process of multiple exchanges and just how contingent – how fortuitous – the pathways of curiosities could be. The networks that brought Sloane collections were not rigidly nationalistic but shifting, fluid and changeable, full of interlopers continually assessing whether the time had come to put themselves first and switch allegiances for survival or personal gain. At the heart of Sloane's Japanese collections was Eisei's curiosity about Europe as much as European curiosity about Asia. Eisei, indeed, shaped all that Kaempfer came to know about his country: when Linnaeus incorporated the botanical name *Ginkgo biloba* into his plant taxonomy in 1771, for example, he cited his source as Kaempfer – but Kaempfer's source was in fact Eisei. In this respect, William King was right all along: Sloane accumulated collections built on layers of trust, relying on what his informants told him and, in turn, on what their informants told them. But this trust worked the other way too: as Sloane's fame grew, he ended up with the greatest Japanese collection in Europe without ever getting anywhere near Japan himself because others now sought out his friendship, his judgement and his purse. By this point Sloane wasn't just a man, he was an operation: his genius lay in his capacity to respond when the curious world came calling and, in this instance at least, to make new collections spectacularly public. In 1727, he brought out Scheuchzer's translation of Kaempfer emblazoned with a dedication to the king for George II's coronation year. The inclusion in the book of Sloane's imprimatur as 'Praes. Soc. Reg.' simultaneously trumpeted his own elevation as Royal Society president that same year. Kaempfer made a glorious advertisement for Sloane's empire of knowledge and cosmopolitan vision in a brilliant riposte at last to Jesuit monopolies of Asian intelligence. What the

British lacked in missionary guile they made up for by tenacious negotiation. Thus it was that the communicative Ulster apothecary now burnished his credentials as the doyen of global information brokers.[38]

## FROM OUR AMERICAN CORRESPONDENTS

Unlike Asia, the Americas witnessed a radical demographic transformation after 1500, owing to the tragic demise of millions of Native Americans from disease, the transportation of millions of Africans into slavery and the flourishing of Creole American settler colonies descended from Europeans. This momentous collision of histories is embodied by the remarkable Akan drum that came into Sloane's possession around 1730 (Plate 18). Now in the British Museum, little is known in detail about how Sloane came to possess it other than the fact that it was obtained in Virginia by a Mr Clerk, who then sent it to Sloane in London. Sloane catalogued it, mistakenly, as an 'Indian drum made of a hollowed tree carv'd the top being brac'd wt. peggs & thongs wt. the bottom hollow' and inked the words 'a drum from Virginia' on its cover, made from deerskin of the kind Amerindians routinely traded to colonists. Scientific analysis of its wooden frame, however, has identified the drum's body as being made of *Cordia* and *Baphia*, woods indigenous to West Africa rather than North America. Sloane's 'Indian drum' is thus itself an Atlantic traveller: it is one of the instruments slave-ship captains acquired on the Guinea coast and brought on board to 'dance the slaves' to maintain a modicum of health on the Middle Passage, preserving them for a life of bondage in the Americas.[39]

The colonization of North America proceeded very differently from British incursions into Asia. Although fitful attempts were made at peaceful accords with Native Americans, such as William Penn's land purchases from the Lenni Lenape in Pennsylvania, most colonies pursued policies of aggressive territorial expansion from Massachusetts Bay to Carolina. The southern colonies reproduced the pattern established in the West Indies, turning to plantation agriculture and slave labour to grow tobacco, rice and wheat. The thirst for land repeatedly prompted bloody confrontations in episodes like Bacon's Rebellion in Virginia, where indentured servants overthrew the government in

1675–6 to seize land from the Powhatan Confederacy of Algonquian-speaking Indian nations around the Chesapeake Bay; and King Philip's War at the same time in New England, where the Wampanoag and their allies sought (unsuccessfully) to beat back the encroachments of the Puritans. Like their Caribbean counterparts, American merchants and planters nurtured a tradition of local autonomy through colonial assemblies that defended their interests against London, even while envisioning themselves as 'freeborn Englishmen' united with the mother country against their common enemies France and Spain. Although commercial expansion made British America far wealthier after the Peace of Utrecht in 1713, colonial life remained volatile and dependent on diplomacy, not simply force. In the Yamasee War of 1715 Carolina put down a native rebellion against English demands for deerskins and Indian slaves, yet the English aimed to moderate their behaviour in its aftermath, realizing that their victory might prove Pyrrhic if their erstwhile trade partners joined forces with the Spanish in Florida or the French in Louisiana. Despite the devastating legacies of disease and slavery, and the advantages they afforded the British, North America remained a continent of middle grounds and borderlands where different empires and nations met, and no one people dominated.[40]

Sloane amassed curiosities from several Amerindian peoples as colonies proliferated in America. The Hudson's Bay Company, for example, had established itself after 1672 in the subarctic regions (later claimed by Canada) through the initiative of renegade French traders who allied themselves with the English to develop the northern fur trade, among them one Pierre Radisson, whose travel journal Sloane acquired. The company made common cause with the Cree Indians, who, together with their Assiniboine neighbours, supplied them with lucrative furs in return for guns, blankets and tools to strengthen their hand against regional rivals like the Atsina. Sloane forged links to several company men who sent him intriguing Inuit objects including fishing implements, snowshoes and a child's cradle. Henry Elking, to whom Sloane gave a copy of the *Natural History of Jamaica* in return for a walrus head, sent over an Inuit sun visor in the late 1720s, commenting that it was 'fair beyond my expectation to see that you value the Greenland trifles' (Plate 17). But Sloane was not the only one to value 'trifles'. A merchant named Alexander Light sent an Inuit doll and even a wolverine that made it alive to Sloane's London garden, acquired through

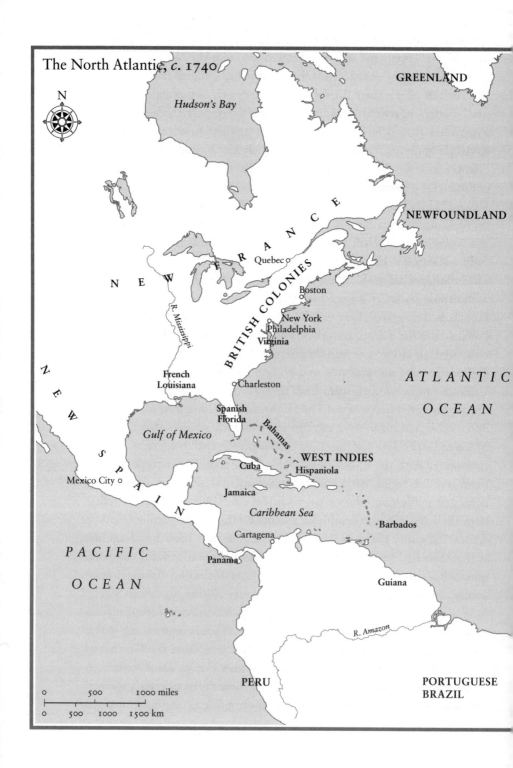

The North Atlantic, *c.* 1740

N

GREENLAND

*Hudson's Bay*

NEWFOUNDLAND

N E W   F R A N C E

Quebec

Boston

BRITISH COLONIES

New York
Philadelphia
Virginia

*R. Mississippi*

French
Louisiana

Charleston

ATLANTIC

OCEAN

N E W

Spanish
Florida

*Bahamas*

*Gulf of Mexico*

WEST INDIES

S P A I N

Cuba

Hispaniola

Mexico City

Jamaica

*Caribbean Sea*

Barbados

Cartagena

Panama

PACIFIC

Guiana

OCEAN

*R. Amazon*

| 0 | 500 | 1000 miles |

PERU

PORTUGUESE
BRAZIL

| 0 | 500 | 1000 | 1500 km |

trades made with Inuit on his ship in the Hudson Strait in 1738. Sloane marvelled that, in return for mere knives and buttons, Light had obtained ivory, whose amazing range of Inuit applications Light recited in a prodigious thirty-five-line list that included harpoons, 'a swivell for a fishing line', ornaments for 'hanging at their breasts', combs, pipes, contraptions for women to carry children on their chests, drills, nasal ornaments, dolls, lances and toys. Light eyed the landscape with envious purpose, telling Sloane it was a 'pleasant country' with a 'great deall of room for industery'.[41]

Native leaders came to negotiate treaties in London bearing all manner of curious diplomatic gifts. Delegates from the Haudenosaunee (or Six Nations of the Iroquois) visited Queen Anne in 1710 to discuss an alliance against French Québec. Although usually referred to as 'the four Indian kings', these emissaries were not chiefs or sachems but carefully selected by American governors and Tory advocates of invading French Canada to convince Anne that fierce yet loyal allies stood by ready to assist. The travellers were introduced to the monarch; toured the Greenwich docks and the Admiralty; were given 'civilizing' gifts such as gunpowder, razors, combs and pistols; and attended a magic lantern show and a performance of *Macbeth* where they sat on the stage so the London audience could observe them. The British did launch an invasion of Canada in 1709–11, though it ended in abject failure. But at least they learned an important lesson, or so some claimed. In the *Spectator* magazine, Joseph Addison published a rapturous relativist fantasy that celebrated the cosmopolitan awakening he insisted had resulted from trailing after the Indian kings through the streets of London and seeing 'every thing that is new or uncommon' through their eyes. According to Addison, the Iroquois and the Londoners found the differences between them equally ridiculous, a discovery that recommended the wisdom of rejecting 'the narrow way of looking at things'. For his part, Sloane obtained several curiosities from the visitors, including a wooden medicine stick to induce vomiting by thrusting it down the throat and a 'tumpline' for carrying sacks made from hemp and porcupine. He was not, however, as broad-minded as Addison in his views. Evidently swayed by stereotypes of Indian savagery, he wrongly thought the tumpline an Indian means of 'tying their prisoners'.[42]

Sometimes Sloane received American curiosities directly from

imperial officers. In 1725, Sir Francis Nicholson, governor of South Carolina, returned to England to face charges of corruption. Nicholson was a soldier and administrator who had supported the plan to invade Canada. He also patronized natural history projects as part of the same circle of sponsors as Sloane, providing financial support for travellers and donating books to the Royal Society and the Society for the Propagation of the Gospel. In negotiating colonial boundaries with the Cherokee in his capacity as governor, he accumulated a number of native artefacts. He brought these back to London and gave several to Sloane. They included a 'large Carolina basket made by the Indians of splitt canes', a 'large tobacco pipe or Calumet de paix', a 'maraca or calabash & gourd wt. something to rattle in it & five or 6 feathers of the white headed eagle on a string' and several arrows and hatchets. He also gave Sloane 'a map describing the situation of the several nations of Indians between South Carolina and the Massisipi River'. This was a copy of a rare native chart done on deerskin that connected several Amerindian nations, long thought to have been Catawba in origin, but possibly Cherokee, and now held in the British Library (Plate 19). Sloane's links to missionaries, through the Society for the Propagation of the Gospel and the Society for the Promotion of Christian Knowledge, brought him yet more treasures. In the mid-1720s, he acquired a 'negro drum' from Elizabeth Standish, wife of David Standish, an Anglican preacher who had travelled to South Carolina to restore his fortunes after the South Sea Bubble.[43]

Acquiring such artefacts often came down to opportunism. In 1734, a Yamacraw delegation led by the aged Tomochichi came to London to discuss the settlement of Georgia, organized by Sloane's friend the soldier turned philanthropist General James Oglethorpe. These negotiations were commemorated in a grand group portrait by the Dutch artist William Verelst. Verelst depicted several of the Yamacraw in native dress and body paint while others wore European clothing, including both Tomochichi's mate and his nephew Tooanahowi, who is pictured shaking hands with Oglethorpe (Plate 20). This cultural cross-dressing was one-sided: natives done up as Europeans signalled English desires to convert them to Christianity. Diplomacy, however, dictated that each people collect the other's objects. The British gave gold watches and pistols while the Yamacraw gave wampum and furs, as well as a live eagle and bear they had brought with them, which

Verelst included on his canvas. The Yamacraw had the same tour as the Haudenosaunee, as though it were a regular itinerary: Greenwich to St Paul's to magic lantern shows, which the Londoners claimed Tomochichi found terrifying. Terrified or not, Tomochichi signed no treaties. The visitors did don British clothing to greet George II but did not convert to Christianity and returned to America, where Tomochichi continued to entertain relations with the Spanish as well. Sloane was not included in Verelst's portrait but he was only just off-stage. He treated Tomochichi's cousin Hinguithi for smallpox (though failed to save his life) and managed to acquire 'the skin of [a] bald eagle from Georgia . . . presented by Tomo Chiche the Indian King', as he catalogued it, as well as the kidney of the Yamacraw bear after it 'dy'd suddenly'. This took some work since these creatures were gifts not to Sloane but to the Duke of Cumberland, who then passed them to Sloane. These American rarities were not, therefore, the glorious trophies of a dramatic diplomatic coup but by-products of routine exchanges that, more often than not, failed to win advantage in the great game of empire.[44]

Because diplomatic missions to London were relatively infrequent, travellers in the American borderlands held special interest for Sloane, while, for those travellers, Sloane's patronage promised preferment and fortune – if not salvation. The enterprising John Burnet, yet another itinerant Scot, was in many ways an ideal Sloane correspondent. He became a South Sea Company employee early in the eighteenth century (possibly placed by Sloane himself) and was stationed at Cartagena on the northern coast of Nueva Granada (Colombia), where the British delivered slaves in great numbers to Spanish America. Burnet's job was to supervise the boatloads of Akan and Ewe captives arriving from Ouidah as well as contraband slaves from Jamaica, and he took advantage of his station to send rarities back to Sloane. In April 1722, in one of many dispatches, he sent Sloane the skin of a sloth preserved in spirits so that, as he put it, 'you may see I did not forget what you charged me with.' Burnet, however, loathed his existence in Cartagena. So he did something Sloane's Asian correspondents almost never did: he demanded Sloane help him. 'The trouble of a surgeon or physitian in looking after their negros faithfully is much greater than any of the other factors have,' he complained. Sometimes he had to save 'seven or eight hundred slaves in each cargo which otherways might die', a task

he found demoralizing. His income was pitiful. He urged Sloane to write to the company's directors on his behalf, which Sloane did, evidently securing him a rise in salary. In return, Burnet sent Sloane more plants, shells, animals and striking anatomical curiosities including 'an abortive negro near full grown', 'three polyist's [polyps?] taken out of the heart's of two negroes' and a 'long worm drawn by piece meal from the Guinea negros leggs and other muscular parts'.[45]

But Burnet brooded on the injustice that kept him a mere surgeon. He could almost touch Cartagena's neighbouring Spanish colonies and the money British merchants were making through smuggling. 'Be strenuous with your freinds,' he implored Sloane; the merchant's life was his 'due & birthright & the station I ought to have come out in'. When the company directors countered that he was not 'bred' to it, he protested that 'it does not follow that a man who is born in a stable should be a horse.' He had served his apprenticeship only to find that the art of trade was no art at all. 'All the mystery I find in merchandize is to sell dear & buy cheap & know to whom & when to trust' and 'getting the personall love of the people & especially of governors'. He begged Sloane to help him become a 'missionary' for the Royal Society and the South Sea Company. Then he could go collecting at Portobelo (Panama), Lima, Potosí and Buenos Aires. But time passed and Burnet stayed put, dutifully sending more curiosities while watching for his chance as the tides of war and peace turned. Writing from Jamaica in 1727, still he begged Sloane to help him 'begin the world anew in Britain and end my days in Europe'. Then, suddenly, he disappeared. He resurfaced two years later, writing to Sloane from Madrid – as court physician to none other than the King of Spain. Burnet had had enough: he had taken the Spanish he had learned as an interpreter and switched sides, offering his services to Spain as an informant on the South Sea Company's contraband trade. In a smuggler's world that arbitrarily enriched some and beggared others, and where death was always close by, loyalty had its limits. Sloane took it all in pragmatic stride. Now he had a good contact in Madrid. Burnet, for his part, was delighted to receive the latest *Philosophical Transactions*, which Sloane sent him from London. Swapping slave cargoes for the Republic of Letters was a dream come true.[46]

Peripatetic collectors were highly unpredictable. Fortunately for Sloane, they were almost always replaceable. Thus it was that William

Houstoun and Robert Millar, two more itinerant Scots surgeons, materialized in Burnet's wake. Houstoun, too, had trained at Leiden, worked for the South Sea Company and sent specimens from Jamaica, Cuba and Vera Cruz on Mexico's east coast (another disembarkation point for slaves entering New Spain) between 1729 and 1733. He was particularly industrious, engaging Amerindians to collect for him around Vera Cruz and supplying Sloane with sketches of harvests of the lucrative cochineal beetle. He also sent *contrayerva* (an antidote for snake-bites) gathered in the Bay of Campeche and numerous seeds for Chelsea Physic Garden, where they were planted in the hothouses. But Houstoun didn't last. He survived a shipwreck in 1731, but by 1733 he was dead. 'The last account we had of him', Sloane observed, 'was that he lay sick at Porto Bello of a fever without the least hopes of recovering.'[47]

Robert Millar's travels were sponsored 'at the expence of severall people of quality', Sloane noted, himself included, and he kept a keen watch on his latest supplier. 'We have subscribed afresh to keep him out another year,' he informed his botanical curator Johann Amman, lauding Millar's dispatches of specimens from Cartagena, Panama, Portobelo and elsewhere as giving 'great satisfaction'. These Millar distributed among various patrons including Sloane, the Quaker merchant botanist Peter Collinson, the Chelsea gardener Philip Miller and the new botanical garden in Georgia. Millar tantalized with botanical possibility. 'There's a gentleman named Lergeant here in his passage from the factory at Panama,' he wrote to Sloane from Jamaica in 1735, 'who says he has gott the seed's of the true Peruvian bark tree.' But Millar's progress was interrupted by illness and the difficulty of securing timely passage to Campeche, Mexico and beyond. Fever slowed him down in Jamaica, so, with Hippocratic faith in the salubriousness of cool airs, he took to the mountains. But he did make it to Maroon country, despite the wars that raged there during the 1730s, visiting a new settlement called Manchieral 'and . . . that famous place, which the rebellious negroes kept so long in their possession, called Nanny Town'. 'In both these towns I found but very few things that were rare or unknown,' he reported, 'and indeed I was in a very bad state of health all that time.' He may not have found new plants but he did furnish Sloane with some exceptionally rare objects from Maroon country, which Sloane had studiously avoided on his own travels half a century earlier, including

several samples of their clothing. Millar longed to return to Britain a rich absentee landlord and urged Sloane to help him acquire land in the West Indies like those 'gentlemen of rank and easy fortunes att home'. He begged Sloane to use his 'sway with the Duke of Richmond', who held 'considerable influence on his Grace of Newcastle', the secretary of state. Like Burnet before him, Millar was exasperated by the Caribbean's maddening juxtaposition of dazzling fortunes with abject misery, and was driven to desperation. 'I must stand or fall as you determine,' he told Sloane. But, unlike Burnet, Millar died frustrated. Sloane recommended him for a professorship in botany and anatomy at Glasgow in 1742 but the post came too late – Millar died that year.[48]

In addition to his dealings with the Royal African, South Sea and Hudson's Bay Companies, Sloane developed significant ties to independent American planters, traders and travellers. Colonel William Byrd II of Virginia was heir to his father's fortune – one built on slavery, tobacco and trade with Native Americans – and had had the benefit of an elite education at Felsted Grammar School in Essex. He had become a Fellow of the Royal Society and president of the Virginia Council by 1709. He knew Sloane personally and had shown up at the society in 1697 to discuss African skin colour, showing off some rattlesnake and opossum specimens for good measure. He criss-crossed the Atlantic as the agent of the Virginia Assembly, constantly seeking office, if often falling short. Yet Byrd was also burdened by cash-flow problems due to careless management of his finances and lamented the lack of learned company in America. 'Nature has thrown away a vast deal of her bounty upon us to no purpose,' he told Sloane in 1706; if only the Virginians had some sort of 'missionary philosopher' to teach the colonists about 'the many usefull things which we now possess to no purpose'. At least Byrd could correspond with Sloane. So he sent him regular specimens such as the medicinal ipecacuanha root – just enough, like a Cuninghame or a Millar, to remind Sloane he was still there.[49]

Byrd's offerings, however, were overtures to an exchange among equals. Would Sloane send him a series of minerals, he asked in 1708, so that he could compare them with some Virginian samples? He wanted to have the kind of learned conversation Sloane carried on with Ray back in England, comparing and identifying species. But it wasn't to be. Sloane agreed with Byrd's hints that there was money to be made

from the ipecacuanha: one could get thirty shillings a pound for it. He acknowledged receipt of a box of specimens, although he noted that the stick-weed which Byrd had mentioned had gone missing. Byrd had asked about a root he called 'poke': it wasn't jalap, Sloane told him, but the root of Ray's *Solanum racemosum americanum.* Colour from the berries Byrd had mentioned was already a common dye in New England; and Byrd's Jamestown weed was a notorious Jamaica poison. Byrd should keep sending his seeds along just the same that 'they may be known and raised here'. When it came to the mineral samples Byrd had requested, Sloane put his American correspondent most emphatically in his place. Because, he wrote, there was 'such variety [of them] 'tis next to impossible to send you over the severall sorts, [and] 'tis much easier to you to send over what you want to be informed of in which case you shall receive the best satisfaction I can give you'. Byrd was cursed by his geography: the prerogative of scientific accumulation and judgement lay with Sloane at the centre of things back in London. 'I suppose my long absence has made your secretarys rank me in the number of the dead,' Byrd quipped a few years later, referring to the disappearance of his name from the official list of Royal Society Fellows, 'but pray let them know I am alive.' As late as 1738, when Sloane was seventy-eight, Byrd was still at it, insisting that American ginseng was not the same as the samples Sloane had seen from Tartary. He at least had a sense of humour though: 'you see sir that the distance of 4000 miles is not sufficient to secure you from the persecution of your most obedient humble servant.'[50]

Byrd was nonetheless an important link in a coterie of naturalists eager to subject the colonies to systematic scientific investigation. Sloane played a leading role in sponsoring such efforts, though his involvement produced tensions over the distribution of scientific labour. In 1712, Byrd hosted the naturalist Mark Catesby who was embarking on an exploratory American voyage. Catesby was no journeyman, however. 'A gentleman of a small fortune', as William Sherard described him, Catesby was the educated heir to a lawyer and gentleman farmer from Essex who had come under the tutelage of Ray. His ambition was to establish himself as an author and profit from the expanding market for illustrated natural histories. After visiting Virginia and Jamaica, he returned to England in 1719 with specimens that impressed both Sloane and Sherard, persuading them to raise funds and send him back

out to survey the relatively unexplored territories of Carolina, Florida and the Bahamas, which he then did between 1722 and 1726. Catesby's *Natural History*, published in two large gilt-edged volumes in 1729 and 1747, was the result. It was a stunning production in the tradition of Sloane's work on Jamaica, extending the project of making detailed visual catalogues of New World species, albeit in more stylized fashion and even outstripping Sloane's volumes with a total of 220 colour engravings of plants and animals, a luxury item for wealthy readers at twenty guineas per set.[51]

Like Sloane's translation of Kaempfer, Catesby's natural history involved multiple acts of brokerage, from securing information from indigenous sources to negotiating the path to publication in Europe. And like most American natural history projects, Catesby's was rooted in interactions with enslaved Africans and Native Americans. On his first trip, for example, he and Byrd visited the Pamunkey, one of the original peoples of the Powhatan Confederacy, collecting specimens as they travelled. Catesby paid an Indian to carry his paints and specimens, and after 1715 visited native groups at Fort Moore, a trading post near Savannah Town, using it as a base for exploring the South Carolina backcountry. He purchased a 'negro boy' and, as Sloane had done, investigated slaves' provision grounds. Violent conflict stalked his progress, however, as the Yamasee War erupted that year. In print Catesby acknowledged his debt to those 'friendly Indians' whose 'hospitality and assistance' made his work possible; he must have learned of many plants and animals by their help. He lamented Indians' declining numbers, blamed Europeans for exposing them to alcohol and smallpox, and expressed appreciation for both native and African plant knowledge, chiding Byrd's improvement of his slaves' diet simply because he 'found it in his interest'. Such sympathies, however, did not prevent him from articulating an imperial vision of the American continent. Despite possessing a natural 'sagacity' – a term with negative connotations of animal cunning rather than rational perception – Native Americans demonstrated no understanding of literature in Catesby's view, while slaves strangely savoured even fetid plants. When he sent Sloane an 'Indian apron' made of wild mulberry bark and a basket of 'split cane', he reckoned it their 'only mechanick art worth notice'. The text he composed for his *Natural History* construed the American landscape as lawless, a perception likely encouraged by the

wars that plagued the borderlands, while his watercolours made a ravishing brochure encouraging romantic notions of American fecundity and designs for transplanting American species to British gardens.[52]

Sloane supported Catesby's work but the great collector also threatened to swallow it whole. Did sponsorship of his voyage mean ownership of its fruits? Sloane had armed Catesby with boxes and bottles for collecting specimens. In return, Catesby sent Sloane tortoises from Carolina, birds from Virginia and numerous plants, although it always seemed a minor miracle when they reached their destination. 'I hope you have received the remains of a cargo of plants, birds, shells, &c. which unfortunately fell into the hands of pirats,' Catesby asked from Charleston, South Carolina, in 1723. But, as usual, Sloane was not Catesby's only patron. In the absence of British state support for scientific expeditions, Sherard had outdone himself by organizing an illustrious cabal of private sponsors, including Samuel Dale, the gardener Thomas Fairchild, the East India Company treasurer Charles DuBois, Dr Richard Mead, Sir Francis Nicholson, the Duke of Chandos and Peter Collinson, who made Catesby a precious interest-free loan. Sherard realized that lining up Sloane first was the key to getting these others on the hook: he was *the* key sponsor of British colonial science in these years and duly subscribed for more copies of Catesby's book than anyone else. But who would get what in return remained in question. Catesby gingerly inquired of Sherard whether Sloane and DuBois would resent it if he sent a combined package of specimens for both rather than transmitting 'distinct collections' to each. Sloane complained about the quality of Catesby's early shipments, while Catesby was vexed by Sloane's demands for original art. 'My sending collections of plants and especially drawings to every one of my subscribers is what I did not think would be expected from me,' he told Sloane defiantly in 1724. His aim was 'to keep my drawing[s] intire that I may get them graved, in order to give a gen[era]ll history of the birds and other animals, which to distribute seperately would wholly frustrate that designe'. So he devised a clever solution: he would give Sloane copies of his pictures and keep the originals for himself. Like Maria Sibylla Merian, he succeeded in profiting from his own talents and even availed himself of Sloane's collections back in Bloomsbury, drawing live animals from his garden, basing his image of an American bison on a sketch by Everhardus Kickius and combining plants and animals in the

same frame possibly as a result of seeing Merian's pictures – one of the distinguishing characteristics of her work – at Sloane's.[53]

While Catesby was wary of Sloane, others felt they had nothing to lose and everything to gain by associating themselves with the great collector. The Pennsylvania Quaker John Bartram supported his family by farming and the income he received for supplying specimens to British patrons, especially his fellow Quaker Peter Collinson in London. Collinson paid him five guineas per hundred specimens, receiving roughly twenty boxes a year between 1735 and 1760. To Bartram's delight, Collinson passed some of his samples on to Sloane, whose *Natural History of Jamaica* he had seen in Trenton, New Jersey, at the house of Governor Lewis Morris. When Collinson assured Bartram he would soon receive his own copy from the president of the Royal Society himself, he swooned. 'It is very kind of thee to endeavor to ingratiate mee into sir hans Sloanes favour,' he told Collinson in 1741. When Sloane's volumes arrived as promised the following year, the plant hunter was delighted by the honour and the connection it gave him to learned London. Bartram sent Sloane a steady stream of curiosities in return including one 'box of insects (with thy name at large on ye box)'. His humble background only intensified the joy of his distinction. He let his American friends know that Sloane 'in particular desired my assistance', reminding them that he had been 'constituted president of ye royal society after sir Isaac newtons decease'. In 1765, George III awarded Bartram a pension worth £50 a year to collect for the Crown. The Quaker later proudly called himself 'King's Botanist', a title he was never quite awarded.[54]

Bartram was a modest man with no formal education but he knew how to collect Sloane and how to display him. After reading of Sloane's 'extraordinary colection of curiosities', he flattered his new patron, he 'thought it would be dificult to send thee any thing of that nature that would be new'. The lowly Quaker was well up to the art of flattery and proceeded to send several Native American artefacts across the Atlantic. One enigmatic 'Indian instrument' presented a perfect occasion to defer: 'you may guess as well as I how it was made & what use it was designed for.' Unlike Byrd, Bartram granted that such judgements were Sloane's to make. 'I should endeavour to give thee an opportunity of seeing it and calling it thy own,' he wrote of a pipe that had been removed from an Amerindian grave. This was no *quid pro quo*, he

insisted, but the freest of gifts: it 'comes in love'. Bartram made sure, however, to obtain visible signs that Sloane loved him back. One of his prize possessions was a silver cup, engraved with the legend 'The Gift of Sr. Hans Sloane Bart. to his Fr. John Bartram, Anno 1742' – a unique token of esteem for a colonial naturalist from the president of the Royal Society (Plate 23). But the cup is not what it seems. It was Bartram who commissioned it, not Sloane. Bartram inquired of Collinson if one of Sloane's five-guinea payments for specimens sent might be used to purchase the cup for him as a gift. 'I desire thee would send me a silver can or cup', Bartram wrote to Collinson, 'as big and good as thee can get for that sum which I or mine may keep to entertain our friends withal, in remembrance of my noble benefactor.' Bartram later thanked Sloane for 'thy kind present' and professed his pleasure that 'thy name is engraved upon it at large so that when my friends drink out of it they may see who was my benefactor.' The great collector had himself become a collector's item.[55]

As with Catesby, embedded in Bartram's exchanges with Sloane were a series of complex relations that afforded him access to native curiosities. The pattern of peaceful negotiations established by William Penn, one facilitated by native diplomats, had eroded since Penn's death in 1718. Bartram's own father had been killed by the Tuscarora, engendering in him a lasting fear and hatred of Indians. In 1743, he nevertheless travelled with Conrad Weiser of Virginia and the Oneida chief Shickellamy to Onondaga, south of Lake Ontario, to sue for peace one year after a group of Virginians had killed several members of the Onondaga, confederates of the powerful Haudenosaunee. The settlers brought £100 worth of gifts; the Onondaga envoy Canasatego reciprocated with a meal of corn and dried eel; and as a gesture of goodwill, all parties smoked a pipe filled with Philadelphia tobacco. Bartram bore Sloane in mind as he travelled, gathering plants for him around Onondaga, several of which remain in the Sloane Herbarium including one 'indians use for ye bite of a rattle snake'. He quizzed members of the Haudenosaunee about such uses: 'ye indians tould me they used [this] root . . . to make them vomit,' he annotated one specimen he sent Sloane. But his unease around what he referred to as 'superstitious and ignorant Indians' remained. In the Observations (1751) he published about his travels, he described a masked 'savage' who startled him by 'braying like an ass' during 'howling' dances. Bartram's hostility was

written on his plants too: he labelled the magnolia he sent Sloane 'found in ye terrible wilderness in ye cuntrey of ye 5 nations' – 'wilderness' connoting colonists' perception of American woods as places of evil haunted by godless heathens. Echoing Sloane in Jamaica and Light in Canada, he looked forward to the time when such woods would be cleared to harvest timber for the colonists. For now, he contented himself with sending his patron the ironic souvenir of a calumet – a peace pipe from a world in many ways at war (Plate 22).[56]

Asian and American curiosities thus made their way to Sloane by a variety of paths. Although he received several gifts from East India Company officers of wealth and station, Sloane obtained most of his Asian curios through payments to humble company surgeons, whose precarious existences often ended in ruin or death. In the Americas, he bought objects from South Sea and Hudson's Bay Company agents, while also receiving gifts from military officers cruising the Atlantic, like First Lord of the Admiralty Sir Charles Wager, who gave him a silver penis protector he had acquired on the Isthmus of Darien. But British imperialism took different forms in different places. In Asia, the British presence consisted largely of trading posts. In America, permanent Creole populations developed, with the result that leading colonists used American curiosities to establish ties to Sloane for reasons of local personal prestige. Men like Byrd and Bartram were hungry for recognition – both in their own eyes and in their friends' – as intellectual participants in an extended British Empire. When John Winthrop of Harvard College sent Sloane and the Royal Society nearly 800 mineral samples from New England that portended 'valuable mines' for 'the brittish nation', as Winthrop put it in 1734, what he asked for in return was the honour of 'a place in yor wonderfull and noble repository'.[57]

Sloane's Asian curiosities might be seen as artefacts of British dependence on local potentates, whereas American objects flowed from a position of British strength, enabled by epidemic disease and African slavery. This difference was reflected in the contrast between British attitudes to South and East Asian peoples, whose 'Oriental' cultures they considered deserving of some measure of respect, and to Native Americans and blacks, whom they regarded as lacking the traditional achievements of civilization, and as physically inferior. Yet as the travels of Tomochichi's eagle and bear suggest, American curiosities

could also be souvenirs of imperial dreams frustrated rather than realized. Rather than the spoils of triumph, such objects were often happenstance fruits of the ebb and flow of goods and gifts, as rival empires groped for advantage around the globe. The reach of Sloane's personal network was nonetheless extraordinary, encompassing Britain's steadily expanding empire and, as we shall see, occasionally stretching beyond it.[58]

# PLUS ULTRA

The geography of curiosity was indeed the geography of *beyond*. In Jamaica, Maroon country was marked on early maps like Edward Slaney's (1678) with the words *ne plus ultra*: go no further. This was the forbidden zone of Caribbean colonization, where Africans ruled rather than Europeans, and Sloane dared not venture. Such limits were anathema to the curious: *plus ultra*, after all, was Bacon's commandment to search beyond the known. Any contacts, even the most fleeting, that could reach outside the usual networks of trade and colonization were thus of immense value. Sloane never boarded a ship after his Jamaica voyage. But his renown allowed him to take the world in his hands because that world now came to him. Three encounters stand out from his half-century of collecting that show how, more than simply buying or selling – though there was plenty of that – the assembly of his museum entailed forging intricate personal relations through which the status of both objects and people was negotiated and contested.[59]

Somewhere in the portrait gallery that Sloane mounted on the walls of his apartments, amid pictures of friends and celebrated historical figures, there lurked the visage of a singularly sullen-eyed character (Plate 24). This figure was no gentleman: he wore no wig and his long hair drooped down to his shoulders. The legend accompanying his portrait (now in London's National Portrait Gallery) done by Thomas Murray, a client of Sloane's, contains a surprising combination: 'pirate and hydrographer'. This scientific buccaneer holds an elegant volume in his hands; his likeness is the portrait of the pirate as a man of letters. His name was William Dampier; the book, his *New Voyage around the World*, published in 1697. A naval soldier and veteran of the Anglo-Dutch

Wars, Dampier had cut his teeth by harassing Spanish ships in the Caribbean. Their romantic outlaw image notwithstanding, pirates had often featured as agents of state policy, especially in the West Indies where so-called privateers from Walter Ralegh to Henry Morgan had licence to attack foreign ships and went on to sing of their exploits to literary acclaim in works like Ralegh's *Discoverie of the Large, Rich and Bewtiful Empyre of Guiana* (1596). Dampier emulated and outdid such examples. The full title of his book told of his remarkable circumnavigation of the globe: *Describing particularly the Isthmus of America, several coasts and islands in the West Indies, the isles of Cape Verde, the passage by Terra del Fuego, the South Sea coasts of Chili, Peru and Mexico, the isle of Guam one of the Ladrones, Mindanao, and other Philippine and East-India islands near Cambodia, China, Formosa, Luconia, Celebes, &c., New Holland, Sumatra, Nicobar Isles, the Cape of Good Hope, and Santa Hellena.* This itinerary stretched across the little-charted South Seas, making him someone every curious Londoner wanted to know, while his *New Voyage*, a mine of naval and ethnographic reconnaissance, became a virtual handbook for the Darien Company's Panama colonization scheme.[60]

When Sloane first met Dampier, he was still building up his medical practice, managing the *Philosophical Transactions* and composing his *Natural History*. But he was alive to the opportunity Dampier presented and secured a number of his shells and objects, including a Panamanian hatchet he bought for six shillings. There were limits to what he could achieve, however, especially at this early stage of his career. Dampier was in high demand. Pepys, Woodward, Evelyn and Robert Southwell all courted his company, which the Cape botanist Starrenburgh confirmed was 'very agreeable'. Ultimately most of the pirate's plants and animals ended up in Oxford, although Sloane did get the prize of Dampier's journal, the basis of his best-selling book. Sloane also collected and displayed Dampier himself: it was he who commissioned the Murray portrait. He was eager to show off his link to Dampier's edgy celebrity, even as the pirate sought to transform himself into a genteel author. While Dampier offered access to glamorous worlds of exotic danger, association with Sloane and his circle offered money and respectability. Dampier's *Voyage* advanced the pirate's makeover from swashbuckling violence to lettered civility. His descriptions of foreign peoples from Panama to New Holland – Australia,

which Dampier was the first English traveller to describe – were part of this process. In his original journal, these were relatively sympathetic and non-judgemental. It is not clear who edited the text for publication (Sloane may have been involved), but whoever did so drew out contrasts between European civility and exotic savagery far more, evidently with readers' prejudices and sales in mind. For example, when Sloane catalogued Dampier's hatchet, he included a reference to the passage in the published *Voyage* that explained its role in enabling the 'sagacious' natives of Panama to carve canoes out of cotton trees, though any sneaking admiration for their art was tempered by Dampier's mention that these 'wild Indians' lacked iron tools – a classic marker of technological backwardness in European eyes. In print, at least, the buccaneer reassured his readers of his own civility by emphasizing the barbarism of those he encountered.[61]

The rough-hewn talents that allowed Dampier to thrive in the violent world of piracy, combined with his penchant for observation and collection, brought him fame in London but also dramatized the hazardous fortunes of those on the margins of society. Dampier also collected human beings. He brought back an enslaved islander from Mindanao in the Philippines whom he called the 'painted prince' Jeoly. Jeoly was an astonishing specimen: his body was covered in tattoos and Dampier intended to exhibit him for money as a curiosity, although he lost possession of him once back in London and never found him again. He also brought back an errant Scot: one Alexander Selkirk, who had been marooned on Juan Fernández Island in the Pacific Ocean, and whose story may have been the inspiration for Daniel Defoe's *Robinson Crusoe* (1719). Such misadventures were irresistibly curious to Sloane, who boasted incredulously to his associate the Abbé Jean-Paul Bignon (librarian to Louis XIV of France) that Selkirk had 'lived by himself for four and a half years on the island of Juan Fernando off the coast of Chile'. Dampier detailed in his *Voyage* how his fellow mariner Lionel Wafer had likewise been marooned among the Kuna Indians of Panama, and Sloane acquired Wafer's writings. But like many of the travellers who supplied Sloane, Dampier paid the price for a life lived betwixt and between. Although rewarded with his own command in 1699, he clashed bitterly with his first officer, who challenged the former pirate's fitness for command. Stung by these slurs, Dampier had him whipped and was court-martialled for his trouble on returning

to London. Though he went on to make new voyages, he died in debt in 1715. Dampier could travel the world and rub shoulders with learned society and Britain's naval command. But, like the people he collected on his travels, he was a curiosity who could not fit anywhere for long.[62]

Like Dampier, the young Benjamin Franklin also had something of a genius for water, though of a rather different kind, and unlike the great navigator he knew how to make a virtue of his marginality. Born in Boston, Franklin had shrugged off his father's ambitions for him to become a clergyman and launched a career as a printer in Philadelphia. In 1725, at the age of nineteen, the young apprentice crossed the Atlantic and looked for work in London. He cut an unusual figure. Among other things, he claimed that the rare physical strength he displayed came from drinking water rather than beer, so his London friends took to calling him the 'Water-American'. At one point when travelling east along the Thames by boat, he stripped off, leaped into the water and swam – something most Europeans didn't know how to do at the time – from Chelsea to Blackfriars, 'performing along the way many feats of activity, both upon and under water'. Ravenously curious about the workings of both nature and society, he had been drawn to the imperial capital by his ambition and the fashion for philosophical freethinking, publishing his own libertine manifesto entitled *A Dissertation on Liberty and Necessity, Pleasure and Pain* in 1725. At the Horns, a Cheapside alehouse, he was thrilled to be introduced to Bernard de Mandeville, author of the scandalous celebration of private vice as public virtue, *The Fable of the Bees* (1714). The man Franklin desperately wanted to meet was Isaac Newton. But an audience with the great natural philosopher never materialized. Instead, he met Sloane.[63]

Almost half a century after their meeting, Franklin told the tale of the encounter in his autobiography in 1771. 'I had brought over a few curiosities, among which the principal was a purse made of the asbestos, which purifies by fire. Sir Hans Sloane heard of it, came to see me, and invited me to his house in Bloomsbury Square, where he show'd me all his curiosities, and persuaded me to let him add that to the number, for which he paid me handsomely' (Plate 21). However, Franklin's original note of introduction to Sloane in 1725 – the oldest surviving letter in Franklin's hand – tells a rather different story.

Sir, having lately been in the northern parts of America, I have brought
from thence a purse made of the stone asbestus, a piece of the stone, and
a piece of wood, the pithy part of which is of the same nature, and call'd
by the inhabitants, Salamander Cotton. As you are noted to be a lover of
curiosities, I have inform'd you of these; and if you have any inclination
to purchase them, or see 'em, let me know your pleasure by a line directed
for me at the Golden Fan in Little Britain, and I will wait upon you with
them . . . P.S. I expect to be out of town in 2 or 3 days, and therefore beg
an immediate answer.

By the time he composed his autobiography decades later, completed
and published in the course of the American Revolution, Franklin had
made his life into a parable of self-making to be emulated by the youth
of the new American republic. But in 1725 it was Franklin the colonial
journeyman who had sought out Sloane the virtuoso, not vice versa;
Franklin who had pressured the collector to meet with him by threat-
ening to leave town; and Franklin who had talked up his curiosities to
get Sloane to buy them.[64]

The meeting between Franklin and Sloane might appear to have
been one of opposites: the colonial apprentice and the metropolitan
connoisseur. The contrast, however, is not as sharp as it seems; perhaps
Sloane even recognized something of himself in the young American.
After all, as with Franklin, much of Sloane's early life had been colonial,
from Ulster to his own Atlantic crossing to Jamaica; his own training
bore the stamp of practical arts, in his case via the apothecaries and
gardeners of Chelsea and Montpellier; and when Franklin sold him his
purse, there were even shades of Sloane impressing the chemist Lémery
with his rare phosphorus samples in France. Both Sloane and Franklin
understood the power of curiosities as commodities of ascent for ambi-
tious men courting patrons and allies and, moreover, how those on the
rise enjoyed certain advantages over their betters. In some ways Frank-
lin had little to lose from his meeting with the great collector, but for
virtuosi like Sloane journeymen like Franklin were his stock in trade
and as such demanded careful attention. Collectors depended on trav-
ellers as much as the other way around. Franklin's asbestos purse might
not look like much – nor the 'flower used for tea in New England' that
he also sold Sloane – but dealing in curiosities was a speculative game;
the value of some strange new substance might come to light only with

the passage of time. So too might the value of an ongoing relationship with such travellers. Sloane could not, of course, have predicted that Franklin would one day help lead a revolution against British rule, prompting him to rewrite their meeting as but one brief episode in the inevitable progress of an American hero. Indeed, Franklin's rewrite is a spectacular example of how stories about collecting vary dramatically depending on who tells them, when and why.[65]

Almost a decade later, in 1733, another striking traveller came into contact with Sloane and, although we do not have his side of the story, the encounter between the two men raises similar questions about the multiple meanings of a single exchange. This traveller's name was Ayuba Suleiman Diallo, a West African who had been pulled towards London by the Atlantic slave trade. He was rather different from the rebellious young African Sloane had been given as a present years earlier by Alexander Stuart, or so observers insisted. All who met him remarked that Diallo was a person of singular grace. 'By his affable carriage and the easy composure of his countenance,' wrote the evangelical Thomas Bluett in his *Memoirs of the Life of Job* (1734), which furnishes much of what we know about Diallo, 'we could perceive he was no common slave.' Others spoke of his 'lean and weakly' aspect and grave yet composed expression, while a minister named Henderson 'gave [him] the character of a person of great piety and learning'. Sloane thought him 'sensitive and polite' and found his decidedly scholarly demeanour highly agreeable. The most tangible legacy of their meeting remains in the British Museum: a series of seventeenth- and eighteenth-century Persian amulets that bear Shi'a inscriptions in Arabic of verses from the Qur'ān. Diallo translated several of these for Sloane. How he came to do so involves one of the most extraordinary tales in all Sloane's collections.[66]

Diallo was known to his London acquaintances by several different names, most commonly Job ben Solomon. Bluett, who claimed he wrote about him at Diallo's own behest and from 'Job's particular information', named him as 'Hyuba, Boon Salumena, Boon Ibrahema' – Job, Son of Solomon, Son of Abraham, identifying his family name as 'Jallo'. Diallo was a member of the Fula people, son of a high-status Muslim cleric and himself an imam in the kingdom of Bundu (Senegal), which the Fula had remade into an Islamic society by the early eighteenth century. He was also a slave trader. One day in

1731, however, he was captured by rival Mandinka merchants along the Gambia River, sold into bondage and sent across the Atlantic to Maryland. In America, Diallo's modest physical strength combined with his habit of daily prayer drew the attention of those around him. He managed to obtain writing materials and composed a letter in Arabic to his father to request that his freedom be purchased without delay. The letter did not reach its target but somehow found its way to General James Oglethorpe instead. Oglethorpe was engaged in planning the settlement of Georgia and was about to host the Yamacraw in London. But on seeing a translation of Diallo's letter, arranged for by the tradesman and antiquary Joseph Ames, he was moved by the plight of its author, so made arrangements for Diallo to be brought to the capital. When the learned Diallo arrived, having acquired some English en route, he quickly became a darling of the London scene, conversing with Sloane, attending the Spalding Gentlemen's Society, spending time with the Duke of Montagu and gaining an audience with George II – evidently thanks to Sloane.[67]

Although they had encountered Muslims across South Asia and Persia, British travellers generally found it difficult to differentiate among the complex variety of ethnicities and faiths in these regions. As a result, their attitudes to Islam tended to fall back on enduring memories of the Crusades, conflict with the pirates of North Africa and the intimidating military might of the Ottoman Empire. But there was a significant history of diplomatic and commercial relations between England and the Muslim powers of the Mediterranean as well that dated back to the time of Elizabeth I. The English traded guns, timber, wool and tobacco for tea, coffee, calicoes and carpets. British hostility towards Islamic peoples, in other words, was far from monolithic or unchanging. It did not preclude mutually beneficial relations, and by the second quarter of the eighteenth century a pattern of sustained intellectual curiosity had developed, facilitated by the fading of the Ottoman military threat after 1683, when Turkish forces were repelled from Vienna. By the time Diallo reached London, the rapprochement between Christians and Muslims included acts of charity. His odyssey was facilitated by 'rich presents', as Bluett put it, totalling more than £500, intended to educate him and his people. He received a gold watch and agricultural implements to alleviate the 'difficulties these [Africans] labour under', and the Duke of Montagu told his

servants to show Diallo how to handle 'tools that are necessary for till-ing the ground'. Diallo was apparently an apt pupil: 'upon seeing a plow, a grist mill, and a clock taken to pieces, he was able to put them together again himself.' Spiritual improvement was another British gift: Diallo was provided with Arabic translations of the New Testament. As with the Yamacraw, British desires to make Christian converts aligned with strategic interests to forge diplomatic alliances.[68]

Even a portrait of Diallo commissioned from the Bath artist William Hoare rendered him in relation to an object: a Qur'ān hangs around his neck like a protective amulet (Plate 25). It is not entirely clear whose choices shaped Hoare's composition; although Diallo took to wearing English clothes, it seems he may have donned 'dress, made up after his own country fashion' at Sloane's prompting. How Diallo felt about picturing the Qur'ān to emphasize his identity as a Muslim, worn in talismanic style and thus connoting magical protective powers in the manner of a charm, is not known. Given the strain of antipathy to iconic representation among many Muslims, he may have objected to it. According to Bluett, Diallo was exceptional because he was 'more moderate in his sentiments than most of his religion are', who enter-tained 'ridiculous and vain' ideas of a 'sensual paradise'. But he was still 'so fixed' in his devotion that 'it was impossible to give him any notion of the trinity' and he baulked at the idea of pictures in general. 'We assured him we never worshipped any picture,' Bluett stressed. But when Hoare said he could not paint Diallo in his native garments because he had never seen them, Bluett recorded Diallo's response thus: 'if you can't draw a dress you never saw, why do some of you painters presume to draw God, whom no one ever saw?' Bluett concluded that Diallo had a 'strong aversion to the least appearance of idolatry' and 'to pictures of all sorts'. He had, indeed, initially refused to be painted and consented only 'with great difficulty'. Yet the inclusion of the Qur'ān in Hoare's portrait may also symbolize Diallo's insistence that he remained true to his faith despite his captivity. Christians were sym-pathetically identified in the Qur'ān as 'people of the book' – sharing with Islam an Abrahamic tradition of divine scriptural revelation and prophecy – but they were still seen by Muslims as notoriously proselytizing.[69]

Objects defined Diallo's relationship with Sloane as well since Diallo had a rare talent: he was one of the few people then in Britain who

could translate Arabic into English. Sloane had acquired a sizeable collection of Persian amulets with Qur'ānic inscriptions, which related to his preoccupation with medical superstition, and for which he enlisted the services of George Sale, the manuscript collector who produced only the second English translation of the Qur'ān in 1734, as well as the Syrian Carolus Dadichi and the Armenian Melchior de Jaspas as translators. But such expertise was hard to come by and Diallo presented a golden opportunity. As was common in the early modern world, captivity and translation went hand in hand: Diallo's enslavement had evidently allowed him to acquire sufficient English to make him linguistically useful to Sloane. Unlike in the *Natural History of Jamaica*, where he named no African source of botanical knowledge, Sloane carefully recorded which verses Diallo interpreted for him in his Catalogue of Gems and Stones Containing Arabic and Persian Inscriptions. The first amulet in the catalogue, for example, is listed as an orange oval carnelian set within green nephrite and inner gold frames, with words to the effect: 'call upon 'Alī who makes wonders appear you will find him a help to you in adversity all care and grief will clear away through your Prophethood O Muhammad through your friendship O 'Alī O 'Alī O 'Alī' (Plate 26). The catalogue entry (written by one of Sloane's amanuenses) contains a transcription of the Arabic original, a Latin translation, a sketch of the object and a note on the amulet's intended use 'against fascination by evil eyes'. The entry acknowledges Diallo's translation by name in the phrase 'translated by the same Job, Mahometan priest from the State of Boonda in Africa, in the year 1733', abbreviated as 'Interpr. Job' in several subsequent entries.[70]

This act of translation was, however, deeply ironic because both men likely held these amulets in low regard. Sloane undoubtedly valued them as specimens of rare stones and things of beauty; some reveal their complex translucent textures only when held up to the light. But as the bearers of prayers designed to work as protective charms, they also furnished more evidence of the folly of belief in magic, recalling the amulets of the Royal Touch, Catholic *ex-votos* and the *obis* of Caribbean slaves. Sloane mocked amulets more than any other kind of object in the world. In one catalogue, he described with seeming neutrality 'a bracelet made of a Cornelian in wch. is engraved a sentence of the Alcoran sett in nephritic stone worn in Persia & Turkey as an amulet agt. the devill &c'. But elsewhere his scorn was explicit. In volume two of

the *Natural History of Jamaica*, published just a few years before he met Diallo, he observed that 'spleen-stone' (jade) was 'thought very much to help in the stone and hypochondriac affections', an 'opinion I take to be owing to a superstitious custom the Turks and Mahometans have of wearing sentences out of the Alcoran in Arabick, &c., wrote upon Cornelians, &c. and lodg'd in these greasy stones which are hung about their necks or arms, to keep them from the power of the devil, diseases, &c.'. Whether Diallo was aware of Sloane's dismissive attitude is unknown but one plausible speculation is that, due to his own likely antipathy to forms of idolatry, he may have shared it. All the while, Diallo must have been only too conscious that each act of translation he performed for his host brought him closer to liberation by engaging him in a pattern of cooperation with those who held the key to his release.[71]

After several months in London, Diallo's freedom was indeed purchased through an arrangement between Oglethorpe, Sloane, several other philanthropists and the Royal African Company. He returned to his native Bundu in 1734 and soon sent presents back to his new friends. Sloane received a tobacco sample, two pipes and a 'poysoned arrow from the river Gambia' (the antidote, Diallo said, would soon follow). 'You have been as a father to me,' he wrote to Sloane that year, 'Mussulmen here love you very heartily, and pray for you.' Sloane, meanwhile, boasted to colleagues of the coup of Diallo's translations, bragging to one about some 'coins I have had interpreted by a native of the inward parts of Africa a black mahometan priest who had great knowledge of the ancient as well as modern Arabick' and whose poisons were 'to be tryed on dogs by the first opportunity'. This back-and-forth went beyond personal gratitude. Sloane read the Fellows of the Royal Society a letter he had received in which Diallo described his return to the Gambia in his new capacity – as an agent of the Royal African Company. The letter conveyed Diallo's stated willingness to use the 'utmost of his power' to aid British efforts to break the stranglehold the French enjoyed on gold mining and gum trading in the region. The Christian philanthropists and their erstwhile Muslim ward were now partners. Diallo went back to trading slaves (he bought one slave with the money he earned by selling the gold watch he'd been given) and assisted British agents in West Africa until he fell foul of French forces who, recognizing the threat he posed to them, threw him in jail. Within a few years,

he appears to have lost all contact with London, and news of his death finally found its way to England decades later in 1773.[72]

Diallo knew his place in the world and how to get back there, but it is hard to place him today. As a West African Muslim sold into American slavery, who secured his freedom in London to return to Bundu as an agent of the Royal African Company, he is arguably the most complex figure Sloane ever encountered and one now claimed by several different narratives: the history of the Atlantic slave trade and the African diaspora; colonial American history; eighteenth-century Britain; the history of Enlightenment tolerationism; and the history of Islam. Making sense of Diallo has become even more pressing since his portrait by Hoare, long lost, resurfaced in the early twenty-first century. The picture has been purchased by the Qatar Museums Authority but remains on loan in Britain where it hangs, like Dampier's, in the National Portrait Gallery. Much has again been staked on collecting Diallo. His has been called the 'first British portrait of a Black African Muslim and freed slave'; campaigners to keep it in Britain heralded it in 2010 as compelling evidence of the heritage of Enlightenment cosmopolitanism, neglecting to mention Diallo's own career as a slave trader and British colonial agent. Such selective projections of enlightenment are not new. In the 1730s, as empires competed not just for territorial gains but for moral legitimacy, Sloane's circle cast Diallo in their own desired image for British society: Protestant benevolence. The evangelical Bluett portrayed Diallo's deliverance as the epitome of Christian 'kindness to strangers' and a 'very remarkable series of providence' – a 'sublime' gift without any expectation of return, the example of which he hoped would 'range round the whole globe, and exert [itself] in all places'. Diallo, he said, had thanked God for his slavery because it had brought him to Britain and kept him from the French and their idolatrous 'popish worship'. British representations of Diallo thus originated in the projection of a charitable Christian nation, even as that nation aggressively pursued its self-interest through colonization and conquest.[73]

Sloane proved singularly adept at collecting the collections of others: at home through friends (and sometimes enemies) and abroad from travellers immersed in many different worlds beyond Europe. Through relations with voyagers like Diallo, his collections came to seem as vast as the globe. But Sloane couldn't simply reach out and take what he

liked; the interloper's world in which he trafficked typically obliged him to accept what others offered him. In reality, the paths of his curiosities traced a map not of the globe but of Britain's colonial outposts, from the slave castles of West Africa and the colonies clustered in North America and the Caribbean to the East India Company factories dotted around South and East Asia. Sloane in truth owned little from *most* parts of the world that lacked British colonies: Australasia, the Pacific, western North America, Central and South America, the Ottoman Empire, Safavid Persia, Russia, Central Asia and the African interior. The albums he acquired featuring pictures of Turks, Persians and Indians in traditional costume provided only glimpses of such regions. Only occasionally could he reach beyond thanks to Dampier's navigations or Diallo's misadventures, and such lucky chances came and went with dizzying speed. It was thus a testament to Sloane's industry, wealth and constancy of purpose that he was able to collect as much as he did. What his many curious treasures added up to is, however, another question and provides the subject of the final two chapters.[74]

# 6

## Putting the World in Order

### MASTER OF SCRAPS

William King had derided Sloane as 'a master of only scraps', but the phrase turned out to be peculiarly apt. Accumulating collections was one thing; organizing, documenting and controlling them through the management of information quite another. More than King realized, 'master of scraps' perfectly captured the painstaking art of cataloguing at which Sloane became adept. The scale of his collections made them impossible to manage single-handedly so he hired a series of learned assistants, armed with knowledge in areas such as languages, botany and librarianship, and versed in the arts of cataloguing. They included the antiquarian and palaeographer Humfrey Wanley, who helped catalogue Sloane's library in 1701–3; the assistant secretary at the Royal Society Alban Thomas, who worked on his library in the 1710s; Johann Gaspar Scheuchzer, whom Sloane 'adopted' and lodged in his home, and who in the years 1722–9 helped revise his manuscripts catalogue, organize his books and complete the translation of Engelbert Kaempfer's *History of Japan*; the Swiss-Russian botanist Johann Amman, who worked on Sloane's plants before assuming a post at the Academy of Sciences in St Petersburg; Thomas Stack, a physician and translator, whom Sloane engaged to recatalogue his library between 1729 and 1741; and, in the 1730s, the physician and secretary of the Royal Society Cromwell Mortimer, who organized Sloane's butterfly collection, worked in his library and helped conduct tours of the collections. Last but not least, there was James Empson, whose mother worked as Sloane's housekeeper. Empson was Sloane's principal curator from 1741 to 1753, annotated his personal copy of the *Natural*

*History of Jamaica* (including via dictation) and became Sloane's most trusted confidant concerning the collections.[1]

Sloane's devotion to documenting his collections generated a rational paperwork labyrinth intended to shed light on every single item inside it (Plate 30). Natural history was nothing if not a science of inscription. Collecting involved literally attaching meanings to things by pasting on to each object labels bearing numbers linking each item to a description in one of fifty-four handwritten catalogues. These humble scraps of paper were the unsung heroes of Sloane's museum; for all the distance they travelled, Sloane's curiosities would have had precious little value without these identifying tags. This was a private system, not designed for public use, and to some extent relied on memory. Sloane and his assistants could not simply look up any given object because the catalogues they created were not alphabetical indexes but accession registers designed for endless extension to incorporate new items. But Sloane *could* take an object in hand and use its number to look up its description in his catalogues; or browse the catalogues and find a specific object, since catalogue numbers typically doubled as location codes. He thus converted his collections into a series of giant numerical lists that corresponded to physical spaces in his apartments. The care he took was enormous. On his retirement in 1742, he moved full time to Chelsea Manor, transporting his entire museum in the process. Visiting him shortly afterwards, Henry Newman of the Society for the Promotion of Christian Knowledge observed with astonishment that Sloane's animal specimens were 'dispos'd in the same succession of numbers they were in at Bloomsbury' and that not one in over a hundred carts of jars and books appeared to have been lost or broken. Not every such assessment was so generous, however. 'I believe he has a multitude of curiositys that [he] himself is scarce aware of,' the Leeds antiquarian Ralph Thoresby observed in 1723.[2]

Sloane's greatest legacy as a writer is contained neither in the *Philosophical Transactions* nor in his encyclopaedic *Natural History* but in his labels and catalogues. His own view was that 'the collection and accurate arrangement of these curiosities constituted my major contribution to the advancement of science.' Rather than prose, the list was his quintessential literary mode, as he and his assistants wrote out many thousands of labels and catalogue entries. After his death in 1753, his executors published a tally of the collections using the categories by which he had organized them. This tally – the sum total of a life spent collecting – is the ultimate Sloane list:

| | |
|---|---|
| The Library | *c.* 347 albums of drawings and illuminated books, 3,516 volumes of manuscripts plus books of prints, totalling *c.* 50,000 volumes |
| Medals and Coins | *c.* 32,000 |
| Antiquities | 1,125 |
| Seals | 268 |
| Cameos and Intaglios | *c.* 700 |
| Precious Stones, Agates and Jaspers | 2,256 |
| Agate and Jasper Vessels | 542 |
| Crystals and Spars | 1,864 |
| Fossils, Flints, Other Stones | 1,275 |
| Metals, Minerals, Ores | 2,725 |
| Earths, Sands, Salts | 1,035 |
| Bitumens, Sulphurs, Ambers | 399 |
| Talcs and Micae | 388 |
| Testacea and Shells | 5,843 |
| Corals and Sponges | 1,421 |
| Echini Marini (sea urchins) | 659 |
| Asteriae, Trochi, Entrochi (shells) | 241 |
| Crustacea or Crabs | 363 |
| Starfish | 173 |
| Fish | 1,555 |
| Birds, Eggs, Nests | 1,172 |
| Vipers and Serpents | 521 |
| Quadrupeds | 1,886 |
| Insects | 5,439 |
| Humana | 756 |
| Vegetable Substances | 12,506 |
| Herbarium Volumes | 334 |
| Miscellaneous Things | 2,098 |
| Framed Pictures and Drawings | 310 |
| Mathematical Instruments | 55[3] |

There is no recorded statement by Sloane discussing how he selected these categories. Broadly speaking, however, they aligned with

encyclopaedic Renaissance schemes for assembling the world in micro-cosm according to type of object, dating back to such works as Samuel Quiccheberg's *Inscriptiones* (1565). Variations on basic categories of natural and artificial objects were adopted and refined by a number of subsequent collectors such as the Danish physician Olaus Wormius, whose mid-seventeenth-century work on classificatory systems, dealing with such classes as minerals, metals, vegetables and animals (1643), Sloane possessed in manuscript form. Partly because Sloane lacked specialist knowledge in areas ranging from classical antiquarianism to mineralogy, he wrote relatively little interpretative commentary on the vast majority of his objects, limiting himself to short descriptions in his catalogues. This intellectual caution seems to have been temperamental; and without doubt Sloane was too busy doctoring, officiating, corre-sponding and cataloguing to conduct his own extensive researches. But his reticence was also a matter of philosophical principle. At the Collegio Romano, the Jesuit polymath Athanasius Kircher had essayed bravura interpretations of arcana to crack what he considered the esoteric codes of the world as a great Baroque mystery, and he sometimes went spec-tacularly awry in the process, for example in his erroneous translations of Egyptian hieroglyphics. The contrast in styles between the two collec-tors is illuminating. Sloane was the anti-Kircher: a cautious, sober and doggedly unimaginative Protestant empiricist – all of which he consid-ered positive virtues as a man of science. His touchstone was Francis Bacon who, as we have seen, called for restoring English fortunes by rebuilding the stock of knowledge through travel, experiment and the collection of matters of fact. Sloane was thus content to accumulate rather than theorize, at least to begin with. It would fall to specialists like Ray and later on Linnaeus to frame new taxonomies of plants and animals by genus and species. Sloane, meanwhile, saw his task as more fundamental: gathering thousands of fragments as the very building blocks for reinterpreting the order of nature, a colossal jigsaw that had to be assembled with great patience. His was a collection that did *not* immediately add up to a new big picture of the world – and that was as it should be.[4]

Sloane's devotion to the mundanities of cataloguing is clear from the huge amount of time he spent writing out entries himself. This pro-cess started with the library he began to assemble in 1680 shortly after his move from Ulster to London. He first catalogued his printed books

by recording information about them including author, title, a physical description and price (possibly, while his fortune was not yet assured, to facilitate resale), using alchemical symbols as codes for value and date of purchase. Most of what he bought until around 1698 was evidently for personal use, comparable in size to the libraries of friends like Pepys and Locke (several thousand volumes), a good number supporting his research for the *Natural History of Jamaica*. After 1698, however, with income flowing in more freely from his medical practice, his salaries and Lady Sloane's plantations, Sloane began acquiring books on a far greater scale for the purpose of collection building, ultimately reaching a total of around 45,000 volumes. With the exception of Georg Mercklin's edition of *Lindenius renovatus* (1686), which Sloane used as an index for his numerous Latin medical books, he did not arrange his library catalogues according to subject matter but instead used letters of the alphabet to denote volumes of different size. Initially, he lumped books and manuscripts together, but separated them after 1694 and started an author index of printed books to increase searchability. After 1700, Wanley, Thomas, Scheuchzer, Stack and Mortimer performed much of this librarianship, gradually introducing refinements including lists of Oriental manuscripts and lists of pictures classified as prints and miniatures. Sloane's aged hand nonetheless remains visible in his library catalogues as late as 1741.[5]

Much of the work of organizing the collections was carried out in the pages of Sloane's catalogues. He and his assistants unwrapped objects and specimens from the boxes sent by correspondents, read through their letters and created labels and catalogue entries, using suppliers' information as well as their own collective expertise concerning each item. Making catalogue entries was an open-ended rather than definitive process: many contain question marks and have blank spaces for adding information later on. Labelling could sometimes be minimal. In entry numbers 553–8 of Sloane's Miscellanies Catalogue, for example, he described some brass Chinese weights for scales followed by 'another smaller', 'another', 'another', 'another' and 'another'. Some entries contain no information at all – just a number so that the item was catalogued even if Sloane wasn't even sure what it was. But elsewhere, there is almost too much to tell, from useful medical information to curious tales. Entry 8119 of the Vegetable Substances records the following: 'Piper Æthopic. Sassinah is a vine & produces a small

black pepper resembling the India pepper and has all its vertues. It is to be had at Abramboc, Fanteen, Angurnia [?] & other inland countryes as also at Antu but at none in any great quantity. The berry is made use of to mix up wt. all medicines either inward or outwardly applied & the vine its selfe is boiled up into a decoction for a sore throat. From the Duke of Chandois who had it from Guinea.' This pepper specimen (and its description) are gifts the Duke of Chandos gave Sloane in return for the botanical advice he provided the Royal African Company. Specimen 607 in Vegetable Substances tells of the mysterious present given to Sloane by Lady Ferrers, whom he had sent to Montpellier for treatment. This was the skeleton of an unidentified creature 'putt into a place called Montperon near Montpelier . . . & lying in the said water five or six hours [whereby] the flesh of those creatures are intirely consumed wch is attributed to that water being impregnated with a sort of [substance] that produces that effect which passes in that country for something curious in its kind'.[6]

Sloane's Vegetable Substances present one of the most striking instances of his masterfully laborious cataloguing. This collection consisted of over 12,000 sealed boxes of dried seeds, fruits and resins sent by numerous correspondents, approximately two-thirds of which survive today, stored in numerical order in approximately ninety drawers in London's Natural History Museum (Plate 31). Drawer number 12, for example, contains specimens labelled 11214–20, lined up in a column, showing how Sloane arranged them to form a sequential list for easy searchability. The specimens exemplify the highly visual culture of natural history: they are housed in small glass boxes, most of which are sealed with marble paper, to allow for the optical inspection of minute physical details and enable the identification of distinct species. Many of the boxes bear paper labels with catalogue numbers, multiple names and miscellaneous information about their contents. A large number of these are in Sloane's own hand, showing that he inspected the item in question and catalogued it himself – giving his personal guarantee that a given name belonged to a given specimen. But the judgements of different people also meet in these boxes. In many cases, Sloane (or more likely one of his assistants) has cut up and pasted information about a given species directly from correspondents' letters on to the box (or transcribed this information on to a label) to make it physically inextricable from the specimen (Plate 32).[7]

The information Sloane's various catalogues contain ranges from simple identifications and physical descriptions to the names of suppliers, places of origin, prices paid, uses, interesting stories and, from time to time, references to accounts in published books. For example, next to entries in Miscellanies for Chinese organs, chopsticks, seals, abacuses and medicinal glue, Sloane cited page numbers in both the *Description de la Chine* (1736) and the *Lettres édifiantes et curieuses* (thirty-four volumes, 1702–76), works compiled by Jean-Baptiste Du Halde from accounts by Jesuit missionaries and cribbed from Chinese sources like the *Bencao gangmu* (1596), the sixteenth-century *materia medica* produced by the physician Li Shizhen. A number of cross-references were made to the works of famed naturalists like Ulisse Aldrovandi and Carolus Clusius or of eminent antiquarians like Bernard de Montfaucon. But most of Sloane's cross-references linked exotic objects to their descriptions in the accounts of prominent travel writers such as Jean-Baptiste Labat, André Thevet, Antonio Pigafetta, Richard Hakluyt, Lionel Wafer and William Dampier. These references indicate how Sloane sought to interlink his collections and his library. Yet their relative scarcity in his catalogues shows that any project of comprehensive annotation he may have envisioned remained dramatically incomplete due to limited time, knowledge and resources. Something similar may be said of a series of calligraphic red labels, apparently designed as systematic labelling for Sloane's vast picture collection, but never evidently used. Such efforts hint at dreams of total information architecture – an integrated system for linking objects, texts and images on a global scale – but these went unfulfilled.[8]

If it was vital to inscribe every item in the collections with a number to give it its place in the catalogues, the sheer physical attachment of labels could itself prove challenging. With considerable dexterity, Sloane and his colleagues entwined labels with specimens of fine branches and slipped them inside hollow objects such as penis sheaths. They wrote numbers and words directly on to the surfaces of shells, bones, leaves, barks and artefacts including the Akan drum, the Jamaican cocoons that inspired Sloane's theory of Atlantic currents and even a delicate palm-leaf manuscript from Sri Lanka, on which Sloane penned the single word 'Zeylon'. The most remarkable such label was one Sloane wrote on the head of a spoon from Massachusetts, dated 1702, where he transcribed a letter by John Winthrop: 'an Indian spoon

the breast bone of a pinguin made by Papenau an Indian whose squaw had both her legs gangren'd & rotted off to her knees and was cured with bathing in balsam water made by Winthrop esq. New England[.] The method was thus he ordered two oxe bladers to be filled with his rare balsamick liquor made warme and the stumps put into the bladers with the water was kept comfortably blood warme, and the leggs were perfectly cured in a few days time' (Plate 27). The spoon shows how Sloane prioritized specific kinds of information, in this case regarding its material composition and Winthrop's intriguing (if self-aggrandizing) story about healing a Native American. Despite its loquacity, the spoon is nevertheless disappointingly silent on the question of how Winthrop got it from the Indian Papenau. As with Sloane's Jamaican banjos, this part of the story is missing. Documenting where rare objects came from counted for collectors like Sloane; provenance added value to curiosities. But telling potentially troublesome stories about taking possession of them did not.[9]

Once catalogued, each object could find a physical home in Sloane's museum, but this apparently simple task was not always straightforward either. Sloane liked to draw together as many objects as possible of a given type to document variation within that group, and aimed to arrange and display his things in sets corresponding to the categories he used in his catalogues. This led him to have such things as plants, musical instruments and shoes arranged in discrete groups (Plate 34). The evidence for these arrangements derives from marginalia in Sloane's catalogues. A series of pencil annotations appears to constitute location codes that may have been used to keep track of Sloane's objects during the move from Bloomsbury to Chelsea in 1742. Location '245', for example, is indicated next to many of his musical instruments: the Akan drum, Standish's 'negro' drum, three drums from Lapland, the Jamaican banjos, a Bengali drum, two Chinese organs, trumpets from Norway, the Congo, Japan and China, eight different pan pipes and more. Sloane likewise had a series of miscellaneous paintings by the French artist Nicolas Robert (acquired through his purchase of William Courten's collection) rearranged by type of specimen and rebound into albums featuring sequences of corals, insects, snakes, monkeys, men, monsters and so on. Unlike those in nineteenth- and twentieth-century museums like the Pitt Rivers in Oxford, the Horniman in London and the American Museum of Natural History in New York,

Sloane's arrangements show that he did not organize his collections according to geographical regions or political borders, cultural or racial groupings, or historical chronologies (evolutionary or otherwise). His curiosity about the bodies of Africans reflected a sustained interest in collecting physical evidence for demonstrating racial difference; as we shall see, he also embraced the prejudices of his time concerning the 'barbarism' of non-Christian peoples. But such views did not *structure* his collections. Instead, Sloane piously sorted his things by type in order to inventory the glorious variety of the divine creation as a whole.[10]

The discrete object groups Sloane liked to arrange vied, however, with a recurrent drift towards miscellaneousness. The process of cataloguing was less orderly than might appear in retrospect. In addition to musical instruments, for example, location '245' also seems to have contained objects related to smoking, including over fifty pipes. As new objects came in, Sloane may simply have placed them where he still had space in his overcrowded museum rather than where they strictly belonged. His catalogues are not in perfectly chronological order and it is likely that cataloguing was often carried out in reverse order, as it were: finding a physical space for an object and then cataloguing it. How to classify objects wasn't always obvious, especially when dealing with rarities whose value lay precisely in their multiple meanings. Sloane listed his coral-encrusted curiosities in both his Corals and Miscellanies catalogues; he put his Jamaican urns in Antiquities rather than Miscellanies; listed manatee straps in both Quadrupeds and Miscellanies; and included 'the heart of a tortoise' in his Humana catalogue. Over time, he seems to have moved his manatee specimens into his *materia medica* collection. The full title of Sloane's Miscellanies Catalogue, where he listed most of his ethnographic artefacts, suggests the contingent character of the categorization process: 'Miscellaneous Things Not Comprehended with the Foregoing [Catalogues], both Natural and Artificial'. While he took pains to preserve his Jamaican urn fragments just as he found them, he had two native Jamaican hatchet heads made of spleen-stone (jade) physically altered to show off their jade to its best aesthetic effect. Such was the enormous discretionary power of the collector, not just to document his collections, but actively to shape them and their meanings.[11]

With the universal survey of both natural and artificial kinds as

Sloane's objective, quantity of acquisition became a positive good in itself, though Sloane did not accept or keep absolutely everything he was offered. He appears to have rejected, for example, the chance to buy anatomical preparations by the Dutch anatomist Fredrik Ruysch, perhaps because of their highly stylized character as works of *nature morte*, and donated a large number of duplicate books to the Bodleian Library in Oxford. Still, the more Sloane possessed, the more he hoped to compare and know. To this end, he was constantly incorporating new information. His personal copy of the *Natural History of Jamaica* provides a glimpse into how he sometimes used different parts of his collections together and how time-consuming the process of integrating encyclopaedic information was in the age of manuscript paperwork. Many of the pages in this copy have columns of plant synonyms and references cut out from Sloane's *Catalogus plantarum* and pasted into the *Natural History* to bring together as much information as possible on a given species. In addition to cutting and pasting, annotations, excerpts and references to other books appear as handwritten marginalia on numerous pages. Juxtaposed with the printed passage where Sloane discussed the extraordinary variety of the world's dietary customs, for instance, his curator James Empson (signing himself 'J. E.') has paraphrased Nicolaus del Techo's *Historia provinciae Paraguariae* (1673), which Sloane had in his library, commenting that the inhabitants of Paraguay live on locusts and that Jean Barbot says the inhabitants of Guinea live off elephants' flesh, alligators and wooden logs. Underneath Empson's marginalia are further notes in Sloane's hand citing passages in the books he mentions in his text on topics like the diet of the Faroe Islanders and the preparation of whale bacon (p. 268).[12]

In addition to using his library to embellish the *Natural History*, Sloane incorporated information from the letters he continued to receive from Caribbean correspondents. These addenda repeatedly feature Walter Tullideph, the Antigua-based merchant who sent Sloane plant specimens and to whom Sloane sent a copy of the *Natural History*. But it is the Jamaica physician Henry Barham who looms largest in these pages. Leaves of paper have been inserted containing transcriptions, evidently in Empson's hand, from the manuscript natural history Barham composed, published posthumously as the *Hortus Americanus* (1794). These insertions contain a wealth of botanical and cultural

the Blood into the Stomach and Guts, and is there mix'd with our comminuted Victuals, is able to open and extract from them what is good and proper, whether they be Roots, Stalks, Leaves, or Seeds of Vegetables of several kinds; Fat or Lean of the Flesh of Animals, or parts of them, fweet or fower, acid or *Alkali*, 'tis all one, the beft parts are kept, and the worft, unufeful, or earthy, thrown off by Excrements. There will be no need of proving this, if we do but confider how many live very well on Vegetables only, thinking it inhuman to kill any thing to eat; others live on Flefh only, moft on both Vegetables and Flefh. Many live on the *Irifh Patatas*, a fort of *Solanum*, (on which, I have heard, they live in the Mines of *Potofi*, and in *Ireland*) the common Brakes, as in the late Famine in *France*; on the Roots of *Argentina*, called Mafcorns, in *Scotland* and the North of *Ireland*, the Stalks of the *Fucus Phafganoides* called *Tangle* in *Scotland*, or on the Roots of *Bulbocaftanum* or Pignuts. The greateft part of Mankind have their chief Suftenance from Grains; as Wheat, Rice, Barley, Oats, Maiz, Buck-wheat, *Zea* or Spelta, Rye, fome from the Seeds of a wild Grafs called *Gramen Mannæ* in *Poland*, or from wild Oats, or *Folle Avoine*, growing in the Lakes of *Canada*, on which the *Indians* feed; or from the Seeds of the feveral forts of Millet and *Panicum*. Some in *Barbary* feed on Palm Oil, others on that drawn from Organ or Erguen Nuts, many on Oil Olive, or that from Walnuts or *Sefamum*, which laft is much ufed in *Egypt* and the *Eaft-Indies*. Kine, Goats, Swine and Sheeps Flefh fuftain moft people in thefe parts, and fo does Camels in *Arabia*, and Horfes in *Tartary*. Moft in *Groenland* feed on large Draughts of Train Oil; and in *England* the poorer fort have ftrong Nourifhment from Milk-meats, (on which feed the longeft Livers) Butter and Cheefe. In many parts of the World, as *Lapland*, &c. Fifh is their chief fubfiftence.

Befides thefe already above mentioned, *Joachimus Struppius*, has written a Book printed *Francof*. 1573. in quarto, called *Anchora Famis,&c.* and *Giovanni Battifta Segni,trattato fopra la Careftia è fame,&c. Bol.* 1602. in quarto. wherein I find fome of the following Vegetable and Animal Productions were made ufe of in times of Famine,which may be not only curious to confider, but ufeful in the direction of others in the like neceffities, fhould it pleafe God to inflict the like Calamity. There are likewife other Inftances of extraordinary feeding taken from other Books, as Voyages, Sieges, &c. *Petronius de victu Romanorum*, Mundy, Muffet, &c. Roots, not mention'd already, affording Suftenance, are Carrots, Parfneps, Parfly, Navews, Skirrets, Radifhes, Onions, Turneps, *Scorzonera*, Saffafie or *Tragopogon*, Peony, *Gladiolus*, *Papyrus*, Fennel, *Daucus*, *Afphodil*, Liquorice, Bur-roots, White-thiftle-roots, *Alifanders*, *Satyrium*, *Trafi*, *Arachidna*, & *Bambu*.

( f ) Though

observations including notes on the coca plant which, Barham explained, was used by Peruvian Indians both as a magical charm and as a means of catching fish. Sloane included several of Barham's notes in his second Jamaica volume, such as Barham's description of how slaves plastered their ailing bodies with the Attoo plant, which Sloane included in an addendum to his entry on the plant *Loti arboris folio angustissimo*, noting its resemblance to the Peruvian bark and its utility as a febrifuge. Barham, he commented approvingly, 'had it from one, who reckoned and kept it as a secret'.[13]

Sloane's drive to accumulate and document collections fused compulsive paperwork with philosophical purpose. While he did not record his own reflections on the significance of his museum in any detail, evidence of his attitudes does survive in the form of sentiments attributed to him by James Empson. Sloane and Empson appear to have become close during their collaboration in the last decade of Sloane's life, so his testimony carries particular weight. After Sloane had died and named him one of his executors, Empson played an important role in reorganizing the collections in their transition to the British Museum. It was in the course of discussions with the new museum's directors that he recorded the following recollection. 'The late Sir Hans', he said, 'always protested against [the] notion' of displaying only one object in its class or division as though similar specimens were true 'duplicates' and thus interchangeable. Sloane, Empson went on, was instead of the view that 'things distinguish themselves from one another either by their colour, or shape, or impressions and marks on them, transparency or opacity, softness or hardness, different mixtures either in them or adhering to them, places of nativity, to which a good many other characteristicks could be added, that all these so differently distinguish'd productions of nature cannot be called the same, or be represented by one sample, *but that they are different specimens, though going under one general name.*' Sloane himself had actually made a similar point, at least in passing, in an undated letter to the Paris naturalist Antoine de Jussieu: 'it is very difficult, not to say impossible, to find two agate stones that resemble each other exactly in terms of colour, shape and markings.'[14]

Such statements suggest that while he engaged in the polite convention of exchanging duplicate specimens with scientific peers, Sloane appears to have shared a version of the so-called species scepticism of

his friend John Locke. This scepticism involved the idea that, while it was possible and even necessary to identify distinct classes of object, such classifications were to some extent arbitrary; they did not adhere to the true order of nature because it remained beyond human knowledge to apprehend the real essences of things as God had created them. Lacking any clear concept of the natural world as a historical entity in which species might evolve or become extinct – ideas that would not find authoritative expression until the 'catastrophist' geology of Georges Cuvier in his *Essay on the History of the Earth* (1813) – Sloane generally described the character of that world as unchanging. In his *Natural History*, he wrote that he took himself to be describing species 'which, in probability, have been ever since the creation, and will remain to the end of the world, in the same condition we now find them', thanks to the 'Providence of Almighty God'. It was probably for this reason that Sloane once remarkably told his fellow collector the Dutch merchant Levinus Vincent that 'there are very few things which I lack.' In Sloane's view, it was possible to collect complete series of species because divine omnipotence rendered His creation eternally fixed, and because His benevolence made the world rationally intelligible to human beings. Yet within that finitude, as Empson's testimony signals, the physical singularity of the creation meant that no two objects were identical, with the result that Sloane could happily collect seemingly endless varieties of the same thing. The contents of the universe were fixed and finite, in other words, but their variation virtually infinite. Herein lay the value of all those tediously repetitive catalogue entries. To write down 'another' and 'another' and 'another', as Sloane did, was in fact the mark of a pious collector's devotion to the irreducible singularity of every thing God had made.[15]

## THE TREASURES OF CURIOSITY

In his biographical memoir of Sloane, Thomas Birch lauded the 'treasure' his friend 'bequeath'd to his country'. The notion of 'treasure' was already something of a commonplace by Sloane's day. Treasure houses dated back to the ancient world, such as the pyramids in which the Egyptian pharaohs had had themselves entombed with their wealth, and the *thesauri* the Greek states had constructed as civic offerings to

their deities. Medieval European churches had assembled treasuries of gold and silver altarpieces (which they sometimes sold off to raise money) as well as fabulous reliquaries encrusted with jewels. By the eighteenth century, perhaps because of the gradual shift away from measuring the wealth of nations exclusively in terms of bullion, 'treasure' became a rather flexible metaphor for different forms of value. The Paris botanist Tournefort thus wrote to Sloane in 1690 to inquire about 'the treasures you have brought back from Jamaica', while Sloane's Royal Society colleague Nehemiah Grew asked if he could see his 'Jamaican treasure' in 1709. But what kinds of treasures *were* Sloane's collections and what value did they actually possess?[16]

With his 334 herbarium volumes at their core, Sloane envisaged his collections as working materials primarily for the study of botany and medicine, as well as a survey of the craftsmanship of the world's peoples. Embracing both arts and sciences, his collections anticipated key aspects of the renowned encyclopaedic publishing projects of the eighteenth century such as Ephraim Chambers's *Cyclopaedia, or an Universal Dictionary of Arts and Sciences* (1728) and Denis Diderot and Jean d'Alembert's *Encyclopédie* (1751–72). Like these, Sloane was committed to the ideal of making useful knowledge public, although there were important differences too. Chambers, Diderot and d'Alembert all emphasized the publication of technical information concerning machinery in a manner distinct from Sloane's pre-industrial preoccupation with manual dexterity. In addition, the *Encyclopédie* published freethinking polemics rejecting Christianity authored by radically anti-clerical writers in the age of Voltaire. Sloane, by contrast, claimed a solemnly religious purpose for his collections, writing that they tended in 'many ways to the manifestation of the glory of God [and] the confutation of atheism and its consequences', much in the spirit of the Boyle Lectures, conceived around the turn of the century by Robert Boyle to discourage the threat of infidelity in an increasingly rationalistic age. That said, Sloane's Christianity was itself rationalistic in character. On one occasion he went so far as to recommend to a Huguenot colleague the freethinking, materialist and republican author John Toland's treatise *Christianity Not Mysterious* (1696).[17]

The actual uses made of the collections during Sloane's lifetime are, however, hard to document. The best example, though in some ways an exceptional one, is the *Natural History of Jamaica*. Here Sloane's

interests in classification, medical recipes, human variation and commercial exploitation are on full display in his account of the plants, animals, curiosities and peoples of the West Indies. Such interests doubtless undergirded his collection of Vegetable Substances and animal specimens as well, though there is little evidence of how they were actually utilized. There is almost no evidence to show how Sloane used his coins, medals or antiquities to research civil or political history, or his miscellanies to articulate assessments of other societies' technical capacities beyond his brief catalogue descriptions. In fact, only intermittently can his use of his collections be glimpsed in surviving sources, such as when he determined the anatomical position of rhinoceros horns based on visual evidence from his medal of the Emperor Domitian or when he juxtaposed one of his Jamaican banjos with African and Asian instruments in his *Natural History*. Sloane owned at least two different astrolabes (instruments used in both astronomy and astrology) and likely kept them together: one came from thirteenth-century England and the other was made by the early eighteenth-century instrument maker Abd 'Alī ibn Muhammad Rafi' al-Juzi, for Shah Solṭān-Hosayn, the last ruler of the Safavid Empire. But the specifics of any comparison of the two Sloane may have envisioned in terms of workmanship, cosmology or aesthetics are unknown.[18]

Sloane's library was compendious. He collected manuscripts on all manner of curious topics, from 'jests and witty sayings' and 'women's wrinkles' to a fourteenth-century 'book of urines'. But the great majority were devoted to medicine, followed by natural history, travel and commerce, with a number of historical, theological and philosophical writings as well. He accumulated work by all manner of naturalists, travellers, physicians and natural philosophers from the Middle Ages down to his own day, from different parts of the world, and ranging from the magical traditions he scorned to the contemporary medicine and botany he prized. Their authors included the chemical physicians Paracelsus and Johannes Baptista van Helmont; his Royal Society colleague Robert Hooke; Hermes Trismegistus, the mythical figure associated with the magical Hermetic Corpus; the anatomist of the circulation of the blood William Harvey; the voyagers William Dampier and Pierre Radisson; the eighth-century Muslim Arab alchemist Jābir ibn Hayyān (Geber); the naturalist Robert Plot; the polymath Sir Thomas Browne; Ishák ibn Sulaimán al-Isráili, a Tunis court physician

at Kairouan (al-Qayrawan); Galen in Arabic translation; commentaries on Avicenna; and notes by several British surgeons on their practices. Sloane's printed books reflected the same interests. Perhaps one-third of his 45,000 volumes related to medicine. He acquired many maps and atlases; illuminated medieval books; works of history and literature, including a second edition of Chaucer's *Canterbury Tales* (1484); *incunabula* (books printed before 1501) and items related to the history of printing; and numerous works in foreign languages including a sizeable library in Japanese, which Johann Gaspar Scheuchzer itemized in his translation of Kaempfer's *History of Japan*.[19]

Rare manuscript materials with complex authorship and composition histories testify to Sloane's interest in science and medicine beyond Europe. The so-called Gurney herbal, owned before Sloane by the private Asia trader John Gurney and evidently produced by an East India Company surgeon named Edward Whiteinge in the 1640s, is an astonishing document (Plate 29). It includes descriptions and illustrations of plants, animals (including snakes and snake-charmers) and medicine from the Sultanate of Jambi (Sumatra), Java, Malacca, the South Sea Islands, Bengal, Mughal territories and the Coromandel Coast; refers to ancient authorities from Pliny and Galen to Avicenna and the ninth-century Persian Muslim polymath Muhammad ibn Zakariyā Rāzī (Rhazes); and records information in English, Malay (Javanese), Chinese, Portuguese, Arabic, Hindustani, Tamil and Gentoo (Telugu). Like the botanical collections sent from Madras by Samuel Browne, the Gurney herbal was produced through interactions with many different peoples across South and East Asia, including enslaved women (it contains significant information on medical knowledge pertaining to women). It is not known how or when Sloane acquired the herbal, nor what he thought of it nor how he may have sought to use it. He did not possess the necessary linguistic expertise to make sense of it, although he did recognize its potential value sufficiently to acquire it. The herbal is thus a telling example of the formidable depth of material Sloane collected beyond his personal comprehension and, no less remarkably, the persistent depth of ignorance about such materials today. For the very first scholarly study of it was published only in 2012, by Savithri Preetha Nair. Many more items in Sloane's collections – texts, objects and perhaps especially pictures – continue to await proper examination over three centuries later, such as the intricate watercolour of a 'great

temple' at Constantinople made by the sixteenth-century English gal-
ley slave Thomas Morgan, to cite but one example. Any easy assumption
about public museums as useful and accessible institutions is chal-
lenged by the fact that large parts even of Sloane's famed collections
have still not been used.[20]

It bears repeating that preservation and documentation were Sloane's
priorities, not his own research. The primary goal he set himself was
to accumulate as many rare materials as possible – and the rarer the
better, such as the remarkable 'booke made in new found land [New-
foundland] of the barke of trees' and the volume of paper samples from
around the world he acquired. His hope in acquiring items like the
Gurney herbal was surely that their value would eventually be brought
to light by others who could decode them. In the meantime, simply
organizing such huge collections was a full-time task that involved the
recataloguing of books, the rebinding of albums and the renumbering
of specimens. That said, Sloane did of course make use of his collec-
tions when he could. In the *Natural History*, for example, the jellyfish
he had depicted alongside his coral-encrusted spar and coins was very
much a collector's coup: this Portuguese man-of-war was in fact the
copy of a watercolour painted off Roanoke Island by the English trav-
eller John White a full century earlier back in the 1580s, which Sloane
had subsequently acquired. He was a compulsive sifter of object, image
and text. 'I confesse I love to look over such tracts,' he once told Locke,
which 'deserve better usage for which reason I have turn'd over many
thousands'. It was precisely by ransacking medical and culinary recipes
that he discovered Luke Rugeley's ointment for sore eyes, which he
published in 1745.[21]

Each of Sloane's individual collections had its own logic and only
rarely were these used in combination. Occasionally, however, Sloane
did draw different kinds of material together to publish work of a more
interpretative character, such as the essay on 'elephants teeth and bones
found under ground' he put out in the *Philosophical Transactions* in
1728. Sloane had acquired an ancient hand-axe from the apothecary
and antiquarian John Conyers, which had originally been found with
the 'fossile teeth of elephants' underground during digging in a gravel
pit at Gray's Inn in 1679 (Plate 36). The challenge was to date these
animal remains and explain their presence on British soil, since ele-
phants no longer roamed the streets of London. The options for dating

were limited. Christian orthodoxy held that the earth had been created in 4004 BCE; that Noah's Flood occurred at 2500–2000 BCE; and that all events before the Roman conquest of Britain around 43 CE could be dated only in such biblical terms. That the Gray's Inn remains had been found at a level *lower* than that typical for Roman antiquities challenged the idea that this elephantine creature must have been brought to Britain by the Romans, raising the possibility that it might date from biblical times or even earlier.[22]

Perhaps cognizant of the scandal over Isaac La Peyrère's *Prae-Adamitae* (1655), which argued against the Christian orthodoxy of a single divine creation by positing several creations of human beings before Adam (a theory known as polygenesis), Sloane did not address the hand-axe's potential significance for deep human history. But he did investigate the 'fossile teeth'. He compared the measurements of animal specimens in his possession from Northampton to Siberia and commissioned dissections of elephants, while sorting through writings on similar remains found in Sicily, Germany, Russia and China. He concluded that such remains were not the bones of ancient giants, as Athanasius Kircher had apparently held; nor unicorn nor narwhal tusks; nor the remnants of 'subterranean beasts' that shunned the surface of the earth, which Russian peasants evidently believed. Instead, Sloane reasoned that they were fragments of pre-Roman animals that must have been killed off by the biblical Flood, which had ushered in a colder climate they could not tolerate. Sloane thus retained a biblical framework while aligning himself with the unorthodox views of such naturalists as Robert Hooke, Nicolas Steno and Thomas Molyneux, by pointing to what the last described as 'great and momentous truths concerning the Deluge' and 'changes that may have happen'd on the surface of this our terraqueous globe'. Despite his repeated statements about the static and unchanging character of the divine creation, therefore, and though he made no definitive pronouncement to the contrary, here at least Sloane countenanced the possibility that species might vanish from the earth due to historic changes in climate.[23]

Beyond his personal use, Sloane granted access to his collections to trusted friends and fellow scholars. Items did sometimes leave his premises, such as the plants he sent to Ray and the books and manuscripts he loaned to the antiquarians John Urry, Thomas Hearne and Thomas Tanner. Borrowing was a perk of friendship. 'I have made ye loane of

ye jewell you lent mee a long one,' Samuel Pepys wrote apologetically in 1702, 'too long (I feare) to be forgiven for it. But indeed I have pleasur'd soe many of my friends with ye sight of it, besides my owne satisfaction in ye frequent use of it . . . that (I protest) I have not known how to lett it goe.' For reasons of security and convenience, work carried out with objects from the collections, like the Jamaica drawings executed by Everhardus Kickius, took place in Sloane's home. Much of this labour was visual in character and involved Sloane's specimen collections as well as his vast 'paper museum' of approximately 100 picture albums, containing an estimated 60,000 drawings, prints and paintings. Sloane permitted Susanna and Anna Lister to draw shells for their father Martin Lister's *Historiae conchyliorum* (1685–92), while a handful of fish and monkeys ended up as engravings in Richard Bradley's *Philosophical Account of the Works of Nature* (1721). Sloane allowed artists and naturalists like George Edwards and Mark Catesby to copy pictures and draw live creatures roaming his garden. Elizabeth Blackwell (née Blachrie) was an Aberdeen merchant's daughter who turned to botanical illustration to support herself and her child when her husband went to prison for debt. Her *Curious Herbal* (1737–9) featured drawings she had made from exotic plants growing in Chelsea Physic Garden and items in Sloane's museum (including rare corals), notes comparing live specimens with Sloane's collections, and plates dedicated to Sloane for his 'generous assistance'. For his translation of Kaempfer's *History of Japan*, Scheuchzer made significant use of Sloane's library, which he called 'the completest in its kind in Europe', and drew many of its illustrations himself based on Kaempfer's original sketches (modifying both these and others by unidentified Japanese artists in the process) and directly from Sloane's Japanese objects, prints and drawings. To some extent, then, Sloane's residence functioned as a collective study centre. It is even possible that Jonathan Swift saw Sloane's Kaempfer materials before publication and was influenced by their account of Japan in imagining Lemuel Gulliver's visit to the island in part three of *Gulliver's Travels*, where Gulliver mentions the complaint of one 'malicious rogue' that he has not 'yet trampled on the crucifix' in the manner reported by Kaempfer.[24]

In addition to their scientific and medical uses, Sloane's collections possessed considerable aesthetic value, too, though what manner of beauty was a matter of debate. The relationship (or lack thereof)

between the exotic and the beautiful was a key theme for commentators persuaded of the superiority of neo-classical aesthetics. In his *Characteristicks of Men, Manners, Opinions, Times*, the Earl of Shaftesbury pointedly criticized Chinese and Indian arts as sensuous and corrupt, 'crooked' and 'barbarous', notwithstanding broad European admiration for the technical achievements of Asian architecture. John Woodward likewise derided the aesthetics of the ancient Egyptians. Under Ray's influence, Sloane delighted in scientific beauty – what Ray called 'the beauteous works of nature' – as an expression of 'the infinite wisdom and goodness of God the Creator'. Yet whether Sloane considered curiosities like his Jamaican banjos or Inuit sun visor beautiful or not is something of a moot point. Judging aesthetic achievement was not his primary concern so much as documenting materials and craftsmanship. His gems, cameos and precious stones were dazzling – but they were also specimens of stone and mineral. Of the visual albums he acquired, only a few drawings by Hans Holbein and Albrecht Dürer are today considered of outstanding artistic merit. For Sloane, however, it was scientific value that counted above all. He would have shared the view of his contemporary Jonathan Richardson, who painted a portrait of him for Oxford University and published rules for the 'science of connoisseurship' in 1719, that 'instruction' was as important as 'pleasure' in art. Sloane thus likely valued the illuminated manuscripts he owned as samples of colour and visual style, as much as for historical or theological reasons, in line with his technical interest in treatises on painting, dyeing and metalwork, which he had assistants like Wanley copy passages from.[25]

With no staff or space exclusively dedicated to facilitating their use on a regular basis, Sloane's collections were dramatically underused during his lifetime and access to them as working materials was severely limited. Such restrictions reflect the absence of commitments to public access in the early eighteenth century and are consistent with assumptions that learning and scholarship were the province of gentlemen. Generous as Sloane was with his friends, their number was small. Other collectors circulated catalogues to garner prestige by broadcasting their possessions or to advertise them when putting them up for sale. Sloane was too busy and too renowned to do likewise; the only partial exception was Edward Bernard's 1697 *Catalogi librorum manuscriptorum Angliae et Hiberniae*, which listed works from Sloane's early

manuscript collections. His house may have been the place 'where all things center', as William Sherard put it, but only for an elite few. As Sherard's conflict with Sloane and his loss of access to the collections demonstrate, their use was strictly by personal permission. The Lord of Chelsea Manor could give and he could take away. Sloane's use of his collections for his own essays in the *Transactions* was thus all the more striking, since few contemporaries commanded both the materials *and* the organ for turning personal collections into published articles.[26]

It is rare in Sloane's writings to find outspoken opinions; his norm was caution, diplomatic even-handedness, even a studied agnosticism concerning the ultimate value of many of his curiosities and the scientific theories of the time. The great exception to this rule, however, is the subject of magic. Sloane, the doctor of society, envisioned one of the critical purposes of his collections as exhibiting the epidemic folly of superstitious belief or fetishism: the attribution of magical powers to material things (Sloane used the word himself when he listed a 'fetish shell' from Guinea in his Miscellanies Catalogue). His exposure to mechanical conceptions of the operations of nature through practices such as chemistry emphasized matter in motion as far preferable to any doctrine that endorsed the possibility of innate purpose or action at a distance. The notion that matter could act where it was not had been branded irredeemably occult by mechanical philosophers like his patron Boyle and disposed Sloane to a deep antipathy towards practices such as alchemy and astrology. Sloane's work as a physician, meanwhile, imbued him with a professional animosity towards magical healing, conjuring and the very idea of spell casting, whether practised by the Obeah men of Jamaica or by the unorthdox healers who continued to ply their trade in Britain.[27]

Sloane spoke out most forcefully against magic in the course of a lengthy memoir addressed to his Paris colleague the Abbé Bignon in 1740. It is the single most revealing document in Sloane's hand. In it, he regaled the Abbé with an extraordinary remembrance of his friend the naturalist and collector John Beaumont, who had died some ten years earlier. Beaumont was a Somerset MP who sometimes passed fossils and minerals on to Sloane, was 'fond of the bottle' and was an 'honest man and very sincere, of the Roman Catholic religion'. He also believed in fairies. Sloane recounted Beaumont's claims that he was visited 'every night by fairies, with whom he conversed', after which he would vomit

and suffer diarrhoea. He took the counsel of his aethereal visitors seriously: when they 'advised him to make his addresses to the maiden sister of Colonel Speccot . . . he did so, and he then married her'. 'What he believed to be real with regard to the fairies', Sloane told Bignon, 'was only imaginary, or a strong impression of a dream,' even though Beaumont protested 'that what he had seen, heard, touched and smelt must be real'. The convivial Sloane found the affair irresistibly amusing and organized a dinner – not unlike the soirées he hosted for the pretended Formosan Psalmanazar – to quiz Beaumont in depth. Had he not asked the fairies, inquired the Duke of Buckingham, like any curious traveller, about the customs of their native land? Beaumont embarrassedly confessed he had not. Beaumont 'did not use conjurations to make them appear', Sloane observed, '(and if he had used them, I very much doubt that they [the spirits] would have obeyed him)'.[28]

Sloane then treated Bignon to tales of ludicrous magical treasure hunts. In one that sounded like the opening of a bad joke, 'a Catholic priest, a Presbyterian minister and a bankrupt prosecutor who had little money and a lot of faith in . . . mystic sciences' had rented a house in Clerkenwell. Searching the premises for the rent they owed, their landlord discovered a book on magic dated 1572 entitled the *Clavicula Salomonis* (the 'Key of Solomon', of which Sloane acquired a copy) whose 'prayers dedicated to each spirit from the different parts of the world' they had used to conjure 'them by their names to appear and reveal' the location of hidden treasure. A table had been placed in the centre of the room and the floor covered in a piece of white satin bearing concentric circles where 'the names of God were written in several languages (mainly Oriental ones)' as protection from harmful spirits. The landlord didn't get his rent but he did pocket £7 by selling his tenants' furniture. A second story concerned 'several persons of high standing' who 'received information about treasure buried below old buildings' in Southwark, south of the Thames. But as they set about unearthing this, they were scared off, being 'attacked and almost ripped to shreds by a large dog that had been stationed there to guard some goods at the surface'. Finally, Sloane told how the seventeenth-century astrologer William Lilly had once 'received information about treasure buried in the cloisters of Westminster Abbey'. Lilly set off to dig it up with his associates, but found only 'coffins containing corpses' and was chased off by a storm that threatened to bury *them* under the

Abbey instead. 'They imagined that this had happened', Sloane drily observed, 'because they had not carried out their fumigations in the proper manner.' Adopting such methods was little more than a 'throw of the dice', yet follies of this kind moved Sloane to obtain astrological manuscripts in Lilly's hand. Even John Dee, Elizabeth I's court astrologer and councillor and 'a great man' in Sloane's estimation, believed that 'he had great and real actions with spririts' brought about through the 'invocations' of his assistant Edward Kelley, to which the latter 'received soft replies (that is to say, in their language, which nobody but Kelley understood)'. Sloane had built up an impressive collection of Dee materials since the 1690s: 'the original manuscripts relating to this, as far as I know, or authentic copies at least, are in my library,' he told Bignon. He also obtained Dee's 'shew stone' and 'seal of God' (Plate 35).[29]

No one culture had a monopoly on such stupidities. Sloane also told Bignon how in 1682 the Moroccan ambassador to Charles II, Muhammad ibn Haddu, had been entertained in London by the alchemist Elias Ashmole. Ashmole then resided in a house in Lambeth previously owned by the astrologer Simon Forman, 'a great expert in the occult sciences' who was 'consulted as an oracle, even by several of Queen Elizabeth's ministers of state'. Sloane invested time and money to document Forman's activities, driven by a zealous desire to expose them: 'I have bought several of his books, but there is one I have not managed to obtain, which seemed to me to deal with necromancy, and which would be worth procuring to see the madness contained within it.' Ashmole had shown Ibn Haddu 'some trees from the West Indies and other countries, which happened to be extremely rare' (planted by John Tradescant, who had taken over the Lambeth house and garden and later founded the museum known as Tradescant's Ark), as well as 'the instruments and the books used by Dr Dee and the gentleman Edward Kelley in their actions with spirits'. Upon this, 'the ambassador asked Mr Ashmole to make some of these spirits appear so that he could speak to them about some events that were taking place in his country at the time,' but Ashmole demurred 'in order to avoid, he said, the disturbances that they might cause'. Ibn Haddu then 'offered to convert himself and several of his fellow countrymen to Christianity and relinquish substantial business interests in his home country, if Mr Ashmole would only show him these spirits'. But still Ashmole refused.[30]

The conclusions Sloane drew from these shenanigans went beyond

enlightened mockery. These fools were insane. Here he followed in the tradition of physicians like Sir Thomas Browne who set themselves up as patrician judges and made collections to correct the epidemic errors of their time. Such delusions deserved laughter, to be sure, not rage – and therapy rather than persecution. Sloane knew how to enjoy a good joke in good company, though he was in no doubt that such cases demanded 'harsh medication'. During the 1730s, the decade before Sloane wrote to Bignon, a group of French Jansenists known as the Saint-Médard Convulsionnaires had exhibited convulsions to astonished onlookers and prompted some of the first concerted attempts to diagnose religious enthusiasm medically as a form of madness. It is not clear how much Sloane bore the example of the Convulsionnaires in mind, though he must have been aware of them. His diagnosis of belief in the reality of supernatural powers was that it was a form of insanity curable only by heroic medicine. 'I have treated several kinds of disorders of the mind or the brain,' he informed Bignon, 'and I believe that some of them stemmed from the fact that these people dream (*somniant*) while awake: [a state] from which it becomes necessary to bring them back, by giving them very strong, powerful and harsh purges when ordinary shaking cannot do it.'[31]

There were, he went on, plants like *Solanum*, 'employed by the sorcerers from Mallorca and the vicinity of Barcelona', that could 'put people into a certain kind of sleep known as ecstasies'. Even common weeds like tobacco made 'people fall into a slumber, during which they imagine that they are awake', giving them the 'strong impression or dream of being present at witches' sabbats', which they tragically 'speak of . . . as a reality', getting themselves hanged by magistrates for their trouble. Sloane concurred with the anatomist Edward Tyson, who had told him that 'dissections only showed a very slight difference between the brains of maniacs and those of people of sound mind,' and it was 'true that there is only a very small divide between even the most sublime geniuses and those who have entirely lost their wits'. Sloane's favoured remedies included bloodletting and strong emetics that worked by causing 'a good deal of physical disturbance'. These 'super-purgations' needed to be strong and 'repeated frequently' and had, he maintained, only 'rarely been unsuccessful' against 'waking dreams'.[32]

Sloane's anti-magical tirade provides crucial context for understanding the purposes he envisaged for key parts of his collections. He owned

a number of curious hybrid objects, for example, part natural craftmanship and part artificial: his coral-encrusted spar from Jamaica; several polished fossils which, as he noted in his catalogues, resembled hearts, penises, testicles and other parts of the body; his ox vertebra bisected by the branch of an oak tree; the shell of a nautilus with biblical-style scenes, replete with putti, carved on to it with a Baroque flourish; and a specimen of the 'vegetable lamb of Tartary' that related to the belief that certain plants in Central Asia spawned living lambs (p. 33, Plates 37, 38, 39). Such items recalled the strange *mirabilia* of early modern wonder-cabinets that most eighteenth-century collections (like the Royal Society's Repository) eschewed, as scholars refocused their attention on nature's regularities rather than its oddities. Sloane's possession of such items must have seemed backward to many of his colleagues. As we have seen, his visual juxtaposition of the jellyfish and spar was reminiscent of less fact-driven approaches to natural history where connoisseurs sought to tease out enigmatic resemblances between objects, spot fakes and search for hidden patterns. Sloane's participation in the so-called Cabala Club during the 1720s, where some members of the Royal Society gathered privately to discuss magic, miracles and the unexplained (probably because they dared not do so among the Fellows) was surely driven by sceptical curiosity rather than belief in the reality of the phenomena discussed. Yet even at the Royal Society, Sloane's programme of curiosity remained strikingly ambiguous owing to its persistent fascination for 'strange facts'. His Newtonian colleagues cannot have enjoyed reading Thomas Stack's account of the sexagenarian breastfeeder Elizabeth Brian in the *Transactions* or seeing their president's name associated publicly with so many commercial curiosity shows in the London gazettes. Nor, had they examined Sloane's catalogues, might they have been impressed by the scientific value of entries such as 'a piece of rope broken by the strong man' – a curio from a fairground – or this item listed in Humana: 'a fetus of 7 months old resembling a monkey wt a cloak which the woman saw playing tricks at Rochester'.[33]

Given his deep-seated antipathy to magic, it becomes clear that Sloane's interest in such curiosities was motivated by the desire to expose superstition. Curing credulity was patrician enlightenment in action and Sloane maintained a large collection of frauds for corrective purposes. His 'vegetable lamb' was in reality the rhizome of a Chinese

fern (now known as *Cibotium barometz*) deliberately fashioned to lampoon the chimerical species, and Sloane vehemently denied its down had the capacity to staunch bleeding as some claimed. The lead and brass Chinese penis ring he acquired likewise aroused his suspicions: he described it in his catalogue entry as merely 'pretended to cause a perpetuall erection of the penis if shutt'. In 1736, he used a microscope to examine an unusually shaped grain of corn to show that it was an 'imposition' and not a work of nature. 'I keep this with other artificial things of the insect tribes contrived to puzzle and amuse people,' he told the Bishop of Kilmore. 'If the fabricators of such things would employ their cunning and art they shew in such productions to usefull purposes, they might be very profitable members of a commonwealth.' He compared them instead to robbers and housebreakers: their talents had been corrupted to wicked ends.[34]

Magical follies abounded in the collections. They included amulets from many different cultures, including those from Persia translated by Ayuba Suleiman Diallo; medals given to those touched for the King's Evil in England; charms or prayers for medical protection; the manuscripts of conjurors like Forman and Ashmole; the stones and talismans of Dee; the 'relicks' even the Protestant Duke of Monmouth carried 'to preserve him from danger'; an 'elfs arrow or thunderbolt sett in silver as an amulet ag[ainst] thunder'; 'a leather purse ... worn to prevent thunder' in the mines of New Spain; and a spectacular 'Lapland drum' of pinewood and reindeer skin made by the indigenous Sámi of subarctic Scandinavia, featuring drawings of spirit-world hunts and used by their shamans until seized during Christian persecution in the seventeenth century (Plate 40). While Sloane might conceivably have ransacked his alchemical and magical manuscripts for useful ingredients, he pilloried their intellectual systems. To his way of thinking, alchemical writings like Geber's would have complemented the 'Quacks Bills' he piled up and the curious medical tales he collected, from the story of Mary Tofts who was reportedly 'brought to bed of rabbits' in 1726, to accounts of the 'delirious' effects produced by swallowing henbane seeds and the 'conjectures on the charming or fascinating power attributed to the rattle-snake' he published, detailing experiments using dogs as bait to disprove the theory that rattlesnakes used 'charms, inchantments and fascinations' to paralyse their victims.[35]

Sloane's crusade against credulity generated a stream of prejudicial

and essentializing statements about foreign peoples. He catalogued various sacred objects from Asia and the Americas as 'idols' – representations of false gods and evidence of the sin of idolatry, some of which he specifically labelled 'heathen', connoting pagan barbarism – including Kaempfer's Buddhist shrines from Japan. Sloane described a snow shoe and elk-hair purse he had obtained from Hudson's Bay Company traders as 'made by the Huron savages of Canada'. Writing to the Paris chemist Claude-Joseph Geoffroy in 1743, he passed from a discussion of South Asian shells to the topic of Indian religion. 'It is unnecessary to go into the detail of the reviews of several ancient and modern philosophers, who have gone to great pains to inform us of the antiquarian opinions of the Indians and Gymnosophists,' he dismissively told Geoffroy, 'one sees everywhere the stupidity and superstition of their theology and forms of worship.' Sweeping dismissals of this kind were commonplace in Sloane's circles. The Oxford-trained Thomas Shaw was chaplain at the English factory at Algiers in Barbary (North Africa) in the years 1720–33 and travelled extensively in Egypt, Sinai, Cyprus, the Holy Land, Tunis, Carthage, Tripoli and Morocco. After 1729, he established contact with Sloane and sent him maps of Algiers and Tunis (which Sloane duly published in the *Transactions*) and curious accounts of what he said were the 'pretended' petrifactions of Ras Sem, south of Benghazi. These included human remains, bread and olives that thanks to blasts of hot wind, Sloane wrote, had been 'turned to a sort of dry leather such as I have from some parts of hungary'. In his Humana Catalogue, he listed 'part of the shank bone of a man from the petrified town in the deserts of Barbary near Tripoli'. But these petrifactions were nothing of the sort, Shaw assured Sloane. The 'olives' were in fact *lapides Judaici* (stones); the loaves fossilized urchins; and the fragments of supposedly petrified children marble statues. Shaw insisted that they came 'not from any blast of wind as pretended by the Arabs', who sought to pawn fake antiquities off on foreigners, and spoke rather to the 'ignorance and uncertainty of the Arabian traditions' which he attributed to their 'wild and extravagant brains'. They were 'always liars', he concluded, asserting that any petrifactions in the area must be remnants of 'the Deluge', though he offered no evidence to support his claim.[36]

Roman Catholicism came in for repeated stinging criticism. Sloane's botanical curator Johann Amman reported from St Petersburg that

the Mongolian 'Callmucks' (Kalmyks) were taught to pray in a language they did not know, like 'the roman catholicks [who] observe the same politick with their latin tongue, certainly with the same design, that the common people may not understand the strange, ridiculous and nasty stuff they are teach'd to adress to their gods'. Sloane adopted language consistent with Protestant polemics which blasted Catholicism as a sham that cowed the weak with hoary tales of magical matter – above all, the miracle of transubstantiation in the Eucharist, according to which bread and wine were transformed into the body and blood of Christ. Sloane acquired what he described as 'severall popish trinkets, crucifixes & beads' for his collections; 'a popish trinket made up like a watch of brasse wt. a crucifix and severall earths from Jerusalem'; depictions of Christ as the lamb of God (*agnus Dei*); a girdle to 'prevent the effects of thunder' adorned by 'the picture of the Virgin Mary'; and a 'sacred vessel' bearing the image of the Virgin Mary 'to be hung by a small cord to the mast of a ship when masse is to be said'. He catalogued these in Miscellanies as though they were the curious fetishes of some weird alien cult, while his use of the term 'trinket' indicates his view that they were baubles of little worth. Such treatment recalls the fulminations of William Beckett and Samuel Werenfels, who lumped together the Royal Touch, astrology and Catholicism as examples of magical mass deception. As Werenfels wrote, 'no absurdity can be too big for a Catholick faith.'[37]

But Sloane spilled little ink in articulating what were in reality brief and formulaic statements of religious and ethnocentric prejudice. For one thing, he lacked the training and temperament to launch into intensive studies of other cultures' languages, theologies, histories or architectures like Athanasius Kircher, who had approached Asian idolatry with serious indological intent as part of a comparative account of the universal history of religion. Again, it would fall to later users to exploit Sloane's collections in such ways. For example, as part of a growing attempt to situate South and East Asia within a generalized history of culture in the eighteenth century, Denis Diderot used Kaempfer's account of Siam in the first chapter of the *History of Japan* to argue in the *Encyclopédie* that the origins of East Asian religion lay in ancient Egypt. Diderot never saw Sloane's Kaempfer manuscripts, but Scheuchzer's translation allowed them to circulate as source material for what subsequently became the popularized Orientalism of the

Enlightenment. This Orientalism had its roots in linguistic study, as Sloane's collections confirm. East India Company employees had long sought to acquire exotic vocabularies both to facilitate trade and to make Christian converts (Boyle sponsored translations of Christian texts into Arabic for this purpose). The manuscripts Sloane acquired in languages such as Turkish, Arabic, Persian, Chinese, Japanese and Malay are consistent with a similar range of aims, embracing topics from medicine to law and religion, and including Christian hymns and psalms written in Romanized Malay by a Dutchman in the 1670s, as well as several copies of the Qur'ān.[38]

'The Orient' was a nebulous term in the European imagination that embraced several vast territories east of the Mediterranean: the Ottoman Empire, the Levant, Persia, India and China. It had often been used to present the cultures of these regions as mysteriously exotic, despotic and superstitious, even as they provoked visions of bountiful commercial possibility as well. With increasing emphasis in the second half of the eighteenth century after the British had consolidated their position in South Asia by defeating France in the Seven Years' War (1756–63), Orientalists depicted Indian civilization as a decadent vestige of its ancient glory, hopelessly mired in devotion to tradition. Sloane's, however, was an Orientalism of the garden and the workshop more than the manuscript, the temple or the ruin, and his collections those of a naturalist rather than an antiquarian or philologist. In line with the ethnographic reconnaissance encouraged by the Royal Society and the 'natural history of man' proposed by Locke, Sloane collected picture albums of Oriental peoples from the Ottoman and Safavid Empires painted in traditional costume, some of which he acquired from Locke himself via William Courten (Plate 28). Occasionally, Sloane published essays in the *Transactions* on Orientalist topics. One brief yet striking entry was Alexander Stuart's description of the 'pagan temple' and caverns at Cannara (Kanheri) on Salsette Island, colonized by the Portuguese near Bombay on India's western coast, with tantalizing notes on their 'sacrificing-places' and 'unknown characters' (only later did Europeans understand Kanheri to be an ancient Buddhist site). But when Sloane published his own articles on eastern topics, his concern was far more likely to be plants, minerals or bezoars than gods, races or languages, as his 1749 article on the alleged powers of healing stones attests. Artificial objects, moreover, often

interested Sloane as natural specimens. For example, in addition to its religious significance he likely valued a soapstone figure of the Buddhist deity Guandi he owned as a specimen both of Chinese craftsmanship and of natural materials, carefully noting in his catalogues what such objects were made of. While natural specimens could reveal the workings of exotic cultures – Amerindians used cacao nuts as money – cultural objects documented the world's vast range of natural materials.[39]

Sloane also intended his collections to point to economic solutions to the commercial challenges Britain faced in the eighteenth century. As Royal Society secretary, he had called in the 1690s for domestic 'imitation' of superior foreign 'instruments and materials' as part of a larger push to compile a general history of crafts and trades. While learned commentators often slighted Asian aesthetics, British silver increasingly flowed to Asia as consumers indulged in the costly and growing fashion for chinoiserie. Securing technical information about foreign manufacturing thus promised major economic benefits if it could jump-start import substitution and keep precious bullion in home coffers. A number of Sloane's Chinese objects spoke to such concerns. The compasses and explosives he acquired betokened longstanding European curiosity about the technical inventiveness of the Celestial Empire, while his specimens of porcelain and 'Japanned' cabinets were examples of the kinds of luxury goods imported at great expense that the British were desperate to make more cheaply for themselves. Sloane's description of the imitation China tea set he had acquired suggests his awareness of European efforts to mimic the Chinese. The set, he wrote, consisted 'of pasteboard & paper painted upon to imitate China ware made by a Dutchman who lived in Japan'. Finally, his possession of two glass vases blown in the Kangxi emperor's Jesuit-run workshops in Peking (Beijing) suggests how a whole range of concerns might cohere in a single object (Plate 41). Sloane has left no explicit commentary on these vases, but he would likely have been well aware that they were blown in imitation of realgar (arsenic sulphide), a substance reportedly believed by Daoist alchemists to confer immortality. The vases could thus point to Asian superstition on the one hand, even though Chinese medical reformers themselves (like Li Shizhen) had long criticized Daoists as quackish magicians. On the other hand, as products of Sino-Jesuit cooperation, the vases also embodied the manufacturing prowess of

economic rivals (both Asian and European) whose successes the British eyed with envy.[40]

The vast majority of the stones and minerals Sloane collected were traditionally associated with magical lore in various cultures. But what counted for him were the mechanical properties of natural substances, their material benefits and their potential commercial profitability. Money, indeed, helped make sense of the world. Common sense dictated, Sloane wrote in his essay on elephant fossils, that mammoth tusks could not have been deliberately buried underground, as some had claimed, because 'no one would be so ridiculous as to bury their ivory teeth, which are of high price with all nations, and ever were.' The value of Sloane's collections was often reckoned in financial terms. Where courtly collectors in Renaissance Italy eschewed frank money talk, their successors in the Netherlands and Britain were happy to talk guilders and shillings. Zacharias Konrad von Uffenbach reported from a tour he had of the collections in 1710 that Sloane had refused the offer of £15,000 for his museum from the Venetian ambassador and was instead 'daily increasing' its size 'for vast sums' and 'at a phenomenal cost'. The gazettes measured Sloane's judgement in money too. 'The great physician (who hath a great collection of curiosities) hath offered 60 livres', reported the *Weekly Journal* in 1717, 'for the gold ring lately found by the workmen in the pulling down a wall at Bridewel.' Such was connoisseurship in enlightened natural history: knowing how much to pay was a keen index of judgement. Only 'the heads of those men of delicacy are furnish'd with peculiar cells for regulation, and esteem in these niceties', opined one writer for the magazine *The Censor*, reviewing what he called 'the treasures of curiosity'. 'No private collection in Europe was equal to that of Sir Hans Sloane,' boasted Tobias Smollett's eponymous gentleman adventurer in his fictional *Adventures of Peregrine Pickle* (1751), 'which, exclusive of presents, had cost an hundred thousand pounds.' The sheer cost of Sloane's famed collections epitomized Britain's rise as one of the world's great powers.[41]

To connoisseurs there was, of course, more to the value of collections than simply how much one spent on them. Sloane's grandson Charles Cadogan shamelessly buttered up his grandfather when he informed him in 1720 that a collection he had visited was 'not to be mentioned wth yours, tho there are many things in it worth seeing; but they

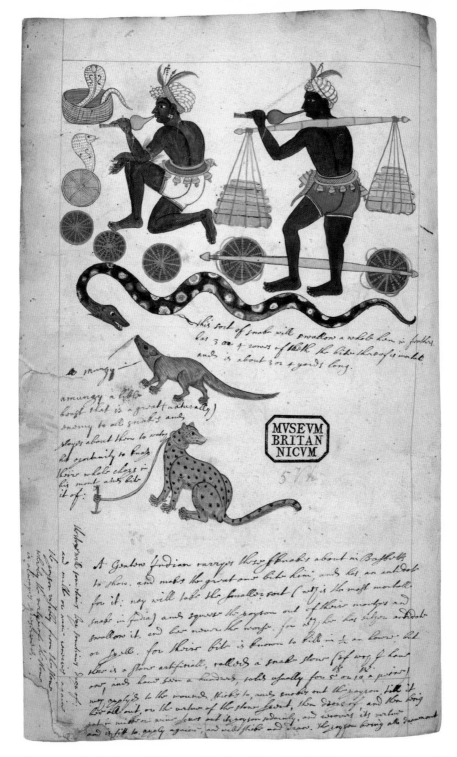

29. The Gurney herbal: compiled across South and East Asia by Edward Whiteinge and subsequently acquired by Sloane, this remarkable seventeenth-century manuscript contains illustrations and descriptions of plants, animals (including snakes and snake-charmers) and medicine in several languages.

20. A juvenile figure, adorned with a Chaplet, and arms broken off. See monumenta Kempian: p. 91. num: 49.

21. A male figure standing, w[t] his right arm e, and a Garment wraped about his left, w falls over his knee on that side.

22. A male figure, w[t] a Compass in his right

23. A General in his military dress.

24. Two Roman Soldiers

25. Two Camilli, of different sizes.

26? A grotesque figure & bust.

27. An arm, hand, and a foot.

28. A Small Tyger, Cow, rabbit, & dolphin

29. A Bull standing H. 3¾. L. 30/4.

30. A Cow lying down L 4[u]

31. A Horse Galloping.

32. Three small vases.

33. Ten matrices for marking earthen vessels, and other purposes

34. Six rings of different sizes, for various poses.

35. Eight keys, of different forms and sizes.

36. Two Lamps, one for a double wick

37. A piece of a Speculum

38. Five javelin heads, two very small

39. Three chisel heads of different sizes, on very small.

30. Sloane's Antiquities Catalogue: one of the fifty-four catalogues (most of which survive) in which Sloane inventoried his collections with a range of information, subdividing them according to type of object.

392. A pale red narrow mouthd Roman urne from Aeculodr.

393. A wide mouthd small gray urne. D.

394. One higher & narrower. D. H 4/9. yr.

395. The same w. lines lozenge ways on the outside, D.

396. A brasse pair of tongs wrought on the outside. D.
Anglo Saxon

397. A large thimble. D.

398. One smaller. D.

399. A great number of brasse pinns, pieces of fibula &c D.

400. A grasse purse of a yellow black & red colour from Guinea by
Mr Dering.

401. A bell of the same. D. the red dyed by mulberry.

402. A garter made of Buffalos hair & glasse beads from Carolina

403. A broad belt made by the Cherickee Indians of silk grasse
or Mulberry bark. D.

404. An Indian Pagod made of earthen ware of a whitish colour
taken from the Spanish Indians by an Inhabitant of
Carolina & brought thence by Mr Standish who gave it
me.

405. A cast of an ancient head in plaister of Paris from
Dr Woodwards collection no. 6. p. 257.

406. Vas Ægyptium uti videtur ultimum D Woodward mus. p.
259

407. part of a garment & some hair of Francisca urn
from Mr Dering

408. A white alabaster urn w. ivy leaves & fruit on branches upon the top &
round the inscription, Dis manibus
Cladiæ
Fortunatæ
Conjugi
Sanctissima
Optima de se merita
fecimanus Aug. Lib.
Actor. XXXX. Gal.

409. A cupid in brasse from some antique from Mr Borlock.

410. A Venus. D. D.

411. Cupid & Venus. D.

31. Nature as a list: one of ninety drawers containing Sloane's 'Vegetable Substances' collection, originally totalling over 12,000 seeds and other vegetable matter, two-thirds of which survives. Each number refers to a matching catalogue entry and description.

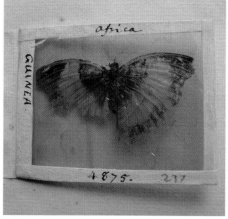

32. Labelling nature: like this pimiento specimen, most of Sloane's Vegetable Substances are sealed in marble paper and labelled with both catalogue numbers and information from Sloane's suppliers in various parts of the world.

33. Guinea butterfly in mica sleeve: these films for preserving delicate specimens – also known as Muscovy glass – allowed for viewing them front and back, impressing visitors to Sloane's collections with their capacity simultaneously to preserve and display, as well as their cost.

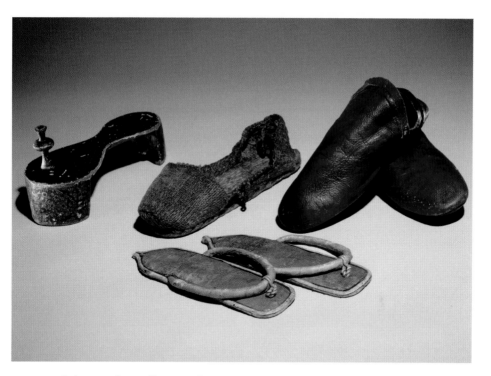

34. Part of Sloane's shoe collection: Sloane organized both his catalogues and displays by types of object to exhibit variety within a given category. Artificial curiosities like shoes documented the natural resources, craftsmanship and aesthetic styles of different cultures.

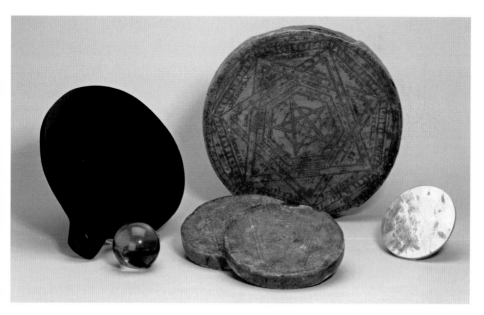

35. Magical instruments belonging to the Elizabethan adept John Dee: Sloane collected manuscripts and objects associated with magic, alchemy and astrology in order to document what he regarded as the mental disorders of those who took such practices seriously.

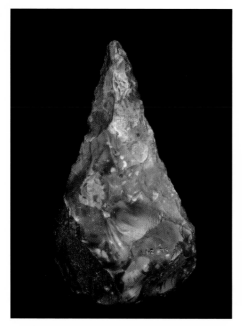

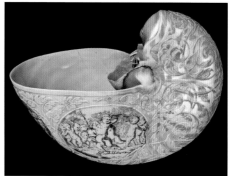

36. Flint hand-axe excavated from Gray's Inn, found with fossilized elephant tusks: these discoveries prompted Sloane to publish an essay arguing that the tusks were remnants of pre-Roman animals which had been made extinct by historic changes in climate.

37. Carved nautilus shell with putti: Sloane delighted in objects that documented both natural and artificial craftsmanship at the same time.

38. The vegetable lamb of Tartary: legend spoke of a Central Asian plant that sprouted living lambs. Sloane's specimen was the rhizome of a Chinese fern (*Cibotium barometz*) fashioned to lampoon belief in the chimerical species.

39. Oak branch inside an ox vertebra: in addition to collecting common plant and animals specimens, Sloane remained interested in irreducibly singular curiosities and older, more playful traditions of natural history.

40. Sámi drum: made of pinewood and reindeer skin, and featuring drawings of spirit-world hunts, such drums were used by Sámi shamans in subarctic Scandinavia until they were seized during Christian persecution in the seventeenth century.

41. Glass vases of imitation realgar: made in China by the Jesuit-run workshops of the Kangxi Emperor, these vases may have been especially intriguing to Sloane because of Daoist alchemists' reported belief that realgar (arsenic sulphide) could confer immortal life.

42. British Museum seal, 1755: while the museum's motto may be translated as 'for the devotees of humane pursuits', and its iconography invokes the illustrious precedent of classical antiquity, its establishment depended on a scandalously venal lottery.

are rather costly than rare'. To Sloane's critics, meanwhile, the commercial pedigree of his prodigiously expensive museum was emblematic of the debasement of learning, the perversion of taste and the corruptions of fame. In 1713, one 'Timothy Cockleshell' wrote to offer a portrait of one of the 'antient kings of Mexico' that was nothing more than a mocking childish scrawl for what he termed Sloane's 'Nicknackatory'. 'Wallowing in money' was how William Sherard irritatedly described his former friend in 1722. To detractors, which he did not lack, Sloane's collections were little more than a cynical machine for the production of his own fame. They cast the man behind the museum as an effeminate creature of passion whose true love was fashion and celebrity, not learning. The poet Edward Young took aim in just this way in his aptly named *Love of Fame, the Universal Passion* (1728), reducing Sloane to 'the foremost toyman of his time' whose ambitions for enlightenment were just padding for the family legacy: 'His nice ambition lies in curious fancies,' wrote Young, 'His daughter's portion a rich shell inhances.' Although he knew Sloane and granted him a man 'of great humanity and learning', Alexander Pope echoed Young's slight in his *Epistle to Burlington, Of the Use of Riches* (1730–31), associating Sloane with that most ephemeral and vain of rarities, the butterfly: 'Rare monkish manuscripts for Hearne alone, / And books for Mead, and butterflies for Sloane'.[42]

'I only beg that when you shew 'em, / You'll tell your friends to whom you owe 'em,' implored one of Sloane's donors. Recording curiosities' pedigrees was, however, precisely one of Sloane's keenest cataloguing habits, since they contributed powerfully to their value. Relics, for example, were traditionally associated with specific saints and the life of Christ; ambassadors exchanged diplomatic gifts to forge bonds of amity between nations; and illustrious former owners raised the value of works of art. Curiosities, too, were prized by collectors in part because they could connect them to famed personages such as kings and queens and other historic figures. Sloane thus took care to catalogue a Brazilian horned beetle in his collection as coming 'from Mrs Rider who had it from her grandfather Dr Wrights collection who was physitian to Oliver Cromwell'. What was unusual with Sloane was the amount of material that connected him to eminent figures from worlds beyond Europe. In the *Natural History of Jamaica*, he noted that the African slave who removed the chego from his foot had been a queen

in her own country, while his catalogue entries repeatedly show the stock he set by the social pedigree of even natural specimens. He noted that his Bombay bath oil was of the kind used by the Mughal emperor; that his eagle scalp came from the Yamacraw leader Tomochichi; and that he owned the 'habet of the Queen of Madagascar', as well as hats belonging to the queen at Tunquin and 'the Patriarch of China'. This was cosmopolitan status by exotic association: it was the rare person who owned rare things.[43]

But famed curiosities provoked mistrust. Such was the fascination with commodities in an age of trade and empire that so-called 'it narratives' began to be published in Britain as stories recounted in the first person by objects themselves as they travelled the world. In reality, of course, objects couldn't tell their own tales, so people spoke for them. Not everyone, however, believed what collectors said. Globe-trotting treasures, sceptics countered, often turned out to be very local lies. 'He shows you a straw-hat, which I know to be made by Madge Peskad, within three miles of Bedford,' the fictional critic Isaac Bickerstaff railed in the *Tatler* magazine in 1709, in a satire launched against one of Sloane's fellow collectors, a former servant of his named James Salter, 'and tells you, it is Pontius Pilate's wife's chamber-maid's sister's hat.' Wheezes of this kind flouted the deference virtuosos expected for claims to glamorous provenance. Edward Young certainly did not take Sloane's word at face value. 'He shews on holidays a sacred pin, / That toucht the ruff, that toucht Queen Bess's chin,' he wrote mockingly of Sloane in *Love of Fame*. 'How his eyes languish ... [and] thoughts adore / That painted coat which Joseph *never* wore.'[44]

Yet Sloane would not stop. The diplomat Charles Hanbury Williams was sincerely grateful for the medical assistance he had received from him but rued the obligations under which this placed him. 'To Sir Hans Sloane, who saved his life,' he entitled a mock ode penned in 1732, 'and desired him to send over all the rarities he could find in his travels.' This was, Hanbury insisted, no exaggeration. Send me 'curious things of ev'ry kind', Sloane had commanded, using the Hanburys of the world to service his relentless hunger for curiosities. According to this view, Sloane commodified his personal relationships in an insatiable quest for what Hanbury too dismissed as mere 'knick-knackatory'. 'I am but just come from Sir Hans Sloane's,' wrote the feminist and Bluestocking Elizabeth Montagu in 1742, herself a collector and similarly

unimpressed by what she had witnessed, 'where I have beheld many odder things than himself, though none so inconsistent: however, I will not rail, for he has given me some of his trumpery to add to my collection.' Richard Mead's curiosities, she judged, were in any case 'much finer' than Sloane's.[45]

Perhaps the most biting attack on Sloane came from the Irish poet Laetitia Pilkington. After waiting two hours to speak with him at Chelsea Manor one day in 1748, Pilkington 'was at length permitted to enter to his supreme majesty', as she put it in her memoirs, turning anti-Catholic polemics on Sloane himself; 'sure the Pope himself in all his pontifical robes never was half so proud' (Sloane's visitors did sometimes kiss his hands). Sloane, she wrote, was 'like the idol to whom a stately temple was consecrated, which a traveller, attracted by its outward magnificence, thought to find an adorable deity in'. On entering, however, she found only 'a ridiculous monkey'. Sloane paid far greater attention to his beloved manuscripts than to any human being in his company, Pilkington observed, until a 'beggar-woman entered with a sore-eyed child' to which he administered a rather violent cure that made the poor girl faint. He then offended Pilkington (who carried with her a letter of introduction from Mead) by offering her half a crown, assuming she must have come 'for charity'. So much for the great man's papal infallibility (she would have thrown the half-crown in Sloane's face but she needed the money). The great collector, she thundered, was a 'conceited, ridiculous imperious old fool', whose reputation for judgement and philanthropy amounted to little more than the power of his enormous wealth.[46]

Pilkington was not alone in her assessment. To this day an impressive Doric archway, designed by the architect Inigo Jones, sits in the grounds of the Earl of Burlington's Palladian villa at Chiswick in west London. The arch comes from Beaufort House, the former Chelsea residence of Sir Thomas More and, subsequently, of Sloane's friend the Duchess of Beaufort. Sloane bought Beaufort's house around 1738 but decided to demolish the place and strip it for parts. He did not give the arch to the earl, therefore, but sold it to him, and tasked the Quaker Edmund Howard with the business of demolishing the property. Howard described Sloane as 'very affable' but thought he had known 'many men superior to him' in talent and the two fell out over how much Howard should earn for the job of collecting rents from tenants living

on Sloane's land in Chelsea. Distressed at being charged with the destruction of the grand Beaufort House, Howard observed that 'the receiving of money was to Sir Hans Sloane more pleasing than parting with it.' He nevertheless continued to work for him and helped oversee the transfer of Sloane's collections from Bloomsbury to Chelsea in 1742, though he remained highly critical. Many of Sloane's curiosities were only 'gimcracks', he judged, while others spoke of his master's true love – money and finery: 'he had many gods of gold and gods of silver.'[47]

## ENTERTAINING MR SLOANE

Understudied and underused, Sloane's collections were not public in his lifetime and ordinary people could not access them. But thanks to numerous private tours of them, they nevertheless became famous. Requests to visit Sloane's museum were legion. In 1709, for example, Robert Hales, an emissary of the Society for the Promotion of Christian Knowledge, wrote to ask if some 'strangers of distinction [could] see your curious cabinet the next Wednesday, Thursday or Saturday'. Their names were Monsieur le Coq, 'a man of great worth' and brother of the Duchesse de la Force; Monsieur Hop, son of the treasurer general of Holland; Monsieur de Neufoillé; Monsieur Chamberlyne, a weighty Amsterdam merchant; and Mr Helmet, brother-in-law to Lord Gray. Requests came too from Sloane's colleagues. 'A nobleman of my country', the Oxford botanist Jacob Bobart wrote in 1716, 'being desirous to see your cabinet, you would extremely oblige me if you would permit it, letting me know when it would most suit with your conveniency.' William Bentinck, Duke of Portland, asked whether he might bring his wife and her two sisters plus one other gentleman on a Thursday if possible. Sloane could name the time, although morning would be preferable. Repeated public notice, as well as word of mouth, spread talk of the collections. The *Daily Post* gossiped in 1724 that 'several foreign ministers went, last week, to see Sir Hans Sloane's extraordinary collection of natural and artificial curiosities'; in 1728, Queen Caroline visited, along with several other members of the royal family; and in 1735, the *London Evening Post* noted that the Prince of Orange and 'several persons of distinction' were 'extremely delighted' by Sloane's

'famous collection of curiosities' and 'sumptuously entertained by Sir Hans'. Seeing the collections thus became a recognized mark of distinction in London society.[48]

The collections' fame drew visitors with the prospect of procuring some of their own. Cecilia Garrard, wife of Sir Nicholas Garrard, the descendant of wealthy London merchants, visited Sloane in 1734 and immediately sent him 'an insect found in a decay'd branch of an apple-tree'. '[I] hope tho convey'd by peny post it will come alive to your hands.' The Amsterdam trader Diederick Smith wrote in 1737 to thank Sloane for affording him a glimpse of his curiosities. In return, he had something curious for the great collector: he teasingly did not say what but would 'be proud of its having a place among the infinity of yours'. 'You were pleased when I was waiting on you to invite me to have a sight of your curiosities,' said the Caribbean naturalist Griffith Hughes in 1743, presuming to request the favour 'in company with some ladies of distinction'. He wished he had something of 'far greater value or at least greater curiosity to present you with', he explained sycophantically, 'but as you have collected ye curiosities of the almost known world, I despair of ever sending you any thing new'. He managed to scrounge up a few jars of Barbadian worms and reptiles, which no doubt found a spot somewhere on Sloane's shelves: 'your acceptance of them will very much oblige me.' Some even tried to use contributions to the collections as the price of admission. A woman who did not know Sloane named Katharine Byde sent him a gift and in the accompanying letter asked if she and her husband might also come for a visit.[49]

No rarity seemed too strange for the most curious man in the world. Calling Sloane 'a perfect judge of every species of matter', Jonathan Partridge sent him some partially digested material in 1713 that 'some ingenious rat [had] made an experiment [of] how far it was conducible to the maintenance of life'. 'Having with excessive pains and much difficulty discover'd the nature of buggs,' John Southall informed Sloane in 1729, 'I have prepard for the press a small treatise on those nauseous venomous vermin wch I hope to be able to speedily publish' and of which 'you Sr who are justly deem'd the most judicious and curious of mankind [will be] the best judge'. In 1735, Peter Carey of Guernsey sent a Peruvian balsam tree from the South Seas, asking Sloane to confirm its identity for him. 'There is not a place in all Europe where your indefatigable desire of searching into nature is not talked of,' crowed

Johan Welin of Åbo University in Finland in 1741. He submitted for approval an account of Finnish peasants' secret for telling fresh eggs from foul by shaking them close to their ears and listening to them (fresh ones were silent, bad ones were not) and taking their temperatures with their tongues (they should be warmer at one end). Years later, the Swedish mystic Emanuel Swedenborg described a vision in which he heard Sloane and Martin Folkes (his successor as Royal Society president) 'conversing together in the spiritual world about the existence of seeds and eggs', trying to decide whether they originated in 'nature' or in 'God the creator'. 'To settle the discussion, a beautiful bird appeared to Sir Hans Sloane, and he was asked to examine it to see whether it differed in the smallest particle from a similar bird on earth. He held it in his hand, examined it, and declared that there was no difference.' Sloane had become the apotheosis of curious judgement.[50]

The best evidence of what it was like to visit Sloane's collections comes from scholars who appear to have taken notes on tours conducted at Bloomsbury and Chelsea. Touring collections was a longstanding tradition. In medieval Europe, reliquaries containing remnants of saints, pieces of the true cross and other sacred objects for healing purposes doubled as pilgrimage sites, with guidebooks available for travellers. Princely cabinets of wonders during the Renaissance mimicked this culture of orchestrated object pilgrimage. Wonder-cabinets offered highly theatrical spectacles that juxtaposed rarities of all kinds to awe spectators with their dazzling variety while forming part of a circuit shaped by conventions of courtly etiquette and scripted by catalogues, guidebooks and conduct-books. Since there were no explanatory written captions, such visits involved conversational exchange and polite jousts over knowledgeability. And because collectors were often aristocrats or potentates, it was generally expected that visitors would praise the magnificence of their collections as an endorsement not merely of their wealth and power but of their discrimination, although scholars and gentlemen did differ about the identity and significance of objects. Because such visits were normally conducted in groups, they were social occasions. For hosts and guests both, all such tours were thus theatrical performances as well. Not for nothing did Renaissance collectors refer to their museums as a *theatrum mundi* – a theatre of the world.[51]

The first substantial description of a Sloane tour dates from 1710:

the visit of the Frankfurt savant Uffenbach to Bloomsbury (although his account was only published in 1753, in German). Uffenbach was deeply impressed by Sloane, noting that he received him and his companion 'with vast politeness' and 'in a very different manner from the coxcomb, Dr Woodward'. Sloane addressed them in French. Such cosmopolitanism 'was most amazing for an Englishman', as most of his fellow countrymen would 'rather appear dumb than converse with a foreigner in any other language than their own'. Sloane led them into a moderate-sized room filled with rows of books and cabinets containing 'extraordinarily curious and valuable things'. Conversation with him was one of the highlights of the tour: Uffenbach jotted down Sloane's story about refusing the Venetian ambassador's offer for the collections, for example. Perhaps inevitably given the size of Sloane's collections and the relatively short time tours lasted, Uffenbach simply made a list of the kinds of things he saw: animals in jars, fish, ores, figured and precious stones, insects, shells, sea urchins, corals, agates, coins and birds, all 'remarkable' and 'choice', as well as 'Indian and other strange costumes'. With visits to other collections in London and Oxford fresh in his mind, Uffenbach ventured some comparisons. He not only found Sloane personally preferable to the querulous Woodward but thought his insects more impressive than those of Joseph Dandridge, in part because of the wealth Sloane had lavished on 'costly' transparent mica films for viewing them known as Muscovy glass (Plate 33). Uffenbach also appreciated the sheer rarity of the collections. He marvelled at 'a sort of cloth that is said to grow on a tree' – Sloane's lacy Jamaican lagetto – while Sloane's *Cochlea terrestris* (a snail) was remarkable not so much for its elegance as for its 'curious breeding from an egg such as we had seen in no other collections'.[52]

Uffenbach's account shows how Sloane's tours extended an intimate level of trust to his guests, allowing them to touch, handle and sometimes even taste his objects. Such trust was a true privilege: with no catalogue or reproductions in circulation, the only way to experience the collections was by strict personal invitation. Some visitors became 'so very curious' about his plants, Sloane commented in 1707, 'as to desire to carry part of them home with them privately, and injure what they left' – perhaps a reference to the episode in 1700 where, unable to break into Sloane's 'heavily bolted' home, two thieves named John

Davis and Phillip Wake aimed to set several fires and make off with its contents by pretending to offer assistance. Accidents could happen too. There is the oft-told tale of the visit years later by George Frideric Handel, when the great court composer damaged one of Sloane's manuscripts by placing a buttered muffin on it ('it put the poor old bookworm terribly out of sorts,' Handel reportedly observed). Others baulked at sensory engagement with the collections. In 1712, Bishop Nicolson of Carlisle noted in his diary that Sloane's Asian 'Nephritic stones' were finely polished 'but greasy to the touch'. Uffenbach, by contrast, relished any opportunity for connoisseurship. He described how 'holding [an] egg against the light, one could see the concham lying concealed within it'. Sloane had nests of 'vastly curious structure' and 'pointed out to us the nests were eaten as a delicacy', inviting guests to taste one of them for the pleasure of the diversion and as a test of their knowledge. 'Judging from its taste, appearance and feeling,' said Uffenbach, 'I took it for a gum resin.' Touring entailed making aesthetic judgements too. Sloane had one Portuguese manuscript on the West Indies with 'elegant paintings', although his butterflies were, Uffenbach thought, 'not so handsome as those of Vincent in Amsterdam'.[53]

Uffenbach was intrigued by Sloane's coins and medals but regretted that 'time was lacking to observe them all with care.' A tour was not a study session. When, for example, Linnaeus visited in 1736, he did not have time to study Sloane's herbarium; instead, he made extensive use later on of the engravings published in Sloane's *Natural History* for his classifications in the *Species plantarum* (1753). As time ran out on Uffenbach's visit, Sloane invited his guests 'into another room, where we sat down at a table and drank coffee while he showed us all manner of curious books': albums of exotic plants and animals, such as those of Maria Sibylla Merian, as well as 'national costumes' done by 'the best artists' and 'collected sheet by sheet from all parts of the world at a phenomenal cost'. They looked over manuscripts, mostly relating to medicine. For all the sociability Uffenbach enjoyed, and the sheer pleasure the collections afforded, he was deeply impressed by Sloane's wealth as well. It was a 'very great honour' to enjoy a tour lasting from half-past two in the afternoon until seven in the evening, he wrote, and measured its generosity by the amount of income Sloane might have earned in the meantime: 'they say that he could earn a guinea an hour.' Uffenbach praised his 'much-travelled' and 'vastly amiable' host,

paying himself a backhanded compliment by noting Sloane's friendliness above all 'to Germans and such persons as have some knowledge of his treasures', for which he helped himself to some of the credit. 'I presented him with a Lohenstein *hystero lythibus* [a uterine stone], such as he had never seen before, and it was especially welcome,' on which account Sloane 'showed us more courtesy than to other persons'.[54]

Uffenbach's résumé of the collections was sober, scholarly and self-important. Others who visited simply made lists of highlights. In 1712, for example, the Bishop of Carlisle singled out in his diary earths of different colours from China and Virginia, iron ore from Gloucestershire, Sloane's coral-encrusted bottles, an ants' nest from Jamaica, dried Chinese plants, a dragon-like salamander, a 'monstrous sea-bear' and two Cornish choughs feeding in a cage. Still others let their imaginations run away with them in visionary transports that cast Sloane's museum as a godlike assembly of the world in miniature. One lyrical visitor was moved to commit his impressions to verse in 1712 in 'A Poem occasion'd by the Viewing Dr. Sloans Musaeum'. The author spoke of a 'world . . . gathered to its master's view', as though he were Adam reincarnate, 'the first man in paradise', fancying himself in Eden while listening to Sloane speak: the 'crowded world thus do I now survey / . . . while I hear thee name each beauteous part / Admire the maker's and the owner's art.' This was the double spectacle Sloane's museum presented: God's power to create and Sloane's power to collect. 'If there's a paradise on earth tis here,' where 'Lappland bears with Borneos creatures meet', together with 'Indian heroines' and 'Persian caravans' and the nymphs of 'black savage Affrick' – all in one 'glorious coppy' of the entire world that 'emulatts the bright originals'. Sloane already had everything worth taking: 'Curious merchants' surely need no longer 'prize / At monstrous rate exotick rarityes'.[55]

The richest account of the collections came in May 1748 when the Swedish naturalist Per Kalm visited Chelsea Manor in the company of several other gentlemen. By then, Sloane was eighty-eight years old but still spent a couple of hours with selected guests. Kalm recorded how a series of drawers was opened by Sloane's assistants to reveal well over a thousand stones of peerless beauty, 'partly polished or artistically treated' to intensify their effects: gems, agates, cameos, cups, saucers and bezoars, 'some as big as [a] fist'. One curious jasper bore a 'picture

of two women who stood and gossiped', or so they were told, because, Kalm added with polite hesitation, 'imagination was needed to make this out.' Human faces looked out at the visitors, too, in the form of cameos and onyx stones fashioned into the visages of rulers and gods such as Alexander the Great and Mars, while other pieces resembled 'sore eyes' and various body parts. A series of boxes was opened as ornate as the stones themselves. Like Uffenbach, Kalm was taken with both their beauty and their cost. One was made from transparent jasper, another fitted with jasper locks. A chest containing the most expensive stones of all contained an interlocking series of drawers and resembled 'a monument over a grave or a house with an Italian roof'. A series of snuffboxes was displayed. One was made of puddingstone, with a knobbly texture like Christmas pudding, of which, Sloane's assistant said, an Englishman had once sold a large quantity in China at a profit of 1,200 per cent – 'very good business'. A set of cups and saucers done in precious stones cost fifty guineas. 'It was said that there were 1,300 different kinds of precious stones' stored in a single cabinet.[56]

The group moved on. They were shown a dazzling set of rings, one containing a 'Mocca' stone for which Sloane was thought to have paid £100 and a beryl stone the Mughal emperor was said to have worn in his headdress. From 'the most expensive stones' they proceeded to an astonishing medley of curiosities. These began with such rarities as the shoes of a Chinese woman 'no bigger than those of a child of 2 or 3 years in Sweden'; a device made of elephant bone 'with which the women of the East Indies scratch their backs'; wooden combs, pearls and idols that fit in one's pocket; and 'rattling and jingling things' worn by Asian dancers. In the next room, Sloane's paintings lined the walls with portraits of Ray, Courten and William Dampier along with the kings and queens of England. Kalm was especially struck by one uncanny canvas on which six 'naked women ... twisted themselves into various postures', evidently to make up Sloane's name: thus 'one of them inscribed the letter S by inclining forwards.' Beyond was a narrow gallery over 100 feet in length and utterly stuffed with objects. On each side, the floor was lined with cabinets containing specimens, with curiosities festooning the walls, which were lined in turn with the tomes of Sloane's library. All Kalm could do was make a list. There was a cupboard filled with goblets; huge quantities of corals; a powerful magnet; coral-encrusted bottles 'which had lain for a long time at the

bottom of the sea'; crystals as 'transparent as the clearest ice'; feathers and eggs; the red-feathered headdress of a West Indian king and a West Indian axe; stuffed fish; a unicorn horn; musical instruments; tobacco pipes; wood from Ireland (perhaps the underground fir given to Sloane by Edward Southwell); shoes from around the world; a cupboard filled with over 10,000 boxes of dried seeds (the vegetable substances); and lagetto fibres 'like linen or paper . . . said to be usable for ruffles'.[57]

There were thousands of seeds and insects, including many exquisite butterflies, each housed in their almost identical numbered boxes and neatly slotted into more than 100 drawers. Each box fit in the palm of a hand. This was storage as spectacle, showing off the art of preservation at its most beautiful and technically accomplished. Kalm was enthralled by the glory of all the finicky detail: 'some had both the cover and the bottom of the box made of a crystal-clear glass, while some had only a transparent glass lid. At the joints where the glass ran up to the sides of the box it was sealed tight with paper in such a way that no air let alone any moth or other insect could get inside to damage the contents.' Still they moved on, passing into yet another room, where massive folios were taken down from Sloane's herbarium and opened to reveal plants from around the globe. Sloane's book-wheel (p. 155) sat close by, for reading 'when there is need to use a number of books at the same time', and was demonstrated for them: 'as the wheel was turned round all of the shelves rotated simultaneously.' They waded through rivers of paper: twenty-four volumes of 'costly' rare books given to Sloane by the King of France; a volume of Chinese papers containing 'splendid paintings'; and 5,300 volumes of manuscripts on medicine, travel, natural history and more, all 'bound in fine bindings'. And still they carried on. Eight more rooms, whose walls were lined from floor to ceiling with books and filled with curiosities past counting. The dried cartilage of whale vertebrae, porous like pumice-stone; a cabinet of sea urchins and other marine creatures; the skeleton of an armadillo; a stuffed porcupine from Hudson's Bay (a former denizen of Sloane's garden); a cup fashioned from tortoise shell; snails and nests; corals gleaming through the doors of a glass cabinet; human skeletons and an Egyptian mummy; antiquities; thousands of animals preserved in spirits in jars of all sizes; clothing worn by the different peoples of the world; a stuffed striped donkey from the Cape of Good Hope; and wooden boats from the West Indies.[58]

Towards the end of the tour, Kalm sought to carry out the scholarly assignment with which he had been charged by Linnaeus, his patron, and the specific purpose of his visit: counting the scales and abdominal plates of the *Cobra de Cabelo*. But he regretted the attempt. 'I had wished that I would not need to go through all this,' he complained, because 'while the others went around and looked at everything ... I had to spend my time trying to count them up, which was very difficult.' This was the wonder-cabinet problem squared, designed to stupefy visitors with sheer riotous abundance – kaleidoscopic variety intensified by lack of time. Sloane's museum defied visitors simply to remember what they saw. The effort made by the naturalist Peter Collinson, who on one occasion wrote to Sloane about 'some specimens of spotted rhomb', was in this respect heroic. He tried to sort through what must have dismayed many visitors as near-impossible miscellany: 'if I mistake not I remember to have seen you have a great number and variety of duplicates in a cabinet that stands on the left hand as I went into the roome where the mummy lies.' Kalm resigned himself to his task and recorded that the *Cobra* had 183 plates and 60–61 scales. But now the tour was over. He and his companions exited into the garden and made their last stop in an outbuilding to contemplate the head of a whale said to have measured 90 feet in length – a fitting climax to the epic scale of all they had witnessed.[59]

If Kalm's account of Sloane's collections is the most vivid, it is not the most historically significant, however. That distinction belongs to the second account of Chelsea Manor penned in 1748: the one occasioned by the visit of the Prince and Princess of Wales in June that year, with which this book opened. This account was the first to make a case for the value of Sloane's collections in an accessible essay published in English and may well have been part of a deliberate strategy of Sloane's to raise the question of the collections' fate after his death as a matter of public concern. Until this account in the widely read *Gentleman's Magazine*, virtually no such publication had described Sloane's collections in any detail. That the *Gentleman's Magazine* had been in existence only since 1731 shows how the print culture of the middling ranks of British society was, indeed, only just being invented at this time. The author was Cromwell Mortimer, the physician, naturalist and secretary of the Royal Society who assisted Sloane and who welcomed the prince and princess to Chelsea Manor. Mortimer began his article

with a resounding endorsement of Sloane and his collections: 'the prince', he recounted, 'expressed the great esteem and value he had for [Sloane] personally, and how much the learned world was obliged to him for his having collected such a vast library of curious books, and such immense treasures of the valuable and instructive productions of nature and art.' The prince likely harboured his own personal motives for lending his weighty public support, as Sloane and Mortimer may well have realized, since he was then making a very serious bid for prestige and influence through conspicuous acts of cultural patronage. For example, he had set to music the patriotic verses of 'Rule, Britannia' that were to become one of the great anthems of a newly imperial British nationalism. By mid-century, with Britain on the verge of global ascendancy and cultural commentators increasingly taking up questions of national self-definition, Sloane's collections might now resonate with the nation's ambitions to own more than just a 'coppy' of the world.[60]

Unlike other descriptions of the collections that aimed at surveying them as a whole, Mortimer used key items to draw out patriotic messages for his readers. First he made the usual whistle-stop listing of Sloane's precious stones and curiosities and 'things too many to mention here'; 'fifty volumes in folio would scarce suffice to contain a detail of this immense museum, consisting of above 200,000 articles.' He made no boasts about how much the collections were worth, nor did he dwell much on their scholarly usefulness. Instead, he stressed a grander if less tangible reason why they were valuable: their capacity to illustrate a patriotic narrative of the progress of British liberty and military might against a backdrop of tyranny from ancient despots to murderous Catholics. In a deft display of numismatic propaganda, Sloane's medals now took pride of place. These included coins featuring Alexander the Great, who, 'mad with ambition, over-r[a]n and invaded his neighbours'; Caesar, 'who inslaved his country to satisfy his own pride'; Pope Gregory XIII and King Charles IX of France, whose 'blind zeal for religion' led to 'the massacre of the protestants in France'; figures representing France and Spain, 'striving which should first pay their obeissance to Britannia'; 'others shewing the effect of popular rage, when overmuch oppressed by their superiors' in the Netherlands; 'the happy deliverance of Britain, by the arrival of King William'; the 'glorious exploits' of John Churchill, Duke of Marlborough, England's

most celebrated military commander through the War of the Spanish Succession; 'and the happy arrival of the present illustrious royal family amongst us' in 1714.[61]

Sloane's collections inspired pious Christian reflection too. 'The remains of the antediluvian world excited the awful idea of that great catastrophe,' Mortimer observed, while 'the variety of animals shews us ye great beauty of all parts of the creation.' He shamelessly flattered the Prince of Wales by painting him as an impeccably learned connoisseur in his own right: 'upon any thing being shewn him he had not seen before, he was ready in recollecting where he had read of it; and upon viewing the ancient and modern medals, he made so many judicious remarks, that he appear'd to be a perfect master of history and chronology.' Such flattery was purposeful: Sloane's treasures were fit for a prince and Britain must, therefore, take charge of them as a matter of national honour, rather than let them disperse or fall into foreign hands. The prince 'express'd the great pleasure it gave him to see so magnificent a collection in England', Mortimer went on, 'esteeming it an ornament to the nation'. His Royal Highness added 'how much it must conduce to the benefit of learning, and how great an honour will redound to Britain, to have it established for publick use to the latest posterity'. Using the Prince of Wales in this way, Mortimer made the case for taking up Sloane's legacy as an issue of national urgency. Within only five years, the fate of the collections did indeed become a matter of public debate as Sloane had hoped it would. There was, however, no precedent for turning a private museum into a great public institution. Just what would become of Sloane's collections remained to be seen.[62]

# 7

# Creating the Public's Museum

## FOR THE IMPROVEMENT, KNOWLEDGE AND INFORMATION OF ALL PERSONS

On 11 January 1753, Sloane died at Chelsea Manor, three months short of his ninety-third birthday. His longevity was a testament to his self-discipline and, as we have seen, proved vital to his career as a collector. At his memorial service, carried out with 'great funeral pomp' at the family vault at Chelsea Parish Church, where Lady Sloane also lay buried, Zachary Pearce, Lord Bishop of Bangor, delivered his eulogy to a 'crowded audience'. Bangor read from the ninetieth Psalm; his theme, he said, was 'ye uncertainty of human life, & ye advantages of a good one'. Sloane had suffered no pain, he observed, nor had the 'pleasures of conversation' forsaken him even at the end. His devotion to Christian charity was manifest in the 'multitudes of lives' he had saved while a doctor and, as one of the learned world's most 'diligent searchers of nature', he was revered at home and abroad with 'lasting marks of esteem from crowned heads as well as private persons'. Bangor emphasized that Sloane's acquaintanceship, a mark of the man, cut strikingly across all ranks of society: 'from ye throne to ye shop, thro' all ranks & conditions of men, he met with that respect & encouragement wch he merited.' This universal friendship was the foundation of his universal collection. 'In no age either pass'd or present, in no country either distant or near, did ever (perhaps) the world see such an almost universal assemblage of things unusual & curious, of things ancient & modern, of things natural & artificial, brought together from almost all times, & almost all climates.'[1]

The bishop attributed solemn religious purpose to this legacy. Sloane

had been determined, he said, 'that ye wisdom & goodness of ye great author of nature might be ye more plainly seen, [where] so large a part of his works were collected & in one place so abundantly displayed to view'. Glossing over their restricted accessibility, and echoing the Prince of Wales, he patriotically insisted that they constituted a public work that brought 'honour to the nation'. Sloane's treasures were a distinctively modern triumph, on a scale unknown in antiquity, outstripping even the treasures of the Roman Empire as catalogued by Pliny: 'what Pliny . . . never conceived the human genius would dare to undertake, we have seen accomplished; and it must warm the heart of every Briton, to remember that it was done in his own country.' Echoing the prince once more, the bishop touted the collections as national treasures while stressing also Sloane's personal glory. 'The Chelsea collection affords, and all worthy men must hope that it will for ages afford, conviction of it, and make the name of Sir Hans Sloane immortal. That a treasure like to this never was amass'd together, is beyond a doubt: all that is call'd great in its kind in the whole world becomes contemptible in the comparison; nor can we imagine that such an one ever can be compil'd again, unless such another almost miraculous combination of causes should appear to give it origin.'[2]

Within days of Sloane's death, the London gazettes were buzzing with rumours about his will and the fate of the collections. One reported that they were worth £50,000 but might be offered to George II for the reduced sum of £20,000. Another valued them at £200,000 and spoke of the use of 'two covered carriages belonging to his Majesty' to deposit the more valuable items in the Bank of England for safekeeping. 'Nothing so fully displays the grandeur of [Sloane's] mind as his immense and rare collections,' which were 'perhaps the fullest and most curious in the world'; one might 'venture to proclaim it the most valuable private collection (perhaps publick one) that ever has yet appeared upon Earth'. Like the Bishop of Bangor, gazette writers stressed the collections' public pedigree. 'These treasures, though collected at his private expence, have not been appropriated to his own pleasure alone' because 'mankind has enjoyed the benefit of them.' Sloane's Britishness also became a source of pride, if ambiguously so. His 'native country', it was said, was 'proud of the honour of giving birth' to him. But was this a reference to Ireland? The *London Evening Post* did mention Sloane's Irish background but only as a yardstick to

measure how far he had come from his provincial origins. He was 'born at Killelagh in the County of Downe and Kingdom of Ireland' but 'his thirst after knowledge tempted him to remove from thence in his youth, in order to employ his talents in a more extended scene of life.'[3]

Bequeathing the collections to create a public museum was a novel and complex proposition, not least because the very notion of the *public* was itself in flux. In early eighteenth-century Britain, the term was mainly associated with the state, its apparatus and its officers rather than the 'general public' or the people at large. But the notion of 'public opinion' as an autonomous and legitimate political entity was taking on new force, even though its source proved hard to specify. For some commentators, public opinion derived from 'the people', yet whether they should be regarded as the moral bedrock of the nation or an unreasoning mob was a matter of debate. Members of the governing class grew alarmed as they perceived the potential of public opinion to destabilize political and economic life. 'There cannot be a more dangerous thing to rely on, nor more likely to mislead one,' John Locke had written in 1689 despite his endorsement of the right of rebellion in the Glorious Revolution, 'since there is so much more falsehood and error amongst men, than truth and knowledge.' On this view, popular opinion was less something for governments to follow than to shape through the skilful propaganda of writers like Daniel Defoe, who sometimes worked for the government as well. According to the philosopher Jürgen Habermas, however, the decades around the turn of the eighteenth century witnessed the emergence of the 'public sphere' as an arena of debate separate from and critical of government, thanks to the flourishing of both coffee houses and print culture.[4]

The idea of a public museum had a number of precursors – depending on how both 'public' and 'museum' are defined. Versions of some such institution can be traced back as far as ancient Alexandria. Unlike the courtly collections of aristocrats and royal families, church treasuries in medieval Europe regularly put relics and other objects on display before entire congregations. Several European collections were public, moreover, in the sense that they belonged to the state or were kept in official palaces. Natural history collections in Bologna were sometimes housed and exhibited in civic buildings by the seventeenth century; so too were the art and antiquities collections of the Capitoline Museum on the Campidoglio in Rome, which opened in 1734. Tsar Peter the

Great of Russia pursued an active programme of public exhibition, albeit as a form of absolutist enlightenment, issuing proclamations in 1704 and 1718 demanding that all 'monstrous' births be sent to the St Petersburg Academy of Sciences, where the peasantry might be educated to see them as natural phenomena rather than demonic portents. In Paris, to celebrate the king's art collections and help mould the national taste in painting, the Luxembourg Palace opened its galleries to visitors on selected nights beginning in 1750.[5]

In England, Charles I's execution in 1649 occasioned a radical re-distribution of royal property when commoners snapped up the headless king's art at auction to raise money for the Republic, though many of these works were given back after the Restoration. Of more lasting significance was the opening of the Ashmolean Museum in 1683 at Oxford, which included the collections amassed by the Tradescant family. Admission to the Ashmolean was not restricted by class or limited to personal invitations but open to any visitor who paid the entrance fee. This made it among the most accessible collections in Europe, although for some the admissions policy was a distressing commercialization of the gentlemanly code of museum-going. Zach-arias Konrad von Uffenbach was woefully put off by the spectacle of commoners in the collections in 1710: 'it was market day and all sorts of country-folk, men and women, were up there . . . as we could have seen nothing well for the crowd, we went down-stairs again and saved it for another day.' 'Even the women are allowed up here for a six-pence,' he noted disdainfully; at Oxford's Bodleian 'peasants and women-folk . . . gaze at the library as a cow might gaze at a new gate with such noise and trampling of feet that others are much disturbed.' Public audiences for collections violated Uffenbach's sense of scholarly civility as though a sacred inner sanctum, defined by class and gender as much as learning, had been defiled by a swinish multitude.[6]

In London, Sir John Cotton had bequeathed his manuscript collection to Parliament in 1700, but it lacked a proper home for decades, nearly burning to a crisp in 1731 in a fire at Ashburnham House. The Royal Society Repository had been curated by the distinguished natu-ralist Nehemiah Grew early on but was languishing by the eighteenth century. Sloane tried to revamp it after becoming president, but it was his own museum that served as the model of expert management, not vice versa – a group of Fellows visited him in Bloomsbury in 1733

to 'better judge what may be proper to be order'd in the Repository'. Traffickers in rarities, meanwhile, had taken the lead in setting up commercial curiosity shows. These included the impecunious Claudius Dupuys who sold rarities to Sloane but also displayed them for money. In Chelsea, Sloane's former servant James Salter ran what became the most popular cabinet of curiosities in eighteenth-century London, and which Sloane himself reportedly visited on a regular basis after his retirement. Exoticizing his name to entice visitors, Salter baptized his establishment Don Saltero's Coffee House, in which he set aside a space called the 'Coffee Room of Curiosities'. Here, customers drank and smoked and paid to see his rarities. The ubiquitous Uffenbach was impressed: 'standing round the walls and hanging from the ceiling are all manner of exotic beasts,' he observed, 'such as crocodiles and turtles, as well as Indian and other strange costumes and weapons.' To him, Saltero's was a bona fide museum that offered real knowledge of strange new worlds.[7]

Others begged to differ. 'I cannot allow a liberty he takes of imposing several names . . . on the collections he has made,' Isaac Bickerstaff complained in the *Tatler*, doubting that Salter possessed either the knowledge or the honesty to be truthful about his wares. On the one hand, many of Salter's objects possessed an impeccable pedigree, coming from virtuosos including Sloane himself, among them one of Sloane's manatee straps – the banned Jamaica slave whip. Salter even published a catalogue in several editions trumpeting his inventory in suitably learned style. On the other hand, he indulged in low humour that suggested parts of the collections were mere jokes. His catalogue listed 'a starved cat, found many years ago between the walls of Westminster Abbey' and dealt in bankable anti-Catholic jibes by describing such relics as 'the pope's infallible candle'. Like the Ashmolean, the mixed reception Don Saltero's occasioned shows how the reputation of curiosity collections remained decidedly chequered in the first half of the eighteenth century, poised between exotic museology and commercial tomfoolery. In any event, no collection, either in Britain or on the continent, was yet the property of a nation that granted free right of access to its citizenry as a matter of principle.[8]

Sloane's own design to create a posthumous public museum appears to have evolved gradually. By 1700, he had started to buy books as a collector rather than for his own personal use; by 1707, he had begun

to organize his correspondence with a view to posterity (this was no mean feat: one estimate puts his total number of correspondents at 1,793). That same year, he commended a plan to unite the Royal Society with the Cotton and Royal Library collections. He was thus publicly or at least institutionally minded from early on, at a time when there were effectively no national institutions to consolidate the many different private collections in the country. Contemporaries likewise came to regard his private museum as a repository of record. When in 1725 the horned lady of Pall Mall finally shed her famous growth, the *London Journal* announced its dispatch to Sloane's museum 'to be deposited amongst his other curiosities' as a logical matter of fact. When the Leeds antiquarian Ralph Thoresby died that year, Thomas Hearne immediately urged to their mutual friend Richard Richardson that Thoresby's things should 'fall into good hands' – 'methinks they might be proper to be joyn'd with Sir Hans Sloane's' – no doubt mindful that Sloane had already collected the Courten and Petiver collections and several others. By 1725 Sloane, too, had begun to speak of himself as a public collector, voicing his hope that acquiring Petiver's specimens would ensure they would be 'preserved and published for the good of the publick'. A number of visitors to Sloane's museum had also contributed to his collections over the years. In all these different ways, Sloane's collections assumed an increasingly public profile as time went by.[9]

It was only in 1738–9, however, that Sloane considered his legacy in earnest as his health started to decline. '[I] begin to think of my affairs other ways than I have done,' he wrote at age seventy-eight. He was not an aristocrat by birth and lacked a male heir. This meant that he was free from the conventional preoccupations of the nobility, who often sought to maintain the family name by ensuring their possessions passed to their children, but also that he was burdened by the concern, no doubt stemming from the prejudices of the time, that his two daughters Sarah and Elizabeth would not make appropriate custodians of his museum. Nor, if he could help it, did he wish to entrust his collections to the royal family or to an academy or learned society in Britain (the poor state of the Royal Society's Repository may have dissuaded him from any such course), though all these options lay open before him. Instead, an original vision took shape in his mind: the foundation of a public museum. After a serious bout of illness in 1739, he focused

CREATING THE PUBLIC'S MUSEUM

his thoughts and began drafting a will to offer his collections to the nation according to a careful set of conditions.[10]

Testimony from James Empson, Sloane's closest curatorial assistant, sheds light on how the project of a public museum coincided with Sloane's personal desire for immortality. Some of the more grandiloquent collectors of the Renaissance had taken to styling themselves in the image of Narcissus, the Greek youth who fell in love with his own reflection. The love of fame was not necessarily the sin Sloane's critics charged; in fact, it was arguably a civic necessity. Eighteenth-century commentators made a nice distinction between *celebrity*, which they defined as fleeting renown achieved during but not outlasting one's lifetime, and imperishable *fame (fama)* as a noble and fitting reward for great works, usually military valour or literary achievement, which would inspire posterity to virtuous emulation. The idea of keeping Sloane's entire collection together held great personal significance too, since collectors were haunted by the possibility that their collections would be dispersed, their labours squandered and their memory lost to posterity. Preserving collections whole was thus essential to preserving the memory of the collectors themselves. Empson championed Sloane's cause after his death. It was the 'duty' of his executors, he stated in 1756 as one of them himself, and 'in justice to his memory', to prevent any part of the collection from being detached 'from the whole' and to ensure that it be 'preserved and continued intire in its utmost perfection and regularity'. 'Having been with the deceased to his last moments,' he recalled, '[I] can positively assert, that one of his greatest inducements for disposing of his so extensive and large collection in the manner he has done, has been that his name, as the collector of it, should be preserved to posterity; far from being ever willing, that it should be eclipsed, or render'd less conspicuous by his collection being mixed with other matters or receiving an addition from other things.' Embedded in Sloane's audacious public gambit of a universal museum that surveyed the creation was the provincial Ulsterman's personal ambition that his name should live for ever.[11]

This dual design of public and personal immortality was no departure for Sloane but the logical extension of a career advanced at almost every step by the intersection of public and private interests and the inextricability of personal and institutional lives. 'I have seen the British Museum,' the fictional Squire Matthew Bramble later declared in

Tobias Smollett's novel *The Expedition of Humphry Clinker* (1771), 'which is a noble collection, and even stupendous, if we consider it was made by a private man, a physician, who was obliged to make his own fortune at the same time.' To call Sloane 'a private man', however, fails to capture either the highly public career he enjoyed as a physician and naturalist or the extent to which he assembled both his own fortune and his collections through a wealth of connections to public persons and institutions in an age of national consolidation and imperial expansion. Sloane had clearly seen himself as playing a leading role in British public life. Writing to the Abbé Bignon in 1737, for example, he praised 'the genius' of French state support for scientific expeditions that had measured the shape of the earth in Peru and at the North Pole, only to lament that in Britain it fell 'among our nobles and persons of consideration and taste' – above all himself – to back voyages such as Mark Catesby's American expeditions by private subscription. When it came to such projects, Sloane and his associates *were* the British state. The contents of Sloane's collections reinforce this view, as his papers often resemble those of a state more than those of a private individual, including descriptions of projects for legal and penal reform, insurance schemes, workhouses and highway and harbour repair. Just as Sloane's banker Gilbert Heathcote had leveraged his private fortune to support both the Glorious Revolution and the creation of the Bank of England, Sloane now aimed to use his massive private collections to force the foundation of a public museum.[12]

Sloane's will was published on his death in 1753. The care with which he had crafted it and its codicils suggests that the lessons of the bitter dispute over the Hamiltons' contested Ulster estates he had witnessed all those years before had stayed with him. Having swallowed so many other collections whole, he understood just how easy it was for a lifetime's work to disappear and so knew what to avoid: there would be no auctions, no sell-offs and no combinations with other collections. After stating his view that his museum was a 'manifestation of the glory of God' that should be used 'for the confutation of atheism and its consequences', the centrepiece of his final draft stipulated that it be accessible in the following terms: 'I do hereby declare, that it is my desire and intention, that my said musaeum or collection be . . . visited and seen by all persons desirous of seeing and viewing the same . . . [and] rendered as useful as possible, as well towards satisfying the desire of

the curious, as for the improvement, knowledge and information of all persons.' To serve the 'public benefit', a museum housing his things should be located 'in and about the city of London, where I have acquired most of my estates, and where they may by the great confluence of people be the most use'. Sloane's use of the phrase 'all persons' suggests literally universal access: that any person who wanted to see the collections should be free to do so. However, he also invoked 'the curious', a rather ambiguous term in the eighteenth century. 'The curious' connoted learned gentlemen (and ladies) possessed of education, wealth and station but by mid-century might also suggest mere curiosity-seekers: those who paid to witness unusual or dubious spectacles in taverns and coffee houses. A related ambiguity lay in the distinction between what Sloane referred to as 'seeing and viewing' the collections and 'rendering them useful'. These activities implied rather different functions for his proposed museum and divergent definitions of the public, leaving open to debate what the correct balance should be between mounting exhibitions for audiences and facilitating research by scholars.[13]

Sloane attached highly specific conditions. First, he did not offer his collections as a gift to the nation, as is often thought, but asked £20,000 for them. This amount was, he claimed, one-quarter of their actual value of £80,000. The proceeds would go to his two daughters. Second, because he could not be sure that the notoriously partisan Parliament would cooperate and embrace his terms, and because he was probably well aware of the neglect of the Cotton collection supposedly in their care, he devised the following contingency plans. If Parliament did not buy his collections within twelve months, they were to be offered, in order, to the scientific academies at St Petersburg, Paris, Berlin and Madrid, each having a year to decide (early versions of Sloane's will had included the Royal Society, the University of Oxford and the Edinburgh College of Physicians, but he later ruled these out). Only in the unlikely event that there proved to be no takers at all were the collections to be auctioned off. This was bold. The threat of sending the collections abroad may have been strategic, but Sloane could not have predicted with certainty that it would succeed in forcing Parliament's hand. Sending the collections overseas might in fact have been genuinely desirable in ways that reflected a significant ambiguity in their status: were they treasures that belonged first and foremost to Britain,

or did they rather belong to the Republic of Letters and international learned society? Was Sloane ultimately more patriot or cosmopolitan? That he was a member of every foreign academy he listed as a possible repository for his museum points to the seriousness with which he contemplated moving his collections out of Britain (he continued to receive foreign honours until 1752, when the Academy of Sciences at Göttingen made him a member at the age of ninety-two). Indeed, he moved St Petersburg up the pecking order after his former curator Johann Amman assured him of the high quality of the Russian facilities. Selling to the Russians was exactly what some did, like the Dutch naturalist Albertus Seba, whose collections Peter the Great acquired in 1716. London was Sloane's first choice, but keeping the collections and his legacy intact was in some ways as important.[14]

Sloane choreographed his own legacy from the moment he died, assembling an impressive group of friends to carry out his plan. He had drawn up a list of attendees for his funeral, each of whom was to be given a commemorative ring worth twenty shillings. He named four chief executors to be led by his grandson Lord Cadogan – the others were James Empson and his nephews William Sloane and Sloane Elsmere – as well as a set of trustees, who met soon after his death at Chelsea Manor. Numbering sixty-three in total, these trustees featured many prominent society figures, family members, friends and Fellows of the Royal Society – a cross-section of the elite public life Sloane had lived. They included John Heathcote, son of Gilbert Heathcote, and an East India Company director, a Bank of England director and the president of the Foundling Society; James Lowther, a South Sea Company director, the storekeeper of ordnance and the Foundling vice-president; General James Oglethorpe, the soldier and founder of Georgia; Joseph Ames, paymaster to the Scottish armed forces; Thomas Burnet, judge of the Common Pleas; Count Nicolaus Zinzendorf, who leased land from Sloane in Chelsea on behalf of the Moravian Church; the Duke of Northumberland, who sat on the Privy Council, and other officers of state such as Edward Southwell, secretary of state for Ireland; Sir Paul Methuen, formerly lord of the Treasury, lord of the Admiralty and secretary of state; the Bishop of Carlisle; and Horace Walpole, the writer and son of the prime minister.[15]

Walpole was among the most interesting because he was in fact highly sceptical regarding Sloane's collections and because that

scepticism embodied an important division in British culture between natural history and art collecting. 'We are a charming, wise set,' he wrote to his friend the diplomat Horace Mann of his fellow trustees in 1753, 'all philosophers, botanists, antiquarians, and mathematicians.' But he had better things to do. 'You will scarce guess how I employ my time,' he continued, 'chiefly at present in the guardianship of embryos and cockleshells . . . [which Sloane valued] at fourscore thousand; and so would any body who loves hippopotamuses, sharks with one ear, and spiders as big as geese! It is a rent-charge, to keep the foetuses in spirits! You may believe that those who think money the most valuable of all curiosities, will not be purchasers.' A few years later in 1757, in an 'advertisement' for a *Catalogue and Description of King Charles the First's Capital Collection of Pictures*, Walpole outlined his personal hope that the new British Museum would inaugurate 'a new aera of virtùe' and inspire collectors to contribute to it for the good of 'their country', rather than see their collections dispersed by 'straggling through auctions into obscurity'. Walpole held conflicting views on auctions: he frequented them avidly but also saw them as a threat to the social order, affording arrivistes quick climbs in status and threatening noble collections with dissolution. These fears were later realized when his father's art collection at Houghton Hall – an expression, ironically, of Sir Robert Walpole's own upward social mobility – was sold to Catherine the Great to pay off debts. Horace thought so little of Sloane because he evidently saw *him* as a parvenu peddling petty curios, bereft of true connoisseurship. Prizing the 'fine arts' rather than the merely 'useful arts' of natural history, his hostility was surely piqued by the vexed status of painting in British culture, due to longstanding associations with Catholic finery and princely corruption. Not until 1768 – after the British Museum had opened – would the Royal Academy be created and establish art galleries as an essential feature of public life. In the meantime, Walpole dreamed of the British Museum, not as the encyclopaedic museum Sloane envisaged, but as an inaugural national art gallery. Shamelessly hijacking Sloane's legacy in his introduction to Charles I's catalogue, Walpole transposed the dead king in Sloane's place as the museum's patron saint, lionizing him as 'the royal virtuoso' who had martyred himself to develop the national taste for art by suffering 'rebellion and rapine' by the 'envious mob' who stole his pictures.[16]

If the other trustees harboured similar reservations, they kept them

to themselves. While parts of the collections sat in the vaults of the Bank of England for safekeeping, Sloane's executors approached Parliament with his terms. The offer, however, did not automatically win assent from MPs: word came back that there was no money in the Treasury for the purchase. Serious advocacy was going to be necessary if Sloane's collections were to be secured. So the trustees petitioned Parliament and succeeded in setting up a debate in the House of Commons on 19 March 1753. Empson, acting as their secretary, was among the leading witnesses called when the day came. The cost of running the museum unsurprisingly emerged as a key issue. Empson did his best to reassure the ministers that the tally would be far from exorbitant by itemizing the estimated salaries, for example, of each proposed member of staff. But scepticism concerning the purpose of the collections persisted, MP William Baker typically dismissing Sloane's museum as 'a collection of butterflies and trifles'.[17]

Fortunately for the trustees, they had allies in the Commons. Arthur Onslow, a Whig member and speaker of the House, took up the case for the creation of the museum. He included the still-pending fate of the Cotton manuscripts in the debate while Henry Pelham, an old friend of Sloane's, took the opportunity to urge that the library of Robert and Edward Harley, the Earls of Oxford, already bequeathed to the nation by the Duchess of Portland, should also form part of any purchase. Given the general scorn for natural history, the addition of these manuscript collections may actually have helped to galvanize MPs' interest. Political manoeuvring for partisan advantage was likely one important subtext of the discussions; collection building was often ideologically motivated. For example, Thomas Hollis was an avowed Whig and an advocate of American rights during the American Revolution who donated many books on political philosophy – specifically concerning republican political thought – to both the British Museum and Harvard College in Massachusetts. Sloane had long enjoyed close ties to prominent Whigs and it was Whig MPs who now championed his cause: Onslow, the member for Bristol, Edward Southwell, Jr (son of Edward and grandson of Robert Southwell, the secretaries of state for Ireland) and Philip Yorke. Sloane had named both Southwell and Yorke as trustees. These men may well have seen the collections as an instrument for promoting Whig politics since they could be taken to embody the traditions of Anglo-Saxon liberty: the Cotton manuscripts contained a copy

of the Magna Carta that might be used as a potent vehicle to ground Whig claims to its legacy. Not that Whigs had a monopoly on such designs. The Tory and Jacobite Thomas Carte had argued for acquiring the Harleian manuscripts in the early 1740s because they were evidence, as he put it, of 'the ancient rights and privileges of Englishmen . . . which our ancestors enjoyed' – and which, by Tory implication, the Whigs had undermined.[18]

Thanks to the efforts of Onslow and his colleagues, Sloane's executors eventually won the debate and the Commons voted to accept the terms of Sloane's will. Parliament would oversee the creation of a public museum. The House of Lords passed the British Museum Act between discussions of a bill for preventing disease in cattle and the setting of a prize for discovering longitude at sea, and on 7 June 1753 George II gave his royal assent. Echoing Sloane, the act stipulated that the collections were 'not only for the inspection and entertainment of the learned and the curious, but for the general use and benefit of the publick'. The precise form the new museum would take and the details of its terms of access, however, remained to be finalized. In return for keeping the collections together and making them available in London, Sloane's executors accepted a series of changes imposed by Parliament, including the installation of officers of state as *ex officio* trustees (rather than exclusively retaining Sloane's personal friends), among them the lord chancellor, the speaker of the House of Commons, the Archbishop of Canterbury and the several secretaries of state. How the new institution came to be baptized the British Museum, and by whom, is not known, but the choice of name was significant. It declared national possession of the collections, making their preservation and display a projection of national honour and power. For the most part these were British things not by origin but by ownership. As the author Edmund Powlett put it in his 1761 guidebook, evidently the first of its kind, the 'Museum of Britain' was 'a lasting monument of glory to the nation'. The Sloane, Cotton and Harley collections would be brought together with the additional library of Major Arthur Edwards (by then joined with the Cottonian Library), the sum of £20,000 paid to Sloane's daughters, and a regular revenue established to support maintenance, financed in part by investment in public stocks.[19]

The purchase of shares wasn't the only form of organized gambling on which the museum was to rely. The bulk of the British Museum Act was in fact taken up by the scheme Parliament hatched for raising the

£20,000 it owed Sloane's daughters by means of a public lottery. It was thus not the allocation of state funds or far-sighted royal patronage that paid for the nation's museum but the money ordinary folk were willing to stake on winning cash prizes by forking out for a ticket or two. The authors of the act were well aware that they were making a public virtue out of private vice, so they ordered a lengthy series of crimes and punishments for cheating, including imprisonment and even the death penalty in the event of tickets being forged. The hoarding of tickets was another major concern. Up to 100,000 were to be issued at £3 each, each drawn up by hand in duplicate, of which there was to be a sliding scale of 4,159 'fortunate tickets', from a grand prize of £10,000 all the way down to 3,000 worth £10 each. The lottery draw eventually began in London's Guildhall on 26 November 1753, and a total of £200,000 was given out in prize money afterwards.[20]

Even by the gamble-happy standards of the eighteenth century, the British Museum lottery was widely seen as scandalous. Parliament ordered an official review the month after it had been completed. One of the appointed lottery managers, Peter Leheup, stood accused of buying tickets in bulk and profiteering on their resale, allegedly making as much as £40,000. He was fined £1,000 and dismissed. A large number of tickets also appear to have been bought by an unidentified individual who adopted a variety of aliases. The gregarious City banker, financier and sometime art collector Samson Gideon reportedly obtained thousands of tickets even though he was allegedly in France at the time (a friend of Sir Robert Walpole's, he was not indicted). Chicanery notwithstanding, £95,194 8s 2d comprised the net proceeds after expenses were deducted, to cover the purchase of the collections and a building to house them, pay Sloane's daughters and make initial investments in shares. This was indeed a British museum. This new temple of the arts and sciences, with its promise of scholarly and practical enlightenment, had been erected on the basis of a private fortune, a vast web of imperial connections, wrangling over money and the national addiction to betting (Plate 42).[21]

Since Chelsea Manor was deemed too far from the centre of London and too small to accommodate large numbers of visitors or indeed the collections themselves (Sloane had taken to using his basement for storage), it was decided that a larger and better-placed site was needed. The then privately owned Buckingham House (now Buckingham Palace)

was one option but was thought too expensive at £30,000, so Montagu House, originally designed by Sloane's Royal Society colleague Robert Hooke and rebuilt after a fire in 1686, was acquired for the bargain price of £10,000 in 1754–5, with a subsequent £8,600 spent on restoration and repair. As chance had it, the building was situated on Great Russell Street, just a few steps from Sloane's original residence off Bloomsbury Square, on the edge of the city and flanked by open fields. In an especially strange coincidence, Montagu House happened to be the former residence of the widowed Duchess of Albemarle – the duke's wife and Sloane's former patron – who had gone on to marry the Duke of Montagu, bizarrely, only after the duke agreed to impersonate the Kangxi emperor to indulge certain exoticist fantasies of hers, or so the story went. The Sloane, Cotton and Harley collections were all carefully checked, as well as Sloane's catalogues, which were found to be 'exactly answerable' to the objects they described. Library books still out on loan at Sloane's death were called back and the trustees began to set up the building and its staff. Early in 1756, the natural philosopher, inventor and wily promoter of magnetic compasses of his own design Gowin Knight secured the key appointment of librarian and headed up his own staff of three, including Empson and the physicians Matthew Maty and Charles Morton. There was much to do: new catalogues to be compiled, wooden cabinets to install, shares to buy and salaries to fix. The physical environment needed work too, since Montagu House turned out to be damp and cold (the source of endless complaints), so the number and cost of candles and coals to light and heat the place needed proper calculation. Many of the decisions were to be overseen by Knight, but the ambitious magnetizer soon overreached, with the museum's standing committee censoring him for choosing his own workmen to effect repairs without consulting them. There was also trouble with some of those who lived on the premises – not the maids or curators but the porters who by all accounts liked their liquor rather too much.[22]

As preparations progressed, the museum staff began to consider what kind of display would be appropriate for presenting the nation's museum to the general public. A number of Sloane's duplicates were disposed of, some claimed by Sloane's daughter Sarah; the plates of the engravings from the *Natural History of Jamaica* also went to the family, as did a few select objects, perhaps for sentimental reasons. Knight,

Empson and their colleague the natural philosopher William Watson decided to rearrange the collections. Keeping them together, they determined, did not mean they could not be reorganized. 'However so much a private person may be at liberty arbitrarily to dispose and place his curiosities,' Empson told the Board of Trustees, 'we are sensible that the British Museum being a public institution subject to the visits of the judicious and intelligent, as well as curious, notice will be taken, whether or no the collection has been arranged in a methodical manner.' Sloane's approach to display was with polite harshness discarded: the change from private to public museum entailed a shift from mere 'curiosity' to 'judiciousness'. Plans drafted by Knight and early descriptions of the museum show that the curators moved towards a more didactic scheme modelled on the Chain of Being, according to which the cosmos was structured by a hierarchy of being passing from God down through the angels to human beings, animals, plants and minerals. Sloane's emphasis on variety within object categories was now dismissed as lacking the coherence and harmony deemed appropriate for a public museum. Knight explained how Sloane's collections could instead 'be properly classed in the three general divisions of fossils, vegetables, and animals' and made to exhibit nature in its 'gradual transitions' as it 'ascended to the next degree of being', so that 'the spectator will be gradually conducted from the simplest to the most compound & most perfect of nature's productions.'[23]

Interestingly, contemporary observers linked museological order with social order. Some feared that free access to the collections might inspire dangerously emboldened passions in the common people. In 1756, after a preview tour of Montagu House, the Berkshire essayist and Bluestocking Catherine Talbot recorded a singular vision that had gripped her. She had been, she wrote, 'delighted' to see 'valuable manuscripts, silent pictures, and ancient mummies' in the museum but 'in another reverie' had imagined 'the books in a different view, and consider'd them (some persons in whose hands I saw them suggested the thought) as a storehouse of arms open to every rebel hand, a shelf of sweetmeats mixed with poison'. It is not clear exactly whom Talbot saw handling the collections, but in her premonition free access raised the spectre of civil unrest. She was not alone in such presentiments. The previous year, the antiquarian and museum trustee John Ward had objected to 'appointing public days for admitting all persons' as giving

free rein to 'the mob'. 'If the common people once taste of this liberty . . . it will be very difficult afterwards to deprive them of it.' The only visitors should be those who 'will conform to the rules & orders', as most 'ordinary people will never be kept in order [and] will make the apartments as dirty as the street', wreck the furniture and gardens '& put the whole oeconomy of the museum into disorder'.[24]

Sloane's provision of free universal access was causing serious consternation. To some the very idea was highly threatening. From early on, the trustees had envisaged different ranks of person enjoying unequal degrees of access to the different parts of the museum. Lord Cadogan urged in 1756 that admission actually be denied to 'very low & improper persons, even menial servants', while early proposals for 'making the collections of proper use to the publick' sought to parse and narrow Sloane's call for universal access 'to prevent as much as possible persons of mean and low degree and rude or ill behaviour from intruding on such who were designed to have free access to the repository for the sake of learning or curiosity'. The curators Charles Morton and Andrew Gifford commented in 1759 that 'from the mechanic up to the first scholar and person of quality in the kingdom, who come all whetted with the edge of curiosity . . . there are hardly any two that apprehend alike, or do not require the same thing to be represented to them in different lights.' Gowin Knight, jealous of his fiefdom, argued for barring persons of 'no distinction' from the library, contending that they posed a threat to the collections and that scholarship was a public mission best served by the learned only. 'The public' may have been a universal category but it was far from a uniform reality.[25]

Turning a private cabinet into a public museum meant bringing people closer to things but also keeping them away from them. New rules recorded by Thomas Birch mandated that all medals, gems and 'other small curiosities of a like nature, in the repository, [should] be locked up in drawers, with glasses or wires over them, thro which they may be seen; but not taken out, and intrusted in the hands of any person, unless in the presence of the keeper or his assistant'. Other objects were also to be put 'in wainscot presses or cases of like dimension and with the like guard of brass wire in the front'. According to Knight, the museum's primary purpose was 'for the use of learned and studious men, as well natives as foreigners', although because it was funded by public money access should be 'as general as possible'. The emphasis

had shifted subtly but surely from Sloane's insistence that 'all persons' be admitted to the museum to the prioritization of good conditions in which scholars might carry out their researches. Where Sloane had given his private guests objects to hold, touch and even taste, the public were to be extended no such trust. 'In viewing the contents of the cabinets no one is to be permitted to lay their hands on any thing,' Knight stated categorically. Further regulations were laid down for the behaviour of visitors, who were to be admitted only in appointed groups. In death as in life, Sloane collected not just a world of things but a world of people: universal access to the museum would swell the numbers of people who saw his collections beyond any historical precedent and make them the most famous the world had ever known. Montagu House's new locked cases and drawers were, however, a sign of the ambivalence with which his successors prepared to greet the public as they passed through the doors of the British Museum for the first time.[26]

## ENTERING THE BRITISH MUSEUM

The British Museum opened on Monday 15 January 1759, six years after Sloane's death, almost to the day. Admission was free but had to be requested in advance in writing, a requirement that kept numbers down. On the appointed day, visitors congregated at the museum gates on Great Russell Street where they were met by one of the porters, who ushered them across the courtyard (opposite). Initially the tours were small – two groups of five were admitted together; a few years later this was expanded to fifteen. Each visit lasted two hours, originally on Mondays and Thursdays only. The museum's managers decided that the majority of visitors would have little interest in the reading room, so most time would be spent in the natural history collections under a watchful curatorial eye (p. 322). By far the best account of the early tours comes from the 1761 guide published by Edmund Powlett, *The General Contents of the British Museum*. Little is known about Powlett. He did, however, explain that his book was a collective effort based on contributions from 'several gentlemen, who gave me notes they had taken on viewing it', as well as 'a lady, who gave me some curious remarks on the recent shells'. Powlett especially thanked one unnamed source – possibly Empson – 'who greatly assisted me, which he was the

more qualified to do, as having been intimately acquainted with Sir Hans Sloane'. His aim was to direct the reader 'to apply his particular attention to that part of the museum that suits his taste', since 'his curiosity will be much more gratified, than if he wanders from object to object'.[27]

Entering Montagu House in all its refurbished glory, visitors were greeted by fine French frescoes above their heads; a stone from the Appian Way in southern Italy and fragments of other Roman landmarks at their feet; the skeleton of a unicorn fish; a buffalo head from Newfoundland; and various stones bearing Latin inscriptions. On the ground before them, they beheld several hexagonal pillars from near Coleraine, County Down, taken from the Giant's Causeway – probably the samples Sloane had acquired back in the 1690s. The tourists then turned left through a stone archway towards the grand staircase and

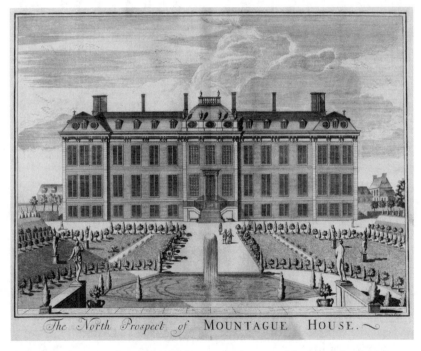

*The North Prospect of* MOUNTAGUE HOUSE.

Montagu House on Great Russell Street: the inaugural home of the British Museum, rebuilt in 1686 and bought by Parliament for £10,000 in 1754–5, it stood on the site of the current museum until the 1840s, when it was demolished.

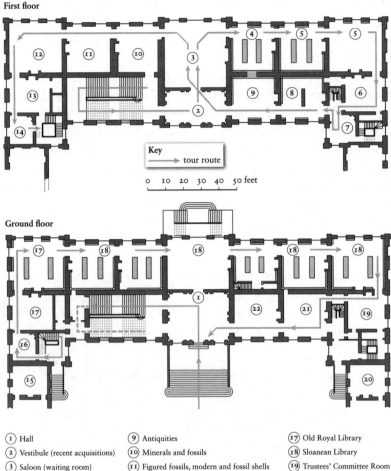

**First floor**

**Key**
→ tour route

0  10  20  30  40  50 feet

**Ground floor**

| | | |
|---|---|---|
| (1) Hall | (9) Antiquities | (17) Old Royal Library |
| (2) Vestibule (recent acquisitions) | (10) Minerals and fossils | (18) Sloanean Library |
| (3) Saloon (waiting room) | (11) Figured fossils, modern and fossil shells | (19) Trustees' Committee Room |
| (4) Cotton and Royal manuscripts | (12) Plants, corals, eggs, insects, crustacea, etc. | (20) Secretary's apartments |
| (5) Harleian manuscripts | (13) Insects, reptiles, birds and mammals | (21) Major Edwards's Library |
| (6) Harleian charters | (14) Modern curiosities | (22) Acquisitions |
| (7) Coins and medals | (15) Principal Librarian's apartments | |
| (8) Sloane manuscripts | (16) Magnet Room | |

Touring the British Museum: early tours moved small groups of ticketed visitors quickly through three departments – manuscripts and coins, artificial and natural productions, and printed books – and a range of subsections in each.

moved past a series of painted mythological scenes, Roman military tableaux, Bacchanalian revels, French landscapes and architectural scenes – holdovers from Montagu House's original classical design. On going upstairs, they filed past 'the busto of Sir Hans Sloane, on a pedestal', but there was little time to dwell. Entering the first chamber on the first floor, they saw an Egyptian mummy, probably the recent gift of the Lethieullier family (London merchants who were among Sloane's trustees), followed by a medley of Sloaneana: corals, wasps' nests, a sample of 'brainstone', a stuffed flamingo and assorted animals coiled into spirit-filled jars. Turning left, they entered the grand saloon and were invited to sit and rest awhile on handsome Virginia walnut chairs. Warmth could be felt from nearby fireplaces. There were more paintings and the wax model of a sculpture depicting the tragic Trojan priest Laocoön. The museum's idyllic gardens were visible through the windows, with the inviting greenery of Hampstead and Highgate off in the distance.[28]

Now the real tour of the museum's three departments began. First, manuscripts and coins. The manuscripts were divided into four parts, each housed separately: Sloane's collection, the library donated by George II just prior to his death in 1760, and the Cotton and Harley collections. The entrance had a portrait gallery including likenesses of kings and queens, Oliver Cromwell, John Locke, William Shakespeare, Francis Bacon, Sloane's portrait of William Dampier, the famed anatomist Andreas Vesalius and the eminent scholar Anna Maria von Schürmann. There were busts too of Homer, Peter the Great, Ulisse Aldrovandi and monarchs from Edward III to Charles II (but no James II). The manuscripts were stored in newly made cabinets and presses wrought of wood and wire, ornamented with still more busts. Learning involved climbing: stepladders and staircases were everywhere. Most of the manuscripts were folded away in drawers, although Cotton's copy of the Magna Carta was prominently displayed in its own glass case – the 'bulwark of our liberties', Powlett called it. Harley's remarkable collection of almost 8,000 manuscripts took up three chambers by themselves, including antique copies of the Bible, the Qur'ān and the Torah. The next room contained the Sloane manuscripts: not the most ancient but of great value for natural history and medicine. Cabinets holding Sloane's thousands of coins and medals filled the next chamber as well.[29]

The museum's second department housed 'artificial and natural productions' in a series of chambers, drawn mostly from Sloane's collections of antiquities and miscellanies. There were artefacts from Mexico and Peru and the model of a Japanese temple; baskets made out of bark; 'hubble-bubbles' (similar to hookah pipes) and tobacco pipes from America; drums from China; amulets and charms in Arabic and from ancient Rome; musical instruments, scientific instruments, instruments of punishment and instruments of sacrifice; classical sculptures; and 'American idols'. These were followed by natural specimens: fossils, vegetables and animals arranged in a sequence to show off the 'chain of gradation', as Gowin Knight had envisioned, all arrayed in yet more exquisite furniture: glass wall cabinets made from deal and mahogany, with table cases and portable show-tables of mahogany and glass. Sloane's minerals and fossils were laid out in a chamber of their own, their cases labelled in Latin. In the next room were shells, more minerals, bezoars and a curiously encrusted skull fished out of the River Tiber in Rome. These were followed by plants and insects, woods, fruits and barks packed into drawers by the thousands – Sloane's vegetable substances. There was silk grass, Indian cotton and Sloane's Jamaican lagetto; virtual reefs of coral; wasps' nests; and countless animals in jars. Rings, intaglios and seals were spread out in glinting variety on large tables, just as they had been for the Prince and Princess of Wales at Chelsea.[30]

The final chamber contained 'modern curiosities'. These included items ranging from glass cups fashioned in imitation of china to 'articles in great esteem among many Roman Catholics, as relics [and] beads', as Powlett diplomatically put it, 'and some models of sacred buildings', as well as crucifixes placed by miners at the entrance to mines in those parts of Germany 'where the Roman Catholic religion prevails'. There were Native American feather crowns and Wampum beads; scalps and specimens of cassava poison; European bronzes and ivories; Engelbert Kaempfer's portable Buddhist shrines; samples of money from the East Indies; Chinese deities done in bronze and congee; forks and counting beads; japanned boxes and vessels; Chinese porcelain and tea leaves; a 'cyclops pig, having only one eye, and that in the middle of the forehead'; and the horn of the horned lady, with her picture, which had made it from Pall Mall to Sloane's and now the British Museum. Finally, visitors made their way back downstairs, past a series

of paintings and canoes. Gowin Knight showed off some of his compasses and magnets before admitting guests to the library, although only for a brief peep at the third and final department: that of printed books (Sloane's included) laid out in a sequence of six rooms, together with Sloane's herbarium and a series of maps spread out on tables. Without actually entering the reading room, most visitors were informed that their two hours were up, escorted to the museum gates and bid good day.[31]

In some respects, little had changed since the private tours Sloane had conducted in his Bloomsbury townhouse. Curiosities still abounded in riotous variety from Roman skulls to cyclops pigs, with surprising juxtapositions of horned ladies and fine Chinese porcelain. Sloane's hybrids of art and nature were still on show like his coral-encrusted bottles and timbers from the 1680s. Mysteries of nature remained too. The *Museum Britannicum*, a guide published by the Dutch artists Jan and Andreas van Rymsdyk in 1778, featured an alluring painting of Sloane's coral hand, which the authors thought 'very curious', noting that the manner of coral's generation was not yet determined by the naturalists (p. xxiv). Nor was the art of recounting curious tales entirely neglected. Powlett told the story of a 'model of a fine rose diamond' of nearly 140 carats that had originally been owned by Charles the Bold until his defeat at Nancy in 1477, when it had fallen 'into the hands of a common soldier' who picked it up on the battlefield but who, in his ignorance, sold it off for a pittance. The diamond then found its way to one of the grand dukes of Tuscany, the Medici family and the Emperor of Germany before somehow winding up in the British Museum. The Rymsdyks also repeated exotic object tales, describing for example how 'black women' used the hairballs Sloane liked to collect for medical purposes (and which they illustrated for their beauty) as deadly poisons.[32]

Powlett also encouraged his readers to keep up the tradition of visitors contributing to the collections. 'I am not without hopes that the time may soon come, when every public-spirited collector', he wrote, 'will deposit the produce of his labour in this most valuable cabinet.' Numerous gifts are recorded in the early years of the museum archives, including letters to James I, a fourteenth-century herbal, exotic plants for the garden, a hornet's nest from Yorkshire, an electrostatic machine, books from China and a human heart preserved in wood found in the

hollow pillar of a Cambridgeshire church. As a result, there was more than ever to see. Given the 'almost infinite number of curiosities', Powlett lamented, it was 'impossible for [tour guides] to gratify every particular person's curiosity'. 'I am sorry to say, it was the rooms, the glass cases, the shelves, or the repository for the books in the British Museum which I saw,' the German author Karl Philipp Moritz complained about the visit he made some years later in 1782, 'and not the museum itself, we were hurried on so rapidly through the apartments.' He spoke of 'rapidly passing through all this vast suite of rooms, in a space of time, little, if at all, exceeding an hour . . . just to cast one poor longing look of astonishment on all these stupendous treasures . . . in the contemplation of which you could with pleasure spend years'. That 'a whole life might be employed in the study of them – quite confuses, stuns, and overpowers one'.[33]

Powlett's description also suggests substantial continuity with Sloane's emphasis on the collections as a survey of the world's resources and commodities. American pipes served to 'discover the industry, genius, and manners of the inhabitants' of the New World, he advised. 'Marble is a hard opake precious stone,' he explained, 'does not strike fire with steel, yields easily to calcination, and ferments with, and is soluble in acid menstrua.' 'Alabaster', he clarified, 'is of the same nature as marble, but of one simple colour, more brittle, softer, and, when cut into thin plates, semi-transparent.' He pointed out how different cultures valued different commodities – hence the high price of ginseng in the Indies but not in Europe, and the great sums Wampum beads fetched in America, while the Chinese valued only their own handicrafts and shunned foreign goods. Imagining their readers as would-be connoisseurs, the early guides warned them about avoiding fraud and even taught them how to do so. The Rymsdyks went so far as to describe practical techniques on 'how to know good pearls' from bad by the use of microscopes. While curiosities offered lessons about commodities, visitors to London saw the city itself as a giant commercial *Wunderkammer*. On the same trip during which he toured the British Museum, Moritz promenaded on the Strand and admired the way that 'paintings, mechanisms, curiosities of all kinds, are here exhibited in the large and light shop windows, in the most advantageous manner', resembling 'a well regulated cabinet of curiosities'.[34]

Powlett's guide kept Sloane's hostility to magic in full view as well,

once again singling out amulets and talismans as examples of the superstitions of backward ancient and foreign peoples. He spoke, vaguely yet pointedly, of 'several small amulets . . . which in Egypt the blind superstition of the inhabitants prompted them to wear about their persons, as charms, or preservatives against bad fortune'. He described Sloane's Sámi drum as being 'of the same sort as those used by their enchanters, by the help of which . . . they were enabled to raise mighty tempests'. There was an ancient Roman charm with the head of the god Mercury and 'Turkish talismans, or charms, with Arabic inscriptions, being generally a sentence of the Alcoran', not unlike the ones Ayuba Suleiman Diallo had translated for Sloane. 'In these the superstitious among the Mahometans have great faith, and rely much on their power' against spirits that 'they believe are continually hovering about the world'. There were bezoars used for protection by 'credulous people' and Sloane's 'Scythian Lamb', in reality 'the root of a plant much like [a] fern'. 'A very little help of the imagination makes it altogether a tolerable lamb,' Powlett sarcastically allowed.[35]

Flush with such contrasts between superstition and enlightenment, Powlett did not stop there. He insisted that the museum's collections had a special power – the power to civilize those who saw them. 'Learning was for many ages in a manner buried in oblivion,' he stressed, intimating a grand if rather hazy narrative of progress, and 'a dark ignorance spread itself over the face of the whole earth', a period during which real innovations in science, medicine and technology had been foolishly derided as 'magic'. In contrast to this epoch of 'blind infatuation' and 'obstinate prejudice', the British Museum displayed 'the progress of art [technology] in the different ages of the world' for all to see, 'exemplified in a variety of utensils each nation in each century has produced'. The contemplation of such tools, Powlett urged, would 'prevent our falling back again into a state of ignorance and barbarism'. 'Many things deemed of small value by a vulgar observer, when viewed by the learned, are found to be of abundant use to science,' he confidently observed. By inculcating lessons that enabled visitors to distinguish treasures from baubles, the museum would prove a mighty bulwark against the 'iron hand of ignorance and superstition'.[36]

Who the 'ignorant' and 'barbarous' were exactly, Powlett did not say. For decades, however, Europeans had used such language to pour scorn on the cultures and belief systems of foreign peoples they

encountered as they built up their empires. Powlett, moreover, was writing during a period of dramatic British gains when the resonance of these terms intensified significantly. Although the Seven Years' War began with a number of setbacks and was not formally concluded until the Peace of Paris in 1763, the British scored decisive victories against the French in the so-called *annus mirabilis* of 1759 – the same year the British Museum opened. By the time the war ended, a largely maritime power that had struggled to emulate its Portuguese, Spanish, Dutch and French rivals in both the Atlantic and Indian Oceans had been transformed into the greatest territorial empire enjoyed by any European nation. After defeating France, Britain set about governing India and Québec using this same language of 'ignorance and barbarism' to justify its subjection of local populations and the agricultural exploitation of their land, insisting that colonial rule would 'improve' backward peoples and savage landscapes alike.[37]

How awareness of Britain's dawning ascendancy shaped early visitors' perceptions of the museum as a set of collections gathered from around the empire – and conversely how the museum shaped perceptions of the empire – is hard to say for sure. When it came to Ireland, for example, Powlett's guide was suggestive rather than declaratory. He stated that the presence in the museum of stones taken from the Giant's Causeway in Sloane's native Ulster redounded 'in honour of our own islands' – an ambiguous phrase that appeared to submerge Ireland (or at least Ulster) in the larger idea of Britain. Unsurprisingly, the moral Powlett drew was one of Irish ignorance. He explained that 'the common people of the country call them the Giants Causeway, from an old tradition that they were placed in that order by the ancient inhabitants of the island, who were of a gigantic stature,' whereas in reality they were 'entirely the work of nature'. More generally, Powlett used the museum's collections to encourage nationalistic pride. The museum was, he said, 'the largest and most curious ... the world has to boast of'. 'There is scarcely a country, though ever so distant,' he pointed out, 'that has not greatly contributed' to its 'almost infinite number of curiosities'. Its fish specimens had been 'brought from various parts of the world'; its flintstones from 'almost all parts of the world'; its ores 'from almost all the known mines in the world'; and its drawings were 'perhaps the finest that are to be seen in the world'. From its beginnings, the

British Museum was framed as a showroom for celebrating the global reach of British power.[38]

The new museum also instituted several important changes in how the collections were handled and experienced. Sloane's stipulation that his collections should not be mixed with others was observed: according to the British Museum Act, these were to be kept 'whole and intire, and with proper marks of distinction'. But they now existed under the same roof with several other impressive libraries donated by aristocrats and even the king himself. Rehoused in a national institution and lacking Sloane's animating presence, the collections inevitably came to lose something of their personal flavour, as did museum tours. Admission was no longer the expression of private favour but a matter of public application. Powlett still mentioned a certain delectable East Asian 'soup nest' but did not invite guests to lick it; such objects were not, after all, his personal property. There were fewer stories about individual curiosities and their pedigrees since these now lay buried in Sloane's correspondence and catalogues, if not with Sloane himself in the family vault at Chelsea. All that remained of his interactions with Ayuba Suleiman Diallo and his dramatic odyssey in and out of slavery, for example, were a few short passages in his letters and the phrase 'Interpr. Job' in his Amulets Catalogue, all quite invisible to most museum goers. Powlett did describe a wasps' nest from Pennsylvania but did not mention that it came from John Bartram, nor did he refer to Pennsylvania's volatile milieu of colonization and war. Institutionalization separated objects from their contexts and depersonalized the collections. As Sloane's curiosities became the nation's, whom they came from became less important than what they were and where they fell in the order of things.[39]

Such order was in the eye of the beholder and subject to change. As Knight and Empson emphasized the Chain of Being to impress visitors with the hierarchies of the creation, Powlett alerted his readers to the Latin terms for many of the species he described. Yet to some, sorting the collections into discrete departments undermined the true purpose of a universal museum: to present a unified picture of the world. 'Great as the collection is,' Smollett had his fictional Squire Bramble grumble, 'it would appear more striking if it was arranged in one spacious saloon, instead of being divided into different apartments, which it does not

entirely fill.' Sloane's triumphant institutional legacy led to the new museum carving the collections into sections that could fit into the various apartments of Montagu House. The dream of total knowledge thus came into view and receded almost in the same instant, summoning a prospect of completeness it could not satisfy due to the exigencies of the physical space available and, Smollett implied, a limited public purse. 'I could wish the series of medals was connected,' Bramble went on regretfully, 'and the whole of the animal, vegetable, and mineral kingdoms completed . . . at the public expence.'[40]

Admitting visitors free of charge who enjoyed no personal relationship to the collections was a highly significant innovation, although since tickets could be slow to materialize (they were required until 1805), knowing someone on the inside still helped. In 1782, Moritz managed to jump the two-week waiting list for tickets thanks to his connection to Karl Woide, a scholar who worked in the library. The logical corollary of admitting the public, who were presumed to lack knowledge of the collections, was the textualization of the museum experience. Written labels now appeared next to the objects on display and 'concise and cheap' guides like Powlett's primed guests for tours. Powlett encouraged readers to study his guide prior to visiting and to keep it as a souvenir; and he recommended it to those who would never visit the museum at all: 'it will likewise serve to give a tolerable idea of the contents to those who have no opportunity of seeing it.' For the first time, general readers would be able to 'see' the collections through the medium of print. By 1778, readers might also view pictorial highlights without visiting thanks to the Rymsdyks' *Museum Britannicum*. Sharing Horace Walpole's vision of the artistic potential of the museum, the Rymsdyks encouraged artists to make their own sketches of items on show, proposing specific distances from which to do so and explaining that there were several 'different ways of imitating an object'. Foreign guides were also published. Moritz brandished one in German by the London-based pastor Frederick Wendeborn, which 'at least, enabled me to take a somewhat more particular notice of some of the principal things; such as the Egyptian mummy, an head of Homer, &c.'. Visiting the museum took its place in the polite culture of the middling as well as upper ranks of society.[41]

In some respects, Sloane's published will and the British Museum Act constitute British equivalents of the American Declaration of

Independence and Federal Constitution of 1787. They are written Enlightenment enunciations of universal egalitarian principles, albeit in the realm of culture and intellectual life rather than politics and government. In reality, what universal access meant in practice continued to evolve. Sloane's 1753 will had stipulated that his collections be 'visited and seen by all persons desirous of seeing and viewing the same . . . [and] rendered as useful as possible, as well towards satisfying the desire of the curious, as for the improvement, knowledge and information of all persons'. But the British Museum Act, published the following year, stated that the collections should 'be kept for the use and benefit of the publick, with free access to view and peruse the same . . . under such restrictions as the Parliament shall think fit'; and that 'a free access to the said general repository, and to the collections therein contained, shall be given to all studious and curious persons, at such times and in such manner, and under such regulations for inspecting and consulting the said collections, as [determined] by the said trustees'. The language of these two documents thus shows how the legal abstraction of creating a public museum with universal access, and the question of how to balance exhibition and display with scholarly research, became subject to oversight by those who hoped to 'restrict' and 'regulate' accessibility.[42]

In a notoriously partisan era, contemporaries nevertheless marvelled at the museum's public status. 'Considering the temper of the times, it is a wonder to see any institution whatsoever established for the benefit of the public,' Smollett's Bramble sighed. Remarkably, universal admission to view the collections was becoming a reality. 'The company . . . was various, and some of all sorts . . . [including] the very lowest classes of the people,' Moritz noted of the museum in 1782, 'for, as it is the property of the nation, every one has the same right (I use the term of the country) to see it.' This was a significant choice of words. Strictly speaking, neither Sloane's will nor the British Museum Act spoke of the collections as national 'property' or of 'rights' of entry – but Moritz now used just these terms. Rights talk had erupted in Britain in the 1760s and 1770s during the explosive debates over the constitutional status of the American colonies, as they came to defend what they saw as their natural rights of life, liberty and property against arbitrary taxation. Radicals like John Wilkes, who advocated making Parliament more representative (and, tellingly, favoured enhanced funding for the British

Museum), and the revolutionary Tom Paine, espoused full-fledged democracy, leading to the formation by 1780 of reformist organizations like the Society for Constitutional Information. Yet before the age of revolution, it was the creation of the British Museum back in the 1750s that first intensified political debate about who the public were and what their status was. Moritz's invocation of 'rights' of entry demonstrates how revolutionary discourse then filtered back into the museum, reframing the question of access in explicitly political terms.[43]

'The public spirit of the English is worthy of remark,' observed François de la Rochefoucauld, the aristocrat and agricultural reformer who visited England to observe its industrialization in 1784. But access remained uneven. The status of women in the museum was markedly subordinate. Maids worked on the most menial rung of the staff, there were no female trustees and women were rarely admitted to the reading room for research. 'I . . . flatter myself', Powlett nonetheless gallantly offered, 'that my readers among the ladies will be very numerous.' Many ladies did indeed visit, though public excursions were fraught with issues of propriety. Caroline Powys visited in 1760 and returned in 1786 with her eleven-year-old daughter, recording her impressions in her diary. She noted collection highlights including several manuscript Bibles and the art of Maria Sibylla Merian, as well as 'one room of curious things in spirits . . . but disagreeable' (Gowin Knight had advised that pregnant women be sheltered from just such sights to prevent the alleged power of imagination from deforming their unborn children). 'Sr Hans seems justly to have gain'd the title of a real virtuoso,' Powys concluded. In partaking of the 'spring diversions of London' as an older woman in 1786, she took care to keep her daughter away from the fashionable pleasures of Ranelagh Gardens, guiding her instead back to the museum. Access to the museum's own gardens, however, was restricted by trustee permission and roiled by class tensions. In 1769, one of the maids had endeavoured to stop a Mrs Ambrose Hankin from walking on the garden's borders and picking a pear from a pear tree. 'You are an impertinent slut to talk to me,' Hankin fulminated, 'for if you knew who you was talking to, you woud not talk in that manner . . . how dare you pretend to dictate to me.'[44]

Scholars battled the tourists, or so they felt. Empson griped in 1762 that his 'constant & necessary attendance on the company that come to see the museum' had 'prevented him from making that progress he

could wish' in his work as a curator. As he reclassified Sloane's plants according to Linnaean nomenclature in the 1760s, the naturalist Daniel Solander also protested at the disruptions caused by 'companies'. Discussions about using the collections for scholarly purposes were in effect discussions about restricting access by class and gender, since 'scholar' was usually a synonym for gentleman. In 1759, Knight had stated that the overarching purpose of the museum was 'to incourage & facilitate the studies & reserches of learned men'. In 1774, during a series of parliamentary hearings on the state of the museum, assistant librarian Matthew Maty offered his opinion that 'the joining of companies is often disagreeable, from persons of different ranks and inclinations being admitted at the same time.' That same year, an official blasted 'persons of low education' who 'mixd' themselves in with the educated merely to gratify their 'idle curiosity' and disrupt tours with 'sense-less questions'. When the anti-Catholic Gordon Riots shook London in 1780, the spectre of mobocracy returned to menace the collections, at least in the minds of their managers. After damage had been done to the Bank of England and the Customs House, Parliament stationed 600 troops around the museum. The nation's collections were now to be protected in the name of the public against the mob. When the French Revolution gave rise to the looting of aristocratic and church property, and prompted the transformation of the Louvre from a royal preserve into a republican institution in 1793, the British Museum decided to station guards on a permanent basis.[45]

The military conflict with France during the Revolutionary and Napoleonic Wars created an atmosphere of deep hostility to republicanism and democracy in much of British society. Yet even before this point, the desire to restrict admission to the British Museum had prompted initiatives to introduce an entry fee, as early as 1774. But the logistics of admission had, in effect, narrowed access from the start. By the 1770s, entrance was allowed between nine in the morning and three in the afternoon, which excluded working people (admission did not include the summer months at this time). Where some recoiled at the idea of different classes mixing in the museum, the experience of access reinforced some visitors' awareness of their low station rather than emboldening egalitarian feeling. Moving through the museum with his own German guidebook, Moritz attracted a crowd of fellow tourists, eager for information, only for one of the curators to express

his 'contempt' at this challenge to his authority. William Hutton, founder of the first circulating library in the city of Birmingham, felt particularly uncomfortable on his visit in 1784. The process of writing to request tickets from the porter required that applicants mention their 'condition' for the approval of the librarian. This was a 'mode [that] seemed totally to exclude me', Hutton commented in his diary, and he ended up *buying* a ticket for nearly two shillings. Once inside, his group 'began to move pretty fast' so he asked a guide for clarification about what they were seeing, whereupon 'a tall genteel young man in person . . . replied with some warmth, "What? would you have me tell you every thing in the museum?" ' The docent brusquely referred him to the captions. 'I was too much humbled by this reply to utter another word,' Hutton confessed, and 'no voice was heard but in whispers.' In the public museum, all members of society were welcome but some were made to feel more welcome than others. Hutton took his leave, 'disgusted' at his treatment.[46]

Admission charges ultimately proved undesirable and unworkable. It was thought that they would lower the museum to the same moral status as commercial pleasure gardens like Ranelagh and Vauxhall while contradicting Sloane's will and the British Museum Act. The drive to introduce them, however, does reveal a persistent pattern of hostility to the idea of equal access as a public 'right' on the part of a number of museum officials. One unnamed officer stated his view in an undated report around this time that the problem was that 'persons of low education' claimed 'a right, which [the librarian] cannot controvert, to an equal participation of his attentions with those of the highest rank or the deepest erudition'. This 'perfect equality in the rights of those who chuse to visit the museum' had originated in 'an opinion' that because the museum had been 'purchased with the money of the people' they were 'intitled to the free use of it'. Such an opinion, however, was 'quite unfounded'. The use of the collections should instead be 'placd in the custody of men of liberal education' who would 'diffuse' knowledge in an appropriate manner.[47]

The museum's public nevertheless expanded dramatically as the nineteenth century dawned, as did its collections. While Britain fought Napoleon on the battlefield and at sea, British collectors battled French rivals for the stunning treasures of antiquity then in the process of being uncovered. The early decades of the century witnessed the installation

of truly spectacular new collections in Bloomsbury. These included the Rosetta Stone, which finally allowed for accurate translations of Egyptian hieroglyphics, and which the British Army took from the French in Ottoman Egypt in 1802; the many Greek and Roman sculptures given by the antiquarian and Grand Tourist Charles Townley in 1805; the Parthenon Marbles Lord Elgin cunningly removed from Athens between 1801 and 1812, before selling them on to the British government; the head of the Younger Memnon (Ramses II) brought from Luxor in 1818 by the erstwhile Italian circus man Giovanni Belzoni; and, a generation later, the Assyrian sculptures excavated and taken from Nimrud and Nineveh (ancient Mesopotamia, now Iraq) by Austen Henry Layard in the 1840s and 1850s. The number of people who saw the collections soared from 12,000 in 1805 to over 200,000 by the 1830s.[48]

As a result, the British Museum which visitors experienced in the nineteenth century – and which we inherit today – was in two crucial respects *not* the one Sloane created. First, the physical site of the museum was completely overhauled to accommodate the collections' expansion. Montagu House was torn down and replaced by a palatial complex constructed in the 1840s in the guise of a Greek temple resembling the Parthenon, designed by Robert Smirke and crowned by Richard Westmacott's neo-classical frieze representing 'the progress of civilization'. This is the building visitors know today. Second, and more importantly, the orientation of the museum was transformed as it took on new collections. Sloane had created a grand natural history cabinet oriented to both his empiricism and his Protestantism: it surveyed the creation as a vast unchanging repository of natural resources for human exploitation, while also exhibiting the follies of magic, superstition and non-Protestant religions. Despite Knight and Empson's reorganization of Sloane's specimens, Powlett's guide shows that the early British Museum remained a curiosity cabinet with scientific lessons about nature and moral warnings about superstition. But it also introduced a language of progress that began to recast the museum more explicitly as a place for judging other cultures in a grand historical narrative of 'the progress of civilization' with Britain, thanks to its increasing ownership of the world's treasures, positioned at its apex as the most civilized nation of all. This reorientation did not happen overnight. In an era of intensifying imperial competition and pseudo-scientific racism, nineteenth-century curators remained dedicated to the idea

that Greece and Rome embodied the zenith of cultural and aesthetic achievement in the civilized world – modern Europeans' identification with the ancient Greeks ultimately became a taproot of white racial identity through philosophies of 'Aryanism' – and struggled to embrace the notion that 'Oriental' antiquities might possess comparable value. Gradually, however, the British Museum did become the encyclopaedic repository for the archaeological history of civilization we know today. Sloane had pointed to the idolatrous errors of other peoples as well as to racial physical difference in his curiosity cabinet. But encyclopaedic museums and the charged polemics that surround them today, which involve bitterly conflicting claims to the rightful possession of the world's antiquities, are the legacy of Victorian imperialism rather more than of his brand of Enlightenment universalism.[49]

One of the crowning ironies of the museum's new form of encyclopaedism was the disappearance of its own founder within the walls of the institution he had created. Expansion entailed reorganization. The museum's departments were rearranged to support the specialization of scholarship and the new professionalized disciplines emerging in the nineteenth century. These many innovations included establishing the Department of Prints and Drawings (1808); separating the original Department of Natural History into autonomous Departments of Botany, Mineralogy, Geology and Zoology (1856–7); setting up the Department of Coins and Medals (1860); dividing Antiquities (1807) into separate departments for Oriental (1860), Greco-Roman (1860) and British and Medieval Antiquities (1866); and creating Oriental Manuscripts (1867). Sloane's collections were divided up in the process. Some of his things were cremated (his rotting animal specimens), while others were put into storage or rehoused in different departments and joined with other collections of like objects. Sloane's curiosities thus became the museum's own antiquities and paled in comparison to the latest acquisitions from abroad. As W. Blanchard Jerrold put it in his 1852 guidebook, Sloane's collections then formed only a 'very insignificant part' of the institution. In the end, founding the British Museum had not kept Sloane's universal cabinet together. This, combined with the fact that his museum did not bear his name, meant that his bid for immortality faded over time, buried alive in the institution his successors remade.[50]

All the while, Sloane's legacy of universal public access continued to

be fought over. When Parliament debated reforming the electoral franchise in the 1830s, it convened hearings about the British Museum. Wasn't one of the museum's tasks 'to improve the vulgar class?' asked one parliamentarian during these sessions. 'The mere gazing at our curiosities is not one of the greatest objects of the museum,' came back the reply, though in truth many of Sloane's guests had done just that. In 1832, Parliament began the gradual process of extending voting rights to men without property by passing the Reform Act. That same year a revealing article about the British Museum was published in the *Penny Magazine*, the organ of the Society for the Diffusion of Useful Knowledge, which advocated the expansion of working-class access to the resources offered by the museum's reading room in particular. 'Will they let me in?' a fictional worker asked of the guards at the museum gate. The anonymous author of the article preached observance of house style on entering: 'touch nothing', 'do not talk loud' and 'be not obtrusive'. The article continued, however, by encouraging readers to claim the museum as public property to which they had an incontrovertible right. In so doing, it sought to communicate a vital lesson about the value of public institutions in general. 'Knock boldly at the gate,' it commanded,

> the porter will open it . . . Do not fear any surly looks or impertinent glances . . . You are come to see your own property. You have as much right to see it, and you are as welcome therefore to see it, as the highest in the land . . . You assist in paying for the purchase, and the maintenance of it; and one of the very best effects that could result from that expense would be to teach every Englishman to set a proper value upon the enjoyments which such public property is capable of affording. Go boldly forward, then.[51]

## CONCLUSION: THE MAN WHO COLLECTED THE WORLD

In 1784, the geologist Barthélemy Faujas de Saint-Fond crossed the Channel to visit the British Isles. Faujas was a commissioner of mines who later became professor at the Jardin des Plantes in Paris during the French Revolution. One of his prime interests in visiting Britain was to

examine the basalt formations of Fingal's Cave on the island of Staffa in the Hebrides, which resembled the stones of the Giant's Causeway. The sociable Faujas met with the new president of the Royal Society Sir Joseph Banks, who had written about Staffa. Like others of his countrymen, he took advantage of his time in London to pay a visit to the British Museum, too, and set out his opinions in a travel journal he published in 1797.[52]

The collections, Faujas acknowledged, constituted an 'immense assemblage of objects', although he reckoned it something of a shame that the founder's possessions had not been preserved under the more 'modest title of Sloane's Museum'. Then, he reasoned, many could have 'viewed with as much astonishment as satisfaction, what the love of science, aided by an affluent fortune and liberal disposition, had been able to perform'. Faujas combined praise of Sloane with praise of Britain and its empire, and yet he criticized the museum. He was 'not pleased that the collection of a private individual' to which had been added 'a crowd of heterogeneous objects . . . should possess the title of The British Museum'. 'A nation, respectable from the highly perfect state of her commerce and manufactures, and the importance of her navy,' he went on, 'ought to have monuments worthy of herself, and more analogous to the grandeur and stateliness of her character.' Such was not the case with the British Museum, where, he judged, 'nothing is in order' and 'every thing is out of its place' and in 'disgusting confusion'. That 'the English have been reproached with not giving sufficient encouragement to the sciences' was ironic if not tragic given the 'glory and distinction' they had reaped from 'uncommon geniuses' like Newton, 'the glory of the English nation'. The museum was little more than 'an immense magazine, in which things have been thrown at random, [rather] than a scientific collection, destined to instruct and honour a great nation'. Despite the efforts of its curators, neither the philosopher 'who loves to behold nature on a great scale' nor 'he who delights in studying the details of that immense chain which seems to connect every species of being . . . [will] find any thing to interest them'. Faujas wrote these words in a period of scientific ferment in France: his rival Georges Cuvier would soon employ new methods of comparative anatomy and fully embrace the reality of species extinction to redefine zoological taxonomy, going well beyond the suggestions advanced by earlier naturalists including Sloane. But British imperial power meant that all hope was not lost. Surely, Faujas concluded, it was

not beyond a nation 'whose ships traverse so many seas' to remedy this state of affairs and in a spirit of 'national rivalship . . . contribute to the enlargement of human knowledge' by emulating the recently founded Muséum d'Histoire Naturelle in Paris, 'which is so justly esteemed superior to every collection of the kind'.[53]

Faujas' reflections provide a fitting conclusion to the story of Sloane's collections because they turn on the crucial question of how private interests, state and empire came together in the making of the British Museum – even though Faujas arguably arrived at the wrong answer. Champions of the British Museum liked to celebrate Sloane's achievement as the legacy of both individual fortune and personal virtue rather than aristocratic, royal or state largesse. There 'never was a museum of such consequence formed by any person under the degree of a sovereign prince before', Powlett declared; it was 'stupendous', said Smollett, that the museum owed its existence to 'a private man'. Such praise implied a paean to British commercial power in gathering such a collection, in contrast to the absolutist monarchs and princely potentates on the continent who assembled wonder-cabinets to embellish their own political authority. (Although, as we have also seen, critics seized on the commercial pedigree and prodigious scale of Sloane's collections as evidence that he was an over-ambitious and shallow arriviste.) Faujas was quite correct that the collections of the British Museum were in many ways the result of contingency more than rational design, because of the opportunistic manner in which Sloane had collected and the way his things were combined with the collections of others. But Faujas was also judging the museum by French standards in charging its accumulations with intellectual and political incoherence. Great scientific works were, he insisted, necessarily state works, not private ones. Across the Channel, the French Revolution had reinforced state control of scientific institutions like the Muséum d'Histoire Naturelle, and military campaigns like Napoleon's expedition to Egypt and Syria in 1798 would yield major contributions to archaeology and antiquarianism. By the time Faujas published his journal, the British were in fact seeking to emulate this French model under the leadership of Banks – in many ways Sloane's successor – and to use the state to play a greater role in organizing science as an instrument of imperial governance, from Captain Cook's Pacific expeditions to the implementation of economic botany as coordinated imperial policy. In Faujas' view, however, the British Museum lacked both proper state

organization and sufficient scientific specialization, amounting to little more than a jumble of curiosities unbecoming of British imperial might.[54]

The truth was that the British Museum was typical of the great early phase of eighteenth-century British institution building, state formation and imperial expansion, in which private interests played a decisive role. Bankers like Gilbert Heathcote organized the Bank of England, independent merchants provisioned the nation's armed forces and naturalists like Sloane sponsored scientific expeditions. The British Museum came about through Sloane's shrewd fusion of his personal ambitions and energetic sociability with the resources of state and empire. His invention of the public museum is an artefact of imperial enlightenment: only a collector at the centre of an empire could draw so many things together in order to tell them apart, in an astonishing attempt to catalogue the entire world. Sloane's ultimate legacy, however, lies less in the specific objects on which he lavished so much time and expense than in their conversion into an immortal public institution. There was perhaps little that was unique about the *kinds* of things he collected in comparison with other collectors of his era. But the scale on which he collected and the stature he enjoyed as one of the nation's most trusted public figures were remarkable. This scale, trust and celebrity mattered: they enabled Sloane to make his personal collections the nation's and, in the process, establish the ideal of free public access to institutions of learning and culture. Sloane, in other words, was a master interloper in an interloper's world, in the broadest sense of the phrase. His genius for intellectual opportunism allowed him to use his links to state offices and public companies to gather private collections from around the world – which he then turned into a public institution. The variety of his curiosities mirrored his prodigious reach; the foundation of the museum reflected his ambition and his vision.

Sloane's hostility to magic, based on an essentially mechanical vision of the natural world, and his ceaseless accumulation of specimens fits well with classic narratives of Baconianism, the Scientific Revolution and the march towards modernity. The same can hardly be said, however, of his penchant for the strange or his adherence to humoralism and Galenical medicine. The man who invented the public museum recommended leeches to his patients to bleed them back to health. More importantly, heroic narratives of scientific progress over *time* tend to ignore the vast amount of labour required to bridge *space* that is fundamental to

scientific work. This spatial element is precisely what counts about the story of Sloane's British Museum. This was an institution built on coordinating the labour of hundreds if not thousands of people around the globe, and which allowed visitors admitted to a building on Great Russell Street to believe that the collections they saw there constituted not merely a great show but a scientific window on the world as it truly was – that they could actually see that world without ever leaving London. This is the work to which all sciences in fact aspire: allowing human witnesses to trust that what they see here, in this place, is a reliable sign of what lies *out there* – that the local might reveal the global.[55]

Like the Iberian and Dutch collections that preceded it and the other institutions it later inspired, Sloane's museum embodied a fusion of empire and information in which the lofty dream of surveying the creation rested on the cunning mundanities of colonial and commercial ambition. From the colonization of Ulster and the exploitation of Caribbean slavery to the cultivation of contacts across Asia and the Americas, Sloane's legacy is an artefact of British imperial power. Not that the creation of the British Museum was an inevitable outcome of that power; it was in fact a great double coup on Sloane's part. It was an act of self-preservation that kept his collections together, even if he became more or less invisible within the museum's walls as the nation's collections outstripped his own and diminished their status. And it was an act of union that allowed people from around the British Isles to assemble in one of the first institutions to be called British, even if some of those who came felt less welcome than others. It is no coincidence that Squire Bramble, who marvelled at Sloane's public spirit in creating the museum – the creation of an Ulsterman – was a fictional Welshman invented by a Scottish writer (Smollett) who dreamed of a fully inclusive British society after the conflicts of the Jacobite era. Such dreams of union hardly erased the sense of national difference between the English, the Scots, the Welsh and the Irish; as discussions of the stones from the Giant's Causeway in Ireland show, British nationalism often simply provided cover to subordinate those nations to English authority. The British Museum was nonetheless a potent new symbol of national unity that helped define British identity through the stewardship of treasures taken from around the empire in the name of the progress of civilization, as well as a grand cosmopolitan gesture that made those treasures available to Britons and foreigners alike.[56]

Sloane's original collection comprised no value-neutral museum. It embodied his judgements about the difference between civilized and superstitious ways of knowing the world – and between civilized and superstitious peoples. It urged the rejection of magical worldviews in favour of a scientific survey that laid the earth bare as a providential yet mechanical resource for use and profit. As his first biographer Thomas Birch put it, Sloane's museum was 'intended for the glory of God' while promoting 'the finding [of] better materials' for every kind of craftsman to 'improve their manufactures'. 'The naturalist will find in this musæum almost every thing', Birch continued, 'which he can wish.' Sloane was 'the father of philosophy [science] in these kingdoms & perhaps in Europe' because of 'the encouragement, which he gave to mariners, travellers, & others to bring hither the curiosities of every country' and because 'the sight of his musæum excited many ingenious persons to study natural history'.[57]

In light of the histories of slavery and empire this book has traced, and the prospect of calamitous climate change to which we have been brought through the exploitation of natural resources by industrial capitalism since Sloane's time, this heritage is troubling. But it is also enlightening. It shows how the cabinet of curiosities gradually gave way to the encyclopaedic museum as well as highlighting the extraordinary variety of people – from savants to slaves – who made this transformation possible. Following curiosities' global journeys into Sloane's collections shows how the British Museum resulted from contact between many different cultures, and how the meanings of objects are not fixed but change across space and time. There was nothing inevitable about the creation of public museums, and there is nothing inevitable about their survival: in a political environment where public goods are increasingly privatized, Sloane's legacy of free access must be championed rather than taken for granted. The art of ranging, moreover, might now hold new value in our age of specialization. The universalism of early modern natural history can still enlighten by revealing the connections *between* nature and society, rather than separating them according to the divisions of modern knowledge. The civic promise of Sloane's legacy thus endures: the use of free public institutions to better understand the interplay of species and cultures that make up our world.[58]

# Acknowledgements

This book was made possible in large part by generous support from the Canadian and American public university systems. I am grateful to the Social Sciences and Humanities Research Council of Canada (SSHRC); the Department of History and Faculty of Arts at McGill University; and the Department of History, School of Arts and Sciences, Research Council, Center for Cultural Analysis and Center for Historical Analysis at Rutgers – the State University of New Jersey. Additional support was provided by the Centre for Research in Arts, Social Sciences and Humanities (CRASSH) at the University of Cambridge; the Institute for Advanced Study in Princeton; the British Academy; the American Philosophical Society; the Max Planck Institute for the History of Science in Berlin; the Paul Mellon Centre for Studies in British Art; and the Department of History of Science at Harvard University.

It is a pleasure to acknowledge the large cast of characters and celebrate the friendships that helped me realize a complex project. My deepest thanks go to my mentor and friend the incomparable Simon Schaffer. Simon has provided the greatest inspiration and warmest encouragement for this book, with both biting humour and true kindness, from start to finish. My admiration and affection for him know no bounds. Several fellow travellers deserve special recognition too for camaraderie of the highest order: Martha Fleming, Mirjam Brusius, Justin Erik Halldór Smith, John Tresch, Toby Jones, Lissa Roberts, Nicholas Dew and Neil Safier. For friendship and support over many years, I also warmly thank Cyrus Schayegh, Erik Goldner, Nuha Ansari, Viken Berberian, Ninon Vinsonneau, Jonathan Magidoff, Adina Ruiu, Cornelius Borck, Susanne Timm, Daniel Carey, Julie Kim, Miles Ogborn, Sanjay Krishnan, Lynn Festa, Henry Turner, Sharon

Jordan and Fredrik Albritton Jonsson. For mentorship and counsel over the long haul, I am especially grateful to my former adviser David Armitage, who has as ever been prodigious in his generosity and vigorous in his support, as well as Steven Shapin, Jorge Cañizares-Esguerra and Richard Drayton. Ann Fabian has been both a mentor and a model who has championed and inspired me in numerous brilliant ways.

For taking the time to offer detailed comments on entire drafts of the manuscript, I thank Cathy Gere, Linda Colley, Miles Ogborn, Simon Schaffer, Laura Kopp, Chris Blakley, Katy Barrett, Ben Sinyor (who made expert recommendations of many kinds) and my marvellous copy-editor Peter James; Stephen Ryan and Richard Mason for their astounding proofreading; and, for advice on specific chapters, Daniel Carey, Lucia Dacome, Arnold Hunt, Julie Kim, Nicholas Dew and Anna Winterbottom. In Montréal, where I began this project over a decade ago, I am grateful to my friends and colleagues Jonathan Sterne, Carrie Rentschler, Laila Parsons, François Furstenberg, Daviken Studnicki-Gizbert, Elizabeth Elbourne, Kate Desbarats, Faith Wallis, Brian Cowan, Brian Lewis and John Hall. At Rutgers, Michael Adas, Tuna Artun, Alastair Bellany, Marisa Fuentes, Jochen Hellbeck, Paul Israel, Jennifer Jones, Seth Koven, Jackson Lears, Julie Livingston, Jim Masschaele, Michael McKeon, Donna Murch and Johanna Schoen have supported me with conversation, counsel and encouragement of every kind. I acknowledge generous assistance from Mark Wasserman and Barbara Cooper as Chairs of the History Department and Jimmy Swenson as Dean of Rutgers' School of Arts and Sciences, and brilliant logistical aid from our staff led by Candace Walcott-Shepherd and including Mary Demeo, Matt Leonaggeo and Tiffany Berg.

For many miscellaneous kindnesses, my thanks go to Elena Aronova, Toby Barnard, Kenneth Bilby, A. J. Blandford, Daniela Bleichmar, Janet Browne, Hugh Cagle, Joyce Chaplin, Wendy Churchill, Hal Cook, Patricia Crone, Laurent Dubois, Richard Duguid, Adrienne Duperly, Elizabeth Eger, James Elwick, Patricia Fara, Joel Fry, Donald Futers, Travis Glasson, Anne Goldgar, Anne Harrington, Anke te Heesen, Florence Hsia, Dominik Huenniger, Michael Hunter, Annabel Huxley, Margaret Jacob, Lisa Jardine, Michael Keevak, Sachiko Kusukawa, Rebecca Lemov, Dániel Margócsy, Alice Marples, Yair Mintzker, Sina Najafi, R. Neville, Maia Nuku, Tara Nummedal, Nathan Perl-Rosenthal, Victoria Pickering, Juan Pimentel, Isola di Ponza, Nick Radburn,

Richard Rath, François Regourd, Felicity Roberts, James Robertson, Anna Marie Roos, Alessandra Russo, Efram Sera-Shriar, Suman Seth, Sujit Sivasundaram, Lisa Smith, Emma Spary, Richard Spiegel, Cameron Strang, Claudia Swan, Stéphane Van Damme, Simon Werrett and Chris Wingfield.

I owe a special debt of gratitude to the curators of Sloane's London collections, who warmly shared their expertise and welcomed me into their places of work, and with whom I collaborated on the 'Reconstructing Sloane' research project. Two people stand out for playing vital roles in my research: Martha Fleming, who walked with me down many a museum corridor as matchless translator and guide; and Kim Sloan, Francis Finlay Curator of the Enlightenment Gallery and Curator of British Drawings and Watercolours before 1880 at the British Museum, whose guidance, intelligence and grace helped keep me sane, at least in part. Thanks also go to Arthur MacGregor, formerly Director of the Ashmolean Museum, and Marjorie Caygill, formerly of the British Museum; Charlie Jarvis, who guided me with good humour through the wonders of the Sloane Herbarium at the Natural History Museum; Jonathan King, who first introduced me to Sloane's collections at the British Museum; and Arnold Hunt and Alison Walker at the British Library. I also acknowledge kind assistance from Julie Harvey, Ranee Prakash, Mark Spencer, Rob Huxley, Kathie Way, Mandy Holloway, Roy Vickery, Dave Goodger, Peter Tandy, John Hunnexe, Tracy-Ann Smith and Katherine Hann at the Natural History Museum; Venetia Porter, J. D. Hill and Stephanie Clarke at the British Museum; Peter Barber and Stephen Parkin at the British Library; Felicity Henderson and Keith Moore at the Royal Society; Dee Cook at Apothecaries' Hall; Rosie Atkins at Chelsea Physic Garden; and Alex Werner at the Museum of London. Ted Widmer and Susan Danforth generously hosted my exhibition 'Voyage to the Islands: Sloane, Slavery and Scientific Travel in the Caribbean' at the John Carter Brown Library in Providence in 2012.

For invitations to present my research and receive crucial feedback, I thank Ken Alder (Northwestern University), Rosie Atkins (Chelsea Physic Garden), Ulrike Beisiegel and Marie Luisa Allemeyer (Georg-August-Universität Göttingen), Catherine Brice and Konstantina Zanou (Université de Paris), Mirjam Brusius and Kavita Singh (Victoria and Albert Museum), Jorge Cañizares-Esguerra (University of Texas – Austin), Alex Csiszar and Anne Harrington (Harvard History of

Science), Samaa Elimam (Harvard School of Design), Ian Foster (Frenchman's Cove, Jamaica), Erik Goldner (California State University – Northridge), Jan Golinski (University of New Hampshire), Pablo Gómez (University of Wisconsin – Madison), Fredrik Jonsson (University of Chicago), Jonathan King (British Museum), Karen Kupperman (NYU), Gesa Mackenthun and Andrea Zittlau (Universität Rostock), María-Elena Martínez and Deborah Harkness (University of Southern California), Peter Miller (Bard Graduate Center), Phil Morgan (Johns Hopkins), Staffan Müller-Wille (Max Planck Institute, Berlin), Kärin Nickelsen and Fabian Krämer (Ludwig-Maximilians-Universität München), Miles Ogborn and Valentina Pugliano (University of London), Giuliano Pancaldi (Università di Bologna), Dahlia Porter and Kelly Wisecup (University of North Texas), Greg Radick and Graeme Gooday (University of Leeds), Roy Ritchie (Huntington Library), Neil Safier (University of British Columbia), Simon Schaffer (University of Cambridge), Londa Schiebinger (Stanford), John Tresch and Michael Zuckerman (University of Pennsylvania), Alison Walker (British Library) and Ted Widmer (John Carter Brown Library). For hosting me during research fellowships, I am grateful to Mary Jacobus and Simon Schaffer (Cambridge), Jonathan Israel (Princeton) and Lorraine Daston (Berlin).

My dear friend Kristen Friedman has played a pivotal role throughout: she was the only research assistant for the entire project, dating back to our time in Montréal, where she unearthed endless leads about Sloane long before I knew what to do with them. My agent Jennifer Lyons has been an unstinting source of support and friendship, while working with Steph Ebdon, Susie Nicklin and the Marsh Agency has been a pleasure, as has reuniting with Kathleen McDermott at Harvard, whom I thank for her excellent work on the North American edition. My editor Stuart Proffitt made many valuable suggestions regarding the book as a whole and improved it very significantly as a result. Jennifer van der Grinten did excellent work on the bibliography and index. Better late than never, I salute George Paxton, my English teacher at school in Reigate, who always encouraged me to keep writing. Quoting a line from Conrad's *Heart of Darkness*, he once instructed us to go home, turn out the light in our bedroom and, when our parents came in to investigate, to respond 'I am lying here in the dark waiting for death' – and gauge their reaction.

Finally, I would be nothing without my beloved family, who have

always looked out for me with love and guidance. I thank my sister Elizabeth Fleure and brother Richard, who cared for me like parents as much as siblings, and my brother David, who remains much missed but still very present. So too do my father Raphael Jack Delbourgo, who was born in the port city of Aden in Yemen and lived in Addis Ababa but spent his later years in Harrington Gardens in Kensington; and my brother-in-law Philip Fleure, whose parents were Jamaican, and who married and made a home with my sister on Old Jamaica Road in Bermondsey. I warmly acknowledge my sister-in-law Helen Cadwallader Delbourgo and my father-in-law the artist Dieter Kopp in Rome. Most of all I thank my mother and my wife, to whom this book is dedicated. Rosella Maria Properzi grew up in Ancona and Porto San Giorgio (Le Marche) before moving to Rome and Addis Ababa and settling in London with my father, where she raised a family. She took me travelling and showed me the world when I was young and I owe my life to her enormous spirit and infinite devotion. My boon companion Laura Kopp has advised me with genius and kindness on every imaginable aspect of this book during our travels from Montréal to New York to London, Rome, Berlin and Jamaica. She makes all good things possible.

New York, March 2017

# Notes

ABBREVIATIONS

| | |
|---|---|
| Add. MS | Additional Manuscript, British Library |
| Birch, 'Memoirs' | Thomas Birch, 'Memoirs Relating to the Life of Sir Hans Sloane', 1753, Add. MS 4241 |
| *BJHS* | *British Journal for the History of Science* |
| BL | British Library |
| BM | British Museum |
| de Beer, *Sloane* | Gavin de Beer, *Sir Hans Sloane and the British Museum*, Oxford University Press, 1953 |
| HS | Sloane Herbarium volume, Botany Department, Natural History Museum, London |
| Hunter, *Books to Bezoars* | Michael Hunter, Alison Walker and Arthur MacGregor (eds.), *From Books to Bezoars: Sir Hans Sloane and His Collections*, British Library, 2012 |
| MacGregor, *Sloane* | Arthur MacGregor (ed.), *Sir Hans Sloane: Collector, Scientist, Antiquary, Founding Father of the British Museum*, British Museum, 1994 |
| *NHJ* | Hans Sloane, *A Voyage to the Islands . . . with the Natural History of [Jamaica]*, 2 vols., London, 1707–25 |
| NHM | Natural History Museum, London |
| *NRRS* | *Notes and Records of the Royal Society of London* |
| *ODNB* | *Oxford Dictionary of National Biography* |
| *PT* | *Philosophical Transactions of the Royal Society* |
| RS | Royal Society |
| Sloane MS | Sloane Manuscript, British Library (unless sourced explicitly to British Museum) |
| *WMQ* | *William and Mary Quarterly* |

## INTRODUCTION

1. [Cromwell Mortimer], 'Account of the Prince and Princess of Wales Visiting Sir Hans Sloane', *Gentleman's Magazine* 18 (1748), 301–2, and *London Evening Post*, 7–9 July 1748.

2. http://www.cadogan.co.uk/pages/estate-development, accessed March 2014; http://www.thebotanistonsloanesquare.com/index.php/photo-gallery/photo/ 180/, http://www.sirhanssloanelondon.co.uk/index.php?page=whyhans, http:// www.quintessentiallyescape.com/Escape_UK/Def_Unique_Chocolate.htm, accessed July 2009; Cadbury trade card, NHM library; Tony Bennett, 'The Exhibitionary Complex', *New Formations* 4 (1988), 73–102, p. 88.

3. De Beer, *Sloane*, 5; Patricia Fara, *Newton: The Making of Genius*, Columbia University Press, 2002; Richard Drayton, *Nature's Government: Science, Imperial Britain, and the 'Improvement' of the World*, Yale University Press, 2000; Mary Terrall, 'Heroic Narratives of Quest and Discovery', *Configurations* 6 (1998), 223–42; H. J. Braunholtz, *Sir Hans Sloane and Ethnography*, British Museum, 1970.

4. On the dispersal of Sloane's paintings to the National Portrait Gallery and Victoria & Albert Museum, and the division of his picture albums between the British Library and the British Museum, see Kim Sloan, 'Sloane's "Pictures and Drawings in Frames" and "Books of Miniature & Painting, Designs, &c.', in Hunter, *Books to Bezoars*, 168–89, pp. 177, 184.

5. Sloane, Corals Catalogue, NHM, 195, and Humana Catalogue, NHM, 5 (shoe); Henry Elking to Sloane, 6 August and 16 November 1726, Sloane MS 4048, fols. 183, 217 (walrus); Sloane, Gemmae & Lapides continentes Inscriptiones Arabicas, Persicas, &c. Catalogue, BM, *passim* (amulets); Arthur MacGregor, 'The Life, Character and Career of Sir Hans Sloane', in MacGregor, *Sloane*, 11–44, p. 28 (Robert); Sloane, Miscellanies Catalogue, BM, 1837 (shrine); Sloane MSS 42 (New Spain and South Seas travel accounts), 1987 (Qur'ān).

6. Edward Miller, *That Noble Cabinet: A History of the British Museum*, Ohio State University Press, 1974; David Wilson, *The British Museum: A History*, British Museum, 2002; Arnold Hunt, 'Sloane as a Collector of Manuscripts', in Hunter, *Books to Bezoars*, 190–207, p. 204.

7. Mike Fitton and Pamela Gilbert, 'Insect Collections', in MacGregor, *Sloane*, 112–22, Leach quotation 120; Elliott Colla, *Conflicted Antiquities: Egyptology, Egyptomania, Egyptian Modernity*, Duke University Press, 2007, ch. 1; W. Blanchard Jerrold, *How to See the British Museum in Four Visits*, London, 1852, 1; Marjorie Caygill, 'Sloane's Catalogues and the Arrangement of his Collections', in Hunter, *Books to Bezoars*, 120–36, p. 276 n. 46; James Dunn, ' "Magic" Chest [Found] among Rubbish: Old Remedies of a Queen's Physician', *Daily Mail*, 11 October 1935; Miller, *Noble*

*Cabinet*, front flap ('confused' and 'flamboyant'); ox-oak caption, n.d., Department of Botany, NHM; Sloane, Vegetable Substances Catalogue, NHM, 1754; Roy Porter, *The Creation of the Modern World: The Untold Story of the British Enlightenment*, Norton, 2000, 239; Paula Findlen, *Possessing Nature: Museums, Collecting and Scientific Culture in Early Modern Italy*, University of California Press, 1994, epilogue; Kim Sloan (ed.), *Enlightenment: Discovering the World in the Eighteenth Century*, British Museum, 2003.

8. Marjorie Swann, *Curiosities and Texts: The Culture of Collecting in Early Modern England*, University of Pennsylvania Press, 2001, 195–200; Barbara Benedict, *Curiosity: A Cultural History of Early Modern Inquiry*, University of Chicago Press, 2001, 180–82; Patrick Mauriès, *Cabinets of Curiosities*, Thames & Hudson, 2002, 211–52; Katharine Conley, 'Value and Hidden Cost in André Breton's Surrealist Collection', *South Central Review* 32 (2015), 8–22; Marion Endt-Jones, 'Reopening the Cabinet of Curiosities: Nature and the Marvellous in Surrealism and Contemporary Art', University of Manchester PhD thesis, 2009; Michel Foucault, *The Order of Things: An Archaeology of the Human Sciences*, 1966, Vintage, 1994, xv; Jorge Luis Borges, 'El idioma analítico de John Wilkins', *La Nación* (Buenos Aires), 8 February 1942; Marjorie Nickson, 'Books and Manuscripts', in MacGregor, *Sloane*, 263–77, p. 263; Carla Nappi, *The Monkey and the Inkpot: Natural History and its Transformations in Early Modern China*, Harvard University Press, 2009, 148–9; Arthur MacGregor and Oliver Impey (eds.), *The Origins of Museums: The Cabinet of Curiosities in Sixteenth- and Seventeenth-Century Europe*, Oxford University Press, 1985; Eilean Hooper-Greenhill, *Museums and the Shaping of Knowledge*, Routledge, 1992; Findlen, *Possessing Nature*; Horst Bredekamp, *The Lure of Antiquity and Cult of the Machine: The Kunstkammer and the Evolution of Nature, Art, and Technology*, Markus Weiner, 1995; Lorraine Daston and Katharine Park, *Wonders and the Order of Nature, 1150–1750*, Zone, 1998.

9. De Beer, *Sloane*, 57–9, 83–7, and *The Sciences were Never at War*, Nelson, 1960, xii, 1; E. Barrington, 'Gavin Rylands de Beer, 1899–1972', *Biographical Memoirs of Fellows of the Royal Society* 19 (1973), 64–93; Eric St John Brooks, *Sir Hans Sloane: The Great Collector and His Circle*, Batchworth Press, 1954; Londa Schiebinger, *Plants and Empire: Colonial Bioprospecting in the Atlantic World*, Harvard University Press, 2004, esp. 25–30. Valuable Sloane anthologies include MacGregor, *Sloane*; Sloan, *Enlightenment*; and Hunter, *Books to Bezoars*; see also Kay Dian Kriz, 'Curiosities, Commodities, and Transplanted Bodies in Hans Sloane's "Natural History of Jamaica"', *WMQ* 57 (2000), 35–78, and Mimi Sheller, *Consuming the Caribbean: From Arawaks to Zombies*, Routledge, 2003, 19–32.

10. Werner Muensterberger, *Collecting – An Unruly Passion: Psychological Perspectives*, Princeton University Press, 1993; Jean Baudrillard, 'The System of Collecting' (1968), in John Elsner and Roger Cardinal (eds.), *The Cultures of Collecting*, Harvard University Press, 1994, 7–24; Bruno Latour, 'From Realpolitik to Dingpolitik, or How to Make Things Public', in Latour and Peter Weibel (eds.), *Making Things Public: Atmospheres of Democracy*, MIT Press, 2005, 4–31, p. 14.

11. Simon Schaffer *et al.* (eds.), *The Brokered World: Go-Betweens and Global Intelligence, 1770–1820*, Science History Publications, 2009; Nicholas Thomas, *Entangled Objects: Exchange, Material Culture, and Colonialism in the Pacific*, Harvard University Press, 1991; Arjun Appadurai (ed.), *The Social Life of Things: Commodities in Cultural Perspective*, Cambridge University Press, 1986; Michael Taussig, *My Cocaine Museum*, University of Chicago Press, 2004.

12. Findlen, *Possessing Nature*, ch. 2; Andrew Erskine, 'Culture and Power in Ptolemaic Egypt: The Museum and Library of Alexandria', *Greece and Rome* 42 (1995), 38–48.

CHAPTER 1: TRANSPLANTATION

1. *NHJ*, 1:preface (unpaginated); 'A Letter from Dr Hans Sloane ... to the Right Honourable the Earl of Cromertie', *PT* 27 (1710–12), 302–8; Sloane to Richard Richardson, 20 November 1725, in John Nichols and John Bower Nichols (eds.), *Illustrations of the Literary History of the Eighteenth Century*, 8 vols., London, 1817–58, 1:283; Sloane to Richardson, 12 September 1724, in Dawson Turner (ed.), *Extracts from the Literary and Scientific Correspondence of Richard Richardson*, Yarmouth, 1835, 213; Jonathan Bardon, *The Plantation of Ulster: The British Colonisation of the North of Ireland in the Seventeenth Century*, Gill & Macmillan, 2011, 149; Peter Foss and Catherine O'Connell, 'Bogland: Study and Utilization', in John Foster (ed.), *Nature in Ireland: A Scientific and Cultural History*, McGill-Queens University Press, 1999, 184–98, p. 186.

2. Eoin Neeson, 'Woodland in History and Culture', in Foster, *Nature in Ireland*, 133–56, esp. 140–45; Foss and O'Connell, 'Bogland'; Nicholas Canny, 'The Ideology of English Colonization: From Ireland to America', *WMQ* 30 (1973), 575–98; Bardon, *Ulster*, chs. 4–5, Davies and James I quotations 115, 124, Blennerhasset quotation 126–7, and Irish Society 128–31.

3. Eric St John Brooks, *Sir Hans Sloane: The Great Collector and his Circle*, Batchworth Press, 1954, 18–21, 24–5; Mark Purcell, ' "Settled in the North of Ireland": Or, Where did Sloane Come From?', in Hunter, *Books to Bezoars*, 24–32, pp. 26–8; Margaret Sanderson, *Ayrshire and the Reformation: People and Change, 1490–1600*, Tuckwell Press, 1997, 110, 133;

Jane Ohlmeyer, *Making Ireland English: The Irish Aristocracy in the Seventeenth Century*, Yale University Press, 2012, 15.

4. Brooks, *Sloane*, 36–8; Bardon, *Ulster*, 135–46; Ohlmeyer, *Making Ireland English*, 202, 416; Purcell, 'Settled', 26–8; D. W. Hayton, *Ruling Ireland, 1685–1742: Politics, Politicians, and Parties*, Boydell, 2004, 46–8, 58, 75; http://www.historyofparliamentonline.org/volume/1690-1715/member/sloane-james-1655-1704, accessed April 2014.

5. Toby Barnard, *A New Anatomy of Ireland: The Irish Protestants, 1649–1770*, Yale University Press, 2003, 325–37; Colin Kidd, *British Identities before Nationalism: Ethnicity and Nationhood in the Atlantic World, 1600–1800*, Cambridge University Press, 1999, ch. 4, Ussher quotation 167, and 251–6; Nicholas Canny, 'Identity Formation in Ireland: The Emergence of the Anglo-Irish', in Canny and Anthony Pagden (eds.), *Colonial Identity in the Atlantic World, 1500–1800*, Princeton University Press, 1987, 159–212; D. W. Hayton, *The Anglo-Irish Experience, 1680–1730: Religion, Identity and Patriotism*, Boydell, 2012, esp. ch. 2.

6. Purcell, 'Settled'; Thomas Stack to Sloane, 28 October 1728, Sloane MS 4048, fol. 254.

7. *NHJ*, 1:preface; Richard Drayton, *Nature's Government: Science, Imperial Britain, and the 'Improvement' of the World*, Yale University Press, 2000, ch. 1, Austen quotation 12.

8. Birch, 'Memoirs', fol. 1.

9. Toby Barnard, *Making the Grand Figure: Lives and Possessions in Ireland, 1641–1770*, Yale University Press, 2004, quotations 333; David Miller, 'The "Hardwicke Circle": The Whig Supremacy and its Demise in the 18th-Century Royal Society', *NRRS* 52 (1998), 73–91, p. 76; John Kenyon, *The Popish Plot*, Heinemann, 1972; William Gould to Sloane, 25 January 1681, Sloane MS 4036, fol. 1.

10. Birch, 'Memoirs', fol. 2; Anita Guerrini, 'Anatomists and Entrepreneurs in Early Eighteenth-Century London', *Journal of the History of Medicine and Allied Sciences* 59 (2004), 219–39; Penelope Hunting, *A History of the Society of Apothecaries*, Society of Apothecaries, 1998; Sue Minter, *The Apothecaries' Garden: A History of the Chelsea Physic Garden*, Sutton Publishing, 2000; Drayton, *Nature's Government*, ch. 1; William Charleton [Courten] to Sloane, 10 September 1687, Sloane MS 3962, fol. 308; Sloane to John Ray, 11 November and 20 December 1684, in Edwin Lankester (ed.), *The Correspondence of John Ray*, The Ray Society, 1848, 156–9; Jill Casid, *Sowing Empire: Landscape and Colonization*, University of Minnesota Press, 2005, ch. 2; Pratik Chakrabarti, *Materials and Medicine: Trade, Conquest and Therapeutics in the Eighteenth Century*, Manchester University Press, 2010, 146–7.

11. Birch, 'Memoirs', fol. 2; de Beer, *Sloane*, 16; Barnard, *Grand Figure*; Hayton, *Anglo-Irish Experience*; Michael Hunter, *Boyle: Between God and*

*Science*, Yale University Press, 2009; HS, 9; J. E. Dandy, *The Sloane Herbarium*, British Museum, 1958, 206.

12. George Saliba, *Islamic Science and the Making of the European Renaissance*, MIT Press, 2007, ch. 6; Howard Turner, *Science in Medieval Islam: An Illustrated Introduction*, University of Texas Press, 1996; Jim Al-Khalili, *The House of Wisdom: How Arabic Science Saved Ancient Wisdom and Gave Us the Renaissance*, Penguin, 2010.

13. William Eamon, *Science and the Secrets of Nature: Books of Secrets in Medieval and Early Modern Europe*, Princeton University Press, 1994; Lauren Kassell, *Medicine and Magic in Elizabethan London: Simon Forman, Astrologer, Alchemist and Physician*, Oxford University Press, 2007; Steven Shapin, *The Scientific Revolution*, University of Chicago Press, 1996; Steven Shapin and Simon Schaffer, *Leviathan and the Air-Pump: Hobbes, Boyle, and the Experimental Life*, Princeton University Press, 1985.

14. Herbert Butterfield, *The Origins of Modern Science, 1300-1800*, 1949, Free Press, 1965; David Wootton, *The Invention of Science: A New History of the Scientific Revolution*, Allen Lane, 2015; Marwa Elshakry, 'When Science Became Western: Historiographical Reflections', *Isis* 101 (2010), 98-109, p. 107; Stephen Gaukroger, *Descartes: An Intellectual Biography*, Oxford University Press, 1995, e.g. ch. 2; Lawrence Principe, *The Aspiring Adept: Robert Boyle and his Alchemical Quest*, Princeton University Press, 2000; Betty Jo Dobbs, *The Foundation of Newton's Alchemy: or, 'The Hunting of the Green Lyon'*, Cambridge University Press, 1975; Patricia Fara, *Newton: The Making of Genius*, Columbia University Press, 2002; Simon Schaffer, 'Natural Philosophy and Public Spectacle in the Eighteenth Century', *History of Science* 21 (1983), 1-43.

15. Allen Debus, *Chemistry and Medical Debate: Van Helmont to Boerhaave*, Science History Publications, 2001; William Newman, 'From Alchemy to "Chymistry"', in Lorraine Daston and Katharine Park (eds.), *The Cambridge History of Science, Volume 3: Early Modern Science*, Cambridge University Press, 2006, 497-517, esp. 497, 502, 511-15; Matthew Eddy *et al.* (eds.), *Chemical Knowledge in the Early Modern World*, vol. 29 of *Osiris* (2014); Charles Webster, *Paracelsus: Medicine, Magic and Mission at the End of Time*, Yale University Press, 2008; Andrew Wear, *Knowledge and Practice in English Medicine*, Cambridge University Press, 2000, 98-9, 354-5.

16. John Powers, ' "Ars Sine Arte": Nicolas Lemery and the End of Alchemy in Eighteenth-Century France', *Ambix* 45 (1998), 163-89, pp. 170, 174, 180-81; for Sloane's ownership of works by Lémery, and his library holdings more generally, see the Sloane Printed Books Catalogue, http://www.bl.uk/catalogues/sloane/, accessed August 2014; Sloane MSS 1232, fols. 41-76, and 3861, fols. 49-62 (Lémery).

17. Daniel Carey, *Locke, Shaftesbury and Hutcheson: Contesting Diversity in the Enlightenment and Beyond*, Cambridge University Press, 2005, chs.

1–3, esp. 24, 30; John Locke to William Molyneux, 22 February 1697, in E. S. de Beer (ed.), *The Correspondence of John Locke*, 8 vols., Clarendon Press, 1976–89, 6:4–9, quotations 7.

18. Charles Raven, *John Ray, Naturalist: His Life and Works*, Cambridge University Press, 1942, 83, quotation from the *Cambridge Catalogue*, 1660; Brian Ogilvie, 'Natural History, Ethics, and Physico-Theology', in Nancy Siraisi and Gianna Pomata (eds.), *Historia: Empiricism and Erudition in Early Modern Europe*, MIT Press, 2005, 75–104; Alexander Wragge-Morley, 'The Work of Verbal Picturing for John Ray and Some of his Contemporaries', *Intellectual History Review* 20 (2010), 165–79; Philip Sloan, 'John Locke, John Ray, and the Problem of the Natural System', *Journal of the History of Biology* 5 (1972), 1–53; Larry Stewart, *The Rise of Public Science: Rhetoric, Technology, and Natural Philosophy in Newtonian Britain, 1660–1750*, Cambridge University Press, 1992, part 1.

19. Birch, 'Memoirs', fols. 2–3; Martin Lister, *A Journey to Paris in the Year 1698*, 3rd edn, London, 1699, 4 ('French air'), 62–71; Gould to Sloane, 25 January 1681, Sloane MS 4036, fol. 1; Linda Levy Peck, *Consuming Splendour: Society and Culture in Seventeenth-Century England*, Cambridge University Press, 2005, 128–35; Anna Marie Roos (ed.), *Every Man's Companion: Or, An Useful Pocket-Book, 1663–6*, MS Lister 19, Bodleian Library, Oxford University, http://lister.history.ox.ac.uk, accessed December 2016, and *Web of Nature: Martin Lister (1639–1712), the First Arachnologist*, Brill, 2011, 69–72, and ch. 3; Alice Stroup, *A Company of Scientists: Botany, Patronage, and Community at the Seventeenth-Century Parisian Royal Academy of Sciences*, University of California Press, 1990; Laurence Brockliss and Colin Jones, *The Medical World of Early Modern France*, Oxford University Press, 1997, esp. 184, 190; Matthew Senior, 'Pierre Donis and Joseph-Guichard Duverney: Teaching Anatomy at the Jardin du Roi, 1673–1730', *Seventeenth-Century French Studies* 26 (2004), 153–69, esp. 162–3; Anita Guerrini, 'Theatrical Anatomy: Duverney in Paris, 1670–1720', *Endeavour* 33 (2009), 7–11.

20. Birch, 'Memoirs', fols. 2–3; Thomas Wakley to Sloane, 11 February 1684, Sloane MS 4036, fol. 6; Sloane, Miscellanies Catalogue, BM, 250–52, 393–5 (phosphorus); Tancred Robinson to Ray, 10 September 1683, Lankester, *Correspondence of John Ray*, 135; de Beer, *Sloane*, 16, 21–2; Jan Golinski, 'A Noble Spectacle: Phosphorus and the Public Cultures of Science in the Early Royal Society', *Isis* 80 (1989), 11–39, pp. 27–8; Powers, ' "Ars Sine Arte" ', 165; Christie Wilson, *Beyond Belief: Surviving the Revocation of the Edict of Nantes in France*, Lehigh University Press, 2011.

21. Archives de Vaucluse, translated in de Beer, *Sloane*, 20–21; Wear, *English Medicine*, chs. 1–4.

22. Birch, 'Memoirs', fol. 4; Andrew Cunningham, 'Thomas Sydenham: Epidemics, Experiment and the "Good Old Cause" ', in Roger French and

Andrew Wear (eds.), *The Medical Revolution of the Seventeenth Century*, Cambridge University Press, 1989, 164–90, pp. 182–3; Dorothy and Roy Porter, *Patient's Progress: Doctors and Doctoring in Eighteenth-Century England*, Stanford University Press, 1989, ch. 7, esp. 131; Simon Schaffer, 'The Glorious Revolution and Medicine in Britain and the Netherlands', *NRRS* 43 (1989), 167–90, pp. 180–81; 'nonsense' quotation in Joseph Payne, *Thomas Sydenham*, T. Fisher Unwin, 1900, 190.

23. Sachiko Kusukawa, *Picturing the Book of Nature: Image, Text, and Argument in Sixteenth-Century Human Anatomy and Medical Botany*, University of Chicago Press, 2012; Harold Cook, 'Medicine', in Daston and Park, *Cambridge History of Science, Volume 3*, 407–34, esp. 410–23; Keith Thomas, *Religion and the Decline of Magic*, Weidenfeld & Nicolson, 1971, chs. 7–8; Peter Forshaw, 'Magical Material and Material Survivals: Amulets, Talismans and Mirrors in Early Modern Europe', in Dietrich Boschung and Jan Bremmer (eds.), *The Materiality of Magic*, Wilhelm Fink, 2015, 357–78; *NHJ*, 1:preface.

24. Birch, 'Memoirs', fols. 2–3; Robert Iliffe, 'Foreign Bodies: Travel, Empire and the Early Royal Society of London, Part One – Englishmen on Tour', *Canadian Journal of History* 33 (1998), 357–85, pp. 360–62; Sloane to Ray, 11 November 1684, Lankester, *Correspondence of John Ray*, 157; HS, 9–10; Dandy, *Herbarium*, 27.

25. E. A. Wrigley, *Poverty, Progress, and Population*, Cambridge University Press, 2004, 49 n. 12; Jerry White, *London in the Eighteenth Century: A Great and Monstrous Thing*, Bodley Head, 2012, introduction and ch. 4; Gretchen Gerzina, *Black England: Life before Emancipation*, John Murray, 1995; Catherine Molineux, *Faces of Perfect Ebony: Encountering Atlantic Slavery in Imperial Britain*, Harvard University Press, 2012, ch. 1 and pl. 1; Ray to Sloane, 11 February 1684, Lankester, *Correspondence of John Ray*, 141.

26. John Eliot, *Empires of the Atlantic World: Britain and Spain in America, 1492–1830*, Yale University Press, 1997; A. J. R. Russell-Wood, *The Portuguese Empire, 1415–1808*, Johns Hopkins University Press, 1998; Philip J. Stern and Carl Wennerlind (eds.), *Mercantilism Reimagined: Political Economy in Early Modern Britain and its Empire*, Oxford University Press, 2013; Daniel Carey, 'Locke's Species: Money and Philosophy in the 1690s', *Annals of Science* 70 (2013), 357–80.

27. Laurent Dubois, *Avengers of the New World: The Story of the Haitian Revolution*, Harvard University Press, 2004, ch. 1; Christian Koot, *Empire at the Periphery: British Colonists, Anglo-Dutch Trade, and the Development of the British Atlantic, 1621–1713*, NYU Press, 2011, chs. 2–3; Joyce Chaplin, *Subject Matter: Technology, Science, and the Body on the Anglo-American Frontier, 1500–1676*, Harvard University Press, 2001, 20, 56, etc.; Walter Ralegh, *The Discoverie of the Large, Rich and*

*Bewtiful Empyre of Guiana*, 1596, Manchester University Press, 1997, 136–7; Richard Dunn, *Sugar and Slaves: The Rise of the Planter Class in the English West Indies, 1624–1723*, University of North Carolina Press, 1972, ch. 3; Susan Amussen, *Caribbean Exchanges: Slavery and the Transformation of English Society, 1640–1700*, University of North Carolina Press, 2007, 29; Carla Pestana, *The English Atlantic in an Age of Revolution, 1640–1661*, Harvard University Press, 177–81; Nuala Zahedieh, *The Capital and the Colonies: London and the Atlantic Economy, 1660–1700*, Cambridge University Press, 2010, 210–26, 280–87.

28. Alfred Crosby, *The Columbian Exchange: Biological and Cultural Consequences of 1492*, Greenwood, 1972; Judith Carney and Richard Rosomoff, *In the Shadow of Slavery: Africa's Botanical Legacy in the Atlantic World*, University of California Press, 2010; Anthony Grafton, *New Worlds, Ancient Texts: The Power of Tradition and the Shock of Discovery*, Harvard University Press, 1992, 197–252; Jorge Cañizares-Esguerra, *Nature, Empire, and Nation: Explorations of the History of Science in the Iberian World*, Stanford University Press, 2006, ch. 3; Ralph Bauer, 'A New World of Secrets: Occult Philosophy and Local Knowledge in the Sixteenth-Century Atlantic', in James Delbourgo and Nicholas Dew (eds.), *Science and Empire in the Atlantic World*, Routledge, 2007, 99–126; Deborah Harkness, *John Dee's Conversations with Angels: Cabala, Alchemy and the End of Nature*, Cambridge University Press, 1999.

29. Londa Schiebinger and Claudia Swan (eds.), *Colonial Botany: Science, Commerce, and Politics in the Early Modern World*, University of Pennsylvania Press, 2005; Harold Cook, *Matters of Exchange: Commerce, Medicine, and Science in the Dutch Golden Age*, Yale University Press, 2007, ch. 1; Paula Findlen, 'Natural History', in Daston and Park, *Cambridge History of Science, Volume 3*, 435–68, pp. 448, 453–4, 463; *NHJ*, 1:i–iv, quotation ii; Maria Fernanda Alegria *et al.*, 'Portuguese Cartography in the Renaissance', in David Woodward (ed.), *The History of Cartography, Volume 3: Cartography in the European Renaissance*, University of Chicago Press, 2007, 975–1068; Juan Pimentel, *Testigos del mundo: Ciencia, literatura y viajes en la ilustración*, Marcial Pons, 2003, 73–94; Antonio Barrera-Osorio, *Experiencing Nature: The Spanish-American Empire and the Early Scientific Revolution*, University of Texas Press, 2006; Trevor Murphy, *Pliny the Elder's Natural History: The Empire in the Encyclopaedia*, Oxford University Press, 2004; Ralph Bauer, *The Cultural Geography of Colonial American Literatures: Empire, Travel, Modernity*, Cambridge University Press, 2003, 19–21; Cañizares-Esguerra, *Nature*, 18–22.

30. Richard Grove, *Green Imperialism: Colonial Expansion, Tropical Island Edens and the Origins of Environmentalism, 1600–1860*, Cambridge University Press, 1996, 22–3, ch. 2, esp. 75, 77, 80, 91 and 133–45; Findlen, 'Natural History'; Anna Winterbottom, *Hybrid Knowledge in the Early East India Company World*, Palgrave Macmillan, 2015.

31. Carol Walker Bynum, *Christian Materiality: An Essay on Religion in Late Medieval Europe*, Zone, 2011; Patrick Geary, 'Sacred Commodities: The Circulation of Medieval Relics', in Arjun Appadurai (ed.), *The Social Life of Things: Commodities in Cultural Perspective*, Cambridge University Press, 1986, 169–91; Krzysztof Pomian, *Collectors and Curiosities: Paris and Venice, 1500–1800* (1987), trans. Elizabeth Wiles-Portier, Polity Press, 1990; Horst Bredekamp, *The Lure of Antiquity and Cult of the Machine: The Kunstkammer, and the Evolution of Art, Nature, and Technology*, Markus Weiner, 1995; Lorraine Daston and Katharine Park, *Wonders and the Order of Nature, 1150–1750*, Zone, 1998; Justin Stagl, *A History of Curiosity: The Theory of Travel, 1550–1800*, Routledge, 1995, ch. 2, esp. 114–16, 121; Mark Meadow and Bruce Robertson (eds.), *The First Treatise on Museums: Samuel Quiccheberg's Inscriptiones, 1565*, Getty Research Institute, 2013, esp. 23–6; Koji Kuwakino, 'The Great Theatre of Creative Thought: The *Inscriptiones vel tituli theatri amplissimi* ... (1565) by Samuel von Quiccheberg', *Journal of the History of Collections* 25 (2013), 303–24; Paula Findlen, *Possessing Nature: Museums, Collecting, and Scientific Culture in Early Modern Italy*, University of California Press, 1994, incl. on Kircher 334–44, and (ed.), *Athanasius Kircher: The Last Man Who Knew Everything*, Routledge, 2004.

32. [Francis Bacon], *Gesta Grayorum*, 1594, in John Nichols (ed.), *The Progresses and Public Processions of Queen Elizabeth*, 3 vols., London, 1823, 3:262–350, quotations p. 290; Paula Findlen, 'Anatomy Theatres, Botanical Gardens, and Natural History Collections', in Daston and Park, *Cambridge History of Science, Volume 3*, 272–89.

33. Francis Bacon, *Novum organum*, London, 1620; Peter Dear, 'The Meanings of Experience', in Daston and Park, *Cambridge History of Science, Volume 3*, 106–31; Lorraine Daston, 'Marvellous Facts and Miraculous Evidence in Early Modern Europe', *Critical Inquiry* 18 (1991), 193–214; Francis Bacon, *New Atlantis*, in James Spedding *et al.* (eds.), *The Works of Francis Bacon*, 14 vols., Longman, 1857–74, 3:125–66, quotations 164, 165, 156, 146, 165–6; Bauer, *Cultural Geography*, 19–21; Cañizares-Esguerra, *Nature*, 18–22.

34. Carl Wennerlind, *Casualties of Credit: The English Financial Revolution, 1620–1720*, Harvard University Press, 2011, ch. 2, Plattes quotation 58; Koji Yamamoto, 'Reformation and the Distrust of the Projector in the Hartlib Circle', *Historical Journal* 55 (2012), 175–97; Eamon Duffy, *The Stripping of the Altars: Traditional Religion in England, c. 1400–c. 1580*, Yale University Press, 1992; Tabitha Barber and Stacy Boldrick (eds.), *Art under Attack: Histories of British Iconoclasm*, Tate Publishing, 2013; John Brewer, *The Pleasures of the Imagination: English Culture in the Eighteenth Century*, HarperCollins, 1997, ch. 6, esp. 87; Jerry Brotton, *The Sale of the Late King's Goods: Charles I and his Art Collection*, Macmillan, 2006; Arthur MacGregor (ed.), *Tradescant's Rarities: Essays on the Foundation of the Ashmolean Museum*, Clarendon Press, 1983, and *The*

*Ashmolean Museum: A Brief History of the Museum and its Collections*, Ashmolean Museum, 2001; Marjorie Swann, *Curiosities and Texts: The Culture of Collecting in Early Modern England*, University of Pennsylvania Press, 2001; Ken Arnold, *Cabinets for the Curious: Looking Back at Early English Museums*, Ashgate, 2006, esp. 197–204; Jennifer Thomas, 'Compiling "God's Great Book [of] Universal Nature": The Royal Society's Collecting Strategies', *Journal of the History of Collections* 23 (2011), 1–13; Peck, *Consuming Splendour*, ch. 8.

35. Cook, *Exchange*, 29–31; Michael Hunter, *Establishing the New Science: The Experience of the Early Royal Society*, Boydell & Brewer, 1989; Thomas Sprat, *The History of the Royal-Society of London, for the Improving of Natural Knowledge*, London, 1667, 74; Eamon, *Secrets of Nature*, chs. 6, 10; Walter Houghton, Jr, 'The English Virtuoso in the Seventeenth Century', parts 1–2, *Journal of the History of Ideas* 3 (1942), 51–73, 190–219, 'excellencie' quotation 59, from Baldassare Castiglione, *The Book of the Courtier*, trans. Thomas Hoby, 1561; Craig Hanson, *The English Virtuoso: Art, Medicine, and Antiquarianism in the Age of Empiricism*, University of Chicago Press, 2009; Findlen, *Possessing Nature*, ch. 7; Bredekamp, *Lure of Antiquity*, 19–27; Susan Scott Parrish, *American Curiosity: Cultures of Natural History in the Colonial British Atlantic World*, University of North Carolina Press, 2006, ch. 5; Gillian Darley, *John Evelyn: Living for Ingenuity*, Yale University Press, 2007; Carol Gibson-Wood, 'Classification and Value in a Seventeenth-Century Museum: William Courten's Collection', *Journal of the History of Collections* 9 (1997), 61–77; Susan Jenkins, *Portrait of a Patron: The Patronage and Collecting of James Bridges, 1st Duke of Chandos (1674–1744)*, Ashgate, 2007; Joseph Levine, *Dr Woodward's Shield: History, Science, and Satire in Augustan England*, University of California Press, 1977; Ludmilla Jordanova, 'Portraits, People and Things: Richard Mead and Medical Identity', *History of Science* 61 (2003), 93–113.

36. Swann, *Curiosities and Texts*, 56–9, 136–45; Barbara Shapiro, *A Culture of Fact: England, 1550–1720*, Cornell University Press, 2000, ch. 3; Susan Scott Parrish, 'Richard Ligon and the Atlantic Science of Commonwealths', *WMQ* 67 (2010), 209–48; James Jacob, *Henry Stubbe, Radical Protestantism and the Early Enlightenment*, Cambridge University Press, 1983, 45–8; Daniel Carey, 'Inquiries, Heads, and Directions: Orienting Early Modern Travel', in Judy Hayden (ed.), *Travel Narratives, the New Science, and Literary Discourse, 1569–1750*, Ashgate, 2012, 25–52; 'Inquiries Recommended to Colonel Linch going to Jamaica', 16 December 1670, Sloane MS 3984, fol. 194; Raymond Stearns, *Science in the British Colonies of America*, University of Illinois Press, 1970, 212–46; Mark Govier, 'The Royal Society, Slavery, and the Island of Jamaica: 1660–1700', *NRRS* 53 (1999), 203–17, Sprat quotation 206; K. Grudzien Baston, 'Vaughan, John, Third Earl of Carbery', *ODNB*.

37. Anne Murphy, *The Origins of English Financial Markets: Investment and Speculation before the South Sea Bubble*, Cambridge University Press, 2012, 10–12, 31, 99, and ch. 3; Zahedieh, *Capital*, 232; Stewart, *Rise of Public Science*; Simon Schaffer, 'Defoe's Natural Philosophy and the Worlds of Credit', in John Christie and Sally Shuttleworth (eds.), *Nature Transfigured: Science and Literature, 1700–1900*, Manchester University Press, 1989, 13–44; Daniel Defoe, *The Complete English Tradesman*, 1726, Alan Sutton, 1987, 46; Thomas, *Magic*, 273–82; J. Kent Clarke, *Goodwin Wharton*, Oxford University Press, 1984, 223–6, 271–5; Anonymous, *Angliae Tutamen: Or, The Safety of England*, London, 1695, 21.

38. *NHJ*, 1:table 'iiii'; Sloane to Arthur Rawdon, 21 May 1687, in Edward Berwick (ed.), *The Rawdon Papers, Consisting of Letters on Various Subjects, Literary, Political and Ecclesiastical*, London, 1819, 388–91, quotations 389, 390; *NHJ*, 1:lxxix–lxxx; Peter Earle, *The Wreck of the Almiranta: Sir William Phips and the Search for the Hispaniola Treasure*, Macmillan, 1979; Sloane MS 50 (Phips journal); for currency conversion here and throughout see http://apps.nationalarchives.gov.uk/currency/defaulto.asp, accessed August 2014; Kay Dian Kriz, 'Curiosities, Commodities, and Transplanted Bodies in Hans Sloane's "Natural History of Jamaica"', *WMQ* 57 (2000), 35–78, pp. 53–7.

39. *NHJ*, 1:lxxx–lxxxi; James Delbourgo, 'Divers Things: Collecting the World under Water', *History of Science* 49 (2011), 149–85.

40. Estelle Ward, *Christopher Monck, Duke of Albemarle*, John Murray, 1915; Bardon, *Ulster*, 142, 145–6; Donal Synnott, 'Botany in Ireland', in Foster, *Nature in Ireland*, 157–83, p. 160; Zahedieh, *Capital*, 115, 119–20; Wear, *English Medicine*, 116, 130; *NHJ*, 1:preface; Gould to Sloane, 25 January 1681, Sloane MS 4036, fol. 1; Sloane to Ray, 29 January 1686, Lankester, *Correspondence of John Ray*, 189.

41. Sydenham quotation, n.d., in de Beer, *Sloane*, 26; Ray to Sloane, 1 April 1687, Lankester, *Correspondence of John Ray*, 192; Ray to Sloane, n.d., Sloane MS 4036, fol. 28; Robinson to Sloane, 8 April 1688, Sloane MS 4046, fol. 32; Jacob Bobart to Sloane, 1 October 1688, Sloane MS 4036, fol. 43.

42. *NHJ*, 1:preface and cxxii; Sloane to unknown, 19 May 1714, Sloane MS 4068, fol. 85; Birch, 'Memoirs', fol. 14; 'Proposals made by Dr Sloane if it be thought fitt that he goe physitian to ye W. india fleet', n.d., Sloane MS 4069, fol. 200; Sloane to Rawdon, 10 September 1687, MS HA 15790, Irish Papers, Huntington Library, San Marino.

## CHAPTER 2: ISLAND OF CURIOSITIES

1. *NHJ*, 1:1–3, 6; Lawrence Wright, Log of HMS *Assistance*, 1687–9: Captains' Logs, 68, National Archives, London.

2. *NHJ*, 1:9–20; Miguel Menezes de Sequeira *et al.*, 'The Madeiran Plants Collected by Sir Hans Sloane in 1687, and his Descriptions', *Taxon* 59 (2010), 598–612; David Hancock, *Oceans of Wine: Madeira and the Emergence of American Trade and Taste*, Yale University Press, 2009.

3. Sloane to William Charleton [Courten], 28 November 1687, Sloane MS 3962, fol. 310; *NHJ*, 1:32–41; Sloane, Albemarle case history, Sloane MS 3984, fols. 282–5; Richard Grove, *Green Imperialism: Colonial Expansion, Tropical Island Edens and the Origins of Environmentalism, 1600–1860*, Cambridge University Press, 1995, 67.

4. *NHJ*, 1:41–7; John Taylor, *Multum in Parvo*, reproduced in David Buisseret (ed.), *Jamaica in 1687: The Taylor Manuscript at the National Library of Jamaica*, University of the West Indies Press, 2008, 299–300; Tancred Robinson to Sloane, 6 December 1687, Sloane MS 4036, fol. 30.

5. Samuel Wilson, *The Archaeology of the Caribbean*, Cambridge University Press, 2007, 102–5, 160, 162, Bernáldez quotations 103; Jan Rogoziński, *A Brief History of the Caribbean: From the Arawak and Carib to the Present*, Plume, 1999, 14–33; Irving Rouse, *The Tainos: Rise and Decline of the People Who Greeted Columbus*, Yale University Press, 1992; Bartolomé de Las Casas, *A Short Account of the Destruction of the Indies*, 1552, trans. Nigel Griffin, Penguin, 1992, 26; Frederic Cassidy, *Jamaica Talk: Three Hundred Years of the English Language in Jamaica*, St Martin's Press, 1961, 10.

6. Francisco Padrón, *Spanish Jamaica*, trans. Patrick Bryan, Ian Randle Publishers, 2003; Susan Amussen, *Caribbean Exchanges: Slavery and the Transformation of English Society, 1640–1700*, University of North Carolina Press, 2007, 33–71, and Richard Dunn, *Sugar and Slaves: The Rise of the Planter Class in the English West Indies, 1624–1713*, University of North Carolina Press, 1972, 149–87.

7. Dunn, *Sugar*, 157–61, 168, 183, 231; Carla Pestana, *The English Atlantic in an Age of Revolution, 1640–1661*, Harvard University Press, 2007, 164; Nuala Zahedieh, *The Capital and the Colonies: London and the Atlantic Economy, 1660–1700*, Cambridge University Press, 2010, 50–51, 115, 119–20; Patricia Cohen, *A Calculating People: The Spread of Numeracy in Early America*, University of Chicago Press, 1982, 47–80; Henry Barham, 'Civil History of Jamaica to 1722', Add. MS 12422, fols. 158–9, 260 ('rods of iron').

8. Trevor Burnard, 'Who Bought Slaves in Early America? Purchasers of Slaves from the Royal African Company in Jamaica, 1674–1708', *Slavery and Abolition* 17 (1996), 68–92, pp. 72–7; David Eltis and David Richardson, *Atlas of the Transatlantic Slave Trade*, Yale University Press, 2010, 126, 129, 136, 138, 169, 201, 204; Stephanie Smallwood, *Saltwater Slavery: A Middle Passage from Africa to American Diaspora*, Harvard University Press, 2009; Marcus Rediker, *The Slave Ship: A Human History*, Penguin, 2008; Olaudah Equiano, *The Interesting Narrative of the Life of Olaudah Equiano*, 1789, Norton, 2001, 38–41; Alexander Byrd,

*Captives and Voyagers: Black Migrants across the Eighteenth-Century British Atlantic World*, Louisiana State University Press, 2010, esp. ch. 3; 1664 slave code ('the negroes an heathenishe brutish and uncertain and dangerous kind of people') quoted in David Barry Gaspar, '"Rigid and Inclement": Origins of the Jamaica Slave Laws of the Seventeenth Century', in Christopher Tomlins and Bruce Mann (eds.), *The Many Legalities of Early America*, University of North Carolina Press, 2001, 78–96, p. 90; Diana Paton, 'Punishment, Crime, and the Bodies of Slaves in Eighteenth-Century Jamaica', *Journal of Social History* 34 (2001), 923–54.

9. Dunn, *Sugar*, 170–71, 189–203; Amussen, *Caribbean Exchanges*, 39–40; Sidney Mintz, *Sweetness and Power: The Place of Sugar in Modern History*, Viking, 1985.

10. Dunn, *Sugar*, 164, 165, 224, 230, 237; Anne Murphy, *The Origins of English Financial Markets: Investment and Speculation before the South Sea Bubble*, Cambridge University Press, 2012, 98; Ian Baucom, *Spectres of the Atlantic: Finance Capital, Slavery, and the Philosophy of History*, Duke University Press, 2005, ch. 3; Robin Blackburn, *The Making of New World Slavery: From the Baroque to the Modern, 1492–1800*, Verso, 1997.

11. *NHJ*, 1:vi, xciv; Andrew Wear, *Knowledge and Practice in English Medicine*, Cambridge University Press, 2000, 185, 190–91; Neil Safier, 'Transformations de la Zone Torride: Les Répertoires de la Nature Tropicale à l'Époque des Lumières', *Annales* 66 (2011), 143–72; Hayes quoted in Susan Scott Parrish, *American Curiosity: Cultures of Natural History in the Colonial British Atlantic World*, University of North Carolina Press, 2006, 83; Karen Kupperman, 'Fear of Hot Climates in the Anglo-American Colonial Experience', *WMQ* 41 (1984), 213–40; Antonello Gerbi, *The Dispute of the New World: The History of a Polemic, 1750–1900*, 1955, trans. Jeremy Moyle, University of Pittsburgh Press, 1973; Jorge Cañizares-Esguerra, *How to Write the History of the New World: Histories, Epistemologies, and Identities in the Eighteenth-Century Atlantic World*, Stanford University Press, 2000; 'Inquiries Recommended to Colonel Linch going to Jamaica', 16 December 1670, Sloane MS 3984, fol. 194.

12. Ned Ward, *A Trip to Jamaica*, London, 1698, 14; James Delbourgo, 'Divers Things: Collecting the World under Water', *History of Science* 49 (2011), 149–85; *NHJ*, 1:25.

13. Wear, *English Medicine*, 172; *NHJ*, 1:xvi–xx, xxv; Verene Shepherd, *Livestock, Sugar and Slavery: Contested Terrain in Colonial Jamaica*, Ian Randle, 2009, 23; Steven Shapin, 'The Sciences of Subjectivity', *Social Studies of Science* 42 (2012), 170–84; Emma Spary, 'Self-Preservation: French Travels between *Cuisine* and *Industrie*', in Simon Schaffer *et al.* (eds.), *The Brokered World: Go-Betweens and Global Intelligence, 1770–1820*, Science History Publications, 2009, 355–86.

14. *NHJ*, 1:xx–xxvi.

15. Sloane to John Wallis, 6 February 1699, MS 7633, fol. 1, Wellcome Library, London; *NHJ*, 1:xx, xxvii; Joyce Chaplin, *Subject Matter: Technology, the Body, and Science on the Anglo-American Frontier, 1500–1676*, Harvard University Press, 2001, ch. 4.

16. *NHJ*, 1:xxvii–xxx, lxix; Kupperman, 'Hot Climates', 222; Sloane to Edward Herbert, 17 April 1688, Sloane MS 4068, fol. 7; Kathleen Wilson, 'The Performance of Freedom: Maroons and the Colonial Order in Eighteenth-Century Jamaica and the Atlantic Sound', *WMQ* 66 (2009), 45–86, pp. 51–2; Benjamin Roberts, 'Drinking Like a Man: The Paradox of Excessive Drinking for Seventeenth-Century Dutch Youths', *Journal of Family History* 29 (2004), 237–52.

17. Trevor Burnard, '"The Countrie Continues Sicklie": White Mortality in Jamaica, 1655–1780', *Social History of Medicine* 12 (1999), 45–72, pp. 55–7; *NHJ*, 1:lix, xc, xxxvii, civ–cvii; Wear, *English Medicine*, 48; Thomas Trapham, *A Discourse of the State of Health in the Island of Jamaica*, London, 1679, 68–9, 122–3; Kenneth Kiple, *The Caribbean Slave: A Biological History*, Cambridge University Press, 1984; Richard Sheridan, *Doctors and Slaves: A Medical and Demographic History of Slavery in the British West Indies, 1680–1834*, Cambridge University Press, 1985.

18. Gianna Pomata, 'Sharing Cases: The *Observationes* in Early Modern Medicine', *Early Science and Medicine* 15 (2010), 193–236; Wear, *English Medicine*, 134; *NHJ*, 1:cxliv, cxii, xciii, cxi, cxxxvii–cxxxviii, cxvii–cxviii; Wendy Churchill, 'Bodily Differences? Gender, Race, and Class in Hans Sloane's Jamaican Medical Practice, 1687–1688', *Journal of the History of Medicine and Allied Sciences* 60 (2005), 391–444.

19. *NHJ*, 1:xc–xci, cliii, cxlviii; Barbara Bush, *Slave Women in Caribbean Society, 1650–1838*, Indiana University Press, 1990, ch. 7; Trevor Burnard, 'A Failed Settler Society: Marriage and Demographic Failure in Early Jamaica', *Journal of Social History* 28 (1994), 63–82, and *Mastery, Tyranny, and Desire: Thomas Thistlewood and his Slaves in the Anglo-Jamaican World*, University of North Carolina Press, 2004, ch. 7.

20. *NHJ*, 1:cxxii, c, cxliii, cvi, cxv, cxxvi; Roy Porter, *Health for Sale: Quackery in England, 1660–1850*, Manchester University Press, 1989, 34; Steven Shapin, 'Trusting George Cheyne: Scientific Expertise, Common Sense, and Moral Authority in Early Eighteenth-Century Dietetic Medicine', *Bulletin of the History of Medicine* 77 (2003), 263–97; Londa Schiebinger, *Plants and Empire: Colonial Bioprospecting in the Atlantic World*, Harvard University Press, 2004, ch. 3; Karol Weaver, *Medical Revolutionaries: The Enslaved Healers of Eighteenth-Century Saint Domingue*, University of Illinois Press, 2006, 24.

21. *NHJ*, 1:cvi, cxxxviii–cxxix, cxli–cxlii, cxiv–cxv, cxxx–cxxxi, clii; Miles Ogborn, 'Talking Plants: Botany and Speech in Eighteenth-Century Jamaica', *History of Science* 51 (2013), 251–82.

22. Pomata, 'Sharing Cases'; Kay Dian Kriz, 'Curiosities, Commodities, and Transplanted Bodies in Hans Sloane's "Natural History of Jamaica"', *WMQ* 57 (2000), 35–78, pp. 39–42; *NHJ*, 1:lii–lv, xc, cxiv–cxv, cxxviii, cxxxvi, cxxxv, ci; Wendy Churchill, 'Sloane's Perspectives on the Medical Knowledge and Health Practices of Non-Europeans', in Hunter, *Books to Bezoars*, 90–98; Julie Kim, 'Obeah and the Secret Sources of Atlantic Medicine', in ibid., 99–104; Suman Seth, *Difference and Disease: Locality and Medicine in the Eighteenth-Century British Empire*, forthcoming; Vincent Brown, *The Reaper's Garden: Death and Power in the World of Atlantic Slavery*, Harvard University Press, 2008, ch. 4; Pablo Gómez, 'The Circulation of Bodily Knowledge in the Seventeenth-Century Black Spanish Caribbean', *Social History of Medicine* 26 (2013), 383–402.

23. John McNeill, *Mosquito Empires: Ecology and War in the Greater Caribbean, 1620–1914*, Cambridge University Press, 2010, ch. 3, 212; James Sweet, *Domingos Álvares, African Healing, and the Intellectual History of the Atlantic World*, University of North Carolina Press, 2011, e.g. 56; *NHJ*, 1:xcviii, cxli; Dorothy and Roy Porter, *Patient's Progress: Doctors and Doctoring in Eighteenth-Century England*, Stanford University Press, 1989, ch. 7; Richard Sheridan, 'The Doctor and the Buccaneer: Sir Hans Sloane's Case History of Sir Henry Morgan, Jamaica, 1688', *Journal of the History of Medicine and Allied Sciences* 41 (1986), 76–87.

24. *NHJ*, 2:xv–xvi; 1:xxxi, ix; Wear, *English Medicine*, 180.

25. Estelle Ward, *Christopher Monck, Duke of Albemarle*, John Murray, 1915; Robin Clifton, 'Monck, Christopher', *ODNB*; Sloane, Albemarle case history, Sloane MS 3984, n.d., fols. 282–5.

26. Sloane, Albemarle case history.

27. Ibid.

28. Ibid.; *NHJ*, 1:xlviii; 'Copies of the Minutes of the Councils held at . . . Jamaica', 27 September–6 October 1688, Sloane MS 1599, fols. 84–6; Keith Thomas, *Man and the Natural World: Changing Attitudes in England, 1500–1800*, Penguin, 1983, 123; Wear, *English Medicine*, 138–9; Katharine Park, 'The Life of the Corpse: Division and Dissection in Late Medieval Europe', *Journal of the History of Medicine* 50 (1995), 111–32; Roy Porter, *Flesh in the Age of Reason*, Allen Lane, 2003, part 1; Brown, *Reaper's Garden*, 89–90; Julia Kristeva, *Powers of Horror: An Essay on Abjection*, trans. Leon Roudiez, Columbia University Press, 1982; Michael Taussig, *My Cocaine Museum*, University of Chicago Press, 2004, 174–5; Sophie Gee, *Making Waste: Leftovers and the Eighteenth-Century Imagination*, Princeton University Press, 2009, 7–8, 126, 130.

29. Sloane, Albemarle case history.

30. *NHJ*, 1:lxxiii.

31. Ibid., 1:lxxv, lx–lxii, 109, lxiii, and 2:table 190 (cotton gin); Lissa Roberts, 'The Death of the Sensuous Chemist: The "New" Chemistry and the

Transformation of Sensuous Technology', *Studies in the History and Philosophy of Science* 26 (1995), 503–29; Kriz, 'Curiosities', 68–73; Jordan Kellman, 'Nature, Networks, and Expert Testimony in the Colonial Atlantic: The Case of Cochineal', *Atlantic Studies* 7 (2010), 373–95.

32. *NHJ*, 1:lx, lxv; Francis Watson to Sloane, 22 April 1689, Sloane MS 4036, fol. 51, and 13 May 1690, ibid., fol. 80; William Bragg to Sloane, 22 April 1689, ibid., fol. 47; Dunn, *Sugar*, 174–5.

33. *NHJ*, 1:xxxviii, lxv, lxiv; Dunn, *Sugar*, 36, 38–9, 213, Helyar quotation 38; Amussen, *Caribbean Exchanges*, ch. 3; Anonymous, 'Rose of Jamaica', *Caribbeana* 5 (1917), 130–39; Burnard, 'Who Bought Slaves?', 74.

34. *NHJ*, 1:lxv–lxvi, 2:xviii, 1:xxxviii.

35. *NHJ*, 1:lxv–lxvi; Anthony Pagden, *The Fall of Natural Man: The American Indian and the Origins of Comparative Ethnology*, Cambridge University Press, 1987, chs. 5–6; E. Shaskan Bumas, 'The Cannibal Butcher Shop: Protestant Uses of Las Casas's *Brevísima Relación* in Europe and the American Colonies', *Early American Literature* 35 (2000), 107–36, Phillips quotations 123; Margaret Greer *et al.* (eds.), *Rereading the Black Legend: The Discourses of Religious and Racial Difference in the Renaissance Empires*, University of Chicago Press, 2008; Michael Gaudio, *Engraving the Savage: The New World and Techniques of Civilization*, University of Minnesota Press, 2008; Francis Bacon, *The Essays*, Penguin, 1985, 162.

36. Thomas Ballard to Sloane, 12 May 1690, Sloane MS 4036, fol. 78; Sloane, Metals Catalogue, NHM, 21; *NHJ*, 1:lxxi, lxxxix; Henry Barham, 'Civil History of Jamaica to 1722', Add. MS 12422, fol. 157; 'Proposals to the Company of Mines Royal in Jamaica', Add. MS 22639, fol. 13; Barham to Sloane, 21 November 1721, Sloane MS 4045, fol. 68, and 17 April 1725, Sloane MS 4047, fol. 337; Zahedieh, *Capital*, 119, 231, 233, 283.

37. *NHJ*, 1:i; Nicolás Wey Gómez, *The Tropics of Empire: Why Columbus Sailed South to the Indies*, MIT Press, 2008; Paula Findlen, *Possessing Nature: Museums, Collecting and Scientific Culture in Early Modern Italy*, University of California Press, 1994, 313–15, Aldrovandi quotation 314, and 'Natural History', in Lorraine Daston and Katharine Park (eds.), *The Cambridge History of Science, Volume 3: Early Modern Science*, Cambridge University Press, 2006, 435–68, p. 448; Sloane, 'Account of Four Sorts of Strange Beans, Frequently Cast on Shoar on the Orkney Isles', *PT* 19 (1695–7), 298–300, quotation 300; *NHJ*, 1:i–iv; Alfred Crosby, *The Columbian Exchange: Biological and Cultural Consequences of 1492*, Greenwood, 1972, ch. 4; Sloane MSS 375, 3052–4 (Las Casas).

38. *NHJ*, 1:lxvi–lxvii (author's translation); Douglas Armstrong and Kenneth Kelly, 'Settlement Patterns and the Origins of African Jamaican Society: Seville Plantation, St. Ann's Bay, Jamaica', *Ethnohistory* 47 (2000), 369–97; Rebecca Tortello and Jonathan Greenland (eds.), *Xaymaca: Life in Spanish Jamaica, 1494–1655*, Institute of Jamaica, 2009.

39. Barbara Shapiro, *A Culture of Fact: England, 1550–1720*, Cornell University Press, 2000, ch. 3; Marjorie Swann, *Curiosities and Texts: The Culture of Collecting in Early Modern England*, University of Pennsylvania Press, 2001, ch. 3, esp. 104–5, 140; Alix Cooper, *Inventing the Indigenous: Local Knowledge and Natural History in Early Modern Europe*, Cambridge University Press, 2007; David Beck, 'County Natural History: Indigenous Science in England, from Civil War to Glorious Revolution', *Intellectual History Review* 24 (2014), 71–87; *NHJ*, 1:lxvi.

40. *NHJ*, 1:xli, lxx–lxxi.

41. Ibid., 1:lxx–lxxi, xxvii; Sloane, Humana Catalogue, NHM, 18–19 (skull), 20 (humerus), 73 (jaw); Antiquities Catalogue, BM, 102 (urn); Mark Hauser, *An Archaeology of Black Markets: Local Ceramics and Economies in Eighteenth-Century Jamaica*, University Press of Florida, 2008, 127–8; Bryan Edwards, *The History, Civil and Commercial, of the British Colonies in the West Indies*, 2 vols., London, 1793, 1:131; Bumas, 'Cannibal Butcher Shop'; Jill Lepore, *The Name of War: King Philip's War and the Origins of American Identity*, Knopf, 1998, 3–18.

42. *NHJ*, 1:xiii, xliv, xiv, preface, lxiii, ix, xxxiii–xlii (weather chart); Sloane to Herbert, 17 April 1688, Sloane MS 4068, fol. 7; Lorraine Daston and Katharine Park, *Wonders and the Order of Nature, 1150–1750*, Zone, 1998, 25–39; Philip Morgan, 'The Caribbean Environment in the Early Modern Era', unpublished paper; Jan Golinski, *British Weather and the Climate of Enlightenment*, University of Chicago Press, 2007, ch. 3; Amussen, *Caribbean Exchanges*, 51; James Robertson, 'Re-Writing the English Conquest of Jamaica in the Late Seventeenth Century', *English Historical Review* 117 (2002), 813–39.

43. Grove, *Green Imperialism*, ch. 1; Graham Parry, *The Trophies of Time: English Antiquarians of the Seventeenth Century*, Oxford University Press, 1996, 26–43; Swann, *Curiosities*, 108–12; Cooper, *Inventing the Indigenous*, 80–86.

44. Murphy, *English Financial Markets*, 97–105; Harold Cook, 'Time's Bodies: Crafting the Preparation and Preservation of Naturalia', in Pamela Smith and Paula Findlen (eds.), *Merchants and Marvels: Commerce, Science, and Art in Early Modern Europe*, Routledge, 2001, 223–47; *NHJ*, 1:xv, lv–lvi, v–vi, vii–viii; James Delbourgo and Staffan Müller-Wille, 'Listmania: Introduction', *Isis* 103 (2012), 710–15; Trevor Murphy, *Pliny the Elder's Natural History: The Empire in the Encyclopaedia*, Oxford University Press, 2004; Jacques Revel, 'Knowledge of the Territory', *Science in Context* 4 (1991), 133–61; Patricia Seed, *Ceremonies of Possession in Europe's Conquest of the New World, 1492–1640*, Cambridge University Press, 1995.

45. *NHJ*, 1:v ('fitter for the produce'); Sloane, 'Some Observations ... concerning some Wonderful Contrivances of Nature in a Family of Plants in Jamaica, to Perfect the Individuum, and Propagate the Species', *PT* 21

(1699), 113–20, quotations 113, 119, 'Account of Four Sorts of Strange Beans', esp. 299–300, and Vegetable Substances Catalogue, NHM, 366; E. Charles Nelson, *Sea Beans and Nickar Nuts*, Botanical Society of the British Isles, 2000, 31–2; *NHJ*, 1:preface ('so much contrivance').

46. *NHJ*, 1:lxxvi–lxxxix.

47. Richard Baxter, *A Christian Directory*, London, 1673, and Morgan Godwyn, *The Negro's and Indians Advocate*, London, 1680, quoted in Christopher Brown, *Moral Capital: Foundations of British Abolitionism*, University of North Carolina Press, 2006, 57, 69; Jack Greene, '"A Plain and Natural Right to Life and Liberty": An Early Natural Rights Attack on the Excesses of the Slave System in Colonial British America', *WMQ* 57 (2000), 793–808; Aphra Behn, *Oroonoko: or, The Royal Slave*, 1688, Norton, 1997, 38; Thomas Tryon, *Friendly Advice to the Gentlemen-Planters of the East and West Indies*, London, 1684, quoted in Philippe Rosenberg, 'Thomas Tryon and the Seventeenth-Century Dimensions of Antislavery', *WMQ* 61 (2004), 609–42, pp. 624–5; Sloane Printed Books Catalogue, http://www.bl.uk/catalogues/sloane/, accessed August 2014.

48. Nicholas Hudson, 'From "Nation" to "Race": The Origin of Racial Classification in Eighteenth-Century Thought', *Eighteenth-Century Studies* 29 (1996), 247–64; Winthrop Jordan, *White over Black: American Attitudes toward the Negro, 1550–1812*, University of North Carolina Press, 1968, 216–65; Roxann Wheeler, *The Complexion of Race: Categories of Difference in Eighteenth-Century British Culture*, University of Pennsylvania Press, 2000, introduction, ch. 1 and esp. 96, 304; Justin Smith, *Nature, Human Nature, and Human Difference: Race in Early Modern Philosophy*, Princeton University Press, 2015; Daston and Park, *Wonders*, 25–39; Ilona Katzew, *Casta Painting: Images of Race in Eighteenth-Century Mexico*, Yale University Press, 2004, ch. 5; Chaplin, *Subject Matter*, 218–20; Herman Bennett, '"Sons of Adam": Text, Context, and the Early Modern African Subject', *Representations* 92 (2005), 16–45; María Elena Martínez, *Genealogical Fictions: Limpieza de Sangre, Religion, and Gender in Colonial Mexico*, Stanford University Press, 2008.

49. Sidney Klaus, 'A History of the Science of Pigmentation', in James Nordlund *et al.* (eds.), *The Pigmentary System: Physiology and Pathophysiology*, 2nd edn, Wiley-Blackwell, 2006, 5–10, p. 6; François Bernier, 'Nouvelle Division de la Terre, par les differentes Espèces ou Races d'hommes qui l'habitent', *Journal des Sçavans* 12 (1684), 148–55; Daniel Carey, 'Inquiries, Heads, and Directions: Orienting Early Modern Travel', in Judy Hayden (ed.), *Travel Narratives, the New Science, and Literary Discourse, 1569–1750*, Ashgate, 2012, 25–52; Ted McCormick, *William Petty and the Ambitions of Political Arithmetic*, Oxford University Press, 2010; Daniel Carey, *Locke, Shaftesbury and Hutcheson: Contesting Diversity in the Enlightenment and Beyond*, Cambridge University Press, 2005; John

Woodward, *Brief Instructions for Making Observations in All Parts of the World*, London, 1696, 8–10.

50. Linda Colley, *Captives: Britain, Empire, and the World, 1600–1850*, Jonathan Cape, 2002, part 1; Paton, 'Punishment', 931; Wheeler, *Complexion*, 57–65, 83–7, 98–9, esp. 57 (Godwyn) and 61–4 (Xury); Bennett, ' "Sons of Adam" '; Felicity Nussbaum, 'Between "Oriental" and "Blacks So Called", 1688–1788', in Daniel Carey and Lynn Festa (eds.), *Postcolonial Enlightenment: Eighteenth-Century Colonialism and Postcolonial Theory*, Oxford University Press, 2009, 137–66; Bush, *Slave Women*, 15; Hilary Beckles, ' "A Riotous and Unruly Lot": Irish Indentured Servants and Free Men in the English West Indies, 1644–1713', *WMQ* 67 (1990), 503–22; Kristen Block and Jenny Shaw, 'Subjects without an Empire: The Irish in the Early Modern Caribbean', *Past and Present* 210 (2011), 33–60.

51. *NHJ*, 1:xlvii–lvii.

52. Wheeler, *Complexion*, 217–18; Jennifer Morgan, *Labouring Women: Reproduction and Gender in New World Slavery*, University of Pennsylvania Press, 2004; Richard Ligon, *A True and Exact History of the Island of Barbadoes*, London, 1657, 51; Amussen, *Caribbean Exchanges*, 62–7; Carey, *Locke*, 40.

53. Andrew Curran, 'Rethinking Race History: The Role of the Albino in the French Enlightenment Life Sciences', *History and Theory* 48 (2009), 151–79, and *The Anatomy of Blackness: Science and Slavery in an Age of Enlightenment*, Johns Hopkins University Press, 2011; *NHJ*, 1:liii; Royal Society Minutes, 29 December 1696, Sloane MS 3341, fol. 28; 9 December 1696, ibid., fol. 25; David Bindman and Henry Louis Gates, Jr (eds.), *The Image of the Black in Western Art, Part III: From the 'Age of Discovery' to the Age of Abolition – The Eighteenth Century*, Belknap Press, 2011, 192–4; William Byrd, 'Account of a Negro-Boy that is Dappel'd in Several Places of His Body with White Spots', *PT* 19 (1695–7), 781–2; James Delbourgo, 'The Newtonian Slave Body: Racial Enlightenment in the Atlantic World', *Atlantic Studies* 9 (2012), 185–207.

54. *NHJ*, 1:liii ('off-spring of the gods'); Royal Society Minutes, 29 December 1696, Sloane MS 3341, fol. 28 ('fluxed'); Kriz, 'Curiosities', 63; Sloane MS 5246, fols. 19, 11; Richard Altick, *The Shows of London*, Belknap Press, 1978, esp. 37; John Appleby, 'Human Curiosities and the Royal Society, 1699–1751', *NRRS* 50 (1996), 13–27; P. Fontes da Costa, 'The Culture of Curiosity at the Royal Society in the First Half of the Eighteenth Century', *NRRS* 56 (2002), 147–66; James Yonge to Sloane, 16 August 1709, Sloane MS 4042, fol. 35; 'A Letter from Mr James Yonge, FRS, to Dr Hans Sloane', *PT* 26 (1709), 424–31; Journal-Book (original), Royal Society, vol. 8, 19 March 1690, 295–7 ('specifick difference' and 'negro race'), quoted and discussed in Cristina Malcolmson, *Studies of Skin Color in the Early Royal Society: Boyle, Cavendish, Swift*, Ashgate, 2013, 76; Journal-Book (original), Royal Society, vol. 9, 10

December 1690, 18–19 ('severall sculls'), quoted, ibid., 79; Sloane, Humana Catalogue, 155, 441 (Malpighi), 527–8 ('skin of a negro'), 284 (black arm skin), 678 (Virginia fetus); Michael Day, 'Humana: Anatomical, Pathological and Curious Human Specimens in Sloane's Museum', in MacGregor, *Sloane*, 69–76; Klaus, 'A History of the Science of Pigmentation', 5–10.

55. *NHJ*, 1:lvii.

56. Anthony Benezet, *A Caution and Warning to Great Britain and her Colonies*, Philadelphia, 1766, 31–2; James Delbourgo, 'Slavery in the Cabinet of Curiosities: Hans Sloane's Atlantic World', 2007, British Museum website, http://www.britishmuseum.org/pdf/delbourgo%20essay.pdf, accessed August 2015, and 'Die Wunderkammer als Ort von Neugier, Horror und Freiheit', in Nike Bätzner (ed.), *Assoziationsraum Wunderkammer: Zeitgenössische Künste zur Kunst- und Naturalienkammer der Franckeschen Stiftungen zu Halle*, Verlag der Franckeschen Stiftungen zu Halle, 2015, 83–96; Kriz, 'Curiosities', 58; Carey, *Locke*, 63.

57. *NHJ*, 1:lvi; Marcus Wood, *Blind Memory: Visual Representations of Slavery in England and America, 1780–1865*, Routledge, 2000, ch. 5, esp. 232; 'Copies of the Minutes of the Councils held at . . . Jamaica', n.d. and 21 January 1688, Sloane MS 1599, fols. 3, 5; Dunn, *Sugar*, 161, 259, 260.

58. Sloane, Miscellanies Catalogue, BM, 45, 56, 57, 402, 503; *NHJ*, 1:lxxxi, xlvi; Orlando Patterson, 'Slavery and Slave Revolts: A Sociohistorical Analysis of the First Maroon War, 1665–1740', in Richard Price (ed.), *Maroon Societies: Rebel Slave Communities in the Americas*, Johns Hopkins University Press, 1973, 246–92; Londa Schiebinger, 'Scientific Exchange in the Eighteenth-Century Atlantic World', in Bernard Bailyn and Patricia Denault (eds.), *Soundings in Atlantic History: Latent Structures and Intellectual Currents, 1500–1800*, Harvard University Press, 2011, 294–328; Kriz, 'Curiosities', 62.

59. *NHJ*, 1:xlviii–li, table 3, and 2:table 232; sketch by Kickius, 5 August 1701, Sloane MS 5234, fol. 75; Richard Rath, 'African Music in Seventeenth-Century Jamaica: Cultural Transit and Transition', *WMQ* 50 (1993), 700–26, and http://www.way.net/music/audio/Rich%20Rath%20-%20Af MusJamRough01.mp3, accessed October 2014; Shlomo Pestcoe, 'Banjo Beginnings: The Afro-Creole "Strum-Strumps" of Jamaica, 1687–89', https://www.facebook.com/notes/banjo-roots-banjo-beginnings/banjo-begin nings-the-afro-creole-strum-strumps-of-jamaica-1687-89/596163280402853, accessed February 2014; Laurent Dubois, private communication; Kriz, 'Curiosities', 57–62.

60. Ligon, *Barbadoes*, 48; Susan Scott Parrish, 'Richard Ligon and the Atlantic Science of Commonwealths', *WMQ* 67 (2010), 209–48; Johannes Nieuhof, *Gedenkweerdige Brasiliaense zee- en lant-reize*, Amsterdam, 1682; *NHJ*, 2:tables 231–2; Daston and Park, *Wonders*, 434 n. 7; Barry Higman, *Montpelier, Jamaica: A Plantation Community in Slavery and Freedom*,

*1739–1912*, University of the West Indies Press, 1998, esp. ch. 7; Hauser, *Black Markets*; Roderick McDonald, *The Economy and Material Culture of Slaves: Goods and Chattels on the Sugar Plantations of Jamaica and Louisiana*, Louisiana State University Press, 1993, 23–44; Jerome Handler, 'The Middle Passage and the Material Culture of Captive Africans', *Slavery and Abolition* 30 (2009), 1–26; Swann, *Curiosities*, ch. 3; Rath, 'African Music'; Pestcoe, 'Banjo Beginnings'.

61. *NHJ*, 1:lii; Rath, 'African Music'; Pestcoe, 'Banjo Beginnings'; Brown, *Reaper's Garden*, 64.

62. Vincent Brown, 'Social Death and Political Life in the Study of Slavery', *American Historical Review* 114 (2009), 1231–49; Douglas Hall (ed.), *In Miserable Slavery: Thomas Thistlewood in Jamaica, 1750–86*, University of the West Indies Press, 1989; Philip Morgan, 'Slaves and Livestock in Eighteenth-Century Jamaica: Vineyard Pen, 1750–51', *WMQ* 52 (1995), 47–76; Burnard, *Mastery*, chs. 6–7.

63. *NHJ*, 1:xlvii.

64. Ibid., 1:preface.

CHAPTER 3: KEEPING THE SPECIES FROM BEING LOST

1. Alfred Crosby, *The Columbian Exchange: Biological Consequences of 1492*, Greenwood, 1972; Marion Schwartz, *A History of Dogs in the Early Americas*, Yale University Press, 1998, 46; Francisco Padrón, *Spanish Jamaica*, trans. Patrick Bryan, Ian Randle Publishers, 2003; Julie Livingston and Jasbir Puar, 'Interspecies', *Social Text* 29 (2011), 3–14.

2. Crosby, *Columbian Exchange*, 73; Judith Carney, *Black Rice: The African Origins of Rice Cultivation in the Americas*, Harvard University Press, 2001, 158, 163–4; Carney and Richard Rosomoff, *In the Shadow of Slavery: Africa's Botanical Legacy in the Atlantic World*, University of California Press, 2009, esp. 125, 167–8; Roderick McDonald, *The Economy and Material Culture of Slaves: Goods and Chattels on the Sugar Plantations of Jamaica and Louisiana*, Louisiana State University Press, 1993, 16–49, esp. 20 and 109; Barry Higman, *Montpelier, Jamaica: A Plantation Community in Slavery and Freedom, 1739–1912*, University of the West Indies Press, 1998, 193–8; Jill Casid, *Sowing Empire: Landscape and Colonization*, University of Minnesota Press, 2005, 191–236; Beth Tobin, *Colonizing Nature: The Tropics in British Arts and Letters, 1760–1820*, University of Pennsylvania Press, 2005, 56–80; Mark Hauser, *An Archaeology of Black Markets: Local Ceramics and Economies in Eighteenth-Century Jamaica*, Florida Museum of Natural History, 2013; *NHJ*, 1:lii, 223.

3. Carney and Rosomoff, *Shadow of Slavery*, 76–8, 92–4; Higman, *Montpelier*, 192; Williams quoted in Vincent Brown, *The Reaper's Garden: Death*

*and Power in the World of Atlantic Slavery*, Harvard University Press, 2008, 125.

4. *NHJ*, 2:1, 74, 3; Joseph Smith, *Old Cudjoe Making Peace*, frontispiece to R. C. Dallas, *The History of the Maroons*, 2 vols., London, 1803, vol. 1; http://aparcelofribbons.co.uk/2011/11/the-maroon-war-settlement-of-1739/, accessed December 2014; David Watts, *The West Indies: Patterns of Development, Culture and Environmental Change since 1492*, Cambridge University Press, 1990, 393–5; Barbara Bush, *Slave Women in Caribbean Society, 1650–1838*, Indiana University Press, 1990, 99; Brown, *Reaper's Garden*, 65; Kenneth Bilby, *True-Born Maroons*, University Press of Florida, 2005, *passim*, e.g. 141, 232, 297–8; Zora Neale Hurston, *Tell my Horse: Voodoo and Life in Haiti and Jamaica*, Perennial Library, 1990, 25, 28–9; Matthew Lewis, *Journal of a West India Proprietor*, 1834, Oxford University Press, 1999, 155–9.

5. Richard Grove, *Green Imperialism: Colonial Expansion, Tropical Island Edens and the Origins of Environmentalism, 1600–1860*, Cambridge University Press, 1995, 41, 57–8, 67 and *passim*; John Evelyn, *Sylva, or a Discourse of Forest-Trees, and the Propagation of Timber*, London, 1664, 1; Keith Thomas, *Man and the Natural World: Changing Attitudes in England, 1500–1800*, Penguin, 1983, 212–23; *NHJ*, 2:2–3, 31–2, 62–3; John McNeill, *Mosquito Empires: Ecology and War in the Greater Caribbean, 1620–1914*, Cambridge University Press, 2010, ch. 2; Jennifer Anderson, *Mahogany: The Costs of Luxury in Early America*, Harvard University Press, 2012, 93–4.

6. *NHJ*, 2:xviii; Kathleen Wilson, 'The Performance of Freedom: Maroons and the Colonial Order in Eighteenth-Century Jamaica and the Atlantic Sound', *WMQ* 66 (2009), 45–86; Bilby, *Maroons*, 375–8 and 153 (David Gray); Barbaro Martinez Ruiz, 'Sketches of Memory: Visual Encounters with Africa in Jamaican Culture', in Tim Barringer *et al.* (eds.), *Art and Emancipation in Jamaica: Isaac Mendes Belisario and His Worlds*, Yale University Press, 2007, 103–20, pp. 107–11; Frederic Cassidy, *Jamaica Talk: Three Hundred Years of the English Language in Jamaica*, St Martin's Press, 1961, 169, 261.

7. Philip Morgan, 'Slaves and Livestock in Eighteenth-Century Jamaica: Vineyard Pen, 1750–1751', *WMQ* 52 (1995), 47–76, pp. 55, 66; Higman, *Montpelier*, 199–202, 206–8; Cassidy, *Jamaica Talk*, 256; Anonymous, *Marly; or, A Planter's Life in Jamaica*, 1828, Oxford University Press, 2005, 9; Douglas Hall (ed.), *In Miserable Slavery: Thomas Thistlewood in Jamaica, 1750–86*, University of West Indies Press, 1999, 147, 72–3, 77; Richard Dunn, *Sugar and Slaves: The Rise of the Planter Class in the English West Indies, 1624–1713*, University of North Carolina Press, 1972, 278; Alan Mikhail, *The Animal in Ottoman Egypt*, Oxford University Press, 2014, 20, 41.

8. Morgan, 'Slaves and Livestock', 55, 59, 68; Verene Shepherd, *Livestock, Sugar and Slavery: Contested Terrain in Colonial Jamaica*, Ian Randle,

2009, 155; *NHJ*, 1:xlviii; Pratik Chakrabarti, *Materials and Medicine: Trade, Conquest and Therapeutics in the Eighteenth Century*, Manchester University Press, 2010, 33–45; Paula Findlen, *Possessing Nature: Museums, Collecting, and Scientific Culture in Early Modern Italy*, University of California Press, 1994, 170–79; Brian Ogilvie, *The Science of Describing: Natural History in Renaissance Europe*, University of Chicago Press, 2006, 264; Henry Barham to Sloane, 29 January 1718, Sloane MS 4045, fol. 89.

9. Kay Dian Kriz, *Slavery, Sugar, and the Culture of Refinement: Picturing the British West Indies, 1700–1840*, Yale University Press, 2008, 37–8, 44, 50–59.

10. Jerome Handler, 'The Middle Passage and the Material Culture of Captive Africans', *Slavery and Abolition* 30 (2009), 1–26; *NHJ*, 1:xlviii; Robin Law, *The Horse in West Africa*, Oxford University Press, 1980, 52, 168–9; Wilson, 'Performance of Freedom', 46; John Taylor, *Multum in Parvo*, reproduced in David Buisseret (ed.), *Jamaica in 1687: The Taylor Manuscript at the National Library of Jamaica*, University of the West Indies Press, 2008, 272; Sylvia Frey and Betty Wood, *Come Shouting to Zion: African American Protestantism in the American South and British Caribbean to 1830*, University of North Carolina Press, 1998, 54; Bilby, *Maroons*, 330, 149–50, 29, 166–7; Wayne Modest, 'We Have Always Been Modern: Museums, Collections, and Modernity in the Caribbean', *Museum Anthropology* 35 (2012), 85–96.

11. Brown, *Reaper's Garden*, ch. 4; Thomas Walduck to James Petiver, 24 November 1710 and n.d. [1712?], Sloane MS 2302, fols. 20, 28; Jerome Handler, 'Slave Medicine and Obeah in Barbados, circa 1650 to 1834', *New West Indian Guide* 74 (2000), 57–90; James Sweet, *Domingos Álvares, African Healing, and the Intellectual History of the Atlantic World*, University of North Carolina Press, 2011.

12. Brown, *Reaper's Garden*, ch. 4, and 'Slave Revolt in Jamaica, 1760–1761: A Cartographic Narrative' (2012), http://revolt.axismaps.com, accessed December 2016; Susan Scott Parrish, 'Diasporic African Sources of Enlightenment Knowledge', in James Delbourgo and Nicholas Dew (eds.), *Science and Empire in the Atlantic World*, Routledge, 2008, 281–310; Trevor Burnard, *Mastery, Tyranny, and Desire: Thomas Thistlewood and his Slaves in the Anglo-Jamaican World*, University of North Carolina Press, 2004, 200; Hall, *Miserable Slavery*, 104; Stephen Fuller 1789 House of Commons report quoted in William Earle, *Obi: or, The History of Three-Fingered Jack*, 1803, ed. Srinivas Aravamudan, Broadview Press, 2005, 171–3; Benjamin Moseley, *A Treatise on Sugar*, London, 1799, 171; Walter Rucker, 'Conjure, Magic, and Power: The Influence of Afro-Atlantic Religious Practices on Slave Resistance and Rebellion', *Journal of Black Studies* 32 (2001), 84–103; Jason Young, *Rituals of Resistance: African Atlantic Religion in*

*Kongo and the Lowcountry South in the Era of Slavery*, Louisiana State University Press, 2007.

13. Taylor, *Jamaica in 1687*, 272; Henry Barham to Sloane, 11 December 1711, Sloane MS 4045, fol. 77; Earle, *Obi*, 170 (Fuller quotation); David Crossley and Richard Saville (eds.), *The Fuller Letters, 1728–1755: Guns, Slaves and Finance*, Sussex Record Society, 1991, xxxvi–xxxvii.

14. Sloane, Birds Catalogue, NHM, 724; HS, 6:36; *NHJ*, 2:51-2, ix, 382; Bryan Edwards, *The History, Civil and Commercial, of the British Colonies in the West Indies*, 2 vols., London, 1793, 2:94; William Grimé, *Ethno-Botany of the Black Americans*, Reference Publications, 1979, 182–3 (and Edwards, *History*, 2:83); Karol Weaver, *Medical Revolutionaries: The Enslaved Healers of Eighteenth-Century Saint Domingue*, University of Illinois Press, 2006, ch. 4, and 43, 118.

15. Dunn, *Sugar and Slaves*; *NHJ*, 2:xviii.

16. Edmund Campos, 'Thomas Gage and the English Colonial Encounter with Chocolate', *Journal of Medieval and Early Modern Studies* 39 (2009), 183–200; Marcy Norton, *Sacred Gifts, Profane Pleasures: A History of Tobacco and Chocolate in the Atlantic World*, Cornell University Press, 2008, 34–5, 121–40; Terrence Kaufman and John Justeson, 'The History of the Word for "Cacao" and Related Terms in Ancient Meso-America', in Cameron McNeil (ed.), *Chocolate in Mesoamerica: A Cultural History of Cacao*, University Press of Florida, 2006, 117–39, p. 134; José Cuatrecasas, 'Cacao and its Allies: A Taxonomic Revision of the Genus Theobroma', *Contributions from the U.S. National Herbarium* 35 (1964), 379, 383; D. Quélus, *The Natural History of Chocolate*, trans. R. Brookes, 2nd edn, London, 1725, 25; Sophie and Michael Coe, *The True History of Chocolate*, Thames & Hudson, 1996, 165–75; Brian Cowan, *The Social Life of Coffee: The Emergence of the British Coffeehouse*, Yale University Press, 2005, 43, 47, 109; http://www.britishmuseum.org/research/collection_online/collection_object_details.aspx?objectId=42888&partId=1&searchText=sloane+chocolate&page=1, accessed July 2016.

17. John Woodward, *Brief Instructions for Making Observations in all Parts of the World*, London, 1696, 15–16; John Banister to Samuel Doody, n.d., Sloane MS 3321, fol. 3; James Petiver to George Harris, 18 October 1698, Sloane MS 3333, fols. 235–6; Petiver to John Colbatch, 5 January 1696, Sloane MS 3332, fol. 174; James Delbourgo, 'Listing People', *Isis* 103 (2012), 735–42; Kathleen Murphy, 'Collecting Slave Traders: James Petiver, Natural History, and the British Slave Trade', *WMQ* 70 (2013), 613–70.

18. *NHJ*, 1:lxv, 2:121 and 185, 1:preface and cxli; Sloane, 'A Description of the Pimienta or Jamaica Pepper-Tree', *PT* 16 (1686–92), 462–8, quotations 463, 464; Steven Shapin, *A Social History of Truth: Civility and Science in Seventeenth-Century England*, University of Chicago Press, 1994, ch. 8; Tracy-Ann Smith and Katherine Hann, 'Sloane, Slavery and

Science: Perspectives from Public Programmes at the Natural History Museum', in Hunter, *Books to Bezoars*, 227–35.

19. *NHJ*, 1:preface; HS, 3:62 and *NHJ*, 175–6 (*Phaseolus*); HS, 2:2 and *NHJ*, 1:104–5 (Guinea corn); HS, 4:66–7, 4:107, 3:85, 2:2; *NHJ*, 1:223, 241, 175–6, 184, 103–5, 2:61, 1:111; Sloane, Vegetable Substances Catalogue, NHM, 8473; Carney and Rosomoff, *Shadow of Slavery*; Watts, *West Indies*, 386–90; Miles Ogborn, 'Talking Plants: Botany and Speech in Eighteenth-Century Jamaica', *History of Science* 51 (2013), 1–32.

20. *NHJ*, 2:61, 1:184, 107 and 170–71 (vervain), including annotated copy of last, Botany Department, NHM, with Barham MS notes inserted; Carney and Rosomoff, *Shadow of Slavery*, 70–72; Julie Kim, 'Obeah and the Secret Sources of Atlantic Medicine', in Hunter, *Books to Bezoars*, 99–104.

21. Ogilvie, *Science of Describing*, 165–74, 210–15; Woodward, *Instructions*, 12–13; William Charleton (Courten), directions to James Reed, September 1689, Sloane MS 4072, fol. 284; Thomas Grigg to James Petiver, 24 October 1712, Sloane MS 4065, fol. 69.

22. Woodward, *Instructions*, 13; Marjorie Swann, *Curiosities and Texts: The Culture of Collecting in Early Modern England*, University of Pennsylvania Press, 2001, 104–5, 140; Alix Cooper, *Inventing the Indigenous: Local Knowledge and Natural History in Early Modern Europe*, Cambridge University Press, 2010, 79–84 (Ray quotation 81); *NHJ*, 2:19, 1:82, 85, 98–9.

23. Ogilvie, *Science of Describing*, 174–203, 262; Nick Grindle, ' "No Other Sign or Note than the Very Order": Francis Willughby, John Ray and the Importance of Collecting Pictures', *Journal of the History of Collections* 17 (2005), 15–22; Sachiko Kusukawa, 'The Historia Piscium (1686)', *NRRS* 54 (2000), 179–97, and *Picturing the Book of Nature: Image, Text, and Argument in Sixteenth-Century Human Anatomy and Medical Botany*, University of Chicago Press, 2012; Lorraine Daston and Peter Galison, *Objectivity*, Zone, 2007, 55–113; Phillip Sloan, 'John Locke, John Ray, and the Problem of the Natural System', *Journal of the History of Biology* 5 (1972), 1–53; Justin Smith and James Delbourgo, 'Introduction', in Smith and Delbourgo (eds.), 'In Kind: Species of Exchange in Early Modern Science', *Annals of Science* 70 (2013), 299–304.

24. HS, 5:59; *NHJ*, 2:15–17; J. E. Dandy, *The Sloane Herbarium*, British Museum, 1958, 16–17; Sachiko Kusukawa, 'Picturing Knowledge in the Early Royal Society: The Examples of Richard Waller and Henry Hunt', *NRRS* 65 (2011), 273–94; Anke te Heesen, 'News, Paper, Scissors: Clippings in the Sciences and Arts around 1920', in Lorraine Daston (ed.), *Things that Talk: Object Lessons from Art and Science*, Zone, 2004, 297–323.

25. HS, 3:106; *NHJ*, 1:preface, 2:v; Garrett Moore to Sloane, 22 April 1689, Sloane MS 4036, fol. 49.

26. 'A Specialist's Guide to the Sloane Database', NHM, http://www.nhm.ac.uk/ research-curation/scientific-resources/collections/botanical-collections/

sloane-herbarium/about-database/index.html, accessed December 2016; Kusukawa, *Book of Nature*, 32–7; HS, 6:57.

27. Claudia Swan, '*Ad vivum, naer het leven*, from the Life: Considerations on a Mode of Representation', *Word and Image* 11 (1995), 353–72; Ogilvie, *Science of Describing*, 192; HS, 7:58–9; *NHJ*, 2:table 217, fig. 3; Bruno Latour, 'Visualisation and Cognition: Drawing Things Together', *Knowledge and Society* 6 (1986), 1–40; Daniela Bleichmar, *Visible Empire: Botanical Expeditions and Visual Culture in the Hispanic Enlightenment*, University of Chicago Press, 2012.

28. Lissa Roberts *et al.* (eds.), *The Mindful Hand: Inquiry and Invention from the Late Renaissance to Early Industrialization*, Royal Netherlands Academy of Arts and Sciences, 2007; Mario Biagioli and Peter Galison (eds.), *Scientific Authorship: Credit and Intellectual Property in Science*, Routledge, 2002; *NHJ*, 2:viii; Shapin, *Truth*, ch. 8; *NHJ*, 1:135, 189; Dandy, *Sloane Herbarium*; Kusukawa, *Book of Nature*, esp. 24; Janice Neri, *The Insect and the Image: Visualizing Nature in Early Modern Europe, 1500–1700*, University of Minnesota Press, 2011, introduction; Birch, 'Memoirs', fol. 7; James Petiver to Johann Philipp Breyne, n.d., 1706, in Ella Reitsma, *Maria Sibylla Merian and Daughters: Women of Art and Science*, Oxford University Press, 2008, 203.

29. Lorraine Daston, 'Type Specimens and Scientific Memory', *Critical Inquiry* 31 (2004), 153–82; Charlie Jarvis, *Order Out of Chaos: Linnaean Plant Names and their Types*, Linnaean Society of London, 2007, 157–8; James Robertson, 'Knowledgeable Readers: Jamaican Critiques of Sloane's Botany', in Hunter, *Books to Bezoars*, 80–89, pp. 87–9; Patrick Browne, *The Civil and Natural History of Jamaica*, London, 1756, and see also Edward Long, *History of Jamaica*, 3 vols., London, 1774, 1:374; Carolus Linnaeus, *Species plantarum*, 2 vols., Stockholm, 1753, 2:782; Antoine de Jussieu to Sloane, 7 December 1714, Sloane MS 4043, fol. 313; *Grub Street Journal*, 10 May 1733.

30. Alexander Wragge-Morley, 'The Work of Verbal Picturing for John Ray and Some of his Contemporaries', *Intellectual History Review* 20 (2010), 165–79; Kusukawa, *Book of Nature*, 229; *NHJ*, 1:preface, 123, 2:293; HS, 3:68; Shapin, *Truth*, ch. 3; Michael Dettelbach, 'Global Physics and Aesthetic Empire: Humboldt's Physical Portrait of the Tropics', in David Miller and Peter Reill (eds.), *Visions of Empire: Voyages, Botany, and Representations of Nature*, Cambridge University Press, 1996, 258–92.

31. John Brewer, *The Pleasures of the Imagination: English Culture in the Eighteenth Century*, HarperCollins, 1997, Ray quotation 492; *NHJ*, 2:15.

32. Michel Foucault, *The Order of Things: An Archaeology of the Human Sciences*, 1966, Vintage, 1994, ch. 5; John Bender and Michael Marrinan, *The Culture of Diagram*, Stanford University Press, 2010; Karen Kupperman, 'Fear of Hot Climates in the Anglo-American Colonial Experience', *WMQ*

41 (1984), 213–40, p. 232; Norton, *Sacred Gifts, Profane Pleasures*, 121–7; *NHJ*, 2:16–17, 1:xx; see also 1:lv–lvi, cix, cxxxiii, cxxxiv, cxlviii; Sloane MS 1555 (Johannes de Laet translation of Hernández); Francisco Hernández, *The Mexican Treasury: The Writings of Dr Francisco Hernández*, ed. Simon Varey, Stanford University Press, 2000, 9–12, 19–22; 'To Prepare Chocolate in the Spanish and English Way' (seventeenth century), Sloane MS 647, fol. 7; Nuala Zahedieh, *The Capital and the Colonies: London and the Atlantic Economy, 1660–1700*, Cambridge University Press, 2010, 229–30.

33. Hernández, *Mexican Treasury*, 108; Norton, *Sacred Gifts, Profane Pleasures*, 123, 125–6; Gianna Pomata and Nancy Siraisi (eds.), *Historia: Empiricism and Erudition in Early Modern Europe*, MIT Press, 2005, introduction, esp. 9; Ogilvie, *Science of Describing*, ch. 3; Kusukawa, *Book of Nature*, ch. 6; Marina Frasca-Spada and Nick Jardine (eds.), *Books and the Sciences in History*, Cambridge University Press, 2000; Ann Blair, *Too Much to Know: Managing Scholarly Information before the Modern Age*, Yale University Press, 2010; *NHJ*, 2:16–17; Foucault, *Order of Things*, ch. 5.

34. *NHJ*, 1:title page; Kay Dian Kriz, 'Curiosities, Commodities, and Transplanted Bodies in Hans Sloane's "Natural History of Jamaica"', *WMQ* 57 (2000), 35–78, pp. 13–14.

35. McNeill, *Mosquito Empires*, 23, 48–56; *NHJ*, 1:clii.

36. Dániel Margócsy, *Commercial Visions: Science, Trade, and Visual Culture in the Dutch Golden Age*, University of Chicago Press, 2014, 33–7; 'Inquiries Recommended to Colonel Linch going to Jamaica', 16 December 1670, Sloane MS 3984, fol. 194; Peter Mason, *Before Disenchantment: Images of Exotic Animals and Plants in the Early Modern World*, Reaktion, 2009.

37. *NHJ*, 1:xvi, xii, 2:89, 335–6, 333, 282–90, 1:lxxxiii–lxxxiv, 51; James Delbourgo, 'Divers Things: Collecting the World under Water', *History of Science* 49 (2011), 149–85; Molly Warsh, 'Enslaved Pearl Divers in the Sixteenth Century Caribbean', *Slavery and Abolition* 31 (2010), 345–62.

38. *NHJ*, 2:327–8, 1:lxxxiv–lxxxv; Shepherd, *Livestock*, ch. 1; Carney and Rosomoff, *Shadow of Slavery*, ch. 9; Sloane, Quadrupeds Catalogue, NHM, 1107.

39. *NHJ*, 2:334–5; Sloane, Quadrupeds Catalogue, 446, 1089, 535; Ogilvie, *Science of Describing*, 263.

40. James Petiver, *Brief Directions for the Easie Making, and Preserving Collections of all Natural Curiosities*, London, 1700?, Sloane's copy, Add. MS 4448, fol. 5; Woodward, *Instructions*, 15; Charleton to Reed, instructions; Harold Cook, 'Time's Bodies: Crafting the Preparation and Preservation of Naturalia', in Pamela Smith and Paula Findlen (eds.), *Merchants and Marvels: Commerce, Science, and Art in Early Modern Europe*, Routledge,

2001, 223–47, and *Matters of Exchange: Commerce, Medicine, and Science in the Dutch Golden Age*, Yale University Press, 2007, 267–76; Michael Lynch, 'Sacrifice and the Transformation of the Animal Body into a Scientific Object: Laboratory Culture and Ritual Practice in the Neurosciences', *Social Studies of Science* 18 (1988), 265–89.

41. Mike Fitton and Pamela Gilbert, 'Insect Collections', in MacGregor, *Sloane*, 112–22; Thomas, *Man and the Natural World*, 18; Giorgio Agamben, *The Open: Man and Animal*, trans. Kevin Attell, Stanford University Press, 2004, 22; Richard Drayton, *Nature's Government: Science, Imperial Britain, and the 'Improvement' of the World*, Yale University Press, 2000, ch. 1; Brian Ogilvie, 'Nature's Bible: Insects in Seventeenth-Century European Art and Science', *Tidsskrift* 3 (2008), 5–21; Neri, *Insect and the Image*; Matthew Hunter, *Wicked Intelligence: Visual Art and the Science of Experiment in Restoration London*, University of Chicago Press, 2013; *NHJ*, 2:189.

42. *NHJ*, 2:185, 191, 198, table 233, figs. 4–5; James Petiver to John Colbatch, 5 January 1696, Sloane MS 3332, fol. 174; John Leming to Sloane, 26 November 1688, Sloane MS 4036, fol. 45; Sloane, Insects Catalogue, NHM, 206.

43. Sloane, Insects Catalogue, 50, 153, 165, 197, 3665; *NHJ*, 2:193–5, 208, 2–3, tables 9, 234 fig. 2, and 233 fig. 8; William Walker to Sloane, 5 March 1740, Sloane MS 4056, fol. 211.

44. *NHJ*, 1:cxxvi, cxv, cxxxii; Sloane, Insects Catalogue, 3492; see also John Burnet to Sloane, 6 April 1722, Sloane MS 4046, fol. 227, and Henry Barham to Sloane, 5 July 1722, Sloane MS 4046, fol. 260.

45. *NHJ*, 1:cxxiv–cxxvi; Barham to Sloane, 29 January 1718, Sloane MS 4045, fol. 89; Wendy Churchill, 'Sloane's Perspectives on the Medical Knowledge and Health Practices of Non-Europeans', in Hunter, *Books to Bezoars*, 90–98, p. 92; Weaver, *Medical Revolutionaries*, 49.

46. *NHJ*, 2:Book II; Ogilvie, 'Nature's Bible'; Neri, *Insect and the Image*, 117–18; Mary Terrall, 'Following Insects Around: Tools and Techniques of Eighteenth-Century Natural History', *BJHS* 43 (2010), 573–88; Emma Spary, 'Scientific Symmetries', *History of Science* 42 (2004), 1–46; Lorraine Daston, 'Attention and the Values of Nature in the Enlightenment', in Daston and Fernando Vidal (eds.), *The Moral Authority of Nature*, University of Chicago Press, 2004, 100–126.

47. *NHJ*, 2:223, 206, 198, 293; [Sloane's hand], 'Account of a Surinam toad, by the Burgomaster of Amsterdam', n.d., Sloane MS 4025, fol. 251.

48. *NHJ*, 2:329–30; Sloane, Quadrupeds Catalogue, 622, 677 and Miscellanies Catalogue, 1027, 543; Grove, *Green Imperialism*, 147–57; Juliet Clutton-Brock, 'Vertebrate Collections', in MacGregor, *Sloane*, 77–92, pp. 83, 84; Vera Keller, 'Nero and the Last Stalk of *Silphion*: Collecting Extinct Nature in Early Modern Europe', *Early Science and Medicine* 19 (2014),

424–47; Natalie Lawrence, 'Assembling the Dodo in Early Modern Natural History', *BJHS* 48 (2015), 387–408.

49. *NHJ*, 1:xvii, 2:298, 294, 1:cxlvii; Bilby, *Maroons*, xiii; Taylor, *Jamaica in 1687*, 295; Douglas Hamilton and Robert Blyth (eds.), *Representing Slavery: Art, Artefacts and Archives in the Collections of the National Maritime Museum*, Lund Humphries, 2007, 162.

50. Burnard, *Mastery*, 4 (crab); Bilby, *Maroons*, xiii, 133, 269, 460 n. 15, 73, 77–8; Morgan, 'Slaves and Livestock', 64, 69–70; Orlando Patterson, *The Sociology of Slavery: An Analysis of the Origins, Development, and Structure of Negro Slave Society in Jamaica*, Fairleigh Dickinson University Press, 1967, 251–3; Wilson Harris on spider man cited in Elizabeth DeLoughrey, *Routes and Roots: Navigating Caribbean and Pacific Island Literatures*, University of Hawai'i Press, 2010, 94.

51. *NHJ*, 1:lxv, 2:329, 1:lxix, lxvii; Sloane, Quadrupeds Catalogue, 145; *NHJ*, 2:298, 1:xxv, 2:194, 1:lii.

52. *NHJ*, 2:200, 196, 221, 1:424–5; Sloane, Birds Catalogue, 424–5.

53. Kriz, 'Curiosities', 48–57; Foucault, *Order of Things*, ch. 5; William Ashworth, Jr, 'Emblematic Natural History of the Renaissance', in Nicholas Jardine *et al.* (eds.), *Cultures of Natural History*, Cambridge University Press, 1996, 17–37; Delbourgo, 'Divers Things'.

54. *NHJ*, 2:222–3, 1:29, 2:201, 1:lxxix, lxxxi–lxxxii, 23–4; Thomas, *Natural World*, 61; Petiver, *Brief Directions*.

55. *NHJ*, 2:332, 1:lxxii–lxxiii.

56. *NHJ*, 2:341, 335–6, 346, 1:lxiv; Dunn, *Sugar*, 161–2, 165, 233; Lawrence Wright, 'Remarkable Observations and Accidents on board His Majesty's Ship *Assistance*', 17 January 1689: Captains' Logs, 68, National Archives, London.

57. *NHJ*, 2:341–3.

58. Ibid., 2:344.

59. Ibid., 2:345–7.

60. Ibid., 2:347–8.

61. Ibid., 2:346; Sloane, Serpents Catalogue, NHM, 48.

## CHAPTER 4: BECOMING HANS SLOANE

1. Jonathan Israel, 'The Dutch Role in the Glorious Revolution', and D. W. Hayton, 'The Williamite Revolution in Ireland, 1688–91', in Israel (ed.), *The Anglo-Dutch Moment: Essays on the Glorious Revolution and its World Impact*, Cambridge University Press, 2003, 105–62 and 185–214; Steven Pincus, *1688: The First Modern Revolution*, Yale University Press, 2009; Lisa Jardine, *Going Dutch: How England Plundered Holland's Glory*, HarperCollins, 2008.

2. William Gould to Sloane, 25 January 1681, Sloane MS 4036, fol. 1; Sloane, Miscellanies Catalogue, BM, 181; Jonathan Bardon, *The Plantation of Ulster: The British Colonisation of the North of Ireland in the Seventeenth Century*, Gill & Macmillan, 2011, ch. 6, esp. 162-5, Aughrim quotation 165; Sloane to Arthur Rawdon, 5 June 1690, in *The Rawdon Papers, Consisting of Letters on Various Subjects, Literary, Political and Ecclesiastical*, London, 1819, 394; D. W. Hayton, *Ruling Ireland, 1685-1742: Politics, Politicians, and Parties*, Boydell, 2004, 46-8, 58, 75; James Hamilton to Arthur Rawdon, 28 March 1691, ibid., 339-43; de Beer, *Sloane*, 50, 69-70.

3. Julian Hoppit, *A Land of Liberty? England, 1689-1727*, Oxford University Press, 2000, chs. 4, 10; John Brewer, *The Sinews of Power: War, Money, and the English State, 1688-1783*, Unwin Hyman, 1989; Anne Murphy, *The Origins of English Financial Markets: Investment and Speculation before the South Sea Bubble*, Cambridge University Press, 2012, chs. 1-2; Carl Wennerlind, *Casualties of Credit: The English Financial Revolution, 1620-1720*, Harvard University Press, 2011.

4. Hoppit, *Liberty*, chs. 2, 5, 9, 12; Paul Langford, *A Polite and Commercial People: England, 1727-1783*, Oxford University Press, 1994, ch. 2; Linda Colley, *Britons: Forging the Nation, 1707-1837*, Yale University Press, 1992, ch. 1, 71-85 and 195-204; Kathleen Wilson, *The Sense of the People: Politics, Culture, and Imperialism in England, 1715-1785*, Cambridge University Press, 1998, ch. 2.

5. Hoppit, *Liberty*, 30; Roy Porter, *English Society in the Eighteenth Century*, Allen Lane, 1982, chs. 1-3, Fielding quotation 75; Steven Shapin, *A Social History of Truth: Civility and Science in Seventeenth-Century England*, University of Chicago Press, 1994, ch. 2.

6. King cited in Porter, *English Society*, 14; Massie cited in Langford, *Polite and Commercial People*, 62-4, and 146 (population).

7. Colley, *Britons*, 56-71; Jack Greene, *Pursuits of Happiness: The Social Development of Early Modern British Colonies and the Formation of American Culture*, University of North Carolina Press, 1988; K. N. Chaudhuri, *The Trading World of Asia and the English East India Company, 1660-1760*, Cambridge University Press, 1978; Kenneth Pomeranz, *The Great Divergence: China, Europe, and the Making of the Modern World Economy*, Princeton University Press, 2000, esp. 56, 204, 221-2; Maxine Berg, *Luxury and Pleasure in Eighteenth-Century Britain*, Oxford University Press, 2007; Porter, *English Society*, 189 (statistics); Frank Trentmann, *Empire of Things: How We Became a World of Consumers, from the Fifteenth Century to the Twenty-First*, Allen Lane, 2016.

8. Joseph Addison, *Spectator* 69, 19 May 1711; Margaret Jacob, *Strangers Nowhere in the World: The Rise of Cosmopolitanism in Early Modern Europe*, University of Pennsylvania Press, 2006; Peter Earle, *The Making*

*of the English Middle Class: Business, Society and Family Life in London,
1660–1730*, University of California Press, 1989, 5–12; Colley, *Britons*, ch.
2; J. C. D. Clark, *English Society, 1660–1832: Religion, Ideology, and
Politics during the Ancien Regime*, Cambridge University Press, rev. edn,
2000; Neil McKendrick *et al.*, *The Birth of a Consumer Society: The Com-
mercialization of Eighteenth-Century England*, Europa, 1982; John Brewer
and Roy Porter (eds.), *Consumption and the World of Goods*, Routledge,
1993; Langford, *Polite and Commercial People*, 34, 41, 65–6; Michael
McKeon, *The Origins of the English Novel, 1600–1740*, Johns Hopkins
University Press, 1987, ch. 4.

9. John Carswell, *The South Sea Bubble*, Cresset, 1960; Wennerlind, *Casual-
ties*, ch. 6, Swift quotation 238; Larry Stewart, 'The Edge of Utility: Slaves
and Smallpox in the Early Eighteenth Century', *Medical History* 29 (1985),
54–70, 'golden phrenzy' quotation 54; Sean Shesgreen (ed.), *Engravings by
Hogarth*, Dover, 1973, plate 1.

10. Massie cited in Langford, *Polite and Commercial People*, 62–4; Simon
Schaffer, 'Defoe's Natural Philosophy and the Worlds of Credit', in John
Christie and Sally Shuttleworth (eds.), *Nature Transfigured: Science and
Literature, 1700–1900*, Manchester University Press, 1989, 13–44; Daniel
Defoe, *The Fortunes and Misfortunes of the Famous Moll Flanders*, Lon-
don, 1722, 68.

11. Sloane quoted in Michael Hunter (ed.), *Magic and Mental Disorder: Sir
Hans Sloane's Memoir of John Beaumont*, Robert Boyle Project, 2011, 6
('acquiring'); Kathleen Wilson, *The Island Race: Englishness, Empire and
Gender in the Eighteenth Century*, Routledge, 2003, 129–68; Markman
Ellis, *The Coffee House: A Cultural History*, Weidenfield & Nicolson,
2004, 187; David Dabydeen, *Hogarth's Blacks: Images of Blacks in
Eighteenth-Century English Art*, University of Georgia Press, 1987, 87–9;
Nuala Zahedieh, *The Capital and the Colonies: London and the Atlantic
Economy, 1660–1700*, Cambridge University Press, 2010, 131–6; William
Pettigrew, *Freedom's Debt: The Royal African Company and the Politics of
the Atlantic Slave Trade, 1672–1752*, University of North Carolina Press,
2013, 42–3; Richard Dunn, *Sugar and Slaves: The Rise of the Planter Class
in the English West Indies, 1624–1713*, University of North Carolina Press,
1972, 208; *NHJ*, 1:lxv; Trevor Burnard, 'Who Bought Slaves in Early
America? Purchasers of Slaves from the Royal African Company in Jamaica,
1674–1708', *Slavery and Abolition* 17 (1996), 68–92, pp. 74, 77; will of Fulke
Rose, 24 March 1694, Prob. 11/420, National Archives, London; Sloane-
Rose marriage settlement, 9 May 1695, Add. Ch. 46345 b., BL; Sloane MS
321 (family pedigree); Eric St John Brooks, *Sir Hans Sloane: The Great Col-
lector and His Circle*, Batchworth Press, 1954, 158–9, 214–16; Anonymous,
'Rose of Jamaica', *Caribbeana* 5 (1917), 130–39, esp. 130, 135; David Crossley
and Richard Saville (eds.), *The Fuller Letters, 1728–1755: Guns, Slaves and*

*Finance*, Sussex Record Society, 1991, xxiv; Arthur MacGregor, 'The Life, Character and Career of Sir Hans Sloane', in MacGregor, *Sloane*, 11–44, p. 37 n. 42; Sloane to Locke, 14 September 1696, in E. S. de Beer (ed.), *The Correspondence of John Locke*, 8 vols., Clarendon Press, 1976–89, 6:737.

12. Sloane to John Ray, 21 August 1700, Sloane MS 4038, fol. 53; to John Locke, 2 January 1701, de Beer, *Correspondence of John Locke*, 7:218; Samuel Pepys to Sloane, 31 July 1702, Sloane MS 4039, fol. 12; Lisa Smith, 'Sloane as Friend and Physician of the Family', in Hunter, *Books to Bezoars*, 48–56, p. 50, and 'The Body Embarrassed? Rethinking the Leaky Male Body in Eighteenth-Century England and France', *Gender and History* 23 (2011), 26–46, p. 33.

13. Porter, *English Society*, 57; Dorothy and Roy Porter, *Patient's Progress: Doctors and Doctoring in Eighteenth-Century England*, Stanford University Press, 1989, 122; Jerry White, *London in the Eighteenth Century: A Great and Monstrous Thing*, Bodley Head, 2012, 72; de Beer, *Sloane*, 51; Marjorie Caygill, 'Sloane's Catalogues and the Arrangement of his Collections', in Hunter, *Books to Bezoars*, 120–36, p. 276 n. 52.

14. Thomas Osborne to Sloane, 15 January 1705, Sloane MS 4078, fol. 198.

15. Nicholas Jewson, 'Medical Knowledge and the Patronage System in 18th-Century England', *Sociology* 8 (1974), 369–85, Sydenham quotation 381; Roy Porter, *Health for Sale: Quackery in England, 1660–1850*, Manchester University Press, 1989, 23, 34, 44, and *Bodies Politic: Disease, Death, and Doctors in Britain, 1650–1900*, Cornell University Press, 2001, ch. 6, esp. 143; Harold Cook, 'Sir John Colbatch and Augustan Medicine: Experimentalism, Character, and Entrepreneurialism', *Annals of Science* 47 (1990), 475–505; Steven Shapin, 'Trusting George Cheyne: Scientific Expertise, Common Sense, and Moral Authority in Early Eighteenth-Century Dietetic Medicine', *Bulletin of the History of Medicine* 77 (2003), 263–97; Hoppit, *Liberty*, 333.

16. Robert Walpole to Sloane, 17 August 1733, Sloane MS 3984, fol. 107; Charles Delafaye to Sloane, 8 September 1724, Sloane MS 4047, fol. 234 (Newcastle); Francis Child to Sloane, n.d., Sloane MS 4058, fol. 121; de Beer, *Sloane*, 68–9 (Bedford); Charles Delafaye to Sloane, 20 February 1722, Sloane MS 3984, fol. 98 (Orrery); Elizabeth Furdell, *The Royal Doctors, 1485–1714: Medical Personnel at the Tudor and Stuart Courts*, University of Rochester Press, 2001; 'Sloane's Museum at Bloomsbury, as described by Zacharias Konrad von Uffenbach, 1710', in MacGregor, *Sloane*, 30; M. Giraudeau to Sloane, 13 July 1709, Sloane MS 4042, fol. 10 (Denmark); Ludmilla Jordanova, 'Portraits, People and Things: Richard Mead and Medical Identity', *History of Science* 61 (2003), 93–113; Birch, 'Memoirs', fol. 14; Jacob Price, 'Heathcote, Gilbert', *ODNB*.

17. Nicolaus Staphorst, the younger, to Sloane, 22 June 1689, Sloane MS 4036, fol. 54; Robert Southwell to Sloane, n.d., Sloane MS 4061, fol. 38; Smith,

'Sloane as Friend', 53–5, including at p. 55 quotation from Elizabeth New-
digate to Sloane, 1 November 1706, Sloane MS 4040, fols. 345–6, and 'Body
Embarrassed'; Catherine Crawford, 'Legalizing Medicine: Early Modern
Legal Systems and the Growth of Medico-Legal Knowledge', in Michael
Clark and Catherine Crawford (eds.), *Legal Medicine in History*, Cam-
bridge University Press, 1994, 89–116, pp. 91, 93; Silvia De Renzi, 'Medical
Expertise, Bodies, and the Law in Early Modern Courts', *Isis* 98 (2007),
315–22.

18. Lady Sondes to Sloane, 1730?, Sloane MS 4061, fols. 285–6, quoted in
Smith, 'Sloane as Friend', 53; Sloane, Miscellanies Catalogue, 1862; Mary
Ferrers to Sloane, n.d., Sloane MS 4058, fols. 327–33, cited in Wayne Wild,
*Medicine-by-Post: The Changing Voice of Illness in Eighteenth-Century
British Consultation Letters and Literature*, Rodopi, 2006, 98–101; Sloane,
Birds Catalogue, NHM, 607.

19. Nicolaus Staphorst, the younger, to Sloane, 22 June 1689, Sloane MS 4036,
fol. 54; de Beer, *Sloane*, 55–7; *NHJ*, 1:i; Larry Stewart, *The Rise of Public
Science: Rhetoric, Technology, and Natural Philosophy in Newtonian
Britain, 1660–1750*, Cambridge University Press, 1992, 144–5; Peter Clark,
*British Clubs and Societies, 1500–1800: The Origins of an Associational
World*, Oxford University Press, 2000, ch. 3; Brian Cowan, *The Social Life
of Coffee: The Emergence of the British Coffeehouse*, Yale University
Press, 2005; Therese O'Malley and Amy Meyers (eds.), *The Art of Natural
History: Illustrated Treatises and Botanical Paintings, 1400–1850*, Yale
University Press, 2010, appendix; John Evelyn, 16 April 1691, in *Memoirs,
Illustrative of the Life and Writings of John Evelyn*, 2nd edn, London,
1819, 25.

20. John Ray to Sloane, 23 June 1696 in Edwin Lankester (ed.), *The Correspond-
ence of John Ray*, The Ray Society, 1848, 295; M. A. E. Nickson, 'Books and
Manuscripts', in MacGregor, *Sloane*, 263–77; Amy Blakeway, 'The Library
Catalogues of Sir Hans Sloane: Their Authors, Organization, and Fun-
ctions', *Electronic British Library Journal* (2011), 1–49, http://www.bl.uk/
eblj/2011articles/pdf/ebljarticle162011.pdf, accessed December 2016.

21. *NHJ*, 1:preface; Francisco Hernández, *The Mexican Treasury: The Writ-
ings of Dr Francisco Hernández*, ed. Simon Varey, Stanford University
Press, 2000, 19–22; William Aglionby to Sloane, 18 June 1692, Sloane MS
4036, fol. 128.

22. Joseph Pitton de Tournefort to Sloane, 20 March 1698, Sloane MS 4037,
fol. 44, and 10 April 1698, ibid., fol. 55; Sloane to Anthoine de Jussieu, 25
May 1714, Sloane MS 4068, fol. 87; *NHJ*, 1:preface; Jean Jacquot, 'Sir
Hans Sloane and French Men of Science', *NRRS* 10 (1953), 85–98.

23. *NHJ*, 1:lxxiv, preface, 98, 2:187; Harold Cook, *Matters of Exchange:
Commerce, Medicine, and Science in the Dutch Golden Age*, Yale Univer-
sity Press, 2007, 325.

24. Tournefort to Sloane, 12 February 1698, Sloane MS 4037, fol. 27; Ray to Sloane, 6 April 1698, Sloane MS 4037, fol. 48, and 22 March 1698, Sloane MS 4037, fol. 235; Phillip Sloan, 'John Locke, John Ray, and the Problem of the Natural System', *Journal of the History of Biology* 5 (1972), 1–53; Sloane to Abbé Jean-Paul Bignon, Sloane MS 4069, n.d. [1723/4], fols. 192–3; Ray to Sloane, n.d., Sloane MS 4060, fol. 168 (venison); and 22 March 1696, Lankester, *Correspondence of John Ray*, 294 (sugar); Ray to Sloane, 10 August 1698, Sloane MS 4037, fol. 108; Charles Raven, *John Ray, Naturalist: His Life and Works*, Cambridge University Press, 1942, 301.

25. Sloane, *NHJ*, 1:preface; Ray to Sloane, 12 February 1695, Sloane MS 4036, fol. 226; Raven, *Ray*, 185.

26. Ray to Sloane, 11 February 1684, Sloane MS 4036, fol. 10 (fungus) 2 June 1699, Sloane MS 4037, fol. 281 (ink); n.d., Sloane MS 4060, fol. 167 (*Amomum*); Lorraine Daston, 'Type Specimens and Scientific Memory', *Critical Inquiry* 31 (2004), 153–82; *NHJ*, 2:xiii, xvii ('endeavouring' and 'great obstruction'), and 8–9 (coco tree); Ray to Sloane, 5 August 1696 (Magellan), Lankester, *Correspondence of John Ray*, 299; Cook, *Exchange*, esp. 311–17, 325; Pratik Chakrabarti, *Materials and Medicine: Trade, Conquest and Therapeutics in the Eighteenth Century*, Manchester University Press, 2011, 149.

27. Birch, 'Memoirs', fol. 5; Michael Hunter, *Establishing the New Science: The Experience of the Early Royal Society*, Boydell, 1995, 341–2; Simon Schaffer, 'Newton on the Beach: The Information Order of *Principia Mathematica*', *History of Science* 47 (2009), 243–76; Edmond Halley to Sloane, 26 October 1700, in Eugene Fairfield MacPike (ed.), *Correspondence and Papers of Edmond Halley*, Clarendon Press, 1932, 115; de Beer, *Sloane*, 55–6; Johann Gaspar Scheuchzer quotation in Engelbert Kaempfer, *The History of Japan*, trans. Scheuchzer, 2 vols., London, 1727, 1:xvii; William Stukeley, *The Family Memoirs of the Reverend William Stukeley*, 3 vols., Surtees Society, 1882–7, 1:126.

28. *PT* 21 (1699), dedication; Sloane, 'A Description of the Pimienta or Jamaica Pepper-Tree, and of the Tree That Bears the Cortex Winteranus', *PT* 16 (1686–92), 462–8; 'Account of a Prodigiously Large Feather of the Bird Cuntur . . . and of the Coffee-Shrub', *PT* 18 (1694), 61–4; 'Letter from Hans Sloane . . . with Several Accounts of the Earthquakes in Peru . . . and at Jamaica', *PT* 18 (1694), 78–100; 'Account of Four Sorts of Strange Beans, Frequently Cast on Shoar on the Orkney Isles', *PT* 19 (1695–7), 298–300; 'Account of the Tongue of a Pastinaca Marina, Frequent in the Seas about Jamaica, and Lately Dug up in Mary-Land, and England', *PT* 19 (1695–7), 674–6; 'Of the Use of the Root Ipecacuanha', *PT* 20 (1698), 69–79; 'Some Observations . . . concerning some Wonderful Contrivances of Nature in a Family of Plants in Jamaica, to Perfect the Individuum, and Propagate the Species', *PT* 21 (1699), 113–20; 'Part of a Letter from Mr George Dampier . . . Concerning the Cure of the Bitings of Mad Creatures', *PT* 20 (1698), 49–52;

Thomas Shaw, 'Letter to Sir Hans Sloane', *PT* 36 (1729–30), 177–84; Sloane to unknown, n.d., Sloane MS 4069, fol. 267; Edward Lhwyd, 'Extracts of Several Letters from Mr. Edward Lhwyd ... Containing Observations in Natural History and Antiquities, Made in His Travels thro' Wales and Scotland', *PT* 28 (1713), 93–101; Elizabeth Yale, *Sociable Knowledge: Natural History and the Nation in Early Modern Britain*, University of Pennsylvania Press, 2016.

29. Raymond Stearns, *James Petiver: Promoter of Natural Science*, American Antiquarian Society, 1953; Richard Coulton, ' "The Darling of the Temple-Coffee-House Club": Science, Sociability, and Satire in Early Eighteenth-Century London', *Journal for Eighteenth-Century Studies* 35 (2012), 43–65; James Delbourgo, 'Listing People', *Isis* 103 (2012), 735–42; Sloane to James Petiver, n.d. [1704?], Sloane MS 4026, fol. 311; James Petiver, *Musei Petiveriani*, London, 1695–1703, and 'Catalogue of Some Guinea-Plants, with Their Native Names and Virtues', *PT* 19 (1695–7), 677–86.

30. Jennifer Thomas, 'Compiling "God's Great Book [of] Universal Nature": The Royal Society's Collecting Strategies', *Journal of the History of Collections* 23 (2011), 1–13; Sloane, Miscellanies Catalogue, 1537 (fir rope); Sloane, Earths, Clays, Chalk, Vitriol, Sands Catalogue, NHM, 44 (mouldy ground); Sloane, 'A Letter from Dr Hans Sloane ... to the Right Honourable the Earl of Cromertie', *PT* 27 (1710–12), 302–8, p. 304; D. W. Hayton, 'Southwell, Edward', *ODNB* ; J. H. Curthoys, 'Hannes, Sir Edward', ibid.; Toby Barnard, 'Boyle, Murrough', ibid.

31. Thomas Molyneux to Sloane, 22 May 1697, BL MS Sloane 4036, fol. 314; William Molyneux to Sloane, 8 January 1698, in K. Theodore Hoppen (ed.), *Papers of the Dublin Philosophical Society, 1683–1709*, 2 vols., Irish Manuscripts Commission, 2008, 2:692; Alexander Pope to Sloane, 22 May 1742, *The Works of Alexander Pope*, John Murray, 1886, 9:515; Alasdair Kennedy, 'In Search of the "True Prospect": Making and Knowing the Giant's Causeway as a Field Site in the Seventeenth Century', *BJHS* 41 (2008), 19–41; de Beer, *Sloane*, 129; http://www.popesgrotto.org.uk/pictures.html, accessed January 2014 (photo 7); [Edmund Powlett], *General Contents of the British Museum*, 2nd edn, London, 1762, 2.

32. Sloane, 'Account of a China Cabinet', *PT* 20 (1698), 390–92; 'A Further Account of the Contents of the China Cabinet', ibid., 461–2; 'A Further Account of a China Cabinet', *PT* 21 (1699), 44; and 'A Further Account of What Was Contain'd in the Chinese Cabinet', ibid., 70–72; quotations at 391–2 ('ear-pickers') and 72 ('wherein they go beyond'); Sloane, Miscellanies Catalogue, 272, 927; Oliver Impey, 'Oriental Antiquities', in MacGregor, *Sloane*, 222–7; Linda Levy Peck, *Consuming Splendour: Society and Culture in Seventeenth-Century England*, Cambridge University Press, 2005, ch. 8 and 347; Sloane, Miscellanies Catalogue, 970; Maxine Berg, *Luxury*

*and Pleasure in Eighteenth-Century Britain*, Oxford University Press, 2007; David Porter, *The Chinese Taste in Eighteenth-Century England*, Cambridge University Press, 2010.

33. Joseph Levine, *The Battle of the Books: History and Literature in the Augustan Age*, Cornell University Press, 1994; T. Christopher Bond, 'Keeping up with the Latest Transactions: The Literary Critique of Scientific Writing in the Hans Sloane Years', *Eighteenth-Century Life* 22 (1998), 1-17; Jonathan Swift, *A Tale of a Tub [1704] and Other Works*, Oxford University Press, 1999, 70, 127; Earl of Shaftesbury, *Characteristicks of Men, Manners, Opinions, Times*, 1711, ed. Lawrence Klein, Cambridge University Press, 1999, 340-42.

34. Sloane, *PT* 19 (1695-7), preface; Joseph Levine, *Dr Woodward's Shield: History, Science, and Satire in Augustan England*, University of California Press, 1977, 86, 89, 122, 125, 247-50, and *Battle of the Books*, 59, 63, 102-5; [William King], *The Transactioneer*, London, 1700, unpaginated preface.

35. King, *Transactioneer*, 13 ('exceeded'), 5 (coral and apple-tree), 6 (limestone), 22 ('guide a ship'), 37 (Aclowa and breeding).

36. James Petiver, *Musei Petiveriani*, London, 1695-1703, 1699 instalment, 43-7; Marjorie Swann, *Curiosities and Texts: The Culture of Collecting in Early Modern England*, University of Pennsylvania Press, 2001, 96; Delbourgo, 'Listing People'; King, *Transactioneer*, 33 ('darling'), 34 ('Sancho' and 'Muffti'), 38 ('kind friends'), 34-5 (Orange and 'cheaper').

37. King, *Transactioneer*, 14-16; Porter, *Chinese Taste*, chs. 3-4; Eugenia Jenkins, *A Taste for China: English Subjectivity and the Prehistory of Orientalism*, Oxford University Press, 2013, esp. 53.

38. King, *Transactioneer*, 86 ('merchandize') and 55 ('peculiar faculty'); John Ray to Edward Lhwyd, 9 November 1690, quoted in Robert Iliffe, 'Foreign Bodies: Travel, Empire and the Early Royal Society of London, Part One – Englishmen on Tour', *Canadian Journal of History* 33 (1998), 357-85, p. 368; Levine, *Shield*, ch. 7, esp. 125.

39. John Martyn to Patrick Blair, 23 June 1724, quoted in Kathryn James, 'Sloane and the Public Performance of Natural History', in Hunter, *Books to Bezoars*, 41-7, p. 46; King, *Transactioneer*, 54-5 (bones) and 88 ('laugh').

40. 'Scurrillus' quotation in de Beer, *Sloane*, 89; Sloane to Ray, 31 January 1685, Lankester, *Correspondence of John Ray*, 159-60; *NHJ*, 1:preface ('malitious'), 94 and 2:xvi (Plukenet); James Petiver to Caspar Comelijn, n.d., Sloane MS 3334, fol. 12; Ray to Sloane, 17 September 1696, Sloane MS 4036, fol. 260; 13 April 1700, Sloane MS 4038, fol. 4; Steven Shapin and Simon Schaffer, *Leviathan and the Air-Pump: Hobbes, Boyle, and the Experimental Life*, Princeton University Press, 1985, 65-6.

41. Christopher Bateman and John Cooper, *A Catalogue of the Library, Antiquities, &c. of the Late Learned Dr. Woodward*, London, 1728, 64,

annotated copy, Cambridge University Library; J. Wetstein and G. Smith to Sloane, 8 September 1733, Sloane MS 4053, fol. 41; Kay Dian Kriz, *Slavery, Sugar, and the Culture of Refinement: Picturing the British West Indies, 1700–1840*, Yale University Press, 2008, 13; Joyce Chaplin, 'Mark Catesby, A Sceptical Newtonian in America', in Amy Meyers and Margaret Beck Pritchard (eds.), *Empire's Nature: Mark Catesby's New World Vision*, University of North Carolina Press, 1998, 34–90; Henry Barham to Sloane, 20 April [July?] 1718, Sloane MS 4045, fol. 110; Joseph Browne to Sloane, 5 May 1707, Sloane MS 4040, fol. 353; William Byrd to Sloane, 10 June 1710, Sloane MS 4042, fol. 143; Kevin Hayes (ed.), *The Library of William Byrd of Westover*, Rowman & Littlefield, 1997.

42. Walter Tullideph to Sloane, 7 May 1728, Sloane MS 4049, fol. 160; John Bartram to Sloane, 14 November 1742, Sloane MS 4057, fol. 157; Henry Elking to Sloane, 6 August and 16 November 1726, Sloane MS 4048, fols. 183, 217; George Plaxton to Ralph Thoresby, 23 June 1707, in W. T. Lancaster (ed.), *Letters Addressed to Ralph Thoresby*, Thoresby Society, 1912, 152; [William King], *The Present State of Physick in the Island of Cajamai*, London, 1710, 4 ('receipt book'), 2 ('white physician'), and *A Voyage to the Island of Cajamai in America*, in *Useful Transactions* in *The Original Works in Verse and Prose of Dr William King*, 3 vols., London, 1776, 2:163 ('burying-places').

43. *NHJ*, 1:preface; John Fuller to Sloane, 11 April 1707, Sloane MS 4040, fol. 338; Henry Barham, 10 May 1712, Sloane MS 4043, fols. 45 and 46 ('great benefit', 'dissatisfyed'), and 17 April 1718, Sloane MS 4045, fol. 108 ('straingers'); James Robertson, 'Knowledgeable Readers: Jamaican Critiques of Sloane's Botany', in Hunter, *Books to Bezoars*, 80–89.

44. Barham to Sloane, 21 October 1717, Sloane MS 4045, fol. 55; *NHJ*, 2:382–96; T. F. Henderson and Anita McConnell, 'Barham, Henry', *ODNB*; Henry Barham, Jr, to Sloane, 24 May 1726, Sloane MS 4048, fol. 156.

45. *NHJ*, 2:viii; Sloane to Arthur Charlett, 26 April 1707, in John Walker (ed.), *Letters Written by Eminent Persons in the Seventeenth and Eighteenth Centuries*, 2 vols., London, 1813, 1:166.

46. Birch, 'Memoirs', fol. 7; Ray, unpublished preface to Sloane's *Catalogus plantarum*, in Lankester, *Correspondence of John Ray*, 467; see also Richard Pulteney, *Historical and Biographical Sketches of the Progress of Botany in England*, 2 vols., London, 1790, 2:69; Peter Dear, '*Totius in Verba*: Rhetoric and Authority in the Early Royal Society', *Isis* 76 (1985), 145–61.

47. De Beer, *Sloane*, 51, 60; http://www.cadogan.co.uk/pages/estate-development, accessed March 2014; http://www.british-history.ac.uk/vch/middx/vol12/pp108-115, accessed August 2016; Birch, 'Memoirs', fol. 8; Blakeway, 'Library Catalogues', 28.

48. Birch, 'Memoirs', fol. 7; Furdell, *Royal Doctors*, 245; Sloane, Miscellanies Catalogue, 2083; *London Evening Post*, 1–3 June 1732; Brooks, *Sloane*, 84–5, 96–9.

49. Liam Chambers, 'Medicine and Miracles in the Late Seventeenth Century: Bernard Connor's *Evangelium Medici* (1697)', in James Kelly and Fiona Clark (eds.), *Ireland and Medicine in the Seventeenth and Eighteenth Centuries*, Ashgate, 2010, 53–72, esp. 62; Harold Cook, *Trials of an Ordinary Doctor: Joannes Groenevelt in Seventeenth-Century London*, Johns Hopkins University Press, 1994, and 'Colbatch'; Keill and Cheyne correspondence quoted and discussed in Anita Guerrini, *Obesity and Depression in the Enlightenment: The Life and Times of George Cheyne*, University of Oklahoma Press, 2000, 91, 92, 99–100, 107–13; Samuel Garth, *The Dispensary: A Poem*, London, 1699, 59.

50. De Beer, *Sloane*, 70; Henry Yeomans, *Alcohol and Moral Regulation: Public Attitudes, Spirited Measures, and Victorian Hangovers*, University of Chicago Press, 2014, 40; 'Belinda' to Sloane, 5 January 1722, Sloane MS 4046, fols. 173–4, quoted in Stewart, 'Edge of Utility', 55–6; Philip Rose to Sloane, 8 January 1722, Sloane MS 4046, fols. 175–6, quoted in Lisa Smith, 'Sir Hans Sloane's "Earnest Desire to be Useful"', unpublished paper.

51. Stewart, 'Edge of Utility', 58, 67–8; de Beer, *Sloane*, 74–7; Sloane, 'Account of Inoculation by Sir Hans Sloane', 1736, *PT* 49 (1755–6), 516–20; Sloane to Richard Richardson, 28 August 1722, in John Nichols and John Bower Nichols (eds.), *Illustrations of the Literary History of the Eighteenth Century*, 8 vols., London, 1817–58, 1:279; Margaret DeLacy, *The Germ of an Idea: Contagionism, Religion, and Society in Britain, 1660–1730*, Palgrave Macmillan, 2016, ch. 8.

52. Sloane to John Milner, 28 October 1748, in John Brownlow (ed.), *Memoranda; or, Chronicles of the Foundling Hospital*, Sampson Low, 1847, 211; P. M. Dunn, 'Sir Hans Sloane (1660–1753) and the Value of Breast Milk', *Archives of Disease in Childhood, Fetal and Neonatal Edition* 85 (2001), F73–F74; Lisa Cody, *Birthing the Nation: Sex, Science, and the Conception of Eighteenth-Century Britons*, Oxford University Press, 2008, 18–20; Andrea Rusnock, *Vital Accounts: Quantifying Health and Population in Eighteenth-Century England and France*, Cambridge University Press, 2002, ch. 2; Stewart, 'Edge of Utility', 64–5.

53. Jessie Sweet, 'Sir Hans Sloane: Life and Mineral Collection, Part III – Mineral Pharmaceutical Collection', *Natural History Magazine* 5 (1935), 145–64; Arthur MacGregor, 'Medicinal *terra sigillata*: A Historical, Geographical and Typological Review', in Christopher Duffin *et al.* (eds.), *A History of Geology and Medicine*, Geological Society of London, 2013, 113–36, p. 116; Jill Cook, 'The Nature of the Earth and the Fossil Debate', in Kim Sloan (ed.), *Enlightenment: Discovering the World in the Eighteenth Century*, British Museum, 2003, 92–9, pp. 96–7; Birch, 'Memoirs', fol. 14.

54. 'Proposals made by Dr Sloane if it be thought fitt that he goe physitian to ye W. india fleet', n.d., Sloane MS 4069, fol. 200; Birch, 'Memoirs', fol. 6; de Beer, *Sloane*, 61, 63–4; W. H. G. Armytage, 'The Royal Society and

the Apothecaries, 1660–1722', *NRRS* 11 (1954), 22–37; Harold Cook, 'The Rose Case Reconsidered: Physic and the Law in Augustan England', *Journal of the History of Medicine* 45 (1990), 527–55, and 'Practical Medicine and the British Armed Forces after the "Glorious Revolution"', *Medical History* 34 (1990), 1–26, and 'Colbatch', 503, and *The Decline of the Old Medical Regime in Stuart London*, Cornell University Press, 1986, esp. ch. 6.

55. Birch, 'Memoirs', fol. 8; Penelope Hunting, *A History of the Society of Apothecaries*, Society of Apothecaries, 1998, esp. 126–7; Sue Minter, *The Apothecaries' Garden: A History of the Chelsea Physic Garden*, Sutton Publishing, 1980, 37; Sally Kevill-Davies, *Sir Hans Sloane's Plants on Chelsea Porcelain*, Elmhirst & Suttie, 2015; *NHJ*, 2:xiv.

56. Andrew Wear, *Knowledge and Practice in English Medicine*, Cambridge University Press, 2000, 98–9, 73, 86–7; Brittanicus to Sloane, n.d., Sloane MS 4058, fol. 65; *NHJ*, 1:xi; Christopher Keon to Sloane, n.d., Sloane MS 4047, fol. 139; John Quincy, *The Dispensatory of the Royal College of Physicians*, 2nd edn, London, 1727, note to reader and preface; Earle, *English Middle Class*, 305; Birch, 'Memoirs', fol. 14.

57. Andrew Cunningham, 'Thomas Sydenham: Epidemics, Experiment and the "Good Old Cause"', in Roger French and Andrew Wear (eds.), *The Medical Revolution of the Seventeenth Century*, Cambridge University Press, 1989, 164–90; Michael Heyd, *'Be Sober and Reasonable': The Critique of Enthusiasm in the Seventeenth and Early Eighteenth Centuries*, Brill, 1995; Shapin and Schaffer, *Leviathan and the Air-Pump*; Margaret Jacob, *The Newtonians and the English Revolution, 1689–1720*, Cornell University Press, 1976.

58. Sloane to Abbé Bignon, n.d., Sloane MS 4069, fol. 115; *NHJ*, 1:preface; Shapin and Schaffer, *Leviathan and the Air-Pump*; Sloane to Gabriel Nisbett, 28 May 1737, Sloane MS 4068, fol. 319; see also Castel de St Pierre to Sloane, 14 April 1724, Sloane MS 4043, fol. 246; Brooks, *Sloane*, 42, 98, 144; de Beer, *Sloane*, 57–8; Margaret Sankey, *Jacobite Prisoners of the 1715 Rebellion: Preventing and Punishing Insurrection in Early Hanoverian Britain*, Ashgate, 2005, 89; Stewart, *Rise of Public Science*, 316.

59. Reid Barbour, *Sir Thomas Browne: A Life*, Oxford University Press, 2013, esp. 336–44; Marjorie Swann, *Curiosities and Texts: The Culture of Collecting in Early Modern England*, University of Pennsylvania Press, 2001, 122–36; Jeremiah Finch (ed.), *A Catalogue of the Libraries of Sir Thomas Browne and Dr. Edward Browne, His Son: A Facsimile Reproduction with an Introduction, Notes and Index*, Brill, 1986, 7, 15; HS, 108; J. E. Dandy, *The Sloane Herbarium*, British Museum, 1958, 99; Sloane MS 1843 (Browne commonplace book); Sloane, Antiquities Catalogue, BM, 109–12 (urns); Hernández, *Mexican Treasury*, 21.

60. Sloane, Humana Catalogue, NHM, 272 (Charleton), 675 (tapestry maker), 466 (Derby), 222 (Hickes), 749 (beef); Sloane, 'Answer to the Marquis de

Caumont's Letter', *PT* 40 (1737–8), 374–7, p. 376 ('put into a silver box'); Marcia Stephenson, 'From Marvellous Antidote to the Poison of Idolatry: The Transatlantic Role of Andean Bezoar Stones in the Late Sixteenth and Seventeenth Centuries', *Hispanic American Historical Review* 90 (2010), 3–39; Cook, *Trials*, 96–7, 203, 207–8.

61. Giles Mandelbrote, 'Sloane and the Preservation of Printed Ephemera', in Mandelbrote and Barry Taylor (eds.), *Libraries within the Library: The Origins of the British Library's Printed Collections*, British Library, 2010, 146–68, pp. 155–9; Sloane MSS 7, 65–6, 72, 94, etc. (charms); *NHJ*, 2:xiv; Sloane to Bignon, n.d., Sloane MS 4069, fol. 115 (Proby); Thomas Stack, 'Letter from Thomas Stack', *PT* 41 (1739), 140–42; Lorraine Daston and Katherine Park, *Wonders and the Order of Nature, 1150–1750*, Zone, 1998, ch. 9.

62. Jane Shaw, *Miracles in Enlightenment England*, Yale University Press, 2006, 70–71, 79–95; Keith Thomas, *Religion and the Decline of Magic*, Weidenfeld & Nicolson, 1971, 231–2, 243, 276–7; Harold Weber, *Paper Bullets: Print and Kingship under Charles II*, University Press of Kentucky, 1995, ch. 2, esp. 63–4; Porter, *Health for Sale*, 28; Simon Schaffer, 'Regeneration: The Body of Natural Philosophers in Restoration England', in Christopher Lawrence and Steven Shapin (eds.), *Science Incarnate: Historical Embodiments of Natural Knowledge*, University of Chicago Press, 1998, 83–120; Simon Werrett, 'Healing the Nation's Wounds: Royal Ritual and Experimental Philosophy in Restoration England', *History of Science* 38 (2000), 377–99; Paul Monod, *Solomon's Secret Arts: The Occult in the Age of Enlightenment*, Yale University Press, 2013.

63. John Cherry, 'Medieval and Later Antiquities: Sir Hans Sloane and the Collecting of History', in MacGregor, *Sloane*, 198–221, pp. 200, 209–11; Marion Archibald, 'Coins and Medals', ibid., 150–66, p. 163; William Courten, 'Things Bought in January & February & March & April 1690', Sloane MS 3961, fol. 39; Sloane, Miscellanies Catalogue, 544, 613.

64. William Beckett, *A Free and Impartial Enquiry into the Antiquity and Efficacy of Touching for the Cure of the King's Evil*, London, 1722, 3, 25, 28–9, 46; Samuel Werenfels, *A Dissertation upon Superstition in Natural Things*, London, 1748, 49; Weber, *Paper Bullets*, 84–7.

65. Zahedieh, *Capital*, 131–6; Sloane Account Books, Ancaster Deposit, Lincolnshire Archives; Crossley and Saville, *Fuller Letters*, xxvi–xxvii; Brooks, *Sloane*, ch. 10.

66. Henry Barham to Sloane, 13 September 1722, Sloane MS 4046, fol. 289; see also Sloane MSS 2902, fols. 151–4; 3984, fols. 165–9, 174–83; 3986, fols. 8–9 on Jamaican commercial affairs; Rose Fuller to Sloane, 21 July 1731, Sloane MS 4051, fol. 278; 19–30 July 1729, Sloane MS 4050, fol. 160 ('far short'); 16 March 1732, Sloane MS 4052, fol. 299 ('mighty well'); 22 December 1739, Sloane MS 4056, fol. 155 ('rebellious negroes').

67. Sloane Account Books, e.g. items ANC 9–D–5a–04384 and ANC 9–D–5a–04387; *The Trans-Atlantic Slave Trade Database*, http://www.slavevoyages.org/voyage/ (*Neptune*, voyage 75921, 1721), accessed August 2015.

68. Sloane–Rose marriage settlement, BL; Anonymous, 'Rose of Jamaica', 130, 134, 135; Crossley and Saville, *Fuller Letters*, xxiv; MacGregor, 'Career of Hans Sloane', 37 n. 42; National Archives Currency Converter, http://www.nationalarchives.gov.uk/currency/defaulto.asp#mid, accessed August 2015.

69. Birch, 'Memoirs', fol. 5; Per Kalm, *Kalm's Account of his Visit to England on his Way to America in 1748*, trans. Joseph Lucas, Macmillan, 1892, 98; Sloane Account Books; Andrea Rusnock (ed.), *The Correspondence of James Jurin (1684–1750): Physician and Secretary to the Royal Society*, Rodopi, 1996, 15, 33–5, 110, 196–7.

70. Sloane Account Books; Hans Sloane and Thomas Isted to Charles Lockyer, 28 January 1723, MS 7633, fol. 6, Wellcome Library.

71. James Brydges, Duke of Chandos, to Sloane, 4 December 1721, Sloane MS 4046, fol. 152; Francis Lynn to Sloane, 29 December 1721, Sloane MS 4046, fol. 166; Sloane, Vegetable Substances Catalogue, NHM, 8125; Stewart, *Rise of Public Science*, 322–3; Pettigrew, *Freedom's Debt*, 165–72; South Sea Company Directors to Sloane, 21 January 1724, Sloane MS 4021, fol. 235; Henry Newman to Sloane, 14 May 1735, Sloane MS 4054, fol. 41; Philip Withington, *Society in Early Modern England: The Vernacular Origins of Some Powerful Ideas*, Polity, 2010, ch. 4; Nicolas Martini to Sloane, 20 December 1717, Sloane MS 4045, fol. 83; Joseph Browne to Sloane, 22 January 1718, Sloane MS 4045, fol. 183; Magnus Prince to Sloane, 1740, Sloane MS 4060, fol. 130, quoted in Toby Barnard, *A New Anatomy of Ireland: The Irish Protestants, 1649–1770*, Yale University Press, 2003, 202.

72. Ezio Bassani, *African Art and Artifacts in European Collections, 1400–1800*, British Museum, 2000, 41–50; Sloane, Miscellanies Catalogue, 32, 59 (caps); 1764–5 (pipes); 424, 1935 (fabrics); 590–92 (bracelets); 723, 1425, 2021 (trumpets); 246 (thong); 1817 (shell); 1090, 1101, 54 (whips); 1796 (bullet); 1966, 1968 (coat and britches, attribution to Millar via 1969, 'all brought from Jamaica given me by Mr Millar'); 1623 (noose); 1830 (knife); 'A Catalogue of Rarities belonging to Will. Walker', n.d., Sloane MS 1968, fols. 172–3, item 38 (knife); 'Voyage of the *Hannibal*, 1693–1694', in Elizabeth Donnan (ed.), *Documents Illustrative of the History of the Slave Trade to America, Volume I: 1441–1700*, Octagon Books, 1969, 392–410, esp. 399–404, 408; Jonathan Symmer to Sloane, 2 [or 20?] September 1736, Sloane MS 4054, fols. 304–7 ('vagina'); n.d., Sloane MS 4061, fol. 158; Sloane, Humana Catalogue, 692 ('negroe girle'), 747 (skull).

73. Alexander Stuart to Sloane, n.d., Sloane MS 4061, fol. 152 ('bearere'); 4 January 1710, Sloane MS 4042, fol. 83 ('black boy'); 22 May 1710, Sloane

MS 4042, fol. 137 ('troubled'); Travis Glasson, *Mastering Christianity: Missionary Anglicanism and Slavery in the Atlantic World*, Oxford University Press, 2011, 101; Gretchen Gerzina, *Black England: Life before Emancipation*, John Murray, 1995, 34; Susan Amussen, *Caribbean Exchanges: Slavery and the Transformation of English Society, 1640–1700*, University of North Carolina Press, 2007, 191–217; David Bindman and Helen Weston, 'Court and City: Fantasies of Domination', in Bindman and Henry Louis Gates, Jr (eds.), *The Image of the Black in Western Art from the 'Age of Discovery' to the Age of Abolition: The Eighteenth Century*, Belknap Press, 2011, 125–70; Catherine Molineux, *Faces of Perfect Ebony: Encountering Atlantic Slavery in Imperial Britain*, Harvard University Press, 2011, esp. 9–11, 39, 65; Simon Gikandi, *Slavery and the Culture of Taste*, Princeton University Press, 2011.

74. Birch, 'Memoirs', fols. 7–8, 11; Donna Andrew, *Philanthropy and Police: London Charity in the Eighteenth Century*, Princeton University Press, 1990, chs. 1–2.

75. Shapin, *Truth*; Anonymous, *Aesculapius: A Poem*, London, 1721, 18; Anonymous, *The Art of Getting into Practice in Physick*, London, 1722, 9–10; King, *Useful Transactions*, in *The Original Works in Verse and Prose of Dr William King*, 2:135 ('Slonenbergh') and 145 ('Slyboots'); Kay Dian Kriz, 'Curiosities, Commodities, and Transplanted Bodies in Hans Sloane's "Natural History of Jamaica"', *WMQ* 57 (2000), 35–78, p. 65.

76. Anon., *Art of Getting into Practice*, 9–18; 'Dr. Wriggle, or The Art of Rising in Physic', *Westminster Magazine*, September 1782, quoted in Porter, *Bodies Politic*, 141.

77. Stewart, *Rise of Public Science*, 129, 132, 176–7, 214; MacGregor, 'Career of Hans Sloane', 18–21; de Beer, *Sloane*, ch. 6, esp. 86–7 (experiments), 106–7 (gravity cubes); William Stukeley, *Of the Spleen*, London, 1723, 91–108 (elephant); John Ranby, 'Some Observations Made in an Ostrich, Dissected by Order of Sir Hans Sloane', *PT* 33 (1724–5), 223–7; John Heilbron, *Physics at the Royal Society during Newton's Presidency*, William Andrews Clark Memorial Library, 1983, 32–3, 36–8, 51, 59; J. B. Shank, *The Newton Wars and the Beginning of the French Enlightenment*, University of Chicago Press, 2008, 117, 184; Mary Terrall, *Catching Nature in the Act: Réaumur and the Practice of Natural History in the Eighteenth Century*, University of Chicago Press, 2014; *Evening Post*, 2–4 April 1723; Jessie Sweet, 'Sir Hans Sloane's Metalline Cubes', *NRRS* 10 (1953), 99–100; Sloane, Miscellanies Catalogue, 182 (Hauksbee gravity balance).

78. Levine, *Shield*, 88, 92, 111–12, 315 and 321 n. 67; de Beer, *Sloane*, 90–92, including Sloane to Thoresby, 3 June 1710; Stukeley, *Family Memoirs*, 1:125; MacGregor, 'Career of Hans Sloane', 18–21 and 40 n. 116; Heilbron, *Physics at the Royal Society*, 33–4 (including 'engross'd' and 'tricking').

79. MacGregor, 'Career of Hans Sloane', 21; Jurin quoted in Mordechai Feingold, 'Mathematicians and Naturalists: Sir Isaac Newton and the Royal

Society', in Jed Buchwald and I. Bernard Cohen (eds.), *Isaac Newton's Natural Philosophy*, MIT Press, 2001, 77–102, pp. 96–7; Schaffer, 'Newton on the Beach'.

80. MacGregor, 'Career of Hans Sloane', 21; Dear, '*Totius in Verba*'; Kim Sloan, 'Sir Hans Sloane's Pictures: The Science of Connoisseurship or the Art of Collecting?', *Huntington Library Quarterly* 78 (2015), 381–415; *NHJ*, 2:22–3, and Sloane to Comte d'Efferon, 31 October 1715, Sloane MS 4068, fol. 100; Sloane, Vegetable Substances Catalogue, 9884; Jennifer Anderson, *Mahogany: The Costs of Luxury in Early America*, Harvard University Press, 2012, 83.

81. Birch, 'Memoirs', fol. 12; Sloane, *An Account of a Most Efficacious Medicine for Soreness, Weakness, and Several Other Distempers of the Eyes*, London, 1745, quotation 14; Arnold Hunt, 'Sloane as a Collector of Manuscripts', in Hunter, *Books to Bezoars*, 190–207, pp. 202–3; Alison Walker, 'Sir Hans Sloane and the Library of Dr Luke Rugeley', *Library* 15 (2014), 383–409; Smith, 'Earnest Desire'; Furdell, *Royal Doctors*, 241; Henry Stubbe, *The Indian Nectar*, London, 1662, 73, 109, 33; Philippe Dufour, *The Manner of Making Coffee, Tea, and Chocolate*, London, 1685, 107, cited in Sophie and Michael Coe, *The True History of Chocolate*, Thames & Hudson, 1996, 173; Bertram Gordon, 'Commerce, Colonies, and Cacao: Chocolate in England from Introduction to Industrialization', in Louis Grivetti and Howard Shapiro (eds.), *Chocolate: History, Culture, and Heritage*, John Wiley & Sons, 2009, 583–94, p. 586; Shapin, *Truth*; Banks and Heal Collection, Prints and Drawings, BM, 38.7 and 38.15 (Sanders and White cards); *Public Advertiser*, 22 December 1774; *Public Ledger*, 7 January 1775; *Lloyd's Evening Post*, 22 February 1775; *Gazetteer and New Daily Advertiser*, 19 August 1775.

82. D. W. Hayton, *The Anglo-Irish Experience, 1680–1730: Religion, Identity and Patriotism*, Boydell, 2012, esp. ch. 2; Robert Whan, *The Presbyterians of Ulster, 1680–1730*, Boydell, 2013, 30; Brooks, *Sloane*, 143–6; de Beer, *Sloane*, 67–8, 117; Sankey, *Jacobite Prisoners*, 89; Brilliana Rawdon to Sloane, 17 February 1705, Sloane MS 4040, fol. 133; Toby Barnard, *Making the Grand Figure: Lives and Possessions in Ireland, 1641–1770*, Yale University Press, 2004, xix–xxi, 173, 325–37; *New Anatomy of Ireland*, 42, 65, 115, 123, 136, and 'The Irish in London and "the London Irish", *c.* 1660–1780', unpublished paper; Colin Kidd, *British Identities before Nationalism: Identity and Nationhood in the Atlantic World, 1600–1800*, Cambridge University Press, 1999, ch. 4 and 251–6; Thomas Stack to Sloane, 28 October 1728, Sloane MS 4049, fol. 254 (author's translation).

83. *Daily Post*, 26 February 1725 (horned lady); *London Evening Post*, 26–29 October 1728 (mynah bird); ibid., 4–6 October 1733 (Chinese effigies); *London Daily Post and General Advertiser*, 24 December 1734 (Suffolk bristles); *Daily Post*, 20 January 1737 ('Oran-hauton'); *London Daily Post and*

*General Advertiser,* 3 February 1739 (basilisk); ibid., 27 February 1739 (Madame Chimpanzee); *Daily Advertiser,* 4 December 1742 (mouth-writer); Mandelbrote, 'Printed Ephemera', 153.

## CHAPTER 5: THE WORLD COMES TO BLOOMSBURY

1. Carol Gibson-Wood, 'Classification and Value in a Seventeenth-Century Museum: William Courten's Collection', *Journal of the History of Collections* 9 (1999), 61–77, esp. 61–3; Walter Benjamin, *The Arcades Project,* trans. Howard Eiland and Kevin McLaughlin, Belknap Press, 1999, 211; Uffenbach cited in J. E. B. Mayor (ed.), *Cambridge under Queen Anne,* Cambridge Antiquarian Society, 1911, 408; Susan Amussen, *Caribbean Exchanges: Slavery and the Transformation of English Society, 1640–1700,* University of North Carolina Press, 2007, 25.

2. Susan Scott Parrish, *American Curiosity: Cultures of Natural History in the Colonial British Atlantic World,* University of North Carolina Press, 2006, chs. 3, 5, 6, and esp. 194; Charlotta Adelkrantz to Sloane, 7 July 1736, Sloane MS 4054, fols. 271–2; Sloane, Miscellanies Catalogue, BM, 1787–91.

3. Natalie Zemon Davis, *Women on the Margins: Three Seventeenth-Century Lives,* Harvard University Press, 1995, 140–202; Londa Schiebinger, *Plants and Empire: Colonial Bioprospecting in the Atlantic World,* Harvard University Press, 2004, esp. 30–35 (including 'myne slaven', 35); Harold Cook, *Matters of Exchange: Commerce, Medicine, and Science in the Dutch Golden Age,* Yale University Press, 2007, 332–8; Janice Neri, *The Insect and the Image: Visualizing Nature in Early Modern Europe, 1500–1700,* University of Minnesota Press, 2011, 142, 158–9, 166; Weeden Butler, 'Pleasing Recollection of a Walk through the British Musaeum', Add. MS 27276, fols. 63–4; James Petiver to Sloane, 7 June 1711, Sloane MS 4042, fol. 295; D. E. Allen, 'Petiver, James', *ODNB*; Petiver to Johann Breyne, n.d. (*c.* 1706), quoted in Ella Reitsma, *Maria Sibylla Merian and Daughters: Women of Art and Science,* Rembrandt House Museum, 2008, 203.

4. Eric St John Brooks, *Sir Hans Sloane: The Great Collector and His Circle,* Batchworth Press, 1954, 126; Pamela Gilbert, 'Glanville, Eleanor', *ODNB*; HS, 131–42, 66, 235; J. E. Dandy, *The Sloane Herbarium,* British Museum, 1958, 209–15 (Petiver quotation 210); Sloane MSS 641, 3343, 3349, 3353–9 (Badminton plant lists); Molly McClain, *Beaufort: The Duke and his Duchess, 1657–1715,* Yale University Press, 2001, 212–14; Schiebinger, *Plants and Empire,* esp. 59–60.

5. Mary Campbell to Sloane, n.d., Sloane MS 4058, fol. 105; Margaret Ray to Sloane, 1706, Sloane MS 4040, fol. 255; Samuel Dale to Sloane, ibid., 14 August 1706 and 5 March 1707, fols. 205, 317; Lisa Smith, 'Sloane as

Friend and Physician of the Family', in Hunter, *Books to Bezoars*, 48–56, pp. 50–51; Claudius Dupuys to Sloane, Sloane MS 4058, fols. 284, 286; Sloane, Miscellanies Catalogue, 1084–124; Richard Altick, *The Shows of London*, Belknap Press, 1978, 16, 51.

6. James Petiver to unknown, n.d., Sloane MS 3332, fol. 5; Petiver to Gidly, 28 September 1694, ibid., fol. 83; [William King], *The Transactioneer*, London, 1700, 38; *NHJ*, 2:iv–v; James Delbourgo, 'Listing People', *Isis* 103 (2012), 735–42; Raymond Stearns, *James Petiver: Promoter of Natural Science*, American Antiquarian Society, 1953; Marjorie Swann, *Curiosities and Texts: The Culture of Collecting in Early Modern England*, University of Pennsylvania Press, 2001, 90–96; Simon Schaffer, ' "On Seeing Me Write": Inscription Devices in the South Seas', *Representations* 97 (2007), 90–122.

7. James Petiver to George Wheeler, 18 May 1695 and 29 October 1696, Sloane MS 3332, fols. 124, 223–5; and to Edward Barter, 15 October 1695, ibid., fols. 164–6; Edward Bulkley to Petiver, Sloane MS 3321, 9 November 1701, fols. 84–5; *NHJ*, 2:iv–v.

8. Arjun Appadurai (ed.), *The Social Life of Things: Commodities in Cultural Perspective*, Cambridge University Press, 1986, 50; Neil De Marchi, 'The Role of Dutch Auctions and Lotteries in Shaping the Art Market(s) of 17th Century Holland', *Journal of Economic Behaviour and Organization* 28 (1995), 203–21; Dániel Margócsy, *Commercial Visions: Science, Trade, and Visual Culture in the Dutch Golden Age*, University of Chicago Press, 2014; Jerry Brotton, *The Sale of the Late King's Goods: Charles I and his Art Collection*, Macmillan, 2006; Cynthia Wall, 'The English Auction: Narratives of Dismantlings', *Eighteenth-Century Studies* 31 (1997), 1–25.

9. Dandy, *Herbarium*, 137–8; G. Scott and M. Hewitt, 'Pioneers in Ethnopharmacology: The Dutch East India Company (VOC) at the Cape from 1650 to 1800', *Journal of Ethnopharmacology* 115 (2008), 339–60; Richard Grove, *Green Imperialism: Colonial Expansion, Tropical Island Edens and the Origins of Environmentalism, 1600–1860*, Cambridge University Press, 1996, 137–8; Cook, *Exchange*, chs. 5, 9; Anna Winterbottom, *Hybrid Knowledge in the Early East India Company World*, Palgrave Macmillan, 2015, ch. 5.

10. William Sherard to Sloane, n.d., Sloane MS 4060, fol. 339 (all quotations); 9 May 1698 and 23 August 1698, Sloane MS 4037, fols. 64, 113; Sloane to Sherard, 2 September 1698, Sherard Papers, fol. 454, RS; HS, 75, 331, 91, 98; Sloane MS 4003, fols. 25–80; Dandy, *Herbarium*, 137–8; John Cannon, 'Botanical Collections', in MacGregor, *Sloane*, 136–49, p. 143; Anna Hermann to Sloane, 17 January 1704, Sloane MS 4039, fol. 231; Sloane to Petiver, n.d., Sloane MS 4069, fol. 187; Petiver to Sloane, 18 June 1711, Sloane MS 4042, fol. 305; M. A. E. Nickson, 'Books and Manuscripts', in MacGregor, *Sloane*, 263–77, pp. 267–8; Arnold Hunt, 'Sloane as a Collector of Manuscripts', in Hunter, *Books to Bezoars*, 190–207.

11. Dandy, *Herbarium*, 183–7; Arthur MacGregor, 'The Life, Character, and Career of Sir Hans Sloane', in MacGregor, *Sloane*, 11–44, p. 23; Mike Fitton and Pamela Gilbert, 'Insect Collections', in ibid., 112–22, p. 119; Ian Jenkins, 'Classical Antiquities: Sloane's "Repository of Time"', in ibid., 167–73, pp. 167–9; Nickson, 'Books and Manuscripts', 267; Giles Mandelbrote, 'Sloane's Purchases at the Sale of Robert Hooke's Library', and Alison Walker, 'Sir Hans Sloane's Printed Books in the British Library: Their Identification and Associations', in Mandelbrote and Barry Taylor (eds.), *Libraries within the Library: The Origins of the British Library's Printed Collections*, British Library, 2010, 98–145 and 89–97, p. 95; Walker, 'Sir Hans Sloane and the Library of Dr Luke Rugeley', *Library* 15 (2014), 383–409.

12. Sloane to Sherard, 2 September 1698, Sherard Papers, fol. 454, RS; Sherard to Sloane, 20 September 1698, Sloane MS 4037, fol. 123, and 29 June 1706, Sloane MS 4040, fol. 187; Hunt, 'Manuscripts', 199, including quotation from Wanley to Sloane, 10 March 1724, Sloane MS 4047, fols. 145–6; George Pasti, 'Consul Sherard: Amateur Botanist and Patron of Learning, 1659–1728', University of Illinois PhD thesis, 1950; *NHJ*, 1:preface; Joseph Levine, *The Battle of the Books: History and Literature in the Augustan Age*, Cornell University Press, 1991, 170 ('anger').

13. Dawson Turner (ed.), *Extracts from the Literary and Scientific Correspondence of Richard Richardson*, Yarmouth, 1835, 181 n. 4 ('wallowing'); Nuala Zahedieh, *The Capital and the Colonies: London and the Atlantic Economy, 1660–1700*, Cambridge University Press, 2010, 136; Sherard to Sloane, 3 May 1692, Sloane MS 4036, fol. 119; 28 May 1711, Sloane MS 4042, fol. 289; MacGregor, 'Career of Hans Sloane', 27 and 43–4 n. 198; Dandy, *Herbarium*, 97, 202–3; D. E. Allen, 'Sherard, William', *ODNB*.

14. Felicity Nussbaum, 'Between "Oriental" and "Blacks So Called", 1688–1788', in Daniel Carey and Lynn Festa (eds.), *Postcolonial Enlightenment: Eighteenth-Century Colonialism and Postcolonial Theory*, Oxford University Press, 2009, 137–66, pp. 158–60; Catherine Molineux, *Faces of Perfect Ebony: Encountering Atlantic Slavery in Imperial Britain*, Harvard University Press, 2012, 195–7; Roy Porter, 'Consumption: Disease of the Consumer Society?', in John Brewer and Porter (eds.), *Consumption and the World of Goods*, Routledge, 1993, 58–81; John Brewer, *The Pleasures of the Imagination: English Culture in the Eighteenth Century*, HarperCollins, 1997, 54, 82.

15. Sloane, 'Accounts of the Pretended Serpent-Stone Called Pietra de Cobra de Cabelos, and of the Pietra de Mombazza or the Rhinoceros Bezoar', *PT* 46 (1749–50), 118–25.

16. 'Sloane's Museum at Chelsea, as described by Per Kalm, 1748', in MacGregor, *Sloane*, 34; Sloane, Miscellanies Catalogue, 2105; Shells Catalogue, NHM, 23, 1382; Miscellanies, 12, 4, 213, 539, 811, 1563; Quadrupeds Catalogue,

NHM, 1674; Miscellanies, 852; Birds Catalogue, NHM, 555; Shells, 1383; Insects Catalogue, NHM, 25; Miscellanies, 847; Insects, 3666; Quadrupeds, 204, 1716, 1682; Miscellanies, 1705, 1281, 9, 64, 970, 1777; Fossils Catalogue, NHM, 42.

17. John Richards, *The Mughal Empire*, Cambridge University Press, 1996; Sanjay Subrahmanyam, *Mughals and Franks: Explorations in Connected History*, Oxford University Press, 2005; Charles Parker, *Global Interactions in the Early Modern Age*, Cambridge University Press, 2010, ch. 2.

18. Grove, *Green Imperialism*, chs. 2-3; K. N. Chaudhuri, *The Trading World of Asia and the English East India Company, 1660–1760*, Cambridge University Press, 1978; Miles Ogborn, *Global Lives: Britain and the World, 1550–1800*, Cambridge University Press, 2008, 80–84; Kanakalatha Mukund, *The Trading World of the Tamil Merchant: Evolution of Merchant Capitalism in the Coromandel*, Orient Longman, 1999, 109–10; Winterbottom, *Hybrid Knowledge*, ch. 1; Miles Ogborn, *Indian Ink: Script and Print in the Making of the English East India Company*, University of Chicago Press, 2007, 30, 60, 62; Sanjay Subrahmanyam, 'Taking Stock of the Franks: South Asian Views of Europeans and Europe, 1500–1800', *Indian Economic Social History Review* 42 (2005), 69–100, and 'Frank Submissions: The Company and the Mughals between Sir Thomas Roe and Sir William Norris', in H. V. Bowen *et al.* (eds.), *The Worlds of the East India Company*, D. S. Brewer, 2002, 69–96, p. 78; Nabil Matar (ed.), *In the Lands of the Christians: Arabic Travel Writing in the Seventeenth Century*, Routledge, 2003, introduction.

19. Winterbottom, *Hybrid Knowledge*, chs. 1, 3; Ogborn, *Indian Ink*, ch. 3; Philip Stern, *The Company State: Corporate Sovereignty and the Early Modern Foundation of the British Empire in India*, Oxford University Press, 2011, chs. 5–6; Anne Murphy, *The Origins of English Financial Markets: Investment and Speculation before the South Sea Bubble*, Cambridge University Press, 2012, 72–7.

20. Sloane, Miscellanies Catalogue, 1721, 852, 811, and Quadrupeds Catalogue, 1674; Stern, *Company State*, 165–72; de Beer, *Sloane*, 157; Sloane to Charles Lockyer, 28 January 1723, MS 7633, fol. 6, Wellcome Library; Marjorie Caygill, 'Sloane's Will and the Establishment of the British Museum', in MacGregor, *Sloane*, 45–68, p. 59; Diana Scarisbrick and Benjamin Zucker, *Elihu Yale: Merchant, Collector and Patron*, Thames & Hudson, 2014, 110, 209, 212.

21. Winterbottom, *Hybrid Knowledge*, ch. 4.

22. Sloane, Miscellanies Catalogue, 12, 1486; Agates Catalogue, NHM, 205; Daniel Waldo to Sloane, 20 January 1704 and n.d., Sloane MS 4039, fols. 424–5; John Thackray, 'Mineral and Fossil Collections', in MacGregor, *Sloane*, 123–35, p. 131; J. C. H. King, 'Ethnographic Collections: Collecting in the Context of Sloane's Catalogue of "Miscellanies"', in ibid.,

228–44, p. 236; Pratik Chakrabarti, *Materials and Medicine: Trade, Conquest and Therapeutics in the Eighteenth Century*, Manchester University Press, 2010, 33–45.

23. Alexander Stuart to Sloane, n.d., Sloane MS 4061, fols. 138, 146, 148, 154, 142; 30 June and 7 November 1711, Sloane MS 4045, fols. 16, 62; HS, 17; Dandy, *Herbarium*, 28; Sloane, Miscellanies Catalogue, 493–7, 1809, Vegetable Substances Catalogue, NHM, 248, and Sloane MS 1546A (Malabar pocket-book); Anita Guerrini, ' "A Scotsman on the Make": The Career of Alexander Stuart', in Paul Wood (ed.), *The Scottish Enlightenment: Essays in Reinterpretation*, University of Rochester Press, 2000, 157–76.

24. Parker, *Global Interactions*, ch. 2; Laura Hostetler, *Qing Colonial Enterprise: Ethnography and Cartography in Early Modern China*, University of Chicago Press, 2001; Kenneth Pomeranz, *The Great Divergence: China, Europe, and the Making of the Modern World Economy*, Princeton University Press, 2000, 119–22; Florence Hsia, *Sojourners in a Strange Land: Jesuits and their Scientific Missions in Late Imperial China*, University of Chicago Press, 2009.

25. HS, 20, 32, 59, 81, 92–4, 156, 163, 189, 243, 247, 252–3, 255–8, 263, 278, 283, 287, 289, 327, 329–32 (Cuninghame specimens); Sloane, Vegetable Substances Catalogue, 250, 254, etc.; Dandy, *Herbarium*, 117–22; James Cuninghame to Sloane, 10 July 1700, Sloane MS 3321, fol. 52; Fa-ti Fan, *British Naturalists in Qing China: Science, Empire, and Cultural Encounter*, Harvard University Press, 2004; Arnoldo Santos-Guerra *et al.*, 'Late 17th-Century Herbarium Collections from the Canary Islands: The Plants Collected by James Cuninghame in La Palma', *Taxon* 60 (2011), 1734–53.

26. Charles Jarvis and Philip Oswald, 'The Collecting Activities of James Cuninghame FRS on the Voyage of *Tuscan* to China (Amoy) between 1697 and 1699', *NRRS* 69 (2015), 135–53, quotation 142.

27. Cuninghame to Sloane, n.d., Sloane MS 4025, fol. 90; 20 December 1700, Sloane MS 3321, fol. 65; 22 November 1701, Sloane MS 4025, fols. 90, 92; Cuninghame, 'Part of Two Letters to the Publisher from Mr James Cunningham', *PT* 23 (1702–3), 1201–9; James Cuninghame to Sloane, 10 July 1700, Sloane MS 3321, fol. 52; 19 July 1700, Sloane MS 4038, fol. 35; Joanna Waley-Cohen, *The Sextants of Beijing: Global Currents in Chinese History*, Norton, 1999, 124–8; Ashley Millar, 'Your Beggarly Commerce! Enlightenment European Views of the China Trade', in Guido Abbattista (ed.), *Encountering Otherness: Diversities and Transcultural Experiences in Early Modern European Culture*, University of Trieste Press, 2011, 205–22.

28. Winterbottom, *Hybrid Knowledge*, ch. 2; Danny Wong Tze-Ken, 'The Destruction of the English East India Company Factory on Condore Island, 1702–1705', *Modern Asian Studies* 46 (2012), 1097–115, esp. 1106; see

also Li Tana, *Nguyễn Cochinchina: Southern Vietnam in the Seventeenth and Eighteenth Centuries*, Cornell University Press, 1998.

29. Cuninghame letter in Charles Lockyer, *Account of the Trade in India*, 2 vols., London, 1711, 1:90–95; Cuninghame to Sloane, 7 January 1704, Sloane MS 4039, fol. 226; Cuninghame to Sloane, 30 April 1707, Sloane MS 4040, fol. 350.

30. Steven Harris, 'Long-Distance Corporations, Big Science and the Geography of Knowledge', *Configurations* 6 (1988), 269–304; Waley-Cohen, *Sextants*, ch. 2, esp. 64, 70–71, 75–6; Hsia, *Sojourners*; Hostetler, *Qing Colonial Enterprise*, ch. 2; 5 March 1708, Sloane MS 3321, fol. 224; 26 August 1702, Sloane MS 4039, fol. 17; Gordon Goodwin, 'Cuninghame, James', *ODNB*.

31. Winterbottom, *Hybrid Knowledge*, ch. 4; Dandy, *Herbarium*, 102, 117–22, 145–8; Sloane, Insects Catalogue, 3494; James Petiver, *Musei Petiveriani*, London, 1695–1703, 1699 instalment, 43–7; George Camelli and Petiver, 'De Monstris, Quasi Monstris, et Monstrosis', *PT* 25 (1706–7), 2266–76; Lorraine Daston, 'The Ideal and Reality of the Republic of Letters in the Enlightenment', *Science in Context* 4 (1991), 367–86; Paula Findlen (ed.), *Athanasius Kircher: The Last Man Who Knew Everything*, Routledge, 2004, 38.

32. Sloane, Miscellanies Catalogue, 7, 119, 269, 323, 469; Vegetable Substances Catalogue, 173; King, 'Ethnographic Collections', 233; John Locke to Sloane, 15 March 1697, in E. S. de Beer (ed.), *The Correspondence of John Locke*, 8 vols., Clarendon Press, 1976–89, 6:35; Sloane to Locke, 26 February 1704, ibid., 8:216; Michael Keevak, *The Pretended Asian: George Psalmanazar's Eighteenth-Century Formosan Hoax*, Wayne State University Press, 2004, esp. 10, 103; Richard Swiderski, *The False Formosan: George Psalmanazar and the Eighteenth-Century Experiment of Identity*, Edwin Mellen, 1991.

33. Michael Keevak, *Becoming Yellow: A Short History of Racial Thinking*, Princeton University Press, 2011; Sloane to Jan de Fontaney, n.d., Sloane MS 4069, fol. 255, and n.d., Sloane MS 4058, fol. 345; Sloane to Locke, 26 February 1704, de Beer, *Correspondence of John Locke*, 8:216; Percy G. Adams, *Travelers and Travel Liars, 1660–1800*, Dover, 1980; Keevak, *Pretended Asian*; Swiderski, *False Formosan*; James Boswell, *The Life of Samuel Johnson*, 1791, Penguin, 2008, 693, 915.

34. Timon Screech, *The Lens within the Heart: The Western Scientific Gaze and Popular Imagery in Later Edo Japan*, University of Hawai'i Press, 2002; Robert Liss, 'Frontier Tales: Tokugawa Japan in Translation', in Simon Schaffer *et al.* (eds.), *The Brokered World: Go-Betweens and Global Intelligence, 1770–1820*, Science History Publications, 2009, 1–47; Lockyer, *Trade in India*, 1:83; Sloane, Miscellanies Catalogue, 1062–79, 1139–70, and Sloane MSS 74, 2914, 2915, 3061, 3062, etc. (Kaempfer).

35. Derek Massarella, 'The History of *The History*: The Purchase and Publication of Kaempfer's *History of Japan*', and Beatrice Bodart-Bailey, 'Writing

*The History of Japan'*, in Bodart-Bailey and Massarella (eds.), *The Furthest Goal: Engelbert Kaempfer's Encounter with Tokugawa Japan*, Japan Library, 1995, 96–131 and 17–43; Robert Markley, *The Far East and the English Imagination, 1600–1730*, Cambridge University Press, 2006.

36. Beatrice Bodart-Bailey (ed.), *Kaempfer's Japan: Tokugawa Culture Observed*, University of Hawai'i Press, 1999, 362–5, 188 ('true of heart'), 364–5 (song). This scholarly translation, based on Engelbert Kaempfer's manuscript 'History of Japan', Sloane MS 3060, corrects errors in *The History of Japan*, trans. Johann Gaspar Scheuchzer, 2 vols., London, 1727; Elizabeth Kowaleski-Wallace, 'The First Samurai: Isolationism in Engelbert Kaempfer's 1727 History of Japan', *Eighteenth Century* 48 (2007), 111–24; Geoffrey Gunn, *First Globalization: The Eurasian Exchange, 1500–1800*, Rowman & Littlefield, 2003, 149–52.

37. Sloane MSS 2907, 2917 a and b, 2920, 2923, 3063, 3064, etc. (Kaempfer); Screech, *Lens*; Yu-Ying Brown, 'Japanese Books and Manuscripts', in MacGregor, *Sloane*, 278–90, and 'Kaempfer's Album of Famous Sights of Seventeenth-Century Japan', *Electronic British Library Journal* 15 (1989), 90–103, http://www.bl.uk/eblj/1989articles/article7.html, accessed November 2015; Bodart-Bailey, *Kaempfer's Japan*, 28–9 (quotations on Eisei), 234–5 (contract made between Kaempfer and Eisei); Cook, *Exchange*, 339.

38. Linnaeus' source for *'Ginkgo'* was Kaempfer's *Amoenitatum exoticarum*, Lemgoviae, 1712: see Toshiyuki Nagata *et al.*, 'Engelbert Kaempfer, Genemon Imamura and the Origin of the Name *Ginkgo'*, *Taxon* 64 (2015), 131–6; Paul van der Velde, 'The Interpreter Interpreted: Kaempfer's Japanese Collaborator Imamura Genemon Eisei', in Bodart-Bailey and Massarella, *The Furthest Goal*, 44–58; Kaempfer, *History of Japan*, trans. Scheuchzer, 2: imprimatur.

39. Sloane, Miscellanies Catalogue, 1368; Jerome Handler, 'The Middle Passage and the Material Culture of Captive Africans', *Slavery and Abolition* 30 (2009), 1–26, pp. 9–11; Neil MacGregor, *A History of the World in 100 Objects*, Allen Lane, 2010, 561–5; Stephanie Smallwood, *Saltwater Slavery: A Middle Passage from Africa to American Diaspora*, Harvard University Press, 2008, chs. 4–5; David Bushnell, Jr, 'The Sloane Collection in the British Museum', *American Anthropologist* 39 (1906), 671–85.

40. James Merrell, *Into the American Woods: Negotiators on the Pennsylvania Frontier*, Norton, 1999; Jack Greene, *Pursuits of Happiness: The Social Development of Early Modern British Colonies and the Formation of American Culture*, University of North Carolina Press, 1988; Edmund Morgan, *American Slavery, American Freedom: The Ordeal of Colonial Virginia*, Norton, 1975; Jill Lepore, *The Name of War: King Philip's War and the Origins of American Identity*, Knopf, 1998; Alan Gallay, *The Indian Slave Trade: The Rise of the English Empire in the American South, 1670–1717*, Yale University Press, 2002, ch. 12; Richard White, *The Middle Ground: Indians, Empires, and Republics in the Great Lakes Region,*

*1650–1815*, Cambridge University Press, 1991; David Weber, *The Spanish Frontier in North America*, Yale University Press, 1992.

41. Sloane MS 3527 (Radisson); J. C. H. King, *First Peoples, First Contacts: Native Peoples of North America*, Harvard University Press, 1999, 195–8; Arthur Ray, *Indians in the Fur Trade: Their Role as Trappers, Hunters, and Middlemen in the Lands Southwest of Hudson Bay, 1660–1870*, University of Toronto Press, 1974, ch. 2; Ted Binnema, *'Enlightened Zeal': The Hudson's Bay Company and Scientific Networks, 1670–1870*, University of Toronto Press, 2014, ch. 2; Henry Elking to Sloane, 6 August 1726, Sloane MS 4048, fol. 183; 16 November 1726, ibid., fol. 217 (quotation); and 5 October 1727, Sloane MS 4049, fol. 44; Sloane, Miscellanies Catalogue, 1933 (ivory list), 1842, 2040; Alexander Light to Sloane, 1738, quoted in Stuart Houston et al. (eds.), *Eighteenth-Century Naturalists of Hudson Bay*, McGill-Queens University Press, 2003, 35.

42. Richmond Bond, *Queen Anne's American Kings*, Clarendon Press, 1952; Eric Hinderaker, 'The "Four Indian Kings" and the Imaginative Construction of the First British Empire', *WMQ* 53 (1996), 487–526; Joseph Roach, *Cities of the Dead: Circum-Atlantic Performance*, Columbia University Press, 1996, ch. 4; *Spectator* 50, 27 April 1711; Sloane, Miscellanies Catalogue, 572–3, 1535.

43. Bruce McCully, 'Governor Francis Nicholson, Patron "Par Excellence" of Religion and Learning in Colonial America', *WMQ* 39 (1982), 310–33, pp. 325, 330–31; Sloane, Miscellanies Catalogue, 1218–28; Hinderaker, ' "Four Indian Kings" ', 488–9; Add. MS 4723 (Catawba map); Robin Beck, *Chiefdoms, Collapse, and Coalescence in the Early American South*, Cambridge University Press, 2013, 223–6; Ian Chambers, 'A Cherokee Origin for the "Catawba" Deerskin Map (*c.* 1721)', *Imago Mundi* 65 (2013), 207–16; Elizabeth Standish to Sloane, 14 October 1729, Sloane MS 4050, fol. 212; Sloane, Miscellanies Catalogue, 1458; Travis Glasson, private communication.

44. Gallay, *Indian Slave Trade*, ch. 12 and 214–15, 350, 356; Alden Vaughan, *Transatlantic Encounters: American Indians in Britain, 1500–1776*, Cambridge University Press, 2006, 150–62; Julie Sweet, 'Bearing Feathers of the Eagle: Tomochichi's Trip to England', *Georgia Historical Quarterly* 86 (2002), 339–71; Robert McPherson (ed.), *The Journal of the Earl of Egmont: Abstract of the Trustees Proceedings for Establishing the Colony of Georgia, 1732–1738*, University of Georgia Press, 1962, 59; Sloane, Birds Catalogue, 821; Quadrupeds Catalogue, 1657; Coll Thrush, *Indigenous London: Native Travelers at the Heart of Empire*, Yale University Press, 2016.

45. John McNeill, *Mosquito Empires: Ecology and War in the Greater Caribbean, 1620–1914*, Cambridge University Press, 2010, 149–51; Walter Tullideph to Sloane, 5 July 1727, Sloane MS 4049, fol. 3; Sloane, *NHJ*, annotated Sloane copy, NHM; Dandy, *Herbarium*, 221–2; John Burnet to Sloane, 6 April 1722, Sloane MS 4046, fol. 227; 6 August 1723, Sloane MS 4047, fol. 29; Burnet to Petiver, 14 May 1716, Sloane MS 4065, fol. 248;

Linda Colley, *Captives: Britain, Empire, and the World, 1600–1850*, Jonathan Cape, 2002; Sloane, Insects Catalogue, 3492.

46. Burnet to Sloane, 6 August 1723, Sloane MS 4047, fol. 29; 17 March 1724, Sloane MS 4047, fol. 329; 6 April 1722, Sloane MS 4046, fol. 227; 17 July 1725, Sloane MS 4048, fol. 26; 10 October 1727, Sloane MS 4049, fol. 50; 2 July 1736, Sloane MS 4054, fol. 266; Vera Lee Brown, 'The South Sea Company and Contraband Trade', *American Historical Review* 31 (1926), 662–78.

47. William Houstoun to Sloane, 9 December 1730, Sloane MS 4051, fol. 141, and 5 March 1731, Sloane MS 4052, fol. 82; Dandy, *Herbarium*, 139–40, 165; Hazel Le Rougetel, *The Chelsea Gardener: Philip Miller, 1691–1771*, Natural History Museum, 1990, 177; Rose Fuller to Sloane, 21 May 1733, Sloane MS 4052, fol. 352; Brooks, *Sloane*, 203.

48. Sloane to Johann Amman, n.d., Sloane MS 4068, fol. 281; Robert Millar to Sloane, 25 November 1735, Sloane MS 4054, fol. 146; 22 July 1737, Sloane MS 4055, fol. 147; 6 December 1737, Sloane MS 4055, fol. 244; Sloane, Miscellanies Catalogue, 1966–9; Millar to Sloane, n.d., Sloane MS 4059, fol. 355; Sloane reference for Millar, 10 April 1742, Sloane MS 3984, fol. 252.

49. William Byrd to Sloane, 20 July 1697, Sloane MS 3342, fol. 54, and 20 April 1706, Sloane MS 4040, fol. 151.

50. Byrd to Sloane, 10 September 1708, Sloane MS 4041, fol. 202; Sloane to Byrd, 7 December 1709, Sloane MS 4068, fol. 54; Byrd to Sloane, 31 May 1737, Sloane MS 4055, fol. 112; 10 April 1741, Sloane MS 4057, fol. 20; 20 August 1738, Sloane MS 4055, fol. 367; de Beer, *Sloane*, 101; Ralph Bauer, *The Cultural Geography of Colonial American Literatures: Empire, Travel, Modernity*, Cambridge University Press, 2003, ch. 6.

51. David Brigham, 'Mark Catesby and the Patronage of Natural History in the First Half of the Eighteenth Century', in Amy Meyers and Margaret Beck Pritchard (eds.), *Empire's Nature: Mark Catesby's New World Vision*, University of North Carolina Press, 1998, 91–146, p. 96; Joyce Chaplin, 'Mark Catesby, a Sceptical Newtonian in America', in ibid., 34–90, pp. 44, 83; Amy Meyers and Margaret Beck Pritchard, 'Introduction: Toward an Understanding of Catesby', in ibid., 1–33, pp. 3–4; Therese O'Malley, 'Mark Catesby and the Culture of Gardens', in ibid., 147–83, p. 155; Dandy, *Herbarium*, 111.

52. Meyers and Pritchard, 'Introduction', 4, 9; Amy Meyers, 'Picturing a World in Flux: Mark Catesby's Response to Environmental Interchange and Colonial Expansion', in Meyers and Pritchard, *Empire's Nature*, 228–61, pp. 252–3, 256–8; Gallay, *Indian Slave Trade*, ch. 12; Catesby to Sloane, 12 March 1724 and 27 November 1724, Sloane MS 4047, fols. 147, 290; Sloane, Miscellanies Catalogue, 1203; Parrish, *American Curiosity*, ch. 6; Chaplin, 'Sceptical Newtonian'.

53. Catesby to Sloane, 15 November 1723, Sloane MS 4047, fol. 90; 16 May 1723, Sloane MS 4046, fol. 352; 12 March 1724 and 15 August 1724, Sloane MS 4047, fols. 147, 213; Dandy, *Herbarium*, 110-11; Sloane, Quadrupeds Catalogue, 1666-7, and Birds Catalogue, 875; Brigham, 'Patronage', 103-4, 108-13, 199, 122; Mark Laird, 'From Callicarpa to Catalpa: The Impact of Mark Catesby's Plant Introductions on English Gardens of the Eighteenth Century', in Meyers and Pritchard, *Empire's Nature*, 184-227, p. 188; Meyers and Pritchard, 'Introduction', 5-7, 13; Thomas Knowlton to Richard Richardson, 18 July 1749, *Correspondence of Richard Richardson*, 400-402; Henrietta McBurney, 'Note on the Natural History Albums of Sir Hans Sloane', in McBurney (ed.), *Mark Catesby's Natural History of America: The Watercolours from the Royal Library, Windsor Castle*, Merrell Holberton, 1997, 33; Amy Meyers, 'The Perfecting of Natural History: Mark Catesby's Drawings of American Flora and Fauna in the Royal Library', in ibid., 11-27, pp. 21, 25; Chaplin, 'Sceptical Newtonian', 85.

54. HS, 332, 334; Dandy, *Herbarium*, 88-9; John Bartram to Sloane, 14 November 1742, Sloane MS 4057, fol. 157; Thomas Slaughter, *The Natures of John and William Bartram*, Knopf, 1996, 23-31, 70, 99.

55. John Bartram to Sloane, 14 November 1742, Sloane MS 4057, fol. 157; Bartram to Peter Collinson, 27 May 1743 and to Sloane, 16 November 1743, in Edmund and Dorothy Smith Berkeley (eds.), *The Correspondence of John Bartram, 1734-1777*, University Press of Florida, 1992, 215, 225.

56. HS, 334:127, 64, 126; John Bartram, *Observations . . . in his Travels from Pensilvania to Onondago*, London, 1751, 35-6, 43, 79; Thomas Hallock, 'Narrative, Nature, and Cultural Contact in John Bartram's *Observations*', and William Goetzmann, 'John Bartram's Journey to Onondaga in Context', in Nancy Hoffmann and John Van Horne (eds.), *America's Curious Botanist: A Tercentennial Reappraisal of John Bartram, 1699-1777*, American Philosophical Society, 2004, 107-26 and 97-106; Merrell, *American Woods*, 129-37, 151, 171-3, 190, 274; William Pencak and Daniel Richter (eds.), *Friends and Enemies in Penn's Woods: Indians, Colonists, and the Racial Construction of Pennsylvania*, Pennsylvania State University Press, 2004; William Fenton, *The Great Law and the Longhouse: A Political History of the Iroquois Confederacy*, University of Oklahoma Press, 152.

57. MacGregor, 'Career of Hans Sloane', 25; Sloane, Miscellanies Catalogue, 579 (sheath), 1729; James Delbourgo, *A Most Amazing Scene of Wonders: Electricity and Enlightenment in Early America*, Harvard University Press, 2006, ch. 1; John Winthrop to Sloane, 15 June 1734, Sloane MS 1968, fol. 58; John Thackray, 'Mineral and Fossil Collections', in MacGregor, *Sloane*, 123-35, p. 129; Raymond Stearns, *Science in the British Colonies of America*, University of Illinois Press, 1970, chs. 5, 11.

58. P. J. Marshall and Glyndwr Williams, *The Great Map of Mankind: British Perceptions of the World in the Age of Enlightenment*, J. M. Dent & Sons,

1982; Markley, *Far East*; Michael Adas, *Machines as the Measure of Men: Science, Technology, and Ideologies of Western Dominance*, Cornell University Press, 1990; Joyce Chaplin, *Subject Matter: Technology, Science, and the Body on the Anglo-American Frontier, 1500–1676*, Harvard University Press, 2001.

59. Edward Slaney, *Tabulae Iamaicae Insulae*, 1678, BL; Nicholas Thomas, *Entangled Objects: Exchange, Material Culture, and Colonialism in the Pacific*, Harvard University Press, 1991; Schaffer *et al.*, *Brokered World*; Paula Findlen, *Possessing Nature: Museums, Collecting, and Scientific Culture in Early Modern Italy*, University of California Press, 1994, ch. 8.

60. Sloane, Pictures and Drawings in Frames Catalogue, BM, 166; Kim Sloan, 'Sir Hans Sloane's Pictures: The Science of Connoisseurship or the Art of Collecting?', *Huntington Library Quarterly* 78 (2015), 381–415; Peter Linebaugh and Marcus Rediker, *The Many-Headed Hydra: Sailors, Slaves, Commoners, and the Hidden History of the Revolutionary Atlantic*, Beacon, 2000, esp. ch. 5; Diana and Michael Preston, *A Pirate of Exquisite Mind: Explorer, Naturalist, and Buccaneer: The Life of William Dampier*, Walker, 2004, 226.

61. Sloane, Miscellanies Catalogue, 43; Kathie Way, 'Invertebrate Collections', in MacGregor, *Sloane*, 93–111, p. 108; John Starrenburgh to James Petiver, 20 January 1701, Sloane MS 4063, fol. 61; Preston and Preston, *Exquisite Mind*, esp. 175 and ch. 18; Dandy, *Herbarium*, 123; Sloane MS 3236, fols. 1–13, 29–233 (journal, 1681–91); Anna Neill, 'Buccaneer Ethnography: Nature, Culture, and Nation in the Journals of William Dampier', *Eighteenth-Century Studies* 33 (2000), 165–80.

62. William Dampier, *A New Voyage Round the World*, London, 5th edn, 1703, 511–19 and ch. 13 (Jeoly); Geraldine Barnes, 'Curiosity, Wonder, and William Dampier's Painted Prince', *Journal for Early Modern Cultural Studies* 6 (2006), 31–50; Sloane to Jean-Paul Bignon, 20 December 1711, Sloane MS 4068, fol. 65; Sloane MS 3236, fols. 14–28 (Wafer); Preston and Preston, *Exquisite Mind*, 90–92 (Kuna), ch. 16 and 218–20 (Jeoly), 255, and chs. 20, 23, 25, including 313–14 (Selkirk).

63. Benjamin Franklin, 'Autobiography', in *Writings*, Library of America, 1987, 1351; Joyce Chaplin, *The First Scientific American: Benjamin Franklin and the Pursuit of Genius*, Basic, 2007.

64. Franklin, 'Autobiography', 1346; Franklin to Sloane, 2 June 1725, Papers of Benjamin Franklin (Yale), http://www.franklinpapers.org/franklin/framedNames.jsp, accessed May 2013.

65. Marcel Mauss, *The Gift: The Form and Reason for Exchange in Archaic Societies*, 1925, trans. W. D. Halls, Norton, 1990, 13; Stuart Schwartz (ed.), *Implicit Understandings: Observing, Reporting, and Reflecting on the Encounters between Europeans and Other Peoples in the Early Modern Era*, Cambridge University Press, 1994.

66. Thomas Bluett, *Some Memoirs of the Life of Job, the Son of Solomon the High Priest of Boonda in Africa*, London, 1734, 13–33, quotations 22, 24, 46;

Sloane to Abbé Bignon, 8 July 1734, Sloane MS 4068, fol. 236, and to unknown, 16 September 1735, ibid., fol. 275; Venetia Porter, *Arabic and Persian Seals and Amulets in the British Museum*, British Museum, 2011, 131–3, 140–43, 149, 154–6, 164–5.

67. Bluett, *Memoirs*, v–vi, 12, 22; Sloane to Bignon, 8 July 1734, Sloane MS 4068, fol. 236; Douglas Grant, *The Fortunate Slave: An Illustration of African Slavery in the Early Eighteenth Century*, Oxford University Press, 1968, esp. 84–5, 105; Michael Gomez, *Pragmatism in the Age of Jihad: The Precolonial State of Bundu*, Cambridge University Press, 1993, 47, 61, 68.

68. Gerald MacLean and Nabil Matar, *Britain and the Islamic World, 1558–1713*, Oxford University Press, 2011, 37 and chs. 2, 6; Colley, *Captives*, part 1; Bluett, *Memoirs*, 31–2, 35–6, 44, 47–8; Grant, *Fortunate Slave*, 107; Adas, *Machines*, 153–65; Travis Glasson, *Mastering Christianity: Missionary Anglicanism and Slavery in the Atlantic World*, Oxford University Press, 2011; Jerry Brotton, *This Orient Isle: Elizabethan England and the Islamic World*, Allen Lane, 2016.

69. Bluett, *Memoirs*, 31, 50–51; Marcia Pointon, 'Slavery and the Possibilities of Portraiture', in Agnes Lugo-Ortiz and Angela Rosenthal (eds.), *Slave Portraiture in the Atlantic World*, Cambridge University Press, 2013, 41–70; Matar, *Lands of the Christians*, xxx; Patricia Crone, private communication.

70. Sloane, Gemmae & Lapides continentes Inscriptiones Arabicas, Persicas, &c. Catalogue, BM (author's translation; catalogue includes names of translators); J. M. Gray, *A History of the Gambia*, Cambridge University Press, 1940, 211; Nabil Matar, *Islam in Britain, 1558–1685*, Cambridge University Press, 1998, ch. 3; Porter, *Arabic and Persian Seals*, 154 (translations); see also Marjorie Caygill, 'Sloane's Catalogues and the Arrangement of his Collections', in Hunter, *Books to Bezoars*, 120–36, p. 123.

71. Sloane, Miscellanies Catalogue, 707; *NHJ*, 2:339; Michael Gomez, *Exchanging our Country Marks: The Transformation of African Identities in the Colonial and Antebellum South*, University of North Carolina Press, 1998, 49–51, 284; Emilie Savage-Smith, 'Amulets and Related Talismanic Objects', in Francis Maddison and Savage-Smith (eds.), *Science, Tools and Magic, Part One: Body and Spirit, Mapping the Universe*, Nour Foundation, 1997, 132–47; Peter Forshaw, 'Magical Material and Material Survivals: Amulets, Talismans and Mirrors in Early Modern Europe', in Dietrich Boschung and Jan Bremmer (eds.), *The Materiality of Magic*, Wilhelm Fink, 2015, 357–78.

72. Sloane, Miscellanies Catalogue, 1763–6; Ayyuh ibn Sulaiman ibn Ibrahaim [Diallo] to Sloane, 8 December 1734, Sloane MS 4053, fol. 341, and *c.* 1736, latter quoted in Grant, *Fortunate Slave*, 186–7; Sloane to unknown, 16 September 1735, Sloane MS 4068, fol. 275 (possibly to Bignon: compare with Sloane to Bignon, 8 July 1734, Sloane MS 4068, fol. 236); see also Thomas Derham to Sloane, 9 October 1734, Sloane MS 4053, fol. 285.

73. Grant, *Fortunate Slave*, 198; Gomez, *Pragmatism*, 68; *London Art Reviews*, 29 July 2013, http://londonartreviews.com/index.php/museums/113-first-portrait-of-slave-diallo-is-back-at-the-national-portrait-gallery1-london, accessed December 2016 ('first British portrait'); *Daily Telegraph*, 7 July2010,http://www.telegraph.co.uk/culture/art/art-news/7877168/Campaign-to-keep-slave-painting-in-Britain.html, accessed June 2013; Sonja Mejcher-Atassi and John Pedro Schwartz (eds.), *Archives, Museums and Collecting Practices in the Modern Arab World*, Ashgate, 2012, introduction; Natalie Zemon Davis, *Trickster Travels: A Sixteenth-Century Muslim between Worlds*, Hill & Wang, 2007; Bluett, *Memoirs*, 44, 50–51, 59–63; Molineux, *Ebony*, ch. 4.

74. 'The Habits of the Grand Signor's Court', Turkey, *c.* 1620, Sloane MS 5258, BM; Deccan inhabitants, South India, Sloane MS 5254, BM; inhabitants of Isfahan, Persia, Kaempfer collection, Sloane MS 5292, BM; see also Sloane, Miscellanies Catalogue, 1748 (Turkish tobacco pipe) and 1768 (habit of inhabitants of Kamchatka sent from St Petersburg).

## CHAPTER 6: PUTTING THE WORLD IN ORDER

1. M. A. E. Nickson, 'Books and Manuscripts', in MacGregor, *Sloane*, 263–77; Amy Blakeway, 'The Library Catalogues of Sir Hans Sloane: Their Authors, Organization, and Functions', *Electronic British Library Journal* (2011), 1–49, http://www.bl.uk/eblj/2011articles/pdf/ebljarticle162011.pdf, accessed December 2016; Alison Walker, 'Sir Hans Sloane's Printed Books in the British Library: Their Identification and Associations', in Giles Mandelbrote and Barry Taylor (eds.), *Libraries within the Library: The Origins of the British Library's Printed Collections*, British Library, 2009, 89–97; *NHJ*, 1:149, NHM Sloane copy (Empson dictation).

2. Anke te Heesen, 'News, Paper, Scissors: Clippings in the Sciences and Arts around 1920', in Lorraine Daston (ed.), *Things that Talk: Object Lessons from Art and Science*, Zone, 2004, 297–323; Staffan Müller-Wille, 'Collection and Collation: Theory and Practice of Linnaean Botany', *Studies in History and Philosophy of Biological and Biomedical Sciences* 38 (2007), 541–62; Peter Jones, 'A Preliminary Check-List of Sir Hans Sloane's Catalogues', *British Library Journal* 14 (1988), 38–51; Marjorie Caygill, 'Sloane's Catalogues and the Arrangement of his Collections', in Hunter, *Books to Bezoars*, 120–36; Ann Blair, *Too Much to Know: Managing Scholarly Information before the Modern Age*, Yale University Press, 2010; Peter Burke, 'Commentary', *Archival Science* 7 (2007), 391–7; Ian Hodder, *Entangled: An Archaeology of the Relationship between Humans and Things*, Wiley-Blackwell, 2012, ch. 5; Bruno Latour, *Science in Action: How to Follow Scientists and Engineers through Society*, Harvard

University Press, 1987, ch. 6; Henry Newman to [?], 21 August 1742, MS 7633, fol. 10, Wellcome Library; Leonard Cowie, *Henry Newman: An American in London, 1708–43*, Church Historical Society, 1956, 55, 61, 68; Ralph Thoresby to Richard Richardson, 21 June 1723, in *Extracts from the Literary and Scientific Correspondence of Richard Richardson*, Yarmouth, 1835, 196.

3. Sloane to Abbé Bignon, n.d., Bibliothèque Nationale, Paris, Fonds Français, MS 22236, quoted in Jack Clarke, 'Sir Hans Sloane and Abbé Bignon: Notes on Collection Building in the Eighteenth Century', *Library Quarterly* 50 (1980), 475–82, p. 478; 'The Names and Numbers of the Several Things, Contain'd in the Musaeum of Sir Hans Sloane, Bart.', in *Authentic Copies of the Codicils belonging to the Last Will and Testament of Sir Hans Sloane*, London, 1753, 33–5; Walker, 'Sloane's Printed Books', 89; Jack Goody, *The Domestication of the Savage Mind*, Cambridge University Press, 1977, ch. 5; Umberto Eco, *The Infinity of Lists*, Rizzoli, 2009; James Delbourgo and Staffan Müller-Wille, 'Listmania: Introduction', *Isis* 103 (2012), 710–15; Richard Yeo, *Notebooks, English Virtuosi, and Early Modern Science*, University of Chicago Press, 2014.

4. Mark Meadow and Bruce Robertson (eds.), *The First Treatise on Museums: Samuel Quiccheberg's Inscriptiones, 1565*, Getty Research Institute, 2013, 23–6; Olaus Wormius, *Historia rerum rariorum, tam naturalium quam artificialium, tam domesticarum quam exoticarum quae Hafniae Danorum in aedibus authoris servantur, cum indice subjuncto 1655*, Sloane MS 1608; Jole Shackelford, 'Documenting the Factual and Artifactual: Ole Worm and Public Knowledge', *Endeavour* 23 (1999), 65–71.

5. Nickson, 'Books and Manuscripts'; Blakeway, 'Library Catalogues'; Sloane's printed books may be searched here: http://www.bl.uk/catalogues/sloane/, accessed June 2010.

6. Sloane, Vegetable Substances Catalogue, NHM, 8119, 607.

7. Anke te Heesen, 'Boxes in Nature', *Studies in the History and Philosophy of Science* 31 (2000), 381–403, and 'Accounting for the Natural World: Double-Entry Bookkeeping in the Field', in Londa Schiebinger and Claudia Swan (eds.), *Colonial Botany: Science, Commerce, and Politics in the Early Modern World*, University of Pennsylvania Press, 2004, 237–51; James Delbourgo, 'What's in the Box?', *Cabinet Magazine* 41 (2011), 46–50; Lorraine Daston, 'Attention and the Values of Nature in the Enlightenment', in Daston and Fernando Vidal (eds.), *The Moral Authority of Nature*, University of Chicago Press, 2004, 100–126.

8. Sloane, Miscellanies Catalogue, BM, 47 (organs), 219 (chopsticks), 419 (seals), 594 (abacus), 1810 (glue); Carla Nappi, *The Monkey and the Inkpot: Natural History and its Transformations in Early Modern China*, Harvard University Press, 2009, 144; Geoffrey Gunn, *First Globalization: The Eurasian Exchange: 1500–1800*, Rowman & Littlefield, 2003, 96;

Kim Sloan, 'Sloane's "Pictures and Drawings in Frames" and "Books of Miniature & Painting, Designs, &c.', in Hunter, *Books to Bezoars*, 168–89, pp. 186, 188.

9. Sloane, Vegetable Substances Catalogue, 8405 (fine branches) and 366 (cocoons); Miscellanies Catalogue, BM, 44 and 579 (sheaths), 1368 (drum), 1730 (auk spoon), 1727–9 (other Winthrop curiosities including candle, soap, 'Indian breastplate', spoon and bowl); Sloane, Oriental MS 1402; Gail Feigenbaum and Inge Reist (eds.), *Provenance: An Alternate History of Art*, Getty Institute, 2013.

10. Caygill, 'Sloane's Catalogues', esp. 128–30; Sloan, 'Sloane's "Pictures and Drawings in Frames"', 173; Carol Gibson-Wood, 'Classification and Value in a Seventeenth-Century Museum: William Courten's Collection', *Journal of the History of Collections* 9 (1997), 61–77, p. 66; Monique Scott, *Rethinking Evolution in the Museum: Envisioning African Origins*, Routledge, 2007, esp. ch. 3 and p. 72.

11. Caygill, 'Sloane's Catalogues', 130; Sloane, Corals Catalogue, NHM, 9–10 (coral encrustations), and Miscellanies Catalogue, 515, 1900 (coral encrustations); Antiquities Catalogue, BM, 102 (urns); Quadrupeds Catalogue, NHM, 10–11 (manatee); Miscellanies, 1090 (manatee strap) and 464 (hatchet); Humana Catalogue, NHM, 273–5 (tortoise); *NHJ*, 2:ii and 339.

12. Eric Jorink, 'Sloane and the Dutch Connection', in Hunter, *Books to Bezoars*, 57–70, p. 64; Nickson, 'Books and Manuscripts', 265; William Poole, 'Francis Lodwick, Hans Sloane, and the Bodleian Library', *Library: The Transactions of the Bibliographical Society* 7 (2006), 377–418; *NHJ*, 1:xxi, NHM Sloane copy.

13. Henry Barham, *Hortus Americanus*, Kingston, 1794; *NHJ*, 1:170–71 with Barham MS notes (coca and verbena), NHM Sloane copy; Barham to Sloane, 11 December 1717, Sloane MS 4045, fol. 77 (Attoo); *NHJ*, 2:385–6, quoting Barham's manuscript; Miles Ogborn, 'Talking Plants: Botany and Speech in Eighteenth-Century Jamaica', *History of Science* 51 (2013), 1–32; Julie Kim, 'Obeah and the Secret Sources of Atlantic Medicine', in Hunter, *Books to Bezoars*, 99–104.

14. James Empson, 'Proposal of a Plan', 27 August 1756, Original Letters and Papers, BM Archives, 1:fols. 39–45, quotation 42 (emphasis added); Sloane to Antoine de Jussieu, n.d., Sloane MS 4069, fol. 170 (author's translation).

15. A. J. Cain, 'John Locke on Species', *Archives of Natural History* 24 (1997), 337–60; Martin Rudwick, *Georges Cuvier, Fossil Bones, and Geological Catastrophes: New Translations and Interpretations of the Primary Texts*, University of Chicago Press, 1998; Daniel Carey, *Locke, Shaftesbury, and Hutcheson: Contesting Diversity in the Enlightenment and Beyond*, Cambridge University Press, 2006, 28–30; *NHJ*, 1:preface; Sloane to Levinus Vincent, n.d., Sloane MS 4069, fol. 200 (author's translation).

16. Birch, 'Memoir', fol. 15; Richard Neer, 'Framing the Gift: The Politics of the Siphnian Treasury at Delphi', *Classical Antiquity* 20 (2001), 273–344; Lorraine Daston and Katharine Park, *Wonders and the Order of Nature, 1150–1750*, Zone, 1998, ch. 2, esp. 74; Patrick Geary, 'Sacred Commodities: The Circulation of Medieval Relics', in Arjun Appadurai (ed.), *The Social Life of Things: Commodities in Cultural Perspective*, Cambridge University Press, 1986, 169–91; David Graeber, *Toward an Anthropological Theory of Value: The False Coin of Our Own Dreams*, Palgrave, 2001; Fred Myers (ed.), *The Empire of Things: Regimes of Value and Material Culture*, SAR Press, 2002; Joseph Pitton de Tournefort to Sloane, 17 June 1690, Sloane MS 4036, fol. 84; Nehemiah Grew to Sloane, 5 August 1709, Sloane MS 4042, fol. 30.

17. Richard Yeo, 'Encyclopaedic Collectors: Hans Sloane and Ephraim Chambers', in Robert Anderson *et al.* (eds.), *Enlightening the British*, British Museum, 2003, 29–36, and *Encyclopaedic Visions: Scientific Dictionaries and Enlightenment Culture*, Cambridge University Press, 2010; Sloane, *Will of Sir Hans Sloane*, London, 1753, 3; Sloane to Henri Basnage de Beauval, 9 November 1696, Sloane MS 4036, fol. 273; Arnold Hunt, 'Sloane as a Collector of Manuscripts', in Hunter, *Books to Bezoars*, 190–207, p. 198; Margaret Jacob, *The Newtonians and the English Revolution, 1689–1720*, Cornell University Press, 1976, chs. 5–6.

18. http://www.britishmuseum.org/research/collection_online/collection_object_details.aspx?objectId=54863&partId=1&searchText=sloane+astrolabe&page=1 (English), and http://www.britishmuseum.org/research/collection_online/collection_object_details.aspx?objectId=245507&partId=1&searchText=sloane+astrolabe&images=true&page=1 (Persian), accessed August 2015; Silke Ackerman and Jane Wess, 'Between Antiquarianism and Experiment: Hans Sloane, George III and Collecting Science', in Kim Sloan (ed.), *Enlightenment: Discovering the World in the Eighteenth Century*, British Museum, 2003, 150–57, pp. 152–3; Sara Schechner Genuth, 'Astrolabes and Medieval Travel', in Robert Bork and Andrea Kann (eds.), *The Art, Science, and Technology of Medieval Travel*, Ashgate, 2008, 181–210, and 'Astrolabes: A Cross-Cultural and Social Perspective', in Roderick and Marjorie Webster, *Western Astrolabes*, Adler Planetarium, 1998, 2–25.

19. Sloane MSS 384 (jests), 1381 (wrinkles), 2196 (urines), 3086 (Paracelsus), 2819 (Helmont), 1039, 4024 (Hooke), 687 (Trismegistus), 230, 236, 302, 486 (Harvey), 3236 (Dampier), 3527 (Radisson), 225, 2459, 3646 (Geber), 1682, 3646 (Plot), 1827, 1839, 1842, 1843, etc. (Browne), 82, 2946, 3096, 3282 (al-Isráili), 3032 (Galen), 344 (Avicenna), 153, 206, 211, 776, etc. (surgeons); Nickson, 'Books and Manuscripts', esp. 268; John Goldfinch, 'Sloane's Incunabula', in Hunter, *Books to Bezoars*, 208–20; Engelbert Kaempfer, *The History of Japan*, trans. Johann Gaspar Scheuchzer, 2 vols., London, 1727, 1:xxxi–li.

20. Savithri Preetha Nair, ' "To Be Serviceable and Profitable for their Health":
A Seventeenth-Century English Herbal of East Indian Plants Owned by
Sloane', in Hunter, *Books to Bezoars*, 105–19; Kapil Raj, 'Surgeons, Fakirs,
Merchants, and Craftsmen: Making L'Empereur's *Jardin* in Early Modern
South Asia', in Schiebinger and Swan, *Colonial Botany*, 252–69, and *Re-
locating Modern Science: Circulation and the Construction of Knowledge
in South Asia and Europe, 1650–1900*, Palgrave, 2010; Sloan, 'Sloane's
"Pictures and Drawings in Frames" ', 186–7.

21. Sloane MSS 2373 (bark) and 5267 (paper); Blakeway, 'Library Catalogues';
Sloan, 'Sloane's "Pictures and Drawings in Frames" ', 173–4; Sloane, Veg-
etable Substances Catalogue, e.g. 10562 and 11893; Kim Sloan (ed.), *A
New World: England's First View of America*, British Museum, 2007, 186,
224–33; Sloane to John Locke, 11 December 1696, in E. S. de Beer (ed.),
*The Correspondence of John Locke*, 8 vols., Clarendon Press, 1976–89,
5:737; Hunt, 'Sloane as a Collector of Manuscripts', recipes 203, e.g. Sloane
MS 703; Elaine Leong and Alisha Rankin (eds.), *Secrets and Knowledge in
Medicine and Science, 1500–1800*, Ashgate, 2011.

22. Sloane, 'Account of Elephants Teeth and Bones Found Under Ground', *PT*
35 (1727–8), 457–71, 497–514; Jill Cook, 'The Elephants in the Collection:
Sloane and the History of the Earth', in Hunter, *Books to Bezoars*, 158–67,
and 'The Nature of the Earth and the Fossil Debate', in Sloan, *Enlighten-
ment*, 92–9; Cyrille Delmer, 'Sloane's Fossils', in Hunter, *Books to Bezoars*,
154–7.

23. Richard Popkin, *Isaac La Peyrère (1596–1676): His Life, Work and Influ-
ence*, Brill, 1987; Sloane, 'Elephants Teeth'; 'Mémoire sur les dents et autres
ossemens de l'éléphant trouvés dans terre', *Mémoires de l'Académie Royale
des Sciences*, 1729, 305–34; and Quadrupeds Catalogue, 116, 1185;
Thomas Molyneux, 'Remarks upon the Aforesaid Letter and Teeth', *PT* 29
(1714), 370–84, p. 382; Rhoda Rappaport, *When Geologists were Histori-
ans, 1665–1750*, Cornell University Press, 1997, 23–4, 115–16, 217;
MacGregor, 'Career of Hans Sloane', in MacGregor, *Sloane*, 11–44, p. 24,
and 'Prehistoric and Romano-British Antiquities', in ibid., 180–97, p. 181;
Ian Jenkins, 'Classical Antiquities: Sloane's "Repository of Time" ', in ibid.,
167–73, pp. 167–9; Colin Kidd, *British Identities before Nationalism:
Identity and Nationhood in the Atlantic World, 1600–1800*, Cambridge
University Press, 1999, chs. 2–3; William Poole, *The World Makers: Scien-
tists of the Restoration and the Search for the Origins of the Earth*, Peter
Lang, 2010, chs. 2, 9.

24. Arnold Hunt, 'Sloane as a Collector of Manuscripts', in Hunter, *Books to
Bezoars*, 190–207, pp. 200–201; Samuel Pepys to Sloane, 31 July 1702,
Sloane MS 4039, fol. 12; Sloan, 'Sloane's "Pictures and Drawings in
Frames" ', 168; Blakeway, 'Library Catalogues', 40; 'Account of Books
Loaned to Several Persons', Sloane MS 4019, fol. 201; Kim Sloan, 'Sir Hans

Sloane's Pictures: The Science of Connoisseurship or the Art of Collecting?', *Huntington Library Quarterly* 78 (2015), 381–415; David Brigham, 'Mark Catesby and the Patronage of Natural History in the First Half of the Eighteenth Century', in Amy Meyers and Margaret Pritchard (eds.), *Empire's Nature: Mark Catesby's New World Vision*, University of North Carolina Press, 1998, 91–146, p. 119; Anna Marie Roos, *Web of Nature: Martin Lister (1639–1712), the First Arachnologist*, Brill, 2011, ch. 12, esp. 310; Elizabeth Blackwell, *A Curious Herbal*, 2 vols., London, 1737–9, dedication in vol. 1 succeeding plate 96, coral in vol. 2 plate 342; Doreen Evenden, 'Blackwell, Elizabeth', *ODNB*; http://www.bl.uk/collection-items/a-curious-herbal-dandelion, accessed August 2016; Kaempfer, *History of Japan*, 1:xvii (quotation), xxxi–li (book list), 2:595 (idol); Maurice Johnson *et al.*, *Gulliver's Travels and Japan*, Doshisha University/Amherst House, 1977; Geoffrey Gunn, *First Globalization: The Eurasian Exchange, 1500–1800*, Rowman & Littlefield, 2003, 55; Yu-Ying Brown, 'Japanese Books and Manuscripts', in MacGregor, *Sloane*, 278–90, p. 287; Jonathan Swift, *Travels into Several Remote Nations of the World, in four parts, by Lemuel Gulliver*, 1726, Penguin, 1985, 263.

25. Carey, *Locke*, ch. 4, esp. 125–8; David Porter, *The Chinese Taste in Eighteenth-Century England*, Cambridge University Press, 2010, 27–30; Partha Mitter, *Much Maligned Monsters: A History of European Reactions to Indian Art*, University of Chicago Press, 1992, chs. 1–2; Arthur MacGregor, 'Egyptian Antiquities', in MacGregor, *Sloane*, 174–9; Mary Helms, 'Essay on Objects: Interpretations of Distance Made Tangible', in Stuart Schwartz (ed.), *Implicit Understandings: Observing, Reporting and Reflecting on the Encounters between Europeans and Other Peoples in the Early Modern Era*, Cambridge University Press, 1994, 355–77; Judy Rudoe, 'Engraved Gems: The Lost Art of Antiquity', in Sloan, *Enlightenment*, 132–9; Andrew Burnett, ' "The King Loves Medals": The Study of Coins in Europe and Britain', in ibid., 122–31; Giulia Bartrum, *Albrecht Dürer and his Legacy: The Graphic Work of a Renaissance Artist*, Princeton University Press, 2002, 8, 285; Carol Gibson-Wood, *Jonathan Richardson: Art Theorist of the English Enlightenment*, Yale University Press, 2000, 70–72; Sloan, 'Sir Hans Sloane's Pictures', and 'Sloane's "Pictures and Drawings in Frames"', 169, 174, 184; Sloane MSS 116 (prayer book) (http://www.bl.uk/catalogues/illuminatedmanuscripts/ILLUMIN.ASP?Size=mid&IllID=6547, accessed June 2014), 1041 (painting instructions), 1585 (dyeing velvet), 1975 and 4016 (herbals and bestiaries), etc.; Hunt, 'Sloane as a Collector of Manuscripts', 193.

26. Susan Bracken *et al.* (eds.), *Women Patrons and Collectors*, Cambridge Scholars Publishing, 2012; Elizabeth Eger, 'Paper Trails and Eloquent Objects: Bluestocking Friendship and Material Culture', *Parergon* 26 (2009), 109–38; Beth Fowkes Tobin, *The Duchess's Shells: Natural History*

*Collecting in the Age of Cook's Voyages*, Yale University Press, 2014; Marjorie Swann, *Curiosities and Texts: The Culture of Collecting in Early Modern England*, University of Pennsylvania Press, 2001, 11–14; Nickson, 'Books and Manuscripts', 264; William Sherard to Richard Richardson, 6 April 1723, in *Correspondence of Richard Richardson*, 194.

27. Keith Thomas, *Religion and the Decline of Magic*, Weidenfeld & Nicolson, 1971; William Pietz, 'The Problem of the Fetish', *Res* 9 (1985), 5–17; ibid., 13 (1987), 23–45; ibid., 16 (1988), 105–24; Sloane, Miscellanies Catalogue, 1817.

28. John Beaumont to Sloane, 2 and 14 May 1702, Sloane MS 4038, fols. 336, 343; Sloane, Fossils Catalogue, NHM, 23; Sloane, Memoir of Beaumont, 1740, Bibliothèque Nationale de France, Fonds Français, 22229, fols. 258–65, reproduced and translated in Michael Hunter (ed.), *Magic and Mental Disorder: Sir Hans Sloane's Memoir of John Beaumont*, Robert Boyle Project, 2011, 5–8; Clarke, 'Sloane and Bignon'; J. B. Shank, *The Newton Wars and the Beginning of the French Enlightenment*, University of Chicago Press, 2008, *passim* (Bignon); see also Joad Raymond (ed.), *Conversations with Angels: Essays toward a History of Spiritual Communication, 1100–1700*, Palgrave, 2011, e.g. Peter Forshaw, '"Behold, the Dreamer Cometh": Hyperphysical Magic and Deific Visions in an Early Modern Theosophical Lab-Oratory', 175–200, pp. 183–4 on Sloane MS 181, 'Tabulæ theosophicæ cabbalisticæ', seventeenth century.

29. Sloane, Beaumont memoir, in Hunter, *Magic*, 9–13; Sloane MS 2731 (*Clavicula Salomonis*); Sloane MSS 15, 3188, 3191, 3677, 3678 (Dee); Thomas, *Decline of Magic*, 273–82; Hunt, 'Sloane as a Collector of Manuscripts', 196–7; Deborah Harkness, *John Dee's Conversations with Angels: Cabala, Alchemy, and the End of Nature*, Cambridge University Press, 1999.

30. Sloane, Beaumont memoir, in Hunter, *Magic*, 12–14; Sloane MS 3856 (Kelley and Ashmole), 99, 2550 (Forman); Lauren Kassell, *Medicine and Magic in Elizabethan London: Simon Forman, Astrologer, Alchemist and Physician*, Oxford University Press, 2007, esp. 58–9, 127, 186, 216, 227–30.

31. Sloane, Beaumont memoir, in Hunter, *Magic*, 17, 8; Michael Heyd, *'Be Sober and Reasonable': The Critique of Enthusiasm in the Seventeenth and Early Eighteenth Centuries*, Brill, 1995, esp. ch. 7.

32. Sloane, Beaumont memoir, in Hunter, *Magic*, 15–16, 18, 20.

33. *NHJ*, 1:table 'iiii' (spar); Sloane, Corals Catalogue, 195 ('hand'); Fossils Catalogue, 24, 37, 38; Daston and Park, *Wonders*, ch. 9; Ken Arnold, *Cabinets for the Curious: Looking Back at Early English Museums*, Ashgate, 2006; Peter Pels, 'The Spirit of Matter: On Fetish, Rarity, Fact, and Fancy', in Patricia Spyer (ed.), *Border Fetishisms: Material Objects in Unstable Spaces*, Routledge, 1998, 91–121; Paula Findlen, 'Inventing Nature: Commerce, Art, and Science in the Early Modern Cabinet of Curiosities', in Pamela Smith and Findlen (eds.), *Merchants and Marvels: Commerce,*

*Science, and Art in Early Modern Europe*, Routledge, 2002, 297–323; Paul Monod, *Solomon's Secret Arts: The Occult in the Age of Enlightenment*, Yale University Press, 2013, 214–15 (Cabala) and 132, 177; Thomas Stack, 'Letter from Thomas Stack', *PT* 41 (1739), 140–42; Sloane, Miscellanies Catalogue, 974 and Humana Catalogue, 662.

34. Sloane, 'A Further Account of the Contents of the China Cabinet', *PT* 20 (1698), 461–2; John Appleby, 'The Royal Society and the Tartar Lamb', *NRRS* 51 (1997), 23–34; Sloane, Miscellanies Catalogue, 1080 (penis ring); Sloane to Bishop of Kilmore, 27 March 1736, Sloane MS 1968, fol. 71.

35. Sloane, Miscellanies Catalogue, 707, 755, 1489, 1750, 2070 (amulets); 821 (Monmouth); 405 (arrow); 540 (purse); 1103 (drum); Robert Storrie, http://www.britishmuseum.org/research/collection_online/collection_object_details. aspx?objectId=671371&partId=1&searchText=sami&images=true&page=1, accessed August 2015; William Courten, 'Things Bought in January & February & March & April 1690', Sloane MS 3961, fol. 39 (Royal Touch); Giles Mandelbrote, 'Sloane and the Preservation of Printed Ephemera', in Mandelbrote and Taylor, *Libraries within the Library*, 146–68, pp. 155–9 (quacks); Jane Shaw, *Miracles in Enlightenment England*, Yale University Press, 2006, 176 (Tofts); Sloane, 'Conjectures on the Charming or Fascinating Power Attributed to the Rattle-Snake', *PT* 38 (1733–4), 321–31; on charms, see Sloane MSS 65, 66, 72, 94, etc.; Edward Lhwyd, 'Extracts of Several Letters from Mr Edward Lhwyd ... Containing Observations in Natural History and Antiquities', *PT* 28 (1713), 93–101, pp. 98–9; and for numerous miscellaneous magical manuscripts see e.g. Sloane MSS 307 (angels), 317 (alchemy), 314 (astrology), 2879 (experimental magic), 3437 (chiromancy/palmistry) and 1171 (Philosopher's Stone), http://www.bl.uk/catalogues/illuminatedmanuscripts/record.asp?MSID=1 217&CollID=9&NStart=1171, accessed May 2014; on amulets, see Emilie Savage-Smith, 'Amulets and Related Talismanic Objects', in Francis Maddison and Savage-Smith (eds.), *Science, Tools and Magic, Part One: Body and Spirit, Mapping the Universe*, Nour Foundation, 1997, 132–47; Peter Forshaw, 'Magical Material and Material Survivals: Amulets, Talismans and Mirrors in Early Modern Europe', in Dietrich Boschung and Jan Bremmer (eds.), *The Materiality of Magic*, Wilhelm Fink, 2015, 357–78.

36. Sloane, Miscellanies Catalogue, 288, 1078, 1134, etc. ('idols'), 1686 ('heathen') and 201–4 ('Huron savages'); Sloane to Claude-Joseph Geoffroy, le jeune, n.d., Sloane MS 4069, fol. 84; Peta Ree, 'Shaw, Thomas', *ODNB*; Linda Colley, *Captives: Britain, Empire, and the World, 1600–1850*, Jonathan Cape, 2002, part 1; Thomas Shaw, 'Letter to Sir Hans Sloane', *PT* 36 (1729–30), 177–84; Sloane to unknown, n.d., Sloane MS 4069, fol. 267; Thomas Shaw, *Travels, or Observations relating to Several Parts of*

*Barbary and the Levant*, 1738, 2nd edn, London, 1757, 155–65, quotations 159–60; see also Sloane MS 4069, fols. 130, 224, 267; Sloane, Humana Catalogue, 570.

37. Sloane, Miscellanies Catalogue, 637–8 ('trinkets'), 1271 (lamb), 542 (girdle), 509 ('masse'); Lucia Dacome, *Malleable Anatomies: Models, Makers and Material Culture in Eighteenth-Century Italy*, Oxford University Press, 2017, ch. 7; Johann Amman to Sloane, 6 September 1736, Sloane MS 4054, fol. 298; William Beckett, *A Free and Impartial Enquiry into the Antiquity and Efficacy of Touching for the Cure of the King's Evil*, London, 1722; Samuel Werenfels, *A Dissertation upon Superstition in Natural Things*, London, 1748, 49.

38. Michael Cole and Rebecca Zorach (eds.), *The Idol in the Age of Art: Objects, Devotions and the Early Modern World*, Ashgate, 2009; Mitter, *Much Maligned Monsters*, esp. 55–6, 73–7; Urs App, *The Birth of Orientalism*, University of Pennsylvania Press, 2010, 180 (Diderot); Gunn, *First Globalization*, 4–5, chs. 6–7; Nicholas Dew, *Orientalism in Louis XIV's France*, Oxford University Press, 2009; Anna Winterbottom, *Hybrid Knowledge in the Early East India Company World*, Palgrave Macmillan, 2015, ch. 2; Sloane MSS 2393 (law in Malay), 3115 (hymns and psalms in Malay), discussed in Annabel Gallop, 'Malay Manuscripts in the Sloane Collection', 2013, http://britishlibrary.typepad.co.uk/asian-and-african/2013/11/malay-manuscripts-in-the-sloane-collection.html, accessed August 2015; Sloane MS 1987 (Qur'ān).

39. Edward Said, *Orientalism*, Pantheon, 1978; Michael Adas, *Machines as the Measure of Men: Science, Technology, and Ideologies of Western Dominance*, Cornell University Press, 1992, 95–108, 166–77; Winterbottom, *Hybrid Knowledge*; Sloane, Miscellanies Catalogue, 147, 1134, 1777; John Gascoigne, 'The Royal Society, Natural History, and the Peoples of the "New World(s)", 1660–1800', *BJHS* 42 (2009), 539–62; Carey, *Locke*, 25 (Sloane MS 5253 from Locke via Courten); 'The Habits of the Grand Signor's Court', Turkey, *c.* 1620, Sloane MS 5258, BM; Deccan inhabitants, South India, Sloane MS 5254, BM; inhabitants of Isfahan, Persia, Kaempfer collection, Sloane MS 5292, BM; Alexander Stuart, 'An Explanation of the Figures of a Pagan Temple and Unknown Characters at Cannara in Salset', *PT* 26 (1708–9), 372; Sloane, 'Accounts of the Pretended Serpent-Stone Called Pietra de Cobra de Cabelos, and of the Pietra de Mombazza or the Rhinoceros Bezoar', *PT* 46 (1749–50), 118–25; Sloane, Miscellanies Catalogue, 1483, 1761.

40. Sloane, 'A Further Account of What Was Contain'd in the Chinese Cabinet', *PT* 21 (1699), 70–72, quotation 72; Porter, *Chinese Taste*, 27 and *passim*; Sloane, Miscellanies Catalogue, 83–92 (Chinaware), 1147–52 (Japanware), 1195–200 (imitation Chinaware from Dresden), 970 (Dutch paper tea set), 1696 (imitation Relgar); Linda Levy Peck, *Consuming Splendour: Society and Culture in Seventeenth-Century England*, Cambridge University Press,

2005, ch. 8; Maxine Berg, *Luxury and Pleasure in Eighteenth-Century Britain*, Oxford University Press, 2007; Joanna Waley-Cohen, *The Sextants of Beijing: Global Currents in Chinese History*, Norton, 1999, 84, 105–6; Benjamin Elman, *A Cultural History of Modern Science in China*, Harvard University Press, 2006, 72–3; Oliver Impey, 'Oriental Antiquities', in MacGregor, *Sloane*, 222–7, p. 223; http://www.britishmuseum.org/research/collection_online/collection_object_details.aspx?objectId=26278 2&partId=1&people=98677&peoA=98677-35&sortBy=imageName&page=1, accessed March 2014; 'Sloane's Treasures: Sloane's Artificial Rarities', British Museum, 2012, presentations on 'Sloane's Chinese Glass, Prints and Paintings' by Jessica Harrison-Hall, Clarissa von Spee and Anne Farrer, http://backdoorbroadcasting.net/2012/05/sloanes-treasures-sloanes-artificial-rarities/, accessed August 2015; Nappi, *Monkey and Inkpot*, 17, 44–6, 78–80.

41. Thomas, *Decline of Magic*; Ursula Klein and Wolfgang Lefèvre (eds.), *Materials in Eighteenth-Century Science: A Historical Ontology*, MIT Press, 2007; Christopher Duffin *et al.* (eds.), *A History of Geology and Medicine*, Geological Society of London, 2013; 29 January 1741, *The Family Memoirs of the Reverend William Stukeley*, 3 vols., Surtees Society, 1882–7, 3:2 (Sloane ivory comment); Dániel Margócsy, 'The Fuzzy Metrics of Money: The Finances of Travel and the Reception of Curiosities in Early Modern Europe', *Annals of Science* 70 (2013), 381–404, and *Commercial Visions: Science, Trade, and Visual Culture in the Dutch Golden Age*, University of Chicago Press, 2014; 'Sloane's Museum at Bloomsbury, as described by Zacharias Konrad von Uffenbach, 1710', in MacGregor, *Sloane*, 30; *Weekly Journal or Saturday's Post*, 31 May 1717; *The Censor*, 27 May 1717; Tobias Smollett, *The Adventures of Peregrine Pickle*, London, 1751, 19; see also Martin Lister, *A Journey to Paris in the Year 1698*, 3rd edn, London, 1699, 82–3.

42. Charles Cadogan to Sloane, 30 March 1720, Sloane MS 4045, fol. 312; 'Timothy Cockleshell' to Sloane, 25 April 1713, Sloane MS 4043, fols. 143–5; Dawson Turner (ed.), *Extracts from the Literary and Scientific Correspondence of Richard Richardson*, Yarmouth, 1835, 181 n. 4 (Sherard); Barbara Benedict, 'Collecting Trouble: Sir Hans Sloane's Literary Reputation in Eighteenth-Century Britain', *Eighteenth-Century Life* 36 (2012), 111–42, Young quotation 128, Pope 131; John Brewer and Roy Porter (eds.), *Consumption and the World of Goods*, Routledge, 1993; Cynthia Wall, *The Prose of Things: Transformations of Description in the Eighteenth Century*, University of Chicago Press, 2006.

43. Charles Hanbury Williams, 'Sir Charles Hanbury to Sir Hans Sloane, Who saved his Life, and desired him to send over all the Rarities he could find in his Travels', quotation from Benedict, 'Collecting Trouble', 126; Feigenbaum and Reist, *Provenance*; Sloane, Insects Catalogue, NHM, 238; *NHJ*, 1:cxxiv–cxxvi; Sloane, Miscellanies Catalogue, 852 (oil), 2105

(Madagascar), 9 (Tunquin), 13 (Patriarch); Birds Catalogue, NHM, 821 (eagle); Quadrupeds Catalogue, 1657.

44. Lynn Festa, 'The Moral Ends of Eighteenth- and Nineteenth-Century Object Narratives', in Mark Blackwell (ed.), *The Secret Life of Things: Animals, Objects, and It-Narratives in Eighteenth-Century England*, Bucknell University Press, 2007, 309–28; *Tatler* 34, 28 June 1709; Brian Cowan, *The Social Life of Coffee: The Emergence of the British Coffee-House*, Yale University Press, 2005, 121–5; Young quoted in Benedict, 'Collecting Trouble', 128.

45. Hanbury quoted in Benedict, 'Collecting Trouble', 125–7; Igor Kopytoff, 'The Cultural Biography of Things: Commoditization as Process', in Appadurai, *Social Life of Things*, 64–91; *Elizabeth Montagu, the Queen of the Blue-Stockings: Her Correspondence from 1720 to 1761*, ed. Emily Climenson, 2 vols., John Murray, 1906, 1:103, 128.

46. *Memoirs of Laetitia Pilkington*, ed. A. C. Elias, Jr, 2 vols., University of Georgia Press, 1997, 2:196–7; Richard Waller to Sloane, 1 September 1696, Sloane MS 4036, fols. 266–7 (kissing).

47. John Harris, *The Palladian Revival: Lord Burlington, his Villa and Garden at Chiswick*, Royal Academy of Arts, 1994, 253; Randall Davies, *The Greatest House at Chelsey*, John Lane, 1914, 262–7 (Howard quotations); de Beer, *Sloane*, 135–7; MacGregor, 'Career of Hans Sloane', 28 and 44 n. 205 ('gods of gold').

48. Robert Hales to Sloane, 24 January 1709, Sloane MS 4042, fol. 92; Jacob Bobart to Sloane, 11 October 1716, Sloane MS 4044, fol. 231; William Bentinck to Sloane, n.d., Sloane MS 4058, fol. 5; *Daily Post*, 2 March 1724; *London Evening Post*, 23–25 April 1728; *London Evening Post*, 19–21 June 1735.

49. Cecilia Garrard to Sloane, 5 February 1734, Sloane MS 4053, fol. 159; Diederick Smith to Sloane, 5 August 1737, Sloane MS 4055, fol. 153; Griffith Hughes to Sloane, 14 November 1743, Sloane MS 4057, fol. 226; Katharine Byde to Sloane, n.d., Sloane MS 4058, fol. 98.

50. Jonathan Partridge to Sloane, 15 September 1713, Sloane MS 4043, fol. 184; John Southall to Sloane, 24 December 1729, Sloane MS 4050, fol. 250; Peter Carey to Sloane, 15 October 1735, Sloane MS 4054, fol. 117; Johan Welin to Sloane, 28 April 1741, Add. MS 4437, fol. 185; Emanuel Swedenborg, *Divine Love and Wisdom*, 1763, A & D Publishing, 2007, 110.

51. Geary, 'Sacred Commodities'; Paula Findlen, *Possessing Nature: Museums, Collecting, and Scientific Culture in Early Modern Italy*, University of California Press, 1994, ch. 3; Barbara Maria Stafford, *Artful Science: Enlightenment Entertainment and the Eclipse of Visual Education*, MIT Press, 1996; Daston and Park, *Wonders*; Michael Wintroub, 'Taking Stock at the End of the World: Rites of Distinction and Practices of Collecting in Early Modern Europe', *Studies in History and Philosophy of Science* 30 (1999), 395–424, esp. 405–7.

52. Uffenbach, 'Sloane's Museum', in MacGregor, *Sloane*, 30–31.

53. Constance Classen, 'Museum Manners: The Sensory Life of the Early Museum', *Journal of Social History* 40 (2007), 895–914; Fiona Candlin, 'Touch, and the Limits of the Rational Museum or Can Matter Think?', *Senses and Society* 3 (2008), 277–92; *NHJ*, 2:xvi–xvii; Anonymous, *An Account of the Apprehending, and Taking of John Davis and Phillip Wake*, London, 1700; de Beer, *Sloane*, 124 (Handel); 12 February 1712, *The London Diaries of William Nicolson, Bishop of Carlisle, 1702–1718*, ed. Clyve Jones and Geoffrey Holmes, Clarendon Press, 1985, 702; Uffenbach, 'Sloane's Museum', in MacGregor, *Sloane*, 30.

54. Uffenbach, 'Sloane's Museum', in MacGregor, *Sloane*, 30–31; de Beer, *Sloane*, 123–4; Carolus Linnaeus, *Species plantarum*, 2 vols., Stockholm, 1753, 2:782.

55. 17 January 1712, *Diaries of Nicolson*, 699–700; 'A Poem occasion'd by the Viewing Dr. Sloans Musaeum', 1712, Sloane MS 1968, fol. 192.

56. 'Sloane's Museum at Chelsea, as described by Per Kalm, 1748', in MacGregor, *Sloane*, 31–4.

57. Ibid.

58. Ibid.

59. Ibid.; Peter Collinson to Sloane, n.d., Sloane MS 4058, fol. 170.

60. [Cromwell Mortimer], 'Account of the Prince and Princess of Wales Visiting Sir Hans Sloane', *Gentleman's Magazine* 18 (1748), 301–2; *London Evening Post*, 7–9 July 1748; Michael McKeon, *The Secret History of Domesticity: Public, Private, and the Division of Knowledge*, Johns Hopkins University Press, 2005, ch. 2.

61. Mortimer, 'Account'.

62. Ibid.

## CHAPTER 7: CREATING THE PUBLIC'S MUSEUM

1. Bishop of Bangor, 'A Sermon preached at the funeral of Sir Hans Sloane Jan. 18th 1753', Add. MS 6269, fol. 266.

2. Ibid.

3. *Public Advertiser*, 12 January 1753; *Old England or the National Gazette*, 20 January 1753; *Read's Weekly Journal or British Gazetteer*, 3 February 1753; *London Evening Post*, 27–30 January 1753.

4. Geoff Baldwin, 'The "Public" as a Rhetorical Community in Early Modern England', in Alexandra Shepard and Phil Withington (eds.), *Communities in Early Modern England*, Manchester University Press, 2000, 199–215; Kathleen Wilson, *The Sense of the People: Politics, Culture, and Imperialism in England, 1715–1785*, Cambridge University Press, 1998, 18; Carl Wennerlind, *Casualties of Credit: The English Financial Revolution, 1620–1720*, Harvard University Press, 2011, 161 (Locke quotation from

*Essay Concerning Human Understanding*) and ch. 5; Jürgen Habermas, *The Structural Transformation of the Public Sphere: An Inquiry into a Category of Bourgeois Society*, trans. Thomas Burger, MIT Press, 1991; Michael McKeon, *The Secret History of Domesticity: Public, Private, and the Division of Knowledge*, Johns Hopkins University Press, 2005; Bruno Latour and Peter Weibel (eds.), *Making Things Public: Atmospheres of Democracy*, MIT Press, 2005.

5. Andrew Erskine, 'Culture and Power in Ptolemaic Egypt: The Museum and Library of Alexandria', *Greece and Rome* 42 (1995), 38–48; Patrick Geary, 'Sacred Commodities: The Circulation of Medieval Relics', in Arjun Appadurai (ed.), *The Social Life of Things: Commodities in Cultural Perspective*, Cambridge University Press, 1986, 169–91; Paula Findlen, *Possessing Nature: Museums, Collecting, and Scientific Culture in Early Modern Italy*, University of California Press, 1994, chs. 2, 8 and 128–9, 147–8, 394–5; Carole Paul, 'Capitoline Museum, Rome: Civic Identity and Personal Cultivation', in Paul (ed.), *The First Modern Museums of Art: The Birth of an Institution in 18th- and Early-19th-Century Europe*, Getty, 2012, 21–46; Michael Hagner, 'Enlightened Monsters', in William Clark *et al.* (eds.), *The Sciences in Enlightened Europe*, University of Chicago Press, 1999, 175–217, pp. 183–5; Andrew McClellan, *Inventing the Louvre: Art, Politics and the Origins of the Modern Museum in Eighteenth-Century Paris*, University of California Press, 1994, ch. 1; see also Debora Meijers, 'Sir Hans Sloane and the European Proto-Museum', in Robert Anderson *et al.* (eds.), *Enlightening the British: Knowledge, Discovery and the Museum in the Eighteenth Century*, British Museum, 2003, 11–17.

6. Jerry Brotton, *The Sale of the Late King's Goods: Charles I and his Art Collection*, Macmillan, 2006, esp. ch. 14; Arthur MacGregor, *The Ashmolean Museum: A Brief History of the Museum and its Collections*, Ashmolean Museum, 2001; Uffenbach quoted in Findlen, *Possessing Nature*, 147–8, and *Oxford in 1710: From the Travels of Zacharias Conrad von Uffenbach*, ed. W. H. and W. J. C. Quarrell, Blackwell, 1928, 2–3, 24, 31.

7. Marjorie Caygill, 'Sloane's Will and the Establishment of the British Museum', in MacGregor, *Sloane*, 45–68, p. 46 (Cotton), and see also 'From Private Collection to Public Museum: The Sloane Collection at Chelsea and the British Museum in Montagu House', in Anderson et al., *Enlightening the British*, 18–28; Arthur MacGregor, 'The Life, Character and Career of Sir Hans Sloane', in MacGregor, *Sloane*, 11–44, p. 20 ('better judge': Royal Society Minutes, 8 May 1733); Jennifer Thomas, 'Compiling "God's Great Book [of] Universal Nature": The Royal Society's Collecting Strategies', *Journal of the History of Collections* 23 (2011), 1–13; Henry Newman to [?], 21 August 1742, MS 7633, fol. 10, Wellcome Library; Richard Altick, *The Shows of London*, Belknap Press, 1978, 16, 51, 114; [James Salter], *A*

*Catalogue of the Rarities to be Seen at Don Saltero's Coffee-House in Chelsea*, London, 1731; Uffenbach quoted and discussed in Brian Cowan, *The Social Life of Coffee: The Emergence of the British Coffee-House*, Yale University Press, 2005, 121-5; Angela Todd, 'Your Humble Servant Shows Himself: Don Saltero and Public Coffeehouse Space', *Journal of International Women's Studies 6* (2005), 119-35.

8. *Tatler* 34, 28 June 1709, quoted and discussed in Cowan, *Social Life of Coffee*, 121-5; Salter, *Catalogue*, 6; James Delbourgo, 'Slavery in the Cabinet of Curiosities: Hans Sloane's Atlantic World', 2007, British Museum website, http://www.britishmuseum.org/pdf/delbourgo%20essay.pdf, accessed August 2015; John Brewer, *The Pleasures of the Imagination: English Culture in the Eighteenth Century*, HarperCollins, 1997, 64.

9. M. A. E. Nickson, 'Books and Manuscripts', in MacGregor, *Sloane*, 263-77; Arnold Hunt, 'Sloane as a Collector of Manuscripts', in Hunter, *Books to Bezoars*, 190-207, pp. 204 and 206-7; Thomas Hearne to Richard Richardson, 1 January 1726, in Dawson Turner (ed.), *Extracts from the Literary and Scientific Correspondence of Richard Richardson*, Yarmouth, 1835, iv (correspondent estimate); Elizabeth Yale, *Sociable Knowledge: Natural History and the Nation in Early Modern Britain*, University of Pennsylvania Press, 2016; *London Journal*, 13 November 1725 (horn); *NHJ*, 2:v.

10. Sloane to unknown, 2 September 1738, Sloane MS 4069, fol. 4; Meijers, 'Proto-Museum'.

11. Findlen, *Possessing Nature*, ch. 7, esp. 295; Stella Tillyard, 'Paths of Glory: Fame and the Public in Eighteenth-Century London', in Martin Postle (ed.), *Joshua Reynolds: The Creation of Celebrity*, Tate Gallery, 2005, 61-9; Elizabeth Barry, 'Celebrity, Cultural Production, and Public Life', *International Journal of Cultural Studies* 11 (2008), 251-8; Keith Thomas, *The Ends of Life: Roads to Fulfilment in Early Modern England*, Oxford University Press, 2009, 235-67; James Empson, 'Proposal of a Plan', 29 August 1756, Original Letters and Papers, BM Archives, 1:fol. 44; Walter Benjamin, *The Arcades Project*, trans. Howard Eiland and Kevin McLaughlin, Belknap Press, 1999, 211.

12. Tobias Smollett, *The Expedition of Humphry Clinker*, 3 vols., London, 1771, 1:215; Sloane to Bignon, 8 September 1737, quoted in Jean Jacquot, 'Sir Hans Sloane and French Men of Science', *NRRS* 10 (1953), 85-98, pp. 96-7; Neil Safier, *Measuring the New World: Enlightenment Science and South America*, University of Chicago Press, 2008; but see also Nicholas Dew, 'Scientific Travel in the Atlantic World: The French Expedition to Gorée and the Antilles, 1681-1683', *BJHS* 43 (2010), 1-17; Giles Mandelbrote, 'Sloane and the Preservation of Printed Ephemera', in Mandelbrote and Barry Taylor (eds.), *Libraries within the Library: The Origins of the British Library's Printed Collections*, British Library, 2010, 146-68, p. 152.

13. Sloane, *Will of Sir Hans Sloane*, London, 1753, 3, 28-9.

14. Sloane, *Authentic Copies of the Codicils belonging to the Last Will and Testament of Sir Hans Sloane*, London, 1753, 20–26, and *Will*, 4–5; Caygill, 'Sloane's Will', 50, 66 n. 16; Meijers, 'Proto-Museum'; Sloane to Johann Amman, 1 May 1730 to 3 December 1740, Russian Academy of Sciences, RS copies, LXXVIII.b.2; MacGregor, *Sloane*, 94–5.

15. Miguel Tamen, *Friends of Interpretable Objects*, Harvard University Press, 2004; Sloane, *Will*, 2, 17–19; Caygill, 'Sloane's Will', appendices, 56–65.

16. Horace Walpole to Horace Mann, 14 February 1753, in Peter Cunningham (ed.), *The Letters of Horace Walpole, Earl of Orford*, 9 vols., London, 1857–9, 2:320–21, and Advertisement to Abraham Van der Doort, *A Catalogue and Description of King Charles the First's Capital Collection of Pictures . . .*, London, 1757, i–iv; Eric Gidal, *Poetic Exhibitions: Romantic Aesthetics and the Pleasures of the British Museum*, Bucknell University Press, 2002, 39; Francis Haskell, *The King's Pictures: The Formation and Dispersal of the Collections of Charles I and his Courtiers*, Yale University Press, 2013; Brewer, *Pleasures*, 84–7 and ch. 5; Eamon Duffy, *The Stripping of the Altars: Traditional Religion in England, c. 1400–c. 1580*, Yale University Press, 1992, part 2; Brotton, *Late King's Goods*, 163, 202–5, 354–7 (includes Walpole, advertisement to *Catalogue*); Cynthia Wall, 'The English Auction: Narratives of Dismantlings', *Eighteenth-Century Studies* 31 (1997), 1–25; Paul Langford, *A Polite and Commercial People: England, 1727–1783*, Oxford University Press, 1994, 304–16.

17. Caygill, 'Sloane's Will' and 'From Private Collection to Public Museum'; Baker quoted in Anne Goldgar, 'The British Museum and the Virtual Representation of Culture in the Eighteenth Century', *Albion* 32 (2000), 195–231, p. 224.

18. Goldgar, 'British Museum', 220–24, Carte quotation 224; Caygill, 'Sloane's Will', 49–50; David Spadafora, *The Idea of Progress in Eighteenth-Century Britain*, Yale University Press, 1990; Colin Kidd, *British Identities before Nationalism: Identity and Nationhood in the Atlantic World, 1600–1800*, Cambridge University Press, 1999, 79–82, 229–33.

19. Caygill, 'Sloane's Will', 50, and 'From Private Collection to Public Museum'; [Edmund Powlett], *The General Contents of the British Museum*, 2nd edn, London, 1762, x, vi; Tony Bennett, 'The Exhibitionary Complex', *New Formations* 4 (1988), 73–102, pp. 73–4; *An Act for the Purchase of the Museum, or Collection of Sir Hans Sloane*, London, 1754, 15 ('benefit of the publick'); Jonathan Williams, 'Parliaments, Museums, Trustees, and the Provision of Public Benefit in the Eighteenth-Century British Atlantic World', *Huntington Library Quarterly* 76 (2013), 195–214.

20. *Act for the Purchase of the Museum*, 11, 14, 63–138.

21. Caygill, 'Sloane's Will', 51–2; Wall, 'English Auction', 2; Gidal, *Poetic Exhibitions*, 13–14; *Act for the Purchase of the Museum*, 82–5.

22. Committee Meeting Minutes, 22 January 1754, BM Archives, 1:fol. 5; 'Proposal for the Establishment of the British Museum', n.d., Add. MS

4,449, fol. 82; Estelle Ward, *Christopher Monck, Duke of Albemarle,* John Murray, 1915, book 1; Powlett, *General Contents,* 209; Patricia Fara, *Sympathetic Attractions: Magnetic Practices, Beliefs, and Symbolism in Eighteenth-Century England,* Princeton University Press, 1996, 36–46; J. E. Dandy, *The Sloane Herbarium,* British Museum, 1958, 28; Caygill, 'Sloane's Will'.

23. Empson, 'Proposal of a Plan', fol. 40; Gowin Knight, 'A Plan for the General Distribution of Sr Hans Sloane's Collection', n.d., Original Letters and Papers, BM Archives, 1:fol. 51.

24. Catherine Talbot, letter of 1756, Add. MS 39311, fol. 83, quoted in Gidal, *Poetic Exhibitions,* 49; John Ward to BM trustees, 'Objections to the Appointing Public Days for Admitting all Persons to see the Museum without Distinction', 1755, quoted, ibid., 59–60.

25. Lord Cadogan, 'Observations on the Plan for Shewing the British Museum', 12 December 1756, Add. MS 4302, fols. 13–14, quoted in Goldgar, 'British Museum', 210; Charles Morton and Andrew Gifford, April 1759, Original Letters and Papers, BM Archives, 1:fols. 106–8, quoted, ibid., 216.

26. Thomas Birch, 'Rules Proposed for the Custody and Use of the British Museum', n.d., Add. MS 4449, fol. 123; Knight, 'Draft Rules for the use of the British Museum', n.d., ibid., fols. 118–20; Svetlana Alpers, 'The Museum as a Way of Seeing', in Steven Lavine and Ivan Karp (eds.), *Exhibiting Cultures: The Poetics and Politics of Museum Display,* Smithsonian Institute, 1991, 25–32; Constance Classen, 'Museum Manners: The Sensory Life of the Early Museum', *Journal of Social History* 40 (2007), 895–914; Fiona Candlin, 'Touch, and the Limits of the Rational Museum or Can Matter Think?', *Senses and Society* 3 (2008), 277–92.

27. Powlett, *General Contents,* xvi–xvii, xxii; see also [Alexander Thomson], *Letters on the British Museum,* London, 1767.

28. Powlett, *General Contents,* 1–25; Kim Sloan, ' "Aimed at Universality and Belonging to the Nation": The Enlightenment and the British Museum', in Sloan (ed.), *Enlightenment: Discovering the World in the Eighteenth Century,* British Museum, 2003, 12–25, pp. 24–5 (Laocoön).

29. Powlett, *General Contents,* 25–34, quotation 27.

30. Ibid., 34–196, quotation 54 ('American idols'); Knight, 'Plan for General Distribution', fol. 51.

31. Powlett, *General Contents,* 196–210, quotations 197 ('great esteem'), 148 ('prevails'), 190 (pig), 202 (horned lady).

32. Jan and Andreas van Rymsdyk, *Museum Britannicum,* London, 1778, 50–51 (coral) and 19 (hairballs); Powlett, *General Contents,* 97–8.

33. Powlett, *General Contents,* vii ('not without hopes'), 35 ('almost infinite'), xv ('impossible'); Edward Miller, *That Noble Cabinet: A History of the British Museum,* Ohio State University Press, 1974, ch. 3; Karl Philipp

Moritz, *Travels, Chiefly on Foot, through Several Parts of England, in 1782*, London, 1795, 69–70.

34. Powlett, *General Contents*, 37 ('industry'), 70 (marble), 71 (alabaster), 155–6 (ginseng and Chinese), 197 (wampum); Rymsdyk and Rymsdyk, *Museum Britannicum*, 5–9; Moritz, *Travels*, 268.

35. Powlett, *General Contents*, 41 (Egypt), 58–9 (Sámi and Romans), 61 (Turkish and Arabic), 127 (bezoars), 149–50 (lamb).

36. Ibid., viii ('oblivion' and 'ignorance'), ix ('blind infatuation'), 35 ('progress of art'), x ('falling back'), 36–7 ('vulgar observer'), 37 ('iron hand').

37. Daniel Baugh, *The Global Seven Years War, 1754–1763: Britain and France in a Great Power Contest*, Routledge, 2011; Linda Colley, *Captives: Britain, Empire, and the World, 1600–1850*, Jonathan Cape, 2002, ch. 6; David Armitage, *The Ideological Origins of the British Empire*, Cambridge University Press, 2000; Richard Drayton, *Nature's Government: Science, Imperial Britain, and the 'Improvement' of the World*, Yale University Press, 2000, 85–128; Elsbeth Heaman, 'Epistemic and Military Failures in Britain and Canada during the Seven Years' War', in Heaman *et al.* (eds.), *Essays in Honour of Michael Bliss: Figuring the Social*, University of Toronto Press, 2008, 93–118; H. V. Bowen, 'British Conceptions of Global Empire, 1756–83', *Journal of Imperial and Commonwealth History* 26 (1998), 1–27.

38. Powlett, *General Contents*, 2–3 (Causeway), 34–5 ('largest and most curious' and 'scarcely a country'), 196 (fish), 66 (stones), 80 (ores), 205 (drawings); Troy Bickham, ' "A Conviction of the Reality of Things": Material Culture, North American Indians and Empire in Eighteenth-Century Britain', *Eighteenth-Century Studies* 39 (2005), 29–47.

39. *Act for the Purchase of the Museum*, 45; Powlett, *General Contents*, 163 (soup), 160 (Bartram's nest).

40. Powlett, *General Contents*, 111 and *passim*; Smollett, *Humphry Clinker*, 1:215–16.

41. Moritz, *Travels*, 69; Powlett, *General Contents*, xvi ('concise'), xiv ('tolerable idea'), xix–xxiii; Rymsdyk and Rymsdyk, *Museum Britannicum*, iii–iv.

42. Sloane, *Will*, pp. 28–9; *Act for the Purchase of the Museum*, 14; Wendy Shaw, *Possessors and Possessed: Museums, Archaeology, and the Visualization of History in the Late Ottoman Empire*, University of California Press, 2003, 130.

43. Miller, *Noble Cabinet*, 70; Smollett, *Humphry Clinker*, 1:215–16; Moritz, *Travels*, 69; Bernard Bailyn, *The Ideological Origins of the American Revolution*, Harvard University Press, 1967; Wilson, *Sense of the People*, chs. 4–5.

44. Jean Marchand (ed.), *A Frenchman in England, 1784: Being the Mélanges sur l'Angleterre of François de la Rochefoucauld*, trans. S. C. Roberts, Caliban Books, 1995, 16; McClellan, *Louvre*; Powlett, *General Contents*, xix; Caroline Powys, diary, Add. MS 42160, fols. 8–10 (1760), 93 (1786);

Knight quoted in Caygill, 'From Private Collection to Public Museum'; Altick, *Shows of London*, 85, 96–7; Goldgar, 'British Museum', 208 (Hankin).

45. Empson, Original Letters and Papers, BM Archives, 1:fol. 177, quoted in Goldgar, 'British Museum', 216; Daniel Solander to British Museum Trustees, 22 February 1765, in *Daniel Solander: Collected Correspondence, 1753–1782*, ed. and trans. Edward Duyker and Per Tingbrand, University of Melbourne Press, 1995, 264; Knight, Add. MS 4449, fols. 119–20, quoted in Goldgar, 'British Museum', 205; Maty, Add. MS 10555, fol. 14, quoted in ibid., 212, and see n. 78; unidentified official, Original Letters and Papers, BM Archives, 2:fol. 745, ibid., 219; ibid., 225 (riots and guards); McClellan, *Inventing the Louvre*.

46. Linda Colley, *Britons: Forging the Nation, 1707–1837*, Yale University Press, 1992, 174–7; Goldgar, 'British Museum', 212–13, 220 (charges); Moritz, *Travels*, 70; William Hutton, *A Journey from Birmingham to London*, Birmingham, 1785, 187–93.

47. Goldgar, 'British Museum', 212–13, 220; unidentified official, Original Letters and Papers, BM Archives, 2:fol. 745, ibid., 219 ('cannot controvert').

48. Maya Jasanoff, *Edge of Empire: Conquest and Collecting on the Eastern Frontier of the British Empire*, Fourth Estate, 2005; Jeanette Greenfield, *The Return of Cultural Treasures*, Cambridge University Press, 3rd edn, 2013, ch. 2; Elliott Colla, *Conflicted Antiquities: Egyptology, Egyptomania, Egyptian Modernity*, Duke University Press, 2007, ch. 1; Mirjam Brusius, 'Misfit Objects: Layard's Excavations in Ancient Mesopotamia and the Biblical Imagination in Mid-Nineteenth Century Britain', *Journal of Literature and Science* 5 (2012), 38–52; Goldgar, 'British Museum', 229–30 (statistics).

49. J. Mordaunt Cook, *The British Museum: A Case-Study in Architectural Politics*, Penguin, 1972, chs. 3–4; Marjorie Caygill and Christopher Date, *Building the British Museum*, British Museum, 1999; Chris Wingfield, 'Placing Britain in the British Museum: Encompassing the Other', in Peter Aronsson *et al.* (eds.), *National Museums*, Routledge, 2011, 123–37; Mark O'Neill, 'Enlightenment Museums: Universal or Merely Global?', *Museum and Society* 2 (2004), 190–202; Shaw, *Possessors and Possessed*; Colla, *Conflicted Antiquities*.

50. Miller, *Noble Cabinet*, chs. 3–5 and 365–7; David Wilson, *The British Museum: A History*, British Museum, 2002; W. Blanchard Jerrold, *How to See the British Museum in Four Visits*, London, 1852, 1.

51. Goldgar, 'British Museum', 229–30 ('vulgar', 'gazing'); Anonymous, 'The British Museum', *Penny Magazine* 1 (1832), 13–15, in Jonah Siegel (ed.), *The Emergence of the Modern Museum: An Anthology of Nineteenth-Century Sources*, Oxford University Press, 2009, 82–4, quotations 83–4; Goldgar, 'British Museum', 228–31.

52. Emma Spary, *Utopia's Garden: French Natural History from Old Regime to Revolution*, University of Chicago Press, 2000, ch. 5, esp. 209.

53. Barthélemy Faujas de Saint-Fond, *Travels in England, Scotland, and the Hebrides*, 2 vols., London, 1799, 1:86–91; Gidal, *Poetic Exhibitions*, 66–8; Nick Hopwood et al., 'Seriality and Scientific Objects in the Nineteenth Century', *History of Science* 48 (2010), 251–85; David Miller and Peter Reill (eds.), *Visions of Empire: Voyages, Botany, and Representations of Nature*, Cambridge University Press, 1996; Charles Gillispie, *Science and Polity in France: The Revolutionary and Napoleonic Years*, Princeton University Press, 2004; Martin Rudwick, *Bursting the Limits of Time: The Reconstruction of Geohistory in the Age of Revolution*, University of Chicago Press, 2005.

54. Powlett, *General Contents*, 34; John Gascoigne, *Science in the Service of Empire: Joseph Banks, the British State and the Uses of Science in the Age of Revolution*, Cambridge University Press, 1998; Drayton, *Nature's Government*, 85–128.

55. Nuala Zahedieh, *The Capital and the Colonies: London and the Atlantic Economy, 1660–1700*, Cambridge University Press, 2010, 131–6; David Hancock, *Citizens of the World: London Merchants and the Integration of the British Atlantic Community, 1735–1785*, Cambridge University Press, 1997, ch. 7; Sloane to Mrs Grey, 17 October 1740, bMs 34.10.1, Ernst Mayr Library, Museum of Comparative Zoology, Harvard University (leeches).

56. Colley, *Britons*, chs. 1–2, esp. 86; Robert Crawford, *Devolving English Literature*, Oxford University Press, 1992, 75; Yale, *Sociable Knowledge*.

57. Birch, 'Memoirs', fols. 14–15.

58. Dipesh Chakrabarty, 'The Climate of History: Four Theses', *Critical Inquiry* 35 (2009), 197–222; Fredrik Albritton Jonsson, *Enlightenment's Frontier: The Scottish Highlands and the Origins of Environmentalism*, Yale University Press, 2013; Jennifer Newell et al. (eds.), *Curating the Future: Museums, Communities and Climate Change*, Routledge, 2016.

# Bibliography

PRIMARY SOURCES

## Manuscripts

British Library: Additional Manuscripts, Sloane Manuscripts
British Museum: Original Letters and Papers, Archives
Harvard University: Ernst Mayr Library Collections, Museum of Comparative
  Zoology
Huntington Library, San Marino: Irish Papers
Lincolnshire Archives: Ancaster Deposit
National Archives, London: Captains' Logs and Probate Records
Royal Society: Minutes, Journal- and Letter Books; Sherard Papers
Wellcome Library: Archives and Manuscripts

## Sloane Manuscript Catalogues

British Museum: Antiquities; Gemmae & Lapides continentes Inscriptiones
  Arabicas, Persicas, &c.; Miscellanies; Pictures and Drawings in Frames
Natural History Museum: Agates; Birds; Corals; Earths, Clays, Chalk, Vitriol,
  Sands; Fossils; Humana; Insects; Metals; Quadrupeds; Serpents; Shells; Veg-
  etable Substances

## Specimen Collections

Sloane Herbarium, Botany Department, Natural History Museum

# Newspapers, Gazettes, Journals & Magazines

*The Censor*
*Daily Advertiser*
*Daily Mail*
*Daily Post*
*Daily Telegraph*
*Evening Post*
*Gazetteer and New Daily Advertiser*
*Gentleman's Magazine*
*Grub Street Journal*
*La Nación* (Buenos Aires)
*Lloyd's Evening Post*
*London Art Review*
*London Daily Post and General Advertiser*
*London Evening Post*
*London Journal*
*Mémoires de l'Académie Royale des Sciences*
*Old England or the National Gazette*
*Penny Magazine*
*Philosophical Transactions of the Royal Society*
*Public Advertiser*
*Public Ledger*
*Read's Weekly Journal or British Gazetteer*
*Spectator*
*Tatler*
*Weekly Journal or Saturday's Post*
*Westminster Magazine*

# Printed Books

*An Act for the Purchase of the Museum, or Collection of Sir Hans Sloane* (London, 1754).

Anonymous. *An Account of the Apprehending, and Taking of John Davis and Phillip Wake* (London, 1700).

——. *Aesculapius: A Poem* (London, 1721).

——. *Angliae Tutamen: Or, The Safety of England* (London, 1695).

——. *The Art of Getting into Practice in Physick* (London, 1722).

——. 'The British Museum', *The Penny Magazine* 1 (1832), 13–15, in Siegel, *Emergence of the Modern Museum*, 82–4.

——. *Marly; or, A Planter's Life in Jamaica* (1828, repr. Oxford University Press, 2005).

Bacon, Francis. *Novum organum* (London, 1620).

———. *New Atlantis*, in James Spedding *et al.* (eds.), *The Works of Francis Bacon*, 14 vols. (Longman, 1857–74), 3:125–66.

[———]. *Gesta Grayorum*, 1594, in Nichols, *Progresses and Public Processions*, 3:262–350.

———. *The Essays* (Penguin, 1985).

Barham, Henry. *Hortus Americanus* (Kingston, 1794).

Bartram, John. *Observations . . . in his Travels from Pensilvania to Onondago* (London, 1751).

Bateman, Christopher and Cooper, John. *A Catalogue of the Library, Antiquities, &c. of the Late Learned Dr Woodward* (London, 1728).

Beckett, William. *A Free and Impartial Enquiry into the Antiquity and Efficacy of Touching for the Cure of the King's Evil* (London, 1722).

Behn, Aphra. *Oroonoko: or, The Royal Slave* (1688, repr. Norton, 1997).

Benezet, Anthony. *A Caution and Warning to Great Britain and her Colonies* (Philadelphia, 1766).

Berkeley, Edmund and Smith, Dorothy (eds.) *The Correspondence of John Bartram, 1734–1777* (University Press of Florida, 1992).

Bernier, François. 'Nouvelle Division de la Terre, par les differentes Espèces ou Races d'hommes qui l'habitent', *Journal des Sçavans* 12 (1684), 148–55.

Berwick, Edward (ed.) *The Rawdon Papers, Consisting of Letters on Various Subjects, Literary, Political and Ecclesiastical* (London, 1819).

Blackwell, Elizabeth. *A Curious Herbal*, 2 vols. (London, 1737–9).

Bluett, Thomas. *Some Memoirs of the Life of Job, the Son of Solomon the High Priest of Boonda in Africa* (London, 1734).

Boswell, James. *The Life of Samuel Johnson* (1791, repr. Penguin, 2008).

Browne, Patrick. *The Civil and Natural History of Jamaica* (London, 1756).

Brownlow, John (ed.) *Memoranda; or, Chronicles of the Foundling Hospital* (Sampson Low, 1847).

Byrd, William. 'Account of a Negro-Boy that is Dappel'd in Several Places of His Body with White Spots', *PT* 19 (1695–7), 781–2.

Camelli, George and Petiver, James. 'De Monstris, Quasi Monstris, et Monstrosis', *PT* 25 (1706–7), 2266–76.

Crossley, David and Saville, Richard (eds.) *The Fuller Letters, 1728–1755: Guns, Slaves and Finance* (Sussex Record Society, 1991).

Cunningham, James. 'Part of Two Letters to the Publisher from Mr James Cunningham', *PT* 23 (1702–3), 1201–9.

Cunningham, Peter (ed.) *The Letters of Horace Walpole, Earl of Orford*, 9 vols. (London, 1857–9).

Dallas, R. C. *The History of the Maroons*, 2 vols. (London, 1803).

Dampier, William. *A New Voyage Round the World*, 5th edn (London, 1703).

De Beer, E. S. (ed.) *The Correspondence of John Locke*, 8 vols. (Clarendon Press, 1976–89).

Defoe, Daniel. *The Fortunes and Misfortunes of the Famous Moll Flanders* (London, 1722).

———. *The Complete English Tradesman* (1726, repr. Alan Sutton, 1987).

De Las Casas, Bartolomé. *A Short Account of the Destruction of the Indies* (1522), trans. Nigel Griffin (Penguin, 1992).

Dufour, Philippe. *The Manner of Making Coffee, Tea, and Chocolate* (London, 1685).

Earle, William. *Obi: or, The History of Three-Fingered Jack* (1803), ed. Srinivas Aravamudan (Broadview Press, 2005).

Edwards, Bryan. *The History, Civil and Commercial, of the British Colonies in the West Indies*, 2 vols. (London, 1793).

Elias, A. C., Jr (ed.) *Memoirs of Laetitia Pilkington*, 2 vols. (University of Georgia Press, 1997).

Equiano, Olaudah. *The Interesting Narrative of the Life of Olaudah Equiano* (1789, repr. Norton, 2001).

Evelyn, John. *Sylva, or a Discourse of Forest-Trees, and the Propagation of Timber* (London, 1664).

———. *Memoirs, Illustrative of the Life and Writings of John Evelyn*, 2nd edn (London, 1819).

Faujas de Saint-Fond, Barthélemy. *Travels in England, Scotland, and the Hebrides*, 2 vols. (London, 1799).

Finch, Jeremiah (ed.) *A Catalogue of the Libraries of Sir Thomas Browne and Dr. Edward Browne, His Son: A Facsimile Reproduction With an Introduction, Notes and Index* (Brill, 1986).

Franklin, Benjamin. 'Autobiography', in *Writings* (Library of America, 1987).

Garth, Samuel. *The Dispensary: A Poem* (London, 1699).

Hall, Douglas (ed.) *In Miserable Slavery: Thomas Thistlewood in Jamaica, 1750–86* (University of the West Indies Press, 1989).

Hayes, Kevin (ed.) *The Library of William Byrd of Westover* (Rowman and Littlefield, 1997).

Hernández, Francisco. *The Mexican Treasury: The Writings of Dr Francisco Hernández*, ed. Simon Varey (Stanford University Press, 2000).

Hoppen, K. Theodore (ed.) *Papers of the Dublin Philosophical Society, 1683–1709*, 2 vols. (Irish Manuscripts Commission, 2008).

Hunter, Michael (ed.) *Magic and Mental Disorder: Sir Hans Sloane's Memoir of John Beaumont* (Robert Boyle Project, 2011).

Hutton, William. *A Journey from Birmingham to London* (London, 1785).

Jerrold, W. Blanchard. *How to See the British Museum in Four Visits* (London, 1852).

Jones, Clyve and Holmes, Geoffrey (eds.) *The London Diaries of William Nicolson, Bishop of Carlisle, 1702–1718* (Clarendon Press, 1985).

Kaempfer, Engelbert. *Amoenitatum exoticarum* (Lemgoviae, 1712).

――――. *The History of Japan*, trans. Johann Gaspar Scheuchzer, 2 vols. (London, 1727).

――――. *Kaempfer's Japan: Tokugawa Culture Observed*, ed. Beatrice Bodart-Bailey (University of Hawai'i Press, 1999).

Kalm, Per. *Kalm's Account of his Visit to England on his Way to America in 1748*, trans. Joseph Lucas (Macmillan, 1892).

King, William. *The Transactioneer* (London, 1700).

――――. *The Present State of Physick in the Island of Cajamai* (London, 1710).

――――. *A Voyage to the Island of Cajamai in America*, in King, *Useful Transactions*.

――――. *Useful Transactions*, in *The Original Works in Verse and Prose of Dr William King*, 3 vols. (London, 1776), vol. 2.

Lancaster, William (ed.) *Letters Addressed to Ralph Thoresby* (Thoresby Society, 1912).

Lankester, Edwin (ed.) *The Correspondence of John Ray* (The Ray Society, 1848).

Lewis, Matthew. *Journal of a West India Proprietor* (1834, repr. Oxford University Press, 1999).

Lhwyd, Edward. 'Extracts of Several Letters from Mr. Edward Lhwyd . . . Containing Observations in Natural History and Antiquities, Made in His Travels thro' Wales and Scotland', *PT* 28 (1713), 93–101.

Ligon, Richard. *A True and Exact History of the Island of Barbadoes* (London, 1657).

Linnaeus, Carolus. *Species plantarum*, 2 vols. (Stockholm, 1753).

Lister, Martin. *A Journey to Paris in the Year 1698*, 3rd edn (London, 1699).

Lockyer, Charles. *Account of the Trade in India*, 2 vols. (London, 1711).

Long, Edward. *History of Jamaica*, 3 vols. (London, 1774).

MacPike, Eugene Fairchild (ed.) *Correspondence and Papers of Edmond Halley* (Clarendon Press, 1932).

Marchand, Jean (ed.) *A Frenchman in England, 1784: Being the Mélanges sur l'Angleterre of François de la Rochefoucauld*, trans. S. C. Roberts (Caliban Books, 1995).

Mayor, J. E. B. (ed.) *Cambridge under Queen Anne* (Cambridge Antiquarian Society, 1911).

McPherson, Robert (ed.) *The Journal of the Earl of Egmont: Abstract of the Trustees Proceedings for Establishing the Colony of Georgia, 1732–1738* (University of Georgia Press, 1962).

Meadow, Mark and Robertson, Bruce (eds.) *The First Treatise on Museums: Samuel Quiccheberg's Inscriptiones, 1565* (Getty Research Institute, 2013).

Molyneux, Thomas. 'Remarks upon the Aforesaid Letter and Teeth', *PT* 29 (1714), 370–84.

Montagu, Elizabeth. *Elizabeth Montagu, the Queen of the Blue-Stockings: Her Correspondence from 1720 to 1761*, ed. Emily Climenson, 2 vols. (John Murray, 1906).

Moritz, Karl Philipp. *Travels, Chiefly on Foot, through Several Parts of England, in 1782* (London, 1795).

[Mortimer, Cromwell]. 'Account of the Prince and Princess of Wales Visiting Sir Hans Sloane', *Gentleman's Magazine* 18 (1748), 301–2.

Moseley, Benjamin. *A Treatise on Sugar* (London, 1799).

Nichols, John (ed.) *The Progresses and Public Processions of Queen Elizabeth*, 3 vols., London, 1823.

—— and Nichols, John Bower (eds.) *Illustrations of the Literary History of the Eighteenth Century*, 8 vols. (London, 1817–58).

Nieuhof, Johannes. *Gedenkweerdige Brasiliaense zee- en lant-reize* (Amsterdam, 1682).

Petiver, James. *Musei Petiveriani* (London, 1695–1703).

——. 'Catalogue of Some Guinea-Plants, with Their Native Names and Virtues', *PT* 19 (1695–7), 677–86.

——. *Brief Directions for the Easie Making, and Preserving Collections of all Natural Curiosities* (London, 1700?).

Pope, Alexander. *The Works of Alexander Pope* (John Murray, 1886).

[Powlett, Edmund]. *The General Contents of the British Museum*, 2nd edn (London, 1762).

Pulteney, Richard. *Historical and Biographical Sketches of the Progress of Botany in England*, 2 vols. (London, 1790).

Quarrell, W. H. and W. J. C. (eds.) *Oxford in 1710: From the Travels of Zacharias Conrad Von Uffenbach* (Blackwell, 1928).

Quélus, D. *The Natural History of Chocolate*, trans. R. Brookes, 2nd edn (London, 1725).

Quincy, John. *The Dispensatory of the Royal College of Physicians*, 2nd edn (London, 1727).

Ralegh, Walter. *The Discoverie of the Large, Rich and Bewtiful Empyre of Guiana* (1596, repr. Manchester University Press, 1997).

Ranby, John. 'Some Observations Made in an Ostrich, Dissected by Order of Sir Hans Sloane', *PT* 33 (1724–5), 223–7.

Ray, John. *Historia plantarum* (London, 1686–1704).

——. *The Wisdom of God Manifested in the Works of Creation* (London, 1691).

Rudwick, Martin. *Georges Cuvier, Fossil Bones, and Geological Catastrophes: New Translations and Interpretations of the Primary Texts* (University of Chicago Press, 1998).

Rusnock, Andrea (ed.) *The Correspondence of James Jurin (1684–1750): Physician and Secretary to the Royal Society* (Rodopi, 1996).

[Salter, James]. *A Catalogue of the Rarities to be Seen at Don Saltero's Coffee-House in Chelsea* (London, 1731).

Shaftesbury, Earl of (Anthony Ashley Cooper). *Characteristicks of Men, Manners, Opinions, Times* (1711), ed. Lawrence Klein (Cambridge University Press, 1999).

Shaw, Thomas. 'Letter to Sir Hans Sloane', *PT* 36 (1729–30), 177–84.

———. *Travels, or Observations relating to Several Parts of Barbary and the Levant* (1738, 2nd edn, London, 1757).

Shesgreen, Sean (ed.) *Engravings by Hogarth* (Dover, 1973).

Siegel, Jonah (ed.) *The Emergence of the Modern Museum: An Anthology of Nineteenth-Century Sources* (Oxford University Press, 2009).

Slaney, Edward. *Tabulae Iamaicae Insulae* (1678).

Sloane, Hans. 'A Description of the Pimienta or Jamaica Pepper-Tree, and of the Tree That Bears the Cortex Winteranus', *PT* 16 (1686–92), 462–8.

———. 'Account of a Prodigiously Large Feather of the Bird Cuntur ... and of the Coffee-Shrub', *PT* 18 (1694), 61–4.

———. 'Letter from Hans Sloane ... with Several Accounts of the Earthquakes in Peru ... and at Jamaica', *PT* 18 (1694), 78–100.

———. 'Account of Four Sorts of Strange Beans, Frequently Cast on Shoar on the Orkney Isles', *PT* 19 (1695–7), 298–300.

———. 'Account of the Tongue of a Pastinaca Marina, Frequent in the Seas about Jamaica, and Lately Dug up in Mary-Land, and England', *PT* 19 (1695–7), 674–6.

———. 'Account of a China Cabinet', *PT* 20 (1698), 390–92.

———. 'A Further Account of the Contents of the China Cabinet', *PT* 20 (1698), 461–2.

———. 'Of the Use of the Root Ipecacuanha', *PT* 20 (1698), 69–79.

———. 'Part of a Letter from Mr George Dampier ... Concerning the Cure of the Bitings of Mad Creatures', *PT* 20 (1698), 49–52.

———. 'A Further Account of a China Cabinet', *PT* 21 (1699), 44.

———. 'A Further Account of What Was Contain'd in the Chinese Cabinet', *PT* 21 (1699), 70–72.

———. 'Some Observations ... concerning some Wonderful Contrivances of Nature in a Family of Plants in Jamaica, to Perfect the Individuum, and Propagate the Species', *PT* 21 (1699), 113–20.

———. *A Voyage to the Islands ... with the Natural History of [Jamaica]*, 2 vols. (London, 1707–25).

———. 'A Letter from Dr Hans Sloane ... to the Right Honourable the Earl of Cromertie', *PT* 27 (1710–12), 302–8.

———. 'Account of Elephants Teeth and Bones Found Under Ground', *PT* 35 (1727–8), 457–71, 497–514.

———. 'Mémoire sur les dents et autres ossemens de l'éléphant trouvés dans terre', *Mémoires de l'Académie Royale des Sciences* (1729), 305–34.

———. 'Conjectures on the Charming or Fascinating Power Attributed to the Rattle-Snake', *PT* 38 (1733–4), 321–31.

———. 'Account of Inoculation by Sir Hans Sloane' (1736), *PT* 49 (1755–6), 516–20.

———. 'Answer to the Marquis de Caumont's Letter', *PT* 40 (1737–8), 374–7.

———. *An Account of a Most Efficacious Medicine for Soreness, Weakness, and Several Other Distempers of the Eyes* (London, 1745).

———. 'Accounts of the Pretended Serpent-Stone Called Pietra de Cobra de Cabelos, and of the Pietra de Mombazza or the Rhinoceros Bezoar', *PT* 46 (1749–50), 118–25.

———. *Authentic Copies of the Codicils belonging to the Last Will and Testament of Sir Hans Sloane* (London, 1753).

———. *Will of Sir Hans Sloane* (London, 1753).

Smollett, Tobias. *The Adventures of Peregrine Pickle* (London, 1751).

———. *The Expedition of Humphry Clinker*, 3 vols. (London, 1771).

Solander, Daniel. *Daniel Solander: Collected Correspondence, 1753–1782*, ed. and trans. Edward Duyker and Per Tingbrand (University of Melbourne Press, 1995).

Sprat, Thomas. *The History of the Royal-Society of London, for the Improving of Natural Knowledge* (London, 1667).

Stack, Thomas. 'Letter from Thomas Stack', *PT* 41 (1739), 140–42.

Stuart, Alexander. 'An Explanation of the Figures of a Pagan Temple and Unknown Characters at Cannara in Salset', *PT* 26 (1708–9), 372.

Stubbe, Henry. *The Indian Nectar* (London, 1662).

Stukeley, William. *Of the Spleen* (London, 1723).

———. *The Family Memoirs of the Reverend William Stukeley* (Surtees Society, 1882–7).

Swedenborg, Emanuel. *Divine Love and Wisdom* (1763, repr. A & D Publishing, 2007).

Swift, Jonathan. *A Tale of a Tub* [1704] *and Other Works* (Oxford University Press, 1999).

———. *Travels into Several Remote Nations of the World, in four parts, by Lemuel Gulliver* (1726, repr. Penguin, 1985).

Taylor, John. *Multum in Parvo*, repr. in David Buisseret (ed.), *Jamaica in 1687: The Taylor Manuscript at the National Library of Jamaica* (University of the West Indies Press, 2008).

[Thomson, Alexander]. *Letters on the British Museum* (London, 1767).

Trapham, Thomas. *A Discourse of the State of Health in the Island of Jamaica* (London, 1679).

Turner, Dawson (ed.) *Extracts from the Literary and Scientific Correspondence of Richard Richardson* (Yarmouth, 1835).

Van der Doort, Abraham. *A Catalogue and Description of King Charles the First's Capital Collection of Pictures* ... (London, 1757).

Van Rymsdyk, Jan and Andreas. *Museum Britannicum* (London, 1778).

'Voyage of the *Hannibal*, 1693–1694', in Elizabeth Donnan (ed.), *Documents Illustrative of the History of the Slave Trade to America, Volume I: 1441–1700* (Octagon Books, 1969), 392–410.

Walker, John (ed.) *Letters Written by Eminent Persons in the Seventeenth and Eighteenth Centuries*, 2 vols. (London, 1813).

Ward, Ned. *A Trip to Jamaica* (London, 1698).

Werenfels, Samuel. *A Dissertation upon Superstition in Natural Things* (London, 1748).

Woodward, John. *Brief Instructions for Making Observations in All Parts of the World* (London, 1696).

Yonge, James. 'A Letter from Mr James Yonge, FRS, to Dr Hans Sloane', *PT* 26 (1709), 424–31.

## SECONDARY SOURCES

Abbattista, Guido (ed.) *Encountering Otherness: Diversities and Transcultural Experiences in Early Modern European Culture* (University of Trieste Press, 2011).

Ackerman, Silke and Wess, Jane. 'Between Antiquarianism and Experiment: Hans Sloane, George III and Collecting Science', in Sloan, *Enlightenment*, 150–57.

Adams, Percy. *Travellers and Travel-Liars, 1660–1800* (Dover, 1980).

Adas, Michael. *Machines as the Measure of Men: Science, Technology, and Ideologies of Western Dominance* (Cornell University Press, 1990).

Agamben, Giorgio. *The Open: Man and Animal*, trans. Kevin Attell (Stanford University Press, 2004).

Alegria, Maria Fernanda, *et al.* 'Portuguese Cartography in the Renaissance', in David Woodward (ed.), *The History of Cartography, Volume 3: Cartography in the European Renaissance* (University of Chicago Press, 2007), 975–1068.

Al-Khalili, Jim. *The House of Wisdom: How Arabic Science Saved Ancient Wisdom and Gave Us the Renaissance* (Penguin, 2010).

Allen, D. E. 'Petiver, James', *ODNB*.

——. 'Sherard, William', *ODNB*.

Alpers, Svetlana. 'The Museum as a Way of Seeing', in Lavine and Karp, *Exhibiting Cultures*, 25–32.

Altick, Richard. *The Shows of London* (Belknap Press, 1978).

Amussen, Susan. *Caribbean Exchanges: Slavery and the Transformation of English Society, 1640–1700* (University of North Carolina Press, 2007).

Anderson, Jennifer. *Mahogany: The Costs of Luxury in Early America* (Harvard University Press, 2012).

Anderson, R. G. W., *et al.* (eds.) *Enlightening the British: Knowledge, Discovery, and the Museum in the Eighteenth Century* (British Museum Press, 2003).

Andrew, Donna. *Philanthropy and Police: London Charity in the Eighteenth Century* (Princeton University Press, 1990).

Anonymous. 'Rose of Jamaica', *Caribbeana* 5 (1917), 130–39.

App, Urs. *The Birth of Orientalism* (University of Pennsylvania Press, 2010).

Appadurai, Arjun (ed.) *The Social Life of Things: Commodities in Cultural Perspective* (Cambridge University Press, 1986).

Appleby, John. 'Human Curiosities and the Royal Society, 1699–1751', *NRRS* 50 (1996), 13–27.

———. 'The Royal Society and the Tartar Lamb', *NRRS* 51 (1997), 23–34.

Archibald, Marion. 'Coins and Medals', in MacGregor, *Sloane*, 150–66.

Armitage, David. *The Ideological Origins of the British Empire* (Cambridge University Press, 2000).

Armstrong, Douglas and Kelly, Kenneth. 'Settlement Patterns and the Origins of African Jamaican Society: Seville Plantation, St. Ann's Bay, Jamaica', *Ethnohistory* 47 (2000), 369–97.

Armytage, W. H. G. 'The Royal Society and the Apothecaries, 1660–1722', *NRRS* 11 (1954), 22–37.

Arnold, Ken. *Cabinets for the Curious: Looking Back at Early English Museums* (Ashgate, 2006).

Aronsson, Peter, *et al.* (eds.) *National Museums: New Studies from Around the World* (Routledge, 2011).

Ashworth, William, Jr. 'Emblematic Natural History of the Renaissance', in Jardine *et al.*, *Cultures of Natural History*, 17–37.

Bailyn, Bernard. *The Ideological Origins of the American Revolution* (Harvard University Press, 1967).

——— and Denault, Patricia (eds.) *Soundings in Atlantic History: Latent Structures and Intellectual Currents, 1500–1800* (Harvard University Press, 2011).

Baldwin, Geoff. 'The "Public" as a Rhetorical Community in Early Modern England', in Shepard and Withington, *Communities in Early Modern England*, 199–215.

Barber, Tabitha and Boldrick, Stacy (eds.) *Art Under Attack: Histories of British Iconoclasm* (Tate, 2013).

Barbour, Reid. *Sir Thomas Browne: A Life* (Oxford University Press, 2013).

Bardon, Jonathan. *The Plantation of Ulster: The British Colonisation of the North of Ireland in the Seventeenth Century* (Gill & Macmillan, 2011).

Barnard, Toby. *A New Anatomy of Ireland: The Irish Protestants, 1649–1770* (Yale University Press, 2003).

———. *Making the Grand Figure: Lives and Possessions in Ireland, 1641–1770* (Yale University Press, 2004).

———. 'Boyle, Murrough', *ODNB*.

———. 'The Irish in London and "the London Irish", *c.* 1660–1780', unpublished paper.

Barnes, Geraldine. 'Curiosity, Wonder, and William Dampier's Painted Prince', *Journal for Early Modern Cultural Studies* 6 (2006), 31–50.

Barrera-Osorio, Antonio. *Experiencing Nature: The Spanish-American Empire and the Early Scientific Revolution* (University of Texas Press, 2006).

Barringer, Tim, *et al.* (eds.) *Art and Emancipation in Jamaica: Isaac Mendes Belisario and His Worlds* (Yale University Press, 2007).

Barrington, E. 'Gavin Rylands de Beer, 1899–1972', *Biographical Memoirs of Fellows of the Royal Society* 19 (1973), 64–93.

Barry, Elizabeth. 'Celebrity, Cultural Production, and Public Life', *International Journal of Cultural Studies* 11 (2008), 251–8.

Bartrum, Giulia. *Albrecht Dürer and his Legacy: The Graphic Work of a Renaissance Artist* (Princeton University Press, 2002).

Bassani, Ezio. *African Art and Artifacts in European Collections, 1400–1800* (British Museum, 2000).

Baston, K. Grudzien. 'Vaughan, John, Third Earl of Carbery', *ODNB*.

Bätzner, Nike (ed.) *Assoziationsraum Wunderkammer: Zeitgenössische Künste zur Kunst und Naturalienkammer der Franckeschen Stiftungen zu Halle* (Verlag der Franckeschen Stiftungen zu Halle, 2015).

Baucom, Ian. *Spectres of the Atlantic: Finance Capital, Slavery, and the Philosophy of History* (Duke University Press, 2005).

Baudrillard, Jean. 'The System of Collecting' (1968), in Elsner and Cardinal, *Cultures of Collecting*, 7–24.

Bauer, Ralph. *The Cultural Geography of Colonial American Literatures: Empire, Travel, Modernity* (Cambridge University Press, 2003).

———. 'A New World of Secrets: Occult Philosophy and Local Knowledge in the Sixteenth-Century Atlantic', in Delbourgo and Dew, *Science and Empire in the Atlantic World*, 99–126.

Baugh, Daniel. *The Global Seven Years War, 1754–1763: Britain and France in a Great Power Contest* (Routledge, 2011).

Beck, David. 'County Natural History: Indigenous Science in England, from Civil War to Glorious Revolution', *Intellectual History Review* 24 (2014), 71–87.

Beck, Robin. *Chiefdoms, Collapse, and Coalescence in the Early American South* (Cambridge University Press, 2013).

Beckles, Hilary. ' "A Riotous and Unruly Lot": Irish Indentured Servants and Free Men in the English West Indies, 1644–1713', *WMQ* 67 (1990), 503–22.

Bender, John and Marrinan, Michael. *The Culture of Diagram* (Stanford University Press, 2010).

Benedict, Barbara. *Curiosity: A Cultural History of Early Modern Inquiry* (University of Chicago Press, 2001).

———. 'Collecting Trouble: Sir Hans Sloane's Literary Reputation in Eighteenth-Century Britain', *Eighteenth-Century Life* 36 (2012), 111–42.

Benjamin, Walter. *The Arcades Project*, trans. Howard Eiland and Kevin McLaughlin (Belknap Press, 1999).

Bennett, Herman. ' "Sons of Adam": Text, Context, and the Early Modern African Subject', *Representations* 92 (2005), 16–45.

Bennett, Tony. 'The Exhibitionary Complex', *New Formations* 4 (1988), 73–102.

Berg, Maxine. *Luxury and Pleasure in Eighteenth-Century Britain* (Oxford University Press, 2007).

Biagioli, Mario and Galison, Peter (eds.) *Scientific Authorship: Credit and Intellectual Property in Science* (Routledge, 2002).

Bickham, Troy. ' "A Conviction of the Reality of Things": Material Culture, North American Indians and Empire in Eighteenth-Century Britain', *Eighteenth-Century Studies* 39 (2005), 29–47.

Bilby, Kenneth. *True-Born Maroons* (University Press of Florida, 2005).

Bindman, David and Gates, Henry Louis, Jr (eds.) *The Image of the Black in Western Art, Part III: From the 'Age of Discovery' to the Age of Abolition – The Eighteenth Century* (Belknap Press, 2011).

—— and Weston, Helen. 'Court and City: Fantasies of Domination', in Bindman and Gates, *Image of the Black*, 125–70.

Binnema, Ted. *'Enlightened Zeal': The Hudson's Bay Company and Scientific Networks, 1670–1870* (University of Toronto Press, 2014).

Blackburn, Robin. *The Making of New World Slavery: From the Baroque to the Modern, 1492–1800* (Verso, 1997).

Blackwell, Mark (ed.) *The Secret Life of Things: Animals, Objects, and It-Narratives in Eighteenth-Century England* (Bucknell University Press, 2007).

Blair, Ann. *Too Much to Know: Managing Scholarly Information before the Modern Age* (Yale University Press, 2010).

Bleichmar, Daniela. *Visible Empire: Botanical Expeditions and Visual Culture in the Hispanic Enlightenment* (University of Chicago Press, 2012).

Block, Kristen and Shaw, Jenny. 'Subjects without an Empire: The Irish in the Early Modern Caribbean', *Past and Present* 210 (2011), 33–60.

Bodart-Bailey, Beatrice. 'Writing *The History of Japan*', in Bodart-Bailey and Massarella, *The Furthest Goal*, 17–43.

—— and Derek Massarella (eds.) *The Furthest Goal: Engelbert Kaempfer's Encounter with Tokugawa Japan* (Japan Library, 1995).

Bond, Richmond. *Queen Anne's American Kings* (Clarendon Press, 1952).

Bond, T. Christopher. 'Keeping up with the Latest Transactions: The Literary Critique of Scientific Writing in the Hans Sloane Years', *Eighteenth-Century Life* 22 (1998), 1–17.

Bork, Robert and Kann, Andrea (eds.) *The Art, Science, and Technology of Medieval Travel* (Ashgate, 2008).

Boschung, Dietrich and Bremmer, Jan (eds.) *The Materiality of Magic* (Wilhelm Fink, 2015).

Bowen, H. V. 'British Conceptions of Global Empire, 1756–83', *Journal of Imperial and Commonwealth History* 26 (1998), 1–27.

—— et al. (eds.) *The Worlds of the East India Company* (D. S. Brewer, 2002).

Bracken, Susan, et al. (eds.) *Women Patrons and Collectors* (Cambridge Scholars Publishing, 2012).

Braunholtz, H. J. *Sir Hans Sloane and Ethnography* (British Museum, 1970).

Bredekamp, Horst. *The Lure of Antiquity and Cult of the Machine: The Kunstkammer and the Evolution of Nature, Art, and Technology* (Markus Weiner, 1995).

Brewer, John. *The Sinews of Power: War, Money, and the English State, 1688–1783* (Unwin Hyman, 1989).

———. *The Pleasures of the Imagination: English Culture in the Eighteenth Century* (HarperCollins, 1997).

——— and Roy Porter (eds.) *Consumption and the World of Goods* (Routledge, 1993).

Brigham, David. 'Mark Catesby and the Patronage of Natural History in the First Half of the Eighteenth Century', in Meyers and Pritchard, *Empire's Nature*, 91–146.

Brockliss, Laurence and Jones, Colin. *The Medical World of Early Modern France* (Oxford University Press, 1997).

Brooks, Eric St John. *Sir Hans Sloane: The Great Collector and His Circle* (Batchworth Press, 1954).

Brotton, Jerry. *The Sale of the Late King's Goods: Charles I and his Art Collection* (Macmillan, 2006).

———. *This Orient Isle: Elizabethan England and the Islamic World* (Allen Lane, 2016).

Brown, Christopher. *Moral Capital: Foundations of British Abolitionism* (University of North Carolina Press, 2006).

Brown, Vera Lee. 'The South Sea Company and Contraband Trade', *American Historical Review* 31 (1926), 662–78.

Brown, Vincent. *The Reaper's Garden: Death and Power in the World of Atlantic Slavery* (Harvard University Press, 2008).

———. 'Social Death and Political Life in the Study of Slavery', *American Historical Review* 114 (2009), 1231–49.

Brown, Yu-Ying. 'Japanese Books and Manuscripts', in MacGregor, *Sloane*, 278–90.

Brusius, Mirjam. 'Misfit Objects: Layard's Excavations in Ancient Mesopotamia and the Biblical Imagination in Mid-Nineteenth Century Britain', *Journal of Literature and Science* 5 (2012), 38–52.

Buchwald, Jed, and Cohen, I. Bernard (eds.) *Isaac Newton's Natural Philosophy* (MIT Press, 2001).

Bumas, E. Shaskan. 'The Cannibal Butcher Shop: Protestant Uses of Las Casas's *Brevísima Relación* in Europe and the American Colonies', *Early American Literature* 35 (2000), 107–36.

Burke, Peter. 'Commentary', *Archival Science* 7 (2007), 391–7.

Burnard, Trevor. 'A Failed Settler Society: Marriage and Demographic Failure in Early Jamaica', *Journal of Social History* 28 (1994), 63–82.

———. 'Who Bought Slaves in Early America? Purchasers of Slaves from the Royal African Company in Jamaica, 1674–1708', *Slavery and Abolition* 17 (1996), 68–92.

———. ' "The Countrie Continues Sicklie": White Mortality in Jamaica, 1655–1780', *Social History of Medicine* 12 (1999), 45–72.

———. *Mastery, Tyranny, and Desire: Thomas Thistlewood and his Slaves in the Anglo-Jamaican World* (University of North Carolina Press, 2004).

Burnett, Andrew. ' "The King Loves Medals": The Study of Coins in Europe and Britain', in Sloan, *Enlightenment*, 122–31.

Bush, Barbara. *Slave Women in Caribbean Society, 1650–1838* (Indiana University Press, 1990).

Bushnell, David, Jr. 'The Sloane Collection in the British Museum', *American Anthropologist* 39 (1906), 671–85.

Butterfield, Herbert. *The Origins of Modern Science, 1300–1800* (1949, repr. Free Press, 1965).

Bynum, Carol Walker. *Christian Materiality: An Essay on Religion in Late Medieval Europe* (Zone, 2011).

Byrd, Alexander. *Captives and Voyagers: Black Migrants across the Eighteenth-Century British Atlantic World* (Louisiana State University Press, 2010).

Cain, A. J. 'John Locke on Species', *Archives of Natural History* 24 (1997), 337–60.

Campos, Edmund. 'Thomas Gage and the English Colonial Encounter with Chocolate', *Journal of Medieval and Early Modern Studies* 39 (2009), 183–200.

Candlin, Fiona. 'Touch, and the Limits of the Rational Museum or Can Matter Think?', *Senses and Society* 3 (2008), 277–92.

Cañizares-Esguerra, Jorge. *How to Write the History of the New World: Histories, Epistemologies, and Identities in the Eighteenth-Century Atlantic World* (Stanford University Press, 2000).

———. *Nature, Empire, and Nation: Explorations of the History of Science in the Iberian World* (Stanford University Press, 2006).

Cannon, John. 'Botanical Collections', in MacGregor, *Sloane*, 136–49.

Canny, Nicholas. 'The Ideology of English Colonization: From Ireland to America', *WMQ* 30 (1973), 575–98.

———. 'Identity Formation in Ireland: The Emergence of the Anglo-Irish', in Canny and Anthony Pagden, *Colonial Identity in the Atlantic World*, 159–212.

——— and Anthony Pagden (eds.) *Colonial Identity in the Atlantic World, 1500–1800* (Princeton University Press, 1987).

Carey, Daniel. *Locke, Shaftesbury and Hutcheson: Contesting Diversity in the Enlightenment and Beyond* (Cambridge University Press, 2005).

———. 'Inquiries, Heads, and Directions: Orienting Early Modern Travel', in Hayden, *Travel Narratives*, 25–52.

———. 'Locke's Species: Money and Philosophy in the 1690s', *Annals of Science* 70 (2013), 357–80.

——— and Festa, Lynn (eds.) *Postcolonial Enlightenment: Eighteenth-Century Colonialism and Postcolonial Theory* (Oxford University Press, 2009).

Carney, Judith. *Black Rice: The African Origins of Rice Cultivation in the Americas* (Harvard University Press, 2001).

——— and Rosomoff, Richard. *In the Shadow of Slavery: Africa's Botanical Legacy in the Atlantic World* (University of California Press, 2010).

Carswell, John. *The South Sea Bubble* (Cresset, 1960).

Casid, Jill. *Sowing Empire: Landscape and Colonization* (University of Minnesota Press, 2005).

Cassidy, Frederic. *Jamaica Talk: Three Hundred Years of the English Language in Jamaica* (St Martin's, 1961).

Caygill, Marjorie. 'Sloane's Will and the Establishment of the British Museum', in MacGregor, *Sloane*, 45–68.

———. 'From Private Collection to Public Museum: The Sloane Collection at Chelsea and the British Museum in Montagu House', in Anderson *et al.*, *Enlightening the British*, 18–28.

———. 'Sloane's Catalogues and the Arrangement of his Collections', in Hunter, *Books to Bezoars*, 120–36.

——— and Date, Christopher. *Building the British Museum* (British Museum, 1999).

Chakrabarti, Pratik. *Materials and Medicine: Trade, Conquest and Therapeutics in the Eighteenth Century* (Manchester University Press, 2010).

Chakrabarty, Dipesh. 'The Climate of History: Four Theses', *Critical Inquiry* 35 (2009), 197–222.

Chambers, Ian. 'A Cherokee Origin for the "Catawba" Deerskin Map (*c*.1721)', *Imago Mundi* 65 (2013), 207–16.

Chambers, Liam. 'Medicine and Miracles in the Late Seventeenth Century: Bernard Connor's *Evangelium Medici* (1697)', in Kelly and Clark, *Ireland and Medicine*, 53–72.

Chaplin, Joyce. 'Mark Catesby, a Sceptical Newtonian in America', in Meyers and Pritchard, *Empire's Nature*, 34–90.

———. *Subject Matter: Technology, Science, and the Body on the Anglo-American Frontier, 1500–1676* (Harvard University Press, 2001).

———. *The First Scientific American: Benjamin Franklin and the Pursuit of Genius* (Basic, 2007).

Chaudhuri, K. N. *The Trading World of Asia and the English East India Company, 1660–1760* (Cambridge University Press, 1978).

Cherry, John. 'Medieval and Later Antiquities: Sir Hans Sloane and the Collecting of History', in MacGregor, *Sloane*, 198–221.

Christie, John and Shuttleworth, Sally (eds.) *Nature Transfigured: Science and Literature, 1700–1900* (Manchester University Press, 1989).

Churchill, Wendy. 'Bodily Differences? Gender, Race, and Class in Hans Sloane's Jamaican Medical Practice, 1687–1688', *Journal of the History of Medicine and Allied Sciences* 60 (2005), 391–444.

——. 'Sloane's Perspectives on the Medical Knowledge and Health Practices of Non-Europeans', in Hunter, *Books to Bezoars*, 90–98.

Clark, J. C. D. *English Society, 1660–1832: Religion, Ideology, and Politics during the Ancien Regime*, rev. edn (Cambridge University Press, 2000).

Clark, Michael and Crawford, Catherine (eds.) *Legal Medicine in History* (Cambridge University Press, 1994).

Clark, Peter. *British Clubs and Societies, 1500–1800: The Origins of an Associational World* (Oxford University Press, 2000).

Clark, William, *et al.* (eds.) *The Sciences in Enlightened Europe* (University of Chicago Press, 1999).

Clarke, J. Kent. *Goodwin Wharton* (Oxford University Press, 1984).

Clarke, Jack. 'Sir Hans Sloane and Abbé Bignon: Notes on Collection Building in the Eighteenth Century', *Library Quarterly* 50 (1980), 475–82.

Classen, Constance. 'Museum Manners: The Sensory Life of the Early Museum', *Journal of Social History* 40 (2007), 895–914.

Clifton, Robin. 'Monck, Christopher', *ODNB*.

Clutton-Brock, Juliet. 'Vertebrate Collections', in MacGregor, *Sloane*, 77–92.

Cody, Lisa. *Birthing the Nation: Sex, Science, and the Conception of Eighteenth-Century Britons* (Oxford University Press, 2008).

Coe, Sophie and Michael. *The True History of Chocolate* (Thames & Hudson, 1996).

Cohen, Patricia. *A Calculating People: The Spread of Numeracy in Early America* (University of Chicago Press, 1982).

Cole, Michael and Zorach, Rebecca (eds.) *The Idol in the Age of Art: Objects, Devotions and the Early Modern World* (Ashgate, 2009).

Colla, Elliot. *Conflicted Antiquities: Egyptology, Egyptomania, Egyptian Modernity* (Duke University Press, 2007).

Colley, Linda. *Britons: Forging the Nation, 1707–1837* (Yale University Press, 1992).

——. *Captives: Britain, Empire, and the World, 1600–1850* (Jonathan Cape, 2002).

Conley, Katharine. 'Value and Hidden Cost in André Breton's Surrealist Collection', *South Central Review* 32 (2015), 8–22.

Cook, Harold. *The Decline of the Old Medical Regime in Stuart London* (Cornell University Press, 1986).

——. 'Practical Medicine and the British Armed Forces After the "Glorious Revolution"', *Medical History* 34 (1990), 1–26.

——. 'The Rose Case Reconsidered: Physic and the Law in Augustan England', *Journal of the History of Medicine* 45 (1990), 527–55.

———. 'Sir John Colbatch and Augustan Medicine: Experimentalism, Character, and Entrepreneurialism', *Annals of Science* 47 (1990), 475–505.

———. *Trials of an Ordinary Doctor: Joannes Groenevelt in Seventeenth-Century London* (Johns Hopkins University Press, 1994).

———. 'Time's Bodies: Crafting the Preparation and Preservation of Naturalia', in Smith and Findlen, *Merchants and Marvels*, 223–47.

———. 'Medicine', in Daston and Park, *Cambridge History of Science, Volume 3*, 407–34.

———. *Matters of Exchange: Commerce, Medicine, and Science in the Dutch Golden Age* (Yale University Press, 2007).

Cook, J. Mordaunt. *The British Museum: A Case-Study in Architectural Politics* (Penguin, 1972).

Cook, Jill. 'The Nature of the Earth and the Fossil Debate', in Sloan, *Enlightenment*, 92–9.

———. 'The Elephants in the Collection: Sloane and the History of the Earth', in Hunter, *Books to Bezoars*, 158–67.

Cooper, Alix. *Inventing the Indigenous: Local Knowledge and Natural History in Early Modern Europe* (Cambridge University Press, 2007).

Coulton, Richard. ' "The Darling of the Temple-Coffee-House Club": Science, Sociability, and Satire in Early Eighteenth-Century London', *Journal for Eighteenth-Century Studies* 35 (2012), 43–65.

Cowan, Brian. *The Social Life of Coffee: The Emergence of the British Coffee-house* (Yale University Press, 2005).

Cowie, Leonard. *Henry Newman: An American in London, 1708–43* (Church Historical Society, 1956).

Crawford, Catherine. 'Legalizing Medicine: Early Modern Legal Systems and the Growth of Medico-Legal Knowledge', in Clark and Crawford, *Legal Medicine in History*, 89–116.

Crawford, Robert. *Devolving English Literature* (Oxford University Press, 1992).

Crosby, Alfred. *The Columbian Exchange: Biological and Cultural Consequences of 1492* (Greenwood, 1972).

Cuatrecasas, José. 'Cacao and its Allies: A Taxonomic Revision of the Genus Theobroma', *Contributions from the U.S. National Herbarium* 35 (1964), 379–614.

Cunningham, Andrew. 'Thomas Sydenham: Epidemics, Experiment and the "Good Old Cause" ', in French and Wear, *Medical Revolution*, 164–90.

Curran, Andrew. 'Rethinking Race History: The Role of the Albino in the French Enlightenment Life Sciences', *History and Theory* 48 (2009), 151–79.

———. *The Anatomy of Blackness: Science and Slavery in an Age of Enlightenment* (Johns Hopkins University Press, 2011).

Curthoys, J. H. 'Hannes, Sir Edward', *ODNB*.

Dabydeen, David. *Hogarth's Blacks: Images of Blacks in Eighteenth-Century English Art* (University of Georgia Press, 1987).

Dacome, Lucia. *Malleable Anatomies: Models, Makers, and Material Culture in Eighteenth-Century Italy* (Oxford University Press, 2017).

Da Costa, P. Fontes. 'The Culture of Curiosity at the Royal Society in the First Half of the Eighteenth Century', *NRRS* 56 (2002), 147–66.

Dandy, J. E. *The Sloane Herbarium* (British Museum, 1958).

Darley, Gillian. *John Evelyn: Living for Ingenuity* (Yale University Press, 2007).

Daston, Lorraine. 'Marvellous Facts and Miraculous Evidence in Early Modern Europe', *Critical Inquiry* 18 (1991), 193–214.

———. 'The Ideal and Reality of the Republic of Letters in the Enlightenment', *Science in Context* 4 (1991), 367–86.

———. 'Attention and the Values of Nature in the Enlightenment', in Daston and Vidal, *Moral Authority of Nature*, 100–26.

——— (ed.) *Things That Talk: Object Lessons from Art and Science* (Zone, 2004).

———. 'Type Specimens and Scientific Memory', *Critical Inquiry* 31 (2004), 153–82.

——— and Galison, Peter. *Objectivity* (Zone, 2007).

——— and Park, Katharine. *Wonders and the Order of Nature, 1150–1750* (Zone, 1998).

——— and Park, Katharine (eds.) *The Cambridge History of Science, Volume 3: Early Modern Science* (Cambridge University Press, 2006).

——— and Vidal, Fernando (eds.) *The Moral Authority of Nature* (University of Chicago Press, 2004).

Davies, Randall. *The Greatest House at Chelsey* (John Lane, 1914).

Davis, Natalie Zemon. *Women on the Margins: Three Seventeenth-Century Lives* (Harvard University Press, 1995).

———. *Trickster Travels: A Sixteenth-Century Muslim between Worlds* (Hill & Wang, 2007).

Day, Michael. 'Humana: Anatomical, Pathological and Curious Human Specimens in Sloane's Museum', in MacGregor, *Sloane*, 69–76.

Dear, Peter. '*Totius in Verba*: Rhetoric and Authority in the Early Royal Society', *Isis* 76 (1985), 145–61.

———. 'The Meanings of Experience', in Daston and Park, *Cambridge History of Science, Volume 3*, 106–31.

De Beer, Gavin. *Sir Hans Sloane and the British Museum* (Oxford University Press, 1953).

———. *The Sciences Were Never at War* (Nelson, 1960).

Debus, Allen. *Chemistry and Medical Debate: Van Helmont to Boerhaave* (Science History Publications, 2001).

DeLacy, Margaret. *The Germ of an Idea: Contagionism, Religion, and Society in Britain, 1660–1730* (Palgrave Macmillan, 2016).

Delbourgo, James. *A Most Amazing Scene of Wonders: Electricity and Enlightenment in Early America* (Harvard University Press, 2006).

———. 'Divers Things: Collecting the World Under Water', *History of Science* 49 (2011), 149–85.

———. 'What's in the Box?', *Cabinet Magazine* 41 (2011), 46–50.

———. 'Listing People', *Isis* 103 (2012), 735–42.

———. 'The Newtonian Slave Body: Racial Enlightenment in the Atlantic World', *Atlantic Studies* 9 (2012), 185–207.

———. 'Die Wunderkammer als Ort von Neugier, Horror und Freiheit', in Bätzner, *Assoziationsraum Wunderkammer*, 83–96.

——— and Dew, Nicholas (eds.) *Science and Empire in the Atlantic World* (Routledge, 2007).

——— and Müller-Wille, Staffan. 'Listmania: Introduction', *Isis* 103 (2012), 710–15.

Delmer, Cyrille. 'Sloane's Fossils', in Hunter, *Books to Bezoars*, 154–7.

DeLoughrey, Elizabeth. *Routes and Roots: Navigating Caribbean and Pacific Island Literatures* (University of Hawai'i Press, 2010).

De Marchi, Neil. 'The Role of Dutch Auctions and Lotteries in Shaping the Art Market(s) of 17th Century Holland', *Journal of Economic Behaviour and Organization* 28 (1995), 203–21.

De Renzi, Silvia. 'Medical Expertise, Bodies, and the Law in Early Modern Courts', *Isis* 98 (2007), 315–22.

De Sequeira, Miguel Menezes, *et al.* 'The Madeiran Plants Collected by Sir Hans Sloane in 1687, and his Descriptions', *Taxon* 59 (2010), 598–612.

Dettelbach, Michael. 'Global Physics and Aesthetic Empire: Humboldt's Physical Portrait of the Tropics', in Miller and Reill, *Visions of Empire*, 258–92.

Dew, Nicholas. *Orientalism in Louis XIV's France* (Oxford University Press, 2009).

———. 'Scientific Travel in the Atlantic World: The French Expedition to Gorée and the Antilles, 1681–1683', *BJHS* 43 (2010), 1–17.

Dobbs, Betty Jo. *The Foundation of Newton's Alchemy: or, 'The Hunting of the Green Lyon'* (Cambridge University Press, 1975).

Drayton, Richard. *Nature's Government: Science, Imperial Britain, and the 'Improvement' of the World* (Yale University Press, 2000).

Dubois, Laurent. *Avengers of the New World: The Story of the Haitian Revolution* (Harvard University Press, 2004).

Duffin, Christopher, *et al.* (eds.) *A History of Geology and Medicine* (Geological Society of London, 2013).

Duffy, Eamon. *The Stripping of the Altars: Traditional Religion in England, c. 1400–c. 1580* (Yale University Press, 1992).

Dunn, P. M. 'Sir Hans Sloane (1660–1753) and the Value of Breast Milk', *Archives of Disease in Childhood, Fetal and Neonatal Edition* 85 (2001), F73–F74.

Dunn, Richard. *Sugar and Slaves: The Rise of the Planter Class in the English West Indies, 1624–1723* (University of North Carolina Press, 1972).

Eamon, William. *Science and the Secrets of Nature: Books of Secrets in Medieval and Early Modern Europe* (Princeton University Press, 1994).

Earle, Peter. *The Wreck of the Almiranta: Sir William Phips and the Search for the Hispaniola Treasure* (Macmillan, 1979).

——. *The Making of the English Middle Class: Business, Society and Family Life in London, 1660–1730* (University of California Press, 1989).

Eco, Umberto. *The Infinity of Lists* (Rizzoli, 2009).

Eddy, Matthew, *et al.* (eds.) *Chemical Knowledge in the Early Modern World*, vol. 29 of *Osiris* (2014).

Eger, Elizabeth. 'Paper Trails and Eloquent Objects: Bluestocking Friendship and Material Culture', *Parergon* 26 (2009), 109–38.

Eliot, John. *Empires of the Atlantic World: Britain and Spain in America, 1492–1830* (Yale University Press, 1997).

Ellis, Markman. *The Coffee House: A Cultural History* (Weidenfeld & Nicolson, 2004).

Elman, Benjamin. *A Cultural History of Modern Science in China* (Harvard University Press, 2006).

Elshakry, Marwa. 'When Science Became Western: Historiographical Reflections', *Isis* 101 (2010), 98–109.

Elsner, John and Cardinal, Roger (eds.) *The Cultures of Collecting* (Harvard University Press, 1994).

Eltis, David and Richardson, David. *Atlas of the Transatlantic Slave Trade* (Yale University Press, 2010).

Endt-Jones, Marion. 'Reopening the Cabinet of Curiosities: Nature and the Marvellous in Surrealism and Contemporary Art', PhD thesis (University of Manchester, 2009).

Erskine, Andrew. 'Culture and Power in Ptolemaic Egypt: The Museum and Library of Alexandria', *Greece and Rome* 42 (1995), 38–48.

Evenden, Doreen. 'Blackwell, Elizabeth', *ODNB*.

Fan, Fa-ti. *British Naturalists in Qing China: Science, Empire, and Cultural Encounter* (Harvard University Press, 2004).

Fara, Patricia. *Sympathetic Attractions: Magnetic Practices, Beliefs, and Symbolism in Eighteenth-Century England* (Princeton University Press, 1996).

——. *Newton: The Making of Genius* (Columbia University Press, 2002).

Feigenbaum, Gail and Reist, Inge (eds.) *Provenance: An Alternate History of Art* (Getty Institute, 2013).

Feingold, Mordechai. 'Mathematicians and Naturalists: Sir Isaac Newton and the Royal Society', in Buchwald and Cohen, *Isaac Newton's Natural Philosophy*, 77–102.

Fenton, William. *The Great Law and the Longhouse: A Political History of the Iroquois Confederacy* (University of Oklahoma Press, 1998).

Festa, Lynn. 'The Moral Ends of Eighteenth- and Nineteenth-Century Object Narratives', in Blackwell, *Secret Life of Things*, 309–28.

Finch, Jeremiah (ed.) *A Catalogue of the Libraries of Sir Thomas Browne and Dr. Edward Browne, His Son: A Facsimile Reproduction with an Introduction, Notes and Index* (Brill, 1986).

Findlen, Paula. *Possessing Nature: Museums, Collecting and Scientific Culture in Early Modern Italy* (University of California Press, 1994).

———. 'Inventing Nature: Commerce, Art, and Science in the Early Modern Cabinet of Curiosities', in Smith and Findlen, *Merchants and Marvels*, 297–323.

——— (ed.) *Athanasius Kircher: The Last Man Who Knew Everything* (Routledge, 2004).

———. 'Anatomy Theatres, Botanical Gardens, and Natural History Collections', in Daston and Park, *Cambridge History of Science, Volume 3*, 272–89.

———. 'Natural History', in Daston and Park, *Cambridge History of Science, Volume 3*, 435–68.

Fitton, Mike and Gilbert, Pamela. 'Insect Collections', in MacGregor, *Sloane*, 112–22.

Forshaw, Peter. ' "Behold, the Dreamer Cometh": Hyperphysical Magic and Deific Visions in an Early Modern Theosophical Lab-Oratory', in Raymond, *Conversations with Angels*, 175–200.

———. 'Magical Material and Material Survivals: Amulets, Talismans and Mirrors in Early Modern Europe', in Boschung and Bremmer, *Materiality of Magic*, 357–78.

Foss, Peter and O'Connell, Catherine. 'Bogland: Study and Utilization', in Foster, *Nature in Ireland*, 184–98.

Foster, John (ed.) *Nature in Ireland: A Scientific and Cultural History* (McGill-Queens University Press, 1999).

Foucault, Michel. *The Order of Things: An Archaeology of the Human Sciences* (1966, repr. Vintage, 1994).

Frasca-Spada, Marina and Jardine, Nick (eds.) *Books and the Sciences in History* (Cambridge University Press, 2000).

French, Roger and Wear, Andrew (eds.) *The Medical Revolution of the Seventeenth Century* (Cambridge University Press, 1989).

Frey, Sylvia and Wood, Betty. *Come Shouting to Zion: African American Protestantism in the American South and British Caribbean to 1830* (University of North Carolina Press, 1998).

Furdell, Elizabeth. *The Royal Doctors, 1485–1714: Medical Personnel at the Tudor and Stuart Courts* (University of Rochester Press, 2001).

Gallay, Alan. *The Indian Slave Trade: The Rise of the English Empire in the American South, 1670–1717* (Yale University Press, 2002).

Gascoigne, John. *Science in the Service of Empire: Joseph Banks, the British State and the Uses of Science in the Age of Revolution* (Cambridge University Press, 1998).

——. 'The Royal Society, Natural History, and the Peoples of the "New World(s)", 1660–1800', *BJHS*, 42 (2009), 539–62.

Gaspar, David Barry. '"Rigid and Inclement": Origins of the Jamaica Slave Laws of the Seventeenth Century', in Tomlins and Mann, *Many Legalities of Early America*, 78–96.

Gaudio, Michael. *Engraving the Savage: The New World and Techniques of Civilization* (University of Minnesota Press, 2008).

Gaukroger, Stephen. *Descartes: An Intellectual Biography* (Oxford University Press, 1995).

Geary, Patrick. 'Sacred Commodities: The Circulation of Medieval Relics', in Appadurai, *Social Life of Things*, 169–91.

Gee, Sophie. *Making Waste: Leftovers and the Eighteenth-Century Imagination* (Princeton University Press, 2009).

Genuth, Sara Schechner. 'Astrolabes: A Cross-Cultural and Social Perspective', in Webster and Webster, *Western Astrolabes*, 2–25.

——. 'Astrolabes and Medieval Travel', in Bork and Kann, *Art, Science, and Technology of Medieval Travel*, 181–210.

Gerbi, Antonello. *The Dispute of the New World: The History of a Polemic, 1750–1900*, trans. Jeremy Moyle (1955, repr. University of Pittsburgh Press, 1973).

Gerzina, Gretchen. *Black England: Life Before Emancipation* (John Murray, 1995).

Gibson-Wood, Carol. 'Classification and Value in a Seventeenth-Century Museum: William Courten's Collection', *Journal of the History of Collections* 9 (1997), 61–77.

——. *Jonathan Richardson: Art Theorist of the English Enlightenment* (Yale University Press, 2000).

Gidal, Eric. *Poetic Exhibitions: Romantic Aesthetics and the Pleasures of the British Museum* (Bucknell University Press, 2002).

Gikandi, Simon. *Slavery and the Culture of Taste* (Princeton University Press, 2011).

Gilbert, Pamela. 'Glanville, Eleanor', *ODNB*.

Gillispie, Charles. *Science and Polity in France: The Revolutionary and Napoleonic Years* (Princeton University Press, 2004).

Glasson, Travis. *Mastering Christianity: Missionary Anglicanism and Slavery in the Atlantic World* (Oxford University Press, 2011).

Goetzmann, William. 'John Bartram's Journey to Onondaga in Context', in Hoffmann and Van Horne, *America's Curious Botanist*, 97–106.

Goldfinch, John. 'Sloane's Incunabula', in Hunter, *Books to Bezoars*, 208–20.

Goldgar, Anne. 'The British Museum and the Virtual Representation of Culture in the Eighteenth Century', *Albion* 32 (2000), 195–231.

Golinski, Jan. 'A Noble Spectacle: Phosphorus and the Public Cultures of Science in the Early Royal Society', *Isis* 80 (1989), 11–39.

———. *British Weather and the Climate of Enlightenment* (University of Chicago Press, 2007).

Gomez, Michael. *Pragmatism in the Age of Jihad: The Precolonial State of Bundu* (Cambridge University Press, 1993).

———. *Exchanging our Country Marks: The Transformation of African Identities in the Colonial and Antebellum South* (University of North Carolina Press, 1998).

Gómez, Nicolás Wey. *The Tropics of Empire: Why Columbus Sailed South to the Indies* (MIT Press, 2008).

Gómez, Pablo. 'The Circulation of Bodily Knowledge in the Seventeenth-Century Black Spanish Caribbean', *Social History of Medicine* 26 (2013), 383–402.

Goodwin, Gordon. 'Cuninghame, James', *ODNB*.

Goody, Jack. *The Domestication of the Savage Mind* (Cambridge University Press, 1977).

Gordon, Bertram. 'Commerce, Colonies, and Cacao: Chocolate in England from Introduction to Industrialization', in Grivetti and Shapiro, *Chocolate*, 583–94.

Govier, Mark. 'The Royal Society, Slavery, and the Island of Jamaica: 1660–1700', *NRRS* 53 (1999), 203–17.

Graeber, David. *Toward an Anthropological Theory of Value: The False Coin of Our Own Dreams* (Palgrave, 2001).

Grafton, Anthony. *New Worlds, Ancient Texts: The Power of Tradition and the Shock of Discovery* (Harvard University Press, 1992).

Grant, Douglas. *The Fortunate Slave: An Illustration of African Slavery in the Early Eighteenth Century* (Oxford University Press, 1968).

Gray, J. M. *A History of the Gambia* (Cambridge University Press, 1940).

Greene, Jack. *Pursuits of Happiness: The Social Development of Early Modern British Colonies and the Formation of American Culture* (University of North Carolina Press, 1988).

———. '"A Plain and Natural Right to Life and Liberty": An Early Natural Rights Attack on the Excesses of the Slave System in Colonial British America', *WMQ* 57 (2000), 793–808.

Greenfield, Jeanette. *The Return of Cultural Treasures*, 3rd edn (Cambridge University Press, 2013).

Greer, Margaret, *et al.* (eds.) *Rereading the Black Legend: The Discourses of Religious and Racial Difference in the Renaissance Empires* (University of Chicago Press, 2008).

Grimé, William. *Ethno-Botany of the Black Americans* (Reference Publications, 1979).

Grindle, Nick. '"No Other Sign or Note than the Very Order": Francis Willughby, John Ray and the Importance of Collecting Pictures', *Journal of the History of Collections* 17 (2005), 15–22.

Grivetti, Louis and Shapiro, Howard (eds.) *Chocolate: History, Culture, and Heritage* (John Wiley and Sons, 2009).

Grove, Richard. *Green Imperialism: Colonial Expansion, Tropical Island Edens and the Origins of Environmentalism, 1600–1860* (Cambridge University Press, 1996).

Guerrini, Anita. *Obesity and Depression in the Enlightenment: The Life and Times of George Cheyne* (University of Oklahoma Press, 2000).

———. ' "A Scotsman on the Make": The Career of Alexander Stuart', in Wood, *Scottish Enlightenment*, 157–76.

———. 'Anatomists and Entrepreneurs in Early Eighteenth-Century London', *Journal of the History of Medicine and Allied Sciences* 59 (2004), 219–39.

———. 'Theatrical Anatomy: Duverney in Paris, 1670–1720', *Endeavour* 33 (2009), 7–11.

Gunn, Geoffrey. *First Globalization: The Eurasian Exchange, 1500–1800* (Rowman & Littlefield, 2003).

Habermas, Jürgen. *The Structural Transformation of the Public Sphere: An Inquiry into a Category of Bourgeois Society*, trans. Thomas Burger (MIT Press, 1991).

Hagner, Michael. 'Enlightened Monsters', in Clark *et al.*, *Sciences in Enlightened Europe*, 175–217.

Hallock, Thomas. 'Narrative, Nature, and Cultural Contact in John Bartram's *Observations*', in Hoffmann and Van Horne, *America's Curious Botanist*, 107–26.

Hamilton, Douglas and Blyth, Robert (eds.) *Representing Slavery: Art, Artefacts and Archives in the Collections of the National Maritime Museum* (Lund Humphries, 2007).

Hancock, David. *Citizens of the World: London Merchants and the Integration of the British Atlantic Community, 1735–1785* (Cambridge University Press, 1997).

———. *Oceans of Wine: Madeira and the Emergence of American Trade and Taste* (Yale University Press, 2009).

Handler, Jerome. 'Slave Medicine and Obeah in Barbados, circa 1650 to 1834', *New West Indian Guide* 74 (2000), 57–90.

———. 'The Middle Passage and the Material Culture of Captive Africans', *Slavery and Abolition* 30 (2009), 1–26.

Hanson, Craig. *The English Virtuoso: Art, Medicine, and Antiquarianism in the Age of Empiricism* (University of Chicago Press, 2009).

Harkness, Deborah. *John Dee's Conversations with Angels: Cabala, Alchemy and the End of Nature* (Cambridge University Press, 1999).

Harris, John. *The Palladian Revival: Lord Burlington, His Villa and Garden at Chiswick* (Royal Academy of Arts, 1994).

Harris, Steven. 'Long-Distance Corporations, Big Science and the Geography of Knowledge', *Configurations* 6 (1988), 269–304.

Haskell, Francis. *The King's Pictures: The Formation and Dispersal of the Collections of Charles I and his Courtiers* (Yale University Press, 2013).

Hauser, Mark. *An Archaeology of Black Markets: Local Ceramics and Economies in Eighteenth-Century Jamaica* (University Press of Florida, 2008).

Hayden, Judy (ed.) *Travel Narratives, the New Science, and Literary Discourse, 1569–1750* (Ashgate, 2012).

Hayes, Kevin (ed.) *The Library of William Byrd of Westover* (Rowman and Littlefield, 1997).

Hayton, David. 'The Williamite Revolution in Ireland, 1688–91', in Israel, *Anglo-Dutch Moment*, 185–214.

———. *Ruling Ireland, 1685–1742: Politics, Politicians, and Parties* (Boydell, 2004).

———. *The Anglo-Irish Experience, 1680–1730: Religion, Identity and Patriotism* (Boydell, 2012).

———. 'Southwell, Edward', *ODNB*.

Heaman, Elsbeth. 'Epistemic and Military Failures in Britain and Canada during the Seven Years' War', in Heaman *et al.*, *Essays in Honour of Michael Bliss*, 93–118.

——— *et al.* (eds.) *Essays in Honour of Michael Bliss: Figuring the Social* (University of Toronto Press, 2008).

Heesen, Anke te. 'Boxes in Nature', *Studies in the History and Philosophy of Science* 31 (2000), 381–403.

———. 'News, Paper, Scissors: Clippings in the Sciences and Arts Around 1920', in Daston, *Things That Talk*, 297–323.

———. 'Accounting for the Natural World: Double-Entry Bookkeeping in the Field', in Schiebinger and Swan, *Colonial Botany*, 237–51.

Heilbron, John. *Physics at the Royal Society during Newton's Presidency* (William Andrews Clark Memorial Library, 1983).

Helms, Mary. 'Essay on Objects: Interpretations of Distance Made Tangible', in Schwartz, *Implicit Understandings*, 355–77.

Henderson, Thomas and McConnell, Anita. 'Barham, Henry', *ODNB*.

Heyd, Michael. *'Be Sober and Reasonable': The Critique of Enthusiasm in the Seventeenth and Early Eighteenth Centuries* (Brill, 1995).

Higman, Barry. *Montpelier, Jamaica: A Plantation Community in Slavery and Freedom, 1739–1912* (University of the West Indies Press, 1998).

Hinderaker, Eric. 'The "Four Indian Kings" and the Imaginative Construction of the First British Empire', *WMQ* 53 (1996), 487–526.

Hodder, Ian. *Entangled: An Archaeology of the Relationship between Humans and Things* (Wiley-Blackwell, 2012).

Hoffmann, Nancy and Van Horne, John (eds.) *America's Curious Botanist: A Tercentennial Reappraisal of John Bartram, 1699–1777* (American Philosophical Society, 2004).

Hooper-Greenhill, Eilean. *Museums and the Shaping of Knowledge* (Routledge, 1992).

Hoppit, Julian. *A Land of Liberty? England, 1689–1727* (Oxford University Press, 2000).

Hopwood, Nick, *et al*. 'Seriality and Scientific Objects in the Nineteenth Century', *History of Science* 48 (2010), 251–85.

Hostetler, Laura. *Qing Colonial Enterprise: Ethnography and Cartography in Early Modern China* (University of Chicago Press, 2001).

Houghton, Walter Jr., 'The English Virtuoso in the Seventeenth Century', parts 1–2, *Journal of the History of Ideas* 3 (1942), 51–73, 190–219.

Houston, Stuart, *et al*. (eds.) *Eighteenth-Century Naturalists of Hudson Bay* (McGill-Queens University Press, 2003).

Hsia, Florence. *Sojourners in a Strange Land: Jesuits and their Scientific Missions in Late Imperial China* (University of Chicago Press, 2009).

Hudson, Nicholas. 'From "Nation" to "Race": The Origin of Racial Classification in Eighteenth-Century Thought', *Eighteenth-Century Studies* 29 (1996), 247–64.

Hunt, Arnold. 'Sloane as a Collector of Manuscripts', in Hunter, *Books to Bezoars*, 190–207.

Hunter, Matthew. *Wicked Intelligence: Visual Art and the Science of Experiment in Restoration London* (University of Chicago Press, 2013).

Hunter, Michael. *Establishing the New Science: The Experience of the Early Royal Society* (Boydell and Brewer, 1989).

——. *Boyle: Between God and Science* (Yale University Press, 2009).

—— *et al*. (eds.) *From Books to Bezoars: Sir Hans Sloane and His Collections* (British Library, 2012).

Hunting, Penelope. *A History of the Society of Apothecaries* (Society of Apothecaries, 1998).

Hurston, Zora Neale. *Tell My Horse: Voodoo and Life in Haiti and Jamaica* (Perennial Library, 1990).

Iliffe, Robert. 'Foreign Bodies: Travel, Empire and the Early Royal Society of London, Part One – Englishmen on Tour', *Canadian Journal of History* 33 (1998), 357–85.

Impey, Oliver. 'Oriental Antiquities', in MacGregor, *Sloane*, 222–7.

Israel, Jonathan (ed.) *The Anglo-Dutch Moment: Essays on the Glorious Revolution and its World Impact* (Cambridge University Press, 2003).

——. 'The Dutch Role in the Glorious Revolution', in Israel, *Anglo-Dutch Moment*, 105–62.

Jacob, James. *Henry Stubbe, Radical Protestantism and the Early Enlightenment* (Cambridge University Press, 1983).

Jacob, Margaret. *The Newtonians and the English Revolution, 1689–1720* (Cornell University Press, 1976).

——. *Strangers Nowhere in the World: The Rise of Cosmopolitanism in Early Modern Europe* (University of Pennsylvania Press, 2006).

Jacquot, Jean. 'Sir Hans Sloane and French Men of Science', *NRRS* 10 (1953), 85–98.

James, Kathryn. 'Sloane and the Public Performance of Natural History', in Hunter, *Books to Bezoars*, 41–7.

Jardine, Lisa. *Going Dutch: How England Plundered Holland's Glory* (Harper-Collins, 2008).

Jardine, Nicholas, *et al.* (eds.) *Cultures of Natural History* (Cambridge University Press, 1996).

Jarvis, Charles. *Order Out of Chaos: Linnaean Plant Names and their Types* (Linnaean Society of London, 2007).

—— and Oswald, Philip. 'The Collecting Activities of James Cuninghame FRS on the Voyage of *Tuscan* to China (Amoy) between 1697 and 1699', *NRRS* 69 (2015), 135–53.

Jasanoff, Maya. *Edge of Empire: Conquest and Collecting on the Eastern Frontier of the British Empire* (Fourth Estate, 2005).

Jenkins, Eugenia. *A Taste for China: English Subjectivity and the Prehistory of Orientalism* (Oxford University Press, 2013).

Jenkins, Ian. 'Classical Antiquities: Sloane's "Repository of Time"', in MacGregor, *Sloane*, 167–73.

Jenkins, Susan. *Portrait of a Patron: The Patronage and Collecting of James Bridges, 1st Duke of Chandos (1674–1744)* (Ashgate, 2007).

Jewson, Nicholas. 'Medical Knowledge and the Patronage System in 18th-Century England', *Sociology* 8 (1974), 369–85.

Johnson, Maurice, *et al. Gulliver's Travels and Japan* (Doshisha University/ Amherst House, 1977).

Jones, Peter. 'A Preliminary Check-List of Sir Hans Sloane's Catalogues', *British Library Journal* 14 (1988), 38–51.

Jonsson, Fredrik Albritton. *Enlightenment's Frontier: The Scottish Highlands and the Origins of Environmentalism* (Yale University Press, 2013).

Jordan, Winthrop. *White Over Black: American Attitudes towards the Negro, 1550–1812* (University of North Carolina Press, 1968).

Jordanova, Ludmilla. 'Portraits, People and Things: Richard Mead and Medical Identity', *History of Science* 61 (2003), 93–113.

Jorink, Eric. 'Sloane and the Dutch Connection', in Hunter, *Books to Bezoars*, 57–70.

Kassell, Lauren. *Medicine and Magic in Elizabethan London: Simon Forman, Astrologer, Alchemist and Physician* (Oxford University Press, 2007).

Katzew, Ilona. *Casta Painting: Images of Race in Eighteenth-Century Mexico* (Yale University Press, 2004).

Kaufman, Terrence and Justeson, John. 'The History of the Word for "Cacao" and Related Terms in Ancient Meso-America', in McNeil, *Chocolate in Mesoamerica*, 117–39.

Keevak, Michael. *The Pretended Asian: George Psalmanazar's Eighteenth-Century Formosan Hoax* (Wayne State University Press, 2004).

———. *Becoming Yellow: A Short History of Racial Thinking* (Princeton University Press, 2011).

Keller, Vera. 'Nero and the Last Stalk of *Silphion*: Collecting Extinct Nature in Early Modern Europe', *Early Science and Medicine* 19 (2014), 424–47.

Kellman, Jordan. 'Nature, Networks, and Expert Testimony in the Colonial Atlantic: The Case of Cochineal', *Atlantic Studies* 7 (2010), 373–95.

Kelly, James, and Clark, Fiona (eds.) *Ireland and Medicine in the Seventeenth and Eighteenth Centuries* (Ashgate, 2010).

Kennedy, Alasdair. 'In Search of the "True Prospect": Making and Knowing the Giant's Causeway as a Field Site in the Seventeenth Century', *BJHS* 41 (2008), 19–41.

Kenyon, John. *The Popish Plot* (Heinemann, 1972).

Kevill-Davies, Sally. *Sir Hans Sloane's Plants on Chelsea Porcelain* (Elmhirst & Suttie, 2015).

Kidd, Colin. *British Identities before Nationalism: Ethnicity and Nationhood in the Atlantic World, 1600–1800* (Cambridge University Press, 1999).

Kim, Julie. 'Obeah and the Secret Sources of Atlantic Medicine', in Hunter, *Books to Bezoars*, 99–104.

King, J. C. H. 'Ethnographic Collections: Collecting in the Context of Sloane's Catalogue of "Miscellanies"', in MacGregor, *Sloane*, 228–44.

———. *First Peoples, First Contacts: Native Peoples of North America* (Harvard University Press, 1999).

Kiple, Kenneth. *The Caribbean Slave: A Biological History* (Cambridge University Press, 1984).

Klaus, Sidney. 'A History of the Science of Pigmentation', in Nordlund *et al.*, *Pigmentary System*, 5–10.

Klein, Ursula and Lefèvre, Wolfgang (eds.) *Materials in Eighteenth-Century Science: A Historical Ontology* (MIT Press, 2007).

Koot, Christian. *Empire at the Periphery: British Colonists, Anglo-Dutch Trade, and the Development of the British Atlantic, 1621–1713* (NYU Press, 2011).

Kopytoff, Igor. 'The Cultural Biography of Things: Commoditization as Process', in Appadurai, *Social Life of Things*, 64–91.

Kowaleski-Wallace, Elizabeth. 'The First Samurai: Isolationism in Engelbert Kaempfer's 1727 *History of Japan*', *The Eighteenth Century* 48 (2007), 111–24.

Kristeva, Julia. *Powers of Horror: An Essay on Abjection*, trans. Leon Roudiez (Columbia University Press, 1982).

Kriz, Kay Dian. 'Curiosities, Commodities, and Transplanted Bodies in Hans Sloane's "Natural History of Jamaica"', *WMQ* 57 (2000), 35–78.

———. *Slavery, Sugar, and the Culture of Refinement: Picturing the British West Indies, 1700–1840* (Yale University Press, 2008).

Kupperman, Karen. 'Fear of Hot Climates in the Anglo-American Colonial Experience', *WMQ* 41 (1984), 213–40.

Kusukawa, Sachiko. 'The Historia Piscium (1686)', *NRRS* 54 (2000), 179–97.

——. 'Picturing Knowledge in the Early Royal Society: The Examples of Richard Waller and Henry Hunt', *NRRS* 65 (2011), 273–94.

——. *Picturing the Book of Nature: Image, Text, and Argument in Sixteenth-Century Human Anatomy and Medical Botany* (University of Chicago Press, 2012).

Kuwakino, Koji. 'The Great Theatre of Creative Thought: The *Inscriptiones vel tituli theatri amplissimi* . . . (1565) by Samuel von Quiccheberg', *Journal of the History of Collections* 25 (2013), 303–24.

Laird, Mark. 'From Callicarpa to Catalpa: The Impact of Mark Catesby's Plant Introductions on English Gardens of the Eighteenth Century', in Meyers and Pritchard, *Empire's Nature*, 184–227.

Langford, Paul. *A Polite and Commercial People: England, 1727–1783* (Oxford University Press, 1994).

Latour, Bruno. 'Visualisation and Cognition: Drawing Things Together', *Knowledge and Society* 6 (1986), 1–40.

——. *Science in Action: How to Follow Scientists and Engineers through Society* (Harvard University Press, 1987).

——. 'From Realpolitik to Dingpolitik, or How to Make Things Public', in Latour and Weibel, *Making Things Public*, 4–31.

—— and Weibel, Peter (eds.) *Making Things Public: Atmospheres of Democracy* (MIT Press, 2005).

Lavine, Steven and Karp, Ivan (eds.) *Exhibiting Cultures: The Poetics and Politics of Museum Display* (Smithsonian Institute, 1991).

Law, Robin. *The Horse in West Africa* (Oxford University Press, 1980).

Lawrence, Christopher and Shapin, Steven (eds.) *Science Incarnate: Historical Embodiments of Natural Knowledge* (University of Chicago Press, 1998).

Lawrence, Natalie. 'Assembling the Dodo in Early Modern Natural History', *BJHS* 48 (2015), 387–408.

Leong, Elaine and Rankin, Alisha (eds.) *Secrets and Knowledge in Medicine and Science, 1500–1800* (Ashgate, 2011).

Lepore, Jill. *The Name of War: King Philip's War and the Origins of American Identity* (Knopf, 1998).

Levine, Joseph. *Dr Woodward's Shield: History, Science, and Satire in Augustan England* (University of California Press, 1977).

——. *The Battle of the Books: History and Literature in the Augustan Age* (Cornell University Press, 1994).

Linebaugh, Peter and Rediker, Marcus. *The Many-Headed Hydra: Sailors, Slaves, Commoners, and the Hidden History of the Revolutionary Atlantic* (Beacon, 2000).

Liss, Robert. 'Frontier Tales: Tokugawa Japan in Translation', in Schaffer *et al.*, *Brokered World*, 1–47.

Livingston, Julie and Puar, Jasbir. 'Interspecies', *Social Text* 29 (2011), 3–14.

Lugo-Ortiz, Agnes and Rosenthal, Angela (eds.) *Slave Portraiture in the Atlantic World* (Cambridge University Press, 2013).

Lynch, Michael. 'Sacrifice and the Transformation of the Animal Body into a Scientific Object: Laboratory Culture and Ritual Practice in the Neurosciences', *Social Studies of Science* 18 (1988), 265–89.

MacGregor, Arthur (ed.) *Tradescant's Rarities: Essays on the Foundation of the Ashmolean Museum* (Clarendon Press, 1983).

———. 'Egyptian Antiquities', in MacGregor, *Sloane*, 174–9.

———. 'The Life, Character and Career of Sir Hans Sloane', in MacGregor, *Sloane*, 11–44.

———. 'Prehistoric and Romano-British Antiquities', in MacGregor, *Sloane*, 180–97.

——— (ed.) *Sir Hans Sloane: Collector, Scientist, Antiquary, Founding Father of the British Museum* (British Museum Press, 1994).

———. *The Ashmolean Museum: A Brief History of the Museum and its Collections* (Ashmolean Museum, 2001).

———. 'Medicinal *terra sigillata*: A Historical, Geographical and Typological Review', in Duffin *et al.*, *History of Geology and Medicine*, 113–36.

——— and Oliver Impey (eds.) *The Origins of Museums: The Cabinet of Curiosities in Sixteenth- and Seventeenth-Century Europe* (Oxford University Press, 1985).

MacGregor, Neil. *A History of the World in 100 Objects* (Allen Lane, 2010).

MacLean, Gerald and Matar, Nabil. *Britain and the Islamic World, 1558–1713* (Oxford University Press, 2011).

Maddison, Francis and Savage-Smith, Emilie (eds.) *Science, Tools and Magic, Part One: Body and Spirit, Mapping the Universe* (Nour Foundation, 1997).

Malcolmson, Cristina. *Studies of Skin Color in the Early Royal Society: Boyle, Cavendish, Swift* (Ashgate, 2013).

Mandelbrote, Giles. 'Sloane and the Preservation of Printed Ephemera', in Mandelbrote and Taylor, *Libraries within the Library*, 146–68.

——— and Barry Taylor (eds.) *Libraries within the Library: The Origins of the British Library's Printed Collections* (British Library, 2010).

Margócsy, Dániel. 'The Fuzzy Metrics of Money: The Finances of Travel and the Reception of Curiosities in Early Modern Europe', *Annals of Science* 70 (2013), 381–404.

———. *Commercial Visions: Science, Trade, and Visual Culture in the Dutch Golden Age* (University of Chicago Press, 2014).

Markley, Robert. *The Far East and the English Imagination, 1600–1730* (Cambridge University Press, 2006).

Marshall, P. J. and Williams, Glyndwr. *The Great Map of Mankind: British Perceptions of the World in the Age of Enlightenment* (J. M. Dent & Sons, 1982).

Martínez, María Elena. *Genealogical Fictions: Limpieza de Sangre, Religion, and Gender in Colonial Mexico* (Stanford University Press, 2008).

Mason, Peter. *Before Disenchantment: Images of Exotic Animals and Plants in the Early Modern World* (Reaktion, 2009).

Massarella, Derek. 'The History of *The History*: The Purchase and Publication of Kaempfer's *History of Japan*', in Bodart-Bailey and Massarella, *The Furthest Goal*, 96–131.

Matar, Nabil. *Islam in Britain, 1558–1685* (Cambridge University Press, 1998).

—— (ed.) *In the Lands of the Christians: Arabic Travel Writing in the Seventeenth Century* (Routledge, 2003).

Mauriès, Patrick. *Cabinets of Curiosities* (Thames & Hudson, 2002).

Mauss, Marcel. *The Gift: The Form and Reason for Exchange in Archaic Societies*, trans. W. D. Halls (1925, repr. Norton, 1990).

McBurney, Henrietta (ed.) *Mark Catesby's Natural History of America: The Watercolours from the Royal Library, Windsor Castle* (Merrell Holberton, 1997).

——. 'Note on the Natural History Albums of Sir Hans Sloane', in McBurney, *Catesby's Natural History*, 33.

McClain, Molly. *Beaufort: The Duke and His Duchess, 1657–1715* (Yale University Press, 2001).

McClellan, Andrew. *Inventing the Louvre: Art, Politics and the Origins of the Modern Museum in Eighteenth-Century Paris* (University of California Press, 1994).

McCormick, Ted. *William Petty and the Ambitions of Political Arithmetic* (Oxford University Press, 2010).

McCully, Bruce. 'Governor Francis Nicholson, Patron "Par Excellence" of Religion and Learning in Colonial America', *WMQ* 39 (1982), 310–33.

McDonald, Roderick. *The Economy and Material Culture of Slaves: Goods and Chattels on the Sugar Plantations of Jamaica and Louisiana* (Louisiana State University Press, 1993).

McKendrick, Neil, *et al. The Birth of a Consumer Society: The Commercialization of Eighteenth-Century England* (Europa, 1982).

McKeon, Michael. *The Origins of the English Novel, 1600–1740* (Johns Hopkins University Press, 1987).

——. *The Secret History of Domesticity: Public, Private, and the Division of Knowledge* (Johns Hopkins University Press, 2005).

McNeil, Cameron (ed.) *Chocolate in Mesoamerica: A Cultural History of Cacao* (University Press of Florida, 2006).

McNeill, John. *Mosquito Empires: Ecology and War in the Greater Caribbean, 1620–1914* (Cambridge University Press, 2010).

Meijers, Debora. 'Sir Hans Sloane and the European Proto-Museum', in Anderson *et al.*, *Enlightening the British*, 11–17.

Mejcher-Atassi, Sonja and Schwartz, John Pedro (eds.) *Archives, Museums and Collecting Practices in the Modern Arab World* (Ashgate, 2012).

Merrell, James. *Into the American Woods: Negotiators on the Pennsylvania Frontier* (Norton, 1999).

Meyers, Amy. 'The Perfecting of Natural History: Mark Catesby's Drawings of American Flora and Fauna in the Royal Library', in McBurney, *Catesby's Natural History*, 11–27.

——. 'Picturing a World in Flux: Mark Catesby's Response to Environmental Interchange and Colonial Expansion', in Meyers and Pritchard, *Empire's Nature*, 228–61.

—— and Margaret Beck Pritchard (eds.) *Empire's Nature: Mark Catesby's New World Vision* (University of North Carolina Press, 1998).

—— and Margaret Beck Pritchard. 'Introduction: Toward an Understanding of Catesby', in Meyers and Pritchard, *Empire's Nature*, 1–33.

Mikhail, Alan. *The Animal in Ottoman Egypt* (Oxford University Press, 2014).

Millar, Ashley. 'Your Beggarly Commerce! Enlightenment European views of the China Trade', in Abbattista, *Encountering Otherness*, 205–22.

Miller, David. 'The "Hardwicke Circle": The Whig Supremacy and its Demise in the 18th-Century Royal Society', *NRRS* 52 (1998), 73–91.

—— and Reill, Peter (eds.) *Visions of Empire: Voyages, Botany, and Representations of Nature* (Cambridge University Press, 1996).

Miller, Edward. *That Noble Cabinet: A History of the British Museum* (Ohio State University Press, 1974).

Minter, Sue. *The Apothecaries' Garden: A History of the Chelsea Physic Garden* (Sutton, 2000).

Mintz, Sidney. *Sweetness and Power: The Place of Sugar in Modern History* (Viking, 1985).

Mitter, Partha. *Much Maligned Monsters: A History of European Reactions to Indian Art* (University of Chicago Press, 1992).

Modest, Wayne. 'We Have Always Been Modern: Museums, Collections, and Modernity in the Caribbean', *Museum Anthropology* 35 (2012), 85–96.

Molineux, Catherine. *Faces of Perfect Ebony: Encountering Atlantic Slavery in Imperial Britain* (Harvard University Press, 2012).

Monod, Paul. *Solomon's Secret Arts: The Occult in the Age of Enlightenment* (Yale University Press, 2013).

Morgan, Edmund. *American Slavery, American Freedom: The Ordeal of Colonial Virginia* (Norton, 1975).

Morgan, Jennifer. *Labouring Women: Reproduction and Gender in New World Slavery* (University of Pennsylvania Press, 2004).

Morgan, Philip. 'Slaves and Livestock in Eighteenth-Century Jamaica: Vineyard Pen, 1750–51', *WMQ* 52 (1995), 47–76.

——. 'The Caribbean Environment in the Early Modern Era', unpublished paper.

Muensterberger, Werner. *Collecting – An Unruly Passion: Psychological Perspectives* (Princeton University Press, 1993).

Mukund, Kanakalatha. *The Trading World of the Tamil Merchant: Evolution of Merchant Capitalism in the Coromandel* (Orient Longman, 1999).

Müller-Wille, Staffan. 'Collection and Collation: Theory and Practice of Linnaean Botany', *Studies in History and Philosophy of Biological and Biomedical Sciences* 38 (2007), 541–62.

Murphy, Anne. *The Origins of English Financial Markets: Investment and Speculation before the South Sea Bubble* (Cambridge University Press, 2012).

Murphy, Kathleen. 'Collecting Slave Traders: James Petiver, Natural History, and the British Slave Trade', *WMQ* 70 (2013), 613–70.

Murphy, Trevor. *Pliny the Elder's Natural History: The Empire in the Encyclopaedia* (Oxford University Press, 2004).

Myers, Fred (ed.) *The Empire of Things: Regimes of Value and Material Culture* (SAR Press, 2002).

Nagata, Toshiyuki, *et al.* 'Engelbert Kaempfer, Genemon Imamura and the Origin of the Name *Ginkgo*', *Taxon* 64 (2015), 131–6.

Nair, Savithri Preetha. ' "To Be Serviceable and Profitable for Their Health": A Seventeenth-Century English Herbal of East Indian Plants Owned by Sloane', in Hunter, *Books to Bezoars*, 105–19.

Nappi, Carla. *The Monkey and the Inkpot: Natural History and its Transformations in Early Modern China* (Harvard University Press, 2009).

Neer, Richard. 'Framing the Gift: The Politics of the Siphnian Treasury at Delphi', *Classical Antiquity* 20 (2001), 273–344.

Neeson, Eoin. 'Woodland in History and Culture', in Foster, *Nature in Ireland*, 133–56.

Neill, Anna. 'Buccaneer Ethnography: Nature, Culture, and Nation in the Journals of William Dampier', *Eighteenth-Century Studies* 33 (2000), 165–80.

Nelson, E. Charles. *Sea Beans and Nickar Nuts* (Botanical Society of the British Isles, 2000).

Neri, Janice. *The Insect and the Image: Visualizing Nature in Early Modern Europe, 1500–1700* (University of Minnesota Press, 2011).

Newell, Jennifer, *et al.* (eds.) *Curating the Future: Museums, Communities and Climate Change* (Routledge, 2016).

Newman, William. 'From Alchemy to "Chymistry"', in Daston and Park, *Cambridge History of Science, Volume 3*, 497–517.

Nickson, Marjorie. 'Books and Manuscripts', in MacGregor, *Sloane*, 263–77.

Nordlund, James, *et al.* (eds.) *The Pigmentary System: Physiology and Pathophysiology*, 2nd edn (Wiley-Blackwell, 2006).

Norton, Marcy. *Sacred Gifts, Profane Pleasures: A History of Tobacco and Chocolate in the Atlantic World* (Cornell University Press, 2008).

Nussbaum, Felicity. 'Between "Oriental" and "Blacks So Called", 1688–1788', in Carey and Festa, *Postcolonial Enlightenment*, 137–66.

Ogborn, Miles. *Indian Ink: Script and Print in the Making of the English East India Company* (University of Chicago Press, 2007).

——. *Global Lives: Britain and the World, 1550–1800* (Cambridge University Press, 2008).

——. 'Talking Plants: Botany and Speech in Eighteenth-Century Jamaica', *History of Science* 51 (2013), 251–82.

Ogilvie, Brian. 'Natural History, Ethics, and Physico-Theology', in Pomata and Siraisi, *Historia*, 75–104.

——. *The Science of Describing: Natural History in Renaissance Europe* (University of Chicago Press, 2006).

——. 'Nature's Bible: Insects in Seventeenth-Century European Art and Science', *Tidsskrift* 3 (2008), 5–21.

Ohlmeyer, Jane. *Making Ireland English: The Irish Aristocracy in the Seventeenth Century* (Yale University Press, 2012).

O'Malley, Therese. 'Mark Catesby and the Culture of Gardens', in Meyers and Pritchard, *Empire's Nature*, 147–83.

—— and Meyers, Amy (eds.) *The Art of Natural History: Illustrated Treatises and Botanical Paintings, 1400–1850* (Yale University Press, 2010).

O'Neill, Mark. 'Enlightenment Museums: Universal or Merely Global?', *Museum and Society* 2 (2004), 190–202.

Padrón, Francisco. *Spanish Jamaica*, trans. Patrick Bryan (Ian Randle, 2003).

Pagden, Anthony. *The Fall of Natural Man: The American Indian and the Origins of Comparative Ethnology* (Cambridge University Press, 1987).

Park, Katharine. 'The Life of the Corpse: Division and Dissection in Late Medieval Europe', *Journal of the History of Medicine* 50 (1995), 111–32.

Parker, Charles. *Global Interactions in the Early Modern Age* (Cambridge University Press, 2010).

Parrish, Susan Scott. *American Curiosity: Cultures of Natural History in the Colonial British Atlantic World* (University of North Carolina Press, 2006).

——. 'Diasporic African Sources of Enlightenment Knowledge', in Delbourgo and Dew, *Science and Empire in the Atlantic World*, 281–310.

——. 'Richard Ligon and the Atlantic Science of Commonwealths', *WMQ* 67 (2010), 209–48.

Parry, Graham. *The Trophies of Time: English Antiquarians of the Seventeenth Century* (Oxford University Press, 1996).

Pasti, George. 'Consul Sherard: Amateur Botanist and Patron of Learning, 1659–1728', PhD thesis (University of Illinois, 1950).

Paton, Diana. 'Punishment, Crime, and the Bodies of Slaves in Eighteenth-Century Jamaica', *Journal of Social History* 34 (2001), 923–54.

Patterson, Orlando. *The Sociology of Slavery: An Analysis of the Origins, Development, and Structure of Negro Slave Society in Jamaica* (Fairleigh Dickinson University Press, 1967).

——. 'Slavery and Slave Revolts: A Sociohistorical Analysis of the First Maroon War, 1665–1740', in Price, *Maroon Societies*, 246–92.

Paul, Carole. 'Capitoline Museum, Rome: Civic Identity and Personal Cultivation', in Paul, *First Modern Museums of Art*, 21–46.

—— (ed.) *The First Modern Museums of Art: The Birth of an Institution in 18th- and Early-19th-Century Europe* (Getty, 2012).

Payne, Joseph. *Thomas Sydenham* (T. Fisher Unwin, 1900).

Peck, Linda Levy. *Consuming Splendour: Society and Culture in Seventeenth-Century England* (Cambridge University Press, 2005).

Pels, Peter. 'The Spirit of Matter: On Fetish, Rarity, Fact, and Fancy', in Spyer, *Border Fetishisms*, 91–121.

Pencak, William and Richter, Daniel (eds.) *Friends and Enemies in Penn's Woods: Indians, Colonists, and the Racial Construction of Pennsylvania* (Pennsylvania State University Press, 2004).

Pestana, Carla. *The English Atlantic in an Age of Revolution, 1640–1661* (Harvard University Press, 2004).

Pettigrew, William. *Freedom's Debt: The Royal African Company and the Politics of the Atlantic Slave Trade, 1672–1752* (University of North Carolina Press, 2013).

Pietz, William. 'The Problem of the Fetish', *Res* 9 (1985), 5–17; ibid., 13 (1987), 23–45; ibid., 16 (1988), 105–24.

Pimentel, Juan. *Testigos del mundo: Ciencia, literatura y viajes en la ilustración* (Marcial Pons, 2003).

Pincus, Steven. *1688: The First Modern Revolution* (Yale University Press, 2009).

Pointon, Marcia. 'Slavery and the Possibilities of Portraiture', in Lugo-Ortiz and Rosenthal, *Slave Portraiture*, 41–70.

Pomata, Gianna. 'Sharing Cases: The *Observationes* in Early Modern Medicine', *Early Science and Medicine* 15 (2010), 193–236.

—— and Siraisi, Nancy (eds.) *Historia: Empiricism and Erudition in Early Modern Europe* (MIT Press, 2005).

Pomeranz, Kenneth. *The Great Divergence: China, Europe, and the Making of the Modern World Economy* (Princeton University Press, 2000).

Pomian, Krzysztof. *Collectors and Curiosities: Paris and Venice, 1500–1800* (1987), trans. Elizabeth Wiles-Portier (Polity, 1990).

Poole, William. 'Francis Lodwick, Hans Sloane, and the Bodleian Library', *The Library: The Transactions of the Bibliographical Society* 7 (2006), 377–418.

——. *The World Makers: Scientists of the Restoration and the Search for the Origins of the Earth* (Peter Lang, 2010).

Popkin, Richard. *Isaac La Peyrère (1596–1676): His Life, Work and Influence* (Brill, 1987).

Porter, David. *The Chinese Taste in Eighteenth-Century England* (Cambridge University Press, 2010).

Porter, Dorothy and Roy. *Patient's Progress: Doctors and Doctoring in Eighteenth-Century England* (Stanford University Press, 1989).

Porter, Roy. *English Society in the Eighteenth Century* (Allen Lane, 1982).

———. *Health for Sale: Quackery in England, 1660–1850* (Manchester University Press, 1989).

———. 'Consumption: Disease of the Consumer Society?', in Brewer and Porter, *Consumption and the World of Goods*, 58–81.

———. *The Creation of the Modern World: The Untold Story of the British Enlightenment* (Norton, 2000).

———. *Bodies Politic: Disease, Death, and Doctors in Britain, 1650–1900* (Cornell University Press, 2001).

———. *Flesh in the Age of Reason* (Allen Lane, 2003).

Porter, Venetia. *Arabic and Persian Seals and Amulets in the British Museum* (British Museum, 2011).

Postle, Martin (ed.) *Joshua Reynolds: The Creation of Celebrity* (Tate Gallery, 2005).

Powers, John. ' "Ars Sine Arte": Nicolas Lemery and the End of Alchemy in Eighteenth-Century France', *Ambix* 45 (1998), 163–89.

Preston, Diana and Michael. *A Pirate of Exquisite Mind: Explorer, Naturalist, and Buccaneer: The Life of William Dampier* (Walker, 2004).

Price, Jacob. 'Heathcote, Gilbert', *ODNB*.

Price, Richard (ed.) *Maroon Societies: Rebel Slave Communities in the Americas* (Johns Hopkins University Press, 1973).

Principe, Lawrence. *The Aspiring Adept: Robert Boyle and his Alchemical Quest* (Princeton University Press, 2000).

Purcell, Mark. ' "Settled in the North of Ireland": Or, Where did Sloane Come From?', in Hunter, *Books to Bezoars*, 24–32.

Raj, Kapil. 'Surgeons, Fakirs, Merchants, and Craftsmen: Making L'Empereur's *Jardin* in Early Modern South Asia', in Schiebinger and Swan, *Colonial Botany*, 252–69.

———. *Relocating Modern Science: Circulation and the Construction of Knowledge in South Asia and Europe, 1650–1900* (Palgrave, 2010).

Rappaport, Rhoda. *When Geologists were Historians, 1665–1750* (Cornell University Press, 1997).

Rath, Richard. 'African Music in Seventeenth-Century Jamaica: Cultural Transit and Transition', *WMQ* 50 (1993), 700–26.

Raven, Charles. *John Ray, Naturalist: His Life and Works* (Cambridge University Press, 1942).

Ray, Arthur. *Indians in the Fur Trade: Their Role as Trappers, Hunters, and Middlemen in the Lands Southwest of Hudson Bay, 1660–1870* (University of Toronto Press, 1974).

Raymond, Joad (ed.) *Conversations with Angels: Essays Toward a History of Spiritual Communication, 1100–1700* (Palgrave, 2011).

Rediker, Marcus. *The Slave Ship: A Human History* (Penguin, 2008).

Ree, Peta. 'Shaw, Thomas', *ODNB*.

Reitsma, Ella. *Maria Sibylla Merian and Daughters: Women of Art and Science* (Oxford University Press, 2008).

Revel, Jacques. 'Knowledge of the Territory', *Science in Context* 4 (1991), 133–61.

Richards, John. *The Mughal Empire* (Cambridge University Press, 1996).

Roach, Joseph. *Cities of the Dead: Circum-Atlantic Performance* (Columbia University Press, 1996).

Roberts, Benjamin. 'Drinking Like a Man: The Paradox of Excessive Drinking for Seventeenth-Century Dutch Youths', *Journal of Family History* 29 (2004), 237–52.

Roberts, Lissa. 'The Death of the Sensuous Chemist: The "New" Chemistry and the Transformation of Sensuous Technology', *Studies in the History and Philosophy of Science* 26 (1995), 503–29.

—— et al. (eds.) *The Mindful Hand: Inquiry and Invention from the Late Renaissance to Early Industrialization* (Royal Netherlands Academy of Arts and Sciences, 2007).

Robertson, James. 'Re-Writing the English Conquest of Jamaica in the Late Seventeenth Century', *English Historical Review* 117 (2002), 813–39.

——. 'Knowledgeable Readers: Jamaican Critiques of Sloane's Botany', in Hunter, *Books to Bezoars*, 80–89.

Rogoziński, Jan. *A Brief History of the Caribbean: From the Arawak and Carib to the Present* (Plume, 1999).

Roos, Anna Marie. *Web of Nature: Martin Lister (1639–1712), the First Arachnologist* (Brill, 2011).

Rosenberg, Philippe. 'Thomas Tryon and the Seventeenth-Century Dimensions of Antislavery', *WMQ* 61 (2004), 609–42.

Rougetel, Hazel Le. *The Chelsea Gardener: Philip Miller, 1691–1771* (Natural History Museum, 1990).

Rouse, Irving. *The Tainos: Rise and Decline of the People Who Greeted Columbus* (Yale University Press, 1992).

Rucker, Walter. 'Conjure, Magic, and Power: The Influence of Afro-Atlantic Religious Practices on Slave Resistance and Rebellion', *Journal of Black Studies* 32 (2001), 84–103.

Rudoe, Judy. 'Engraved Gems: The Lost Art of Antiquity', in Sloan, *Enlightenment*, 132–9.

Rudwick, Martin. *Bursting the Limits of Time: The Reconstruction of Geohistory in the Age of Revolution* (University of Chicago Press, 2005).

Ruiz, Barbaro Martinez. 'Sketches of Memory: Visual Encounters with Africa in Jamaican Culture', in Barringer et al., *Art and Emancipation in Jamaica*, 103–20.

Rusnock, Andrea. *Vital Accounts: Quantifying Health and Population in Eighteenth-Century England and France* (Cambridge University Press, 2002).

Russell-Wood, A. J. R. *The Portuguese Empire, 1415–1808* (Johns Hopkins University Press, 1998).

Safier, Neil. *Measuring the New World: Enlightenment Science and South America* (University of Chicago Press, 2008).

——. 'Transformations de la Zone Torride: Les Répertoires de la Nature Tropicale à l'Époque des Lumières', *Annales* 66 (2011), 143–72.

Said, Edward. *Orientalism* (Pantheon, 1978).

Saliba, George. *Islamic Science and the Making of the European Renaissance* (MIT Press, 2007).

Sanderson, Margaret. *Ayrshire and the Reformation: People and Change, 1490–1600* (Tuckwell, 1997).

Sankey, Margaret. *Jacobite Prisoners of the 1715 Rebellion: Preventing and Punishing Insurrection in Early Hanoverian Britain* (Ashgate, 2005).

Santos-Guerra, Arnoldo, *et al.* 'Late 17th-Century Herbarium Collections from the Canary Islands: The Plants Collected by James Cuninghame in La Palma', *Taxon* 60 (2011), 1734–53.

Savage-Smith, Emilie. 'Amulets and Related Talismanic Objects', in Maddison and Savage-Smith, *Science, Tools and Magic*, 132–47.

Scarisbrick, Diana and Zucker, Benjamin. *Elihu Yale: Merchant, Collector and Patron* (Thames & Hudson, 2014).

Schaffer, Simon. 'Natural Philosophy and Public Spectacle in the Eighteenth Century', *History of Science* 21 (1983), 1–43.

——. 'Defoe's Natural Philosophy and the Worlds of Credit', in Christie and Shuttleworth, *Nature Transfigured*, 13–44.

——. 'The Glorious Revolution and Medicine in Britain and the Netherlands', *NRRS* 43 (1989), 167–90.

——. 'Regeneration: The Body of Natural Philosophers in Restoration England', in Lawrence and Shapin, *Science Incarnate*, 83–120.

——. ' "On Seeing Me Write": Inscription Devices in the South Seas', *Representations* 97 (2007), 90–122.

——. 'Newton on the Beach: The Information Order of *Principia Mathematica*', *History of Science* 47 (2009), 243–76.

—— *et al.* (eds.) *The Brokered World: Go-Betweens and Global Intelligence, 1770–1820* (Science History Publications, 2009).

Schiebinger, Londa. *Plants and Empire: Colonial Bioprospecting in the Atlantic World* (Harvard University Press, 2004).

——. 'Scientific Exchange in the Eighteenth-Century Atlantic World', in Bailyn and Denault, *Soundings in Atlantic History*, 294–328.

—— and Swan, Claudia (eds.) *Colonial Botany: Science, Commerce, and Politics in the Early Modern World* (University of Pennsylvania Press, 2005).

Schwartz, Marion. *A History of Dogs in the Early Americas* (Yale University Press, 1998).

Schwartz, Stuart (ed.) *Implicit Understandings: Observing, Reporting, and Reflecting on the Encounters between Europeans and Other Peoples in the Early Modern Era* (Cambridge University Press, 1994).

Scott, G. and Hewitt, M. 'Pioneers in Ethnopharmacology: The Dutch East India Company (VOC) at the Cape from 1650 to 1800', *Journal of Ethnopharmacology* 115 (2008), 339–60.

Scott, Monique. *Rethinking Evolution in the Museum: Envisioning African Origins* (Routledge, 2007).

Screech, Timon. *The Lens within the Heart: The Western Scientific Gaze and Popular Imagery in Later Edo Japan* (University of Hawai'i Press, 2002).

Seed, Patricia. *Ceremonies of Possession in Europe's Conquest of the New World, 1492–1640* (Cambridge University Press, 1995).

Senior, Matthew. 'Pierre Donis and Joseph-Guichard Duverney: Teaching Anatomy at the Jardin du Roi, 1673–1730', *Seventeenth-Century French Studies* 26 (2004), 153–69.

Seth, Suman. *Difference and Disease: Locality and Medicine in the Eighteenth-Century British Empire*, forthcoming.

Shackelford, Jole. 'Documenting the Factual and Artifactual: Ole Worm and Public Knowledge', *Endeavour* 23 (1999), 65–71.

Shank, J. B. *The Newton Wars and the Beginning of the French Enlightenment* (University of Chicago Press, 2008).

Shapin, Steven. *A Social History of Truth: Civility and Science in Seventeenth-Century England* (University of Chicago Press, 1994).

———. *The Scientific Revolution* (University of Chicago Press, 1996).

———. 'Trusting George Cheyne: Scientific Expertise, Common Sense, and Moral Authority in Early Eighteenth-Century Dietetic Medicine', *Bulletin of the History of Medicine* 77 (2003), 263–97.

———. 'The Sciences of Subjectivity', *Social Studies of Science* 42 (2012), 170–84.

——— and Schaffer, Simon. *Leviathan and the Air-Pump: Hobbes, Boyle, and the Experimental Life* (Princeton University Press, 1985).

Shapiro, Barbara. *A Culture of Fact: England, 1550–1720* (Cornell University Press, 2000).

Shaw, Jane. *Miracles in Enlightenment England* (Yale University Press, 2006).

Shaw, Wendy. *Possessors and Possessed: Museums, Archaeology, and the Visualization of History in the Late Ottoman Empire* (University of California Press, 2003).

Sheller, Mimi. *Consuming the Caribbean: From Arawaks to Zombies* (Routledge, 2003).

Shepard, Alexandra, and Withington, Phil (eds.) *Communities in Early Modern England* (Manchester University Press, 2000).

Shepherd, Verene. *Livestock, Sugar and Slavery: Contested Terrain in Colonial Jamaica* (Ian Randle, 2009).

Sheridan, Richard. *Doctors and Slaves: A Medical and Demographic History of Slavery in the British West Indies, 1680–1834* (Cambridge University Press, 1985).

——. 'The Doctor and the Buccaneer: Sir Hans Sloane's Case History of Sir Henry Morgan, Jamaica, 1688', *Journal of the History of Medicine and Allied Sciences* 41 (1986), 76–87.

Slaughter, Thomas. *The Natures of John and William Bartram* (Knopf, 1996).

Sloan, Kim (ed.) *Enlightenment: Discovering the World in the Eighteenth Century* (British Museum, 2003).

——. ' "Aimed at Universality and Belonging to the Nation": The Enlightenment and the British Museum', in Sloan, *Enlightenment*, 12–25.

—— (ed.) *A New World: England's First View of America* (British Museum, 2007).

——. 'Sloane's "Pictures and Drawings in Frames" and "Books of Miniature & Painting, Designs, &c.', in Hunter, *Books to Bezoars*, 168–89.

——. 'Sir Hans Sloane's Pictures: The Science of Connoisseurship or the Art of Collecting?', *Huntington Library Quarterly* 78 (2015), 381–415.

Sloan, Philip. 'John Locke, John Ray, and the Problem of the Natural System', *Journal of the History of Biology* 5 (1972), 1–53.

Smallwood, Stephanie. *Saltwater Slavery: A Middle Passage from Africa to American Diaspora* (Harvard University Press, 2009).

Smith, Justin. *Nature, Human Nature, and Human Difference: Race in Early Modern Philosophy* (Princeton University Press, 2015).

—— and Delbourgo, James. 'Introduction', in Smith and Delbourgo (eds.), 'In Kind: Species of Exchange in Early Modern Science', *Annals of Science* 70 (2013), 299–304.

Smith, Lisa. 'The Body Embarrassed? Rethinking the Leaky Male Body in Eighteenth-Century England and France', *Gender and History* 23 (2011), 26–46.

——. 'Sloane as Friend and Physician of the Family', in Hunter, *Books to Bezoars*, 48–56.

——. 'Sir Hans Sloane's "Earnest Desire to be Useful" ', unpublished paper.

Smith, Pamela, and Findlen, Paula (eds.) *Merchants and Marvels: Commerce, Science, and Art in Early Modern Europe* (Routledge, 2001).

Smith, Tracy-Ann and Hann, Katherine. 'Sloane, Slavery and Science: Perspectives from Public Programmes at the Natural History Museum', in Hunter, *Books to Bezoars*, 227–35.

Spadafora, David. *The Idea of Progress in Eighteenth-Century Britain* (Yale University Press, 1990).

Spary, Emma. *Utopia's Garden: French Natural History from Old Regime to Revolution* (University of Chicago Press, 2000).

——. 'Scientific Symmetries', *History of Science* 42 (2004), 1–46.

——. 'Self-Preservation: French Travels between *Cuisine* and *Industrie*', in Schaffer *et al.*, *Brokered World*, 355–86.

Spyer, Patricia (ed.) *Border Fetishisms: Material Objects in Unstable Spaces* (Routledge, 1998).

Stafford, Barbara Maria. *Artful Science: Enlightenment Entertainment and the Eclipse of Visual Education* (MIT Press, 1996).

Stagl, Justin. *A History of Curiosity: The Theory of Travel, 1550–1800* (Routledge, 1995).

Stearns, Raymond. *James Petiver: Promoter of Natural Science* (American Antiquarian Society, 1953).

———. *Science in the British Colonies of America* (University of Illinois Press, 1970).

Stephenson, Marcia. 'From Marvellous Antidote to the Poison of Idolatry: The Transatlantic Role of Andean Bezoar Stones in the Late Sixteenth and Seventeenth Centuries', *Hispanic American Historical Review* 90 (2010), 3–39.

Stern, Philip. *The Company State: Corporate Sovereignty and the Early Modern Foundation of the British Empire in India* (Oxford University Press, 2011).

——— and Wennerlind, Carl (eds.) *Mercantilism Reimagined: Political Economy in Early Modern Britain and its Empire* (Oxford University Press, 2013).

Stewart, Larry. 'The Edge of Utility: Slaves and Smallpox in the Early Eighteenth Century', *Medical History* 29 (1985), 54–70.

———. *The Rise of Public Science: Rhetoric, Technology, and Natural Philosophy in Newtonian Britain, 1660–1750* (Cambridge University Press, 1992).

Stroup, Alice. *A Company of Scientists: Botany, Patronage, and Community at the Seventeenth-Century Parisian Royal Academy of Sciences* (University of California Press, 1990).

Subrahmanyam, Sanjay. 'Frank Submissions: The Company and the Mughals between Sir Thomas Roe and Sir William Norris', in Bowen *et al.*, *Worlds of the East India Company*, 69–96.

———. *Mughals and Franks: Explorations in Connected History* (Oxford University Press, 2005).

———. 'Taking Stock of the Franks: South Asian Views of Europeans and Europe, 1500–1800', *Indian Economic Social History Review* 42 (2005), 69–100.

Swan, Claudia. '*Ad vivum, naer het leven*, from the Life: Considerations on a Mode of Representation', *Word and Image* 11 (1995), 353–72.

Swann, Marjorie. *Curiosities and Texts: The Culture of Collecting in Early Modern England* (University of Pennsylvania Press, 2001).

Sweet, James. *Domingos Álvares, African Healing, and the Intellectual History of the Atlantic World* (University of North Carolina Press, 2011).

Sweet, Jessie. 'Sir Hans Sloane: Life and Mineral Collection, Part III – Mineral Pharmaceutical Collection', *Natural History Magazine* 5 (1935), 145–64.

———. 'Sir Hans Sloane's Metalline Cubes', *NRRS* 10 (1953), 99–100.

Sweet, Julie. 'Bearing Feathers of the Eagle: Tomochichi's Trip to England', *Georgia Historical Quarterly* 86 (2002), 339–71.

Swiderski, Richard. *The False Formosan: George Psalmanazar and the Eighteenth-Century Experiment of Identity* (Edwin Mellen, 1991).

Synnott, David. 'Botany in Ireland', in Foster, *Nature in Ireland*, 157–83.

Tamen, Miguel. *Friends of Interpretable Objects* (Harvard University Press, 2004).

Tana, Li. *Nguyễn Cochinchina: Southern Vietnam in the Seventeenth and Eighteenth Centuries* (Cornell University Press, 1998).

Taussig, Michael. *My Cocaine Museum* (University of Chicago Press, 2004).

Terrall, Mary. 'Heroic Narratives of Quest and Discovery', *Configurations* 6 (1998), 223–42.

———. 'Following Insects Around: Tools and Techniques of Eighteenth-Century Natural History', *BJHS* 43 (2010), 573–88.

———. *Catching Nature in the Act: Réaumur and the Practice of Natural History in the Eighteenth Century* (University of Chicago Press, 2014).

Thackray, John. 'Mineral and Fossil Collections', in MacGregor, *Sloane*, 123–35.

Thomas, Jennifer. 'Compiling "God's Great Book [of] Universal Nature": The Royal Society's Collecting Strategies', *Journal of the History of Collections* 23 (2011), 1–13.

Thomas, Keith. *Religion and the Decline of Magic* (Weidenfeld & Nicolson, 1971).

———. *Man and the Natural World: Changing Attitudes in England, 1500–1800* (Penguin, 1983).

———. *The Ends of Life: Roads to Fulfilment in Early Modern England* (Oxford University Press, 2009).

Thomas, Nicholas. *Entangled Objects: Exchange, Material Culture, and Colonialism in the Pacific* (Harvard University Press, 1991).

Thrush, Coll. *Indigenous London: Native Travelers at the Heart of Empire* (Yale University Press, 2016).

Tillyard, Stella. 'Paths of Glory: Fame and the Public in Eighteenth-Century London', in Postle, *Joshua Reynolds*, 61–9.

Tobin, Beth. *Colonizing Nature: The Tropics in British Arts and Letters, 1760–1820* (University of Pennsylvania Press, 2005).

———. *The Duchess's Shells: Natural History Collecting in the Age of Cook's Voyages* (Yale University Press, 2014).

Todd, Angela. 'Your Humble Servant Shows Himself: Don Saltero and Public Coffeehouse Space', *Journal of International Women's Studies* 6 (2005), 119–35.

Tomlins, Christopher and Mann, Bruce (eds.) *The Many Legalities of Early America* (University of North Carolina Press, 2001).

Tortello, Rebecca and Greenland, Jonathan (eds.) *Xaymaca: Life in Spanish Jamaica, 1494–1655* (Institute of Jamaica, 2009).

Trentmann, Frank. *Empire of Things: How We Became a World of Consumers, from the Fifteenth Century to the Twenty-First* (Allen Lane, 2016).

Turner, Howard. *Science in Medieval Islam: An Illustrated Introduction* (University of Texas Press, 1996).

Tze-Ken, Danny Wong. 'The Destruction of the English East India Company Factory on Condore Island, 1702–1705', *Modern Asian Studies* 46 (2012), 1097–115.

van der Velde, Paul. 'The Interpreter Interpreted: Kaempfer's Japanese Collaborator Imamura Genemon Eisei', in Bodart-Bailey and Massarella, *The Furthest Goal*, 44–58.

Vaughan, Alden. *Transatlantic Encounters: American Indians in Britain, 1500–1776* (Cambridge University Press, 2006).

Waley-Cohen, Joanna. *The Sextants of Beijing: Global Currents in Chinese History* (Norton, 1999).

Walker, Alison. 'Sir Hans Sloane's Printed Books in the British Library: Their Identification and Associations', in Mandelbrote and Taylor, *Libraries within the Library*, 89–97.

———. 'Sir Hans Sloane and the Library of Dr Luke Rugeley', *The Library* 15 (2014), 383–409.

Wall, Cynthia. 'The English Auction: Narratives of Dismantlings', *Eighteenth-Century Studies* 31 (1997), 1–25.

———. *The Prose of Things: Transformations of Description in the Eighteenth Century* (University of Chicago Press, 2006).

Ward, Estelle. *Christopher Monck, Duke of Albemarle* (John Murray, 1915).

Warsh, Molly. 'Enslaved Pearl Divers in the Sixteenth Century Caribbean', *Slavery and Abolition* 31 (2010), 345–62.

Watts, David. *The West Indies: Patterns of Development, Culture and Environmental Change since 1492* (Cambridge University Press, 1990).

Way, Kathie. 'Invertebrate Collections', in MacGregor, *Sloane*, 93–111.

Wear, Andrew. *Knowledge and Practice in English Medicine* (Cambridge University Press, 2000).

Weaver, Karol. *Medical Revolutionaries: The Enslaved Healers of Eighteenth-Century Saint Domingue* (University of Illinois Press, 2006).

Weber, David. *The Spanish Frontier in North America* (Yale University Press, 1992).

Weber, Harold. *Paper Bullets: Print and Kingship under Charles II* (University Press of Kentucky, 1995).

Webster, Charles. *Paracelsus: Medicine, Magic and Mission at the End of Time* (Yale University Press, 2008).

Webster, Roderick and Marjorie. *Western Astrolabes* (Adler Planetarium, 1998).

Wennerlind, Carl. *Casualties of Credit: The English Financial Revolution, 1620–1720* (Harvard University Press, 2011).

Werrett, Simon. 'Healing the Nation's Wounds: Royal Ritual and Experimental Philosophy in Restoration England', *History of Science* 38 (2000), 377–99.

Whan, Robert. *The Presbyterians of Ulster, 1680–1730* (Boydell, 2013).

Wheeler, Roxann. *The Complexion of Race: Categories of Difference in Eighteenth-Century British Culture* (University of Pennsylvania Press, 2000).

White, Jerry. *London in the Eighteenth Century: A Great and Monstrous Thing* (Bodley Head, 2012).

White, Richard. *The Middle Ground: Indians, Empires, and Republics in the Great Lakes Region, 1650–1815* (Cambridge University Press, 1991).

Wild, Wayne. *Medicine-by-Post: The Changing Voice of Illness in Eighteenth-Century British Consultation Letters and Literature* (Rodopi, 2006).

Williams, Jonathan. 'Parliaments, Museums, Trustees, and the Provision of Public Benefit in the Eighteenth-Century British Atlantic World', *Huntington Library Quarterly* 76 (2013), 195–214.

Wilson, Christie. *Beyond Belief: Surviving the Revocation of the Edict of Nantes in France* (Lehigh University Press, 2011).

Wilson, David. *The British Museum: A History* (British Museum, 2002).

Wilson, Kathleen. *The Sense of the People: Politics, Culture, and Imperialism in England, 1715–1785* (Cambridge University Press, 1998).

———. *The Island Race: Englishness, Empire and Gender in the Eighteenth Century* (Routledge, 2003).

———. 'The Performance of Freedom: Maroons and the Colonial Order in Eighteenth-Century Jamaica and the Atlantic Sound', *WMQ* 66 (2009), 45–86.

Wilson, Samuel. *The Archaeology of the Caribbean* (Cambridge University Press, 2007).

Wingfield, Chris. 'Placing Britain in the British Museum: Encompassing the Other', in Aronsson *et al.*, *National Museums*, 123–37.

Winterbottom, Anna. *Hybrid Knowledge in the Early East India Company World* (Palgrave Macmillan, 2015).

Wintroub, Michael. 'Taking Stock at the End of the World: Rites of Distinction and Practices of Collecting in Early Modern Europe', *Studies in History and Philosophy of Science* 30 (1999), 395–424.

Withington, Philip. *Society in Early Modern England: The Vernacular Origins of Some Powerful Ideas* (Polity, 2010).

Wood, Marcus. *Blind Memory: Visual Representations of Slavery in England and America, 1780–1865* (Routledge, 2000).

Wood, Paul (ed.) *The Scottish Enlightenment: Essays in Reinterpretation* (University of Rochester Press, 2000).

Wootton, David. *The Invention of Science: A New History of the Scientific Revolution* (Allen Lane, 2015).

Wragge-Morley, Alexander. 'The Work of Verbal Picturing for John Ray and Some of his Contemporaries', *Intellectual History Review* 20 (2010), 165–79.

Wrigley, Tony. *Poverty, Progress, and Population* (Cambridge University Press, 2004).

Yale, Elizabeth. *Sociable Knowledge: Natural History and the Nation in Early Modern Britain* (University of Pennsylvania Press, 2016).

Yamamoto, Koji. 'Reformation and the Distrust of the Projector in the Hartlib Circle', *Historical Journal* 55 (2012), 175–97.

Yeo, Richard. 'Encyclopaedic Collectors: Hans Sloane and Ephraim Chambers', in Anderson *et al.*, *Enlightening the British*, 29–36.

———. *Encyclopaedic Visions: Scientific Dictionaries and Enlightenment Culture* (Cambridge University Press, 2010).

———. *Notebooks, English Virtuosi, and Early Modern Science* (University of Chicago Press, 2014).

Yeomans, Henry. *Alcohol and Moral Regulation: Public Attitudes, Spirited Measures, and Victorian Hangovers* (University of Chicago Press, 2014).

Young, Jason. *Rituals of Resistance: African Atlantic Religion in Kongo and the Lowcountry South in the Era of Slavery* (Louisiana State University Press, 2007).

Zahedieh, Nuala. *The Capital and the Colonies: London and the Atlantic Economy, 1660–1700* (Cambridge University Press, 2010).

## WEBSITES CONSULTED

(Note: websites accurately quoted at time of consultation but some no longer maintained)

Blakeway, Amy. 'The Library Catalogues of Sir Hans Sloane: Their Authors, Organization, and Functions', *Electronic British Library Journal* (2011), 1–49: http://www.bl.uk/eblj/2011articles/pdf/ebljarticle162011.pdf (accessed December 2016).

The Botanist. http://www.thebotanistonsloanesquare.com/index.php/photo-gallery/photo/180/ (accessed July 2009).

British History Online. http://www.british-history.ac.uk/vch/middx/vol12/pp 108-115 (accessed August 2016).

British Library. Elizabeth Blackwell, *Curious Herbal*: http://www.bl.uk/collection-items/a-curious-herbal-dandelion (accessed August 2016).

———. Annabel Gallop, 'Malay Manuscripts in the Sloane Collection', 2013: http://britishlibrary.typepad.co.uk/asian-and-african/2013/11/malay-manuscripts-in-the-sloane-collection.html (accessed August 2015).

———. Sloane MS 116 (prayer book): http://www.bl.uk/catalogues/illuminated manuscripts/ILLUMIN.ASP?Size=mid&IllID=6547 (accessed June 2014).

———. Sloane MS 1171 (Philosopher's Stone): http://www.bl.uk/catalogues/illuminatedmanuscripts/record.asp?MSID=1217&CollID=9&NStart=1171 (accessed May 2014).

———. Sloane Printed Books Catalogue: http://www.bl.uk/catalogues/sloane/ (accessed August 2014).

British Museum. Chocolate cups: http://www.britishmuseum.org/research/col lection_online/collection_object_details.aspx?objectId=42888&partId=1&se archText=sloane+chocolate&page=1 (accessed July 2016).

―――. Qing Vases: http://www.britishmuseum.org/research/collection_online/collection_object_details.aspx?objectId=262782&partId=1&people=98677&peoA=98677-35&sortBy=imageName&page=1 (accessed March 2014).

―――. Robert Storrie on Sámi Drum: http://www.britishmuseum.org/research/collection_online/collection_object_details.aspx?objectId=671371&partId=1&searchText=sami&images=true&page=1 (accessed August 2015).

―――. Sloane Astrolabe (English): http://www.britishmuseum.org/research/collection_online/collection_object_details.aspx?objectId=54863&partId=1&searchText=sloane+astrolabe&page=1 (English) (accessed August 2015).

―――. Sloane Astrolabe (Safavid): http://www.britishmuseum.org/research/collection_online/collection_object_details.aspx?objectId=245507&partId=1&searchText=sloane+astrolabe&images=true&page=1 (Persian) (accessed August 2015).

―――. 'Sloane's Treasures: Sloane's Artificial Rarities', 2012, presentations on 'Sloane's Chinese Glass, Prints and Paintings' by Jessica Harrison-Hall, Clarissa von Spee and Anne Farrer: http://backdoorbroadcasting.net/2012/05/sloanes-treasures-sloanes-artificial-rarities/ (accessed August 2015).

Brown, Vincent. 'Slave Revolt in Jamaica, 1760–1761: A Cartographic Narrative', 2012: http://revolt.axismaps.com (accessed December 2016).

Brown, Yu-Ying. 'Kaempfer's Album of Famous Sights of Seventeenth-Century Japan', *Electronic British Library Journal* (1989), 90–103: http://www.bl.uk/eblj/1989articles/pdf/article7.pdf (accessed November 2015).

The Cadogan Estate. http://www.cadogan.co.uk/pages/estate-development (accessed March 2014).

*Daily Telegraph.* http://www.telegraph.co.uk/culture/art/art-news/7877168/Campaign-to-keep-slave-painting-in-Britain.html (accessed June 2013).

Delbourgo, James. 'Slavery in the Cabinet of Curiosities: Hans Sloane's Atlantic World', 2007, British Museum: http://www.britishmuseum.org/pdf/delbourgo%20essay.pdf (accessed August 2015).

―――. 'Voyage to the Islands: Hans Sloane, Slavery, and Scientific Travel in the Caribbean', 2012: http://www.brown.edu/Facilities/John_Carter_Brown_Library/exhibitions/sloane/index.html (accessed December 2016).

Dubois, Laurent, *et al.* Musical Passage: http://www.musicalpassage.org/#explore, 2015 (accessed September 2016).

Franklin, Benjamin. Franklin to Sloane, 2 June 1725, Papers of Benjamin Franklin (Yale): http://www.franklinpapers.org/franklin/framedNames.jsp (accessed May 2013).

Hans Sloane (Chocolates). http://www.sirhanssloanelondon.co.uk/index.php?page=whyhans and http://www.quintessentiallyescape.com/Escape_UK/Def_Unique_Chocolate.htm (accessed July 2009).

The History of Parliament. http://www.historyofparliamentonline.org/volume/1690-1715/member/sloane-james-1655-1704 (accessed April 2014).

Lister, Martin. *Every Man's Companion: or, An Useful Pocket-Book*, 1663–6, ed. Anna Marie Roos, MS Lister 19, Bodleian Library, Oxford University: http://lister.history.ox.ac.uk (accessed December 2016).

London Art Reviews. David Franchi, 2013: http://londonartreviews.com/index.php/museums/113-first-portrait-of-slave-diallo-is-back-at-the-national-portrait-gallery-london (accessed December 2016).

National Archives. Currency converter: http://apps.nationalarchives.gov.uk/currency/defaulto.asp (accessed August 2014).

Natural History Museum. 'A Specialist's Guide to the Sloane Database': http://www.nhm.ac.uk/research-curation/scientific-resources/collections/botanical-collections/sloane-herbarium/about-database/index.html (accessed December 2016).

A Parcel of Ribbons: Eighteenth-Century Jamaica Viewed through Family Stories and Documents. http://aparcelofribbons.co.uk/2011/11/the-maroon-war-settlement-of-1739/ (accessed December 2014).

Pestcoe, Shlomo. 'Banjo Beginnings: The Afro-Creole "Strum-Strumps" of Jamaica, 1687–89': https://www.facebook.com/notes/banjo-roots-banjo-beginnings/banjo-beginnings-the-afro-creole-strum-strumps-of-jamaica-1687-89/596163280402853 (accessed February 2014).

Pope's Grotto Preservation Trust. http://www.popesgrotto.org.uk/pictures.html (accessed January 2014) (photo 7).

Rath, Richard. http://www.way.net/music/audio/Rich%20Rath%20-%20AfMusJamRough01.mp3 (accessed October 2014).

The Trans-Atlantic Slave Trade Database. http://www.slavevoyages.org/voyage/ (accessed August 2015).

# Index

abolitionism (anti-slavery), 71, 78–9
Académie des Sciences, Paris,
    29, 223
Academy of Sciences, Berlin, 311
Academy of Sciences, Göttingen, 312
Academy of Sciences, Madrid, 311
Academy of Sciences, St Petersburg,
    258, 306, 311, 312
Accademia del Cimento, Florence, 12
Act of Settlement (1701), 142–3
Act of Union (1707), 143, 200
acupuncture, 226
Addison, Joseph, 147, 234
Adelkrantz, Charlotta, 203
Aesculapius, 193, 197
aesthetics of the natural world, 125,
    158, 172, 197, 254, 276–7,
    296, 297, 302
aesthetics of non-European peoples
    (European views on), 277, 287
Africa (general), xx, xxii, 20, 77, 81,
    87, 165, 190, 197, 211, 257 (see
    also Africans in diaspora; East
    Africa; North Africa; slaves and
    slavery; West Africa)
Africans in diaspora:
    botanical knowledge of, 87–8,
        98–100, 118, 241, 254, 269
    doctors, 48–53, 85, 93–5, 99, 100,
        124, 134

hunters, 59, 92, 118, 119, 120,
    Plate 2
Jamaica, 71–86
markets (Caribbean), 81, 85, 91,
    92, 120, Plate 2
women, 49–51, 76–7, 84, 124, 127,
    167, 191, 203, 325
interactions with animals, 90–94,
    117, 118, 119, 120, 127–8,
    Plate 2
(see also Akan people; Caribbean
    islands; Coromantees; Ewe
    people; fugitive slaves; Jamaica;
    Maroons; slaves and slavery;
    West Africa)
Aglionby, William, 156
agriculture, 7–8, 22, 29, 40, 85, 87,
    88, 97, 143, 252–3
Akan people, 42, 84, 94, 230, 236,
    264, 265, Plate 18
Akbar (Mughal emperor), 213
al-Isráli, Ishák Ibn Sulaimán, 272
al-Juzi, Abd 'Ali ibn Muhammad
    Rafi', 272
al-Ma'mūn (Abbasid caliph), 11
Albemarle, second Duke of
    (Christopher Monck),
    32–9, 41, 42, 44, 54, 55,
    56–7, 58, 63, 70, 80,
    149, 177

Albemarle, Duchess of, 57, 132, 136, 148, 152, 317

alchemy, 11, 12, 13, 14, 29, 209, 278, 280, 283, 287

Aldersgate, 97, 161

Aldrovandi, Ulisse, 17, 24, 63, 264, 323

Alexander the Great, xx, 298, 301

Alexandria, xxxi, 11, 305

Algiers, 284

America, Central, 96, 257

America, North, xxi, 17, 41, 165, 230, 231, 239–46, 257 (*see also* Canada)

America, South, 21, 71, 88, 124, 257

American Museum of Natural History, 265

American Revolution, 314, 330–32

Americas (general), xxviii, 4, 15, 17, 21–3, 25, 32, 35, 41, 44–7, 57, 62–3, 68, 71, 73, 81, 83, 87–8, 96–7, 230–67 (232–3), 284, 310, 314, 324, 326, 330, 331, 341

Ames, Joseph, 252, 312

Amman, Johann, 238, 258, 284–5, 312

Amsterdam, 186, 203, 204, 292, 293, 296

amulets, 19, 89, 160, 184–5, 253, 327 (*see also* charms; magic; Sloane: collections: amulets, charms; superstition)

Anansi stories (African), 89, 128

anatomy, 9, 16, 18, 19, 53, 201, 219, 228, 239, 267, 272, 339 (*see also* dissections; Sloane: collections: anatomy)

ancients, knowledge of the, 23, 35, 163, 172, 177

angels, 31, 126

Anglo-Dutch Wars (1652–74), 22, 246–7

Anglo-Irish community, 4–8, 10, 19, 141–2, 162, 200

Angola, 57, 81, 84, 123, 191

animals: *see* Sloane: collections

animism, 128

Anne (Queen), 143, 151, 168, 173, 184, 200, 234

anti-clericalism, 271

Antigua, 91, 92, 101, 169, 203, 267, *Plates 2–3*

antiquarianism, xxv, 82, 160, 209, 260, 261, 264, 284 (*see also* Sloane: collections: antiquities)

Antwerp, 63

apothecaries, 9, 17, 36, 48, 97, 161, 172, 175, 176, 177–8, *179*, 180, 250, *Plate 10* (*see also* Chelsea Physic Garden)

Apothecaries Hall, 9

Appian Way, 321

Arbuthnot, John, 175

archaeology, 336

Aristotle, 11, 22, 44

Armenians, 216

arrivisme, xxxi, 147–8, 193, 210–11 (*210*), 313, 339

art collecting, 16, 28, 206, 313

artisans, 29, 208, 216, 250 (*see also* artists; craft traditions)

artists (scientific illustrators & engravers), 101–12 (*105–106*, *108–109*, *110–11*), *119*, *123*, *133*, 171, 203–204, 220–21, 276, *Plates 6–8, 13, 28–9* (*see also* craft traditions; visual knowledge)

Arundel, Earl of, 16

Ashburnham House, 306

Ashmole, Elias, 29, 280, 283

Ashmolean Museum, 29, 306–307

Asia (general), xxviii, 22, 23, 24, 46, 78, 157, 159, 201, 204, 211, 212, 213, 214–15, 229, 230, 236, 245, 277, 284, 285, 287–8, 296, 298, 324, 341 (*see also* Asia: Central, East, South)

Asia, Central, 220, 257, 282

Asia, East, xxi, 20, 205, 219–29, 245, 257, 273, 285 (*see also* China)

Asia, South, xxi, 20, 24, 82, 92, 146–7, 205, 211–19, 221, 245, 252, 257, 273, 284, 285, 286 (*see also* India and Indians)

Assiniboine people (Canada), 231

astrology, 12, 22, 52, 272, 278–80, 285

astronomy, 11–12, 13, 14–15, 223, 272

Atlantic Ocean, 35, 38, 42, 44, 60–61, 63, 68, 70, 88, 96, 113, 132–7, 187, 133, 134, 137, 156, 203, 230, 232–3, 239, 243, 245, 249, 250, 252, 264, 328 (*see also* slave trade; travel)

Atsina (Gros Ventre) people (Canada), 231

auctions, 164, 182, 186, 202, 206–208, 210, 210–11, 311, 313 (*see also* Sloane: collecting: via brokers)

Aughrim (Ireland), Battle of, 142

Aurangzeb (Mughal emperor), 213

Austen, Ralph, 7, 9

Australia, 247

Avicenna (Ibn Sīnā), 11, 23, 273

Avignon, 225

Ayrshire, 4, 5, 200

Ayurveda, 24, 218

Azores, 21, 64, 136

Aztec Empire, 96 (*see also* Mexico)

Babur (Mughal emperor), 213

Bacon, Francis, 25–9, 62, 246, 261, 323

Baconianism, 25, 28–9, 81, 102, 130, 182, 246, 261, 340 (*see* Sloane: biography: philosophy of science)

Bacon's Rebellion (1675–6), 230

Badminton, 157, 204

Bagford, John, 208

Baghdad, 11

Bahamas, 64, 241

Ballard, Thomas (Jamaica planter), 48–9, 56, 58, 62, 69, 129

Banister, John, 97, 98

Banjarmasin (Borneo), 223

Bank of England, xxii, 31, 142, 149, 304, 310, 312, 314, 333, 340

Banks, Joseph, xxiii, 338, 339

Baptiste (Caribbean musician), 80, 83

Barbados, 21, 30, 38–9, 41, 43, 54, 72, 81, 93, 95, 99, 130, 149, 202, 293

Barbary: *see* North Africa

Barbot, Jean, 267

Barcelona, 281

Bardon, Jonathan, 142

Barham, Henry, 63, 92, 94, 100, 122, 124, 169–70, 178, 180, 186, 191, 267, 269

Barham, Henry, Jr, 171

Baroque science, 25, 261, 282

Bartram, John, 169, 243–5, 329, *Plates* 22–3

Barwick, Peter, 34

Batavia (Jakarta), 24, 212, 219, 220, 223, 228

Battle of the Books, 163–4

Baxter, Richard, 72

Beastall, William, 92

Beaufort, Duchess of (Mary Somerset), 204, 209, 291

Beaufort House, 204, 291, 292

Beaumont, John, 278–9

Beckett, William, 185, 285

Bedford, Duke of, 151–2, 153, 173

Behn, Aphra, 72

Belfast, 142, 190

Belisario, Isaac Mendes, 90

Bell, Johann Adam Schall von, 223

Belzoni, Giovanni, 335

Benezet, Anthony, 78–9

Bengal, 216, 273

Bengal, Bay of, 212, 217

Benghazi, 284

Bentinck, William (Duke of Portland), 292
Bentley, Richard, 180
Berlin, 311
Bermudas, 34, 41
Bernáldez, Andrés, 40
Bernard, Edward, 277–8
Bernier, François, 73
Bible, Christian, 7, 22, 227, 323
Bickerstaff, Isaac, 290, 307
Bight of Benin, 42
Bight of Biafra, 42, 93
Bignon, Abbé Jean-Paul, 248, 278–81, 310
Bilby, Kenneth, 90
Birch, Thomas, 8, 10, 17, 18, 35, 152, 172, 177, 180, 188, 192, 270, 319, 342
Black Legend (Spain), 62–7, 72, 80, 85, 129, 224
Blackfriars, 9, 249
Blackwell, Elizabeth, 276
Blair, Patrick, 167, 181
Blake, William, 13
Blennerhasset, Thomas, 4
Bloomsbury, 151, 160, 173, 242, 259, 265, 292, 294, 295, 306, 325, 335
Bloomsbury Square, xxii, 150, 249, 317
Blue Mountains (Jamaica), 40, 59, 90
Bluett, Thomas, 251–3, 256
Board of Trade and Plantations, 15
Bobart, Jacob, 35, 292
Bodleian Library, 267, 306
Boerhaave, Hermann, 219
Bolingbroke, Viscount, 173
Bologna, 17, 24, 63, 73, 305
Bombay (Mumbai), 146, 212, 217, 218, 286, 240
Bonnie Prince Charlie, 173
Bonny (West Africa), 42
Bontius, Jacobus, 100
Bordeaux, 135

borderlands, American colonial, 231, 236, 241–2
Borges, Jorge Luis, xxvii–xxviii
Borneo, 201, 212, 219, 223, 297
Boston (Massachusetts), 249
botany, xxii, xxv, xxx, 7, 9–10, 15–16, 18, 23–4, 34–5, 96–116 (104–106, 108–109, 110, 111), 118, 154, 156–72, 178, 179, 190, 197, 207–208, 209, 218–21, 229, 238, 240–43, 254, 258, 263, 267, 271, 273, 286, Plates 1, 4–8, 13 (see also Africans in diaspora: botanical knowledge of; classification; Linnaeus, Carolus; natural history; plant acclimatization and transplantation; Ray, John; Sloane: collections; visual knowledge)
botany, East Asian, 220–21, 229
botany, South African, 207–208
botany, South Asian, 24, 207, 208, 218
Bourbon, Duke of, 211
Bourden, Colonel (Jamaica), 99, 101
boxes and chests, in relation to collections, xxvi, 97, 121, 132, 182, 205, 218–19, 240, 242, 243, 262, 263, 298, 299, 324, Plates 10, 31–2
Boyle, Mary, 10
Boyle, Michael, 161
Boyle, Murrough (Viscount Blessington), 161
Boyle, Robert, 10, 12, 14–15, 17, 18, 30, 73, 98, 180, 181, 184, 271, 278, 286
Boyle Lectures, 271
Boyne River (Ireland), Battle of the, 142
Brackenhoffer, Elias, 119
Bradley, Richard, 167, 276
Brazil, 21, 44, 81, 159

Breton, André, xxviii
Breyne, Johann Philipp, 204, 210
Brian, Elizabeth, 183–4, 282
Bridgetown (Barbados), 38
Bristol, 133, 175, 314
Britain, xix, xx–xxi, xxiii, xxviii, xxix, xxx, 4, 20, 43, 60, 70, 141–8, 151, 153, 159, 160, 164, 174, 176, 178, 179, 186, 196, 200–201, 208, 211, 226, 237, 239, 246, 253, 256–7, 275, 278, 287–8, 290, 301–302, 305, 307, 308, 310, 311–12, 315, 328, 331, 334, 335, 337–41 (*see also* British Empire)
British Empire, xxi, xxviii, xxix, 22, 25, 30, 44, *60–61*, 68–9, 72, 122–3, 137, 146–8, 162, 168, 178, 200–201, 211, 212–23, 230–57, 301, 328–9, 338–42 (*see also* Africans in diaspora; Britain; colonialism; Jamaica; slaves and slavery; trade)
British Library, xxii, xxiii, xxv, 235
British Museum, xxi, xxii, xxiii, xxv, xxvi, xxix, xxxi, 162, 230, 251, 269, 309, 313–16, 318, 320–42 (*321–2*), Plate 42
   tours, 320–30 (*322*), 332
British Museum Act (1753), 314–15, 329–31, 334
British Museum lottery, 316
British nationalism, xx–xxi, 301–302, 304, 341
Browne, Joseph, 169, 190
Browne, Patrick, 112
Browne, Samuel, 218, 224, 273
Browne, Thomas, 182, 272, 281
Buckingham, Duke of, 209, 279
Buckingham Palace, 316–17
Buddhism, xxiv, 226–7, 284, 286–7, 324, *Plate 16*

Buenos Aires, 237
Bulkley, Edward, 162, 224
Bundu (Senegal), 251, 255–6
Burlington, Earl of, 291
Burma (*see* Myanmar)
Burnet, Gilbert, 174
Burnet, John, 124, 236–8, 239
Burnet, Thomas, 312
Butterfield, Herbert, 12
Byde, Katharine, 293
Byrd, William, II, 77, 169, 239–41, 243, 245
Byzantium, 11

Cabala Club, 282
cacao, xxii, 22, 40, 59, 69, 87, 89, 90, 96–7, 102–103, *104–106*, 107, 114–16, 132, 157, 287 (*see also* chocolate)
Cadburys, xxii
Cadogan, Charles, xxi–xxii, 189, 288–9, 312, 319
Cairo, 12
Calabar, Old and New (West Africa), 42
Calcutta (Kolkata), 146, 223
Cambodia, 222
Cambridge, 15, 101, 191
Cambridge University, 54
Camden, William, 69
Camelli, George, 224
Campbell, Mary, 204
Campeche, 71, 135, 238
Campeche, Bay of, 115, 134, 238
Canada, 231, 234, 235, 245, 284 (*see also* America, North)
Canary Islands, 220, 221
Canasatego (Onondaga), 244
cannibalism, 62, 210, 225
Canterbury, Archbishop of, 177, 217, 315
Canton (Guangdong), 213, 221, 222

Cape Coast Castle (West Africa), 161
Cape of Good Hope, xx, 24, 46, 207,
    212, 220, 222, 299 (*see also*
    South Africa)
capitalism, xxviii, 7–8, 31, 43, 342
Capitoline Museum, 305
Caribbean islands, xxi, xxii, xxiv, 21,
    28, 30–31, 35, 38, 40–44, 47, 48,
    60–61, 63–4, 68, 70, 71, 81,
    87–95, 99, 107, 112, 116–17, 122,
    124, 130, 133, 135, 148, 149, 152,
    156–7, 162, 165, 169, 170, 172,
    178, 187–8, *188–9*, 190, 192, 198,
    204, 230, 231, 239, 246–7, 254,
    257, 267, 272, 280, 296, 299, 341
    (*see also* Africans in diaspora;
    Antigua; Barbados; British
    Empire; Caribbean Sea; Jamaica)
Caribbean Sea, 31, 32, 39, 60–61, 71,
    130
Carlisle, Bishop Nicolson of,
    296–7, 312
Carolina, 15, 63, 230, 231, 235,
    241–2
Caroline (Queen), 176, 292
Cartagena, 32, 69, 124, 236, 237, 238
Carte, Thomas, 315
Carthage, 284
Casa de Contratación (Seville), 23, 29
Casa de Índia (Lisbon), 23
catalogues and cataloguing: *see*
    Sloane: collections: catalogues
    and cataloguing
Cataluña, 46
Catawba people, 235
Catesby, Mark, 209, 240–44, 276, 310
Catherine the Great, 313
Catholicism and Catholics, 4, 5, 6,
    8–9, 17, 19, 20, 62–5, 71, 85,
    141–3, 167, 184, 212, 223–5,
    254, 278, 285, 291, 307, 313, 324
    (*see also* credulity; Protestantism
    and Protestants; superstition)

Cayman Islands, 134
Céspedes, Andrés García de, 23, 28
Ceylon (Sri Lanka), 132, 207, 208, 264
Chain of Being, 125–6, 318, 329, 338
Cham people, 222
Chambers, Ephraim, 271
Chandos, Duke of, 30, 190, 242, 263
charity and charitable institutions,
    13, 146, 159, 176, 192, 200, 205,
    252, 256, 291
Charles I, 5, 28, 65, 70, 306, 313
Charles II, xxi, 5, 9, 14, 29, 34, 41,
    150, 182, 184–5, 197, 198,
    280, 323 (*see also* Royal Touch)
Charles IX of France, 301
Charles the Bold, 325
Charleton, Walter, 182
charms, 254, 269, 327 (*see also*
    amulets; magic; Sloane: collections:
    amulets, charms; superstition)
Chaucer, Geoffrey, 273
Cheapside, 249
Chelsea, xix, xxi, 10, 16, 157, 173,
    178, 190, 204, 249, 250, 265,
    291–2, 304, 307, 312, 324, 329
Chelsea Manor, xxii, 173–4 (*174*),
    190, 204, 259, 278, 291, 297,
    300, 303, 312, 316 (*see also*
    Sloane: biography: as baronet)
Chelsea Physic Garden, xxii, 9, 152,
    178, 179 (*179*), 192, 238, 276
    (*see also* apothecaries)
chemistry, 9, 13–14, 16, 17, 46–7,
    180, 250
Cherokee people, 235
Chesapeake Bay, 231
Cheyne, George, 151, 174–5
Cheyne Walk, 173
Child, Francis, 151
Chile, 160, 248
Chilton, John, 115
China, xxiv, xxvii, 21, 25, 147, 162–
    3, 165–7, 176, 201, 205, 212–13,

217, 218, 219–24, 225, 228, 262, 264, 265, 275, 277, 282–3, 286, 287, 290, 297, 298, 299, 324, 325, 326, *Plates 11, 41* (*see also* Asia, East)

chinoiserie, 287

Chirac, Pierre, 16

Chiswick, 291

chocolate, 30, 43, 96–7, 114–16, 199–200, *199, 210, Plate 9* (*see also* cacao)

Christ's College (Cambridge), 191

Christ's Hospital, 159

Christie's, 206

Church of England, 143

Church of Ireland, 6, 142

Churchill, John, 301–302

Chusan (Zhoushan), 220, 221, 227

*Citizen Kane* (Orson Welles, 1941), xxix

Civil Wars, English, 5, 14, 180–81, 182

civility and civilization (versus barbarism), xxvii, 46, 72–3, 216, 219, 234, 245, 247–8, 266, 284, 327–8, 335, 342 (*see also* progress; race and racism; superstition)

Clanbrassil, Alice, 5–6

Clanbrassil, Earl of, 4–5, 10

Clanbrassil, Henry, 5–6

Clandeboye, Viscount, 4

Clark, William, 91, 92

Clarke, Samuel, 180

Clarkson, Thomas, 79

class and science, 19, 103, 110, 113, 143–4, 161, 165–6, 172, 177–8, 180, 183, 306 (*see also* gentlemanliness and science; Sloane: biography: scientific persona)

classification (scientific), xxii–xxiii, xxvi, xxvii–xxviii, 15–16, 24, 29, 72–3, 102, 112, 117–18, 125, 129, 157–9, 172, 229, 239–40, 260–61, 265–6, 269–70, 272, 333, 338 (*see also* Sloane: collections: catalogues and cataloguing)

Clerkenwell, 148–9, 279

climate, 39, 40, 44, 45, 47, 48, 56, 66, 68, 73, 85, 96, 118, 275

clothing (in collections), 191, 239, 299

Clusius, Carolus, 23, 264

Cochinchina (Vietnam), 220, 222–3

cochineal dye, 58, 122, 238

Cockpit County (Jamaica), 59, 90

coffee, 21, 43, 160, 252

coffee houses, 97, 147, 154, 161, 165, 167, 201, 219, 311

Colbatch, John, 151, 174

Colbert, Jean-Baptiste, 208

Cold War, xxviii

Coleraine, 162, 321

collecting (*see also* collectors, competition among; Sloane: collecting, collections)
directions and instructions for, 97, 100–101, 120–22, 131, 205–206
and gender: *see* gender, curiosity and collecting; women and collecting
and museums, historiography of, xxv–xxix
and religion, 24, 28–9 (*see also* Sloane: collecting: and religion)

collectors, competition among, 208–210, 220–21, 247

Collegio Romano, 17, 25, 223, 261

Collinson, Peter, 238, 242, 243–4, 300

colonialism, 4, 6–7, 8, 14–15, 21, 23, 62, 64, 117, 230–34 (*see also* British Empire; colonialism and science; Spanish Empire; trade)

colonialism and science, 23, 25, 28, 30–31, 35, 96–137, 157, 160, 161–2, 172, 177, 178, 207, 212–57, 261, 338–42

Columbian Exchange, 22, 40, 87–8, 96–7, 99–100, 230 (*see also* environmental transformation)

Columbus, Bartholomew, 63

Columbus, Christopher, 20, 22, 28, 40, 62–4, 68, 136, 156

commerce: *see* trade

comparison of specimens and objects, 66, 82, 158–9, 161–2, 172, 239–40, 265–6, 267, 269, 272, 275, 276, 294, 338 (*see also* Sloane: biography: scientific judgement and connoisseurship)

Confucianism, 220, 223

Congo, 42, 191, 265

connoisseurship (general), 58, 192, 206, 252, 272, 277, 282, 288, 296, 302, 313, 326 (*see also* Sloane: biography: scientific judgement and connoisseurship)

Connor, Bernard, 174

Constantinople (Istanbul), 11, 176, 274

contraband: *see* smuggling

conversion, religious, 223, 235, 253, 280, 286

Conyers, John, 274

Cook, Captain James, xxiii, 339

Copeland Isles (Ulster), 7

Copernicus, Nicolaus, 11–12, 19, 22

Cork, Earl of, 10

Coromandel Coast, 212, 213, 273

Coromantees (West Africa), 42

Corporations and Test Acts (1661 and 1673), 143

corpuscularianism: *see* mechanical philosophy

cosmopolitanism, 20, 147, 229–30, 234, 256, 290, 295, 312, 341

Cospi, Fernando, 24

Côte d'Ivoire, 42

Cotton, John, 306, 308, 311, 314–17, 323

cotton and cotton trees, 58, 69, 89, 90, 147, 178, 248, 324

Counter-Reformation, Catholic, 223

Court of Chancery, 153

Courten, William, 11, 30, 38–9, 101, 121, 149, 162, 184–5, 202, 206, 208, 209, 265, 286, 298, 308

Covel, John, 191

Cowper, William, 182

craft traditions, 24, 40, 64, 81–2, 163, 216, 271, 277, 282, 287, 342 (*see also* artisans; artists)

credulity, 32, 167, 182–3, 225, 282–3, 327 (*see also* magic; superstition)

Cree people, 231

Cromertie, Earl of, 3

Cromwell, Oliver, 5, 21, 28, 40–41, 62–63, 180, 289, 323

Crusades, 252

Cuba, 40, 69, 134, 238

Cudjoe (Maroon leader), 88, 90

Cumberland, Duke of, 236

Cuninghame, James, 220–23, 227, 239

curiosities, xxiv, xxvii, 10, 22–3, 26–7, 29, 31–2, 33, 66, 78, 80–86 (82–3), 130, 132, 153, 160, 161, 162–8, 182–3, 185, 189, 191, 193–4, 202–57 (210), 259, 264–6, 277, 278, 282, 284, 287, 289–302, 308, 313, 324–6, 340, 342, *Plates 11–12, 14, 16–18, 21–2, 26–7, 34–41* (*see also* curiosities, human; Sloane: collections)

curiosities, human, 76–9, 201, 248–9, 308, 324–5 (*see also* race and racism; skin colour; Sloane: collections: anatomy)

curiosity, xxvi, 10, 20, 28, 29–30, 70–71, 73, 76–86, 92, 115–16, 119, 120, 160, 161, 162–8, 183, 191, 201, 203, 205, 221, 228,

229, 248, 250, 252, 282, 288, 293–5, 311, 326, 333
curiosity cabinets, 116, 125, 205, 307, 326 (*see also* wonder-cabinets)
Cuvier, Georges, 270, 338
cyclops pig, 324–5
Cyprus, 284

d'Alembert, Jean, 271
da Orta, Garcia, 23
Dadichi, Carolus, 254
*Daily Mail*, xxv
Dale, Samuel, 205, 242
Dampier, William, 115, 160, 246, 247–9, 256, 257, 264, 272, 298, 323, *Plate 24*
Dandridge, Joseph, 208, 224, 295
Danzig, 204, 210
Daoists, 287
Darien, Isthmus of, 245 (*see also* Panama)
Darien Company, 143, 247
Darwin, Charles, xxiii
Dassier, Jacques Antoine, 196 (*196*)
Davies, John, 4
Davis Strait, 201
de Acosta, José, 115, 154
de Beer, Gavin, xxviii
de Bry, Theodor, 62
de Jaspas, Melchior, 254
de Jussieu, Antoine, 112, 269
de la Force, Duchesse, 292
de Las Casas, Bartolomé, 62, 64
de Mandeville, Bernard, 249
de Montfaucon, Bernard, 264
de Oviedo, Gonzalo Fernández, 23
de Rochefort, Charles, 156
Dee, John, 22, 280, *Plate 35*
Defoe, Daniel, 31, 79, 148, 208, 248, 305
deforestation, 4, 89, 116–17 (*see also* environmental transformation)

degeneracy (physical), 4–7, 53, 73, 85, 96–7, 118, 121, 126 (*see also* climate; race and racism)
Deidier, Antoine, 153
deism, 271
Dejima Island (Nagasaki), 226–7
del Techo, Nicolaus, 267
Democritus, 13
Derry, 142
Desaguliers, John Theophilus, 194
Descartes, René, 12, 130
Devereux Court, 154
Devil, the, 34, 52, 77, 93, 96, 255
Diallo, Ayuba Suleiman, 251–7, 283, 327, 329, *Plates 25–6*
Diana of Ephesus, 197
Diderot, Denis, 271, 285
Dieppe, 16
diet and food, 22, 43, 45–7, 53, 54, 69, 74–5, 84, 87–8, 91, 99, 114, 118, 126, 134, 146, 267, 268
Dillenius, John Jakob, 209
Dioscordes, 172, 177
diplomacy, xxviii, 156, 218, 222, 231, 234, 235–6, 244, 252–3, 289 (*see also* gift-giving)
disease, 22, 34, 40, 47, 48, 50–51, 53, 58, 64, 77, 85, 87, 100, 117, 134, 151, 153, 170, 175–6, 184, 230, 231, 236, 241, 245
dispute of the New World, 44
dissections, 19, 56, 73, 78, 120, 122, 131, 134, 194, 275, 281 (*see also* anatomy; Sloane: collections: anatomy)
diving and diving bells, 31–2, 33, 71, 118
Dominion of New England, 41
Don Saltero's Coffee House, 306
Doody, Samuel, 221
Down, County, 5–6, 200, 32
Drax family (Jamaica), 122
drinking and drunkenness, 38, 47–9, 53–6, 63, 85, 175

drugs, xxiv, xxv, 9, 20, 35, 120, 151, 160, 161, 169, 177, 178–9, 180, 182, 239–40, *Plate 10* (*see also* medicine; Sloane: biography: medical regulation programme)
Du Halde, Jean-Baptiste, 264
Du Tertre, Jean-Baptiste, 156
Dublin, 183
DuBois, Charles, 217, 221, 242
Duke of Monmouth's Rebellion (1685), 54, 184
duplicate specimens, 156, 267, 269–70, 300 (*see also* Sloane: biography: philosophy of science)
Dupuys, Claudius, 205, 307
Dürer, Albrecht, 277
Dutch colonialism, 21, 24, 31, 147, 207, 212, 213, 216, 222, 226–9, 328 (*see also* Dutch East India Company)
Dutch East India Company, 24, 81, 203, 207, 212, 226
Duverney, Joseph Guichard, 16

East Africa, 74, 212
East India Company (English), 146, 162, 190–91, 194, 212–24 (214–15), 242, 245, 257, 273, 286, 312
East Indies: *see* Asia
East Turkestan, 220
economy, global, 146–7, 163, 203, 287–8
Edict of Nantes, Revocation of (1685), 17
Edo (Tokyo), 226–8
Edward III, 323
Edwards, Arthur, 315
Edwards, Bryan, 67, 95
Edwards, George, 276
Egypt, xx, xxxi, 11, 25, 208, 261, 270, 277, 284, 285, 299, 323, 327, 330, 335, 339
Eisei: *see* Gen'emon, Imamura

El Dorado, 21
electricity, 13, 194, 352
Elizabeth (Queen), 22, 213, 252, 280
Elking, Henry, 169, 231, *Plate 17*
Elsmere, Sloane, 312
empiricism, 12, 13, 18, 19, 23, 28, 51, 131, 171–2, 180–81, 185, 261, 335
empirics, 19 (*see also* quacks and quackery)
Empson, James, 258, 267–70, 309, 312, 314, 317, 318, 320, 329, 332, 335
encyclopaedias, 271
encyclopaedism, xxi, xxvii–xxviii, 23, 24–5, 26–7, 29, 69, 82, 113–16, *155*, 171, 172, 267, 271–2, 336, 342 (*see also* universalism)
England: *see* Britain
England, empire: see British Empire
English Channel, 16, 17, 37, 135–7, 141
English Republic (1649–60), 14, 28, 180, 306
engravers: *see* artists
Enlightenment, xxvi, 114, 256, 282–3, 285–6, 306, 327, 331, 336
enthusiasm, religious, 180
environmental transformation, 87–8, 96–7, 99–100, 116–17, 126, 146, 244–5, 275, 342 (*see also* capitalism; Columbian Exchange; deforestation; extinction; providentialism)
Epicurus, 13
Equator, the, 45
Equiano, Olaudah, 42
Escorial (Spain), the, 156
Essex, 15, 149, 158, 239, 240
Ethiopia, 77
ethnography, xxiii 15, 71–86, 115–16, 220, 224–5, 227, 247–8, 257, 274, 286, *Plate 28* (*see also* Sloane: collections)

Eucharist, the, 185, 285
Evelyn, John, 30, 89, 149, 154, 247
Ewe people, 236
Exclusion Crisis (1679–81), 9, 141
exhibitions: *see* Sloane: collections:
  tours (pre-British Museum);
  British Museum, tours
exoticism, xxvii–xxviii, 125, 162–6,
  219, 225, 227, 229, 247, 277,
  286–7, 290, 307, 325
experiment(s), 11, 12–13, 25, 28, 58,
  165, 176, 180, 192, 194–5, 283
exploration: *see* travel
extinction, 126, 270, 275, 338 (*see
  also* environmental
  transformation)
Ezhava (Kerala, India), 24

Fairchild, Thomas, 242
fairies, 278–9
Faroe Islanders, 267–8
Faujas de Saint-Fond, Barthélemy,
  337–9
feathers, xx, 95, 235, 299
Ferrers, Lady, 153, 263
fetishism, 94, 95, 127, 278, 285
Ficino, Marsilio, 19
Fielding, Henry, 143
financial speculation, 31–4, 43, 69,
  142, 147–8, 167, 190, 315
Fingal's Cave (Staffa Island,
  Scotland), 338
Fleet Street, 18, 20, 184
Flood, biblical, 72, 275, 284, 302
Florence, 12
Florida, 70, 80, 231, 241
Folkes, Martin, 294
folklore, 113, 114, 160, 294, 328
Fontaney, Jan de, 224–5
food: *see* diet and food
Forman, Simon, 280, 283
Formosa (Taiwan), 224–5
Fort Moore (Carolina), 241

Fort St George, Madras (Chennai),
  146, 162, 213, 216, 218
Foucault, Michel, xxvii, 114
Foundling Hospital, 176, 312
France, xxiv, xxx, 9, 12, 14, 16, 17,
  20, 34, 68, 97, 134–6, 141, 142,
  147, 152, 153, 156, 159, 185, 199,
  231, 248, 250, 286, 299, 301,
  316, 328, 333, 339 (*see also*
  French colonialism; French
  Revolution)
Frankfurt-am-Main, 203
Franklin, Benjamin, 249–51, *Plate 21*
Franks, Augustus, xxv
fraud and fakes, 180, 224–5, 282–3,
  284, 307, *Plate 38*
French colonialism, 21, 24, 135, 231,
  234, 255, 328
French Revolution, 333, 337, 339
fugitive slaves, 59, 90, 94, 96, 127,
  187, 191 (*see also* Maroons; slave
  rebellions and resistance; slaves
  and slavery)
Fulham, 157
Fuller, John, 170, 186
Fuller, Rose, 186–7
Fuller, Stephen, 94
Funchal (Madeira), 38
furniture (and collecting), 163, 217

Galen, 11, 13, 16, 18, 19, 151, 172,
  273, 340 (*see also* humoralism)
Gambia, the, 57, 123
Galilei, Galileo, 11–12, 22
Garden of Eden, 7, 30, 68, 121,
  203, 297
gardens (botanical), 3, 7–8, 9–10, 16,
  23–4, 25, 35, 88, 99, 157, 159,
  170, 178, *179*, 204, 207, 218,
  238, 280, 299
Garrard, Cecilia and Nicholas, 293
Garth, Samuel, 175
Gassendi, Pierre, 12

Geber: *see* Jābir ibn Hayyān
Gen'emon, Imamura (Eisei), 228–9, *Plate 16*
gender, class and museum-going, 306, 318–20, 331–4, 336–7 (*see also* Sloane: collections: access to (pre-British Museum))
gender, curiosity and collecting, 29–30, 203–205, 306, 308 (*see also* women and collecting)
gentility, 20, 143–4, 147, 148, 173, 177, 193, 206, 247, 277
*Gentleman's Magazine*, 300
gentlemanliness and science, 19, 103, 110, 165, 172, 178, 240–41, 306 (*see also* class and science; Sloane: biography: scientific persona)
Geoffroy, Claude-Joseph, 284
geology, 270
George I, 143, 151, 172, 226
George II, 151, 229, 236, 243, 252, 304, 315, 323
Georgia (America), 178, 235, 236, 238, 252, 312, *Plate 20*
Germany, 226–7, 275, 324 (*see also* Hanover and Hanoverian Succession)
Gessner, Konrad, 113
Ghana, 42
Ghini, Luca, 100
Giant's Causeway, 162, 321, 328, 338, 341
Gideon, Samson, 316
Gifford, Andrew, 319
gift-giving, 17, 122, 141, 153, 156, 157, 162, 169, 170, 182, 190, 191–2, 203, 211, 216, 219, 222, 224, 227, 235–6, 243–4, 245, 246, 250, 252–3, 289, 293 (*see also* Sloane: collecting: via gifts)
Gilles, Pierre, 131
Glanville, Eleanor, 204

global scientific knowledge, xxi, xxiv, xxvi, 14–15, 82, 157, 160, 163, 196–7, 256–7, 264, 297, 328–9, 341, 342
Glorious Revolution (1688–9), xxi, xxx, 18, 134, 136–7, 141–3, 153, 184, 200, 305, 310
Gloucestershire, 297
go-betweens, 156, 216, 218, 226–30, 236–7, 273 (*see also* Sloane: collecting: via brokers)
Goa, 159
Godwyn, Morgan, 72, 74
Golconda, 213
gold, 21, 22, 32, 40, 62–4, 255
Gold Coast, 42, 57, 123
Gough, Henry, 221
Gould, William, 9, 16
Granfa Welcome (Maroon), 128
Gray, David (Maroon), 90
Gray, Lord, 292
Gray's Inn, 112, 274–5
Great Russell Street, xxv, 150, 317, 320, 321, 341
Greatrakes, Valentine, 184
Greece, xx, 11, 176, 336
Greenhouses, 10, 157, 192, 204, 238
Greenland, 201, 231
Greenwich, 234, 236
Gresham College, 161, 184 (*see also* Royal Society)
Grew, Nehemiah, 208, 271, 306
Grigg, Rachel, 203
Grigg, Thomas, 101
Groenevelt, Joannes, 174
Grub Street, 45
Guadeloupe, 39, 171
Gualtieri, Filippo, 208
Guandi (Bodhisattva), 287
Guernsey, 293
Guiana, 21
Guildhall, the, 316

Guinea, 37, 57, 74, 76, 77, 99, 123,
    124, 161, 165, 176, 190, 191,
    201, 230, 237, 261, 267, 278
    (see also West Africa)
Gujarat, 218
Gundelsheimer, Andreas von, 156
Gurney, John, 273–4, Plate 29
Guthrie, James, 88
Guy, Madam (Jamaica), 80

Habermas, Jürgen, 305
Haddu, Muhammad ibn, 280
Haiti, 20, 80 (see also Hispaniola;
    Saint Domingue)
Hakluyt, Richard, 25, 154, 264
Hales, Robert, 292
Halle, 207
Halley, Edmond, 32, 98, 160, 225
Hamilton, Sophia, 6
Hamilton family (Ulster), 4–8, 10, 36,
    142, 200, 310 (see also
    Clanbrassil, Earl of, and
    Clandeboye, Viscount)
Hamilton of Dunlop, John (Hans), 5
Hampton Court, 63
Handel, George Frideric, 296
Hankin, Ambrose, Mrs, 332
Hannes, Edward, 161
Hanover and Hanoverian succession,
    143, 173, 226–7
Harley, Edward, 209, 314, 315,
    317, 323
Harley, Robert, 147, 209, 314, 315,
    317, 323
Harlow, James, 157
Harris, George, 98
Harrison, Captain (Jamaica), 99, 157
Hartlib, Samuel, 29
Harvard College, 314
Harvey, William, 272
Haudenosaunee Confederacy, 234,
    236, 244
Hauksbee, Francis, 194–5

Havana, 134
Hayes, Edward, 44
Jābir ibn Hayyān (Geber), 11, 272, 283
healing: see Africans in diaspora;
    apothecaries; doctors medicine;
    Native Americans: healers;
    obeah; physicians; Sloane:
    biography: as physician, medical
    regulation programme
Hearne, Thomas, 275, 289, 308
Hearst, William Randolph, xxix
Heathcote, Gilbert, 149, 152, 186,
    217, 221, 224, 310, 312, 340
Heathcote, John, 312
heliocentrism, 11–12, 19
Helyar, John, 59
Hemmings, Richard, 62, 65
Henry VII, 63
Henry VIII, xix, 173, 174
herbaria, origins of, 100 (see also
    Sloane: collections: herbarium)
Herbert, Edward, 47, 53
Hermann, Anna, 207–208
Hermann, Paul, 159, 207–208
Hernández, Francisco, 114, 115, 116,
    154, 156, 182
Hickes, George, 181, 182
Hindus and Hinduism, 213, 218
Hinguithi (Yamacraw), 236
Hippocrates, 18, 44, 73, 96, 238
Hispaniola, 20, 21, 32, 40, 64, 69
Hoare, William, 253, 256
Hobbes, Thomas, 180
Hogarth, William, 148, 210 (210), 211
Holbein, Hans, 277
Holland: see Netherlands
Holland, Henry, xxi
Hollis, Thomas, 314
Holy Land, 284
Holy Roman Empire, 142
Homer, 323, 330
Hooke, Robert, 102, 121, 208, 272,
    275, 317

Hôpital de la Charité, 16
Horned Lady of Pall Mall, 201, 308, 324, 325
Horniman Museum, 265
hospitals, 16, 159, 161, 176, 192, 218
Houghton Hall, 313
House of Commons, 94, 314, 315 (see also Parliament)
House of Lords, 175, 177–8, 315 (see also Parliament)
House of Wisdom, Baghdad (Bayt al Hikma), 11
Houstoun, James, 148
Houstoun, William, 237–8
Howard, Edmund, 291–2
Hudson, Captain (Jamaica), 76
Hudson Strait, 234
Hudson's Bay, 299
Hudson's Bay Company, 169, 231, 245, 284, Plate 17
Hughes, Griffith, 293
Hugli River, 216
Huguenots, 17, 20, 153, 271
humoralism, 13, 18, 44, 45, 51, 54–6, 73, 96–7, 151, 281, 340 (see also climate; Galen; medicine; race and racism)
Hunt, Henry, 102, 110
hunting, 40, 59, 80, 84, 92, 118, 119, 120, 126, 127, 129, 283 (see also Africans in diaspora: hunters; Native Americans: hunters)
Huron people, 79, 284
Hutton, William, 334

Iberian Peninsula, 11, 23, 97
idolatry, 253, 255–6, 285, 336 (see also Sloane: collections: idols)
ignorance, 244, 273, 327–8 (see also civility and civilization; credulity; progress; superstition)
Imperato, Ferrante, 24

imperialism: see British Empire; colonialism; colonialism and science; Dutch colonialism; French colonialism; Portuguese Empire; Qing dynasty; slaves and slavery; Spanish Empire
indentured servants, 31, 41, 47, 48, 50–51, 186, 230–31
indexes and indexing: see Sloane: collections: indexes and indexing
India and Indians (South Asia), xx, xxiv, 21, 23, 24, 82, 146, 162, 165, 197, 212–19, 227, 257, 277, 284, 286, 328, Plate 28 (see also Asia, South)
Indian Ocean, 74, 220, 328
Indian science, 23
Indians: see India and Indians; Native Americans
Indonesia, 212, 217
Industrial Revolution, 146
inoculation, 175–6, 194
interloping, 216, 221, 222, 229, 257, 340 (see also Sloane: biography: private and public lives, intersection between)
Inuit people, 231, 234, 277, Plate 17
Ipecacuanha, 160, 169, 177, 180, 239–40 (see also drugs)
Iraq, 335
Ireland, xx, 4, 6–7, 10, 32, 62, 70, 73, 136, 141–3, 152–3, 157, 161–2, 165, 176, 200, 299, 304–305, 312, 314, 328, 341 (see also Ulster; Sloane: biography: Irishness)
Irish Rebellions (1641), 5, 34
Irish Sea, 7, 8, 10
Irish Society, the (17th century), 4, 6, 10 (see also Anglo-Irish community)
Iroquois Confederacy: see Haudenosaunee
Isabella (Queen of Castile), 23
Isfahan, 227

Islam and Muslims, 11, 74, 84, 213, 216, 218, 251–6, 272, 273, 280, 327
Islamic Caliphates, 11, 13, 23
Islamic science, 11, 23, 218, 272–3
Isted, Thomas, 186–7, 190
Italy, 11, 16, 17, 23, 65, 153, 223, 288, 321, 335

Jacobite Rebellion (1715), 143, 181
Jacobite Rebellion (1745), 143
Jacobites, 142, 143, 181, 315, 341
Jahangir (Mughal emperor), 216
Jamaica (general), xxii, xxiii, xxviii, xxx, 20, 30–31, 34–6, 37–134, 149, 154, 158, 160, 165, 168–72, 177, 178, 186–91 (188–9), 197, 198, 200, 237, 238, 240–41, 245, 250, 267, 269, 272
Jamaica:
    animals, 116–34
    Assembly, 41, 42, 44, 56, 80, 94
    botany, 96–116 (104–106, 108–109, 110, 111), Plates 4–8
    diet and food, 45–7, 53
    healing and medicine, 47–57
    physical geography, 40, 60–61, 68, 87–95, 96–7
    planters, xxiii, xxx, 35–6, 41, 49, 56, 57–60, 62, 65–7, 69, 76, 85, 87–8, 93, 99–100, 101, 122, 129, 149, 203, 231, 239–40
    slaves and slavery, 71–86 (82–3)
    Sloane's travels in, 57–67, 97–101
    Spanish Jamaica, 40, 52, 62–7, 85, 129
    trade, 68–71
    (see also Africans in diaspora; Maroons; planters; slaves and slavery; Sloane: biography: Jamaica, slaves and race; Taíno people)
Jambi, Sultan of, 212, 273
James I (and IV), 4, 25, 325

James II, 34, 41, 54, 134, 136, 141–2, 173, 216, 323
Jamestown (Virginia), 240
Jansenists, 281
Japan, xx, xxiv, 205, 213, 224–9, 258, 265, 273, 276, 284, 285, 286, 287, 324, Plates 15–16
Jardin des Plantes, 337 (see also Jardin du Roi)
Jardin du Roi, 16 (see also Jardin des Plantes)
Java, 24, 273
Jeoly (Mindanao), 248
Jerrold, W. Blanchard, 336
Jesuits, 17, 25, 115, 167, 220, 223–5, 229, 261, 264, 287–8
Johnson, Samuel, 225
Jones, Inigo, 291
Jonkonnu, 81, 90, 92
Juan Fernandez Island, 258
Jurin, James, 176, 195–6

Kaempfer, Engelbert, 212, 227–9, 241, 258, 273, 276, 284, 285, 324, Plates 15–16, 28
Kaempfer, Johann Hermann, 226–7
Kalm, Per, 188, 297–300
Kalmyk people, 285
Kangxi emperor, 220, 221, 223, 287, 317
Kanheri caves (India), 286
Kannon (Bodhisattva), 227, Plate 16
Kasi Viranna, 216
Keill, James, 174
Kelley, Edward, 280
Kensington, xxi, xxv
Kew Gardens, xxii
Khan, Qasim, 218
Kickius, Everhardus, 103, 104, 105, 107, 108, 110, 157, 204, 242, 276, Plates 7–8
Killyleagh, 5, 7, 8, 142, 157
Kilmore, Bishop of, 283

King, Gregory, 146

King, William, 164–8, 169, 183, 193, 205, 225, 229, 258

King Jeremy (Mosquito Indian), 70

King Philip's War (1675–6), 231

King's Arms (Ludgate Hill), 160

Kircher, Athanasius, 17, 25, 167, 223, 261, 275, 285

Kneller, Godfrey, xxii, 150

Knight, Gowin, 317–20, 324, 325, 329, 332, 333, 335

Knowles Plantation (Jamaica), 187 (*see also* Middleton Plantation; St Thomas in the Vale; Sixteen Mile Walk)

Kongo: *see* Congo

Kormantse (West Africa), 42

Koyré, Alexandre, 12

Krieg, David, 221

Kuna people (Panama), 248

La Palma (Canaries), 221

La Peyrère, Isaac, 275

La Rochelle, 135

Labat, Jean-Baptiste, 264

labels, scientific: *see* Sloane: collections: labels

Lambeth, 280

Langley, John, 149

language and science, xxvii, 15, 19, 29, 101–102, 112, 113–16, 154, 159, 168, 170, 178, 273 (*see also* languages; translation and translators)

languages (general), 25, 83, 183, 219, 225, 228, 254, 255, 258, 262, 286, 295 (*see also* language and science; translation and translators)

Lapland, 203, 265, 283 (*see also* Sámi people)

Latour, Bruno, xxviii

Layard, Austen Henry, 335

Leach, William, xxv

Leeds, Duke of, 150

Leheup, Peter, 316

Leiden, 25, 157, 159, 166, 192, 219, 220, 238

Leiden, University of, 24, 207

Leipzig, 16

Leméry, Nicolas, 14, 16, 17, 37, 250

Leming, Mr John and Mrs, 122, 203

Lenni Lenape people, 230

Leominster, Lord and Lady, 174

Levant, the, 23, 219, 227, 286

Levant Company, 176, 209

Lewis, Matthew 'Monk', 89

Lhwyd, Edward, 160

Li Shizhen, 264, 287

libraries, xxxi, 25, 156, 169, 205, 208, 262, 267, 329 (*see also* Sloane: collections: books, library, manuscripts)

Light, Alexander, 231, 234, 245

Ligon, Richard, 30, 81, 130

Liguanee (Jamaica), 55, 76, 99, 157

Lilly, William, 279–80

Lima, 237

Lincoln's Inn Fields, xxii, 176

Linnaeus, Carolus, xxii, xxiii, 106, 112, 172, 229, 261, 296, 300

Lister, Martin, 276

lists, xxvii–xxviii, 30, 69, 91, 97, 161, 165–6, 203, 205–207, 234, 240, 277–8, 295, 297, 298–9, 307 (*see also* Sloane: collections: lists)

livestock, 22, 76, 84, 87, 91, 100, 117, 119, 127, 129, 131

Locke, John, 15, 18, 73, 79, 149–50, 224–5, 262, 269–70, 274, 286, 305, 323

Lockyer, Charles, 190, 211, 212, 217, 226

London, xix, xxi, xxiii, xxix–xxx, 4, 6, 8, 10, 12, 14, 16, 18–20, 22, 30, 41, 57, 69, 76–7, 96, 97, 99, 102–104, 107, 112, 114, 116, 136–7, 141–54 (144–5), 157, 161,

162, 169, 171–9 (*174*, *179*), 187,
192, 200–201, 205, 208, 210–11
(*210*), 212, 218, 221, 224–5, 231,
234–7, 240, 243, 246–9, 251,
252, 255, 261, 280, 282, 291, 293,
295, 304, 306, 307, 311, 312, 316,
321, 326, 332, 333, 338, 341
Louis XIV, 9, 142, 208, 248
Louisiana, 231
Lowther, James, 312
Ludgate Hill, 160
Luxembourg Palace, 306
Luxor, 335
luxury consumption, 97, 146–7, 163,
169, *Plate 9* (*see also* trade)
Lynch, Thomas, 30, 42, 44, 117

Macao, 222
machines, 130, 194, 229, 271
Madagascar, 74, 191, 216
Madagascar, Queen of, 212, 290
Madeira, 37–8
madness, 93, 148, 160, 180, 204,
280–81
Madras (Chennai), 146, 213, 216–18,
224, 273 (*see also* Fort St George)
Madrid, 23, 156, 237, 311
magic, xxvi, xxxi, 12, 13, 14, 19, 22,
24, 25, 28, 31, 93–5, 114, 128, 148,
182–3, 184–5, 191, 193, 211–12,
253, 254, 269, 272, 278–85, 287–8,
326–7, 335, 340, 342, *Plates 29, 35,
40* (*see also* charms; Royal Touch;
Sloane: biography: philosophy of
science, view of natural world;
collections: amulets, charms;
superstition)
magic lanterns, 25, 234, 236
Magnol, Pierre, 16, 17
Makassarese people, 222
Malabar coast, 24, 218
Malacca (Malaysia), xx, 212, 219,
220, 273
Malay people, 222
Mallorca, 281
Malpighi, Marcello, 73, 78
manatee straps (slave whips), 127,
191, 266 (*see also* whipping,
torture and executions)
manatees, 79, 126–7, 191, 266, 307
Manchu people, 220
Mandinka people, 252
Mann, Horace, 313
Mansong, Jack (Jamaica), 94
manufacturing, 146, 147, 163, 213,
287–8, 338, 342
Maratha Empire, 213, 218
Maroon War, First (1731–9), 90
Maroon–British Treaty, Jamaica
(1739), 93, 187
Maroons (general), 88
Maroons (Jamaica), 41, 59, 80, 84, 88–
90, 92, 93, 128, 187, 191, 238–9,
246 (*see also* Africans in diaspora)
Marseilles, 131, 175
Martini, Nicolas, 190
Martinique, 39
Martyn, John, 167
Martyr, Peter, 65, 115, 116
Mary (Queen), 168 (*see also* William
and Mary)
Maryland, 158, 160, 252
Massachusetts, 230, 264, 314
Massie, Joseph, 146, 148
Master, Streynsham, 212, 216, 217
mathematics, 11, 13, 196 (*196*)
Maty, Matthew, 317, 333
Maya people, 96
Mead, Richard, 30, 150, 152, 173,
175, 242, 289, 291
mechanical philosophy, 12, 13, 14,
16, 18, 174, 278
Medici family, 325
medicine, 9, 11, 13–14, 16, 17–19, 23,
25, 35, 47–57, 85, 89, 94, 95, 99,
100, 101, 114–15, 116–17, 124,

126, 149–53, 160, 161, 165, 166,
170, 173–8, *179*, 180, 182, 184–5,
186, 192–4, 196 (*196*), 198, 209,
211–12, 218, 219, 226, 228, 244–5,
254, 262–3, 265, 266, 271, 272–3,
281, 283, 286, 296, 299, *Plate 29*
(*see also* Africans in diaspora:
doctors; drugs; Native Americans:
healers; physicians; Sloane:
biography: medical regulation
programme, as physician)
Mediterranean 23, 74, 252, 286
mercantilism, 21, 271
merchants, 24, 41, 43, 57, 147, 148,
175, 191, 192, 203, 213, 216,
221, 226, 231, 237, 267, 297
(*see also* trade)
Mercklin, Georg, 262
Merian, Dorothea, 203
Merian, Maria Sibylla, 203, 242,
296, 332, *Plate 13*
Merrett, Christopher, 208
Mesopotamia: *see* Iraq
Methuen, Paul, 312
Meure, Abraham, 153
Mexica people, 96
Mexico (New Spain), 15, 21, 58, 96,
134, 156, 205, 238, 283, 289, 324
Mexico City, 114
Miao albums (China), 220
microcosm/macrocosm, 13–14, 24–5,
26–7, 261, 297
microscopy, 121, 141, 161
Middle Passage, 42, 57, 88, 128, 176,
230 (*see also* Africans in
diaspora; Atlantic Ocean; slaves
and slavery; slave trade)
Middleton Plantation (Jamaica), 187
(*see also* Knowles Plantation; St
Thomas in the Vale; Sixteen Mile
Walk)
Millar, Robert, 191, 238–9
millenarianism, 28, 29

Miller, Phillip, 238
Mindanao (Philippines), 248
mines and mining, 4, 21, 29, 38, 63,
64, 147, 245, 283
Ming dynasty, 220, 223
miracles, 174, 183–5, 201, 282
miscellaneousness, 163–4, 172,
266, 300
Mississippi River, 235
modernity and moderns, xxvi, xxvii,
12, 163, 340, 342
Modyford, Thomas, 59
Molyneux, Thomas, 162, 275
Molyneux, William, 162
Monardes, Nicolás, 100
Monck, George, 34
Monmouth, Duke of, 54, 184, 283
Monmouth, Earl of, 4
monsters, 25, 68, 118, 125, 126, 265
Montagu, Duke of, 252, 317
Montagu, Elizabeth, 290–91
Montagu, Lady Mary Wortley, 176
Montagu House, xxv, 317, 318, 320,
321, 321–2, 323, 330, 335 (*see
also* British Museum)
Montpellier, 16–17, 19, 153, 250, 263
Montserrat, 39
Moore, Garrett, 103–105, 107, 110,
118, 125, 132, *Plates 6–7*
Moore, John, 208
Moorfields, 208
moral philosophy, 79
Moravian Church, 312
More, Thomas, 291
Morgan, Henry, 41, 42, 52–3, 59, 70,
130, 247
Morgan, Thomas, 273–4
Moritz, Karl Philipp, 326, 330–33
Morocco, 284
Morris, Lewis, 243
Mortimer, Cromwell, xix–xx, 258,
262, 300–302
Morton, Charles, 317, 319

Moseley, Benjamin, 99, 249
Mosquito Coast, 80
Mount Diablo (Jamaica), 59, 101, 128
Moyra (Ulster), 157
Mughal Empire, 213–18, 273, 290, 298
Munster, 152
Murray, Thomas, 246–7
Muséum d'Histoire Naturelle (Paris), 339
museums, genealogy of, xxxi, 305–307 (*see also* museums, public; collecting: and museums, historiography of)
museums, public, xxxi, 274, 302, 305–42 (*see also* gender, class and museum-going; public, the)
Musschenbroek, Pieter van, 141
Myanmar, 212
mysticism, 13, 25

Nair, Savithri Preetha, 273
Nanny (Maroon leader), 93
Nanny Town, 238
Naples, 24, 156, 173
Napoleonic Expedition to Syria and Egypt (1798), 339
Napoleonic Wars (1803–15), 333, 334
National Portrait Gallery (London), xxii, 246, 256
Native Americans, 21, 22, 32, 58, 62, 70–71, 80, 97, 117, 132, 203, 230–31, 234–6, 238, 239, 241, 243–5, 247–8, 265, 287, 324, *Plates* 19–20, 22, 27 (*see also* Atsina (Gros Ventre) people; Assiniboine people; Catawba people; Cherokee people; Cree people; Haudenosaunee confederacy; Huron people; Inuit people; Kuna people; Lenni Lenape people; Maya people;

Mexica people; Oneida people; Pamunkey people; Taíno people; Wampanoag people; Tuscarora people; Yamacraw people)
and collecting, 231–45
as guides, 241
healers, 52, 53, 100, 134
hunters, 40, 59, 80, 118
natural knowledge of, 98–9, 114, 118, 132, 241, 244–5 (*see also* Taíno people)
natural history, xxii–xxiii, xxiv–xxv, xxvi, 3, 11, 16, 17, 22–32, 65, 69, 71–86 (*82–3*), 96–134 (*104–106, 108–109, 110, 111, 119, 123*), 154, 156–72, 181, 194, 196, *196*, 203–12, 218–26, 229–30, 239–45, 250–51, 259, 263, 267, 269–70, 272, 282, 286, 288, 299, 300, 313, 314, 342 (*see also* Baconianism; botany; colonialism and science; encyclopaedism; ethnography; Linnaeus, Carolus; Ray, John; Sloane: biography, collections; stories and story-telling; universalism; visual knowledge)
natural history, emblematic, 33, 66, 130, 282
Natural History Museum (London), xxii, xxiii, xxv, xxviii, 99, 263
natural philosophy, xxii, 11–13, 98, 143, 160, 193, 194, 196 (*196*), 272
natural theology, 15, 158, 172, 180 (*see also* Protestantism and science; providentialism)
naturalism, art of, in scientific illustrations, 102–11
nature and artifice, interplay between in natural history, 66, 130, 282, 325, *Plates 37, 39*

Naudé, Gabriel, 181
Navigation Acts (17th century), 21–2
Nedham, Colonel (Jamaica), 71, 130
Negril (Jamaica), 134
neo-liberalism, xxviii
Neo-Platonism, 12, 19, 25
networks, correspondence, xxi, xxiii–
    xxiv, xxviii, xxix, 19–20, 24, 97,
    120, 159, 160, 161–2, 165–6,
    167–9, 170–71, 178, 186, 205–
    206, 212–57, 267 (see also
    Sloane: collecting: via networks
    of correspondents)
Nevis, 39, 41, 167
New England, 21, 32, 69, 176, 231,
    240, 245, 250, 265
New Holland (Australia), 247
New Jersey, 243
New Spain: see Mexico
New York, 64, 265
Newcastle, Duke of, 151, 239
Newdigate, Elizabeth, 152
Newdigate, Richard, 152–3
Newfoundland, 135, 274, 321
Newgate Jail, 176
Newman, Henry, 190, 259
Newton, Isaac, xxii, xxiii, 13, 14–15,
    180–81, 194–6, 243, 249, 338
Newtonianism, 13, 151, 180–81, 196
Netherlands, 32, 97, 141, 186, 228,
    288, 292, 301 (see also Dutch
    colonialism; Dutch East India
    Company)
Nguyễn people, 222
Nicholson, Francis, 235, 242, Plate 19
Nieuhof, Johannes, 81, 82
Nimrud, xxv, 335
Nineveh, xxv, 335
Nine Years' War (1688–97), 142
North Africa, 11, 74, 160, 252, 284
North Pole, 310
    Northumberland, Duke of, 312
Norway, 265

Nowel, Captain (Jamaica), 49–50
Nueva Granada (Colombia), 236
numismatics: see Sloane: collections:
    coins and medals

Oates, Titus, 8
Obeah, 84, 89, 93–5, 100, 124, 185,
    254, 278
O'Donnells, the (Ulster), 4
offerings, objects as, 270–71
Oglethorpe, James, 235, 252, 255, 312
Oldenburg, Henry, 30, 31, 73, 159
Oneida people, 244
O'Neills, the (Ulster), 4
Onondaga, 244
Onslow, Arthur, 314–15
Orange, principality of, 17, 19, 166
Orange, Bishop of, 17
Orange, University of, 17
Orientalism, 166–7, 210–11 (210),
    245, 262, 285–6, 336
Orkney Islands, 70, 160
Orrery, Earl of, 151
Orton, Anna, 152
Osborne, Thomas (Earl of Danby),
    112, 150, 151
Ottoman Empire, 11, 165, 176, 205,
    209, 252, 254, 257, 286, 335,
    Plate 28
Ouidah (Benin), 191, 236, Plate 12
Oxford, 9, 35, 157, 209, 210, 247,
    267, 284, 292, 295, 306, 314
Oxford University, 29, 225, 277, 311

Pacific Ocean, 248, 257, 339 (see also
    South Seas)
Padua, 25, 166
Paine, Tom, 332
Pall Mall, 201, 308, 324
Pamunkey people, 241
Panama, 41, 143, 237, 238, 247–8
Papenau (Native American), 265
Paracelsus, 13–14, 272

Paraguay, 267, 268

Paris, 14, 16, 17, 19, 20, 29, 112, 156, 186, 223, 269, 271, 278, 284, 306, 311, 337, 339

Paris, Peace of (1763), 328

Parker, John, 48

Parliament, xxi, 9, 21, 43, 94, 141–3, 175, 306, 311, 314–16, 331, 333, 337 (*see also* House of Commons; House of Lords)

Parthenon Marbles (Elgin), xxv, 335

Partridge, Jonathan, 293

patronage, 101, 174–5, 178, 209, 219, 235, 238–43, 301, 310

Paulet, Charles (Marquess of Winchester), 34, 141

Pearce, Zachary (Lord Bishop of Bangor), 303–304

pedigree of objects, 217, 289–90, 307, 325, 328 (*see also* provenance of objects)

Peking (Beijing), 223, 287

Pelham, Henry, 314

Pembroke, Lord, 209, 225

penis ring, 283

Pennsylvania, 169, 230, 243, 329

Penn, William, 230, 244

Pepys, Samuel, 149–50, 208, 247, 262, 276

Percivale, John, 152

Persia, 11, 212, 216, 218, 227, 251, 252, 254, 257, 272, 273, 283, 286, 297

Persian Gulf, 213

Peru, xx, 4, 31, 269, 310, 324 (*see also* Potosí)

Peruvian bark, 35, 49, 51, 71, 99, 177, 178, 238, 269 (*see also* drugs)

Peter the Great, 305–306, 312, 323

Petiver, James, 97, 98, 101, 120, 122, 131, 157, 161, 165, 166, 168, 203–208, 210, 218, 221, 222, 224, 308

Petty, William, 73, 176

pharmacopoeia and pharmacy: *see* drugs; Sloane: biography: medical regulation programme

Philadelphia, 244, 249

Philip II of Spain, 63

Philippines, 126, 224, 248

Phillips, John, 62

Phips, William, 32

physicians, 29, 34, 38, 50–53, 151, 173, 175–8, 180, 185, 193–4, 199–200, 226–9, 264, 267, 269, 300–301 (*see also* Africans in diaspora; apothecaries; doctors; medicine; Sloane: biography: as physician)

Pigafetta, Antonio, 264

Pilkington, Laetitia, 291

Pillars of Hercules, 23, 28

piracy and pirates, 21, 34, 39, 40, 41, 51, 71, 133, 134, 136, 242, 246–9, *Plate 24*

Pisa, 11, 100

Pitchy-Patchy: *see* Jonkonnu

Pitt, Thomas, 216, 217

Pitt Rivers Museum, 265

plant acclimatization and transplantation, 10, 39, 98, 99–100, 157, 194, 204, 242, 276, 280 (*see also* botany; Sloane: collections)

Plattes, Gabriel, 29

Plaxton, George, 169

Pliny the Elder, 23, 63, 69, 172, 177, 273, 304

Plot, Robert, 30, 272

Plukenet, Leonard, 168, 208–10, 221

Plumier, Charles, 156–7

Plymouth, 77, 135, 136

poisons, 47, 84, 93, 100, 176, 240, 255

Poland, 205

political arithmetic (statistics), 73, 176

polygenesis, 275
Pope, Alexander, 162, 186, 289, 291
Pope Gregory XIII, 301
Popish Plot (1679), 8–9, 150
porcelain, 147, 163, 287, 324, 325
Port Royal, 39, 45, 56, 57, 61, 69, 71, 118, 131, 160
Porter, Roy, xxvi
Portland, Duchess of, 313
Portobelo, 69, 237, 238
Portuguese Empire, 20–1, 23–4, 147, 207, 213, 286, 328
Potosí, 21, 237
Powhatan Confederacy, 231, 241
Powlett, Edmond, 315, 320, 323–30, 332, 335, 339
Powys, Caroline, 332
Presbyterians, 4
Prince, Magnus, 190–91
Prince George of Denmark, 152
Privy Council, 312
prodigies, 77, 85 (see also wonder, wonders and marvels)
progress, xxvi, xxvii, 25, 301, 327–8, 335–6, 340, 341
projecting and projects, 31, 63, 147, 310
Protestantism and Protestants, 4, 5, 6, 7, 8–9, 17, 18, 19, 20, 28–9, 38, 62–5, 141–3, 161, 167, 184, 185, 200, 223, 224, 256, 285 (see also Catholicism and Catholics; Protestantism and science; Ulster Protestants)
Protestantism and science, 7, 9, 12, 15, 28–9, 70, 117, 121, 125, 126, 130, 158, 161, 181, 185, 203, 261, 270, 277, 335 (see also environmental transformation; natural theology; providentialism)
provenance of objects, 101, 119, 122, 213, 218, 224, 236, 264–5,

289–90, 301, 325 (see also pedigree of objects)
providentialism, 7, 9, 12, 45, 46–7, 70–71, 85, 118, 121, 125, 126, 130, 160, 172, 181, 256, 270, 271, 275, 277, 303–304, 342 (see also environmental transformation; natural theology; Protestantism and science)
provision plantations, slaves', 88, 91, 93–4, 99, 241, Plates 4–5
Psalmanazar, George, 224–5, 279
Ptolemy, 11, 44
public, the, xxi, xxxi, 177, 206, 229, 271, 277, 300, 302, 304–305, 317, 319–20 (see also museums, public; public sphere)
public sphere, 147, 305
Pulo Condore (Côn Sơn Island), 212, 220, 222
Puritans and Puritanism, 7, 14, 28, 72, 180, 231

Qatar Museums Authority, 256
Qing dynasty, 220, 223
quacks and quackery, 19, 177, 183, 185, 193, 283, 287 (see also fraud and fakes; empirics; Sloane: biography: medical regulation programme)
quadrupeds: see Sloane: collections
Quakers, 101, 238, 243, 291
quarantine, 175, 193
Québec, 21, 135, 234, 328
Quélus, D., 97
Quiccheberg, Samuel, 24, 261
Qur'ān, xxiv, 253–5, 286, 323, 327 (see also Islam and Muslims)
race and racism, 42–3, 52, 71–8, 91, 92, 160, 191, 225, 237, 266, 286, 335–6 (see also Africans in diaspora; civility and civilization; degeneracy; ethnography; humoralism; skin colour)

Radisson, Pierre, 231, 272
Ralegh, Walter, 21, 247
Ranelagh Gardens, 332, 334
Ras Sem (nr Benghazi), 284
Rawdon, Arthur, 32, 34, 36, 142,
    157, 209
Ray, John, 15–16, 17, 19, 20, 34–5,
    92, 101–103, 112, 113, 117, 119,
    125, 149–50, 154, 157–9, 167,
    168, 172, 204, 205, 221, 239,
    240, 261, 275, 277, 298
Ray, Margaret, 205
Rāzī, Muhammad ibn Zakariyyā
    (Rhazes), 273
Red Sea, 213
Reform Act (1832), 337
Reformation, 4, 5, 28
relics, 24, 28, 270, 283, 289, 294,
    307, 324
religions of non-European peoples
    (European views on), 75, 76,
    252, 284, 285–6, 335
religious toleration, 9, 213, 256
Renaissance, xxvii, 11, 23, 24, 26–7,
    100, 113, 114, 261, 288,
    294, 309
Republic of Letters, xxiv, 159, 168,
    172, 186, 203, 237, 312
Restoration of Charles II (1660), xxi,
    xxix, 14, 34, 180–81, 200,
    206, 306
Revolt of the Three Feudatories
    (1673–81), 220
Ricci, Matteo, 223
Richardson, Jonathan, 277
Richardson, Richard, 3, 209, 308
Richmond, Duke of, 239
Riga, 190
Rijsbrack, Jan, 178
Rites Controversy (China), 223
Rivinus, Augustus, 16
Roanoke Island, 274
Robert, Nicolas, 265

Robinson, Tancred, 16, 17, 25, 35, 40
Rochefoucauld, François de la, 332
Roman Empire, 11, 23, 46, 275, 304
    (see also Rome and Romans,
    ancient)
Romanticism, 13
Rome (early modern), xx, 6, 17, 25,
    156, 207, 208, 305, 324
Rome and Romans (ancient), xx, 11,
    46, 122, 275, 324, 335–6 (see
    also Greece; Roman Empire)
Rose, Fulke, 55, 59, 69, 149, 186–8
Rosetta Stone, 335
Rosse, Viscount, 8
Royal Academy (London), 313
Royal African Company, 30, 41–3,
    97, 161, 190, 255–6, 263
Royal College of Physicians
    (Edinburgh), 311
Royal College of Physicians
    (London), xxiii, 34, 149, 174,
    175, 177, 178, 184, 185, 192,
    195, 219, 311
Royal Company of Mines, 63
Royal Exchange, 147
Royal Library, 308
Royal Navy, 31, 89, 338–9
Royal Society, xix, xxii, xxiii, xxvii,
    xxx, 8, 10, 12, 15, 29, 30–31, 41,
    73, 76–7, 89, 98, 102, 103, 149,
    152, 154, 159–62, 164, 168, 176,
    178, 180, 184, 192, 194–7, 208,
    217, 218, 219, 221, 223, 225,
    227, 229, 235, 237, 239, 240,
    243, 244, 245, 255, 258, 271,
    272, 282, 286, 287, 294, 300,
    306, 308, 311, 312, 317, 338,
    Plate 1 (see also Sloane:
    biography: Royal Society)
Philosophical Transactions, 70, 77,
    98, 107, 159, 160, 161, 164–7,
    176, 183, 194, 195, 211, 219,
    221, 224, 237, 247, 259, 274,

278, 282, 284, 286 (*see also* Sloane: biography: *Philosophical Transactions*)

Repository, 29, 102, 161, 245, 282, 306–307, 308

Royal Touch, 184–5, 197, 254, 285

Rugeley, Luke, 199, 274

Russia, 190, 257, 275, 305–306, 312

Ruysch, Fredrik, 267

Sadler, Mrs (Jamaica), 127

Safavid Empire: *see* Persia

St Ann's (Jamaica), 59, 98, 103

St Bartholomew's Hospital, 161

Saint Domingue, 21, 80

St James's Park, 34–5

St Lucia, 39

Saint-Médard Convulsionnaires, 281

St Paul's (London), 208, 236

St Petersburg, 258, 284–5, 306, 311, 312

St Thomas in the Vale (Jamaica), 58, 59, 69 (*see also* Knowles Plantation; Middleton Plantation; Sixteen Mile Walk)

Sale, George, 254

Salter, James, 290, 307

Sámi people, 283, 327, *Plate 40*

Sanders, Nicholas, 199

Santa Margarita, 97, 118

Santa Martha, 69

satire, 45, 163–8, 193–4, 225, 307

Savage, John, 107

Savannah Town, 241

Scandinavia, 283, *Plate 40*

Scheuchzer, Johann Gaspar, 160, 227, 258, 273

Scheuchzer, Johann Jakob, 227

Schiebinger, Londa, xxviii

Schürmann, Anna Maria von, 323

science, historiography of, xxii–xxiii, xxvi–xxviii

scientific authorship, 103, 110, 203–204, 219, 240–43, 247

scientific revolution narrative, xxvi, 12–13, 171–2, 340 (*see also* modernity and moderns)

Scilly Isles, 135

Scotland and Scots, 3–5, 6, 31, 70, 99, 143, 148, 160, 165, 167, 191, 192, 200, 219–21, 236, 238, 248, 301, 312, 341

Seba, Albertus, 186, 312

secret knowledge, tradition of, 22, 158, 199, 212, 269, 294

secularism, 12

Selkirk, Alexander, 248

sensory knowledge, 57, 113, 114, 181, 295–6, 320

Seven Years' War (1756–63), xxi, 286, 328

Sevilla la Nueva (New Seville, Jamaica), 59–60, 62, 64, 65, 122, 129

Seville, 23

sex and sexuality, 49–50, 75–6, 81, 84

Shadwell, Thomas, 165

Shaftesbury, Earl of, 163–4, 277

Shah Solṭān-Ḥosayn, 272

Shakespeare, William, 68, 323

Shaw, Thomas, 160, 284

Sherard, William, 157, 176, 204, 207–208, 209–210, 240, 242, 278, 289

Shickellamy (Oneida), 244

shoes, xxiv, 127, 203, 226, 265, 299, *Plate 34*

Siam (Thailand), 222, 285

Sicily, 275

Sikhs, 213

silks and spices, Asian, 21, 147, 207, 213

silver, 4, 21, 31–2, 33, 63, 130, 147, 163

Sinai, 284

*Sir Hans Sloane's Milk Chocolate*, 199–200 (*199*)

Sixteen Mile Walk (Jamaica), 54, 101, 132, 149, 186, 187 (*see also* Knowles Plantation; Middleton Plantation; St Thomas in the Vale)

skin colour, 45, 73–8, 160, 191, 225, 239 (*see also* degeneracy; race and racism)

Slaney, Edward, 246

slave codes (Caribbean), 42–3, 74, 91

slave rebellions and resistance, 34, 42, 47, 51, 78–80, 83, 84, 94–5, 128, 137, 191 (*see also* fugitive slaves; Maroons)

slave trade, Atlantic, 20, 21, 22, 41–4, 57, 68–9, 87, 91, 99–100, 117, 128, 146, 147, 161, 176, 187, 190, 191, 230, 236–7, 251–2, 255–7, *Plate 18* (*see also* Africans in diaspora; Atlantic Ocean; slaves and slavery)

slaves and slavery, African, in the Americas (esp. Caribbean and Jamaican), xxi, xxiii, 20, 21, 30, 35–6, 37, 38, 39, 40, 41–4, 45, 46, 49–53, 57–9, 63, 65, 67, 71–86 (*82–3*), 87–95, 97–99, 117, 118, 122, 123 (*123*), 124, 127–8, 130, 132, 134, 146, 149, 160, 170–71, 172, 176, 186–92 (*188–9*), 203, 210, 219, 230, 231, 235, 236–8, 241, 245, 251–2, 256, 269, 341, 342, *Plates 2–5* (*see also* Africans in diaspora; Akan people; Coromantees; Ewe people; Jamaica; race and racism; slave codes; slave rebellions and resistance; slave trade; Sloane: biography: and Jamaica, slaves and race; wealth and fortune; collecting: via slaves)

slaves (Pacific Islands), 248

slaves (South Asia), 216, 218

slaves as collectors, 97–8, 101, 122, 203

Sloane, Alexander (father), 5

Sloane, Hans

**biography:**

as baronet, 173–4, *199*, 200

Britishness of, 6, 200, 304–305, 341

*Catalogus plantarum* (1696), 154, 158, 168, 267

criticisms of, 153–4, 164–71, 193–7, 204, 209–10, 282–92, 313, 339

education, training and formation, 7–8, 9–11, 13–20

fame, 159, 174, 194, 199–201, 229–30, 243–4, 274, 289–90, 293–4, 309

ill health, 8, 18, 19–20, 35, 177, 308–309

as information broker, xxx, 159–63, 224–30, 258–70

Irishness, 3–8, 10, 18, 19, 141–2, 161, 200, 304–305, 309

and Jamaica, slaves and race, 37–137, 186–91 (*188–9*), 192, *198*

marriage to Elizabeth Langley Rose, 59, 80, 149, 150, 186–90 (*188–9*), 203, 262

medical regulation programme, 176–8, 180, 182–3

and memory, xxi–xxviii, 323, 336

*Natural History of Jamaica* (1707–25), xxx, 3, 19, 28, 31–2, 37, 53, 54, 58, 63, 80, 81, 89, 95, 96–116 (*104–106, 108–109, 110, 111*), 119, 123, 133, 154, 156–9, 168–72, 191, 206, 209, 231, 241, 243, 254–5, 258–9, 262, 267, 268, 270–71, 274, 289–90, 296, 317

non-partisanship, 167, 181

personal attributes, 18, 150, 159–60, 195, 200, 261, 279, 281, 291–2, 295

**biography** – *cont.*

and *Philosophical Transactions*, 159–60, 164, 194, 195, 278

philosophy of science, 181, 261, 269–70, 275, 278, 282, 287–8

as physician, xxiii, xxix, 17–19, 35, 37, 38, 44, 47–57 (in Jamaica), 58–9, 85, 103, 114–15, 116–17, 132, 149–53, 164, 166, 168, 169–70, 173–8, 180, 181–5, 193–4, 197–200 (*199*), 236, 261, 278, 281, 303, 310

portraits, *196*, 197, 277, *Plate 1*

private and public lives, intersection between, 154, 159, 161, 162, 174, 197, 199–200, 212, 308, 309–10, 312, 338–40

relations with foreign naturalists, 16–18, 112, 156–7, 225–30, 250, 311–12

religious views, 7, 9, 17, 158, 181, 271, 310

reputation for judgement, discretion and impartiality, 152–3, 155, 167, 175, 181, 185, 200, 201, 229, 245, 278

and Royal Society, 159–68, 178, 194–6, *196*, 197, 225, 229–30, 306–307, 312

scientific judgement and connoisseurship, 9–10, 57–8, 240, 243, 245, 288, 293–4

scientific persona, 103, 110, 116, 164–72, 197–201, 278, 281, *Plate 1*

view of natural world, 126, 163, 278, 342

wealth and fortune, 35–6, 59, 80, 151–2, 159, 173–4, 185–90 (*188–9*), 192–4, 199, 200, 203, 211, 289–92, 295, 296, 298

will, 308–20, 330–31

**collecting:**

via brokers, 204–10, 226–30, 241–3

collections of others, 202–11, 241–3, 256, 308, 310

via exchange, 83, 84–5, 99, 169, 202–206, 217, 219, 228–9, 231, 234, 239–40, 243–4, 246–57, 262–3

via gifts, 182–3, 234–6, 243–4, 245, 246, 262–3, 325

via markets, 91–2, 118, 132, 218

via medical patients, 153, 263, 182–3

via networks of correspondents, 202–11 (Europe), 211–19 (South Asia), 219–29 (East Asia), 245–6 & 257 (Asia: general), 230–51 & 257 (Americas)

via piracy, 246–9

via purchase, 85, 97–8, 118, 184–5, 204, 206–209, 211, 219, 226–7, 243, 244, 245, 246, 247, 249–50, 277

and religion, 266, 270, 271, 297, 302, 303–304, 310

via slaves, 97–8, 101, 122, 203

via smuggling, 228–9

via wills, 202–206

**collections** (*see also* British Museum; curiosities):

access to (pre-British Museum), 209–210, 275–8, 292–302, 304, 311, 319–20

amulets, xxiv, 218, 251, 254–5, 283, 324, *Plate 26*

anatomy (animal and human), 67, 73, 76, 77–8, 120, 125, 131, 134, 182–3, 191, 194, 211, 237, 260, 266, 272, 282, 284, 297, 299

animal specimens, xx, xxiv, xxv, xxvi, 3, 15, 29, 66, 91–2, 95, 116–37 (*119, 123, 133*), 162, 169, 191, 205–6, 207, 211–13, 219, 221, 223, 226, 227, 235–7, 239, 242,

247, 260, 261, 263, 266, 274–5, 289–90, 297, 299–300, 324, 336

animal specimens (live), 132–3 (*133*), 136–7, 194, 201, 217, 235–6, 242, 245–6, 276, 297

antiquities, xx, 16, 29–30, 65, 202, 208, 266, 272, 274–5, 299, 324, *Plate 36*

arrangement and display of, 265–6, 318, 338–9

astrolabes, xxv, 272

bezoars, xix, xxx, 118–19, 162, 182, 195, 211–12, 286, 297, 324, 327

birds, 3, 15, 22, 37, 95, 125, 126, 128, 132, 207, 218, 260, 295

books (printed), xx, xxiii, xxiv, 29, 154, 156, 158, 258, 261–2, 267, 273, 275

catalogues and cataloguing, xxiii, xxvii, xxix–xxx, 15, 22, 23, 46, 78, 95, 103, 116–30, 136, 157, 159, 161, 169, 172, 182, 190, 191, 203, 207–11, 212, 218, 224, 226, 230, 236, 241, 248, 254, 258–70, 272, 274, 277, 278, 282–90, 294, 295, 304, 307, 313, 317, 329, 340, *Plate 30*

charms, xxxi, 183, 185, 253–5, 283, 324, *Plate 26*

coins and medals, xx, xxv, 29, 31, 33, 130, 184, 202, 208, 209, 211, 255, 260, 272, 283, 295, 296, 301–302, 323

corals, xiv, xx, xxiv, 32, 33, 121, 132, 165, 260, 265, 266, 276, 295, 298, 299, 324

cost of, xxvi, 202–207, 211, 219, 226–7, 261–2, 264, 280, 288–92, 295, 296, 298, 299, 304, 311

curators, xxv, xxvi, xxx, 258–9, 267, 268, 277, 300–302, 309, 318

eggs, 3, 7, 260, 296, 299

fame of, 292–302, 304, 308, 340, 342

fish, 117, 118, 120, 125, 126, 132, 260, 276, 295, 321, 328

fossils, xx, 25, 29, 160, 260, 274–5, 278, 282, 284, 288, 324

gems, xix–xx, 32, 217, 277

herbarium, xx, xxii, xxiii, xxiv, xxv, 99–116 (*104–105, 108–109, 110*), 157, 158, 197, 198, 210, 218, 244–5, 260, 296, 299, 325, *Plates 4–8*

idols, 213, 218, 226, 227, 284, 287, 291, 298, 324, *Plate 16*

indexes and indexing, 158, 163, 259, 262, 264

insects, xx, 15, 67, 70–71, 89–90, 97–8, 116–17, 121–5, 129, 130, 132, 204, 206, 208, 243, 258, 260, 265, 293, 295, 296, 299, 324, *Plate 33*

labels, 100, 101, 102–103, *104–106, 108–111,* 113, 206, 218, 259, 262, 263, 264, 265–6, 330, *Plates 4–5, 7, 31–3*

library, xx, xxiii, 29, 75, 114–16, 154, *155,* 156, 172, 207, 209, 258, 260, 262, 264, 267, 272–4, 276, 280, 298, 299, 301, 317

lists and listing, 69, 78, 89, 91, 95, 118–20, 122, 129, 154, 182, 207, 224, 254, 259–60, 262, 263, 265–6, 278, 282, 284, 301, 312, *Plates 30–31*

manuscripts, xx, xxiii, xxiv, xxv, 29, 114, 154, 156, 182, 197, 209, 226, 258, 267, 272–3, 275, 277–80, 283, 285–6, 296, 323

maps, 60–61, 63, 68–9, 160, 171, 226, 228, 235, 273, 284, 325, *Plate 19*

collections – *cont.*

minerals, xx, 13, 29, 121, 205, 218, 239–40, 245, 260, 277, 278, 286, 288, 324

music and musical instruments, 80–85 (*82–3*), 92, 103, 132, 191, 230, 235, 265, 266, 277, 283, 299, 324, *Plate 18*

organization of, 206, 258–70, 274

picture albums: *see* visual knowledge

plant specimens, xx, xxiii, xxvi, 10–11, 15, 19, 24, 29, 30, 34–5, 59, 92, 96–116 (*104–106, 108–109, 110, 111*), 129, 154, 156, 158–9, 160, 161, 168, 182, *198*, 202, 204, 205–206, 208, 213, 218, 220–21, 222, 223, 237, 238, 240, 242, 243, 247, 258, 261, 262–3, 265, 267, 269, 297, 324, *Plates 4–5, 7–8*

reptiles, 39, 45, 53, 92, 118, *119*, 120, 132, 136, 293

shells, xx, xxv, 121, 132, 218, 219, 237, 247, 260, 276, 295, *Plate 37*

significance and purpose of, 261, 266, 269–70, 270–92

snakes, xxv, 15, 45, 118, 120, 132, *133*, 136, 186, 211–12, 260, 265, 300

stones (general), 162, 260, 269, 277, 283, 284, 288, 295, 296, 297–8, 301, 328

storage, 299, 336, *Plates 31–3*

tours (pre-British Museum), xix–xx, 154, 156, 202, 258, 288, 292–302, 306–307, 320

use of (during lifetime), 271–8, 285–6

vegetable substances, 263–4, 272, 299, 324, *Plates 31–2*

Sloane, James (brother), 5

Sloane, Lady, Elizabeth Langley Rose, 149, 150, 185–90, 195, 203, 262, 303

Sloane, Sarah (mother), 5

Sloane, Sarah and Elizabeth (daughters), 189, 308, 317

Sloane, William (brother), 5

Sloane, William (nephew), 186, 312

Sloane Plates (porcelain), 178

Smirke, Robert, 335

Smith, Diedrick, 293

Smollett, Tobias, 288, 309–10, 329–31, 339, 341

smuggling, 41, 115, 236–7

Smyrna (İzmir), 176

Smyth, John, 161

Soane, John, xxii

Society of Antiquaries, 16

Society of Apothecaries, 9, 178, 179

Society for Constitutional Information, 332

Society for the Promotion of Christian Knowledge, 235, 259, 292

Society for the Propagation of the Gospel, 192, 235

Solander, Daniel, 333

Solomon, Job ben: *see* Diallo, Ayuba Suleiman

Somerset, 204, 278

Sommers, Lord, 160

Sondes, Lady, 153

sorcery: *see* witchcraft

Sotheby's, 206

South Africa, 208, 217 (*see also* Cape of Good Hope)

Southall, John, 293

Southampton, Earl of, 150

South Sea Bubble, 147, 151, 175, 219, 235

South Sea Company, 124, 147, 176, 187, 190, 212, 217, 236–8, 245, 312

South Sea Islands, 273
South Seas, 71, 148, 159, 247, 293
    (*see also* Pacific Ocean)
Southwell, Edward, 153, 161, 299, 312
Southwell, Edward, Jr, 314
Southwell, Robert, 152, 153, 159,
    247, 314
Spain, 4, 21, 23, 25, 63, 156, 231,
    237, 301 (*see also* Spanish
    Empire)
Spalding Gentleman's Society, 252
Spanish Empire, 21, 23, 25, 28, 58,
    62–7, 80, 85, 87, 96–7, 98,
    114–16, 124, 129, 130, 134, 147,
    156, 190, 224, 231, 236–8
Spanish Town (Jamaica), 44, 55,
    57–9, 65, 69, 92, 97, 121, 171
specialization of knowledge, xxv,
    336, 342
*Spectator*, the, 147, 148, 234
Sprat, Thomas, 29, 30
Stack, Thomas, 7, 183, 200, 258,
    262, 282
Standish, Elizabeth and David,
    235, 265
Stanley, George, 189
Staphorst, Nicolaus, 9, 10
Staphorst, Nicolaus, the younger,
    152, 154
Steele, Richard, 149, 150
Steigertahl, Johann, 226–7, 229
Steno, Nicolas, 275
Sterbini, Abbé Bernardo, 208
stories and story-telling, 62–3, 67,
    70–71, 84, 85, 88–9, 128–9, 131,
    133–4, 167, 183, 278–80, 283,
    290, 298, 325, 329
Strait of Gibraltar, 23
Straits of Magellan, 159
Strand, the, 154, 326
Strangford Lough (Ulster), 7
Stuart, Alexander, 192, 212, 219,
    251, 286
Stuart, House of, 20, 143, 173, 184–5
Stubbe, Henry, 30
Stukeley, William, 160, 194, 195
sugar, 21, 22, 30, 37, 38, 39, 40, 41,
    43, 46, 57–8, 65, 69, 87, 88,
    90–91, 93, 97, 129, 132, 146,
    158, 187–9, 216, *Plate 2*
Sumatra, 194, 212, 219, 223, 297
Sunderland, Earl of, 176
superstition, xxv, xxix, 89, 93, 180,
    182, 185, 211, 221–2, 244, 254–
    5, 278, 282–4, 286, 287, 327,
    335, 342 (*see also* amulets;
    charms; credulity; magic;
    progress; Sloane: collections:
    amulets, charms)
Surat, 212, 218
surgeons and surgery, 20, 36, 48,
    123–4, 165–6, 169, 176, 177,
    182, 190, 191, 207, 218–23,
    236–8, 245, 273
Surinam, 21, 203, 204
Surrealism, xxvii
Sweden, 227, 298
Swedenborg, Emanuel, 294
Swift, Jonathan, 148, 163–5, 225, 276
Sydenham, Thomas, 18–20, 34, 48,
    149, 151, 180
Symmer, Jonathan, 191
Syria, 339

Tacky's Rebellion, Jamaica (1760), 95
    (*see also* slave rebellions and
    resistance)
Taíno people (Jamaica), 40, 62, 64–7
    (66), 67, 82, 87, 98, 116–17, 129
Talbot, Catherine, 318
talismans: see amulets; charms
Tanner, Thomas, 275
Tartary, 240, 282
*Tatler*, the, 290, 307
Taylor, John, 92, 94, 128
tea, 43, 100, 147, 222, 252

Temple Coffee House, 161, 165

Tenerife, 71

Thames, River, xix, 29, 32, 192, 249, 279

Thevet, André, 264

Thistlewood, Thomas, 84, 91, 128

Thomas, Alban, 258

Thomson, James, 301

Thoresby, Ralph, 169, 195, 259, 308

Three-Fingered Jack: see Mansong, Jack

Tibet, 220

tobacco, 22, 58, 93, 124, 127, 146, 190, 230, 239, 244, 252, 255

Tobago, 71

Tobermory, 31

Tofts, Mary, 283

Tokugawa Shōgunate: see Japan

Tokyo: see Edo

Toland, John, 271

Tomochichi, 235–6, 245, 290, *Plate 20*

Tooanahowi (Yamacraw), 235

tools (in collections), 162–3, 166, 224, 231, 234, 243, 247–8

Tordesillas, Treaty of (1494), 20

Tories, 9, 34, 143, 147, 164, 173, 175, 234, 315

Tournefort, Joseph Pitton de, 16, 156, 157, 271

Townley, Charles, 335

trade, xxiv, xxx, 14–15, 20, 21–2, 23, 24, 30, 58, 68–71, 85, 89–91, 98, 114–15, 117, 126, 127, 143, 146–8, 152, 163–4, 167, 169, 172, 175, 190–91, 197, 207, 210–11, 213, 216, 221–3, 224, 226–8, 230–57, 272, 286, 287, 288, 326, 338–9, 341 (*see also* British Empire; colonialism; merchants)

Tradescant, John, 29, 280, 306

Tradescant's Ark: see Tradescant, John

translation and translators, 11, 23, 25, 62, 112, 114, 164, 226–9, 237, 251–6, 258, 261, 273, 276, 285–6, 327, 335 (*see also* language and science; languages)

Trapham, Thomas, 48, 51, 55–6, 58, 114

travel, 14–15, 19–20, 22–4, 28, 30, 34–6, 44, 57–67, 97–8, 125, 190–91, 203–204, 209, 211–57, 299

travel accounts, 25, 115–16, 154, 169, 209, 247–8, 264, 272–3

travel questionnaires, 30, 44, 73–4, 117–18

treasuries and treasure, 24, 29, 31–2, *33*, 34, 25, 38, 62–3, 71, 85, 130, 270–71, 279–80

Tripoli, 284

Trismegistus, Hermes, 12, 14, 272

Tryon, Thomas, 72

Tullideph, Walter, 169, 267

Tunis, 160, 272–3, 284

Tunquin (Tonkin), 213, 290

Turkey: see Ottoman Empire

Tuscany, grand dukes of, 325

Tuscarora people, 244

Twickenham, 162

Tyson, Edward, 281

Uffenbach, Zacharias Konrad von, 151, 202, 288, 295–8, 306, 307

Ulster, xxi, xxix, 4–8, 10, 18, 19, 20, 32, 36, 41, 141, 142, 153, 157, 162, 200, 209, 230, 250, 261, 310, 328, 341 (*see also* Anglo-Irish community; Sloane: biography: Irishness; Ulster Protestants)

Ulster Protestants, 6, 19–20, 141–2

Unani medicine (South Asia), 218

universalism, xxi, xxiv–xxv, xxvii, xxviii–xxxi, 14–15, 24, 26–7,

29, 82, 257, 256–7, 266–7, 270, 303, 329–30, 330–31, 336, 342 (*see also* encyclopaedism; microcosm/macrocosm)
universities, European (general), 11–12
Urry, John, 275
Ussher, James, Archbishop, 6
Utrecht, Peace of (1713), 146, 231
Uvedale, Robert, 221

van der Gucht, Michael, 107
van Helmont, Johannes Baptista, 14, 272
van Reede, Hendrick, 24
van Rymsdyk, Jan and Andreas, 325, 326, 330
Vaughan, John, 31
Vauxhall Gardens, 334
vegetable lamb of Tartary, 282–3, 327, *Plate 38* (*see also* fraud and fakes)
Venice, 23, 207
Vera Cruz, 238
Verelst, William, 235–6, *Plate 20*
Vesalius, Andreas, 19, 323
Vienna, 252
Vietnam: *see* Cochinchina
Vincent, Levinus, 270, 296
Virginia, 21, 25, 41, 44, 77, 97, 169, 177, 191, 230, 239, 240, 242, 244, 297
Virginia Company, 25
virtuosos and collecting, 29–30, 89, 164–6, 197, 250, 290
visual knowledge, xx, xxiii, 15–16, 19, 24, 96–116 (*104–106, 108–109, 110, 111*), 118, 119, 122, 123, 125, 129–30, *133*, 157–9, 166, 171, 172, 197, 203–204, 208, 221–2, 238, 240–43, 257, 260, 262, 263, 264, 265, 273–4, 276, 277, 286, 296, *Plates 1, 6, 13, 28–9* (*see also* artists; botany; natural history)
Voltaire, 147, 271

Wafer, Lionel, 248, 264
Wager, Charles, 245
Waite, Nicholas, 217
Wakley, Thomas, 16, 17, 25
Waldo, Daniel, 211, 212, 218
Walduck, Thomas, 93, 95, 100
Wales, 4, 160, 165, 342
Wales, Frederick, Prince (and Princess Augusta) of, xix–xxi, 55, 300, 302, 304, 324
Wallis, John, 46
Walpole, Catherine, 175
Walpole, Horace, 312–13, 330
Walpole, Robert, 151, 313, 316
Walpole, Thomas, 312
Wampanoag people, 231
Wampum, 235, 324, 326
Wanley, Humphrey, 209, 258, 262, 277
war and science, xxviii, 156–7
War of the Spanish Succession (1701–14), 142, 146, 302
Ward, John, 318–19
Ward, Ned, 45, 126
Waterford, County, 10
Watson, Francis, 49, 55, 56, 58, 69
Watson, William, 318
Watts, Mr (Chelsea Physic Garden), 10
Weiser, Conrad, 244
Welin, Johan, 293–4
Wendelborn, Frederick, 330
Werenfels, Samuel, 185, 285
West Africa, 20, 21, 22, 32, 40, 42, 69, 74, 81–4, 88, 89, 90, 99, 117, 128, 157, 176, 187, 230, 251, 255–7, 268, *Plates 12, 18, 25, 33* (*see also* Africans in diaspora; Guinea; slaves and slavery; slave trade)
West Indies: *see* Caribbean islands
Western Design, Cromwell's (1655), 21, 40, 63

Westmacott, Richard, 335
Westminster, 141, 143
Westminster Abbey, 57, 279, 307
wet nursing, 49–50, 176
Wharton, Goodwin, 31
Whigs, 5, 9, 31, 34, 141, 143, 150, 151, 174, 181, 185, 193, 314–15
whipping, torture and executions, 42, 51, 65, 67, 78–80, 84–5, 88, 95, 127, 191, 248 (*see also* slaves and slavery)
White, John, 274
White, William, Edward and John, 199–200
Whitehall, 136
Whiteinge, Edward, 273, *Plate 29*
Wilkes, John, 331–2
Wilkins, John, 29, 101
William III, xx, 17–18, 32, 133–4, 136, 141–3, 150, 156, 159, 161, 193, 200, 292, 301
and Mary, 142–3, 200 (*see also* Mary (Queen))
William of Orange-Nassau: *see* William III
Williams, Charles Hanbury, 290
Williams, Cynric, 88
Winthrop, John, 245, 264–5, *Plate 27*
witchcraft, 52, 95, 100, 281
Woide, Karl, 330

women and collecting, 122, 203–205, 290–91 (*see also* gender, class and museum-going; gender, curiosity and collecting)
wonder, wonders and marvels, 22, 24, 29, 77, 85, 128–9, 167, 169, 183, 203, 294
wonder-cabinets, xxvii, 24, 26–7, 130, 282, 294, 300, 326, 339 (*see also* curiosity cabinets)
Woodward, John, 30, 73, 74, 97, 100, 101, 102, 120–21, 193, 195, 208–209, 221, 247, 277, 295
Wormius, Olaus, 26–7, 261
worms, 46, 91, 122–3 (*123*), 124, 132
Wren, Christopher, 150
Wright, Lawrence (HMS *Assistance*), 133
Wriothesley, Rachel, 150

Yale, Elihu, 217, 222, *Plate 14*
Yamacraw people, 235–6, 252, 253, 290, *Plate 20*
Yamasee War (1715), 231, 241
Yonge, James, 77
Yorke, Philip, 314
Yorkshire, 325
Young, Edward, 289, 290

Zinzendorf, Nicolaus, 312
Zollman, Philip Henry, 227
zoology: *see* Sloane: collections